CÉZANNE TO VAN GOGH

The Collection of Doctor Gachet

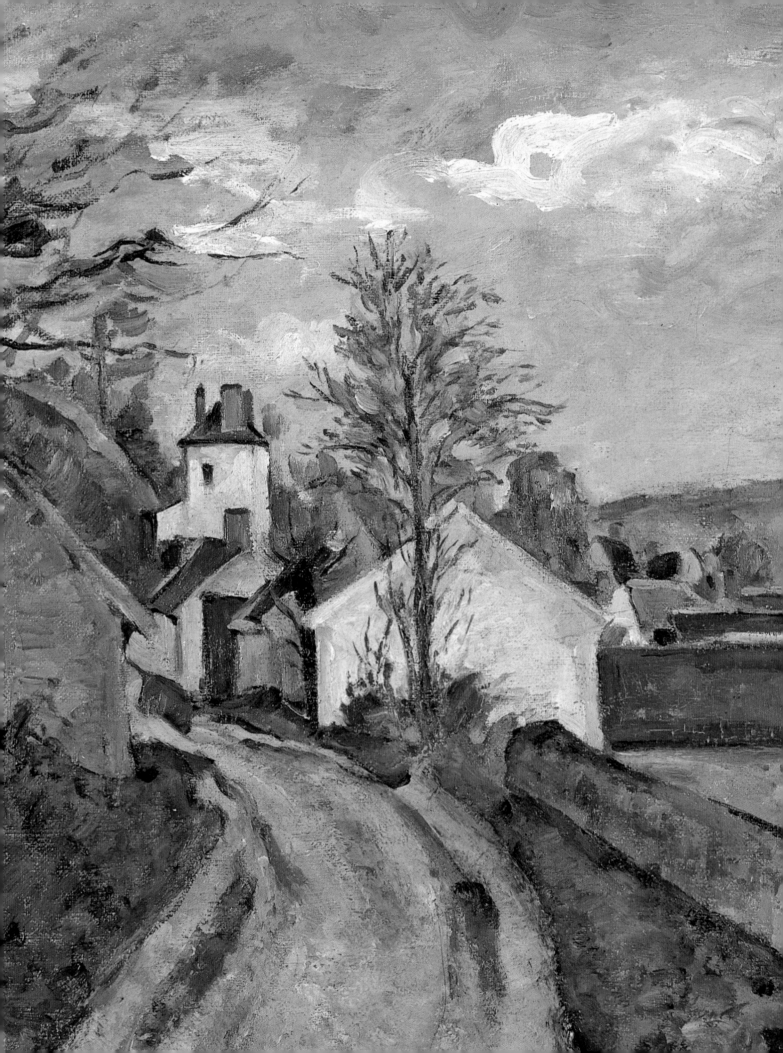

Cézanne to Van Gogh

The Collection of Doctor Gachet

Anne Distel and Susan Alyson Stein

The Metropolitan Museum of Art, New York

Distributed by Harry N. Abrams, Inc., New York

This catalogue is published in conjunction with the exhibition "Cézanne to Van Gogh: The Collection of Doctor Gachet" held at the Grand Palais, Paris, January 28–April 26, 1999, at The Metropolitan Museum of Art, New York, May 25–August 15, 1999, and at the Van Gogh Museum, Amsterdam, September 24–December 5, 1999.

The exhibition is made possible in part by **Metropolitan Life Foundation**.

Additional support for the exhibition and its accompanying publication has been provided by Janice H. Levin.

An indemnity has been granted by the Federal Council on the Arts and the Humanities.

The exhibition was organized by the The Metropolitan Museum of Art, New York, the Réunion des Musées Nationaux / Musée d'Orsay, Paris, and the Van Gogh Museum, Amsterdam.

Published by The Metropolitan Museum of Art, New York

John P. O'Neill, Editor in Chief
Ruth Lurie Kozodoy, Editor
Bruce Campbell, Designer
Katherine van Kessel, Production, with the assistance of Merantine Hens-Nolan
Ilana Greenberg, Desktop Publishing

Translations from the French by Mark Polizzotti, Jean Marie Clarke, and Frederick Brown

Color separations made by Professional Graphics Inc., Rockford, Illinois
Printed and bound by Arnoldo Mondadori Editore, S.p.A., Verona, Italy

Library of Congress Cataloguing-in-Publication Data

Distel, Anne.
Cézanne to Van Gogh: the collection of Doctor Gachet / Anne Distel and Susan Alyson Stein.
p. cm.
Catalogue of an exhibition held at the Musée d'Orsay, Paris, Jan. 28–Apr. 26, 1999, the Metropolitan Museum of Art, New York, May 25–Aug. 15, 1999, and the Van Gogh Museum, Amsterdam, Sept. 24–Dec. 5, 1999.
Includes bibliographical references and index.
ISBN 0-87099-903-6 (hardcover)
ISBN 0-87099-904-4 (pbk.: alk. paper)
ISBN 0-8109-6538-0 (Abrams)
1. Impressionism (Art)—France Exhibitions. 2. Post-impressionism (Art)—France Exhibitions. 3. Art, French Exhibitions. 4. Art, Modern—19th century—France Exhibitions. 5. Gachet, Paul Ferdinand, 1828–1909—Art collections Exhibitions. 6. Art—France—Paris Exhibitions 7. Musée d'Orsay Exhibitions. I. Stein, Susan Alyson. II. Musée d'Orsay. III. Metropolitan Museum of Art (New York, N.Y.) IV. Van Gogh Museum, Amsterdam. V. Title.
N6847.5.14D57 1999 99-20464
709 .03 4407444361—dc21 CIP

Jacket/cover illustration: Detail, Vincent van Gogh, *Portrait of Doctor Paul Gachet*, 1890; cat. no. 13
Frontispiece: Detail, Paul Cézanne, *Dr. Gachet's House at Auvers*, 1872–73; cat. no. 2

Contents

Curators of the Exhibition

Susan Alyson Stein
Associate Curator, The Metropolitan Museum of Art

Anne Distel
Curator in Chief, Musée d'Orsay

Andreas Blühm
Head of Exhibitions, Van Gogh Museum

Organizing Committee

Philippe de Montebello
Director, The Metropolitan Museum of Art, New York

Irène Bizot
General Administrator, Réunion des Musées Nationaux

Henri Loyrette
Director, Musée d'Orsay, Paris

John Leighton
Director, Van Gogh Museum, Amsterdam

Lenders to the Exhibition

Amsterdam Van Gogh Museum (Vincent van Gogh Foundation)

Boston Museum of Fine Arts

Cambridge, Massachusetts Fogg Art Museum, Harvard University Art Museums

Chicago The Art Institute of Chicago

Lille Musée des Beaux-Arts

Madrid Museo Thyssen-Bornemisza

New York The Metropolitan Museum of Art
 The New York Public Library
 The Pierpont Morgan Library, Thaw Collection

Paris Bibliothèque Nationale de France
 Musée de l'Orangerie
 Musée d'Histoire de la Médecine
 Musée d'Orsay
 Musée du Louvre
 Musée National des Arts Asiatiques-Guimet
 Wildenstein Institute

Philadelphia Philadelphia Museum of Art

Pontoise Musée Tavet-Delacour

Poughkeepsie, New York The Frances Lehman Loeb Art Center, Vassar College

Michael Pakenham

Private collections

Directors' Foreword

Cézanne to Van Gogh: The Collection of Doctor Gachet" was originally conceived as a Musée d'Orsay "dossier" exhibition organized around the Gachet family's gift to the French state and intended to acquaint the public with the personality of Dr. Gachet. It took a different turn, however, when two of the museum's longstanding partners, The Metropolitan Museum of Art in New York and the Van Gogh Museum in Amsterdam, decided to participate in the project and thus give it international exposure. Since, with the exception of the two famous portraits by Van Gogh that were included in the centennial retrospective held in Amsterdam in 1990, virtually none of the works in the Gachet donation have ever before left France, this exhibition is not only an exciting event but also one of unquestionable importance.

A fascinating and multisided individual, Paul-Ferdinand Gachet (1828–1909) was a homeopathic physician, an amateur printmaker and painter, and the friend and patron of a cluster of Impressionist and Postimpressionist artists—including Cézanne, Pissarro, Guillaumin, Monet, Renoir, and Van Gogh—whose talents he was among the first to recognize. The exhibition presents major examples of the artists' work; it also features copies made after them at the turn of

the century by Dr. Gachet, by his son, and by other amateurs in their circle, as well as a trove of "souvenirs" (artist's palettes and still-life and household objects) that record Gachet's close relationships with pioneering nineteenth-century painters.

This occasion also highlights the role of Paul Gachet *fils* (1873–1962), the doctor's son and namesake, who preserved his father's legacy by acting as biographer, as cataloguer and jealous guardian of the legendary collection, and, between 1949 and 1954, as munificent donor to the French state. At that time he expressed the desire, which was fully supported by the curators, to restrict loans to temporary exhibitions. However, he made it clear that those now responsible for the works would be free to judge if and when the merits of an exhibition warranted lending them. A half-century after the first gift in 1949 seems the right moment to pay homage both to Dr. Gachet and to the artists he loved.

The Gachet donation boasts many famous but little-known paintings, including such undisputed masterpieces as Cézanne's *A Modern Olympia* of 1874 and Van Gogh's hypnotic *Self-Portrait* of 1889. It also includes works that have sparked considerable debate among scholars. In this timely and provocative exhibition, viewers will have the opportunity to compare

originals and copies and to reassess, in the light of new technical and documentary findings, those works—such as the Musée d'Orsay version of Van Gogh's *Portrait of Doctor Paul Gachet*—that have been the subject of particular controversy.

The Gachet donation is here seen in its full scope for the first time since 1954–55 and, thanks to the generosity of private and public collections, enriched by additional loans. The event is of special significance to all three organizing institutions: with it the Musée d'Orsay pays tribute to a collector and to a significant donor, while the Metropolitan and Van Gogh museums offer their visitors a rare view of a distinctive group of works. In all three museums, a thought-provoking dialogue takes place between masterpiece and copy, and the often vexing questions of attribution are addressed with clarity. At the same time the exhibition provides an intimate glimpse of a private collection formed at a time of great artistic innovation by an individual whom his contemporaries regarded as (in the words of Paul Alexis) "one of the liveliest and most sympathetically original of men."

We are deeply grateful to the lenders to this exhibition and to all those named in the acknowledgments. In particular, Daniel Wildenstein and Michael Pakenham generously shared crucial information.

An outstanding effort was made by the curators and authors, Anne Distel and Susan Alyson Stein, to produce a book that would serve both as a catalogue of the exhibition and as an original and solid foundation for further study. We salute them and also Andreas Blühm, who organized the exhibition at its Amsterdam venue.

In New York, the exhibition is sponsored in part by the Metropolitan Life Foundation, an important ongoing donor to the Metropolitan Museum's exhibition program. We would also like to express our immense appreciation to Janice H. Levin for generously contributing funds that help to defray the cost of this undertaking. Finally, the exhibition is supported by an indemnity granted by the Federal Council on the Arts and the Humanities.

Philippe de Montebello
Director, The Metropolitan Museum of Art, New York

Henri Loyrette
Director, Musée d'Orsay, Paris

John Leighton
Director, Van Gogh Museum, Amsterdam

Introduction

Half a century ago, when the contents of the Gachet donation to the French state were first unveiled in a 1954–55 exhibition, the public was afforded a rare opportunity to see paintings that were famous, little known, and—as headlines like *Le Figaro*'s "Ces toiles sont-elles de Van Gogh?" ("Are These Canvases by Van Gogh?") proclaimed—the subject of controversy. Today this legendary group of works makes its first appearance outside France amid remarkably similar doubts, reminding us that history has an uncanny way of repeating itself and, where Van Gogh's most famous (or infamous) sitter is concerned, of being rewritten as well.

Over the years, the literature has given us different and contradictory perceptions of the doctor-collector-amateur-artist Paul-Ferdinand Gachet (1828–1909) and of the works he owned by Impressionist and Postimpressionist painters once unappreciated but now revered. No less enigmatic is Dr. Gachet's son, Paul Gachet *fils* (1873–1962), who shared his father's name, eccentricities, enthusiasms, and modest artistic talent that commended itself to copying. Indeed, by the time he was seventeen and Van Gogh arrived in Auvers, bringing his own copies after Daumier, Delacroix, and Gauguin, the practice of copying was already well established in the Gachet household by the artistic interchanges of the 1870s between Cézanne, Guillaumin, Pissarro, and Dr. Gachet.

In his writings and by donating an important part of the legacy that he had safeguarded for most of his adult life, Gachet *fils* introduced the public to the sympathetic doctor, who "painted in his spare moments" and "has been in contact with all the Impressionists," as Pissarro told Theo van Gogh in 1890. Dr. Gachet was one of the first to recognize the talents of artists then "groping, not always successfully, for new modes of expression," to borrow John Rewald's apt description of Cézanne in the early 1870s. Gachet was also one of the first, as he said of himself in 1890, to "regard Vincent

as a *giant*." The idea that he exploited these artists rather than supporting them and forged their works in order to ensure his own posthumous fame—or that he did so with the connivance of his son, or that his son was the chief perpetrator (the distinction is not always clear)—seems to be a twentieth-century invention.

Predicating questions of authenticity not on the works themselves but on suppositions about the Gachets' integrity sidesteps the difficult challenges of attribution presented by this fascinating group of works, which are often from periods of the artists' careers not fully understood. (The scholarship assigns more works to Van Gogh's Auvers period than he could possibly have made.) Increasingly, works have been doubted simply because the Gachets are regarded as suspect and the works themselves fail a single "test": for Van Gogh, whether a painting was mentioned by the artist in a letter, and for Cézanne, whether it is recorded in a photograph from the group made around 1905 by the dealer Ambroise Vollard (two bodies of evidence that are only partially extant). Indulgence in this kind of methodology has invited even further speculation, as researchers eager to resolve the doubts that scholars have left to innuendo zealously furnish "proof" of foul play, using strategies more familiar to tabloid journalism than to art-historical research.

Ironically, what is perceived as the most incriminating evidence of all—the existence of copies of works in the collection, made by the Gachets and by others in their circle—tends to support rather than undermine the correctness of attributions. Many of the copies are dated between 1900 and 1903, and the practice of making them is recorded as early as 1904. Their documentary value may be compared to that of Vollard photographs, since they allow us to establish the presence and appearance at an early date (before pigments discolored and cheap supports disintegrated) of numerous works in the Gachet collection. Indeed, it is

too early a date for the artists' works to have been forged for posterity, unless the Gachets possessed not only the requisite artistic talent, which is questionable enough, but also the power to predict the future. In 1904 the German critic Julius Meier-Graefe wrote that Van Gogh's place in the history of art was already assured, largely because of collectors like Gachet, whom he listed as owning twenty-six of the artist's paintings (effectively establishing an early provenance for the entire collection); yet he also added, "It is improbable that the time will ever come when [Van Gogh's] pictures are appreciated by the layman; it is more conceivable that pictures should cease to be produced altogether than that Van Gogh's should become popular."

That year a "portrait of a man" by Van Gogh was sold by a dealer for roughly $400. In 1990, when the same painting sold at auction for the record-breaking sum of $82,500,000, the already well known sitter for the *Portrait of Doctor Paul Gachet* became even more famous. History might have reserved a negligible place for both painter and subject had their legacies not been preserved by two individuals, a sister-in-law and a son—Johanna van Gogh and Paul Gachet *fils*—motivated by a peculiar attachment to the memory of an artist each hardly knew.[1]

This catalogue, like the exhibition it accompanies, began modestly but evolved into an ambitious, and within the short time allotted often daunting, undertaking. Anne Distel and I recognized that scholarship, and any real understanding it could afford, had reached an impasse because speculation had taken over where factual information was lacking or ignored. This volume was designed to furnish the documentation necessary for the making of informed judgments about authenticity. It contains new information on the Gachets, the history, nature, and contents of their collection, recent technical findings on the works, and the copies, as well as all the excerpts from the known 1889–91 correspondence pertaining to Dr. Gachet's relationship with Van Gogh. It is meant as an introduction to this most original collection and a starting point for serious study and reassessment.

Susan Alyson Stein

1. It proved impossible to accommodate even within the broadened scope of this catalogue the nearly three hundred unpublished letters written over the course of more than fifty years (1904–61) between the Gachets, the artist's sister-in-law, Johanna van Gogh-Bonger, and her son, Vincent Willem van Gogh, that are preserved in the archives of the Van Gogh Museum. We have generously quoted from this correspondence and provided references to relevant letters in the Summary Catalogue entries. It is only from reading these letters that one gains a sense of the later history of the collection, as Johanna understood it: "a friendship not ended by death, for Dr. Gachet and his children continued to honor Vincent's memory with rare piety which became a form of worship, touching in its simplicity and sincerity" (from her preface to the 1914 edition of Van Gogh's correspondence, reprinted in Van Gogh Letters 1958, vol. 1, p. LI). The imperfect knowledge Johanna van Gogh-Bonger and Paul Gachet *fils* each had of their legacies was the mainstay of twenty-odd years of letter-writing. Each refused to part with certain works and let go of others, a cause for later regret (the Van Gogh Museum presently lacks, for example, an *Arlésienne*, a *Berceuse*, a *Postman Roulin*), and it is not impossible that both sold works they had innocently misattributed (a fact that has not been considered by scholars, who have put blind faith in Johanna's sale records as proof of authenticity). As for V. W. van Gogh's virulent distrust of the Gachets, which caused him to doubt virtually all the works they owned (including the one he had warmly accepted in 1954, and even those mentioned in the correspondence), this too has to be seen in context: his complete change of mind came, as it did for others of his generation, in the wake of the insinuations and sensational journalism that followed the revelation of the Gachet donation.

Acknowledgments

Viewers in New York and Amsterdam have the unique opportunity to see this fascinating ensemble of works because of the generosity of our colleagues in Paris. In particular we would like to acknowledge our debt to Henri Loyrette, Director of the Musée d'Orsay, who recognized the value of this historic show for an international audience, and to Irène Bizot, General Administrator of the Réunion des Musées Nationaux, who oversaw the arrangements that made the loan possible. Philippe de Montebello at the Metropolitan Museum and John Leighton at the Van Gogh Museum secured for their respective institutions the distinction of hosting this once-in-a-lifetime event.

We thank our colleagues at other museums and public collections in France for kindly lending Gachet donations that have enriched their own holdings. The Van Gogh Museum has participated generously in this undertaking with an important group of works owned by the Vincent van Gogh Foundation, a loan that was generously expanded for the venues in New York and Amsterdam. For his invaluable assistance in selecting these loans and for the benefit of his expertise and advice throughout the realization of this project, we are grateful to Sjraar van Heugten, Curator of Drawings and Prints at the Van Gogh Museum. Our desire to supplement the exhibitions in New York and Amsterdam with certain key works formerly owned by Dr. Gachet was met with generosity on the part of their present owners. These paintings, drawings, and etchings (including surrogate impressions of prints that are now lost or otherwise unavailable) allow us to document more fully Gachet's rich and varied collection.

For making special accommodations to lend to this project and for their responsiveness to our requests for information about works in their collections, we would especially like to thank Clifford Ackley, Laure Beaumont-Maillet, Arnauld Brejon de Lavergnée, Francesca Consagara, James Cuno, Jean Pierre Cuzin, Cara Denison, Douglas Druick, Christophe Duvivier, Pierre Georgel, Gloria Groom, Jean-François Jarrige, Laurence Kanter, Sarah Kianofsky, Isabelle Le Masne de Chermont, Tomás Llorens, James Mundy, Ann Percy, Charles E. Pierce Jr., Innis Howe Shoemaker, Eugene V. Thaw, Françoise Viatte, Roberta Waddell, James Wood, and Elizabeth Wyckoff.

The ambitious scope of the catalogue is in large part a reflection of new findings that came about because of generous collaboration. Above all we wish to single out Daniel Wildenstein, who warmly supported the project and granted us exceptional access to unpublished documentation, including the collection catalogue by Paul Gachet *fils*, in the archives of the Wildenstein Institute, Paris. At the firm we were fortunate to have the advice of Rodolphe Walter and the assistance of Sophie Pietri and Fabienne Charpin, and we thank Patrice Schmidt of the Musée d'Orsay for making photographs available to us for purposes of study and publication. We are equally indebted to Ay-Whang Hsia of the New York branch of Wildenstein, for the considerable time and dedication she devoted to establishing the later histories of works bought from Gachet *fils* and sold by the gallery.

Our colleagues at the Van Gogh Museum, Fieke Pabst and Monique Hageman, made sure that we had access to all the relevant documentation available in their archives and could not have been more helpful or gracious in response to our many inquiries and requests. We are grateful to Albert Chatelet and Jeannine Baticle for the historical perspective they offered on the reception of the Gachet donation at mid-century; to Agnès Galmiche for assisting our research in the Druet archives; and to Marie-Véronique Clin for guiding us through the material housed in the Musée d'Histoire de la Médecine.

Works from the Gachet collection are now scattered around the world; in our efforts to identify and locate them and establish their subsequent provenances we have been assisted by many individuals on both sides of the Atlantic. For generously consulting archives and sale records on our behalf, we would like to thank Jean-Claude Bellier, Camilla Bois, Christopher Burge, Guy-Patrice Dauberville and Michel Dauberville, Richard Feigen, Walter Feilchenfeldt, Evelyne Ferlay, Kate Garmeson, and Melissa de Medieros. We are equally grateful to colleagues in other museums and to private collectors who shared information about works in their possession or under their care: Noriko Adachi, Hélène Bayou, Christoph Becker, Siegfried Billesberger, Claude Bouret, Jill DeVoyar-Zansky, Cecile Dupont-Logié, Michel Hilaire, Nicholas King, Christophe Leribault, Erika Lindt, Hélène Lorblanchet, Marie-Dominque Nobecourt, Iris Peruga, Anne-Marie Peylhard, Maxime Préaud, Patrick Ramade, Maria Elena Ramos, Valérie Sueur, Marielène Weber, Michael Werner, Signe Westergaard-Nielson, Hakan Wettre, Elliot K. Wolk, Mr. and Mrs. Ralph Wyman, and also those owners who wish to remain anonymous. We also express our warmest thanks to scholars: Jayne Warman, for her collegial help in fielding numerous Cézanne-related queries; Roland Dorn and Bogomila Welsh-Ovcharov, for the insights they contributed on Van Gogh issues; and Joachim Pissarro for generously sharing unpublished material on Pissarro.

Many other individuals have answered inquiries, provided information or assistance, and directed us through their archives, libraries, and collections; we especially thank Geneviève Aitken, Yves d'Auvers, Irene Avens, Bénédicte Chantelard, Frédéric Chappey, Jacques Collette, Bernadette Cordina, Annick Couffy, Marie-Paule Défossez, Stéphane Delobel, Alain Duval, Gérard Fabre, Marina Ferretti, Jacques Fischer, Jacques Foucart, Mme Garcia, Caroline Durand-Ruel Godfroy, Roger Golbéry, Odile Guillon, Mme Philippe Huisman, Gilles Kraemer, Christian Lahanier, Brigitte Lainé, Isabelle de Lannoy, Maurice Lemaitre, Walter Liedtke, Francis Macoin, Mme Marco, Elisabeth Martin, Gaëlle Masse, Alain Mercier, Charles S. Moffett, Pierre Mollier, Alain Mothe, Christophe Moulherat, Chantal Nessler, Keiko Omoto, Ronald Pickvance, Brigette Riboureau, Anne Roquebert, Loren Rubin, Joseph Salomon, Véronique Sintobin, Maurice Solier, and Elisabeth Valsanis.

All of the contributors to the catalogue deserve our particular gratitude, not only for the individual texts they have written but also for their helpful collaboration in our general effort to better understand the Gachet collection. We thank Danièle Giraudy, Jean-Pierre Mohen, Élisabeth Ravaud, and Jean-Paul Rioux for sharing their technical expertise. Michael Pakenham, whom we had the great fortune to meet thanks to Luce Abélès, generously placed at our disposal his archives and his great wealth of knowledge, making indispensable contributions. A great debt of gratitude is owed Julie Steiner. At the Metropolitan Museum, she was intimately involved in all aspects of the project large and small, dedicating her keen research skills and abundant enthusiasm to each of the tasks at hand. We particularly acknowledge her instrumental help in compiling the documentation for the Summary Catalogue and in manning the database program that contained it.

For recognizing the value of this documentation from the start and then undertaking—with patience and seeming ease—the enormous task of bringing it to light, an incalculable debt is owed Senior Editor Ruth Kozodoy. Her guiding intellect shaped, in essential ways, the present form and content of the book, and her skill and sensitivity as an editor made it better. John O'Neill, Editor in Chief, and Gwen Roginsky, Chief Production Manager, devoted their support and considerable resources to the project. Katherine van Kessel, assisted by Merantine Hens-Nolan, skillfully and with great dedication saw the book through its various stages of production. We were equally fortunate to have the extremely capable and gracious services of Ilana Greenberg for the desktop publishing, with the additional help of Carol Liebowitz. Bruce Campbell is responsible for the book's handsome design. Penny Jones compiled the bibliography and Peter Rooney the

index. Cynthia Clark, Georgette Felix, Lory Frankel, Stephen Frankel, Kathleen Howard, Joan Meinhardt, Tonia Payne, and Ellen Shultz all provided valuable editorial assistance. Frederick Brown, Jean Marie Clarke, and Mark Polizzotti translated the French texts. The French edition of the catalogue, produced under the direction of Anne de Margerie, was edited by Céline Julhiet-Charvet and Françoise Dios and designed by Cécile Neuville. All worked indefatigably on the book, assisted by Annie Desvachez, Tania Hagemeister, Charlotte Liébert, and translator Dennis Collins.

At the Musée d'Orsay, we would like to acknowledge the research and installation assistance of Isabelle Cahn, Laurence des Cars, Emmanuelle Héran, Pierre Korzilius, Monique Nonne, Édouard Papet, Sylvie Patin, Renaud Piérard, Anne Pingeot, Marie-Pierre Salé, Laurent Stanich, Philippe Thiébaut, and Jean-Claude Yon, and the able management of all press-related matters by Aggy Lerolle and Patricia Oranin. Further thanks are extended to Françoise Cachin, Director of the Musées Nationaux.

At the Metropolitan Museum, special thanks are owed Gary Tinterow, who is to be credited for the idea of the Museum's involvement in the project and who contributed to its realization by generously giving us the benefit of his advice and sound judgment. Dan Kershaw carried out a design for the exhibition in New York that sympathetically displays original and copy and that engages the viewer's eye and intellect; Sophia Geronimus created the attractive exhibition graphics. It would be impossible to imagine mounting an exhibition at the Metropolitan without the initiative of Linda Sylling or the wisdom of Mahrukh Tarapor, whose encouragement and counsel are sincerely appreciated. A debt of gratitude is owed to Colta Ives and another to Rebecca Rabinow for contributions that proved invaluable. Martha Deese kindly offered administrative assistance. Everett Fahy was most supportive.

At the Van Gogh Museum, we extend our thanks to Louis van Tilborgh for his numerous helpful suggestions and to Josette van Gemert for expediting photographic requests.

For expertly handling all the practical arrangements for the loans to the three venues, we thank Anne Fréling and Isabella Marcarella at the Réunion des Musées Nationaux, Doric Grunchec and Manou Dufour, registrars at the Musée d'Orsay, Herbert Moskowitz of the Metropolitan Museum, and Martine Kilburn and Aly Noordermeer of the Van Gogh Museum.

For the New York showing, we would like to express our appreciation to the United States Government Indemnity panel and especially to Alice M. Whelihan, Indemnity Administrator at the National Endowment for the Arts, for their important endorsement of this project. We also thank Michael Findlay, who kindly devoted time and effort to reviewing the indemnity application. We extend our warmest thanks to Janice Levin for her generous contribution of funds toward the project. Finally, we would like to acknowledge with gratitude that the exhibition was made possible in part by Metropolitan Life Foundation.

There are three people for whom no words of thanks seem adequate: Alex and Robert Burwasser and Estelle Jaffe.

Susan Alyson Stein
Anne Distel
Andreas Blühm

The Collection of Doctor Gachet

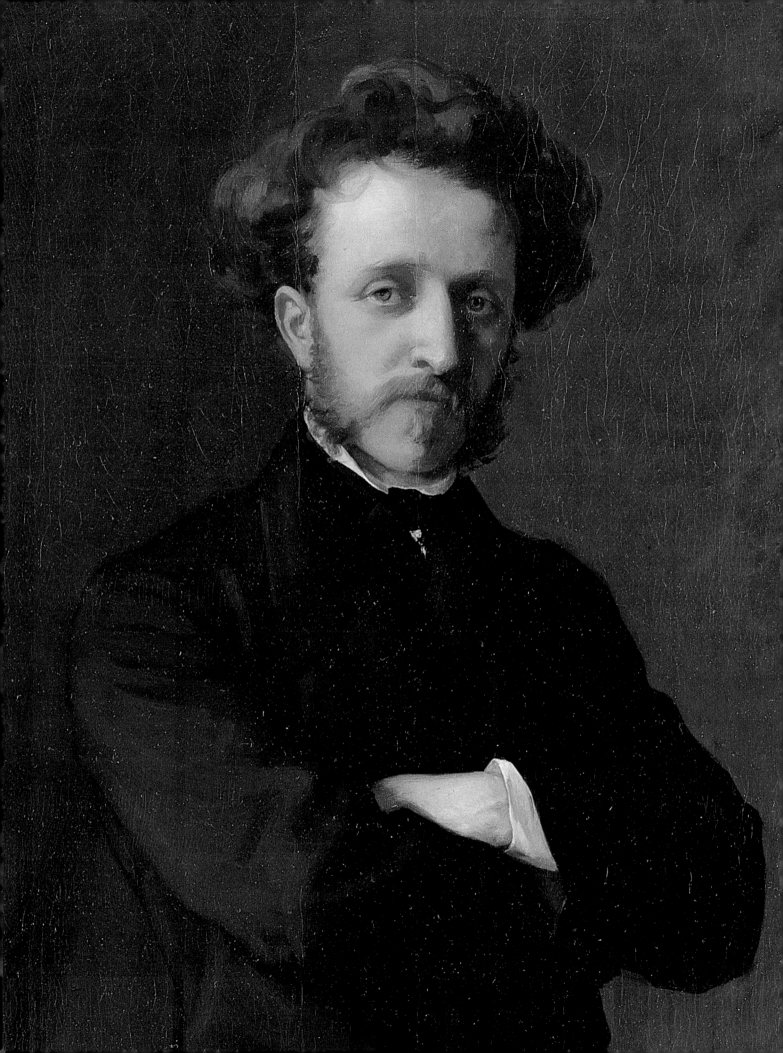

Gachet, Father and Son

ANNE DISTEL

The simple act of lending Paul Cézanne's painting *A Modern Olympia* to the first Impressionist exhibition of 1874 would have been enough to distinguish Dr. Paul Gachet (1828–1909) as a collector of note and even a hero in the artistic battles of the 1870s. That he also welcomed Vincent van Gogh, who painted his portrait in Auvers-sur-Oise during the final weeks of the artist's short and tumultuous career (May–July 1890), ensured the doctor's immortality. Then, years later, an important part of his collection of pictures by Cézanne, Guillaumin, Pissarro, Monet, Renoir, Van Gogh, and others, assembled during the last three decades of the nineteenth century, was given to the French state between 1949 and 1954 by his children, Paul Gachet (1873–1962) and Marguerite Gachet (1869–1949)—heightening, if there were still any need, the fame of both the collector and the works once belonging to him.

Dr. Gachet has already had one zealous and vocal admirer in the person of his son; but, as with any hagiography, the writings of the younger Gachet have attracted their share of criticism. One aim of this study is to disentangle the facts from the various interpretations. It is easy to be put off by the pedantic and often inaccurate or confused prose of Gachet *fils;*[1] nonetheless, when he sticks to facts, the author's obsessive energy—which spares no detail, however obscure, and draws on the accumulated family papers of a household where nothing was thrown out in a hundred years—deserves a certain respect. For that reason this volume also includes the previously unpublished chronology of Dr. Gachet's career (pp. 273–88), set down by his son in 1928, which provides a wealth of facts in a raw state[2] and an initial view of the doctor's multifaceted personality. What follows here is an attempt to bring the man and his active life into sharper focus.

Fig. 1. Detail of Amand Gautier, *Dr. Paul Gachet*, 1859–61 (see fig. 19)

A DOCTOR AND PATRON OF THE ARTS

Born in the north of France into a provincial middle-class family that enjoyed a degree of financial comfort (his father had invented a method of spinning flax mechanically), Paul-Ferdinand Gachet decided on a career as a doctor and in 1848, at the age of twenty, went off to study medicine in Paris. Ten years later, he earned his diploma in Montpellier, having completed a doctoral thesis entitled "Study of Melancholy" that is ample testimony to the young physician's already awakened interest in mental disturbance. His training as an extern under the guidance of enlightened

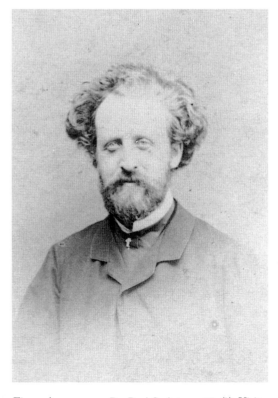

Fig. 2. Anonymous, *Dr. Paul Gachet*, ca. 1860(?). Visiting card photograph. Archives, Wildenstein Institute, Paris

practitioners at Bicêtre in Gentilly and the Salpêtrière in Paris, two hospitals that welcomed mentally ill patients, had provided him with the raw materials for his observations.[3] But Gachet had been a less-than-assiduous medical student, and the main reasons seem to have been the interest he took in painting and his friendship with the painter Amand Gautier, whom he had known since childhood.

Amand Gautier (1825–1894) today figures in histories of art only as a disciple of the realist movement, but he was justly appreciated at the beginning of his career. Closely linked to everyone who counted in avant-garde circles and a friend of Gustave Courbet and the critic Champfleury, he led the young medical student into the bohemia of the 1850s. Likewise, when Paul Gachet volunteered to fight the

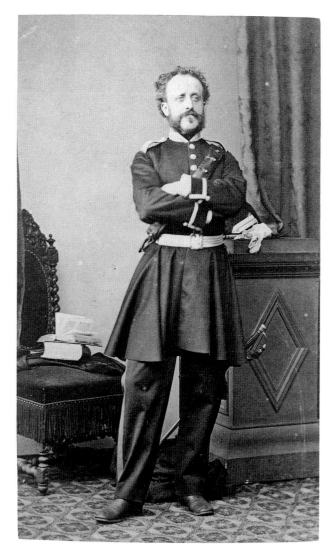

Fig. 3. Anonymous, *Dr. Paul Gachet as Assistant Surgeon-Major*, 1870. Visiting card photograph. Archives, Wildenstein Institute, Paris

cholera epidemic in the Jura in 1854, Gautier went with him; and through his externship at La Salpêtrière, Gachet gave Gautier access to the ward for female mental patients, where his friend found a subject for the painting that would launch his career at the Salon of 1857.

It was thanks to Gautier (and via Courbet) that Gachet, in Montpellier in 1857–58, obtained an introduction to one of the most famous "advanced" collectors of the period, Alfred Bruyas (1821–1877), a local notable, admirer of Delacroix, and renowned protector of Courbet.[4] The meeting was no more than a courtesy call, but it undoubtedly flattered the young man, who was delighted to be traveling in these artistic circles. (It clearly became an important milestone in Gachet's memory, since thirty years later, when Vincent van Gogh arrived in Auvers-sur-Oise in the spring of 1890, it was the subject of one of the first conversations between the two men.)[5] Once Paul Gachet had become a Parisian physician charging 5 francs per consultation, he could even permit himself to act as patron to Amand Gautier: for 23 francs he furnished the canvas for a full-length portrait of himself (fig. 19), which was accepted for exhibition at the Salon of 1861 and then consecrated by becoming the subject of several caricatures. Either as purchases or as gifts, a large number of Gautier's works[6] eventually found a home with Gachet. But after 1872 the doctor at last grew weary of paying the painter's grocery bills, and the two men seem to have had a falling-out.[7]

It was also thanks to Gautier, himself a maker of prints, that Dr. Gachet met Charles Méryon (1821–1868), one of the premier printmakers of his day. Méryon was praised by Victor Hugo and Charles Baudelaire, and his career fascinated his contemporaries; however, it was marked by bouts of madness. I have not been able to verify how many visits Dr. Gachet paid the poor hospitalized artist,[8] but it is certain that Méryon wrote to him on two occasions, in 1861 and 1862, concerning the purchase of prints.[9] This encounter too takes on its full significance only in hindsight. Additionally, it serves to remind us of the doctor's enthusiastic interest in etchings: an avid collector of images, of all kinds[10] and every quality, he would himself become an amateur printmaker.

To all appearances, then, the young physician was a collector, although his collection remained modest. At around that time he seems to have been particularly close to a curio dealer and restorer of old paintings named Joseph Bouilly, who was also an acquaintance of Amand Gautier and from whom he acquired the "black, black

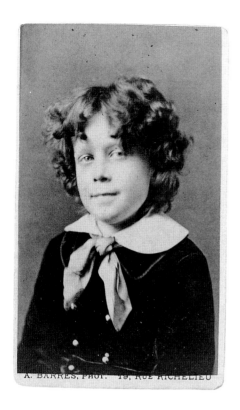

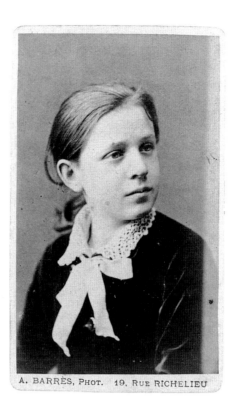

antiques"—knickknacks and furniture—that disconcerted Van Gogh on his first visits to Auvers.[11]

The doctor sketched and painted on occasion,[12] but this was only a hobby, and it did not prevent him from pursuing a conventional medical career. No sooner was his diploma in hand than he signed a lease for an opulent apartment at 9, rue Montholon, where he opened his first office on January 1, 1859; at the beginning of 1863 he moved to 78, rue du Faubourg Saint-Denis, his professional address to the end of his life as well as his private residence (see Inventory, pp. 289–91). Employing traditional medical methods (water cures at the small, neglected thermal spa of Évaux) as well as less orthodox approaches (homeopathy and the use of electricity), he worked at building a clientele. He lost no opportunity to publish works of popular medicine[13] intended for the mainstream public, or to give lectures, notably for art students and artisans who attended the public school of drawing and sculpture on the rue des Petits-Hôtels.[14] Gachet also treated actors and musicians (who obtained free tickets to shows for him). And along with his private practice, he worked in public clinics and with professional organizations. Having received his National Guard rifle in 1864, he was soon promoted to the rank of assistant surgical officer and swore loyalty to the emperor—apparently without qualms, even though he moved in Republican circles.

In 1868 the doctor married a young woman of twenty-eight, Blanche Castets.[15] Almost nothing is known about her except that her father was a cork merchant living on the rue Sainte-Anne, with family ties in Mézin (Lot-and-Garonne region), and that she was a talented pianist, able to compose her own melodies.[16] Their first child, a daughter named Marguerite-Clémentine-Élisa, was born in 1869.

Although the marriage had been blessed at the church of Saint-Roch, Dr. Gachet was a positivist and a freemason,[17] which was not at all unusual in his milieu. Living in Paris at the time of the collapse of the Second Empire, the Prussians' siege of the capital, and the Commune of 1870–71, he sided with the moderate bourgeois who welcomed the secular Republic but kept their distance from the extreme Left. As a physician he demonstrated a dedication that, despite several influential connections and his own persistent applications, was never rewarded with a medal of the Legion of Honor; nonetheless, he received enough diplomas and medals to flatter his vanity.

It seems that after 1870 Gachet's career took a new turn. His deceased parents left him an inheritance,[18] and the pace of his private practice appears to have slowed.[19] Was he tiring of pursuing the career of a neighborhood physician? Concerned about the health of his tubercular wife, he decided to transfer his residence to the country, and in 1872

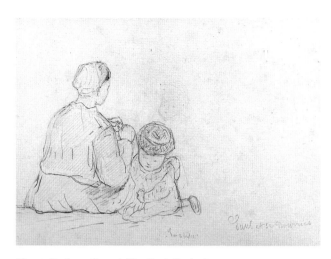

Fig. 6. Paul van Ryssel (Dr. Paul Gachet), *Paul-Louis Gachet and His Nurse*, 1874. Pencil sketch from a friendship album, 7⅞ x 10¼ in. (20 x 26 cm). Archives, Wildenstein Institute, Paris

he settled in Auvers-sur-Oise, an hour's train ride north-west from Paris;[20] it was there that his son, named Paul after him, was born in 1873.[21] However, his wife died not in the country but in the apartment on the rue du Faubourg Saint-Denis, in 1875. From then on, Gachet's professional activities kept him shuttling between Paris and Auvers. A housekeeper, Mme Chevalier,[22] was hired to look after the home in Auvers and raise the children; Gachet never remarried. And his interest in art took a new turn.

PISSARRO, CÉZANNE, AND GUILLAUMIN AT DR. GACHET'S IN AUVERS

Answering questions from the younger Paul Gachet in 1927,[23] Lucien Pissarro precisely placed Dr. Gachet's first visit to his father, Camille Pissarro, in the year 1871—to treat Lucien's younger brother Manzana, born on November 22, 1871, and then still an infant.[24] Between 1871 and 1881 Pissarro regularly called the doctor for himself and his family,[25] especially since Gachet practiced homeopathy (in which the painter was a great believer) and gladly accepted artworks in payment for his services. The Pissarro family's move to nearby Pontoise in the summer of 1872 further strengthened their relations. Camille Pissarro's correspondence testifies that contacts between the two men, though infrequent, continued until the painter's death in 1903.[26] The man primarily responsible for

introducing the doctor to the future Impressionists at the beginning of the 1870s, Pissarro also served, as he did for so many others, as Gachet's living link to the generation of young artists emerging at the end of the 1880s—the Post-impressionists—and especially to Vincent van Gogh.

The Pissarros' move to Pontoise also drew Paul Cézanne to the area, first to Pontoise and then to Auvers in the fall of 1872. It was a decisive moment in his life, both artisti-cally and personally.[27] As a result of his contact with Pissarro, Cézanne's vehement style and somber palette began to move toward a lighter, more constructed approach. Cézanne and his companion, Hortense Fiquet, had just had a son; and, repeatedly rejected by the official Salon, the painter was scraping by on the meager allowance sent by his father, who knew nothing about either Hortense or the child. (A letter from Cézanne's father to Dr. Gachet is tes-timony that the two men were acquainted.)[28] Armand Guillaumin, a friend of both Pissarro and Cézanne who was trying to reconcile his administrative day job with his fledgling career as a painter, also came to see Dr. Gachet.[29] Thus there are reasons why the village of Auvers (like many others around Paris, it already housed a small colony of artists—most famously Charles Daubigny) later became known as the cradle of the new movement in painting.

This creative atmosphere inspired Dr. Gachet to return to his own art—probably not to painting, since, possibly apart from copies, no oil paintings by him are known from this time, but to drawing and printmaking: *The Hautes-Bruyères,* an etching based on a view "near Arcueil, done from life," is dated November 1872. Gachet embellished the plate with a little duck, his mark, but did not etch (as he did on slightly later plates) the signature Paul van Ryssel—Paul "from Lille" (his native city), in Flemish—which he had adopted as his pseudonym. Gachet's explorations in this medium, of which no prior examples are known,[30] were sanctioned by their publication along with works by Guillaumin in *Paris à l'eau-forte,* a literary and artistic journal edited by Richard Lesclide. Although we must not overestimate the importance of the engraving studio in the Auvers attic—where, according to Paul Gachet *fils,* Van Ryssel, Guillaumin, Cézanne, and Pissarro all vied with one another[31]—it is undeniable that Pissarro and Guillaumin, both highly skilled printmakers, took a real interest in etching techniques at the time; and even Cézanne, who did not share their enthusiasm, contented himself with a few attempts, although they do him no particular credit (see cat. no. 10).

The entry into Dr. Gachet's collection of most of its works by Pissarro, Cézanne, and Guillaumin can be dated from these visits to Auvers. It is certain that by then Dr. Gachet had long been treating artists and had no qualms about accepting paintings in exchange for his services. Additionally, he seems to have been willing to embrace even works that were not of top quality, including some rescued from the back corners of studios. It is even possible that he bought some of them from the minor dealers who handled works by the future Impressionists, dealers such as Latouche, "Père" Tanguy, and "Père" Martin, whose names are listed in the younger Gachet's chronology without further explanation—although we have no way of knowing whether he drew on his father's notes or, loosely, on his own readings in the history of Impressionism.

Dr. Gachet's interest in Cézanne and Guillaumin was symbolically marked by his loan of the former's *A Modern Olympia* (cat. no. 1) and the latter's *Sunset at Ivry* (cat. no. 30) to the breakaway exhibition of 1874. The collector had probably learned very early on about the anonymous society of painters, sculptors, engravers, and others formed to organize what has since become known as the first Impressionist exhibition of 1874. A man who relished polemic, he was surely pleased to enter the arena, if not as an artist then at least as an art lover and collector. Far from putting him off, the brouhaha that surrounded the exhibition, and especially Cézanne's works (see cat. no. 1),[32] only incited Gachet to pursue further acquisitions.

MANET, MONET, RENOIR, AND OTHERS

The exhibition of 1874 provided an opportunity for the collector of Pissarro, Cézanne, and Guillaumin to become more familiar with Claude Monet and Auguste Renoir—even though Gachet, under his writing pseudonym Blanche de Mézin, had criticized the inaccurate drawing of *Bather with Griffon* (Museú de Arte, São Paulo), a large nude, much influenced by Courbet, that Renoir had exhibited at the Salon of 1870.[33] Gachet's correspondence with the two painters (more cordial with Renoir than with Monet, who maintained a certain reserve) suggests his relations with them were relatively steady in the late 1870s but fell more or less by the wayside after 1880.[34] The canvases that the doctor acquired from the two painters were in exchange for services rendered (see cat. nos. 33, 39). As for Sisley, Dr. Gachet had bought the only painting he owned by that artist (cat. no. 40) from a dealer at the time

of the Salon of 1870, and seems to have had little direct contact with the painter himself.[35] What is certain is that Dr. Gachet's interest in those three artists was given a boost around 1877–78 by a collector who was both highly improbable and highly enthusiastic: Eugène Murer (1841–1906)—his real name was Eugène Meunier—a pastry chef, writer, and amateur painter who was justly saved from total neglect by the writings of Gachet *fils*.[36] Murer had mixed with the painters of the Impressionist group from early on, thanks to his childhood friend Guillaumin, and his remarkable collection was superior to the doctor's in both quality and quantity. Often, the sometimes laborious transactions with painters were carried on jointly by the two collectors.[37] Murer's move to Auvers after 1880 strengthened even further the friendship between the two men.

From reading Gachet *fils* one would think that his father enjoyed a true friendship with Édouard Manet, even though the son was the first to point out that the doctor, trying his hand at criticism during the Salon of 1870,[38] had not shown much discernment regarding the painter of *Olympia*. Still, we have proof that Dr. Gachet later had the opportunity to meet Manet, through his rather close relationship with Richard Lesclide. Lesclide is remembered as Victor Hugo's unofficial secretary and as the editor of several periodicals[39] to which Gachet contributed both etchings and articles on medicine or the arts (including *Le vélocipède illustré*, founded in 1869, and especially *Paris à l'eau-forte*, begun in 1873), but his finest achievements were surely his publication of *Le fleuve* by Charles Cros and *Le corbeau*, Stéphane Mallarmé's translation of Edgar Allan Poe's *The Raven*—both illustrated by Manet—in 1874 and 1875.[40] At least one other, more prosaic connection brought the doctor into contact with the painter: the engraver Henri Guérard asked his friend Gachet to stand in at the last minute for a suddenly indisposed uncle as the fourth witness of his marriage to Manet's student Éva Gonzalès; among the other witnesses was Manet himself.[41]

It is therefore beyond question that by the end of the 1870s Dr. Gachet was a familiar figure in Impressionist circles and owned several works by painters in the group. Despite this, Théodore Duret (1838–1927), critic, early historian of Impressionism, and a great collector himself, did not list Gachet among the movement's first collectors in his 1878 monograph *Les peintres impressionnistes*, which did include the noted collector Count Armand Doria (1824–1896), who bought Cézanne's *House of the Hanged Man at Auvers* (Musée d'Orsay, Paris); Étienne Baudry

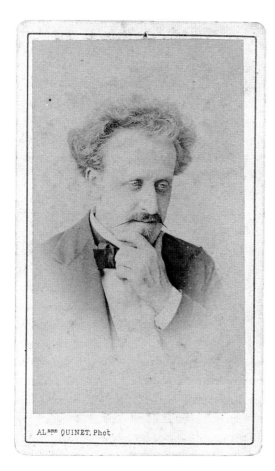

Fig. 7. Alexandre Quinet, *Dr. Paul Gachet,*
ca. 1875(?). Visiting card photograph. Archives,
Wildenstein Institute, Paris

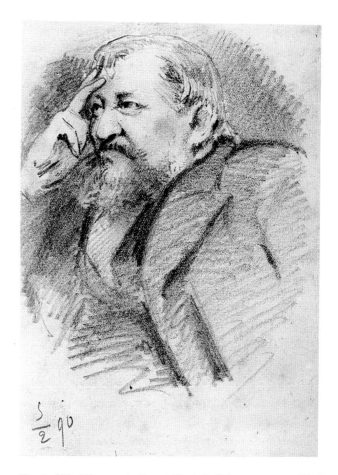

Fig. 8. Alfred Bourgeois, *Ernest Hoschedé,* February 5, 1890. Black
pencil, 4½ x 4⅛ in. (11.5 x 10.5 cm). Musée du Louvre, Paris,
Département des Arts Graphiques, Fonds du Musée
d'Orsay, gift of Paul Gachet, 1951 (RF 29 929)

(1830–1908), a great collector of art by Gustave Courbet; the Romanian doctor and aristocrat Georges de Bellio (1828–1894), who owned *Impression: Sunrise* by Monet (Musée Marmottan, Paris), and his friend Constantin de Rasty (1840–1923); the publisher Georges Charpentier (1846–1905), who launched Renoir; Victor Chocquet (1821–1891), Cézanne's great supporter; Charles Deudon (1832–1914), a man of leisure with excellent taste; the industrialist Jean Dollfus (1823–1911); the singer Jean-Baptiste Faure (1830–1914), who was immortalized by Manet; and finally, Gachet's friend Murer. That Dr. Gachet was omitted suggests that he was perceived as a negligible figure at the time. The only major collector Duret left out intentionally (apart from Henri Rouart and Gustave Caillebotte, who were put in the category of painters in the group) was Ernest Hoschedé (1837–1891), whose fortune had recently been swallowed up by his passion for Impressionist paintings and his collection sold off at auction in 1878 after a

resounding bankruptcy. (Several years later Hoschedé was on friendly terms with Dr. Gachet, who became his personal physician.[42])

But Dr. Gachet's attention was not devoted exclusively to the Impressionists. Shortly before the opening of their 1874 exhibition he tried to assist Honoré Daumier, then aged and blind, by organizing for his benefit a sale of works by Pissarro, "Manet, Monet, Sisley, Piette, Gautier, Degas, Guillaumin, Cézanne, and the entire cooperative."[43] Daumier was living then in Valmondois, near Auvers-sur-Oise, and this proximity allowed the renewal of relations that dated back to the doctor's youth, according to Paul Gachet *fils.*[44] Dr. Gachet also published, under his pseudonym Paul van Ryssel, an article in a local newspaper about the burial of Daumier in February 1879.[45] However, Dr. Gachet's only association with Daubigny, the most famous painter connected with Auvers (before the arrival of Cézanne and Van Gogh), seems to have been the

appearance of their names on a list of Republican candidates for election to the Auvers municipal council in January 1878; both men were defeated.[46] Finally, one should mention Gachet's admiration for Jean-François Millet, which inspired an article and an etching published by Lesclide at the time of the painter's death in 1875.[47]

DR. GACHET AMONG POETS AND MUSICIANS

While our emphasis is on Dr. Gachet's relations with painters, it must not be forgotten that he was familiar with literary figures as well. Although in some cases these contacts probably went no further than a friendly inscription in a book or an invitation to a party, his friendship with Richard Lesclide did in fact put him in touch with authors the latter knew and published. Foremost among these was Victor Hugo: "Thursday [December 10, 1874]," the doctor wrote to his wife, "I spent the evening at the home of Victor Hugo, who was very cordial. He told me when shaking my hand that I had great talent and that he thought my etchings very good."[48] But Lesclide also had more exotic acquaintances, such as "Théophile Gautier's Chinaman" Ting Tun-ling, and Desbarolles, a palm reader whose skill he mentioned to his friend.[49] A truly fascinating character whom Dr. Gachet greatly appreciated was the eccentric musician and bohemian Ernest Cabaner (1833–1881); a friend of Cézanne, and painted by Manet (Musée d'Orsay, Paris), he was famous for his relations with the poets Charles Cros and Arthur Rimbaud and was among the habitués of the parties given by Nina de Callias, herself immortalized in Manet's *Woman with Fans* (Musée d'Orsay, Paris). Dr. Gachet designated Cabaner his "regular composer," collected his scores, and listened to him play his own arrangement of a melody by Mme Gachet on the piano.[50] The doctor also had more orthodox musician friends, notably Peter Benoît (1834–1901) and François-Auguste Gevaert (1828–1908), two Belgians who had spent part of their careers in Paris.[51]

DR. GACHET AT DINNER: "ECLECTIC," "TRANSFORMIST," "INDEPENDENT"

Dr. Gachet's good humor was much appreciated in his youth, and throughout his life he belonged to societies and associations of various kinds (see the Chronology). The most important one to him was undoubtedly the Société des Éclectiques, whose stated purpose was "monthly to bring together around the table a few friends who care less about fine food than about sharing good times and discussing plays, books, and paintings that are currently causing a stir."[52] The society had been founded in 1872; Gachet became a member one year later and faithfully attended its meetings until 1904, when the poet Alexis Martin, one of its founders, died. The doctor even served as president of the group in 1887. Indeed, its two leaders—Martin and the painter, engraver, and bibliophile Aglaüs Bouvenne (1829–1903)—have escaped total neglect largely because of the younger Gachet's filial piety,[53] since their own achievements were too slender to ensure a lasting memory of the society's modest banquets in unprepossessing Left Bank restaurants.

Dr. Gachet's interest in science (with a penchant for the esoteric) also brought him into contact with the archaeologist and anthropologist Gabriel de Mortillet (1821–1897), a figure whose work was contested by his peers but whose innovative hypotheses are now being reevaluated. The two men saw each other mainly at the "Lamarck Dinners" held in honor of the French naturalist and during archaeological hikes, on which the doctor brought along his young son.[54]

Another group that met around a table included Dr. Gachet: the "Red and Blue" dinners of 1886–87. Their participants were critics and painters, many of whom exhibited at the Salon des Indépendants, founded in 1884: Albert Dubois-Pillet,[55] Edmond Valton, Georges Seurat, Paul Signac, Lucien Pissarro, Henri Edmond Cross, Odilon Redon, and the sculptor Rupert Carabin, a whole generation of Postimpressionists—evidence that Dr. Gachet took an interest in younger artists. He never met Paul Gauguin, however, and he seems not to have acted on Murer's request that he find accommodations in Auvers for Mme Gauguin and her children. Later, in an 1890 letter to Vincent van Gogh, Gauguin confirmed that he had never met Dr. Gachet.[56] The critic Paul Alexis (alias Trublot), who regularly chronicled the Red and Blue gatherings in *Le cri du peuple*,[57] often stayed in Auvers with his wife and children and in 1887 wrote about the doctor's collection,[58] giving Gachet his first taste of recognition in the press. Even while serving as physician to the Compagnie des Chemins de Fer du Nord (Northern Railway Company) and the public schools of the 18th arrondissement, Gachet kept abreast of the activities of the artistic avant-garde. It was therefore quite natural for Camille Pissarro to think of him when, in the fall of 1889, Theo van Gogh, a young

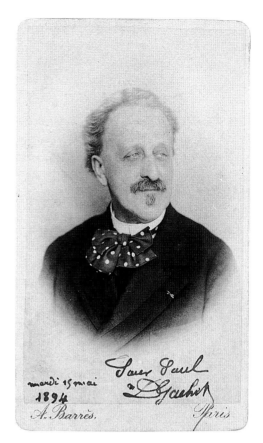

Fig. 9. A. Barrès, *Dr. Paul Gachet*, 1894.
Visiting card photograph. Archives, Wildenstein
Institute, Paris

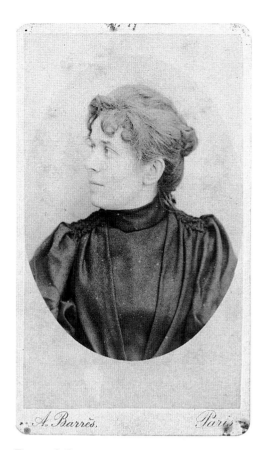

Fig. 10. A. Barrès, *Marguerite Gachet*, 1894. Visiting card photograph, with the dedication on the reverse side, "To my brother, with the affectionate thoughts of his sister and friend Marguerite Gachet, Tuesday May 15, 1894." Archives, Wildenstein Institute, Paris

Paris dealer who was laboring to gain some exposure for the first-generation Impressionists as well as for Gauguin and Redon, told Pissarro of his difficulties in finding lodgings near Paris for his brother Vincent.[59]

At the time, which followed the psychotic episode during which he had cut off part of his ear, Vincent van Gogh was still hospitalized in the asylum at Saint-Rémy-de-Provence, but he wanted to leave the south of France.[60] Despite the relapses that had punctuated his stay at Saint-Rémy (including several suicide attempts), arrangements were accordingly made: Theo contacted Dr. Gachet in the spring of 1890, and on May 16 Vincent left the asylum. After a brief stay at his brother's home in Paris, where he met for the first time his sister-in-law, Jo, and his nephew, Vincent Willem (born on January 31, 1890), the painter, armed with a letter of introduction to Dr. Gachet from his brother, left for Auvers-sur-Oise, arriving on Tuesday, May 20.[61] What

happened next is known from Vincent van Gogh's letters to his family, which were fewer and less detailed than previously, perhaps because the painter expected his brother to visit him in Auvers and to see Dr. Gachet in Paris. For the first-hand account that the letters provide, the reader is directed to the Excerpts from the Correspondence; here, the discussion is limited to the summarizing of a few essential facts.

Vincent van Gogh in Auvers with Dr. Gachet

Van Gogh's first contact with the doctor was positive: Gachet helped him get settled in, even though Vincent preferred to take cheaper lodgings than the inn that he had recommended. The doctor invited Van Gogh to his home, where the painter took pleasure in seeing works by Pissarro

and Cézanne and could thus feel he was on friendly territory. Gachet also reassured Van Gogh about his mental condition and encouraged him to paint, and Vincent immediately announced his desire to do the doctor's portrait. Although Dr. Gachet did not seem to remember any of the artist's works—he could have seen, for example, those shown at the Indépendants exhibition of 1888–89 or the ten canvases shown later, in the spring of 1890—it is clear that he took a genuine interest in what Van Gogh was doing, beyond any professional concern. The painter was evidently stimulated by this interest. He left behind a glimpse of the doctor's own personality: a sad widower, "disheartened by his medical work" and complaining of the cost of living but cheered when the conversation turned to art; a "strange" but self-controlled man.

Van Gogh painted in the doctor's house and especially worked on a portrait of him, which he thought might lead to future commissions. He gave Gachet at least two studies (see cat. nos. 14, 15), painted a portrait of his daughter, Marguerite, at the piano (fig. 87), and hinted to his own family that if he were to need medical care, Gachet could be paid in artwork. He made one etching (cat. no. 23b) and planned to make others, which the doctor would print on his press "for free."

Theo, Jo, and their baby came to Auvers at the doctor's invitation on Sunday, June 8;[62] although Vincent had hoped for an extended visit, they did not stay long. Theo was worried about his and his family's health and also faced professional difficulties that needed his attention. Early the next month he left for Holland with his wife and child, right after Vincent had spent the day with them in Paris on July 6—even though the visit left Theo feeling concerned about his brother.

Shortly afterward, the tragedy occurred: on Sunday, July 27, Vincent van Gogh shot himself in the chest. His death agony was long, and he finally died at 1:30 in the morning on Tuesday, July 29. Theo, notified by Dr. Gachet, had returned to France alone and was at his side. The burial took place in Auvers the next day. Because so much has since been written on the events of those three days, I will follow Ronald Pickvance's lead[63] and concentrate on the facts that highlight Dr. Gachet's involvement as both doctor and friend and that demonstrate his admiration for and grief over the artist.

Allegations by other witnesses questioned long after the fact have only muddled and embittered our understanding of the issue: for example, the painter Anton Hirshig did not recall the doctor's son being present, although Gachet *fils* describes being at his father's side; and Adeline Ravoux-Carrié, daughter of the owner of the inn where Van Gogh was staying and one of the painter's models, mainly remembered the haste—greedy and indecent, in her eyes—with which Dr. Gachet and his son gathered up the paintings left in Vincent's room.[64]

Indeed, the event has spawned endless commentary and a welter of myths spun around Dr. Gachet. However, for our purposes it is enough to know that Dr. Gachet was present; that his deeds and demeanor were received with gratitude by Vincent's family; and that the circumstances of the painter's death allowed him to obtain works that few then cared about and that had almost no monetary value. In the short period between Theo van Gogh's hospitalization in mid-October 1890 and his death on January 25, 1891, he discussed with Dr. Gachet plans for a book and an exhibition of his brother's work,[65] and at no time did he or his widow, Jo, who lived until 1925, express any reticence toward the doctor—quite the contrary.[66]

In the immediate aftermath of the tragedy there were few commemorative events: Theo arranged a showing of Vincent's paintings in his apartment in Montmarte, assisted by Émile Bernard, at the end of September 1890, and Paul Signac organized the display of ten of the artist's works at the Salon des Indépendants in the spring of 1891.[67] At that Salon Dr. Gachet exhibited for the first time, under his own name, ten paintings, drawings, and engravings, including a charcoal drawing done from life of Vincent van Gogh on his death bed (see cat. no. 41). Dr. Gachet exhibited again in 1892 and 1893, then not until 1905, the year a new Vincent van Gogh retrospective was held to which he also lent the artist's portrait of him (cat. no. 13) and several other works from his collection.[68] Some months later, in July 1905, at Jo's request, he sent his portrait to the Van Gogh exhibition at the Stedelijk Museum in Amsterdam, along with *Thatched Huts at Cordeville, Auvers* (cat. no. 19) and the etching *Portrait of Dr. Gachet (Man with a Pipe)* (cat. no. 23b).

Meanwhile, during the period between 1891 and 1905, as Vincent van Gogh's reputation continued to rise, another neglected genius, Paul Cézanne, was finally gaining public renown in his lifetime. Dr. Gachet's fame as a collector also began to grow, and he achieved recognition among the same public of collectors, critics, and artists.

Friend of Cézanne and Van Gogh

The first to arrive in Auvers were the painters. Émile Bernard (1868–1941), a friend of Van Gogh and Gauguin, sent long, flowery missives to Gachet, with even the envelope of one addressed in a style reminiscent of Mallarmé's "postal diversions": "To the most learned Doctor Gachet / In the village of Auvers-sur-Oise / In the countryside next to Pontoise / Insufficiently hidden away."[69] (The letters themselves mainly concern himself and his sister's family problems.) In May 1891, in the first long article ever devoted to Cézanne, Bernard included the doctor not only among Van Gogh's admirers but also in the select circle of those who knew and appreciated Cézanne's work.[70]

One of the first testimonies to Dr. Gachet's increased fame is contained in a letter of May 12, 1891, from Lucien Pissarro, who congratulated his colleague on his debut at the Indépendants and asked to acquire from him (by exchange) the etching that Van Gogh had done at his home.[71] A few years later, in a remarkable article on Cézanne published in *Le journal* (March 25, 1894), Gustave Geffroy cited among Cézanne's rare admirers, alongside Émile Zola, Théodore Duret, Victor Chocquet, Paul Alexis, and the dealer Tanguy, "Doctor Gachet in Auvers, near Pontoise." Gachet's reputation as a friend of Cézanne was such that Durand-Ruel's employee C. Destrée sent him a note asking for Cézanne's date and place of birth (rather than going directly to Cézanne, whose prickly personality was well known).[72] And Ambroise Vollard, who organized the first Cézanne exhibition in his gallery in 1895, seems to have been introduced to Gachet by the painter Norbert Goeneutte sometime before Goeneutte's death in Auvers-sur-Oise on October 9, 1894.[73] Although there is no evidence of commercial dealings between Vollard and Gachet, we know that Vollard had photographs taken of the Cézannes that Gachet owned, probably in 1905.[74]

Another visitor was the critic and collector Théodore Duret, who, although he had had to sell his own collections of Japanese art and Impressionist paintings in the early 1890s, continued to indulge his passion for discovering new works. After a visit to the doctor's, still "amazed by the curious mix of Van Gogh paintings" he found there, he proposed (in a letter of April 4, 1900) to buy one or two, adding, "you will not miss them out of so many"; he suggested a price of 2,000 francs for "the large painting of flowers which hangs at the upper right in the first room and the heads of young women in blue located on the center panel in the second room."[75] Gachet did not wish to sell, but Duret managed to establish relations with his son after the doctor died.[76] Shortly after Duret's visit, the German art historian Julius Meier-Graefe went to Auvers (July 20, 1903) to do research on Vincent van Gogh, whom he intended to treat extensively in a major work he was writing on contemporary art. Published in 1904, it established for the first time Dr. Gachet's ownership of twenty-six Van Goghs, though citing only a few by specific titles.[77] Thus, by the turn of the century Dr. Gachet's name was definitively linked with those of Van Gogh and Cézanne; however, the resulting attention was not always positive. For instance, the writer Joseph Conrad penned a scathing commentary on what he referred to as "painting from the School of Charenton," using the name of a notorious Parisian insane asylum. (Conrad's aunt and correspondent, Marguerite Poradovska, née Gachet, a cousin of the doctor who had stayed for a while in Auvers, had given him a description of the Gachet household.)[78]

During the same period, the French national museums accepted with some anxiety Manet's *Olympia*, which was donated in 1890 by a group of subscribers at the initiative of Claude Monet (who had not bothered to ask his former collector for a contribution); then, in 1894, the museum curators sifted through the magnificent collection bequeathed by Gustave Caillebotte. They may have known nothing whatever about the eccentric collector from Auvers. But in 1892 Dr. Gachet became a donor to what was then the national museum of contemporary art, the Musée du Luxembourg, by giving it the portrait Norbert Goeneutte had painted of him in 1891 (see fig. 28).

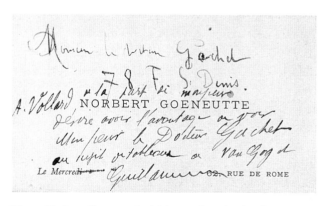

Fig. 11. Norbert Goeneutte's visiting card, with a brief message asking that Dr. Paul Gachet receive Ambroise Vollard at home. Michael Pakenham collection

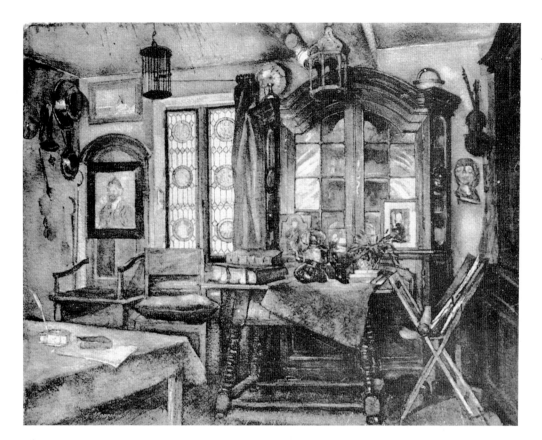

Fig. 12. Léopold Robin, *Dr. Gachet's Salon at Auvers*, 1903. Water-color, dimensions and present location unknown; reproduced in Gachet 1956a, fig. 58

DR. GACHET, DONOR TO THE NATIONAL MUSEUMS

Dr. Gachet probably met Norbert Goeneutte (1854–1894), a painter and engraver, in 1889 or earlier. Already seriously ill with tuberculosis, Goeneutte settled shortly afterward in Auvers in a house close to the doctor's, and Gachet treated him and made etchings with him. Goeneutte dedicated his portrait of the doctor to him in 1891; but at the request of the minister of fine arts (probably made after the Salon exhibition of the Société Nationale des Beaux-Arts, where the work was shown), Gachet donated it to the Musée du Luxembourg, where it was immediately put on display.[79] His contacts with Roger Marx, an important critic and the young supervisor of fine arts, did not, however, go any further; nor did the director of the French national museums respond in 1909 when he received an announcement of the doctor's death.

What Dr. Gachet thought about the newfound fame of his collection we do not know, but it is likely that his notoriety sometimes weighed on him. A friend, Jérôme Doucet—the brother-in-law of Murer, who had sold off his own collection during his lifetime—even advised Gachet in 1904 to sell his works by Monet, Renoir, Pissarro, Cézanne, Guillaumin, and Sisley (the commercial value of which, he warned, might well collapse, as that of Meissonier's works had) and to hang pictures by his son in their place. He added, "Show off your Van Goghs, which are marvelous even if not very sought-after; don't listen to what others say; and avoid dealers, who are the hoodlums of the art world."[80] The doctor did not follow Doucet's principal advice, and when he died in 1909 his collection was probably more or less intact (see Summary Catalogue).

Dr. Gachet's death went largely unnoticed by the general public,[81] but condolences were expressed to his children by those who had known him; one of the most heartfelt letters came from Theo van Gogh's widow, Jo, who by then was Mme Cohen-Gosschalk.[82] In 1909, in memory of the doctor, his children gave the Musée de Lille a large full-length portrait of him by Amand Gautier (fig. 19).

PAUL GACHET THE YOUNGER

The story of Dr. Gachet does not end with his death. On the contrary, his son took pains to keep alive the memory of his father and of the man he always called Vincent, both

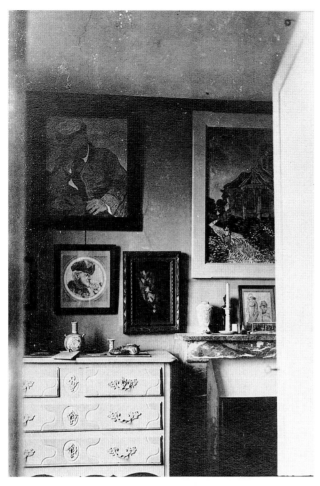

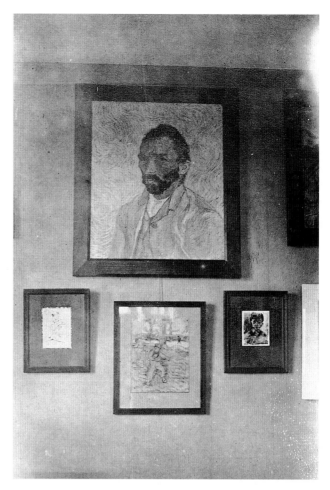

Fig. 13. Anonymous, *"Portrait of Doctor Paul Gachet" and "The Church at Auvers" by Van Gogh in the House at Auvers* (cat. nos. 13, 17), before 1949. Photograph. Michael Pakenham collection. Beneath the portrait hang *The Smoker (Portrait of Dr. Gachet)* by Norbert Goeneutte and *Still Life with Game Birds* by Cézanne (P.G. II-20); on the mantelpiece is a sketch, *Study of Two Women*, by Van Gogh (P.G. III-38).

Fig. 14. Anonymous, *Van Gogh's Self-Portrait in the House at Auvers*, before 1949. Photograph. Michael Pakenham collection. Beneath the self-portrait (cat. no. 12) is a Van Gogh sketch, *The Sower* (P.G. III-35), framed by two Cézanne prints, *Guillaumin at the House of the Hanged Man* (cat. no. 10e) and *Head of a Young Girl* (cat. no. 10b); at the upper right one can make out Van Gogh's painting *Two Children* (cat. no. 18).

through his writings and through contact with the countless curious—historians and art lovers interested in learning about Impressionism, Cézanne, and Van Gogh.

Paul Gachet *fils* (1873–1962) is hard to characterize in a few lines; there is not space here even to name all those who made pilgrimages to Auvers or sought to meet him. Educated in childhood by his father, then prepared by his studies at the École de Grignon for a career in agricultural engineering,[83] Paul Gachet never actually had a profession; the only title he ever claimed for himself (apart from friend of Van Gogh) was that of painter. Between 1903 and 1910 he exhibited at the Salon des Indépendants, under the name Louis van Ryssel (with a bow toward his father), works inspired by the examples of Van Gogh and Cézanne.

As he himself explained, his artistic education consisted simply of copying the paintings by those two artists that were in his father's house.[84] His father's death in 1909, then World War I (he served for almost five years), seem to have distanced him from painting.[85] All of his time was consumed instead by research aimed at bringing to fruition Dr. Gachet's great project: a book devoted to Van Gogh, illustrated with watercolors and lettered with calligraphy by the doctor's son.[86] The book never saw the light of day, but the work of Gachet *fils*—organizing his father's papers, trying to discover or understand the facts that had eluded him, and writing—took up nearly forty years. His labors were crowned by several publications in the 1950s and by another, posthumous one on Van Gogh's seventy

days in Auvers. His friends, his wife, Émilienne (they married in 1911 but had no children), and his sister, Marguerite, who never married, were the silent and respectful witnesses to this parsimonious life consumed by study, in a household frozen in the past.[87]

After the war, visitors began coming to Auvers again: one of the first, in 1921, was the critic Gustave Coquiot. In his *Paul Cézanne,* published in 1919, he gave the first substantial portrait of Dr. Gachet, one respectful of the collector's original personality but leaning toward caricature.[88] Next came Coquiot's *Vincent van Gogh,* published in 1923, which drew on interviews with Paul Gachet, who apparently did not hold against him his earlier portrayal of Dr. Gachet as an eccentric. But the most important contribution to Dr. Gachet's posthumous fame was made by Dr. Victor Doiteau, who in 1923–24 (before the appearance of his celebrated essay on Van Gogh) published the first extended article on Dr. Gachet, a much-cited study inspired by the younger Gachet.[89]

Paul Gachet tirelessly preserved his father's memory and considered himself the legitimate guardian of Vincent and Theo van Gogh's twin graves in the cemetery at Auvers.[90] He was quick to point out inaccuracies that found their way into print and systematically refused to release photographs of works in his collection or to divulge detailed information. This attitude eventually earned him the enmity of two prominent scholars, Jacob-Baert de la Faille (who wrote the comprehensive catalogue on Van Gogh) and to a lesser extent Lionello Venturi (who wrote the one on Cézanne and also a book on Pissarro)—even though Gachet *fils* had initially given both men a warm welcome.[91]

He also refused to lend works that he rightly deemed too fragile, although he did accede to official requests for loans to the large Cézanne and Van Gogh retrospectives held in Paris in 1936 and 1937. They were the occasions for his first contacts with the painting curators of the Louvre.

Then, after World War II, in 1949, 1951, and 1954, Paul Gachet—first with his sister and then alone after her death—made a series of lavish donations to the French state. His personality, together with the surprise of discovering completely unknown masterworks such as Van Gogh's *Church at Auvers* (cat. no. 17), turned these generous gifts into an event widely covered in the media. It seemed that Gachet's wish was to make all the works of importance available to whoever would put them to good use and preserve the memory of a connection between Van Gogh and the Gachet family. At the same time, as he explained to

Vincent Willem van Gogh, the painter's nephew, who was himself setting up a foundation to manage his collection, "Life in France gets more expensive all the time, and, since I don't have a vast fortune, I can't afford to give everything away."[92] Official encomiums[93] and membership in the Legion of Honor, awarded him on December 28, 1961 (an honor his father had never received), were tempered by some vicious attacks. Paul Gachet, it was said, was proud and selfish, a ridiculous hermit who enjoyed quoting "his friend Vincent," whom in fact he had barely known; he was not a harmless lunatic who had come to believe the fairy tales he had been telling for fifty years, but a manipulator, a fraud.

It is difficult to summarize the origin of these attacks, which poisoned the end of Paul Gachet's life, but we can easily identify a few key elements. Generally speaking, after World War II, Van Gogh's works became known to an ever-growing segment of the French public, for a variety of reasons: the widespread availability of Vincent's letters to Theo, first published in French in 1937 and reissued in 1953; the Van Gogh retrospective held in Paris at the Orangerie (January–March 1947); a significant number of publications and popularizations; even, in 1956, the film

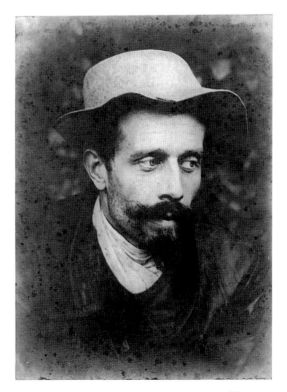

Fig. 15. Anonymous, *Paul Gachet fils,* ca. 1905. Photograph. Michael Pakenham collection

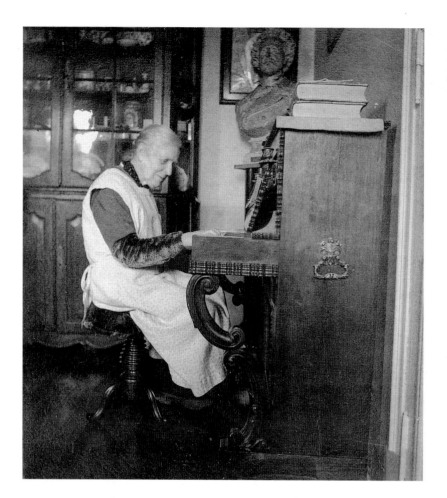

Lust for Life, directed by Vincente Minnelli and based on Irving Stone's romanticized biography of 1934. Antonin Artaud, soon after his visit to the 1947 exhibition, published a text called *Van Gogh le suicidé de la société* (*Van Gogh, Suicided by Society*), in which he projected his own obsessions onto Van Gogh's sufferings: "And yet more than ever I believe it was because of Dr. Gachet of Auvers-sur-Oise, because of him, I say, that Van Gogh on that day, the day he committed suicide in Auvers-sur-Oise, departed this life."[94] These words of the insane poet slowly made their way into the public mind, leaving the image of Dr. Gachet as a charlatan and murderer.

Still, the main detractor of both the elder and younger Gachets was an "independent scholar" named Louis Anfray, who made his reputation by identifying a Van Gogh bought at a flea market. Starting with an attempt to cast doubt on Van Gogh's only etching (see cat. no. 23b), he launched a campaign at the time of the Gachet donations, from 1953 on, flooding the newspapers with incendiary and muddled tracts.[95] He won over to his cause the elderly J.-B. de la Faille (d. 1959), who, as noted, already

bore a grudge against Paul Gachet. Even Van Gogh's nephew, who until then had maintained very cordial relations with the younger Paul Gachet and had suggested that Gachet house his collection at the recently created Van Gogh Foundation in Amsterdam,[96] was swayed; he declared that Van Gogh's *Garden of the Asylum in Saint-Rémy* (fig. 89), which Gachet had given to him for the foundation in March 1954, was a fake. Today, the painting is generally regarded as authentic.[97]

The apogee of the debate coincided with the exhibition held at the Orangerie (November 1954–February 1955), which paid homage to Paul Gachet by showing all of his donated works, along with some borrowed (notably from V. W. van Gogh), under the title "Van Gogh et les peintres d'Auvers-sur-Oise." On the one hand, a catalogue containing a preface by Germain Bazin and unusually substantial entries by the scholar Albert Chatelet, which clearly explained and formally refuted Anfray's allegations, set out the museum's position; on the other, the newspapers, delighted to have such a juicy subject, abounded in "investigations."[98] Several art historians, among them

Fig. 17. Anonymous, *Paul Gachet fils in His Garden at Auvers*, ca. 1935–40. Photograph. Bignou album, Archives, Musée d'Orsay, Paris

Douglas Cooper,[99] tried hard to make themselves heard above the din. Paul Gachet merely proclaimed with vehemence his fidelity to the memory of Van Gogh; invariably buttoned to the chin in his dolman coat, he was always willing to add another relic to the commemorative monument.[100] There were many who knew Gachet at the time[101] and remained indulgent toward the solitary old man, whose indifference to material wealth had helped sustain an *idée fixe* that ultimately benefited the public.

Paul Gachet *fils* died on April 29, 1962, and, following his wishes, his papers and the house in Auvers were sold off at public auction. It was widely regretted at the time that no state institution had stepped in to prevent the dispersal of a heritage so laden with emotional significance.[102] Since then, times have changed: the house in Auvers was acquired in 1994 by the Regional Council of the Val d'Oise so that it could be opened to the public.[103]

The time has also come for reevaluation. Beginning with the observation that among the works from Dr. Gachet's collection are some weak pieces attributed to artists as great as Cézanne and Van Gogh—and whose mediocrity offends our admiration for those masters—conclusions have been drawn that they were misattributed or even forged; that the Gachets, alone or with help, fabricated these paintings themselves.[104] In debating the question, it is a great boon that a large number of these works

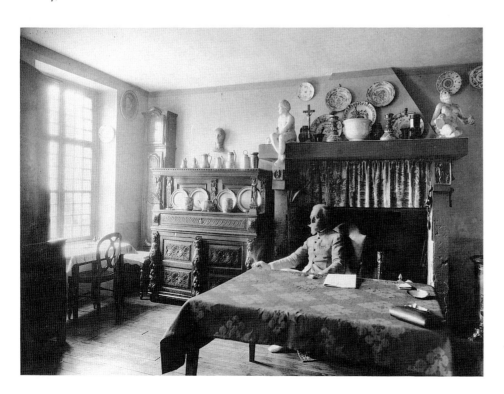

Fig. 18. Anonymous, *Paul Gachet fils in His Salon at Auvers*, ca. 1935–40. Photograph. Bignou album, Archives, Musée d'Orsay, Paris

were given to museums or public collections, which allows them to be examined impartially. Nevertheless, it is by no means certain that a decisive resolution can be offered in every case. I have tried to do so in the following catalogue entries, placing the debate on a firmer basis than the heated accusations, devoid of proof, that until now have fueled a rather vain polemic—which Van Gogh's name alone has sufficed to inflame. Finally, consider that Dr. Gachet surely would not have been displeased by this controversy, which has placed his name and likeness in the spotlight of the here-and-now.

1. These characteristics are especially apparent in Gachet's principal work, *Le docteur Gachet et Murer: Deux amis des impressionnistes* (Gachet 1956a).

2. The facts in the 1928 chronology are corroborated by the documents that Gachet *fils* donated in 1958 to the Musée d'Histoire de la Médecine in Paris.

3. Dr. Jean Vinchon, who knew Paul Gachet *fils*, published a series of drawings by Dr. Gachet depicting mental patients whom he had seen during his externship at La Salpêtrière (Vinchon 1958, pp. 9–22). Vinchon has since donated these twenty-five drawings to the Centre d'Études de l'Expression Clinique des Maladies Mentales et de l'Encéphale at the Sainte-Anne hospital in Paris. They can be divided into two groups. The first is a series of rapid pencil sketches in a small notebook which depict female figures, not all of whom are obviously mentally ill. These crude drawings might date from the 1850s: one is on stationery bearing the letterhead of the hospital at 110, rue du Faubourg Saint-Denis, where Gachet worked in 1852. A watercolor, similar in style but larger in format, shows a woman wearing a straitjacket. The second group, a series of twelve ink drawings vividly executed in thick pen strokes, all the same size (9⅞ x 6½ in. [25 x 16.4 cm]), is clearly more recent; one of them is dated 1903. Dr. Vinchon also amassed a number of letters written by madwomen that had been collected by Gachet. Several of Dr. Gachet's unpublished writings on madness, such as "Traité de la folie à l'usage des gens du monde" ("Treatise on Insanity for Use by Society People"), are in the archives of the Musée de l'Histoire de la Médecine in Paris. And in the *Annuaire de la santé et de l'hygiène pour l'année 1875*, edited by Dr. Gachet, he wrote: "I myself, having spent much time while a student in the various wards of Bicêtre and La Salpêtrière hospitals, admit to having experienced an acute sense of uneasiness when I left my poor patients for the last time just before returning to ordinary life. Something indefinable, a kind of attraction, brought me back to them periodically. I let more and more time pass between visits, and little by little the feeling abated. My opinion is that I could not have stopped seeing them so abruptly without doing harm." Farther on, he states his opposition to "total isolation, except as punishment," and to the "exclusive segregation of the mentally ill among themselves." He recommends allowing them contact with society at large, the company of pets, and gymnastics.

4. Gachet left Paris for Montpellier without telling his parents; only Amand Gautier knew, and gave him several messages for Courbet (see Courbet Letters 1996, no. 57-2, for Courbet's letter to Gautier, dated June 23, 1857, accompanied by a humorous postscript from Gachet). Gachet went to some trouble to reach Courbet, but it seems he was in no great hurry to contact Bruyas; he apparently did not do so until the spring of 1858, when Gautier urged him to convince Bruyas to buy one of his paintings (unpublished letters, Amand Gautier to Dr. Gachet, July 17, 1857, and March 22, 1858; Archives, Wildenstein Institute, Paris). Paul Gachet *fils*, in Gachet 1956a (fig. 8), reproduces a photograph of Bruyas inscribed "à Mr. Gachet en souvenir de sympathies communes."

5. Letter from Vincent van Gogh to his brother Theo, LT 638; see Excerpts from the Correspondence, June 3, 1890.

6. In 1928 Paul Gachet compiled a catalogue of the works by Amand Gautier in Dr. Gachet's collection, which remains unpublished (Archives, Wildenstein Institute, Paris). He listed sixty-two paintings, forty watercolors, one pastel, and drawings and prints, but he never specified how the works were acquired, except for the large full-length portrait, one painting, and eight watercolors bought at a public auction organized by the artist at the Hôtel Drouot in Paris on March 2, 1872. Dr. Gachet bought nothing at the sales Gautier held at Drouot on April 10, 1875, and March 27, 1878, according to the records in the Archives de Paris.

7. Gachet was present when Gautier, accused of "unauthorized impersonation of a curator of the Musée du Louvre," was arrested in June 1871; he visited Gautier at Mazas Prison along with his dealer Detrimont. After being tried and acquitted, Gautier considered abandoning painting for the business of selling products from the south of France, but his correspondence with Gachet ended shortly after this point. In 1874 Gautier again had work accepted for exhibition at the Salon. The following year, at the time of Mme Gachet's death, Gautier still owed Gachet the considerable sum of 2,029 francs (posthumous inventory of Mme Gachet, November 13, 1875; Archives Nationales, Paris, Minutier Central, ET XXXI/1105), which may explain why the two old friends had their falling-out.

8. Paul Gachet (Gachet 1956a, pp. 29–30, fig. 15) states that his father visited Méryon in May 1858, during the engraver's first period of internment in the asylum at Charenton (where he had been committed by Dr. Eugène Sémerie), and then again in 1867–68; apparently Dr. Gachet made sketches (reproduced in Bouvenne 1883) while visitng Méryon during his later incarceration. Dr. Gachet, in a letter to his friend Aglaüs Bouvenne, December 1, 1881, describes Méryon, creating a verbal portrait that is superior to any of the sketches; this letter is reproduced in Delteil 1927, p. 49.

9. Gachet 1957a, pp. 181–83. See Checklist of Artists and Works, Méryon.

10. Some notion of what Dr. Gachet's portfolios might have contained is conveyed in Drouot 1993.

11. Letter from Vincent van Gogh to his brother Theo, LT 635; see Excerpts from the Correspondence, May 20, 1890. These furnishings and objects had been listed in 1875 in the posthumous inventory of Mme Gachet's estate (see pp. 289–91). Paul Gachet *fils* saved the obituary of Joseph Bouilly, who died at the age of sixty-three, on August 16, 1894, at his home at 41, rue des Martyrs, and noted that he was born in Sept-Forges (Orne) in 1831 (Archives, Wildenstein Institute, Paris).

12. Very few works by Dr. Gachet before 1870 are known. There is a small, creditably executed watercolor, *Windmill in the Countryside,* at the Van Gogh Museum, Amsterdam, D 603; 5⅞ x 11¼ in. (14.8 x 28.6 cm), annotated on the verso: P. Gachet 1850 Septembre/ Faubourg de Gand/Varier par des gris Trop de couleurs/et trop en noir (P. Gachet 1850 September/Faubourg de Gand/Vary with grays Too many colors/and too much black); and a drawing included in an album reproduced in Gachet 1956a, fig. 36, annotated: Ma maison à Berck 1865 (Archives, Wildenstein Institute, Paris). Gachet *fils* also mentions youthful copies painted in oils (Gachet 1956a, fig. 65).

13. See 1859, 1862, 1865, and 1866 in the Chronology. My colleague Luce Abélès has discovered another article, not listed by Gachet *fils,* entitled "Hygiène publique" (Gachet 1864), which Dr. Gachet published in the *Almanach parisien* alongside contributions by Théophile Gautier, Edmond Duranty, and Théodore de Banville.

14. See 1865, 1870, and 1874 in the Chronology. The rather uninspired syllabus for this course, which Dr. Gachet began teaching on December 19, 1867, is at the Musée de l'Histoire de la Médecine in Paris, as is the certificate signed on August 15, 1876, by the school's director, the sculptor Justin Lequien *fils,* certifying that classes were taught gratis by Dr. Gachet between 1865 and 1876. This school, which enjoyed an excellent reputation in its day, can boast of having given Seurat and his friend Edmond-François Aman-Jean their first artistic training between 1876 and 1878. They might even have studied with the doctor, whom Seurat would meet again at the "Red and Blue" dinners organized by the Indépendants in 1886–87.

15. She undoubtedly went by the name Blanche, for her son always called her Blanche, and this is the name on her death certificate (which gives her date and place of death as May 25, 1875, at 78, rue du Faubourg Saint-Denis, Paris). However, on other documents, notably her marriage contract and the posthumous inventory of her possessions, she is referred to by her legal forenames Élisa Angélique. The marriage contract (Archives Nationales, Paris, Minutier Central, ET XXXI/1030) was signed and witnessed on September 15, 1868, before Maître Potier, notary public in Paris. It stipulates that, as dowry, P.-F. Gachet would receive from his father (his mother had died in 1863 and her estate had not yet been settled) an ongoing income of 2,500 francs per annum from a capital of 50,000 francs—a not-inconsiderable sum, which ensured the young doctor the necessary comforts. The bride contributed some 30,000 francs from various sources.

16. See 1875 in the Chronology.

17. See 1862, 1864, and 1870 in the Chronology.

18. On this point, see the analysis of the estates of the doctor's father, Louis-Eugène Gachet, who died on May 26, 1870, and of his mother, who died on April 15, 1863, drawn up in 1875 after Dr. Gachet's wife died and her inventory was taken (see n. 7, above). See also the tax declaration on the younger Mme Gachet's estate (Archives de Paris, DQW7 12625), which indicates that the doctor was the beneficiary of a sizable inheritance, from which he immediately received more than 60,000 francs. In addition, he owned several pieces of real estate jointly with his brother Louis, from which he received an income in rent.

19. The real-estate register for the apartment at 78, rue du Faubourg Saint-Denis (Archives de Paris, D1P4, 1876) is annotated, "No longer a doctor, does not practice here." This suggests that by the late 1870s Dr. Gachet was satisfied with just working at the clinics, then at the Compagnie des Chemins de Fer du Nord, and as medical inspector of schools in the 18th arrondissement.

20. Paul Gachet *fils* (in Gachet 1956a, pp. 50–53) discusses his father's acquisition of this house on April 9, 1872, at length, but does not give the price, which is specified in Mme Gachet's posthumous inventory as 9,000 francs, paid in cash.

21. His full name was Paul-Louis-Lucien Gachet. A drawing made by Dr. Gachet in Auvers on October 21, 1874, showing the Gachet children in a bathtub in front of a window (Van Gogh Museum, Amsterdam, D 490), though quite mediocre, provides a glimpse of the family's life there.

22. Paul Gachet *fils* pays tribute to Mme Louise-Anne-Virginie Chevalier (1847–1904). Dr. Gachet used her as a model several times, for example in a gouache of December 1877, *Mme Chevalier and Her Dog Taffa* (Van Gogh Museum, Amsterdam, D 596); it seems that he also depicted her on her deathbed (D 496). Visitors to the family in Auvers never failed in their letters to send regards to Mme Chevalier (and to her daughter, who married Théophile Bigny). Gachet *fils* mentions that Theo van Gogh gave her a small painting by his brother, *Huts in the Sunshine: Reminiscence of the North* (see Summary Catalogue, P. G. III-8 bis). See also Gachet 1956a, p. 71 and fig. 47; fig. 68; p. 72.

23. Letter from Lucien Pissarro (1863–1944) to Paul Gachet *fils,* November 4, 1927 (Gachet 1957a, pp. 53–54).

24. However, Lucien did not exclude the possibility that Pissarro and the doctor met before that, through Amand Gautier. The first known letter from Pissarro to Dr. Gachet, from Louveciennes and annotated February 17, 1872 (probably based on the postmark), specifies in the postscript that a visit from the doctor and Amand Gautier was expected for the following Sunday (see Pissarro Letters 1980–91, vol. 1, letter 15).

25. Gachet 1957a, pp. 25–37; reprinted in Pissarro Letters 1980–91, vol. 1, letters 15, 16, 23–26, 28, 31–35, 90, 91, 154, 206. Paul Gachet *fils* also published letters from Pissarro's mother, stating—although nothing has been found to corroborate this—that the doctor had been treating her since 1860–65 (Gachet 1956a, pp. 11, 21–24).

26. Pissarro Letters 1980–91, vol. 2, letters 489, 516–18, and vol. 5, letter 1791. In a letter to his son Lucien dated January 17, 1901, Pissarro notes, "Gachet has just left; he asked me to say hello"; however, he might be referring here to the younger Gachet. Lucien, too, later kept up a correspondence with the doctor, then with his son; and one of Lucien's brothers, Ludovic-Rodo Pissarro (1878–1952), also remained on good terms with the younger Gachet.

27. In his correspondence Camille Pissarro confirms that Cézanne was in Auvers by September 1872 and during the year 1873 (Pissarro Letters 1980–91, vol. 1, letters 18, 23). On Cézanne's house in Auvers, see Gachet 1956a, fig. 33. Alain Mothe (in Gachet 1994, p. 85 n. 33) gives the address as 66, rue Rémy.

28. See Gachet 1956a, p. 28, and especially the letter from Louis-Auguste Cézanne (the painter's father) to Dr. Gachet, August 10, 1873, published in Gachet 1957a, p. 61, and reprinted in Cézanne Letters 1978, p. 143.

29. See Gachet 1957a, pp. 65–78. The earliest letter between Guillaumin and Dr. Gachet is dated Friday, August 30, 1872; its rather formal tone indicates that the two men did not know each other very well at the time.

30. Gachet *fils* (in Gachet 1954a; text from 1928) enumerates all the printmakers Gachet knew of but designates none of them as his father's teacher. In Gachet 1956a, p. 132, he cites Félix Buhot (1847–1898), Henri Guérard (1846–1897), Alphonse Leroy (b. 1821), who was mainly a technician, Martinez, and Félix Régamey (1844–1907).

31. Gachet 1952. Note that Paul Gachet *fils* was born in 1873 and thus had no firsthand knowledge of his father's activity at that time. It is puzzling that the inventory made after Mme Gachet's death in 1875 (see pp. 289–91) makes no mention of a press, a heavy object that could not be moved easily; but if he did not have a press in 1872–73, Gachet could have had his plates printed by a professional.

32. And see Gachet 1956a, p. 58, for the pessimistic letter written by the dealer Latouche.

33. Gachet 1870, which reprints articles that were published in *Le vélocipède illustré*. The pseudonym comes from Mme Gachet's Christian name and her family's ties to the Mézin region. One may even wonder whether the author was not in fact Mme Gachet herself, even though the younger Paul Gachet always maintained that it was his father.

34. Gachet 1957a, pp. 81–88, 113–15. Renoir's first letter to the doctor dates from 1879 and his last from 1894; Monet's correspondence with Dr. Gachet was brief, consisting of an exchange of letters between late 1877 and early 1878.

35. Ibid., p. 164.

36. Gachet 1956a and Gachet 1957a. See also Distel 1990, pp. 207–15.

37. Gachet 1957a, pp. 163–67, 177.

38. See note 33, above.

39. Pakenham 1996.

40. Gachet's papers contain a visiting card from Lesclide with an introduction to Manet that Lesclide wrote for Dr. Gachet (Archives, Wildenstein Institute, Paris).

41. Additional witnesses were the publisher Dentu and Philippe-Auguste Jourde, editor of *Le siècle* and the bride's godfather. The wedding took place on February 15, 1879. See the marriage certificate, in the town hall of the 9th arrondissement, Paris, and an undated letter from Guérard to Dr. Gachet (Archives, Wildenstein Institute, Paris). Later, Dr. Gachet was involved in another family matter, as a witness at the custody hearing held at the same town hall regarding the couple's son, Jean Guérard, whose mother had died in 1883. Another letter from Guérard, dated January 2, 1882, mentions in a postscript: "You have no doubt learned of Manet's decoration [from the Legion of Honor]. He thinks you are quite unusual; we spoke about you yesterday" (Archives, Wildenstein Institute, Paris). There is nothing, however, to confirm that Gachet was consulted as a physician during Manet's final illness.

42. Notes dated between January 16 and November 18, 1890, refer to Hoschedé's attacks of gout; Dr. Gachet had been recommended to him by the engraver Norbert Goeneutte (Archives, Wildenstein Institute, Paris). Ironically, Hoschedé's review of the art salons of 1890 (Hoschedé 1890) was acidly critical of Vincent van Gogh in a chapter devoted to the Salon des Indépendants: "I fear, however, that M. Van Gogh's preposterous fantasies belong to an enchanted realm of art accessible to very few minds."

43. Drouot 1975, no. 26 (letter, Dr. Gachet to Camille Pissarro, March 5, 1874).

44. Gachet 1956a, pp. 21–22. The man who introduced them was probably Achille Ricourt (1776–1875), a native of Lille and a friend of Dr. Gachet's father and of Amand Gautier. Ricourt was a painter, actor, and founder of the magazine *L'artiste*, which supported and published Honoré Daumier.

45. Ibid., pp. 22–23.

46. Ibid., p. 72. A handbill relating to this election can be found in the Gachet papers at the Musée de l'Histoire de la Médecine: Daubigny is no. 5, and Dr. Gachet no. 8.

47. Paul Gachet *fils*, in ibid., p. 89, writes that his father had met Millet at Amand Gautier's, which is plausible but has not been confirmed. For the print, see cat. no. 46h.

48. Ibid., p. 66 n. 2. The younger Gachet gave the Maison de Victor Hugo, on the place des Vosges, Paris, two books inscribed to him and his sister by the poet. Note also that Dr. Gachet had in his library an inscribed copy of the novel *M. de Boisd'hyver* by Champfleury (Jules Husson), illustrated by Amand Gautier in 1867.

49. Letter from Lesclide to Dr. Gachet, July 15, 1875, in ibid., p. 66. The letter is bound with Dr. Gachet's copy of *La petite pantoufle*, a novel by Ting Tun-ling published by Lesclide in 1875 and acquired from his son by the Musée Guimet, Paris (62336).

50. Gachet 1954c. This booklet was reproduced, along with the musical scores and manuscripts that Paul Gachet *fils* gave to the Bibliothèque Nationale in 1954, in Colomer 1993. Cabaner, who knew Cézanne well, was also friendly with Murer, who owned Renoir's well-known work *The Artist's Studio, Rue Saint-Georges* (now in the Norton Simon Museum, Pasadena), in which depictions of Pierre-Eugène Lestringuez, Georges Rivière, Camille Pissarro, Ernest Cabaner, and Frédéric Cordey are recognizable.

51. Dr. Gachet had known Benoît since the 1860s, thanks to Amand Gautier. It was because Gevaert had played the piano in the Auvers house that Paul Gachet *fils* donated it to the Musée Instrumental in Brussels in 1952. See Gachet 1953b.

52. *Almanach fantaisiste pour 1882 de la Société des Éclectiques*. This small work informs us that the society was founded by Aglaüs Bouvenne, Alexis Martin, Karl Fichot *fils*, and Maurice Tourneux, who were joined by Edmond d'Hervilly, Ernest Flamant, Charles Asselineau, Antonin Voisin, and Ernest Causin. The almanac published by this group of writers, printmakers, and draftsmen, many of them amateurs, featured articles and prints by its members. Under his pseudonym Paul van Ryssel, Dr. Gachet contributed to the issues for 1882 and 1884.

53. Gachet 1956a, pp. 68–70.

54. Ibid., pp. 90–91. On a visiting card dated January 6, 1887, Gabriel de Mortillet thanks Dr. Gachet for the portrait of Lamarck that he engraved for the society (Archives, Wildenstein Institute, Paris). On Mortillet and his son, see Mohen 1987.

55. Dubois-Pillet, who was president of the society, urged Dr. Gachet to confirm his support of the Indépendants on June 17, 1886 (Archives, Wildenstein Institute, Paris).

56. Gachet 1957a, pp. 168–69. The date seems to have been misread at first; it was given in the original manuscript as June 12, 1883 (not 1890) (Archives, Wildenstein Institute, Paris). Gauguin's letter to Vincent van Gogh is in Cooper 1983, no. 42; see Excerpts from the Correspondence, June 27, 1890.

57. Trublot 1886–87.

58. Trublot (Paul Alexis), "Trubl'au vert—Trubl'Auvers-sur-Oise," in *Le cri du peuple* (August 15, 1887), which also mentions the doctor's children: "Monsieur Coco" (Paul Gachet) and "the silly geese," which probably refers not only to Dr. Gachet's daughter, Marguerite, but also to Mme Chevalier and her daughter, the other female members of the household; reprinted in part, in English translation, in New York 1986–87, pp. 195–96. The extant correspondence between Paul Alexis and Dr. Gachet runs from July 10, 1887 (when Alexis thanks the physician for his hospitality at Auvers-sur-Oise), to May 26, 1901, a few months before the writer's death (Archives, Wildenstein Institute, Paris).

59. Letter from Camille Pissarro to his wife, Julie, September 28, 1889; Pissarro Letters 1980–91, vol. 2, letter 544. Letter from Theo van Gogh to Camille Pissarro, catalogue of the sale of the Camille Pissarro archives, Hôtel Drouot, Paris, November 21, 1975, no. 189 (acquired by the Archives du Val d'Oise). Letters from Theo to Vincent van Gogh, October 4 and 22, November 16, and December 22, 1889 (T 18, 19, 20, 22), and from Vincent to Theo, October 5, 1889 (LT 609). See Excerpts from the Correspondence; see also Van Gogh Letters 1958, vol. 3, pp. 553–60, 220–22.

60. Vincent van Gogh was admitted at his own request to the Saint-Rémy asylum on May 8, 1889. On the Arles episode, see the documents collected in Stein 1986, pp. 132–34.

61. Letters from Theo van Gogh to Vincent van Gogh, March 29 and May 10, 1890 (T31, 34); letters from Theo to Dr. Gachet, May 9 and 19, 1890; letter from Vincent to Theo and Jo van Gogh, May 20, 1890 (LT 635); see Excerpts from the Correspondence; see also Van Gogh Letters 1958, vol. 3. Paul Gachet *fils* was the first to identify the day on which Vincent arrived in Auvers as May 20 (now the commonly accepted date). He based his conclusion on the following: Vincent wrote to Gauguin that he had spent three days in Paris before going to Auvers; the doctor was not in Auvers on Wednesday, May 21, because he saw patients in Paris on Wednesdays; thus Vincent, having visited Dr. Gachet immediately on arriving in Auvers, must have been there by Tuesday, May 20 (see Gachet 1956a, p. 106 nn. 2, 3). Moreover, he cites one of Dr. Gachet's datebooks in which the doctor noted for May 20, "M. Van Gogh. A [for Auvers]." This datebook has not been located. The date of May 21 for Vincent's arrival in Auvers (given in the first chronology) had been advanced by Jo in her Preface to the first, 1914 edition of Vincent van Gogh's letters, an English translation of which was published in Van Gogh Letters 1958 and recently published with emendations and corrections in Pickvance 1992. For a day-by-day account of Vincent's stay in Auvers, see Mothe in Gachet 1994.

62. Not June 10, as Jo had first written in her Preface to Vincent van Gogh's letters (see n. 61, above).

63. Pickvance 1992, pp. 25–41. There are three firsthand accounts: a letter from Dr. Gachet notifying Theo on the evening of July 27, 1890; two from Theo to his wife, July 28 and August 1; and a very long one—perhaps written with publication in mind—from Émile Bernard to the critic Albert Aurier on the day after the burial (see Excerpts from the Correspondence). Paul Gachet *fils* had carefully recopied in his notes (Archives, Wildenstein Institute, Paris) two contemporary press clippings, from *Le régional* of August 7, 1890, and from *La petite presse* of August 18, 1890 (Gachet 1994, pp. 283–84, 313 n. 185). He also had a later account by Le Masque Rouge, "La fin de Van Gogh," in *L'action* (Jan. 12, 1903), which was very favorable to Dr. Gachet.

64. Anton Hirschig in Bredius 1934; reprinted in Stein 1986, pp. 210–11. See also Alain Mothe's comments in Gachet 1994, pp. 286–87, 313 n. 184, for another letter from Hirschig to Albert Plasshaert (Sept. 8, 1911).

For Adeline Ravoux-Carrié, see Gauthier 1953, and Ravoux-Carrié 1955, reprinted in Stein 1986, pp. 211–19.

Finally, it was in the account he gave in his last book that the younger Gachet truly put himself in the picture (see Gachet 1994, pp. 247–48, 252), telling the story in greater detail than he had in Gachet 1956a, p. 121. His earliest description of the circumstances surrounding Van Gogh's death was apparently contained in the letter he sent Jo, Theo's widow—unfortunately, not dated, but from Jo's replies we can infer that it was written sometime during the last two weeks of February 1912 (Archives, Van Gogh Museum, Amsterdam, b3398 V/1984). In this version, he and his father were fishing when someone came to tell them of the painter's attempted suicide. The elder Gachet watched over the artist during the first night, while Gachet *fils*, Theo, and a young Dutch painter (Hirschig) spent the second night at the dying man's bedside. It is possible that Gachet *fils* believed this more emotional version, in which he plays a greater role than may have been the case; and, given his well-documented meticulousness, this account may even be accurate. At any rate, these details have only a tangential bearing on the history of art.

65. Letters from Theo van Gogh to Dr. Gachet, August 12 and September 12, 1890; see Excerpts from the Correspondence.

66. In a letter to Paul Gachet of August 15, 1905 (Van Gogh Museum, Amsterdam, b2134 V/1982), Jo was especially indignant over an article that included this passage in a note: "Dr. Gachet—a foresighted collector, we might say—currently owns a valuable group of works by Vincent, which he owes as much to the artist's reckless extravagance as to the extreme generosity of the latter's family. We would have reproduced several of these strange canvases if Dr. Gachet, vigilantly guarding his sudden fortune and worried about publicity, hadn't been afraid to divulge their existence, and thus to confirm that gratitude is the most profitable of virtues" (Bever 1905, no. 374, p. 605).

67. For Bernard's involvement in organizing the September 1890 show at Theo's in Cité Pigalle, see Van Gogh Letters 1911, pp. 2–4. According to a letter from Paul Signac to Octave Maus, October 23, 1890, the avant-garde artists' group Les Vingt in Brussels (of which Maus was the leader) was also planning to mount a Van Gogh retrospective; Signac advised Maus to get what he needed from the dealer Père Tanguy, who had "almost a hundred paintings by the poor boy, almost all of them very beautiful." See Chartrain-Hebbelinck 1969, p. 67.

68. See cat. nos. 12, 13, 18, 19, 21, 41; for loans not included in the donation, see Summary Catalogue, P.G. II-6, and "The Gachet Donation in Context," n. 35; see also the Chronology.

On the occasion of the 1905 retrospective, Paul Signac, vice president of the Indépendants, who lent the painting that Van Gogh had given him, wrote to Dr. Gachet: "My dear colleague, I wanted to thank you for your invaluable assistance. We knew who we were dealing with: a man who has always loved beauty and justice. We also hope that you and your son will participate in our exhibition with your own works, which would be most welcome. With my gratitude and cordial best wishes, P. Signac, Vice President" (Archives, Wildenstein Institute, Paris). Both Gachets exhibited at the show, along with their protégée Blanche Derousse, and were to do so again over the next several years. In a letter to Jo of July 3 or 4, 1905 (Van Gogh Museum, Amsterdam, b3368 V/1984), Paul Gachet *fils* specifies that the declared insurance value of the works he lent to the Indépendants is 15,000 francs for the *Portrait of Dr. Paul Gachet* (cat. no. 13) and 10,000 francs for another painting, which we have since learned was *Thatched Huts at Cordeville, Auvers* (cat. no. 19). These figures are somewhat high for a Van Gogh at the time, proving that the Gachets carefully followed the rising market value of Van Gogh's works. In comparison, they would have been average sale prices then for a Renoir or a Monet.

69. "Au docteur très docte Gachet/Sis en le bourg d'Auvers-sur-Oise/ Dans les verdures auprès Pointoise/Trop insuffisamment caché" (October 9, 1890).

70. Bernard 1891. We know of three letters from Bernard to Dr. Gachet in September 1890 (Archives, Wildenstein Institute, Paris). Bernard thanks the doctor for having put in a word for him with Theo van Gogh and also asks him, "When are you going to Schuffenecker's?" In 1934, in a letter addressed to the younger Gachet, he points out an omission in an article in *Aesculape*: the author neglects to mention Charles Laval as being among the friends present at Van Gogh's burial.

71. Gachet 1957a, pp. 51–52; see Excerpts from the Correspondence, May 12, 1891.

Dr. Doiteau (in Doiteau 1923–24 [Jan. 1924], p. 11), claims that Henri Matisse wrote to Dr. Gachet to arrange a visit to see his collection, but I have not found this letter in the Gachet papers.

72. Letter from C. Destrée to Dr. Gachet, October 7, 1897 (Archives, Wildenstein Institute, Paris). An announcement of Cézanne's death in 1906, addressed to "Dr. Gachet and family," is also among the Gachet papers.

73. A card from Norbert Goeneutte introducing Vollard to Gachet was formerly in the Gachet papers (collection of Michael Pakenham): "A. Vollard requests the pleasure of seeing Dr. Gachet regarding paintings by Van Gog [*sic*] and Guillaumin."

74. In attempting to find these photographs, I have focused my research on books dating from 1894 or that are in the Vollard archives at the Musée d'Orsay; contained therein is a set of photographs of works by Cézanne that Vollard had taken. The Archives of the Wildenstein Institute, Paris, contain other prints of the Vollard photographs (which were used by Rewald for his catalogue raisonné of the painter's work), as well as a letter from Vollard dated February 22, 1905, announcing to Dr. Gachet that he is sending his photographer

to see him. Vollard's book on Cézanne (Vollard 1914) reproduces several works from the Gachet collection, including *A Modern Olympia* (see cat. no. 1). Gachet's address also shows up in one of Vollard's address books (Bibliothèque des Musées Nationaux, Paris, Fonds du Musée d'Orsay).

75. Letter from Théodore Duret to Dr. Gachet, April 4, 1900 (Archives, Wildenstein Institute, Paris). There may be some uncertainty about the identity of the large painting of flowers, but the second painting is clearly *Two Children* (cat. no. 18).

76. A letter from Théodore Duret to Paul Gachet, February 13, 1914 (Archives, Wildenstein Institute, Paris), recalls his visit "one Sunday in Auvers at your father's house, where he showed me works by Cézanne and Van Gogh" and requests a meeting to collect information for a book he was writing on Van Gogh. In another letter, dated March 1, 1914, he talks about prints and asks Gachet to give the Bibliothèque Doucet his Van Gogh lithograph of *The Potato Eaters* "as well as a proof of the etched portrait of your father," which he had seen only in a proof at Delteil's. Paul Gachet *fils* gave an impression of Van Gogh's etching *Portrait of Dr. Gachet (The Man with a Pipe)* and an impression of Cézanne's *Head of a Young Girl* to the Bibliothèque Doucet in November 1920, but he gave the *Potato Eaters* lithograph to the Bibliothèque Nationale in 1953 (see cat. nos. 23b, 23d, 10b).

77. Letters from Meier-Graefe to Dr. Gachet, July 9 and 21, 1903 (Archives, Wildenstein Institute, Paris). In the first he requests a meeting. In the second he expresses thanks for his welcome at Auvers the day before and gives the address of Jo, now Mme Gosschalk; Dr. Gachet had apparently lost touch with her and probably wanted, among other things, to remind her of the expiration of the lease on Vincent van Gogh's cemetery plot in 1905. Meier-Graefe also responds to specific questions from the doctor. Regarding the work he had undertaken, he explains, "I have limited myself to citing the collections and the number of paintings [they contain], and to naming the most important ones," adding that so far, in France, he had seen Schuffenecker, Hessel, Aghion, the Bernheims, Mirbeau, Rodin, Émile Bernard, and Vollard; and in Holland, Jo, her brother A. Bonger, B. Veth, F. van Eeden, and Van Valkenburg, and asking Gachet to suggest others. He tells Gachet that he would be pleased to welcome his son in Berlin: "I would be very happy if he brought me the etching by Vincent, which I will certainly publish," alluding to *Portrait of Dr. Gachet (The Man with a Pipe)* (see cat. no. 23b).

On January 14, 1909, a few days after Dr. Gachet died, Meier-Graefe sent the younger Paul Gachet his condolences, adding, "I would love to purchase the little stream [fig. 84] by Van Gogh. I don't dare think about the others" (Archives, Wildenstein Institute, Paris). In his book (Meier-Graefe 1904, pp. 119–20 n. 1), alongside other owners of works by Van Gogh, he outlines the contents of Dr. Gachet's collection, specifying twenty-six paintings, only the most important of which are individually named or described. See Summary Catalogue, P.G. III-5, 6, 7, 12, 13, 16–18, 20, 23, 25, and III-a. Others were referred to generally as views of Auvers. Meier-Grafe also mentions the existence of Van Gogh's only etching.

78. Moore 1993. In 1917 Marguerite Poradovska (1848–1937) also wrote for her cousins a brief, and probably unpublished, account of her stay in Auvers in 1891 (Archives, Wildenstein Institute, Paris).

79. Letter from Dr. Gachet to Léon Bourgeois, Minister for Public Education and Religion, early October 1892 (Archives, Musée du Louvre, Paris): "Desiring to ensure during my lifetime certain provisions of my last will and testament, I am pleased to give the State as of now, as an irrevocable gift to the Musée du Luxembourg, the small portrait of me painted by Norbert Goeneutte, which critics have unanimously judged as one of the artist's major works as well as a significant milestone in the history of modern portraiture."

An undated letter from Goeneutte to Dr. Gachet (Archives, Wildenstein Institute, Paris) specifies, "The director of the national museums has asked me for your portrait, the understanding is that it will go immediately to the Luxembourg, where it will be hung at once." Another reads, "The Luxembourg reopened yesterday . . . the portrait is very well placed; it is hung on the picture rail . . . near a door. However, the frame seems too small because of all the enormous frames surrounding it."

80. Letter from Jérôme Doucet to Dr. Gachet, October 2, 1904 (Archives, Wildenstein Institute, Paris).

81. This obituary appeared in La chronique des arts et de la curiosité (Jan. 16, 1909), p. 23: "Doctor Paul-Ferdinand Gachet, who lived in Auvers-sur-Oise and was friendly with the painters from the Impressionist movement who spent time in that area, among them Van Gogh, died on January 9. He was himself a landscape painter and engraver, and under the pseudonym Van Ryssel he produced etched portraits of Monticelli and Van Gogh. A portrait of him by Goeneutte is at the Musée du Luxembourg." In Holland, Jo wrote a short, affectionate note that was published in a newspaper there; Susan Stein quotes from it below, p. 243 (see also Gachet 1956a, p. 140).

82. Gachet 1957a, pp. 156–58.

83. Dr. Gachet's cousin Marguerite Poradovska, in her 1917 account of her stay in Auvers in 1891 (see n. 78, above), recalls the doctor's thoughts on this subject: "'You see,' he told me, 'I have never brought in a teacher for my children! I believe one must learn everything on one's own! Instruction is useless, a joke! And the same goes for exams! One learns only when it is voluntary'" (Archives, Wildenstein Institute, Paris). See also Golbéry 1990, pp. 86–87.

84. Gachet 1956a, p. 131. These copies (see cat. nos. 5a, 6a, 8a, 8b, 9a and Checklist of Copies) date from about 1900. Some graphic works from the late 1890s (see Drouot 1993) show an Art Nouveau style reminiscent of A. Andréas (1868–1899), a friend of Murer and of Dr. Gachet. Paul Gachet's file in the archives of the Société des Indépendants indicates that he kept up his membership until August 1914, when he was drafted. A private showing of his works took place in Murer's studio just below Montmartre, at 39, rue Victor-Massé, from May 1 to 20, 1908, and Wildenstein exhibited them in 1954 (see New York 1954), when this important dealer was trying to persuade Gachet to sell him the noteworthy works in his collection.

85. In a letter to Jo, Paul Gachet wrote, "Since our father's death, I have stopped painting" (Archives, Van Gogh Museum, Amsterdam, b3415 V/1984); and to Paul Signac on October 14, 1923, "I no longer take time off to paint. I'm so behind in organizing papers that I don't know if I will ever get through it all" (Signac archives, Paris).

86. Letter from Paul Gachet to Gustave Coquiot, April 1, 1922: "My father wanted to do something on Vincent. It would have been in a unique copy that I was to hand-letter on parchment. Alas, he died, taking this and so many other projects with him! The idea remains" (Archives, Van Gogh Museum, Amsterdam, b3310 V/1966). Paul Gachet hand-lettered in calligraphy all his writings from at least 1905 until the early 1950s, when old age forced him to use his housekeeper's typewriter.

87. On life in Auvers, see Golbéry 1990.

88. See the cordial correspondence between Coquiot and Gachet beginning in 1921 (Archives, Van Gogh Museum, Amsterdam); Gachet contented himself with having Coquiot's assertions about his father rectified in Doiteau's article (see n. 89, below) and doing so himself in Gachet 1956a, pp. 96–97, 99–100. Another brief portrait appeared in 1921, also something of a caricature, by the critic Georges Rivière (who had known Dr. Gachet) in his monograph on Renoir (Rivière 1921). He later presented a fairer version in an article on Guillaumin (Rivière 1927).

89. Doiteau 1923–24. The copy bound by Paul Gachet with a print of Van Gogh's etching Portrait of Dr. Gachet (The Man with a Pipe) was acquired by the paintings department of the Louvre in 1959 (Bibliothèque des Musées Nationaux, Paris). Dr. Doiteau's original notes and his correspondence with Paul Gachet are at the Bibliothèque d'Art et d'Archéologie Jacques Doucet, Paris (Mfb LXXXII).

90. The 1905 expiration of the first fifteen-year lease on Vincent van Gogh's plot in the Auvers cemetery provided the impetus for the renewed correspondence between Dr. Gachet, soon followed by his son, and Theo's widow, Jo; Theo's remains were transferred to Auvers later, shortly before World War I began. The maintenance of the graves and plans for various commemorative monuments take up considerable space in the correspondence between the Gachets, Jo van Gogh-Bonger, and her son, V. W. van Gogh, until the death of Paul Gachet fils (Archives, Van Gogh Museum, Amsterdam).

91. De la Faille came recommended by both Theo's widow, Jo (letter of February 17, 1923; Archives, Van Gogh Museum, Amsterdam, b1521 V/1962), and Loys Delteil, an expert on engravings who died in 1927 (letter, Archives, Wildenstein Institute, Paris). Venturi wrote to Paul Gachet on May 2, 1934, "If you ever decide to sell the Portrait of a Model by Renoir or Cézanne's Bouquet of Flowers, I would be thrilled beyond words to buy them" (Archives, Wildenstein Institute, Paris, for both Venturi and Delteil). But in a preface (Venturi 1936) he recounted the difficulties he had had with three collectors: Dr. Barnes, Gachet, and Charles Loeser.

92. Letter from Paul Gachet to the engineer V. W. van Gogh, August 14, 1950 (Archives, Van Gogh Museum, Amsterdam, b3078 V/1962). Another letter to the same correspondent (b3433 V/1962), dated May 2, 1948, is still more explicit: "I have long been working on a project based on information from my father, which, given my excessive prudence, is moving forward little by little. Once I could have envisioned things more generously; today I can no longer allow myself to do so unless forced to: it depends entirely on the overall economic situation, which, alas, is slow to improve. I hope soon to begin taking some steps that must surely succeed: for me it is a moral sacrifice but it is also a duty, except that since I have been

making sacrifices of another sort for so long everything must begin again from the beginning."

93. Malraux 1951.

94. Artaud 1974, pp. 30–39.

95. Anfray 1953, 1954a–d, 1958a, b.

96. Letter from V. W. van Gogh to Paul Gachet, May 5, 1948 (Archives, Van Gogh Museum, Amsterdam, b 2838 V/1982).

97. Accepted by J.-B. de la Faille, in Faille 1928 (no. 659, *Le jardin de l'hôpital à Saint-Rémy en automne*) and in Faille 1970, where an editor's note mentions V. W. van Gogh's doubts; doubts are harbored as well by Jan Hulsker (Hulsker 1996, no. 1850 and p. 424). For a reasoned commentary arguing for the authenticity of this painting, which may be seen at the Van Gogh Museum, see Ronald Pickvance in New York 1986–87, p. 147, fig. 31. Paul Gachet's relations with V. W. van Gogh seem to have soured when he extended his historical inquiry into the Van Gogh brothers' medical histories and the causes of Theo's death (see V. W. van Gogh's letter to Paul Gachet, October 23, 1957, Archives, Van Gogh Museum, Amsterdam, b3092 V/1962).

98. Paris 1954–55; and Anonymous, "Ces toiles sont-elles de Van Gogh?," *Le Figaro littéraire*, Dec. 4, 1954, with reproductions of Van Gogh's *Two Children* and *Cows* (cat. nos. 18, 20); Bouret 1954; Cayeux 1954. Frank Elgar complained in his review of the exhibition (Elgar 1954) that a weekly (the reference is undoubtedly to *Arts*) was given information in advance and thus was able to scoop everyone else with a lengthy article on the eve of the press showing. The inflammatory press coverage was kindly brought to my attention by Susan Stein.

99. Cooper (in Cooper 1955, p. 105) took issue with Anfray on the subject of the *Portrait of Doctor Paul Gachet* now at the Musée d'Orsay (cat. no. 13) as well as of the etching. He regretted—as we do now—that a comparison with the other version of this portrait could not have been arranged at the time of the exhibition. In his view, *Cows* (cat. no. 20) is a "strange, Gauguinesque and unpleasing" work, but definitely Van Gogh's.

100. Besides the gifts cited explicitly in the catalogue entries and essays in this catalogue (to: the French national museums; the museums in Lille, Valenciennes, and Montpellier; the Bibliothèque Nationale; the Bibliothèque d'Art et d'Archéologie Jacques Doucet, Paris; the Museé de l'Histoire de la Médecine, Paris; the Van Gogh Foundation [now the Van Gogh Museum], Amsterdam; the department of prints and drawings of the Rijksmuseum, Amsterdam; the British Museum, London), Paul Gachet saw to it that a large number of valuable and less valuable objects and memorabilia should, in his words, be "honorably placed," by making outright gifts or gifts requiring partial purchase. Most of these went to museums in Paris: to the Musée de l'Armée, the uniform of an assistant surgeon-major in the National Guard (donated 1926) and decorations bestowed on Dr. Jean Cabrol, who had been friends with his father (1951); to the Bibliothèque Polonaise, manuscripts and a bust of his younger cousin, the writer Marguerite Poradovska, by Thomas Jules Vincotte (September 1945); to the Musée Carnavalet, a painting by Camille Delpy entitled *Snow at Montmartre*, 1869 (1953; P. G. I-24);

to the Musée de Vieux-Montmartre, prints, a medallion representing Dr. Gachet by Henry Fugère, and various documents (1955); to the Musée du Petit Palais, a pastel by Norbert Goeneutte dedicated to Dr. Gachet, *The Beautiful Flower Girl*, 1888 (1958); to the Maison de Victor Hugo, copies of Hugo's *L'année terrible* and *Le livre des mères* dedicated to the Gachet children (Aug. 1958); and to the Musée de la Monnaie, family medals. The rest went to museums in several other cities in France and to one in Brussels: to the École des Beaux-Arts, Lille, two studies by Amand Gautier (Sept. 1950); to the Musée de Pont-de-Vaux (Ain), a print by Dr. Gachet, *Monticelli* (1924); to Musée Tavet, Pontoise, one of his own paintings, *Interior of the Church of Saint-Maclou at Pontoise* (Nov. 1950), and twelve etchings by Dr. Gachet (1961); to the Musée des Beaux-Arts, Lille, the *Portrait of Amand Gautier* by Courbet, bought from Wildenstein with the intention of offering it to the museum (1952); to the Musée de l'Île-de-France, Sceaux (just south of Paris), a collection of dresses and female headgear from around Auvers-sur-Oise (1954); to the Musée Courbet, Ornans, a transfer lithograph of Manet's portrait of Courbet dedicated to Dr. Gachet and 20,000 francs toward the purchase of the *Portrait of Hugues Cuénod* (1955); and, finally, to the Musée Instrumental, Brussels, the piano from Auvers (1952). He sold Vincent van Gogh's Japanese prints to the Musée Guimet, Paris, in 1958 and on that occasion gave the museum a group of books and his own publications translated into Japanese. Of special interest are three Japanese-style albums that contain the drawings and signatures of 255 Japanese visitors to the Gachet house in Auvers between 1922 and 1939; Keiko Omoto, who is preparing for publication a study of the subject, has kindly drawn our attention to the importance of these cultural contacts for Japanese artists and art critics such as Yūsō Saki, Bakusen Tsuchida, Kikuo Kojima, and Yukio Yashiro, and for the poet Mokichi Saito. Plans for giving the Conservatoire des Arts et Métiers, Paris, certain family documents that pertain to the spinning of linen apparently never materialized. Finally, in 1954 Paul Gachet expressed his wish to help Auvers-sur-Oise maintain the tombs of Vincent and Theo Van Gogh in the town cemetery with a donation of 100,000 francs.

101. See Golbéry 1990; Rewald 1952; Tralbaut 1967. I do not know when Rewald met Paul Gachet, but there is a letter from Rewald expressing his condolences on the death of Marguerite-Clémentine Gachet, which he learned about from Ludovic-Rodo Pissarro (Rewald to Gachet, November 23, 1949, Archives, Wildenstein Institute, Paris). Mark Tralbaut knew the younger Gachet well and hints that he met him "before the war" (Tralbaut 1967, p. 101); but Paul Gachet, in a letter to V. W. van Gogh dated August 16, 1949, wrote, "I've had a visit from a Belgian gentleman whose name I've forgotten (Dr. Tabor, I think). He came at your suggestion and told me he knew you and Mr. Sandberg well. He lives in Antwerp and has written, he says, a work on Vincent in Antwerp and one on Vincent and *japonisme*. He is a professor of art history"—which suggests that the two of them did not meet until 1949.

102. Golbéry (1990, pp. 78–82) describes the efforts to draw public attention to this heritage. The French national museums, though

approached, were already in charge of several costly "artists' homes" and decided not to assume financial responsibility for yet another establishment.

The curators of the Louvre's Department of Paintings—René Huygue and Germain Bazin from 1936–37, and also, after World War II, Michel Florisoone, Albert Chatelet, and Jeannine Baticle—stayed in touch with Paul Gachet until his death; the last letter from Gachet to Germain Bazin is dated March 23, 1962 (Archives, Musée du Louvre, Paris, Z 62). (I warmly thank Albert Châtelet and Jeannine Baticle for sharing their memories of Gachet with me.)

103. Report to the Regional Council, no. 7-18, session of September 23, 1994. The house was classified as a historic monument in 1991 and was bought (with the objects that had been left in it after the first sale) for 2 million francs by the heirs of the Vandenbrouckes. Gratitude is due to this American couple, with their passionate interest in the history of the house, for having preserved it almost exactly as Paul Gachet left it.

104. Landais 1997, pp. 109–17; Walter Feilchenfeldt in Rewald 1996, p. 15.

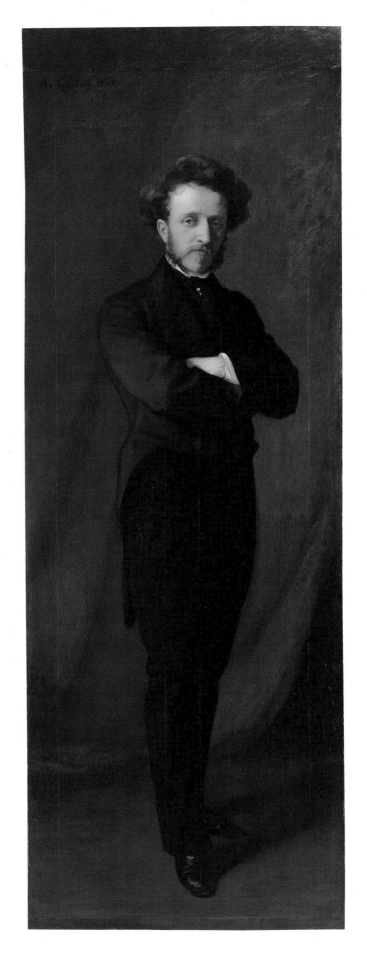

Fig. 19. Amand Gautier
(1825–1894), *Dr. Paul
Gachet,* 1859–61. Oil on
canvas, 78¾ x 29½ in.
(200 x 75 cm). Musée des
Beaux-Arts, Lille, gift of
Paul and Marguerite
Gachet, 1909. Exhibited
Salon of 1861, no. 1227

Portraits of Dr. Gachet and His Children

The substantial number of painted, drawn, etched, sculpted, and photographed portraits that were made of Dr. Gachet suggests just how much pleasure the man derived from seeing himself depicted. His son drew up a list of the portraits (see below) and made sure that many of them eventually went to museums.

One of the earliest of the works is the likeness of Dr. Gachet painted in 1859–61 by Amand Gautier (1825–1894), which was donated by Paul and Marguerite Gachet in 1909, the year of their father's death, to the Musée de Lille, the native city of both artist and model (fig. 19).[1] Gautier, a friend of Gachet's from childhood who chose a career as a painter and quickly moved into avant-garde artistic and literary circles, became a chronicler of the two young men's lives (figs. 22, 23)[2] and his friend's principal portraitist (fig. 21). (Earlier likenesses had been done by the obscure Edmond Lemoine and by Ambroise Detrez [fig. 20],[3] who gave watercolor lessons to the young Gachet.) According to a note recorded by Gachet's son, the newly licensed physician paid 23 francs on August 25, 1859, for a large piece of canvas on which Gautier immediately began painting his portrait, which originally included a cat at the model's feet that was later scraped out. The portrait was first shown at the 1860 Beaux-Arts exhibition in Troyes, where it won a gold medal. It appeared next at the Paris Salon of 1861 and earned an honorable mention, two caricatures in the papers, and a glowing review by Théophile Gautier in his *Abécédaire du Salon de 1861*: "By an idiosyncrasy that his talent has no need of to attract attention, M. A. Gautier has given his portraits the bizarre shape of a pier glass or photographic calling card. I rather appreciate this approach. The figure, confined in a narrow frame, takes on a certain elegance and shows to good effect. The portraits of the prince of San Castaldo, M. Tailhardat, and Dr. Gachet are distinguished by their accuracy of resemblance, their original aspect, and the vigorous sobriety of their color." Gachet's portrait was lithographed by E. Vernier. The model had reason to be pleased, for although he had not

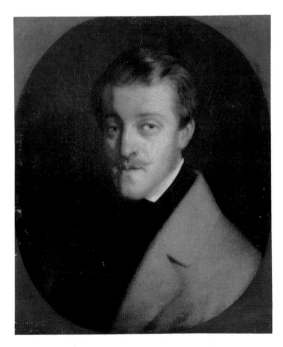

Fig. 20. Ambroise Detrez (1811–1863), *P. F. Gachet as a Student*, ca. 1850–52. Oil on canvas, 22⅞ x 19⅛ in. (58 x 48.5 cm). Musée des Beaux-Arts, Valenciennes, gift of Paul and Marguerite Gachet, 1947 (on deposit for the Louvre, RF 1947-34)

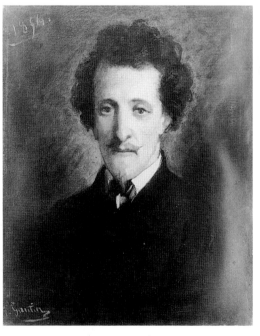

Fig. 21. Amand Gautier (1825–1894), *P. F. Gachet*, 1854. Oil on paper backed with canvas, 13 x 10⅝ in. (33 x 27 cm). Signed lower left: Gautier; dated upper right: 1854. Musée Fabre, Montpellier, gift of Paul Gachet, 1947–49

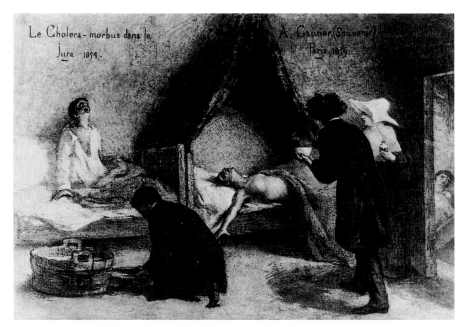

Fig. 22. Amand Gautier, *P. F. Gachet*, 1856. Graphite sketch, 8¼ x 4¾ in. (21 x 12 cm). Musée du Louvre, Paris, Département des Arts Graphiques, Fonds du Musée d'Orsay, gift of Paul Gachet, 1951 (RF 29 923)

Fig. 23. Amand Gautier, *Asiatic Cholera in the Jura*, 1859. Black graphite, 12 x 17⅞ in. (30.4 x 45.3 cm). Inscribed upper left: Le Choléra morbus dans le Jura 1854; upper right: A. Gautier (souvenir) Paris 1859. Wellcome Museum of Medical Science, London, acquired from Paul Gachet, 1928. Blanche Derousse made an engraved copy of the work that was exhibited at the Salon des Indépendants in 1908. A painting by Gautier based on this composition was shown at the Salon of 1887.

become a painter himself, he was nonetheless participating in artistic creation; his future course thus seems to have been laid out for him early on.

Among the doctor's Impressionist friends, Cézanne has left us allusive sketches of no great interest (figs. 24, 25),[4] reserving his brush for the portrayal of Gachet's house (cat. no. 2). Before the arrival of Vincent van Gogh in Auvers (see cat. no. 1 and fig. 56), the doctor posed only for such minor artists as Frédéric Régamey, Émile Godmer, Rodolphe Piguet (fig. 26),[5] Édouard Letourneau, and Charles Léandre (fig. 27),[6] all of them more or less connected with the group known as the "Éclectiques," of which the doctor was a faithful member.

It would be unfair not to recognize, along with the portrait by Van Gogh, the true merits of the portrait painted in 1891 by Norbert Goeneutte (fig. 28),[7] which earned Dr. Gachet first the honor of having his likeness hang at the Salon of the Société Nationale des Beaux-Arts and then that of its entering a museum collection in 1892. Goeneutte, who had tuberculosis and was Gachet's patient, had come to live in Auvers, where he later died; he maintained very cordial relations with his doctor, who was both

neighbor and fellow printmaker, and made several other portraits of him as well (fig. 29).

Finally, mention should also be made of the 1903 watercolor done by Dr. Gachet's son, Paul (pseudonym: Louis van Ryssel), who portrayed his father in medical garb (fig. 30).[8]

The doctor's children, Marguerite (1869–1949) and Paul (1873–1962), were also the subjects of portraits; the most glorious, that of Marguerite at the piano, painted by Van Gogh (fig. 87), was described by the artist in a letter to his brother Theo.[9] There are also more modest depictions of both Marguerite and Paul, by Amand Gautier and Norbert Goeneutte (figs. 31, 32).[10] Constant-Auguste Thomsen's medallion likeness of the younger Gachet of 1905 (fig. 34),[11] was followed by the portrait by Émile Bernard (fig. 33),[12] which shows Paul in 1926, wearing the type of military-style short cape that he sported to the end of his life. Among those who made the pilgrimage to Auvers in the years between the two world wars were two Japanese visitors who painted portraits of Paul Gachet *fils* (see below).

AD

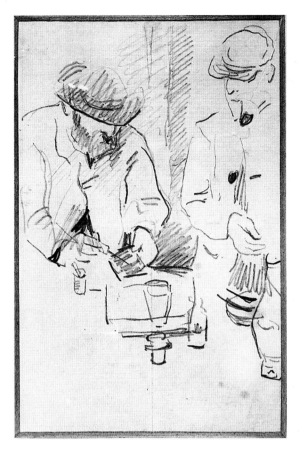

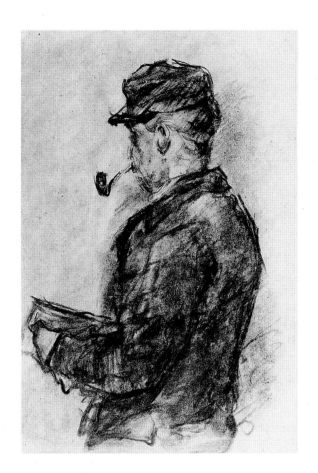

Fig. 24. Paul Cézanne (1839–1906), *Dr. Gachet and Cézanne Making an Etching,* ca. 1872–73. Graphite on laid writing paper with a faded black border, 8⅛ x 5⅛ in. (20.5 x 13 cm). Musée du Louvre, Paris, Département des Arts Graphiques, Fonds du Musée d'Orsay, gift of Paul Gachet, 1951 (RF 29 925). P.G. II-40

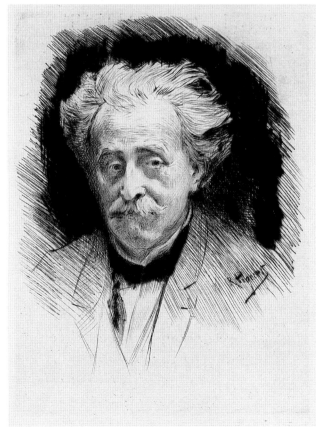

Fig. 25 (upper right). Paul Cézanne, *Dr. Paul Gachet,* ca. 1872–73. Charcoal on faded gray paper with traces of yellowed fixative(?), 12¾ x 8½ in. (32.5 x 21.5 cm). Musée du Louvre, Paris, Département des Arts Graphiques, Fonds du Musée d'Orsay, gift of Paul Gachet, 1951 (RF 29 926). P.G. II-39

Fig. 26 (right). Rodolphe Piguet (1840–1915), *Dr. Paul Gachet, Éclectique,* 1885. Drypoint, 4⅞ x 3½ in. (12.5 x 9 cm). Musée du Louvre, Paris, Département des Peintures, Service de Documentation, bequest of Étienne Moreau-Nélaton, 1927

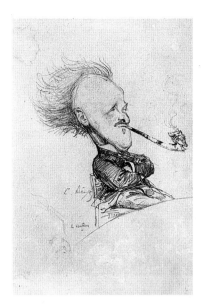

Fig. 27. Charles Léandre (1862–1930), *Caricature of Dr. Paul Gachet*, ca. 1887–88. Graphite on gray paper, 7⅞ x 5½ in. (20 x 14 cm). Musée du Louvre, Paris, Département des Arts Graphiques, Fonds du Musée d'Orsay, gift of Paul Gachet, 1951 (RF 29 927)

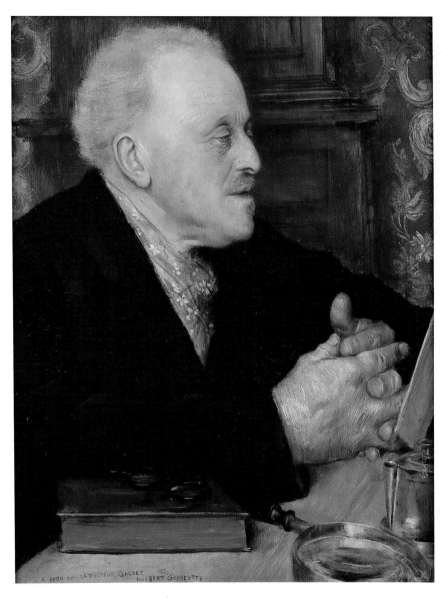

Fig. 28. Norbert Goeneutte (1854–1894), *Dr. Paul Gachet*, 1891. Oil on panel, 13¾ x 10⅝ in. (35 x 27 cm). Exhibited Salon of the Société Nationale des Beaux-Arts, Paris, 1892, no. 479. Musée d'Orsay, Paris, gift of Dr. Paul Gachet, 1892 (RF 757)

1. Signed upper left: A. Gautier. A lithograph of the work by E. Vernier was printed in 1862 by Lemercier (black ink on rice paper, 16¾ x 6⅛ in. [42.6 x 15.6 cm]; signed upper left, on the stone: E. VERNIER LITH.; upper right: A. Gautier pinx; Musée d'Orsay, Paris, bequest of Dr. Robert Le Masle, 1972). We know of two caricatures that appeared at the time of the 1861 Salon, one in the *Journal amusant* of June 22, 1861, the other in an album of caricatures by Galletti (Bibliothèque Historique de la Ville de Paris, Paris).

2. Fig. 22 annotated lower left: Dr. P. F. Gachet étudiant par Gautier; on the back: Paris, le 5 juin 1856, nous dînons ensemble. P. Gachet. Anticipé sur mon paradis futur. E. Delrue. J'espère que nous nous reverrons à pareille époque si ce n'est plus tôt. Gautier.

3. Signed at right. The donation of this work, made via a letter of May 23, 1939, was not registered until after World War II, and the painting, mistakenly sent to Montpellier, was not officially restored to the Musée des Beaux-Arts in Valenciennes until 1951.

4. See P.G. II-40, 39. Both drawings are included in the listing of Cézanne's drawings, Chappuis 1973 (nos. 292, 295). A third sketch by Cézanne, of a man's head and upper torso seen from the back (Chappuis 1973, no. 296; location unknown), which was part of the Gachet collection (see Summary Catalogue, P.G. II-38), was also considered by the younger Gachet to be a "portrait" of his father.

5. Signed lower right, on the plate: R. Piguet. See Leroi 1892, p. 274.

6. Signed at left: C. Léandre; annotated: le docteur.

7. Signed, dated, and dedicated lower left: À mon ami le docteur Gachet. Norbert Goeneutte, Paris, 1891. Blanche Derousse made a drypoint copy of this work that was exhibited at the 1906 Salon des Indépendants (Van Gogh Museum, Amsterdam, P201, 202 V/1966).

8. Dated upper right: MCMIII; signed lower left, in pencil: Louis van Ryssel. This watercolor can be related to the painting (oil on panel, 22⅞ x 16½ in. [58 x 42 cm]; signed lower left: LVR; dated upper left: ANNO DNI / 1903; private collection) that may be the work exhibited as no. 2398, *Portrait du Dr X*, at the 1903 Salon des Indépendants.

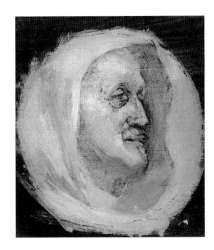

Fig. 29. Norbert Goeneutte, *Dr. Paul Gachet*, 1892. Monochrome medallion; panel, 12⅜ x 10⅞ in. (31.5 x 27.6 cm). Musée Atger, Montpellier, gift of Paul and Marguerite Gachet, 1949 (inv. 339)

Fig. 30. Louis van Ryssel (Paul Gachet *fils*, 1873–1962), *Dr. Paul Gachet in Medical Garb*, 1903. Watercolor and colored pencil, arched at top, 25¼ x 19 in. (64 x 48.4 cm). Musée du Louvre, Paris, Département des Arts Graphiques, Fonds du Musée d'Orsay (RF 43 334). Acquired at public auction, Hôtel Drouot, Paris, May 15, 1993, no. 227

9. The letter was given to Dr. Gachet by Theo's widow, Jo, in June 1905 to thank him for his welcome in Auvers-sur-Oise, where she had gone to renew the lease for Vincent's grave; see the letter from Jo Cohen-Gosschalk (she had since remarried) to Dr. Gachet, June 14, 1905 (b2131 V/1982, Van Gogh Museum, Amsterdam). It was saved by Paul Gachet *fils* and lent by him to Jo when she was editing Vincent's letters, then returned to Auvers (see the correspondence between Paul Gachet and Jo, February 1912, b3398 V/1984, b2151–53 V/1982, Van Gogh Museum; and Gachet 1953b, figs. 9, 10). It was later sold, and its current location is unknown. See Summary Catalogue, F1873, p. 230.

10. Fig. 31, annotated in black chalk: N. Goeneutte; and on the back, in pen, in the hand of Paul Gachet *fils:* Norbert Goeneutte / Paul Gachet fils / Auvers 1893 / Inscription au recto Dr Gachet / Tirage Paul Gachet. Fig. 32, dedicated at lower right, in pencil: à mademoiselle Marguerite / Norbert Goeneutte; annotated on the back: Norbert Goeneutte / La Femme à la lanterne / (Melle Marguerite Gachet) / (Auvers 1893) / Tirage Paul Gachet. Another print by Goeneutte is

considered to be a portrait of Marguerite Gachet (see Pontoise 1994–95, no. 78, repr.), but the model seems older. Among Paul Gachet's donations to the Bibliothèque Nationale there is an additional print by Goeneutte linked to the Gachet household: *The Armoire,* 1892(?), etching and drypoint, second state, 10¾ x 4¼ in. (27.2 x 10.7 cm); annotated: N. Goeneutte 2 état épreuve; on the back, in pen, in the hand of Paul Gachet *fils:* Norbert Goeneutte / L'Armoire (Melle / Suzanne Froliger) / Auvers (à la maison Gachet) / 1892? / inscription au crayon manuscrite / par le Dr Gachet / "imprimeur" de l'épreuve. Bibliothèque Nationale, Paris, Département des Estampes et de la Photographie, gift of Paul Gachet, 1953 (DO 8776).

11. Signed and dated at right: C. Thomsen 1905. Thomsen, a sculptor born in Paris, was a student of Gabriel-Jules Thomas, Charles Gauthier, and Aimé Mille, who exhibited at the Salon des Artistes Français between 1887 and 1907.

12. Dedicated on the back: à mon ami et compatriote Paul Gachet, Émile Bernard 1926.

Fig. 31. Norbert Goeneutte, *Paul Gachet fils,* 1893. Etching and drypoint, 7¼ x 5⅞ in. (18.5 x 15 cm). Bibliothèque Nationale de France, Paris, Département des Estampes et de la Photographie, gift of Paul Gachet, 1953 (DO 8776)

Fig. 32. Norbert Goeneutte, *Woman with a Lantern (Marguerite Gachet),* 1893. Etching and drypoint, second state, 8⅝ x 6½ in. (21.8 x 16.5 cm). Bibliothèque Nationale de France, Paris, Département des Estampes et de la Photographie, gift of Paul Gachet, 1953 (DO 8776)

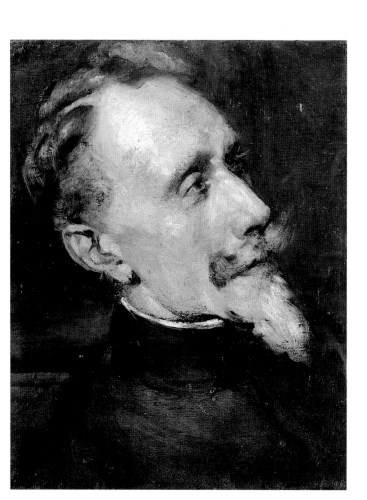

Fig. 33. Émile Bernard (1868–1941), *Paul Gachet fils,* 1926. Oil on canvas, 15¾ x 12⅝ in. (40 x 32 cm). Musée d'Orsay, Paris, gift of Paul Gachet, 1950 (RF 1977-39)

This list contains a number of works not illustrated here. It is based on a typewritten document prepared between 1940 and 1950 by Paul Gachet *fils*, "Le docteur Gachet, ses portraits," which was kindly made available by Dr. Michael Pakenham.

Portraits of Dr. Gachet

Edmond Lemoine, *P. F. Gachet at the Age of Twelve*, 1840. Oil on canvas, 14⅝ x 17⅛ in. (37 x 43.5 cm). Location unknown; see Paul Gachet 1956, fig. 6. Gachet *fils* mentions a reproduction by Blanche Derousse (etching and drypoint, 3⅝ x 3⅛ in. [9.1 x 8 cm]) that has not been identified, unless it is the print (color etching, 3½ x 3⅛ in. [9 x 8 cm]; private collection) that reproduces the portrait in the same direction and carries the inscription: G / MCMI Aetatis Suae XII anno Ejus Filius L. van Ryssel Pinxit.

Amand Gautier (1825–1894), *The Remedy (Episode in the Mission against Asiatic Cholera in the Jura)*, 1854. Watercolor, 7½ x 5⅞ in. (19 x 15 cm). Location unknown. Paul Gachet interprets this sketch as a portrait of his father, but the identification is not certain.

Amand Gautier, *P. F. Gachet and His Thesis*, 1858 (?). Pen-and-ink sketch, dimensions and location unknown; see Gachet 1956a, fig. 11.

Amand Gautier, *Dr. Paul Gachet in the Pose of Saint Francis of Assisi in Prayer, in the Manner of Zurbarán*, ca. 1860. Watercolor, 11½ x 8⅜ in. (29.2 x 21.4 cm). Location unknown; see Gachet 1956a, fig. 27.

Amand Gautier, *Dr. Paul Gachet as an Ambulance Doctor*, 1870–71. Watercolor, 8¾ x 5⅛ in. (22.2 x 13.1 cm). Location unknown; see Gachet 1956a, fig. 25.

Frédéric Régamey (1849–1925), *Dr. Paul Gachet Reading His Report to a Meeting of the Éclectiques*, 1870–73. Graphite sketch, 5⅝ x 3⅝ in. (14.2 x 9.1 cm). With dedication: à M. Paul Gachet en souvenir de mon ami le Dr. Gachet, Frédéric Régamey février 1910. Location unknown.

Frédéric Régamey, *Bust of Dr. Paul Gachet, Front View, Pipe in Mouth*. Graphite sketch, 5⅝ x 3⅝ in. (14.2 x 9.1 cm). Signed upper left. Location unknown.

Frédéric Régamey, *Dr. Paul Gachet in Right Profile*. Pencil sketch, 5⅝ x 3⅝ in. (14.2 x 9.2 cm). Signed lower right: Frédéric Régamey. Location unknown; see Gachet 1956a, fig. 37.

Émile Godmer (1839–1892), *Dr. Paul Gachet*. Plaster bust with terracotta patina, height 31½ in. (80 cm). Exhibited Salon of 1878, no. 4294. Location unknown.

Édouard Letourneau (d. 1907), *Dr. Paul Gachet in Profile with Pipe*, 1886. Graphite sketch, 7⅞ x 5⅛ in. (20 x 13 cm). With dedication at bottom: à l'ami Gachet. Location unknown.

Norbert Goeneutte (1854–1894), *The Smoker*, 1891. Charcoal, diameter 10 in. (25.5 cm). Location unknown; see Gachet 1956a, fig. 1. According to Paul Gachet, Blanche Derousse made a print after this work in 1900 (Van Gogh Museum, Amsterdam, P215–18 V/1966).

Émile de Specht (b. 1843), *Dr. Paul Gachet*, 1895. Conté crayon sketch, 8¼ x 5¼ in. (21 x 13.5 cm). Signed, dated, and dedicated at lower right: Paris, 19 décembre 1895 à notre frère et ami Emile de Specht. Location unknown. Paul van Ryssel (Dr. Gachet) made a print after this work (Musée du Louvre, Paris, Département des Peintures, Service de Documentation, bequest of Étienne Moreau-Nélaton, 1927).

Fig. 34. Constant-Auguste Thomsen, *Paul Gachet fils*, 1905. Medallion in coated plaster, diameter 13 in. (33 cm). Musée d'Orsay, Paris, gift of Paul Gachet, 1950 (RF 3869)

Henry Fugère (1872–1944), *Dr. Paul Gachet in Left Profile*, 1898. Plaster medallion, diameter 7⅛ in. (18.2 cm), signed, dated, and dedicated: Au docteur Gachet bien affectueux souvenir H. Fugère 1898. Exhibited Salon des Artistes Français, 1900, no. 2209. Wellcome Museum of Medical Science, London, acquired from Paul Gachet, 1928.

Henry Fugère, *Dr. Paul Gachet in Right Profile*, 1898. Plaster medallion, diameter 9½ in. (24 cm). Signed and dated: 3 juillet 1898. Location unknown.

Henry Fugère, *Dr. Paul Gachet in Left Profile*, 1898. Plaster medallion, diameter 7⅛ in. (18.2 cm). Location unknown.

Casimir Barcinski, *Gachetopathy*, 1900. Pen-and-ink drawing, 7⅛ x 5⅞ in. (18 x 15 cm). Inscribed: Vive la Gachetopathie Les Eclectiques, 13 août 1900, au docteur Gachet, Un sauvé. C. B. Location unknown. This caricature depicts Dr. Gachet wearing a bowler hat, whip in hand, chasing a skeleton crowned by Science surrounded by roses.

Léopold Robin, *Dr. Paul Gachet*, 1903. Oil on cardboard, 12¾ x 9⅝ in. (32.5 x 24.5 cm). Signed and dated lower right: LR 1903. Location unknown.

Portraits of Paul and Marguerite Gachet

Amand Gautier, *Marguerite Gachet as a Child*. Watercolor, dimensions unknown. Signed lower right: A. Gautier; dated lower left: 11 janvier 1871. Location unknown; see Gachet 1953b, fig. 7.

Micao Kono, *Paul Gachet fils*, 1927. Graphite, 20½ x 16⅛ in. (52 x 41 cm). Musée Guimet, Paris (MA 2108). This Japanese painter was a student of Fujita.

Yuki Some, *Paul Gachet fils*, 1930. Brush and India ink, 9½ x 13¾ in. (24 x 35 cm). Musée Guimet, Paris (MA 2104).

The Role of the Research Laboratory of the Musées de France

The Research Laboratory of the Musées de France, Paris, has participated in the preparation of the exhibition "The Collection of Dr. Gachet" from the outset. Its task has been to compare paintings by Cézanne and Van Gogh with the copies made by Dr. Gachet, his son, and their friends (notably Blanche Derousse).

Using standard photographic methods, in conjunction with a raking light, macrographic enlargement, and infrared and ultraviolet light, the surface and hidden elements of every painting were thoroughly examined from all angles. The components of the canvas and the paint layer were identified after studying such evidence as canvas fibers and the results of the chemical analyses of pigments and priming substances. The information that emerged reveals much about the character of each work. But rather than write a separate entry for each painting—since the discoveries are of far greater interest for some than for others—we have chosen to present our findings in terms of three main themes.

The first study is the comparison of Cézanne's *A Modern Olympia* and its copy by Dr. Gachet (pp. 39–43) conducted by Danièle Giraudy, who headed the laboratory group assigned to the project. The study relied on close observation, augmented by the optical methods cited above, to uncover any historical or technical evidence that would shed light on a particular aspect of the work, however slight. This method of comparison is especially useful in highlighting the respective characteristics of the original and the copy—the creative spirit of the painter who has mastered his craft versus the careful application of the copyist who strives to achieve the same effect. The issues of interest were not only matters of style but also various aspects of technique.

In the second study, radiographs of paintings by Cézanne and Van Gogh in the Gachet collection were analyzed (pp. 65–70). Close examination by experts revealed recurring characteristics of the most frequently employed types of supports used by the two artists, as well as indications of each man's personal style and technique.

The third study, on the subject of the fading of pink and purple pigments in works painted by Van Gogh at Auvers-sur-Oise (pp. 104–13), was conducted by Jean-Paul Rioux, a chemist at the laboratory. His work exemplifies the way the analysis of even minute details of a work can alter our understanding of paintings that we thought we knew well. Research of this nature must be pursued further, for it is essential if we are to comprehend the balance of colors and their aesthetic value.

Each of the three studies contributes to our knowledge of these paintings, both as individual works and as part of the production of a great artist or of a copyist. None of these investigations is exhaustive, and research that follows, even the most modest, no doubt will allow us to delve further into these works in order to appreciate their uniqueness as artistic creations, as well as the condition in which they have come down to us.

Jean-Pierre Mohen

CATALOGUE

The Gachet Donation

CÉZANNE AND VAN GOGH

PAUL CÉZANNE (1839–1906)

1 *A Modern Olympia (Sketch)*

1873–74
Oil on canvas, 18⅛ x 21⅝ in. (46 x 55 cm)
Musée d'Orsay, Paris
Gift of Paul Gachet (RF 1951-31)
P.G. II-25

This is without doubt the most important of the paintings
by Paul Cézanne that Dr. Gachet owned. By lending it to
the Impressionists' first group show in 1874, Gachet drew
attention to Cézanne, a perpetual *refusé* of the official
Salons. Even more, the doctor distinguished himself for
posterity as one of the first admirers of this painter, who
was scorned for almost his entire career and whose short
period of fame before his death came about only because
of a small group of enlightened collectors and fellow artists.

In 1874 *A Modern Olympia (Sketch)*—as it was listed in
the catalogue—was greeted with jeers from both the press
and the public. Louis Leroy, inventor of the derogatory
term "impressionist," poked fun at the small canvas, even
though it had been prudently labeled a "sketch": he main-
tained that Manet's *Olympia* from the Salon of 1865,
which had been shown again at Manet's solo exhibition in
1867 and which had created a scandal that was still very
much alive, was "a masterpiece of drawing, decency, and
polish compared with M. Cézanne's."[1] The critic for
L'Artiste, though preferring this composition to the land-
scapes Cézanne also exhibited, saw in it only a "bit of
artificial paradise" evoked by the fumes of an eminently
literary hashish, adding, "M. Cézanne appears to be noth-
ing more than a kind of lunatic, painting under the effects
of *delirium tremens*."[2] Finally, the critic Jules Castagnary,
normally a fan of realism, portrayed the painting as a
bogeyman that would teach a lesson to those who,
"neglecting to think and learn, have pursued impressions
to excess."[3] If we also bear in mind the comments of the
art dealer Latouche, who manned the exhibit one Sunday
in April 1874—"I'm keeping an eye on your Cézanne. I
won't answer for its safety, as I'm quite fearful that it will
be returned to you with a gash in it"[4]—we get a sense of
the total incomprehension that met the work in 1874.

Paul van Ryssel (Dr. Paul Gachet)
1a Copy after Cézanne, *A Modern Olympia*
Pen-and-ink and wash on cream-colored paper, 7⅞ x 10¼ in.
(20 x 26 cm)
Van Gogh Museum (Vincent van Gogh Foundation),
Amsterdam (D599)

Paul van Ryssel (Dr. Paul Gachet)
1b Copy after Cézanne, *A Modern Olympia*
Oil on canvas, 17⅞ x 21⅝ in. (45.5 x 55 cm)
Musée d'Orsay, Paris, gift of Paul Gachet, 1958 (RF 1958-17)

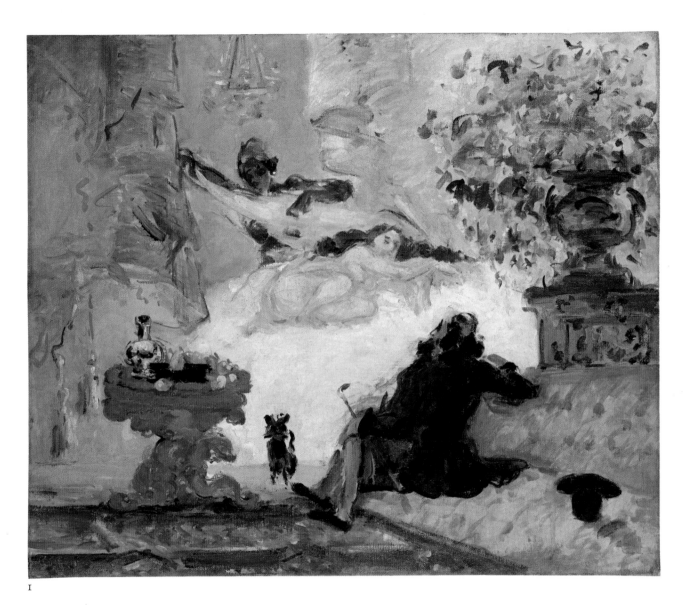

I

The younger Paul Gachet gave his version of the painting's genesis:[5] during a conversation with Dr. Gachet in Auvers about Manet's *Olympia*, Cézanne "retorted rather sharply that to invent an *Olympia*, even a new one, was mere child's play for him," whereupon he produced a "marvelous sketch that Gachet immediately took away for safekeeping, fearing that Cézanne might destroy it by trying to *push* it further. The doctor suggested the artist make a replica, giving him a blank canvas on which to copy the painting, but this was never done." Gachet *fils* added that Cézanne had already taken up the theme earlier, citing especially *The Pasha*.[6]

This narrative, wittily composed as a playlet, might seem a bit too picturesque to modern critics, but it touches on the obvious elements of Cézanne's painting: a subject that harks back to the erotic bacchanals of the artist's earlier compositions; the use of bright colors at a time when he was progressively moving away from his early, more somber palette; and a half-joking, half-earnest challenge from Cézanne to the great Manet. We might add that even if the title, with all its implications, was the doctor's own invention (a reasonable hypothesis, since he was the first to lend the painting), Cézanne does not appear to have objected to it. What *is* perplexing is the superfluous detail the younger Gachet supplied about the doctor giving Cézanne a virgin canvas for an unrealized copy, a memory that must have been relayed to him by his father, since he himself either hadn't yet been born or was an infant at the time.[7] The date Gachet *fils* assigned the painting, 1872, has been challenged by several specialists;[8] because it is fluid in style and paint application, contrasting with the darker, clumsier pictures Cézanne painted at

Blanche Derousse
1c Copy after Cézanne, *A Modern Olympia*
Watercolor over faint graphite sketch on white paper, 10⅜ x
14⅛ in. (26.5 x 36 cm); image 9¼ x 10⅝ in. (23.5 x 27 cm)
Musée du Louvre, Paris, Département des Arts Graphiques,
Fonds du Musée d'Orsay, acquired from Paul Gachet, Dec. 1960
(RF 31 237)

Blanche Derousse
1d Copy after Cézanne, *A Modern Olympia*
Drypoint, 9 x 10⅞ in. (23 x 27.6 cm)
Van Gogh Museum (Vincent van Gogh Foundation),
Amsterdam (P210)

the start of his Auvers period, they prefer to place the
work as close as possible to its first exhibition, in the
spring of 1874. I agree with this hypothesis.

Dr. Gachet copied the work at least twice, in pen and
ink (cat. no. 1a)[9] and in oil on canvas (cat. no. 1b), at dates
unknown. A comparison between the original and the oil
copy, which makes clear the copyist's approach and brings
out his weaknesses, is part of the analysis made by the
Research Laboratory of the Musées de France that appears
below. There is also a watercolor copy done by Blanche
Derousse at Dr. Gachet's request and under his guidance,
dated March 21, 1901 (cat. no. 1c);[10] and one more copy, a
drypoint by Derousse, was exhibited at the Salon des
Indépendants in 1907 (cat. no. 1d),[11] serving, at the opportune
moment when Cézanne was being posthumously honored,
as a reminder of the painting in the doctor's collection.

In itself, Derousse's modest entry at the Salon des
Indépendants would not have brought Cézanne's historic
painting to the mind of anyone except visitors to the
Gachet house in Auvers; but it is fitting that Ambroise
Vollard published and reproduced it—apparently for the
first time—in his 1914 monograph on Cézanne.[12] Since
then, almost every study on Cézanne has made reference
to the work,[13] although it was shown only twice by

Gachet *fils*, in 1936 and in 1939,[14] before being donated to
the national museums of France in 1951.

<div align="right">AD</div>

1. "A woman bent double, from whom a negress removes a final veil to
 offer her hideous charms to the enraptured gaze of a dark-skinned
 martinet." Leroy 1874.
2. Montifaud 1874.
3. Castagnary 1874.
4. Letter from Latouche to Dr. Gachet, April 26, 1874; published in
 Gachet 1956a, p. 58.
5. Gachet 1956a, pp. 57–58; also in Gachet 1956b. The same version of
 the facts appears in an entry of his unpublished catalogue, written in
 1928: Gachet Unpub. Cat., II, P.G. 25.
6. Rewald 1996, no. 171, dated 1869–70; sold at Sotheby's, New York,
 Nov. 13, 1997, no. 112.
7. Here is a slender hypothesis: might Paul Gachet, knowing that a
 copy of Cézanne's picture by his father existed, have tried in the
 notes he wrote to ward off the possibility of the copy's being used for
 fraudulent purposes?
8. Rewald 1996, no. 225, with bibliography.
9. Annotated in ink at lower left: *L'Olympia de Cézanne*. On the back,
 in pencil, in the handwriting of Gachet *fils*: *Dessin de P. Van Ryssel*
 [Dr. Gachet].
10. Signed lower right, in blue: *B.D.* Stamped lower left: *ML*. Anno-
 tated in the margins and at center left, in ink: H=23+6+/29
 L=27+6=/33; at lower left, in pencil: h 23/27; at lower right: 21 mars
 1901. On the back, in blue pencil (in the artist's hand?): *L'Olympia
 d'après le tableau de P. Cézanne / 21 mars 1901*.

11. Shown at the Salon des Indépendants (Paris 1907), no. 1514, under the heading "*La Nouvelle Olympia, point sèche, d'après le tableau de P. Cézanne (Collection du Dr. Gachet)."*

12. Vollard 1914, pp. 32–33, 34 n. 1, pl. 10. Rewald (1996, no. 225) mentions a photograph, no. 269 from the Vollard archives (now, Archives, Musée d'Orsay, Paris). The date of this proof is unknown. Rewald also mentions a photographic proof on which Cézanne's son wrote the date 1875 (present location unknown). I have found among Dr. Gachet's papers (Archives, Wildenstein Institute, Paris) a letter from Vollard to the doctor dated Feb. 22, 1905, telling him that his photographer will be paying a visit; this may be when the doctor's Cézannes were photographed for Vollard.

13. See Rewald 1996, no. 225, for the bibliography.

14. "Cézanne," Musée de l'Orangerie (Paris 1936, no. 28); "Centenaire du peintre indépendant Paul Cézanne, 1839–1906," Grand Palais (Paris 1939, no. 11).

A Modern Olympia: A Technical Comparison of Cézanne's Painting and Its Copy by Paul van Ryssel (Dr. Gachet)

A Modern Olympia by Paul Cézanne

What information do we have on the technique Cézanne employed in painting *A Modern Olympia* (fig. 35), and what can we learn from an examination of this "sketch," as it was called at its first exhibition?

The small, unsigned canvas, a size 10 canvas (portrait format), 46 x 55 centimeters (ca. 18 x 21½ inches), is high quality and in good condition. The canvas support has a density of 13 x 13 threads per square centimeter and a slightly irregular weave. There is distinct puckering on all four sides. Remounting on new stretchers with adjustable keys has left the upper right edge of the original canvas exposed.

The primer is not dense—probably very thin—and the overall contrast of the X-radiograph is good. The radiographic image matches the surface appearance of the work in direct light: there are no revisions or reworkings in this quick sketch, which is typical of Cézanne's technique during this pre-Impressionist period. It was a time of transition for the artist, who was in his early thirties in 1872.

That the piece was rapidly executed is also evident from the fact that it is identical to the composition seen in X-radiographs. Nothing beneath could be detected by infrared reflectography; Cézanne evidently sketched in his composition with a flexible brush without making any preliminary drawing, his usual method. He set out the volumes directly in color, in undulating touches that define their shapes: the ocher-and-white trimming on the curtain on the left (fig. 43), the arm and brown-green turban of the black servant girl, the still life, the feet of the vermilion pedestal table (fig. 38a), the silhouette of the visitor with his cane.

A mistake badly repaired in blue-gray is noticeable on the bowl to the right, at the curl of the foot; it is clearly visible in X-ray and ultraviolet photographs.

Photographs taken in raking light confirm an observer's initial visual impression: the paint is fluid and evenly applied. The free, sinuous, somewhat nervous brushstrokes are generally long, except on the bowl to the right, where transparent, triangular leaves and flowers are dabbed onto the canvas with a shorter brush (figs. 40a, 41). Cézanne's brushes have rounded tips, unlike the flat brushes and palette knife used by Dr. Gachet for his copy.

The layer of paint adheres well to the canvas. Generally speaking, it is homogeneous and thin, except for the central, luminous figure of the model's nude body, mottled in pink with a pearly gray sheen and highlighted by thicker applications of white paint for the sheets surrounding her (fig. 37a). At the center, a heavier application completely covers the texture of the canvas. The few thick areas include Olympia's folded legs (where the paint is riddled with cracks) and the visitor's dark gray suit. Otherwise, the canvas—light, thin, with a slightly irregular weave—generally remains visible beneath the transparent colors, which were thinned with turpentine.

Two thick strokes of white stand out under raking light: in the belly of the porcelain vase (part of the small still life posed on the table to the left) and in the leaves at the foot of the bowl to the right. The macrophotographs by Odile Guillon highlight these strokes.

The thick areas are encrusted with old varnish, visible in the hollows of the brushstrokes under a binocular loupe

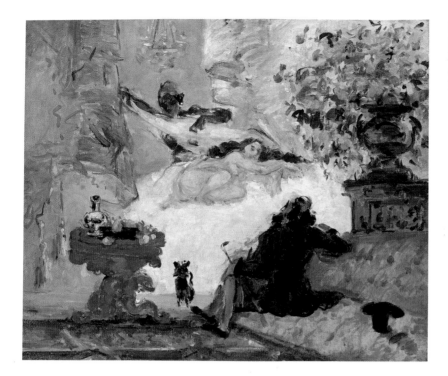

Fig. 35. Paul Cézanne, *A Modern Olympia (Sketch)* (cat. no. 1), ca. 1872–74. Oil on linen canvas, remounted in 1957; 46 x 55 cm. Undated, unsigned. Musée d'Orsay, Paris (RF 1951-31)

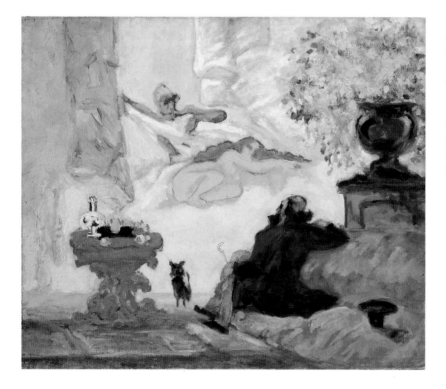

Fig. 36. Paul van Ryssel (Dr. Paul Gachet), copy after Cézanne, *A Modern Olympia* (cat. no. 1b), ca. 1890. Oil on linen canvas, 45.5 x 55 cm. Undated, unsigned. Musée d'Orsay, Paris (RF 1958-17)

Color photographs of the works under similar lighting reveal the difference between the varnished original and the unvarnished copy.

(magnifier). The varnish forms a thin layer over the entire shiny surface of the work and, today, gives the whole picture a slightly yellowish cast. A few thick, amber-colored flakes, which are quite visible under a loupe, remain stuck to the surface of the paint, notably in the white sheets.

Examination also reveals unevenly mixed color in the celadon green of the back wall.

It is evident that the painting is impulsively and spontaneously composed, justifying its original title: *A Modern Olympia (Sketch)*.

37a

37b

Fig. 37. Figure of Olympia, details
a. *Cézanne:* Rapid brush sketch of Olympia's curled body on the white sheets; slightly thickened applications of color that sculpt the shape of the body.
b. *Van Ryssel:* The flat color is applied over an underlying drawing, within the sketch lines (arms and breasts). The weak drawing is revised over the paint in a clumsy attempt to better delineate its shape (legs and feet).

Fig. 38. Pedestal table, detail
a. *Cézanne:* Painted spontaneously; the artist firmly shapes the arabesques of the Oriental tripod.
b. *Van Ryssel:* The precisely rendered outline (a tracing?) makes for a limp inner shape that undermines the form of the object.

38a

38b

Fig. 39. Small black dog, detail
a. *Cézanne:* A few rapid strokes suggest the animal's excited trembling.
b. *Van Ryssel:* In a black more like gray, the copyist's hesitant brush stiffens the animal's form.

Fig. 40. Bowl of greenery, detail
a. *Cézanne:* Impressionistic indications with green and yellow brushstrokes. The colors, juxtaposed by the rounded brush, and the fluid consistency of the paint give life and depth to the mass of vegetation.
b. *Van Ryssel:* The copyist used a spatula and a palette knife (tools that Cézanne had already abandoned some years before) to layer on his paint, flattened into a mass of pigment that makes the vegetation heavy and lifeless.

39a

39b

40a

40b

Fig. 41. Cézanne: Detail of a leaf of the bowl; macrophotograph
The transparent color poised on the rounded brushtip is dabbed onto the canvas without stroking, creating the shapes of the leaves.

Fig. 42. Van Ryssel: Detail of a leaf of the bowl; macrophotograph
The paint is spread with a spatula, without texture; the thick layer of paint conceals the canvas backing.

Fig. 43. Cézanne: Detail of the gold trimming on the curtain; macrophotograph
Quick S-shaped strokes—stenographic indications—highlight the drape of the pink curtain.

A Modern Olympia, copy after Cézanne by Paul van Ryssel (Dr. Gachet)

The support chosen by Dr. Gachet for his copy (fig. 36) is made of a thinner-weave canvas than Cézanne's, with a density of 19 x 19 threads per square centimeter; there is distinct puckering on the lower edge and less defined puckering on the other three sides. The weave of this machine-made canvas is slightly irregular. Examination of a bit of thread under electron microscope identifies it as jute, which is unusual. The slight difference in size between the two paintings (half a centimeter) can be attributed to the remounting of Cézanne's onto a new frame. The Van Ryssel picture is stretched on an adjustable frame, with keys.

X-ray analysis reveals a fairly dense primer layer, something confirmed by the poor overall contrast of the radiographic image, which is partly due to the amount of lead white in the primer. This preparatory layer was applied by machine, as the edges, primed but unpainted, testify. The painted layer offers little contrast, which is the case with all of Van Ryssel's laboriously rendered copies. The brushstrokes are indistinguishable. The figures, particularly the seated man, cannot be identified in the X-radiograph. In the areas offering the highest contrast, particularly the right-hand portion around the bowl, it is clear that the brushstrokes were flattened with a palette knife, a tool that Cézanne abandoned very early in his career (figs. 40b, 42).

The penciled layout, visible under reflectography, is clumsy but fairly faithful to the original (fig. 37b). It is probably a tracing, as we might suppose from the thumbtack holes visible all around the work. It might also have been traced from another full-size copy of the same work painted at about the same time by Dr. Gachet's protégée Blanche Derousse, whose watercolor also shows holes at the four corners; or, Van Ryssel's copy might have been used by her. We do not know in what order the copies were made. The strokes, done with a flat brush, cover the entire canvas and hide its layer of white primer (fig. 42). Cézanne used rounded brushes with more elongated bristles.

The colors, slightly brighter than those in the original, are applied inside the penciled guidelines, in discrete zones (the curtains, the green background, the settee, the carpet). The colors were mixed on the palette before being applied rather than reworked on the canvas in a creative burst, as is the case with Cézanne's original. The overall harmony is more intense, but the surface is dull, clashing with the color effect of each area. The painting demon-

A MODERN OLYMPIA

Comparative Table

	Paul CÉZANNE	Paul VAN RYSSEL
Date	Ca. 1873	End of 19th century
Frame	With keys, new	With keys, new
Dimensions	46 x 55 cm	45.5 x 55 cm
Condition	One hole repaired	Good. Some pinholes in the lower part (for a tracing?)
Canvas	Remounted, 13 x 13 threads per square centimeter; linen	19 x 19 threads per square centimeter; jute
Primer	White, applied by machine, lead white	Applied by machine, lead white
Pigments	Lead white + small amounts of zinc and barium Cobalt blue: bowl Copper green (Veronese): foliage/carpet Vermilion red: pedestal table	Lead white + large amount of zinc Prussian blue (ferricyanide) Green not identified; organic Vermilion red: pedestal table
Technique	Oil on canvas, thinned with turpentine Drawn directly with the brush Long, sinuous strokes made with rounded brush Paint fluid and transparent Few thick areas; oily; lightly cracked	Drawing beneath in black pencil and occasionally in blue, with redrawings in lead over the paint Strokes made with a flat brush; use of a palette knife in the foliage at the right Paint rather opaque and thickly applied, not rich in oil
Varnish	Yes—light Glossy surface	No Matte surface
Signature	None	None

strates a certain clumsiness of drawing and an ignorance of how to move from one tone to another: the green back wall overlaps the curtains framing it, the settee fades away, the arabesque on the right foot of the pedestal table is poorly rendered, making it look wobbly (fig. 38b), and the blue bowl appears concave.

The drawing has been further reworked on top of the painted layer, in pencil, around the underlying sketch, which is still visible beneath the paint. This is notably true with Olympia's body, which is especially badly drawn and anatomically improbable (see the thighs, knees, feet) (fig. 37b), and with the visitor's head and cane.

All these details, observable to the naked eye, become more visible still with macrophotography, which makes evident how different the brushstrokes are in the two paintings.

In the copy, the outline of each element was first precisely drawn in pencil; except for the central chandelier, which is missing, it is painstakingly faithful to the original. Each form remains separate from the neighboring ones, with no intermixing or overlapping of hues. Indeed, the amateur painter had no knowledge of the art of

transition: the paint seems brushed on with a broom, the surface flat and without texture. The only exception is in some thick portions rendered with a knife (particularly the foliage of the bowl, to the right), where the copyist improvised, using tools and pale colors that differ from those employed by Cézanne (figs. 41, 42).

Except for the images of the visitor, the dog, and the bowl, all the colors are lightened by a white that "clogs them up," whereas the transparent touches of paint in the original work give it lightness and fluidity. These differences are further heightened by the ultimately dull appearance of the copy, which is unvarnished.[1]

Danièle Giraudy

1. Sources useful in the writing of this study were London, Paris, Washington, 1988–89, pp. 39–40, and 126–27 for the 1869 variant (formerly Pellerin collection); and Cadorin 1991, pp. 13, 16, 17 n. 6.

 Tests conducted by the Research Laboratory of the Musées de France were: X-radiography, 22KV/10mA/2 min. (M. Solier); macrophotography (Odile Guillon); examination under electron microscope (C. Moulhérat); microfluorescence X and pigment analysis (Alain Duval); infrared reflectography (Patrick Le Chanu); and radiographic study (Élisabeth Ravaud).

Paul Cézanne (1839–1906)

2 *Dr. Gachet's House at Auvers*

1872–73
Oil on canvas, 18⅛ x 15 in. (46 x 38 cm)
Musée d'Orsay, Paris
Gift of Paul Gachet, 1951 (RF 1951-32)
P.G. II-5

This landscape's traditional title refers to the light-colored building seen higher up and in the background, a little to the left of center: the western facade of Dr. Gachet's famous house in Auvers.[1] The road with its slight curve; the gables of the houses, marking the successive levels of a composition that is distinctly defined, but softened by the hazy network of branches; the sober palette, composed mainly of grays, tans, ochers, browns, and greens, highlighted by blue and a few touches of brick red; all belong to the idiom that Cézanne developed during his stay in Auvers under the influence of his friend Camille Pissarro. Because the work belonged to Dr. Gachet, it is an especially resonant symbol of the relationships linking the two painters with their collector and imitator. This small picture demonstrates a particularly light touch, with the texture of the canvas left visible in spots, whereas many other paintings by Cézanne from this period, such as the famous *House of the Hanged Man* in the Musée d'Orsay, show a heavily reworked surface. His accomplished work of the Auvers years is generally thought to date from 1872–73;[2] the lightness of this painting suggests that it was made toward the end of that period. Two other landscapes depicting Dr. Gachet's house are often likened to this work: one with a very similar composition, at the Yale University Art Gallery in New Haven, and a second showing the house from a different angle, at the Kunstmuseum in Basel.[3]

In studying this painting for the Research Laboratory of the Musées de France, Anne Roquebert has drawn attention to the stamp that was on the back of the original canvas before it was relined in 1986. It is that of the tradesman Chabod, the successor to Bovard, the merchant of paints and canvas at 15, rue de Bucy. Chabod appears in the commercial directories only between 1870 and 1872, dates that mesh with the generally accepted time frame for this painting. AD

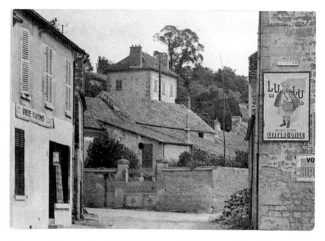

Fig. 44. View of Dr. Gachet's house. Photograph by John Rewald

1. See Venturi 1936, no. 145, with the title *Maison du Dr. Gachet, Auvers*, the date 1873, and the somewhat exaggerated description "all in blue." Gachet *fils* (Gachet Unpub. Cat., II, P.G. 5) called it *Paysage—La maison du Dr. Gachet* (Auvers 1873). Gachet specified that Cézanne "was facing away from the House of the Hanged Man"—in other words, that he had set up his easel on the street now called rue François-Coppée, past the current intersection with rue Rémy. Michel Florisoone, who studied the work at the time of its acquisition by the national museums and tried to recapture the painter's viewpoint with a camera, noted that Cézanne bent the true perspective to fit his composition, giving the Gachet house a monumentality that it would not actually have from this angle: see Florisoone 1952, p. 14, with a photograph of the southern facade of the Gachet house as seen from the Pontoise road, which runs below it.
2. Rewald 1996, no. 192, with bibliography. He mentions an old photo from the Vollard archives, a copy of which can be found in the archives of the Musée d'Orsay.
3. Rewald 1996, nos. 193, 194.

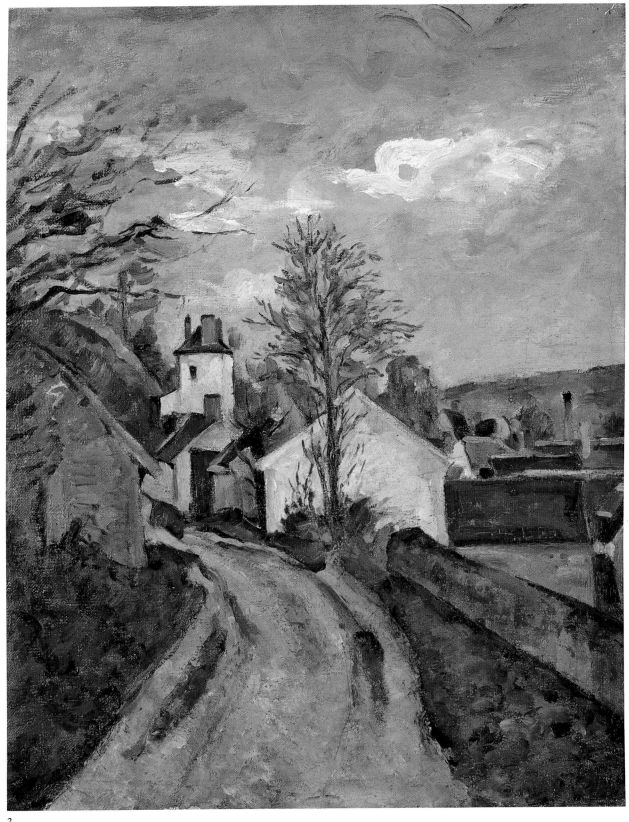

2

Paul Cézanne (1839–1906)

3 *Crossroad of Rue Rémy, Auvers*

1872
Oil on canvas, 15 x 17⅞ in. (38 x 45.5 cm)
Musée d'Orsay, Paris
Gift of Paul Gachet, 1954 (RF 1954-8)
P.G. II-3

Unknown when it was acquired by the French national museums in 1954, this somber work has not inspired much extended commentary since, but its authenticity has never been challenged.[1] The hesitant arrangement of heavy shapes harks back to the style of Cézanne's first period and argues for dating the work to the very beginning of his stay in Auvers, about 1872 (as John Rewald has done). A comparison with *Dr. Gachet's House at Auvers* (cat. no. 2), painted a year later at most, allows us to measure the evolution of the artist's style during this period. In his unpublished catalogue, Paul Gachet *fils* identified in detail the spot painted by Cézanne, very near the Gachet house "at the top of the rue Rémy, which continued at the time into what is now the rue des Vessenots; the rue des Pylones (its modern name) and La Chevalrue or Jouarue begin at the same intersection. At that time, the place served as a tennis court."[2]

Laboratory examination confirms that the much-reworked composition had been so damaged that the canvas needed to be lined.

AD

1. Not catalogued in Venturi 1936, it was named *Carrefour de la rue Rémy à Auvers* on the basis of information from Paul Gachet *fils* and reproduced for the first time in Paris 1954–55, no. 5. For the subsequent bibliography, see Rewald 1996, no. 185, which mentions the existence of an old photograph that Vollard had taken of the work, annotated in the handwriting of Cézanne's son: Auvers 1873. A print of this photograph, marked "334" in blue pencil on the verso, is among the photographs in the Vollard archives (Archives, Musée d'Orsay, Paris).
2. Gachet Unpub. Cat., II, P.G. 3, under the title *Carrefour de la rue Rémy* (Auvers 1873). On this painting, see also Reidemeister 1963, p. 61, with a modern photo of the intersection.

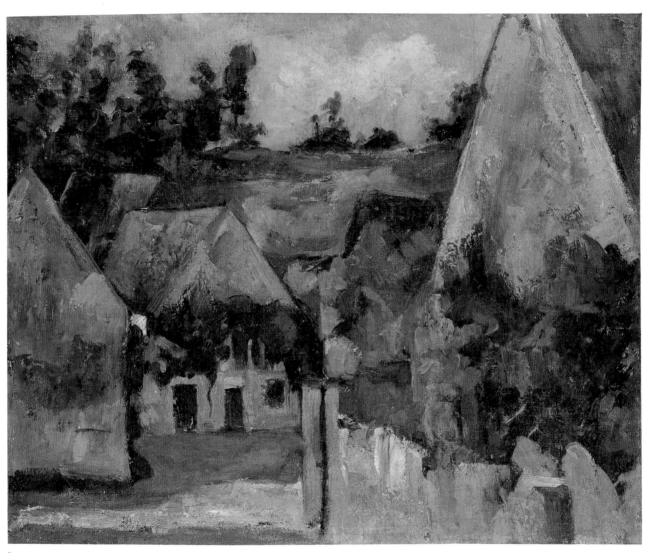

3

Paul Cézanne (1839–1906)

4 The Accessories of Cézanne: Still Life with Medallion of Philippe Solari

1872
Oil on cardboard, transferred to canvas, 23⅝ x 31⅞ in. (60 x 81 cm)
Musée d'Orsay, Paris
Gift of Paul Gachet, 1954 (RF 1954-7)
P.G. II-10

The upper portion of this still life has been removed, having suffered considerable damage during the mounting of its original support, a worn piece of cardboard, onto canvas. Unlike some other Cézannes in the Gachet collection, this dark and not very attractive painting has from early on engendered a bibliography; a photograph of the work, taken by Ambroise Vollard before the upper part was lost (fig. 46),[1] was published well before Paul Gachet *fils* donated it to the French national museums in 1954. He wrote that the still life was executed at Cézanne's house in Auvers in 1873[2] and that in it the painter included a broken plaster medallion of his friend the sculptor Philippe Solari (1840–1906), which was later given to Dr. Gachet and subsequently restored. Emphasizing the date—1870—of the medallion, which he regarded as a self-portrait by Solari, the younger Gachet added that his father had named the painting *The Accessories of Cézanne*, a title maintained to this day. The medallion was given to the French national museums by Gachet *fils* in 1951 (see p. 64); for want of more precise information, we must continue to assume that its portrait subject and its creator were one and the same. Solari, a native of Aix, was an intimate of Cézanne and Zola, but little is known about his career apart from his relations with his illustrious friends.

The issue of the medallion remains minor next to questions raised by the work itself, which were summarized in 1996 by John Rewald.[3] Rewald expressed surprise that a work by Cézanne dating back no further than 1872 (if we accept its supposed history) could be so awkward, when the painter had already demonstrated his mastery of such subjects by that time. This consideration led Walter Feilchenfeldt to question the work's authenticity, along with that of other works from the Gachet collection, in his preface to Rewald's book.[4] Feilchenfeldt's hypothesis has been strenuously disputed by Theodore Reff,[5] who points out that this painting, photographed by Vollard

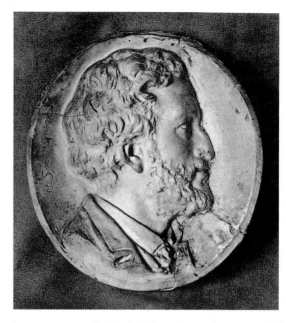

Fig. 45. Philippe Solari, *Self-Portrait*, 1870. Plaster medallion, Diam. 9⅞ in. (25 cm). Musée d'Orsay, Paris, gift of Paul Gachet, 1951 (OD 22)

(something Feilchenfeldt did not know), has been published unchallenged as a Cézanne since 1923 and in addition comes to us considerably altered. It seems highly unlikely that so unattractive a work would have been "fabricated" at the beginning of the century and passed off as a Cézanne. The only other possibility is a faulty attribution, owing more to the failing memory of Dr. Gachet—who could have conveyed erroneous information—and to the ignorance of his son than to an attempted fraud, which could easily have been discredited at the time. But if one tries to imagine who else might have painted the work, no "candidate" seems convincing, partly because there are no conclusive points for comparison: not Dr. Gachet himself, his friend Amand Gautier, Armand Guillaumin, nor even Solari, who according to the critic Coquiot was a painter in his own right.[6] Given the provenance of the work, it therefore seems prudent to stick with the attribution to Cézanne—who was, unfortunately, quite capable of producing mediocre art, overworked and stilted.

AD

4

1. This is most likely the photograph (though not specifically captioned) that was reproduced in Venturi 1936, no. 67, with the title *Nature morte, bas-relief, parchemin, encrier* (*Still Life: Bas-Relief, Parchment, Inkwell*), dated 1870–72, and with the medallion of Solari mistakenly identified as a portrait of Dr. Gachet. The first mention of the work, in 1923, presents a confused and inaccurate description: "ca. 1870, *Still Life with Inkwell*: sphinx with the head of Adolphe Thiers. A goose feather is stuck in the inkwell, napkin rolled in a ring, other small accessories, all placed on a table" (Rivière 1923, p. 199).

2. Gachet 1953a, unpaginated. Gachet *fils* communicated this information (which he dated from 1928, as does Gachet Unpub. Cat., where the same information appears in II, P.G. 10) to Michel Florisoone, who used it in Florisoone 1952, p. 24.

3. Rewald 1996, no. 211.

4. Ibid., p. 15 n. 3.

5. Reff 1997, p. 801.

6. Coquiot 1919, pp. 137–39.

Fig. 46. Photograph of *The Accessories of Cézanne: Still Life with Medallion of Philippe Solari* before restoration, from the Vollard archives. Archives, Musée d'Orsay, Paris

Paul Cézanne (1839–1906)

5 *Bouquet with Yellow Dahlia*

1873?
Oil on canvas, 21¼ x 25¼ in. (54 x 64 cm)
Signed lower right, in red: P. Cézanne
Musée d'Orsay, Paris
Gift of Paul Gachet, 1954 (RF 1954-5)
P.G. II-11

John Rewald compared the awkward execution of this still
life with that of the one called *The Accessories of Cézanne*
(cat. no. 4) but also recognized that the brushwork for the
flowers recalls another painting from the Gachet collec-
tion, *Dahlias* (cat. no. 9), long considered one of the best
still lifes Cézanne painted in Auvers.[1] Before it went to
the French national museums, the *Bouquet with Yellow
Dahlia* attracted little attention,[2] except from Paul Gachet
fils, who made a watercolor copy of it (cat. no. 5a)[3] and
donated to the museum the quite ordinary stoneware
pitcher with blue decorations that had served as Cézanne's
model.[4] We should note the very visible signature in red,
oddly contorted along the frame: Cézanne rarely signed
his works, but when he did, the signature is often in red.
Its presence on a canvas may suggest that the work was
intended for a collector or a public exhibition, but in all
these cases we have to wonder whether the signatures
were applied at first or were added after the fact, and even
whether they are in Cézanne's own hand (leaving aside
questions about the authenticity of the works themselves).

AD

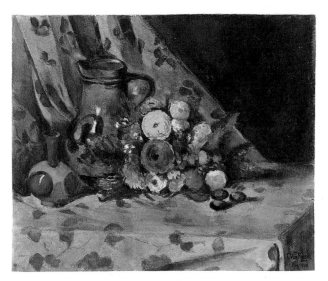

Louis van Ryssel (Paul Gachet *fils*)
5a Copy after Cézanne, *Bouquet with Yellow Dahlia*
Watercolor, 13⅛ x 16 in. (33.5 x 40.5 cm)
Musée du Louvre, Paris, Département des Arts Graphiques,
Fonds du Musée d'Orsay, acquired from Paul Gachet, 1960
(RF 31 257)

1. Rewald 1996, no. 214. He mentions the existence of several photos
 from the Vollard collection, including one, annotated by Cézanne's
 son, giving a date of 1875; a print is in the Vollard archives (Archives,
 Musée d'Orsay, Paris).
2. Venturi (1936, p. 347) gives it only a mention: "Still life: Two vases.
 Dark brown vase with flowers arranged on a gray-blue tablecloth,
 which falls diagonally from left to right, against a black background."
 In Gachet Unpub. Cat., II, P.G. 11, Paul Gachet listed it as *Bouquet au
 dahlia jaune avec cruche de grès* (Auvers 1873) and underscored the simi-
 larity between the fabric painted by Cézanne and that in a still life by
 Guillaumin (see cat. no. 28). His comments are repeated in Gachet
 1953a.
3. Signed and dated lower right, in blue: L. Van Ryssel/Fev. 1900; anno-
 tated on the verso in pencil in Gachet *fils*'s handwriting: Nach dem
 Gemalde von P. Cézanne 53½ x 64 L. Van Ryssel/Fev 1900.
4. See cat. no. 11; gift of Paul Gachet, 1951 (OD 26).

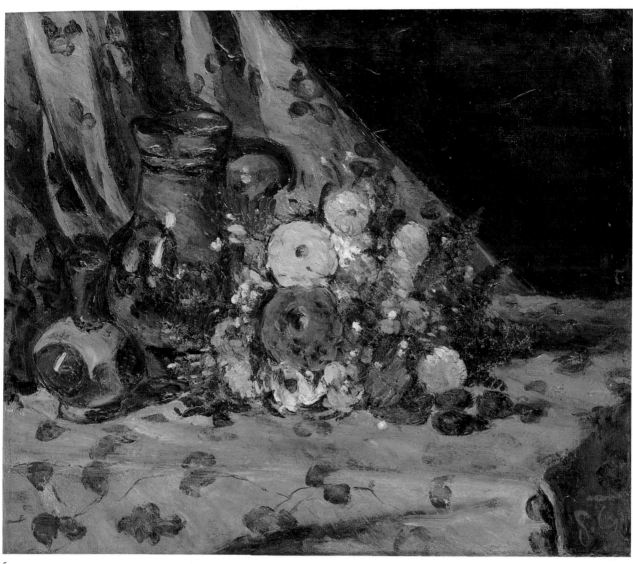

5

Paul Cézanne (1839–1906)

6 *Green Apples*

Ca. 1872–73?
Oil on canvas, 10¼ x 12⅝ in. (26 x 32 cm)
Musée d'Orsay, Paris
Gift of Paul Gachet, 1954 (RF 1954-6)
P.G. II-17

Although exhibited for the first time when it was acquired by the French national museums,[1] *Green Apples* had been catalogued by Lionello Venturi in his 1936 corpus of Cézanne's work.[2] This lively, unassuming little piece could pass for an exercise in style and is placed in the Auvers period mainly on the strength of its provenance.[3] Cézanne's sketch was soon joined in the museum by the copies made by Dr. Gachet's two "students": his son (under the alias "Louis van Ryssel") and Blanche Derousse (cat. nos. 6a, 6b).[4]

AD

1. Paris 1954–55, no. 9, pl. VI.
2. Venturi 1936, no. 66, *Nature morte: pommes et feuilles*, dated 1870–72, with the caption "photograph by Venturi." Gachet *fils* wrote a short notice commenting on the spirited style of the work, which he called *Pommes vertes*—Peintes à la maison Gachet—1873: Gachet Unpub. Cat., II, P.G. 17. The photograph accompanying it, presumably taken before the donation, already shows traces of the diagonal pencil lines between the four corners.
3. Rewald 1996, no. 213, dated 1872–73, with bibliography. Rewald mentions a photo by Vollard (no. 184) of the work, annotated by Cézanne's son, which dates the painting 1875, but there is no copy of it in the Vollard archives in the Musée d'Orsay.
4. Signed and dated lower right, in blue: BD./7bre [September] 1900; annotated on the back in pencil, probably handwritten by Paul Gachet *fils*: Aquarelle de Blanche Derousse d'après Cézanne grandeur de l'original [Watercolor by Blanche Derousse after Cézanne same size as original].

Louis van Ryssel (Paul Gachet *fils*)
6a Copy after Cézanne, *Green Apples*
Oil on canvas, 10¼ x 12⅝ in. (26 x 32 cm)
Musée d'Orsay, Paris, gift of Paul Gachet, 1958 (RF 1958-22)

Blanche Derousse
6b Copy after Cézanne, *Green Apples*
Watercolor over faint graphite sketch on white paper, 9⅛ x 12⅝ in. (23.3 x 32 cm)
Musée du Louvre, Paris, Département des Arts Graphiques, Fonds du Musée d'Orsay, acquired from Paul Gachet, 1960 (RF 31 238)

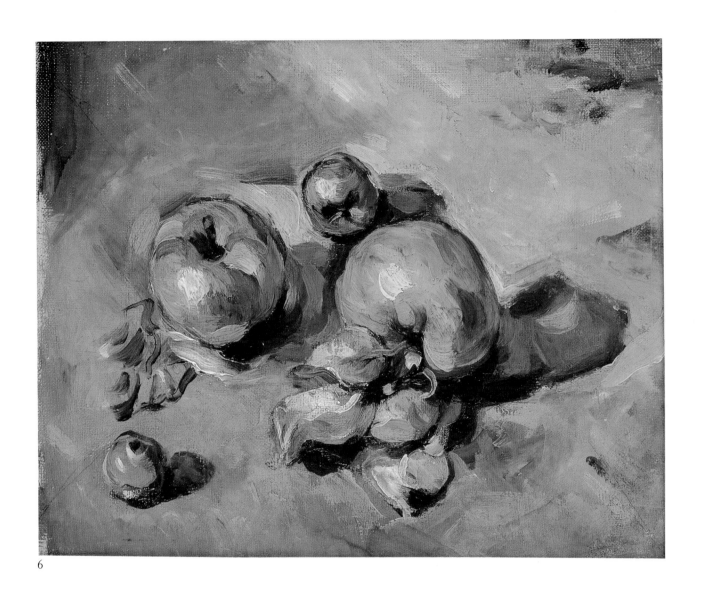

6

Attributed to Paul Cézanne

7 Still Life with Fruit

Oil on cardboard, 8⅝ x 12⅝ in. (22 x 32 cm)
Musée de l'Orangerie, Paris
Jean Walter–Paul Guillaume collection (RF 1963-10)
P.G. II-18

Formerly recorded as a work by Cézanne,[1] and as such part of the Walter-Guillaume collection that was acquired by the state in a single lot in 1963,[2] this small still life is included here because it belonged to Paul Gachet.[3] John Rewald deattributed it in his 1996 catalogue raisonné,[4] with the approbation of the museum's curators.[5] Because this painting belonged to a public collection and thus had no market interest, art historians were left complete liberty of judgment; this has proven fatal to a painting that, though modest, is not without virtues. For the moment, the wisest course seems to be to keep the question open while stressing that its awkward qualities—the heaviness of the shadows and of the pictorial motif—may simply be due to the unambitious nature of the study. In addition, there is an old photograph of the painting in the Vollard archives,[6] a criterion that Rewald himself (along with most other Cézanne experts) has always regarded as likely to indicate that a work is indeed by Cézanne.

AD

1. On the verso, in what seems to be Dr. Gachet's hand, there appears twice an inscription in black pencil: Auvers/Septembre 1873/ Paul Cézanne. I have found no previous mention of this.
2. I am grateful to Pierre Georgel for having shown me an unpublished note by Mme Walter indicating that she acquired the painting in April 1951, "in exchange with Methey [or Mathey] for two Soutines, came directly from Gachet."
3. Catalogued by Gachet *fils* as *Nature-morte (fruits)*, Auvers 1873, in Gachet Unpub. Cat., II, P.G. 18.
4. Rewald (1996, p. 155) reproduces the work in the commentary for no. 209, as a copy after Cézanne.
5. Hoog 1984, no. 15, with bibliography and a list of previous exhibitions.
6. Several copies of it are in the archives of the Musée d'Orsay, Paris.`

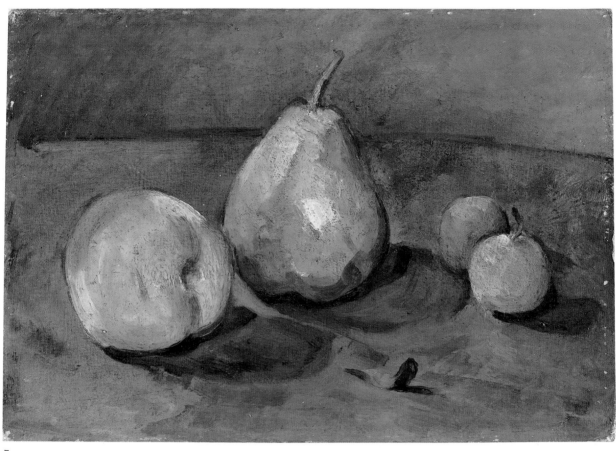

7

PAUL CÉZANNE (1839–1906)

8 *Bouquet in a Small Delft Vase*

1873?
Oil on canvas, 16⅛ x 10⅝ in. (41 x 27 cm)
Signed lower left: P. Cézanne. Annotated on the back, on the
stretcher bar (in Dr. Gachet's hand, according to Gachet *fils*):
P. Cézanne Août 1873.
Musée d'Orsay, Paris
Gift of Paul Gachet, 1951 (RF 1951-33)
P.G. II-15

In 1936 Lionello Venturi mentioned this small still life in
the Gachet collection,[1] reproducing it and noting that it
was probably one of the "two beautiful bouquets by
Cézanne" that Vincent van Gogh wrote he had seen at
Dr. Gachet's house on his first visit.[2] But the work did not
really come to public attention until it was donated to the
national museums in 1951,[3] along with the small vase that

had "posed" for the picture (see cat. no. 11). According to
Gachet *fils*, it was his father who suggested to Cézanne
that he adopt a small format, the better to "liven up" the
piece.[4] There is another, slightly larger painting with the
same vase, but different flowers, in a private collection.[5]
The Gachet painting, with its energetic yet rather heavy
strokes, bright colors, and somewhat clumsy composition

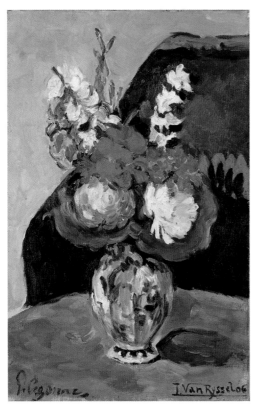

Louis van Ryssel (Paul Gachet *fils*)
8a Copy after Cézanne, *Bouquet in a Small Delft Vase*
Oil on canvas, 16⅛ x 10⅝ in. (41 x 27 cm)
Musée d'Orsay, Paris, gift of Paul Gachet, 1958
(RF 1958-21)

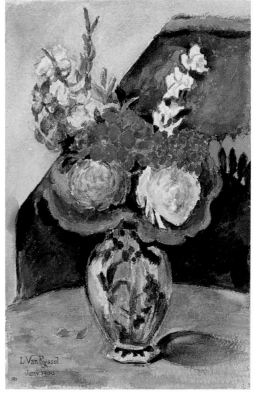

Louis van Ryssel (Paul Gachet *fils*)
8b Copy after Cézanne, *Bouquet in a Small Delft Vase*
Watercolor, 15⅛ x 10 in. (38.5 x 25.4 cm)
Musée du Louvre, Paris, Département des Arts
Graphiques, Fonds du Musée d'Orsay, acquired
from Paul Gachet, 1960 (RF 31 255)

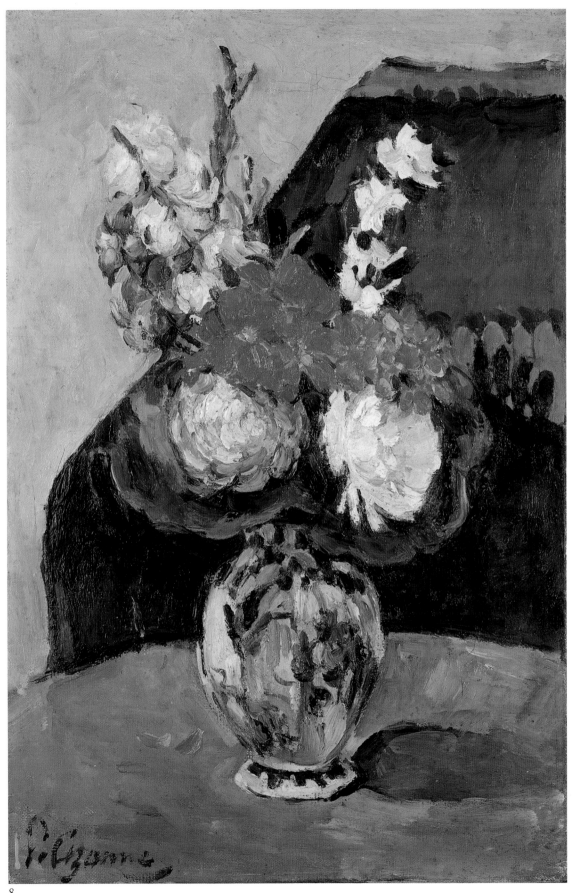

8

(how should we read the dark mass in the background: drapery, furniture, or recess?), is certainly the less appealing of the two. Two same-size copies of the *Bouquet in a Small Delft Vase*, one in oil[6] and the other in watercolor,[7] were made by the younger Gachet (cat. nos. 8a, 8b).

AD

1. Venturi 1936, no. 183: *Vase de fleurs*, 1873–75.
2. Letter from Vincent van Gogh to his brother Theo and sister-in-law Jo, LT 635; see Excerpts from the Correspondence, May 20, 1890.
3. Florisoone 1952, p. 25 and pl. III (in color). Rewald (1996, no. 227) notes that there is a photo of the work, taken by Vollard.
4. Gachet *fils* published this anecdote in Gachet 1953a. It also appears in Gachet Unpub. Cat., II, P.G. 15, as *Bouquet dans un vase de Delft*.
5. Rewald 1996, no. 226, *Géraniums et pieds d'alouette dans un petit vase de Delft*, 1873, 52 x 39 cm, signed lower left, in red: P. Cézanne; as having belonged to a grocer from Pontoise, Armand Rondest (1832–1907), then to Dr. Gachet [doubtful], Vollard, and Bernheim-Jeune. Gachet *fils*, in Gachet 1953a and Gachet Unpub. Cat., clearly said that he knew of *two* other paintings with the same subject as that donated by him to the national museums: a size-8 canvas, 46 x 38 or 33 cm (18⅛ x 15 or 13 in.), a "small bouquet of zinnias and coreopsis also painted at the doctor's home," which his father had made Rondest buy; and a size-10 canvas, 55 x 46 or 38 cm (21⅝ x 18⅛ or 15 in.), with "different flowers and background," also signed lower left, which he identifies as "no. 31 in the Cézanne exhibition at the Orangerie in 1936" (no. 226 in Rewald 1996). Thus, unless Gachet *fils* was mistaken, there existed another version of the painting, now lost. See Summary Catalogue, Appendix.
6. Signed and dated lower right: L. Van Ryssel 06; copied signature lower left: Paul Cézanne.
7. Signed and dated lower left, in red: L. Van Ryssel/janv. 1900; annotated on the verso, probably in the artist's hand: Nach Dem Gemalde von P. Cézanne/40l/2 x 27/L. Van Ryssel Pontoise 1901 [*sic*].

PAUL CÉZANNE (1839–1906)

9 *Dahlias*

1873
Oil on canvas, 28¾ x 21¼ in. (73 x 54 cm)
Signed and dated lower left, in red: P. Cézanne.
Musée d'Orsay, Paris
Bequest of Count Isaac de Camondo, 1911 (RF 1971)
P.G. II-14

This Cézanne still life was not among the Gachet donations, having gone to the Louvre shortly before World War I as part of the Count Isaac de Camondo bequest; its inclusion nonetheless in the present exhibition is motivated by the discovery of unpublished documents that confirm anew its brief passage through the Gachet collection, a fact heretofore ignored.[1] Indeed, the Gachet provenance has always been mentioned in the museum's catalogues since the work was acquired. The papers of Camondo also contain a record of his purchase of the painting from Gachet on May 11, 1907, for 9,000 francs, through a minor dealer on the rue Laffitte named L. Moline (who at the same time liquidated the collection of Dr. Gachet's neighbor and friend Murer).[2] In addition, this must be one of the "two beautiful bouquets by Cézanne" that Van Gogh described having seen at Dr. Gachet's home on his first visit there in 1890.[3] We might also compare this perfectly mastered still life from the Auvers period with

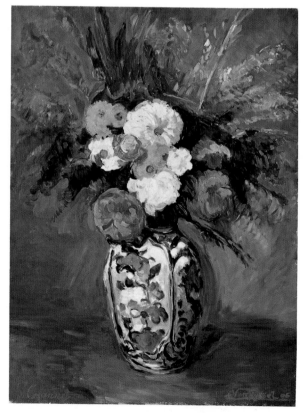

Louis van Ryssel (Paul Gachet *fils*)
9a Copy after Cézanne, *Dahlias*
Oil on canvas, 28¾ x 21¼ in. (73 x 54 cm)
Musée d'Orsay, Paris, gift of Paul Gachet, 1958 (RF 1958-20)

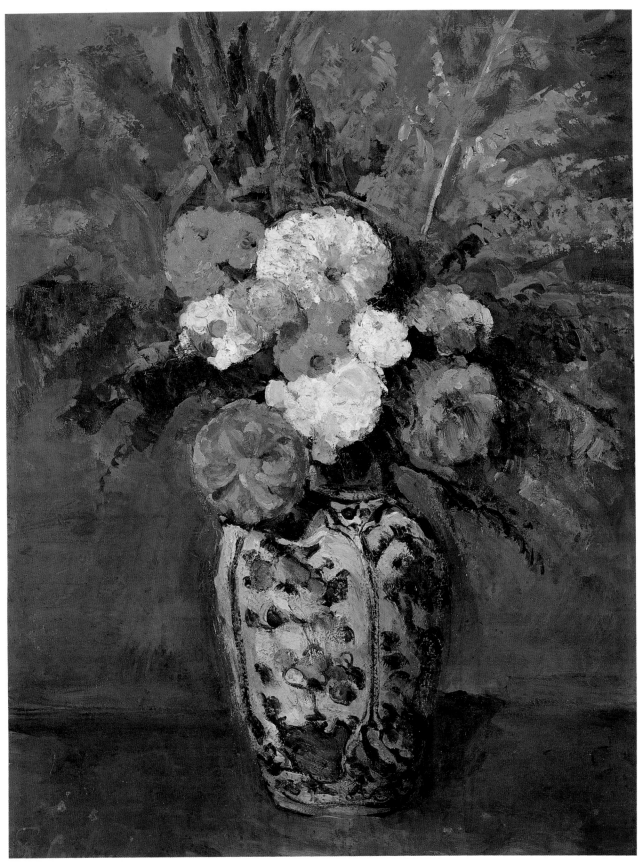

9

the less successful examples that remained in the doctor's possession and then in his son's. Moreover, in 1906 Gachet *fils* signed a same-size copy in oil (cat. no. 9a) in which he replicated even the remarkable red signature,[4] thereby giving us the opportunity to analyze and compare the original and the copy.[5] The younger Gachet donated the Delft faience vase to the national museums in 1951 (see p. 64).

Working with the Research Laboratory of the Musées de France, M. Eveno analyzed the painting's pigments with X-microfluorescence and determined that vermilion was used for the signature. Anne Roquebert emphasized in her report that the signature was added over a ground already dry, after many attempts from which light traces of wiped-off color remain. As his letters testify, Cézanne sometimes signed a work long after it was finished.[6]

AD

1. Venturi (1936, no. 179) cites as its provenance, before it went to Isaac de Camondo, a private collection in Pontoise and the Galerie Bernheim-Jeune; Rewald (1996, no. 223) states that the work belonged to the Pontoise grocer Armand Rondest and later to Bernheim-Jeune, even though he notes that one of the photos of the painting in the Vollard archives bears the annotation "Gachet."

2. I am grateful to Sophie Le Tarnec for letting me see the typewritten note (kept in the Musée Nissim de Camondo, Paris) that summarizes the purchases of artworks in 1906–7. The museum also owns the hand-written letter, signed "Louis van Ryssel," that Paul Gachet *fils* sent Camondo on May 3, 1908, in hopes of visiting the count's collection (Seni and Le Tarnec 1997, p. 187). Gachet *fils* included the work in his unpublished catalogue as *Bouquet de dahlias. Peint chez le Dr Gachet, Auvers 1873* (Gachet Unpub. Cat., II, P.G. 14). His commentary relating that the bouquet had been arranged by Dr. Gachet for a still life of his own and then "yielded" to Cézanne was published in Gachet 1953a. He also wrote to Gustave Coquiot on April 1, 1922 (Archives Van Gogh Museum, Amsterdam, b3310 V/1966): "I still own the Delft vase from the marvelous *Bouquet of Dahlias* in the Louvre that I sold to Camondo." It is possible that the work belonged for a time to Rondest (or some other local "collector"), from whom Dr. Gachet bought it, although his son never said as much and unequivocally states in his unpublished entry that it was one of the works seen by Van Gogh in 1890.

3. Letter from Vincent van Gogh to his brother Theo and sister-in-law Jo, LT 635; see Excerpts from the Correspondence, May 20, 1890.

4. As Theodore Reff (1962, p. 225 n. 17) and later John Rewald (1969, pp. 49–50 n. 43) have emphasized, these signatures probably indicate that the paintings were intended for collectors or public exhibition.

5. Signed and dated lower right: L. Van Ryssel 06; copied signature lower left: P. Cézanne. Gachet *fils* also made a watercolor (17⅜ x 12⅞ in. [44 x 32.7 cm]), signed and dated lower left: L. Van Ryssel 1900; and annotated on the verso: 53½ x 72 [i.e., the original painting's dimensions]. Musée du Louvre, Paris, Département des Arts Graphiques, Fonds du Musée d'Orsay, gift of Paul Gachet, Dec. 1960 (RF 31 254).

6. Rewald 1978, p. 144.

Paul Cézanne (1839–1906)

PRINTS

10a *Sailboats on the Seine at Bercy (after Guillaumin)*

1873
Etching, 8½ x 10⅜ in. (21.5 x 26.5 cm), only known proof
Annotated in reverse, in the plate: *d'après Armand Guillaumin Pictor*
Bibliothèque Nationale de France, Paris, Département des Estampes et de la Photographie, gift of Paul Gachet, 1953

According to Paul Gachet *fils*, this copy of a September 1871 painting by Guillaumin (see cat. no. 27) was Cézanne's first engraving.

No mention of Cézanne's stay in Auvers or of his relations with Dr. Gachet would be complete without some discussion of the prints that the painter is reputed to have made there under the collector's guidance, alongside Pissarro and Guillaumin. Although the first extensive study devoted to the subject was the one Paul Gachet *fils* published in 1952,[1] Cézanne's prints did not remain unknown until that date. Before World War I, Théodore Duret, Ambroise Vollard, and Gustave Coquiot had already made mention of them.[2] Nonetheless, it was certainly the picturesque narrative by Gachet *fils* that drew this group of prints of no substantial interest (each of which, to the best of my knowledge, exists in only a single state) to the attention of collectors. For this discussion we will focus on the younger Gachet's remarks about these prints and will illustrate only the ones that he gave to the

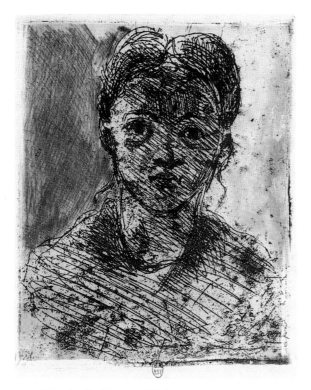

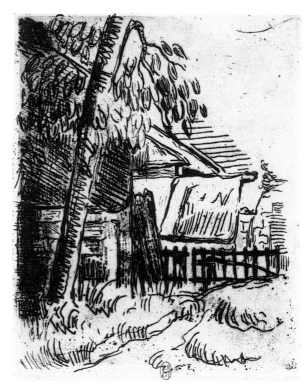

10b *Head of a Young Girl*

1873
Etching, 4¾ x 3¾ in. (12 x 9.5 cm); signed and dated lower right,
on the plate: 73/ Paul Cézanne
Bibliothèque Nationale de France, Paris, Département des
Estampes et de la Photographie, gift of Paul Gachet, 1953

Gachet *fils* thought the model was the same as that for a drawing
in the Gachet collection (Chappuis 273, Philadelphia Museum of
Art), but this seems unlikely, given the probable later date of the
drawing.

10c *Entrance to a Farm, Rue Rémy in Auvers*

1873
Etching, 5⅛ x 4⅛ in. (13 x 10.5 cm); proof annotated in
Dr. Gachet's hand: P. Cézanne / juillet 1873
Bibliothèque Nationale de France, Paris, Département des
Estampes et de la Photographie, gift of Paul Gachet, 1953

The print is an interpretation of a painting by Cézanne that had
belonged to Pissarro (Rewald 1996, no. 196).

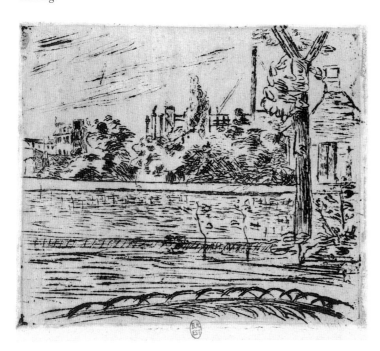

10d *View of a Garden at Bicêtre*

1873
Etching, 4⅛ x 5⅛ in. (10.6 x 13 cm), only known proof
Bibliothèque Nationale de France, Paris, Département
des Estampes et de la Photographie, gift of Paul
Gachet, 1953

Dr. Gachet made a print of the same subject, also
dated 1873.

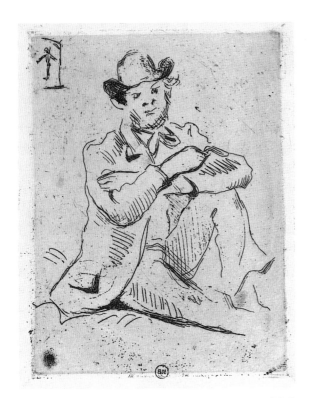

10e *Guillaumin at the House of the Hanged Man*

1873
Etching, 5¾ x 4⅜ in. (14.5 x 11 cm)
Bibliothèque Nationale de France, Paris, Département des Estampes
et de la Photographie

simply making drawings on compact plates that were later printed by professionals. We should not go so far as to deny Cézanne the paternity of these prints, which, despite strong similarities to those signed "Paul van Ryssel," boast a firmer line. Like Loys Delteil, who was in turn cited by Gachet *fils*, I continue to think that "his little sketches traced on copper would have gone completely unnoticed by historians and art lovers, had they not been made by a master artist of his scope who exerted such an influence on painting by sole virtue of his talent. They are sought after and collected out of respect for the master more than admiration for the pieces themselves."[4]

AD

1. Gachet 1952 established for the first time a list of five etchings, all dated 1873: *Péniches sur la Seine à Bercy (d'après Guillaumin); Guillaumin au pendu; Vue dans un jardin (Bicêtre); Tête de jeune fille;* and *Entrée de ferme, rue Rémy* (see Summary Catalogue). Gachet later returned to the subject (1954a, pp. 13, 17), though with a text that he dates 1927 or 1928. See Leymarie and Melot 1971.
2. Duret (1906, opp. p. 170) illustrates the original engraving of *Guillaumin at the House of the Hanged Man*; Vollard (1914) reproduces *Head of a Young Girl*; and *Landscape with Viaduct and Railway* is reproduced in the album *Cézanne* (Bernheim-Jeune 1914), pl. 1. Coquiot (1919, p. 62) cites all three, noting that Dr. Gachet was at the root of all these attempts, as does Venturi (1936, nos. 1159–61). Although more time is needed to identify the original source of these prints, it is possible that Gachet *fils* himself kept the plates that were reprinted in a larger quantity, since he owned the only two proofs known to date of *Sailboats on the Seine at Bercy* and *View of a Garden at Bicêtre*.
3. A letter from Guillaumin to Dr. Gachet dated Sept. 6, 1873 (Gachet 1957a, p. 66), in which Guillaumin gives the address of a printer, seems to corroborate this hypothesis.
4. Delteil (1925, vol. 1, p. 299) cites the three published prints (see n. 2, above).

Bibliothèque Nationale in February 1953 so that its holdings of the artist's portfolio would be complete.

Although it is well established that Dr. Gachet regularly produced prints beginning in 1872, the date of his move to Auvers, I believe that (contrary to his son's claim) he still did not have a press in his home in 1875, since the inventories of his residences drawn up after his wife's death in that year do not mention any such object (see pp. 289–91). He must therefore have resorted to a printer's services, probably in Paris.[3] The small format of his plates would have made this a simple matter. Cézanne, probably at the doctor's instigation, might well have done the same. Consequently, the joyful rivalry engaged in by the quartet of Paul van Ryssel (Dr. Gachet), Pissarro, Guillaumin, and Cézanne, which Gachet *fils* described as being the creative precursor of the "artist's print," comes down to

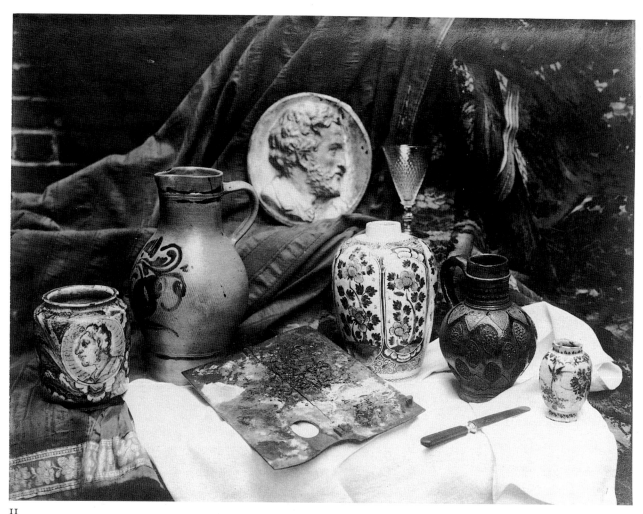

II

II *Souvenirs of Cézanne*

Photograph of an arrangement by Paul Gachet *fils*
Published in Gachet 1953a

This photograph shows an arrangement of Cézanne memorabilia made by the younger Gachet and published in *Souvenirs de Cézanne et de Van Gogh à Auvers* (Gachet 1953a). In 1951 he gave to the Louvre these objects that Cézanne used; they were published in Florisoone 1952 and in Paris 1954–55; they are now housed in the Musée d'Orsay.

Set against the background of a red Adrianople drapery, one can recognize, from left to right: the *"Urbino" vase* (Sicilian ware, decorations in blue, green, yellow, and ocher, H. 6½ in. [16.5 cm], inv. OD 25); a *stoneware pitcher* (gray with bluish decoration, H. 13 in. [33 cm], OD 26); a *folding palette used by Cézanne* (13⅛ x 8¼ in. [33.5 x 21 cm],

OD 21); the *medallion of Philippe Solari* (plaster, Diam. 9⅞ in. [25 cm], signed: Pp Solari 1870; OD 22); the *large Delft vase* (decoration in monochrome blue on a white background, H. 9⅞ in. [25 cm], OD 23); a *goblet with a honeycomb pattern* (H. 6¼ in. [16 cm], OD 28); a *table knife* (OD 29); a *stoneware pitcher* (gray embellished with blue enamel, H. 8½ in. [21.5 cm], OD 27); and a *small Delft vase* (decoration in monochrome blue on a white background, van Eenhorn mark, H. 4⅜ in. [11 cm], OD 24). The goblet, the knife, and the smaller stoneware pitcher (OD 27) were used by Cézanne for a still life now at the Fondation Angladon-Dubrujeaud, Avignon (fig. 79). AD

The Use of X-Radiography to Study Paintings by Cézanne and Van Gogh in the Gachet Collection

Radiography, which allows us to obtain an image by transmitting X-rays (depending on the thickness and atomic density of various parts of a picture), is a widely used investigative tool in the study of paintings. It can yield a great deal of information about the original support, which often is inaccessible because works frequently have been remounted. Radiography also reveals much about the original layout of the composition and the characteristics of the artist's brushwork.

The study conducted at the Research Laboratory of the Musées de France attempted to focus on the methods employed by Cézanne and Van Gogh and, by comparison, those of the copyists, Dr. Gachet and his son. The conclusions drawn from these analyses nonetheless must be viewed with caution, for the paintings examined represent but a small portion of the vast oeuvres of these two artists.

CÉZANNE'S TECHNIQUE

The study centered on seven paintings by Cézanne in the Gachet collection, now at the Musée d'Orsay, and on the radiographic files of twenty other pictures by Cézanne, most also housed there, that were painted before and after the artist's stay in Auvers. The files had previously been made available to the laboratory.[1]

Radiographs reveal Cézanne's use of several different supports. Generally he painted on a canvas-weave fabric, but one work, the *Still Life with Soup Tureen*, is on a twill weave. Cézanne also used cardboard as a support at the beginning of his career, as, for example, for the *Still Life with Medallion of Philippe Solari* (cat. no. 4).

Initially Cézanne often used fine or even very fine fabrics (23 to 30 threads per centimeter), which have proven to be extremely fragile,[2] but after 1873—coincident with his stay in Auvers—the artist employed noticeably different types of canvas. They are still of linen fabric,[3] but with a density varying from 13 to 15 threads per centimeter and a slightly irregular weave. It appears that these also were not very strong supports, for many of the paintings on them have had to be remounted. An examination of the supports from a chronological perspective shows that a fabric with the same characteristics had already been used for *L'Estaque, Effect of Evening*, which John Rewald

dated to about 1871 or perhaps 1876.[4] The small painting *Three Bathers* (dated to about 1873–74 by Rewald) is the first on canvas of a greater density—18 x 17 threads per centimeter—but this canvas was used only sporadically for the works under consideration.

The paintings from the Auvers period all show very pronounced puckering from tension on all four sides,[5] which suggests that the fabric was highly susceptible to loosening and that Cézanne painted on canvases right after they had been stretched on frames. A few rare paintings, such as *Woman at the Mirror* and the later *Eight Bathers* (RF 1982-39), exhibit puckering on only one or two sides, which may imply that they were trimmed at the edges, though these small compositions appear to be intact. Quite likely, this peculiarity illustrates a practice first noted by Ambroise Vollard,[6] who related that Cézanne would paint small studies of various subjects on the same canvas and the dealer "Père" Tanguy would then

Fig. 47. Radiograph of *Still Life with Medallion of Philippe Solari* by Paul Cézanne (cat. no. 4), revealing the underlying bust-length portrait of a man perpendicular to the visible composition. The upper part of the man's face is highly contrasted; his hair is of medium length; the triangular collar of his shirt is visible; and his left shoulder is defined by a heavy line. Near the left edge the back of a chair juts out from behind the figure.

cut them apart, with the artist's consent.[7] The resulting small compositions were then offered for sale to less affluent collectors.

Examination of the paint layer has enabled us to better understand the artist's technique. At the beginning of his career, Cézanne often reused the same support, as is the case with the *Head of an Old Man,* which was painted over another composition. In the *Still Life with Medallion of Philippe Solari* (cat. no. 4), radiographs reveal an underlying composition, a portrait bust oriented vertically (fig. 47). The elongated face, in almost three-quarter view, is set off by contrasting lead white in its upper half. The hair is medium length, and the obscured lower part of the face suggests the presence of a beard. The collar of the figure's jacket and his left shoulder are recognizable. A chair or sofa seems to emerge at his left shoulder. It is not possible to tell from the radiographs whether this composition on cardboard was finished when the still life was begun.

In his paintings from the Gachet collection, Cézanne used a generous amount of paint and often returned to compositions and reworked them. The radiographs, therefore, are rather murky but rich in contrast. The backgrounds of his still lifes appear quite animated under radiography, with large flat areas of paint. He put the shadows down right away rather than adding them with glaze in a second step. Generally speaking, he worked with various rounded brushes of different diameters; he almost never used a knife or a flat brush.

COPIES OF CÉZANNE'S PAINTINGS BY DR. GACHET AND GACHET *FILS*

These copies are not precisely dated. Although Dr. Gachet had been painting for many years, he did not consider himself an artist until after Van Gogh's death. His son painted primarily between 1900 and 1914. Radiographs of the copies made by the two Gachets vary markedly from those of Cézanne's originals, and the techniques of the two copyists, as they are revealed in these radiograph images, also differ.

Five works by Dr. Gachet (who signed his works Paul van Ryssel) were examined, of which two are copies after Cézanne. The only direct comparison made between original and copy was of the two versions of *A Modern Olympia* (cat. nos. 1, 1b). Dr. Gachet sometimes used canvas apparently identical to that selected by Cézanne during his stay in Auvers (did they have the same supplier for a

Fig. 48. Radiograph of *A Modern Olympia* by Paul Cézanne (cat. no. 1).

Fig. 49. Radiograph of *A Modern Olympia* by Paul van Ryssel (Dr. Gachet) (cat. no. 1b).

The radiographs show differences in the nature of the supports, the density of the primers, and the pictorial techniques. Unlike Cézanne, Paul van Ryssel uses little paint, with no thick areas and with hesitant, indistinct strokes. He ignores the background. He uses a palette knife, rarely employed by Cézanne at that time.

while?); sometimes he used a thinner canvas (figs. 48, 49). For two of Dr. Gachet's paintings, *A Modern Olympia* (cat. no. 1b) and *Flowers and Fruits* (cat. no. 45), the radiograph has a generally fuzzy appearance, which may relate to the quality of the canvas. The primers used by Dr. Gachet are much denser than those of Cézanne. Three Gachet paintings—*A Modern Olympia; The Old*

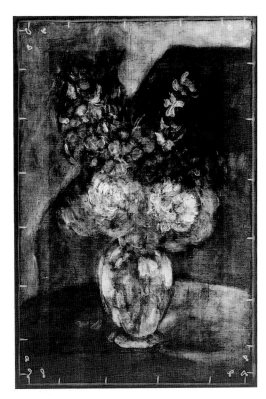

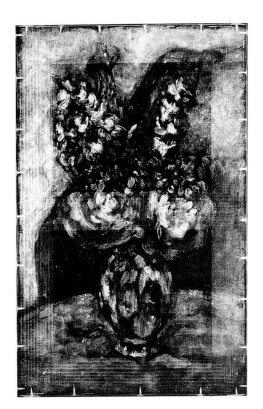

Fig. 50. Radiograph of *Bouquet in a Small Delft Vase* by Paul Cézanne (cat. no. 8).

Fig. 51. Radiograph of *Bouquet in a Small Delft Vase* by Louis van Ryssel (Paul Gachet *fils*) (cat. no. 8a).

Cézanne's progressive creative process is revealed in the radiograph, with the painter's minor adjustments resulting in a slightly fuzzy image. Shadows are painted in from the outset, the paint is applied abundantly, and the background is heavily worked. In contrast, Louis van Ryssel (who was more talented than his father) renders only the visible final stage of the painting: the composition shows no reworking, the highlights are precise and limited, and the shadows are added after the fact. A single type of brush is used throughout.

Road at Auvers-sur-Oise, Snow Effect (cat. no. 42); and *Flowers and Fruits*—yield a similar type of radiographic image: very little contrast, no highlights, and no discernible individual brushstrokes. The paint is sparsely applied. In this regard, comparison of the two *Olympia*s is quite significant. The two other paintings, Gachet's *Apples* (cat. no. 43) and his copy after Pissarro's *Study at Louveciennes, Snow* (cat. no. 44), show in their radiographs greater contrasts and thicker applications of paint.

Three copies after Cézanne by Paul Gachet *fils* (who signed his work Louis van Ryssel) were analyzed, along with the originals. In all three cases, Gachet *fils* used denser supports (about 20 x 20 threads per square centimeter) with a very regular weave and showing little or no puckering. These canvases are probably strong because

they have not been remounted. Various primers were used. The compositions are always clear, the highlights applied without hesitation and very localized. These findings contrast with the somewhat confused radiographic appearance of Cézanne's works, where radiography reveals his process of gradual elaboration, with progressive reworking and exploration aimed at finding the perfect form of a subject. The copyist has ignored the backgrounds and has not reproduced the textures observed in Cézanne. In addition, his shadows are executed in rather uniform underlayers, whereas Cézanne clearly anticipated them from the moment he sketched out the composition. Except for a few thick areas, the paint is applied less abundantly in the copies. The same brush is generally used for the entire painting (see figs. 50, 51).

Fig. 52. Radiograph of *Roses and Anemones* by Vincent van Gogh (cat. no. 16) (detail). This detail of the upper left of the radiograph shows the asymmetrical weave of the canvas (12 x 18 threads per centimeter) and the small dense spots, located on a primed but unpainted edge, that characterize the preparation on this type of canvas. The edges show no puckering, indicating that the canvas was loosely pinned to the stretcher. The brushstrokes, with their characteristic cross-hatching, were made with fairly liquid paint that formed thicker ridges on the sides.

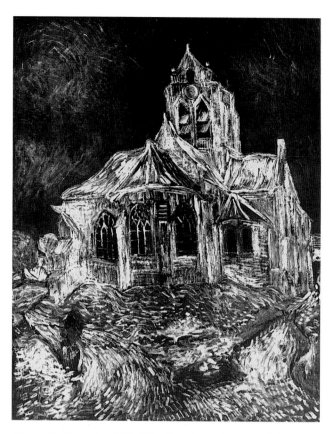

Fig. 53. Radiograph of *The Church at Auvers* (cat. no. 17) by Vincent van Gogh. The radiograph's excellent black-and-white contrast and close correspondence to the finished composition are evidence of the artist's speed and sureness of hand.

Van Gogh's Technique

The study of paintings by Van Gogh focused on seven works from the Gachet collection. These were compared with fifteen other compositions, previously examined at the laboratory, with dates ranging between 1884 and 1890.[8]

An analysis of the backings in these works has revealed several chronological tendencies. During Van Gogh's Paris years, from 1886 to 1888, he used canvases of rather varied density, most commonly about 12 x 13 threads per square centimeter. Toward the end of his life, however, the majority of the canvases he employed had a weave that was slightly irregular and asymmetrical, with 12 x 18 threads per square centimeter. With the exception of *The Church at Auvers* (cat. no. 17), all the paintings by him in the Gachet collection were executed on this kind of support. Among the series under study, this canvas was first used for the *Portrait of Eugène Boch* and then for *Starry Night,* both dated September 1888.[9] Van Gogh's correspondence reveals that after buying supplies locally when he arrived in Arles, he decided to have prepared canvases from the supplier Tasset et L'Hôte sent to him from Paris,[10] beginning in April 1888.[11] He mentions to his brother Theo an absorbent canvas with which he is not entirely satisfied, as much for its fabric as for its priming.[12] At the end of July (after Theo had no doubt related his criticisms to Tasset), Van Gogh received a new prepared canvas costing 5.50 francs per meter, with which he is satisfied: "It is very good and just what I wanted. If I do a portrait, or indeed anything that I am anxious to make lasting, he may be sure that I'll use it. But not much of it, as I have just made up my mind to use cheap canvas for the studies."[13] When he met Eugène Boch at the beginning of September 1888 he painted his portrait, commenting to Theo in a letter, "Well, thanks to him, I finally have a sketch of a painting that I've dreamed of for a long time—The Poet. He posed for it."[14] No doubt the support of "12 x 18" density employed for his friend's portrait was precisely this new canvas, which he so appreciated and reserved for his most valued compositions.

After 1888, however, he does not seem to have made use of this canvas again. This period coincides with Paul Gauguin's stay, and another of Van Gogh's letters to Theo explains the writer's thinking: "We'll probably give Tasset the slip entirely, since we've decided, at least for the most part, to use cheaper supplies, Gauguin and I. As for the canvas, we'll prime it ourselves."[15] Then: "Gauguin bought . . . 20 meters of very strong canvas."[16] This canvas was identified in the study of Gauguin's *Portrait of Van Gogh Painting Sunflowers*, now in the Van Gogh Museum, Amsterdam. It is a coarse fabric made of jute, with a density of 7 x 8 threads per square centimeter.[17] A canvas of the same density also served for Van Gogh's *L'Arlésienne* of November 1888, now at the Musée d'Orsay. The series studied here includes no paintings done between December 1888 and September 1889, when the *Self-Portrait* (Musée d'Orsay, Paris, RF 1949-17) was painted at Saint-Rémy, once more on a "12 x 18" canvas. After that, this canvas was used for all the paintings in the examined group except for *Saint Paul's Hospital in Saint-Rémy* (Musée d'Orsay, RF 1973-25) and *The Church at Auvers*.

Radiographs of Van Gogh's works rarely show puckering, which is caused by tension in a canvas stretched on a frame. This fact reflects the artist's practice of cutting the canvas approximately to the chosen size and pinning it loosely onto a stretcher, the more easily to detach it and let it dry before rolling it up and sending it to Theo. Among the paintings by Van Gogh in the Gachet collection studied by the laboratory, only *The Church at Auvers* shows puckering on all four sides, suggesting that this canvas, unlike the other compositions, was actually stretched on a frame.

Van Gogh's applications of primer always show low density in radiographs, which allows us to obtain images with excellent contrast. In numerous paintings, radiographs also reveal the existence of small dense spots, always situated precisely between two adjacent threads of the canvas support. A systematic study of these images has led us to conclude that they were not caused by the paint but rather by the primer and that they are distributed very irregularly. We find this dotting on the unpainted but primed left border (fig. 52) of *Roses and Anemones* (cat. no. 16). The white spots occur only on the canvas of 12 x 18 threads per square centimeter used by Van Gogh toward the end of his career. They do not appear in radiographs of *Saint Paul's Hospital in Saint-Rémy* (painted on a canvas with a regular density of 24 x 28 threads per square centimeter) nor in radiographs of *The Church at*

Auvers (on canvas with a regular density of 18 x 18 threads per square centimeter). Together these radiographic examinations of Van Gogh's canvases and primers allow us to describe fairly precisely the supports frequently used by him in the last years of his life.

Radiographs of Van Gogh's paintings show up as exact gray-tone versions of what we see in them by direct observation, confirming the artist's rapid execution and lack of hesitation (fig. 53). The paint is generally fluid, with thicker ridges at the edges of the brushstrokes. Many of the pigments are opaque in radiographs. The brushstrokes become noticeably longer during the artist's Auvers period.

However, the features of the face at right in the painting *Two Children* (cat. no. 18) appear surprisingly flat and without relief, in contrast to those of the other face (fig. 54). The pictorial technique of this painting, as of that of the portrait of Dr. Gachet, seems less elaborated, but that is quite understandable if here, as with the Gachet portrait, we are dealing with a second version of the subject. Although a comparison with the first versions was not possible, it would surely be very instructive.

X-radiograph analysis of a number of paintings in the Gachet collection has allowed us to define certain aspects

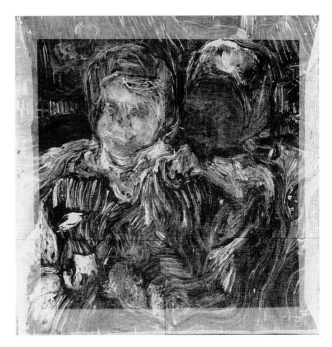

Fig. 54. Radiograph of *Two Children* (cat. no. 18) by Vincent van Gogh. Here Van Gogh's technique seems little developed. The face of the girl at right is curiously flat and not very thick. The dotting of the primer coat is visible on this "12 x 18" canvas.

of the techniques and methods that Cézanne and Van Gogh employed in their paintings. With both artists, radiography demonstrated the predominant use of a particular type of canvas during the time spent in Auvers. Cézanne's technique has become clearer because the radiographs reveal the preliminary phases of the artist's work, stages lacking in the copies. For Van Gogh's paintings, radiographs provide a precise black-and-white translation of the image, evoking above all the sureness and rapidity of the artist's gesture.

Perhaps this study will lead to useful comparisons with paintings in other collections, which may make possible a refinement of the observations and hypotheses advanced in this preliminary analysis.[18]

Élisabeth Ravaud

1. The paintings, arranged chronologically and identified by their numbers in Rewald 1996, are as follows:
 1859–71: *Head of an Old Man*, Musée d'Orsay, Paris, R 97; *Portrait of the Artist's Father*, National Gallery of Art, Washington, D.C., R 101; *Portrait of Uncle Dominic*, Musée d'Orsay, R 106; *Woman at the Mirror*, Musée d'Orsay, R 127; *Still Life with Kettle*, Musée du Louvre, Paris, R 137; *Portrait of Achille Empéraire*, Musée d'Orsay, R 139; *Sorrow*, or *The Penitent Magdalen*, Musée d'Orsay, R 146; *Pastorale*, Musée d'Orsay, R 166; *Estaque, Effect of Evening*, Musée du Louvre, R 170.
 1872–80: *Crossroad of Rue Rémy, Auvers* (cat. no. 3), Musée d'Orsay, R 185; *Still Life with Medallion of Philippe Solari* (cat. no. 4), Musée d'Orsay, R 211; *Dr. Gachet's House at Auvers* (cat. no. 2), Musée d'Orsay, R 192; *Green Apples* (cat. no. 6), Musée d'Orsay, R 213; *Bouquet with Yellow Dahlia* (cat. no. 5), Musée d'Orsay, R 214; *Village Road in Auvers*, Musée d'Orsay, R 191; *House of the Hanged Man*, 1873, Musée d'Orsay, R 202; *Dahlias* (cat. no. 9), Musée d'Orsay, R 223; *Bouquet in a Small Delft Vase* (cat. no. 8), Musée d'Orsay, R 227; *A Modern Olympia* (cat. no. 1), Musée d'Orsay, R 225; *Three Bathers*, Musée d'Orsay, R 258; *Self-Portrait*, Musée d'Orsay, R 182; *Déjeuner sur l'herbe*, Musée de l'Orangerie, Paris, R 287; *The Temptation of Saint Anthony*, Musée d'Orsay, R 300; *Still Life with Soup Tureen*, Musée d'Orsay, R 302; *Five Bathers*, Musée Picasso, Paris, R 365; *The Gulf of Marseilles Seen from L'Estaque*, Musée d'Orsay, R 390; *The Sea at L'Estaque*, Musée Picasso, R 395; *The Maincy Bridge*, Musée d'Orsay, R 436; *Still Life with Fruits and Flowers*, R 471, and *Flowers in a Blue Vase*, R 472, both Musée de l'Orangerie.

2. Under radiography, several works from this period (*Head of an Old Man, Pastorale*) show fairly dense impressions left by the passage of a wide brush. These marks may correspond to transfer coating. The same observation can also be made in *Still Life with Soup Tureen*,

remounted in 1952. Other works, such as *Portrait of the Artist's Father*, have numerous gaps.

3. C. Moulhérat, "Analysis of the Supports in the Collection of Dr. Gachet." Internal report, Research Laboratory of the Musées de France.

4. Rewald 1996.

5. Deformation of the edges of the canvas caused by the stress of nails driven into the stretcher, forming distinct undulations that become highly visible in radiography.

6. Vollard 1919, pp. 68–69.

7. In contrast to the two still lifes in the Walter-Guillaume collection at the Musée de l'Orangerie (R 471, R 472), which made up one huge composition. Radiographs of these two paintings confirm this hypothesis, showing the same type of canvas and the disappearance of compositional elements in the foreground of painting R 471. The asymmetrical distribution of puckering over the two paintings also suggests that the composition continued farther at the bottom.

8. The paintings, arranged chronologically, are as follows:
 1884: *Head of a Peasant Woman*, Musée d'Orsay, Paris, RF 1954-20.
 1886: *Dance Hall*, Musée d'Orsay, RF 2243.
 1887: *Butterflies*, Musée d'Orsay, RF 1989; *The Restaurant La Sirène*, Musée d'Orsay, RF 2325; *Père Tanguy*, Musée Rodin, Paris; *Self-Portrait*, Musée d'Orsay, RF 1947-28; *The Italian Woman*, Musée d'Orsay, RF 1965-14.
 1888: *The Harvest*, Musée Rodin; *Caravans*, Musée d'Orsay, RF 3670; *Portrait of Eugène Boch*, Musée d'Orsay, RF 1944-9; *Starry Night*, Musée d'Orsay, RF 1975-19; *L'Arlésienne*, Musée d'Orsay, RF 1952-6; *L'Arlésienne*, The Metropolitan Museum of Art, New York, 51.112.3; *Dance Hall in Arles*, Musée d'Orsay, RF 1950-9.
 1889: *Self-Portrait* (cat. no. 12), Musée d'Orsay; *Vincent's Room*, Musée d'Orsay, RF 1959-2; *Saint Paul's Hospital in Saint-Rémy*, Musée d'Orsay, RF 1973-25; *The Siesta* or *Noon*, Musée d'Orsay, RF 1952-17.
 1890: *Dr. Gachet's Garden* (cat. no. 14), Musée d'Orsay; *Mademoiselle Gachet at the Piano* (fig. 87), Kunstmuseum Basel; *The Church at Auvers* (cat. no. 17), Musée d'Orsay; *Portrait of Doctor Paul Gachet* (cat. no. 13), Musée d'Orsay; *Roses and Anemones* (cat. no. 16), Musée d'Orsay; *Two Children* (cat. no. 18), Musée d'Orsay; *Cows* (cat. no. 20), Musée des Beaux-Arts, Lille.

9. Walther and Metzger 1997.

10. Tasset et L'Hôte, Framers, 31, rue Fontaine; canvases and fine paints.

11. Letter, Vincent van Gogh to Theo, LT 475.

12. LT 488.

13. LT 517.

14. LT 531.

15. LT 547.

16. LT 559.

17. Travers Newton 1991, p. 106.

18. The radiographs discussed here were produced by M. Solier. Macrophotographs of them were made by M. Solier, O. Guillon, and J. P. Vandenbossche of the Research Laboratory of the Musées de France.

Vincent van Gogh (1853–1890)

12 Self-Portrait

Early September 1889, Saint-Rémy
Oil on canvas, 25⅝ x 21¼ in. (65 x 54 cm)
Musée d'Orsay, Paris
Gift of Paul and Marguerite Gachet, 1949 (RF 1949-17)
P.G. III-5

Unlike other Van Goghs in the Gachet collection, this admirable self-portrait never eluded the notice of admirers and scholars. Dr. Gachet, who, according to his son, bought the painting from Theo van Gogh after Vincent's death,[1] sent it at Paul Signac's request to the 1905 Paris retrospective dedicated to Van Gogh and organized by the Société des Indépendants, with which the artist had exhibited during his lifetime.[2] Gachet *fils* lent it again, in 1925[3] and 1937,[4] before donating it to the Louvre in 1949. In addition, a photograph of it had been taken by the dealer Druet at the 1905 Indépendants exhibition,[5] much to the chagrin of the younger Gachet, who could not prevent widespread reproduction of the image.[6] (There were direct effects: in 1909 he wrote to Theo van Gogh's widow, Jo, "Since he [Druet] took photos of the paintings exhibited at the Indépendants in 1905 despite the fact that my father had denied him authorization, I didn't want him to pull the same trick, and I've written him to say that I will not be lending any paintings."[7])

These circumstances virtually ensured that the painting would be written about frequently following its first mention by the German critic and historian Julius Meier-Graefe in 1904,[8] after he had seen it at the Gachet home. The beauty and mastery of the work are universally recognized, and Van Gogh's gaze has never stopped fascinating the public. The many commentators have attempted to determine the date when the portrait was made, looking for clues in the artist's letters: was it painted when the artist was in Saint-Rémy or in Auvers?[9] A reading of the correspondence that seems to satisfy most recent critics[10] can be summarized this way: in early September 1889, while Van Gogh was at the Saint-Rémy asylum, painting and recovering from his breakdown but already dreaming of leaving the Midi, he wrote that he was sending his brother a "portrait with a light-colored background."[11] This does seem to be the same painting that Van Gogh described in another letter, referring to the "fine blue of the Midi and clothes [of] light lilac," and that he picked up later at Theo's in Paris and brought with him to Auvers, where Dr. Gachet saw it and so admired it that he arranged to become its owner.[12] The fact that Theo van Gogh and then his widow, Jo, apparently had no regrets about leaving this very late image of Vincent to Dr. Gachet seems one more indication of the trust that Vincent's family had placed in him.

In 1902 Dr. Gachet's "student" Blanche Derousse made a same-size watercolor copy of the self-portrait (cat. no. 12a).[13] We have, unusually, two documents that locate the painting in the Auvers house and show how it looked (see "Gachet, Father and Son," figs. 12, 14). In the first, Léopold Robin's watercolor dated 1903, the work is bizarrely hung above the back of a kind of cathedral chair in the ground-floor salon of the house in Auvers; the second, a photograph by an anonymous amateur, shows it in its very simple wooden frame, most likely stained with one of the concoctions of walnut stain, potassium bichromate, or Lefranc's Soehné varnish that the younger Gachet recommended and described to Jo van Gogh, who asked his advice in 1905.[14]

AD

1. Florisoone 1949, p. 150; but this information is not given in Gachet Unpub. Cat., III, P.G. 5.
2. Paris 1905, no. 20: *Portrait de Van Gogh*, Auvers [*sic*] 1889 (painting), Collection of Dr. Gachet. See the letter from Signac published by Jean Monneret in Paris 1990, p. 78, and also Signac's letter of thanks (see "Gachet, Father and Son," p. 22 n. 67).
3. Paris 1925, no. 50.
4. Paris 1937b, no. 42.
5. I am grateful to Agnès Galmiche, who knows the Druet-Vizzavona holdings better than anyone, for searching with me for the original glass plate no. 2386, but we were not able to locate it.
6. As, for example, in the Japanese magazine *Shirakaba* of November 1917; see Koyama-Richard 1993.
7. Paul Gachet *fils* to Johanna van Gogh, Nov. 13, 1909; Archives, Van Gogh Museum, Amsterdam (b3394 V/1984).
8. Meier-Graefe 1904, p. 119: "das Selbstporträt blau auf blau von 1890."
9. According to Meier-Graefe (1904, p. 119), the picture dates from 1890. Faille (1928, no. 627, with photo by Druet) gives a date of Sept. 1889 and refers to letter 604, cited below; however, Faille later (1939, no. 748)

Blanche Derousse
12a Copy after Van Gogh, *Self-Portrait*, 1902
Watercolor over faint graphite sketch, 23⅝ x 19¼ in. (60 x 49
cm), image 22⅞ x 18⅞ in. (58 x 48 cm)
Musée du Louvre, Paris, Département des Arts Graphiques,
Fonds du Musée d'Orsay, acquired from Paul Gachet, Dec. 1960
(RF 31 222)

dated it May 1890. The Saint-Rémy hypothesis was strongly defended
by Michel Florisoone at the time the painting was acquired by the
French national museums (Florisoone 1949, pp. 143–49, and Paris
1954–55, no. 42). Cooper (1955) suggests April–May 1890, which
would be just before Van Gogh departed Saint-Rémy for Auvers.

10. Faille 1970, F 627; Pickvance in New York 1986–87, pp. 121–24, 296;
 Hulsker 1996, no. 1772. Gachet *fils* inclined toward a Saint-Rémy
 origin for the work but did not exclude the possibility of Auvers.
11. LT 604, LT 605, LT 607.
12. LT 638, W 22; see Excerpts from the Correspondence, June 3 and ca.
 June 5, 1890.
13. Signed and dated lower right, in blue: B.D. Juillet 02. This watercolor
 may have figured in the 1903 Indépendants exhibition (Paris 1903),
 where no. 691 was listed as "V. van Gogh watercolor." Derousse also
 made a drypoint after the painting that was sent to the Salon des
 Indépendants and the Van Gogh retrospective at the Stedelijk
 Museum (Amsterdam 1905).
14. Letter from Johanna van Gogh to Paul Gachet *fils*, postmarked
 June 7, 1905; Archives, Van Gogh Museum, Amsterdam
 (b3364 V/1984).

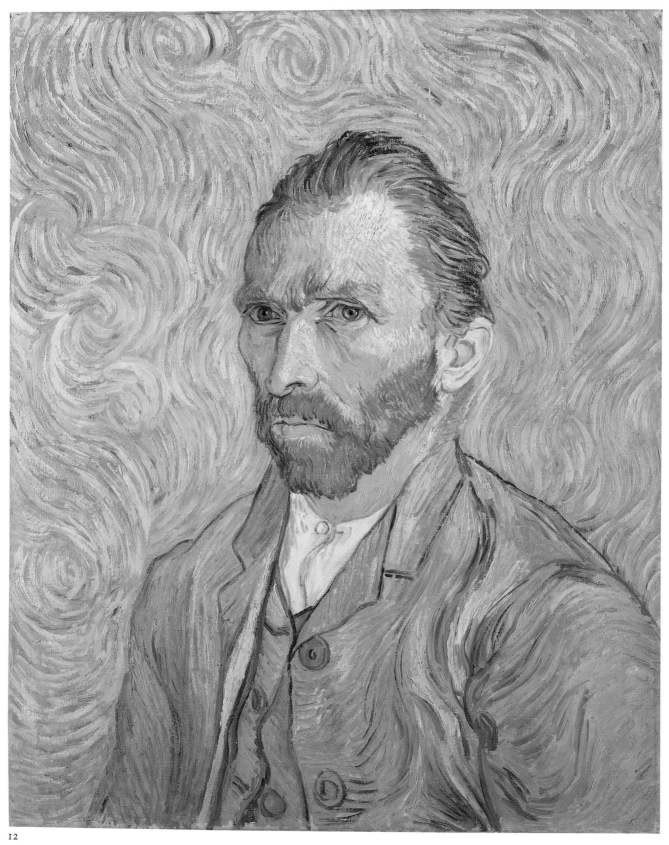

12

VINCENT VAN GOGH (1853–1890)

13 *Portrait of Doctor Paul Gachet*

June 1890
Oil on canvas, 26¾ x 22⁷⁄₁₆ in. (68 x 57 cm)
Musée d'Orsay, Paris
Gift of Paul and Marguerite Gachet, 1949 (RF 1949-16)
P.G. III-16

When Dr. Paul Gachet lent the portrait of him painted
by Vincent van Gogh to two retrospectives of the artist's
work in 1905—the first, organized by the Société des
Indépendants, in Paris, the second at the Stedelijk
Museum in Amsterdam[1]—he was probably, among other
things, indulging in a bit of vanity. His likeness had
already appeared years before at the Paris Salon, with the
exhibition in 1861 of his portrait by Amand Gautier (fig. 19);
and, as portrayed by Norbert Goeneutte, he had been a
presence in the Musée du Luxembourg since 1892 (fig. 28).
But the doctor's pleasure over the Van Gogh exhibition
was no doubt diminished by the unauthorized photograph
of the painting that Druet took there (fig. 55)—even
though the photo, which was subsequently widely pub-
lished, contributed to the fame of both the work and its
model[2] well before Dr. Gachet's children donated the
painting to the Louvre in 1949.

J.-B. de la Faille, the cataloguer of Van Gogh, who was
already compiling a hefty bibliography beginning with the
first mention of the work by Julius Meier-Graefe in 1904,[3]
included the photograph in his 1928 catalogue raisonné,[4]
where it was reproduced facing what the author regarded
as a first version of the portrait (fig. 56). That alternate
version, which we might call the version "with books,"
belonged at the time to the museum in Frankfurt and
came from the collection of Theo van Gogh's widow.[5] De la
Faille naturally referred to the letter, usually dated June 3,
1890, and decorated with a sketch (cat. no. 13a), in which
Vincent van Gogh described to his brother the portrait he
was then painting of Dr. Gachet:

> I am working at his portrait, the head with a white cap,
> very fair, very light, the hands also a light flesh tint, a
> blue frock coat and a cobalt blue background, leaning
> on a red table, on which are a yellow book and a fox-
> glove plant with purple flowers. It has the same senti-
> ment as the self-portrait I did when I left for this place.
>
> M. Gachet is absolutely *fanatical* about this portrait,
> and wants me to do one for him, if I can, exactly like it.

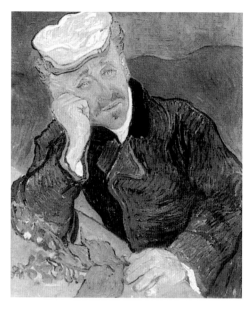

Fig. 55. Photograph of Van Gogh's *Portrait of Doctor
Paul Gachet*, taken by Druet at the 1905 Salon des
Indépendants. Fonds Druet-Vizzavona, Paris
(no. 2385)

> I should like to myself. He has now got so far as to
> understand the last portrait of the Arlésienne, of which
> you have one in pink; he always comes back to these
> two portraits when he comes to see the studies, and he
> understands them exactly, exactly, I tell you, as they are.
>
> I hope to send you a portrait of him soon.[6]

At the time, De la Faille did not know about Van Gogh's
letter to his sister in which the artist talked of the same
issues:

> My friend Dr. Gachet is *decidedly enthusiastic* about
> [Theo's] portrait of the Arlésienne, which I have made
> a copy of for myself—and also about a self-portrait,
> which I am very glad of, seeing that he will urge me to
> paint figures, and I hope he is going to find some inter-
> esting models for me to paint.

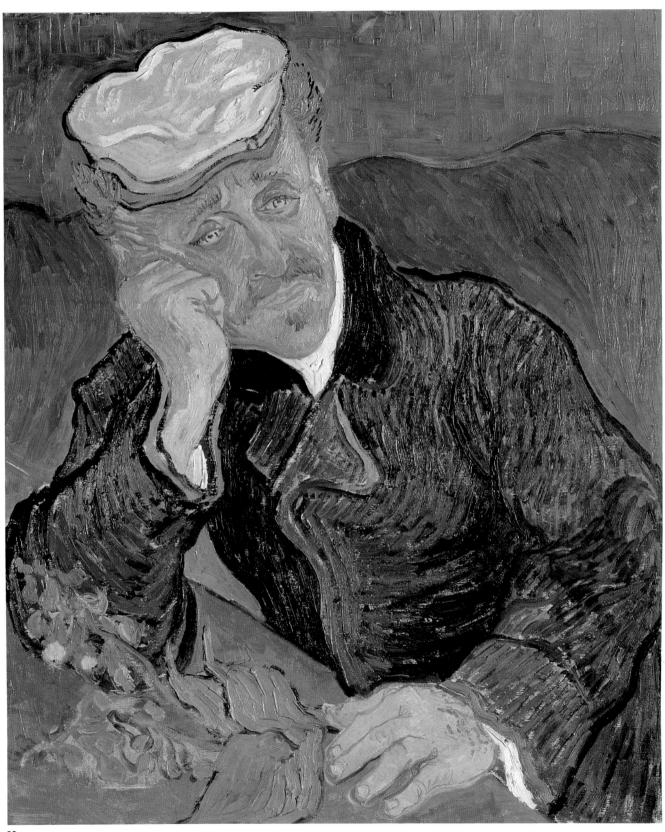

13

Fig. 56. Vincent van Gogh, *Portrait of Doctor Paul Gachet*, June 1890. Oil on canvas, 26 x 22½ in. (66 x 57 cm). Present location unknown

Fig. 57. Color photograph of Van Gogh's *Portrait of Doctor Paul Gachet* (fig. 56), probably 1908–10. Autochrome. Fonds Druet-Vizzavona, Paris

What impassions me most—much, much more than all the rest of my métier—is the portrait, the modern portrait. I seek it in color, and surely I am not the only one to seek it in this direction. I *should like* . . . to paint portraits which would appear after a century to the people living then as apparitions. By which I mean that I do not endeavor to achieve this by a photographic resemblance, but by means of our impassioned expressions—that is to say, using our knowledge of and our modern taste for color as a means of arriving at the expression and intensification of the character. So the portrait of Dr. Gachet shows you a face the color of an overheated brick, and scorched by the sun, with reddish hair and a white cap, surrounded by a rustic scenery with a background of blue hills; his clothes are ultramarine—this brings out the face and makes it paler, notwithstanding the fact that it is brick-colored. His hands, the hands of an obstetrician, are paler than the face. Before him, lying on a red garden table, are yellow novels and a foxglove flower of a somber purple hue.[7]

Finally, a third letter from Van Gogh, to Paul Gauguin, also evokes the portrait of "his friend": "I have a portrait of Dr. Gachet with the heartbroken expression of our time. *If you like,* something like what you said of your 'Christ in the Garden of Olives,' not meant to be understood."[8]

We can conclude from reading these letters that Dr. Gachet—"enthusiastic" about the artist's self-portrait, which he would end up owning (cat. no. 12), and about the *Arlésienne*, an *hommage* to Gauguin—encouraged Van Gogh to paint figures. The artist began by painting the doctor himself. In letters he referred twice to the portrait that includes books, but he did not allude to the second version, the one in the Musée d'Orsay. This has led several critics to infer that the version Gachet kept was not in fact by Van Gogh.[9] But to do so is on the one hand to ignore the spirit and authority of the Gachet version, a painting perfectly in keeping with, for example, *The Church at Auvers*, and on the other hand to pay no attention to the circumstances surrounding the work's creation.

13a Detail of a letter from Vincent van Gogh to his brother Theo, June 3, 1890 (LT 638). Archives, Van Gogh Museum, Amsterdam

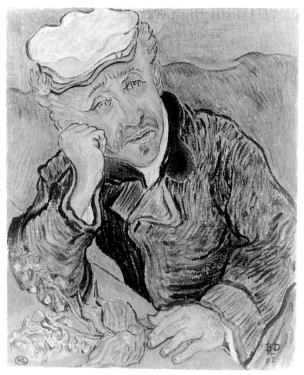

Blanche Derousse
13b Copy after Van Gogh, *Portrait of Doctor Paul Gachet*, 1901
Watercolor over faint graphite sketch, 6¼ x 5¼ in. (15.9 x 13.4 cm), image 6⅛ x 5⅛ in. (15.6 x 13 cm)
Musée du Louvre, Paris, Département des Arts Graphiques, Fonds du Musée d'Orsay, acquired from Paul Gachet, Dec. 1960 (RF 31 223)

That a second version is not mentioned in the correspondence is perhaps to be explained by the loss of a letter or by the fact that Vincent, having recently seen Theo and hoping to see him again soon, neglected to write about a rather self-evident courtesy toward Dr. Gachet. Of course Van Gogh wished to keep the portrait of the doctor, considering it a successful painting. But how could he avoid making one for Gachet, who was such an exceptional model, when he had done the same in other instances? The existence of this "duplicate" (as the younger Gachet called it) from Van Gogh's hand[10] is therefore entirely understandable. Regrettably, it was not possible to hang the two versions side by side—something that has never been done—the better to study the differences between them. The simplifications generally noted in the Musée d'Orsay version—in the foreground still life, which was scraped off and cursorily reworked, and in the treatment of the large colored areas that organize the space—should perhaps be seen not as an impoverishment of the image but rather as a final search for visual effectiveness, the mark only of a creator.

Blanche Derousse made a watercolor copy (cat. no. 13b) of the painting in 1901, as well as a drypoint version (Van Gogh Museum, Amsterdam, P202–4); certain details of the watercolor indicating carmine tones have directed the technical investigation of the work toward pigment preservation, an issue addressed in the study by the Research Laboratory of the Musées de France (pp. 104–13).

AD

1. Paris 1905, no. 19: *Portrait du Dr Gachet* (P. Van Ryssel des Indépendants), Auvers 1889 [*sic*] (peinture); Amsterdam 1905, no. 229a: *Portret van Dr G*, Eigendom van Dr Gachet te Parijs.

2. See, for example, the reproduction of the work facing a Japanese print of a juggler, published in Macke 1912, p. 112. The portrait was again shown at the exhibition "Vincent van Gogh," Galerie Marcel Bernheim et Cie (Paris 1925, no. 49) and at the 1937 World's Fair (Paris 1937, no. 48).

3. Meier-Graefe (1904, p. 120) names among the paintings of the Auvers period "der Homme à la pipe (Porträt des Dr. G.)," confusing its title with that traditionally given Van Gogh's only etching, which he cites at the end, mentioning that its copperplate has been preserved (see cat. no. 23a).

4. Faille 1928, no. 754, dated June 1890.

5. The work is listed in Faille 1928, no. 753; and in Hulsker 1996, no. 2007, dated June 3, 1890. Its tortuous history was the subject of a well-documented book (Saltzman 1998) that traces the painting's peregrinations, from Jo van Gogh and Ambroise Vollard down to its sale in New York at Christie's on May 15, 1990, where, at $82,500,000, it became the most expensive painting in the world. On the way it passed through the collections of the Danish artist and collector Alice Ruben Faber (1897); the painter Mogens Ballin; the Berlin dealer Paul Cassirer, who sold it to Count Harry Kessler (1904); and the Parisian dealer Druet (1908), who ceded it to a collector from Frankfurt, Victor Mossinger, thanks to whom the painting entered the Städelsches Kunstinstitut in Frankfurt in 1911. The painting was later sold by Germany's Nazi government and went with the Kramarsky collection to the United States, where it remained until its sale in 1990 to the Japanese Ryoei Saito, who died, financially ruined, in 1996. Its current location has not been made public.

6. LT 638; see Excerpts from the Correspondence, June 3, 1890.

7. W 22; see Excerpts from the Correspondence, ca. June 5, 1890.

8. LT 643; see Excerpts from the Correspondence, ca. June 17, 1890.

9. Anfray 1954c, pp. 4–6; Faille 1970: "We consider this painting a very weak replica of the preceding one, missing the piercing look of F 753 [the version "with books"] and the 'grieving expression of our time'" (quoting Van Gogh's letter to Gauguin [LT 643], cited above, and voicing an opinion not seconded by De la Faille's editors); Hulsker 1996, p. 460 and no. 2014; Landais 1997, pp. 109–14.

10. Supposing that Van Gogh had not had time to make a replica, we might reasonably imagine that Theo van Gogh, who was deeply grateful to Dr. Gachet, would have given him the first version—all the more so because, commercially speaking, the portrait of an older man is not easy for a dealer to sell. Theo's widow, Jo, sold this version "with books" as early as 1897 to the dealer Vollard for about 250 francs, a comparatively modest sum compared with the prices of the other works sold in the same lot. The theory that a copy of the portrait was made during its prolonged stay at Vollard's specifically at the behest of Dr. Gachet, and that that copy was the painting in the Gachet donation, does not hold up: even leaving aside the work's obvious quality, it is difficult to imagine why a copyist would not have reproduced the composition faithfully; moreover, given the price of the original at the time, it simply would not have been worth the effort.

VINCENT VAN GOGH (1853–1890)

14 *Dr. Gachet's Garden*

Late May 1890
Oil on canvas, 28¾ x 20¼ in. (73 x 51.5 cm)
Musée d'Orsay, Paris
Gift of Paul Gachet, 1954 (RF 1954-15)
P.G. III-14

In letters to Theo and to their sister Wil,[1] Vincent van Gogh made specific reference to this study executed in Dr. Gachet's garden, mentioning "southern plants, aloes, cypresses, marigolds." The chronology we can establish from this correspondence dates the work near the end of May 1890, perhaps to May 27. The painting has been listed in every catalogue of Van Gogh's work, even though it was neither exhibited to the public nor reproduced until it became part of the national collections.[2] It is amusing to note that Van Gogh gave to these "plants of the Midi" southern French names, aloe and cypress, whereas they were in fact, as the younger Gachet pointed out, yucca and thuja.[3] Like *Mademoiselle Gachet in the Garden* (cat. no. 15), this brightly colored sketch (which tries out an unusually tall format, with an eye toward *japonisme*) depicts many details of the doctor's garden, such as the narrow terraces spread about the sloping grounds. It also reflects, in its exuberance—evident in the quality of the brushstrokes—

Blanche Derousse
14a Copy after Van Gogh, *Dr. Gachet's Garden*
Watercolor, 6¾ x 4¾ in. (17 x 12 cm)
Musée du Louvre, Paris, Département des Arts Graphiques, Fonds du Musée d'Orsay, acquired from Paul Gachet, Dec. 1960 (RF 31 226)

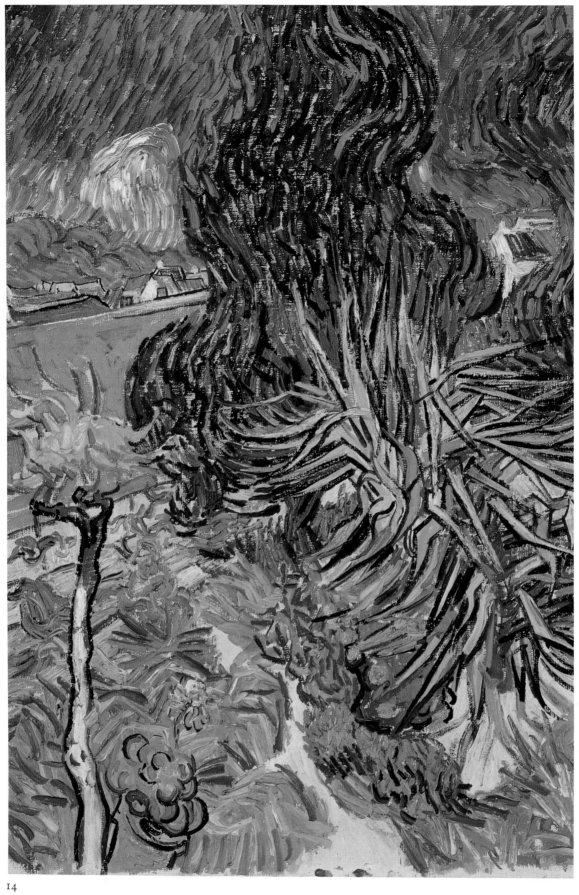

14

the painter's state of mind; with his experiences in the Midi still fresh, Van Gogh wrote at the time to his brother Theo: "It did me good to go to the Midi; I was better able to see the North."[4] The painting, on its original canvas (which was hastily nailed to the frame, leaving wide white margins that are still visible), was never varnished, and studies conducted by the Research Laboratory of the Musées de France have demonstrated the discoloration of some strokes that were originally pink (see pp. 104–13).

<div style="text-align:right">AD</div>

1. LT 638 and W 22; See Excerpts from the Correspondence, June 3 and ca. June 5, 1890.
2. Faille 1928, no. 755: *Le jardin du docteur Gachet,* juin 1890, located in the collection of Dr. Paul Gachet, Auvers-sur-Oise; Faille 1970, F 755: *Dr. Gachet's Garden, Auvers,* end May 1890; Hulsker 1996, no. 1999 and p. 458: *Doctor Gachet's Garden,* late May 1890; Paris 1954–55, no. 43, repr. pl. XVI, under the title *Dans le jardin du Gachet* and dated May 27, 1890 (date based on the correspondence, as in Gachet Unpub. Cat., III, P.G. 14).
3. Gachet Unpub. Cat., III, P.G. 14.
4. LT 636.

Vincent van Gogh (1853–1890)

15 *Mademoiselle Gachet in the Garden*

Sunday, June 1, 1890
Oil on canvas, 18⅛ x 21¾ in. (46 x 55 cm)
Musée d'Orsay, Paris
Gift of Paul Gachet, 1954 (RF 1954-13)
P.G. III-15

"I have painted two studies at [Dr. Gachet's] house, which I gave him last week, an aloe with marigolds and cypresses [cat. no. 14], then last Sunday some white roses, vines and a white figure in it." So wrote Vincent van Gogh to his brother Theo at the beginning of June 1890, information that he repeated in similar terms in a letter to his sister Wil.[1] The artist himself thus described and dated this study from the Gachet collection, which, though listed by J.-B. de la Faille in his 1928 catalogue of Van Gogh's works, and by subsequent authors,[2] was not exhibited or reproduced until it entered the French national museums' collections.[3] In the painting we see the elusive silhouette of Marguerite-Clémentine-Élisa Gachet (1869–1949), whose portrait at the piano (fig. 87) Van Gogh would later paint and whom he hoped to see become a friend to Theo's wife, Jo.[4] Marguerite Gachet, until her death co-donor of these works with her brother, remained a discreet presence in these collections, in keeping with the quiet woman known by her contemporaries.

<div style="text-align:right">AD</div>

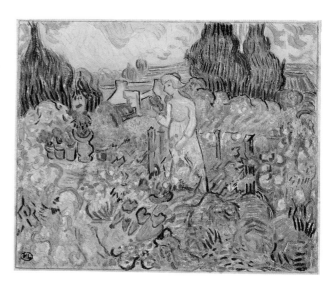

Blanche Derousse
15a Copy after Van Gogh, *Mademoiselle Gachet in the Garden*
Watercolor, 4½ x 5½ in. (11.5 x 14.1 cm)
Musée du Louvre, Paris, Département des Arts Graphiques, Fonds du Musée d'Orsay, acquired from Paul Gachet, Dec. 1960 (RF 31 225)

1. LT 638 and W 22; see Excerpts from the Correspondence, June 3 and ca. June 5, 1890.
2. Faille 1928, no. 756: *Mademoiselle Gachet dans son jardin,* juin 1890, with reference to letter 638 and located in the collection of

Dr. Paul Gachet, Auvers-sur-Oise; Faille 1970, F 756: *Marguerite Gachet in the Garden,* June 1, 1890; Hulsker 1996, no. 2005: *Marguerite Gachet in the Garden,* June 1, 1890, and p. 458.
3. Paris 1954–55, no. 44, pl. XVII: *Mademoiselle Gachet au jardin,* dimanche 1er juin 1890, repeating the title and date given in Gachet Unpub. Cat., III, P.G. 15.
4. LT 638 (see n. 1, above). Van Gogh wrote that she was nineteen years old, but since she was born on June 21, she in fact celebrated her twenty-first birthday during the painter's stay in Auvers; Paul Gachet *fils,* also born on June 21, turned seventeen that summer, although Vincent said he was sixteen (LT 639, ca. June 4, 1890).

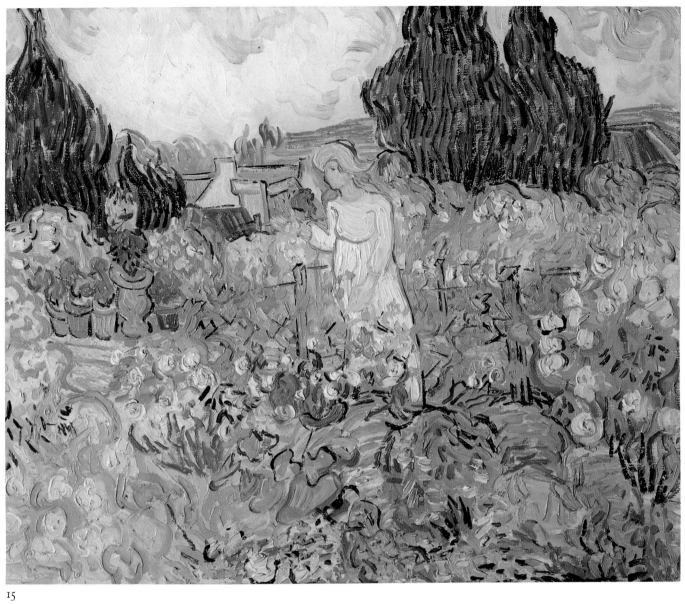

15

VINCENT VAN GOGH (1853–1890)

16 *Roses and Anemones*

1890
Oil on canvas, 20¼ x 20½ in. (51.5 x 52 cm)
Musée d'Orsay, Paris
Gift of Paul Gachet, 1954 (RF 1954-12)
P.G. III-19

This still life's first presentation to the public (and first reproduction) occurred when it was donated to the French national museums in 1954. Paul Gachet *fils* had stated quite precisely that it was painted at the Gachet home in Auvers in one outdoor session (the bouquet was posed on the red garden table that also figures in the *Portrait of Doctor Paul Gachet,* cat. no. 13), and that he had been given the little painting by Theo van Gogh, in thanks for having spent the night at the bedside of the dying Vincent van Gogh.[1] This moving detail constitutes the main interest of this otherwise not very attractive still life, with its conventional composition, heavy paint application, and dull coloring. The picture was known by scholars—it is listed, but not reproduced, in De la Faille's catalogue of 1928[2]—and its authenticity has never been challenged.[3] Gachet *fils* donated to the French museums the Japanese vase used for the still life (see p. 103).

It has been pointed out[4] that the flowers other than roses depicted in this painting are more likely to have been buttercups than anemones, given their double corolla and their yellow and orange coloring, which is not found in anemones.[5] Indeed, buttercups, which, like roses, bloom in May and June, are a more likely subject for a painting of Van Gogh's Auvers period than anemones, which in the Paris region tend to bloom earlier, at the beginning of spring. These considerations in particular suggest a connection between this still life and a passage in a letter from Van Gogh to his sister Wil, where, after mentioning the two studies he painted at Dr. Gachet's home (cat. nos. 14, 15), he adds, "then a bouquet of buttercups."[6] This could well be a reference to the present painting, as the younger Gachet also observed.[7] But botany teaches that there are no blue buttercups or roses, as there are anemones; and this bouquet contains suggestions of flowers underscored by an almost turquoise or faded blue stroke, a "pallid" blue, as André Chastel remarked.[8] Thus, our hypothesis is somewhat weakened, although one could easily maintain that the painter might have mixed other varieties into his bouquet or freely interpreted his commonplace subject. These observations have also led to further studies by the Research Laboratory of the Musées de France into how well the pigments used in the painting have survived (pp. 104–13).

AD

1. Gachet 1953a, n.p. (repr.), which repeats information from Gachet Unpub. Cat., III, P.G. 19, and Paris 1954–55, no. 50, pl. XXI.
2. Faille 1928, no. 764, with a reference to letter 642 that seems pointless and confusing. Meier-Graefe (1904) cites a "vase of flowers painted on a dish towel," which, because of that technical detail, can refer only to F 763 (P.G. III-18).
3. Faille (1970, F 764: *Still Life: Japanese Vase with Roses and Anemones*) and Hulsker (1996, no. 2045 and p. 468: *Japanese Vase with Roses and Anemones*) both date it to June 1890.
4. By an attentive visitor to the Musée d'Orsay, A. J. M. Byvet, citing the catalogue published in 1890 in French by his horticulturist ancestors near Haarlem.
5. The younger Gachet was apparently the first to call it *Roses and Anemones,* adding a lengthy commentary on the symbolism of the anemone, the flower of perseverance: Gachet Unpub. Cat., III, P.G. 19.
6. Letter W 22, "puis un bouquet de renoncules." For a somewhat different translation, see Excerpts from the Correspondence, ca. June 5, 1890.
7. Gachet 1994, pp. 93–94, 172 n. 47.
8. Chastel 1954.

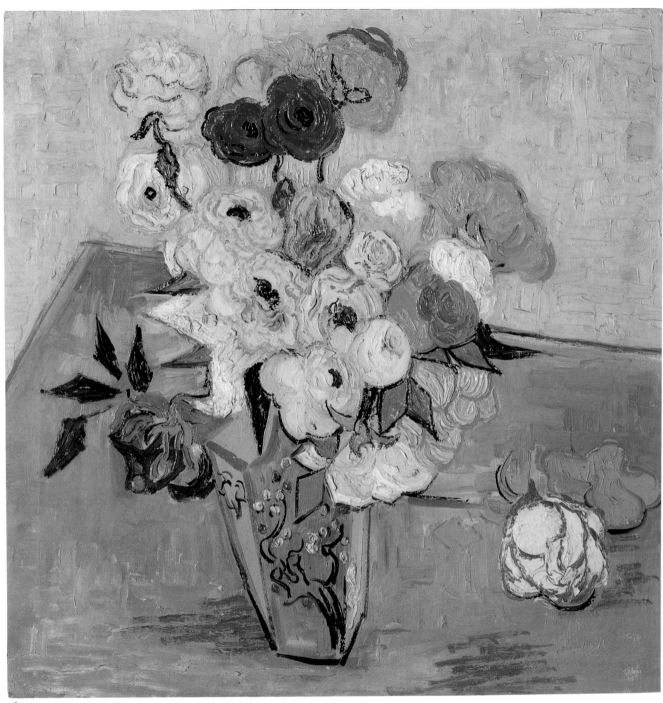

16

Vincent van Gogh (1853–1890)

17 *The Church at Auvers*

Early June 1890
Oil on canvas, 37 x 29⅛ in. (94 x 74 cm)
Musée d'Orsay, Paris
Acquired in 1951 with the assistance of Paul Gachet and an anonymous Canadian donor (RF 1951-42)
P.G. III-25

Shortly after his arrival in Auvers-sur-Oise, Vincent van Gogh wrote to his sister Wil about the studies he had painted at Dr. Gachet's home (cat. nos. 14, 15, and possibly 16) and then went on to describe one of his last paintings: "Apart from these I have a larger picture of the village church—an effect in which the building appears to be violet-hued against a sky of a simple deep blue color, pure cobalt; the stained-glass windows appear as ultramarine blotches, the roof is violet and partly orange. In the foreground some green plants in bloom, and sand with the pink glow of sunshine on it. . . . [I]t is nearly the same thing as the studies I did in Nuenen of the old tower and the cemetery, only it is probable that now the color is more expressive, more sumptuous."[1] That single quotation provides, in its simplicity, a moving counterpoint to the flood of writing—much of it prone to excess—elicited by this painting, which is surely the most beautiful from the artist's Auvers period and one of the masterworks of his entire career. Just two points will be underscored here, in the context of its presentation as part of the Gachet collection.

Although art historians have long made written reference to this painting, following the 1904 example of the German art historian and critic Julius Meier-Graefe,[2] they were not able to see it (and its photograph was not published) until 1951, when it entered the French national museums.[3] Paul Gachet *fils* justified his continuing refusal to make reproductions available to researchers:

> Contrary to his usual thinking regarding the popularization of his works, Vincent said one day to Dr. Gachet, on the subject of this canvas, *that such a painting should never be seen except in the atmosphere in which it was conceived.* That desire, which became like a *command,* has until now been realized; something that has earned me every conceivable form of invective, idiocy, and nonsense. On the other hand, it has helped me measure how much interest there is in unpublished works of art, truly beautiful ones: I came to understand that people

Blanche Derousse
17a Copy after Van Gogh, *The Church at Auvers,* 1901
Watercolor over graphite sketch, 11⅛ x 8⅝ in. (28.3 x 22 cm); image 8 x 6¼ in. (20.4 x 16 cm)
Musée du Louvre, Paris, Département des Arts Graphiques, Fonds du Musée d'Orsay, acquired from Paul Gachet, Dec. 1960 (RF 31 227)

speak with more curiosity of a so-called unknown work than of one that has been widely reproduced. But such an attitude calls down upon the owner of the work epithets as varied as they are ludicrous, which are more than compensated by the special interest that the painting has gained by not being popularized.[4]

That interest, proven when the work finally became accessible, was probably further heightened by the publication at the same time of the artist's letters to his sister Wil. The letters, which had long remained unavailable and unknown, are a remarkable source of information, as the quotation cited at the beginning of this entry makes clear.

My second point concerns the actual medium of the work. Van Gogh describes the foreground of his painting

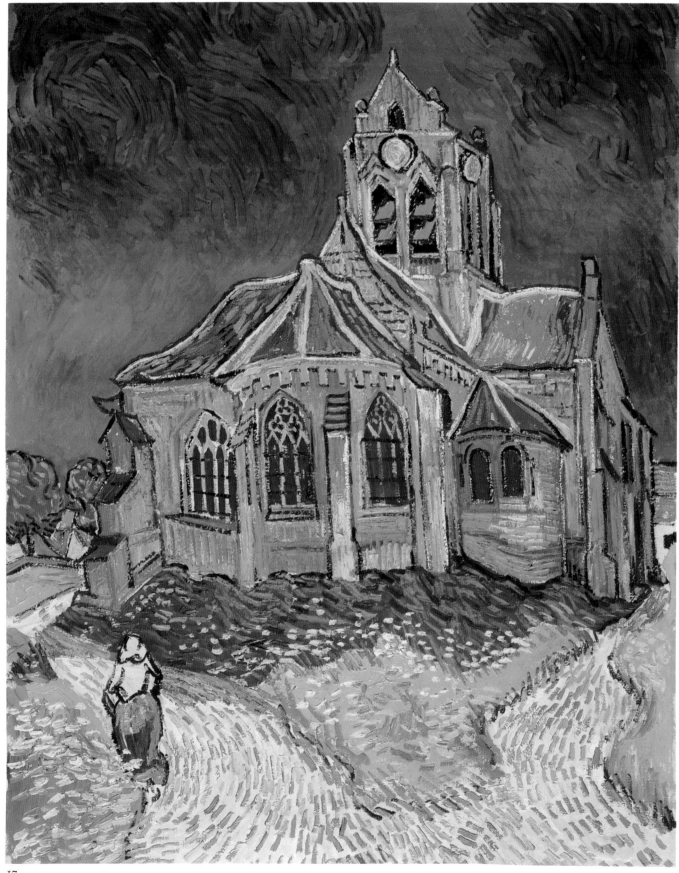

17

as being illuminated by "sand with the pink glow of sun-
shine on it," something indeed visible in the precious
small watercolor copy of the work painted by Blanche
Derousse in 1901 (cat. no. 17a).[5] Of course, Derousse knew
only the painting itself, not the letter to Wil. And if we
study the edges of Van Gogh's painting hidden by the
frame, we find a few remaining traces (minuscule but
quite real) of unfaded pink. Thus, a victim of unstable pig-
ments—deprived of its rose tones, which have now faded
to beige—*The Church at Auvers* has lost some of its har-
mony. This situation, observable with the naked eye, has
been more closely examined by the Research Laboratory
of the Musées de France (pp. 104–13). AD

1. Letter W 22, dated ca. June 5, 1890: Van Gogh Letters 1958, vol. 3,
 p. 470.
2. Meier-Graefe 1904, p. 119 (as *Die Kirche von Auvers*); Coquiot 1923,
 p. 240 (as located in the collection of Dr. Paul Gachet, Auvers);
 Faille 1928, no. 789; Hulsker 1996, no. 2006 (as *The Church in Auvers*,
 ca. June 5, 1890).
3. Malraux 1951, repr. in black and white, and in Florisoone 1952, pp. 13,
 27, pl. 1 (in color).
4. Gachet Unpub. Cat., III, P.G. 25.
5. There is also a drypoint retouched in watercolor, 4¾ x 5⅛ in. (12 x 13
 cm), dated 1901, at the Van Gogh Museum in Amsterdam (D 460);
 see Checklist of Copies.

VINCENT VAN GOGH (1853–1890)

18 *Two Children*

June 1890
Oil on canvas, 20⅛ x 20 in. (51.2 x 51 cm)
Musée d'Orsay, Paris
Gift of Paul Gachet, 1954 (RF 1954-16)
P.G. III-23

This portrait of two little girls—the daughters of the sig-
nalman at a railroad crossing in Auvers, according to Gus-
tave Coquiot, who questioned Paul Gachet *fils* at
length[1]—has been known to connoisseurs for a long time;
lent by Dr. Gachet to the Van Gogh retrospective orga-
nized by the Indépendants in 1905,[2] the painting was pho-
tographed[3] and reproduced, notably in Émile Bernard's
1911 edition of Vincent van Gogh's letters.[4] Even before

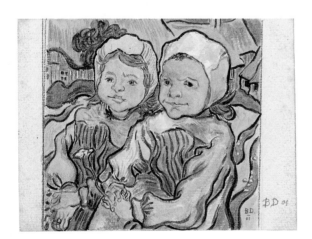

Blanche Derousse
18a Copy after Van Gogh, *Two Children*, 1901
Watercolor over faint graphite sketch, 4⅝ x 6¼ in.
(11.8 x 16 cm); image 4⅝ x 4⅞ in. (11.8 x 12.5 cm)
Musée du Louvre, Paris, Département des Arts
Graphiques, Fonds du Musée d'Orsay, acquired from
Paul Gachet, Dec. 1960 (RF 31 231)

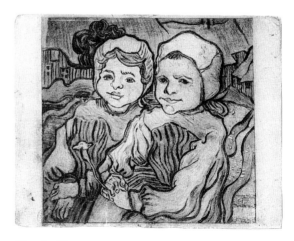

Blanche Derousse
18b Copy after Van Gogh, *Two Children*, 1901
Drypoint, 4¾ x 5⅛ in. (12 x 13 cm)
Private collection

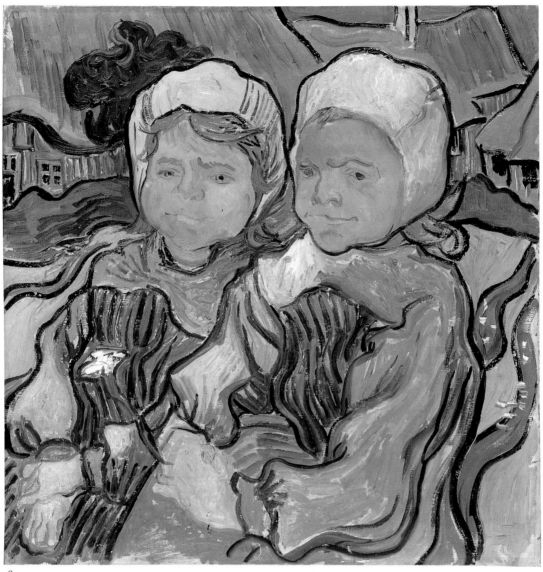

18

the art historian Julius Meier-Graefe (who saw the painting at the Gachet home in Auvers) published his commentary in 1904,[5] the critic and collector Théodore Duret had his own account to relate: on April 4, 1900, after a visit to Auvers, Duret offered to pay Dr. Gachet 2,000 francs for two of his Van Goghs, a large painting of flowers and "the heads of two young girls in blue, set in the center of the panel in the second room."[6] The proposal was evidently not accepted, since the painting was given by the younger Gachet to the French national museums in 1954.[7] The picture was copied by Blanche Derousse, in watercolor in 1901 (cat. no. 18a)[8] as well as in a drypoint version (cat. no. 18b) that remained with the doctor's son.

A second version of this subject (fig. 58), painted in June–July 1890 and whose history of ownership we can

trace from Theo van Gogh's widow to the present day, has, like the original painting,[9] been included in catalogues raisonnés of Van Gogh's works. This second, quite similar rendition[10] underwent a careful restoration by Paolo Cadorin, who uncovered a portion of the painted canvas folded under the frame (and therefore not exposed to the light) and compared the whole with a copy made in 1907 by Cuno Amiet. Cadorin established that certain originally purplish colors had faded to blue and that the pink tones had entirely disappeared.[11] He attributed this change to Van Gogh's use of an unstable geranium lake. In the same way, the Gachet version—a horizontal rectangle in the copy by Derousse—had at some unspecified date been mounted on an almost-square stretcher, as evidenced by old nail marks and a strip, hidden by the frame

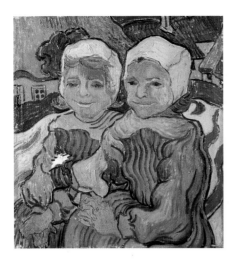

Fig. 58. Vincent van Gogh, *Two Children,* June–July 1890. Oil on canvas, 20½ x 20½ in. (52 x 52 cm). Private collection

the technical similarity of the two versions will help put a definitive end to a debate, begun when the painting was first exhibited at the Musée de l'Orangerie in 1954–55, that challenged the very authenticity of the Gachet picture.[12]

AD

1. Coquiot 1923, p. 253; however, Paul Gachet does not mention this detail in Gachet Unpub. Cat. (III, P.G. 23), where the painting is titled simply *Les deux fillettes* (*Two Little Girls*).
2. Paris 1905, no. 18: *Les deux soeurs,* Auvers, 1889 [*sic*] collection Dr. Gachet.
3. Despite Dr. Gachet's interdiction, by the dealer Druet: photograph no. 2387, Van Gogh, *Deux jumelles* (*Two Twins*).
4. Van Gogh Letters 1911, pl. LXXXXVII, *Les deux enfants,* painting.
5. Meier-Graefe 1904, p. 120: *Deux petites filles.*
6. Théodore Duret to Dr. Gachet, April 4, 1900 (Archives, Wildenstein Institute, Paris).
7. Paris 1954–55, no. 51: *Les deux fillettes,* painted in June 1890 (?), pl. XXII.
8. Signed and dated at lower right: B.D. / 01; and a second time in the margin in pencil: BD 01.
9. Faille 1928, no. 783, and vol. 2, pl. CCXVIII: *Les deux enfants,* located in the collection of Dr. P. Gachet, Auvers-sur-Oise; Faille 1970, F 783: *Two Children,* June 1890; Hulsker 1996, no. 2051 and p. 468: *Two Children,* June–July 1890.
10. Hulsker 1996, no. 2052: *Two Children,* 20½ x 20½ in. (52 x 52 cm; dimensions after restoration), June–July 1890.
11. Cadorin 1991.
12. Ces toiles 1954: "A canvas with little expressiveness; the painter's smooth technique does not belong to his Auvers period. By Van Gogh, perhaps, if you insist! But well before 1890. The catalogue, moreover, adds a question mark after the mention that it was painted in June 1890."

in the upper left, that retained traces of the purplish color. Examining the watercolor copy, we are struck by the presence of a clearly purplish line used to underscore, among other things, the sinuous roof at upper left, and some purple touches in the hair, forehead, and eye of the child on the right—tones not found in the painting today. A study conducted by the Research Laboratory of the Musées de France has made it possible to confirm and complete these observations (pp. 104–13). One hopes that

VINCENT VAN GOGH (1853–1890)

19 *Thatched Huts at Cordeville, Auvers,* formerly known as *Thatched Huts in Montcel*

Late May or early June 1890
Oil on canvas, 20⅜ x 35⅞ in. (72 x 91 cm)
Musée d'Orsay, Paris
Gift of Paul Gachet, 1954 (RF 1954-14)
P.G. III-26

This work was exhibited in 1905 both in Paris, during the Van Gogh retrospective at the Salon des Indépendants,[1] and in Amsterdam, at the Stedelijk Museum;[2] and, like the *Portrait of Doctor Paul Gachet* (cat. no. 13), it was reproduced and cited with great frequency well before its acquisition by the French national museums in 1954.[3] Apart from the issue of its original title, *Thatched Huts in Montcel,* which Gachet *fils* changed to *Thatched Huts at*

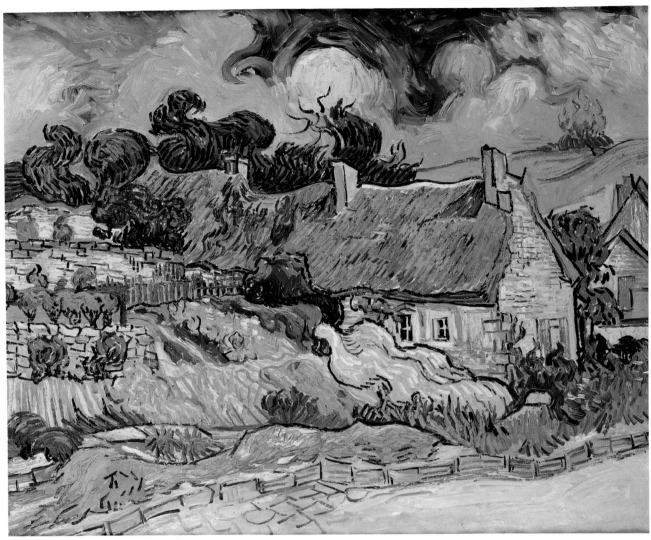

19

Cordeville[4] (the section of Auvers where these cottages were found), the painting has raised few questions. It has, however, elicited numerous commentaries praising the firmness of its composition and the energy of its treatment,[5] which make it one of the most successful landscapes from the artist's Auvers period.

AD

1. Paris 1905, no. 21: *Chaumes du Montcel, Auvers 1889* [*sic*] (painting), collection of Dr. Gachet. The painting was photographed by the dealer Druet at the Salon des Indépendants in 1905; Druet photo no. 2396: *Van Gogh, Chaumière.*
2. Amsterdam 1905, no. 229b: *Hutten te Auvers Eigendom van Dr Gachet te Parijs.*
3. Paris 1954–55, no. 47, pl. XX.
4. Gachet Unpub. Cat., III, P.G. 26; title adopted in Paris 1954–55.
5. Faille 1928, no. 792, pl. CCXXII; Faille 1970, F 792; Hulsker 1996, no. 1987.

Vincent van Gogh (1853–1890)

20 *Cows (after Van Ryssel and Jordaens)*

1890
Oil on canvas, 21⅝ x 25⅝ in. (55 x 65 cm)
Musée des Beaux-Arts, Lille
Gift of Paul Gachet, 1950 (RF 1950-49; deposited in the Musée de
Lille[1] in 1951, no. 1765)
P.G. III-17

During his visit to Dr. Gachet in 1903, the German critic
and art historian Julius Meier-Graefe made a list of Van
Gogh's works that he saw there and, in a work published
the following year, cited those he considered most impor-
tant. Among them was a canvas that he called by the
French title *Les boeufs* (*The Oxen*)[2] and that he noted was
inspired by a print Dr. Gachet (calling himself Paul van
Ryssel) had made (cat. no. 20a) from a painting by Jacob
Jordaens in the museum in Lille (fig. 59). This informa-
tion, which evidently came from Dr. Gachet himself, was
repeated by his son[3] and by J.-B. de la Faille, who
included Van Gogh's work in his 1928 catalogue (where it
was discussed but not reproduced). De la Faille added to
the entry a comment that was to have serious repercussions:
"The painting described here does not greatly recall Vin-
cent's hand, but Dr. Gachet strongly assured me that Vin-
cent made this work during his stay at Auvers."[4]

Van Gogh's *Cows* gained notoriety when the younger
Gachet decided in 1950 to donate it, along with the Van
Ryssel engraving, to the Musée de Lille[5] (which not only
owned the Jordaens but also was in the Gachet family's
native city), in memory of his father and of his recently
deceased sister. The unfortunate painting immediately
gave rise to a debate within the committee of curators
appointed to ratify the donation. The argument pitted the
curatorship of paintings at the Louvre, then in the midst
of negotiations for the Gachet donations of 1951—which
would include the completely unexpected acquisition of
The Church at Auvers (cat. no. 17)—against the inspec-
torate of provincial museums, which deemed the work
"not sufficiently representative of the artist's genius to be
housed in a provincial museum" and recommended that
the painting be stored in the Louvre's "documentary
rooms." These were such veritable dungeons that Paul
Gachet vehemently refused the proposal in the name of
his father's memory.[6] The violence of this debate can still
be felt nearly fifty years after an unidentified person who
had read the file on the proceedings furiously scrawled

Paul van Ryssel (Dr. Paul Gachet)
20a Copy after Jordaens, *Cows*, 1873
Etching, 4 x 5⅜ in. (10 x 13.5 cm)
Musée des Beaux-Arts, Lille, gift of Paul Gachet, 1951
(inv. GW 4046)

Fig. 59. Jacob Jordaens, *Cows*. Oil on canvas, 26 x 32¼ in.
(66 x 82 cm). Musée des Beaux-Arts, Lille. Shown after 1975
conservation, with old additional strips removed

across it: "Let those goddamn cows go to Lille ("Que les
vaches de vaches aillent à Lille"). The painting was regis-
tered in the Louvre inventories and deposited at the Musée
de Lille, with the idea that one day it could return to the
Louvre reserves, where it would be available for study.

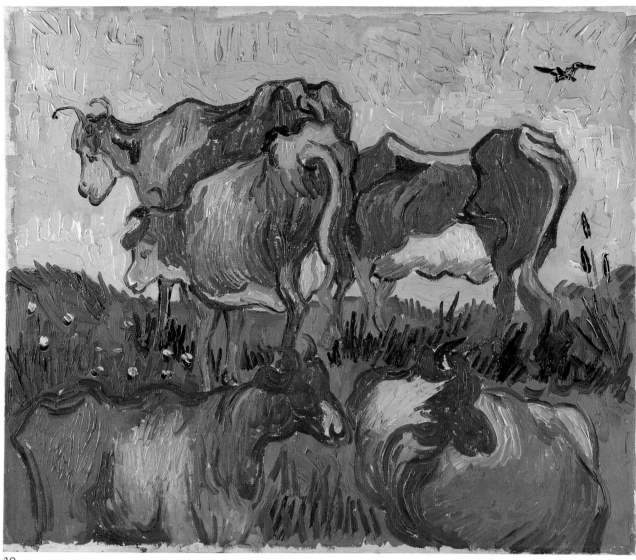

20

The work was violently attacked[7] when it was exhibited at the Musée de l'Orangerie in 1954–55 with the rest of the Gachet bequest.[8] Questioning the authenticity of these paintings was commonplace at the time, following an anti-Gachet campaign led by Louis Anfray, with De la Faille's support, which had begun in 1953 over the etching *Portrait of Dr. Gachet* (*The Man with a Pipe*) (cat. no. 23b). The polemic, inspired solely by the (uncontested) weakness of this minor work, continued at a low level over the subsequent years. The last edition of De la Faille's catalogue (1970), while reminding readers of the author's original doubts, nonetheless included *Cows* within the body of Van Gogh's works.[9] Only recently, however, Jan Hulsker argued that the attribution of this work, which is not mentioned in Van Gogh's letters, rests only on statements made by the younger Gachet in 1954 (Hulsker completely ignored Meier-Graefe's 1904 publication) and added after the presumed date of the composition a defamatory question mark.[10] Hulsker's negative opinion was widely disseminated by the press.[11]

We might indeed wonder why Van Gogh, who produced works after Millet and Rembrandt, would have copied Paul van Ryssel's pedestrian etching; but then again, the artist took his inspiration where he found it and did not disdain to use simple images from the illustrated newspapers. We might also imagine the influence on the artist of the doctor's enthusiastic comments about the original Jordaens (fig. 59), which Van Gogh had never seen—one of those timeless works of art that Gachet, an insightful collector of Courbet and Manet, had wanted to

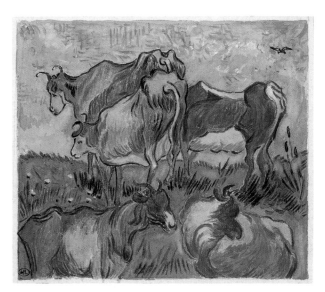

Blanche Derousse
20b Copy after Van Gogh, *Cows*
Watercolor over faint graphite sketch, 5¼ x 6⅛ in. (13.4 x 15.5 cm); image 5⅛ x 5⅞ in. (13 x 15 cm)
Musée du Louvre, Paris, Département des Arts Graphiques, Fonds du Musée d'Orsay, acquired from Paul Gachet, Dec. 1960 (RF 31 232)

copy in the early 1870s during a visit to Lille. (Van Ryssel's etching reproduces the composition of the Jordaens work with a larger background, corresponding to the painting's appearance with the strips of canvas that were attached long before; they were removed during a 1975 restoration.) Susan Stein,[12] referring to some sketches made in Auvers, observed that Van Gogh seemed to have been planning a composition that would include cows in a range of reddish browns, for which the painting in Lille might have

been a preliminary study. Laboratory examination has revealed no anomalies in this rapidly painted canvas,[13] which in its decisiveness hardly suggests the cautious workings of a forger. It seems more logical to accept the work as an original, albeit ill-conceived sketch, created by Van Gogh in the exceptional circumstances that accompanied the end of his career in Auvers, than to assume the precocious fabrication (before Meier-Graefe's 1903 visit) of a "Van Gogh" that at the time had no commercial value. This conclusion is supported by the clumsiness of the work, which in no way glorifies the painter but rather draws attention to his limitations.

AD

1. At that time the museum was known as the Musée de Lille.
2. Meier-Graefe 1904, p. 120: *"Les boeufs,* free [copy] after an etching that Dr. Gachet had made after a painting by Jordaens."
3. Gachet 1954b.
4. Faille 1928, no. 822.
5. Letter from Paul Gachet *fils* to the director of the Musées de France, Oct. 20, 1950 (Archives, Musée du Louvre, Paris).
6. Letter from Michael Florisoone to Vergnet-Ruiz, Dec. 22, 1950, and minutes of the committee of curators meeting of Jan. 4, 1951 (Archives, Musée du Louvre, Paris).
7. Ces toiles 1954.
8. Paris 1954–55, no. 49; not repr.
9. Faille 1970: with a note that it had been "left out by Faille in his manuscript for the present edition but accepted as authentic by the editors." It is interesting to note that the engineer V. W. van Gogh, whose animosity toward Paul Gachet *fils* (after decades of excellent relations) made him doubt the authenticity of almost the entire collection, had no such doubts about *Cows.*
10. Hulsker 1996, no. 2095 and p. 474: *Cows (after Jordaens), July 1890?*
11. Bailey 1997a, Bailey 1997b.
12. In New York, Paris 1992–93/1995, no. 42.
13. Except that it is painted on hemp; but, since Van Gogh used all kinds of textiles, this is not remarkable.

VINCENT VAN GOGH (1853–1890)

21 *The Farm of Père Eloi*

1890
Graphite and brown ink on paper (watermark at lower left: a caduceus and the letters C F [Catel et Farcy] in a crest), 18⅞ x 24⅜ in. (48 x 61.7 cm)
Musée du Louvre, Paris, Département des Arts Graphiques, Fonds du Musée d'Orsay
Gift of Paul Gachet, 1954 (RF 30 271)
P.G. III-34

In December 1909 the younger Paul Gachet mentioned this drawing in a letter to Jo van Gogh, Theo's widow:[1] "In Paris in the office where I work, I've framed a large graphite drawing; it is hung below a Guillaumin and next to two Daumiers; it depicts an old place in the countryside around Auvers that no longer exists but that I knew well, since I sketched it myself. From my garden you can see the spot where the motif stood, but not from the

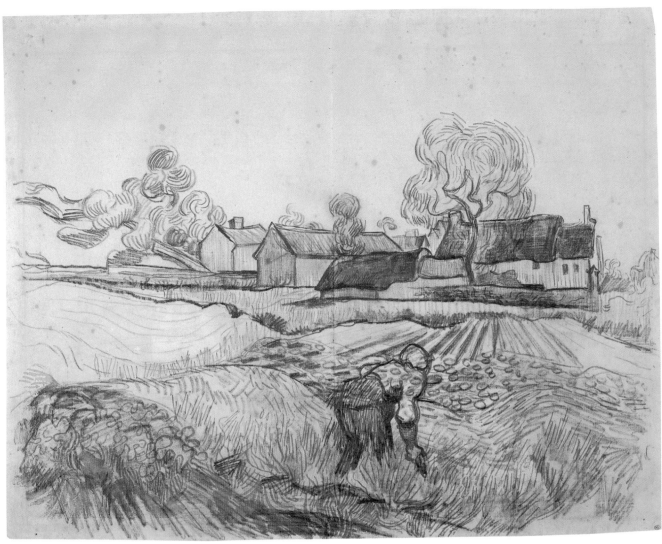

21

direction that Vincent drew it." The drawing was exhibited at the Salon des Indépendants in 1905[2] and was lent to the Van Gogh exhibition of 1937;[3] it was cited by De la Faille in 1928 but not reproduced.[4] Since its acquisition by the French national museums in 1954[5] the drawing has become more widely known and has generally been accepted as one of the artist's Auvers works.[6] Damaged by overexposure to light, *The Farm of Père Eloi* is not among the most beautiful drawings from that period but is still a moving work, and it is a valuable example in the French public collections, which contain very few drawings by Van Gogh. AD

1. Archives, Van Gogh Museum, Amsterdam, b3396 V/1984.
2. Paris 1905, no. 23: *Les Vessenots*, Auvers, 1889 [*sic*] (pencil and reed pen drawing); Gachet Unpub. Cat., III, P.G. 34. Druet photographed the paintings on exhibition but not the drawings.
3. Paris 1937b, no. 80.
4. Faille 1928, no. 1653: *La ferme du Père Eloi*, collection of Dr. Paul Gachet, Auvers-sur-Oise.
5. Albert Chatelet in Paris 1954–55, no. 59, pl. XXVIII; he remarked that "the dryness of the drawing and hardness of the line might lead us to think that we are not looking at a work drawn from life" and that Van Gogh had perhaps been inspired by a lost composition by Pissarro.
6. Pickvance in Otterlo 1990, no. 243; repr. in color ("the peasant seems to be a later addition"); Hulsker 1996, no. 1993: *Cottages with Woman Working in the Foreground*, May 1890.

Vincent van Gogh (1853–1890)

Five pages from a sketchbook

June–July 1890
Crayon and graphite on blue-lined graph paper, very yellowed, with red edging and rounded corners, 15¼ x 3⅜ in. (13.2 x 8.5 cm)

22a *Seated Woman with Child*
P.G. III-40 (3) (RF 29 885)

22b *Woman, Man, and Child Walking*
P.G. III-40 (4) (RF 29 886)

22c *Woman with Striped Skirt* (recto),
Woman in Checked Dress and Hat (verso)
P.G. III-40 (1) (RF 29 883)

22d *Hind Legs of a Horse* (recto),
Head of a Young Man with a Hat (verso)
P.G. III-40 (2) (RF 29 884)

Musée du Louvre, Paris
Département des Arts Graphiques, Fonds du Musée d'Orsay, acquired in 1951

22e *Café Scene*, also called *Counter at Ravoux's Inn* (recto), *Two Chickens* (verso)
P.G. III-41

Van Gogh Museum (Vincent van Gogh Foundation), Amsterdam, D384 m/1975

During the period he worked in Auvers, Van Gogh made use of a small sketchbook that could be slipped out of his pocket and opened when an image caught his attention or an idea came to mind. It was filled with quick jottings of people and animals and landscape motifs he spotted along his way; a few figure studies he had copied after Bargue's drawing manual; thumbnail sketches of paintings he had already made, and first ideas for others he would eventually paint.

22a

22b

22c (recto)

22c (verso)

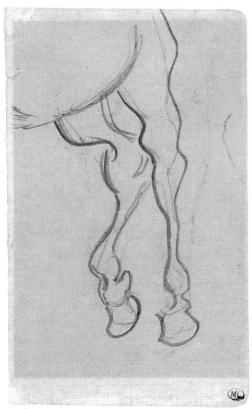

22d (recto)

22d (verso)

22e (recto)

22e (verso)

The sketchbook, store-bought (rather than handmade), consisted of sheets of blue-lined graph paper edged in red. It did not survive entirely intact, but the linen-covered book and most of its sheets, both bound and loose, were preserved by his heirs and deposited on permanent loan at the Van Gogh Museum in Amsterdam. Recently the sketchbook was reconstructed by Johannes van der Wolk, with meticulous attention to the proper placement and sequence of detached leaves, and was published in facsimile.[1] His intensive codicological study enabled him to determine that the original sketchbook contained 160 pages; that eight pages are missing at present; and that the only displaced sheets to have been recovered are the five pages illustrated here, which belonged to Dr. Gachet and later to his children. One of these sheets, acquired by the Van Gogh Museum in 1975, has been reinserted in its proper place in the sketchbook, while the four others are in the Louvre's Département des Arts Graphiques.

How did the Gachets come to own these sketches? Presumably they were left behind at the Gachet house by the artist or were found after his death amid the stash of artworks and other items that remained in his room at Ravoux's Inn. There were a large number of loose sheets from the first two signatures of the sketchbook, including the five that belonged to the Gachets; it is surprising that

only a handful were "lost," considering the casual nature of the pages and the circumstances that dictated the abrupt packing up of the artist's belongings. (It is possible, for example, that these five small drawings had been mixed in among the various Japanese prints and other personal effects that Theo van Gogh purportedly gave Dr. Gachet and his son after the funeral.) There is nothing exceptional about these particular pages to suggest that they had been specially set aside for Dr. Gachet. On the contrary, only one, the café scene, has any real substance or distinction; the others all have counterparts in drawings of figures and animals on neighboring pages. In fact, one of the sketches is only a fragment of a larger drawing: Gachet owned the hind legs of the horse whose front legs and lower torso continued on the adjacent page.[2] Certainly this was not a gift.

Perhaps these modest little sketches, which were kept for more than half a century and specially framed for display by the Gachets, offer the most obvious proof that the owners cherished every scrap of paper from Vincent's hand. They were first published (but not reproduced) by De la Faille in 1928, and before they left the collection at midcentury they were catalogued by Paul Gachet *fils*.[3] The leaves he had grouped under the heading "six petit croquis," because two of the four pages show images on both sides, were purchased by the Louvre in 1951 from a Mme Walter.[4] The other "petit dessin," which Gachet *fils* described as "a curious souvenir of Auvers; *At the Counter at Ravoux's*," was sent on October 24, 1951, as a gift to an American friend and devotee of Van Gogh, Eduard Buckman. Gachet sent it unframed but noted that it had been sandwiched between two pieces of glass. In a succeeding letter he recommended that his friend do the same: "Put it between two plates of glass with a border around it; that will give it more importance." Buckman designed such a frame and continued to "marvel at" his prized possession until his death;[5] it was acquired from his estate (along with his archives and library) by the Van Gogh Museum in 1975. This information solves at least one riddle: the curious state of conservation of the four sheets in the Louvre and the one in the Van Gogh Museum. All are yellowed and faded on both sides, although in each case one side had received more exposure than the other, and around each page is a slim margin where the paper has not discolored to the same extent. Of their condition Gachet *fils* had stated simply, "The paper of these sketches is yellowed by fixative and by time."[6]

SAS

1. Van der Wolk 1987; see pp. 212–64.
2. Ibid., p. 26, figs. 32, 33; and facsimile repr., p. 256.
3. See the Summary Catalogue, P.G. III-40, 41, for the Faille references.
4. No relation, apparently, to the collectors Jean Walter and Paul Guillaume. The price was 70,000 francs (committee of Jan. 4, 1951). This information was provided to me by Anne Distel.
5. Letters from Paul Gachet *fils* to Eduard Buckman, Oct. 24 and Nov. 7, 1951; Buckman to Gachet *fils*, Feb. 7, 1952 (Archives, Van Gogh Museum). Other letters regarding this gift are cited in the Summary Catalogue at P.G. III-41. Eduard Buckman is principally known for his valiant effort to compile a comprehensive bibliography on Van Gogh. The friendship between Buckman and Gachet *fils*, who enjoyed a lively correspondence for two decades, was initiated by a letter of inquiry that Buckman sent Gachet in 1938 and was solidified when they met in 1945 (Buckman returned to Auvers in 1955). At the time of his first visit they had drinks together at the Café Ravoux (which by then had been renamed for Van Gogh), and thus the gift was a meaningful memento of their visit together; however, the identification of the locale as Ravoux's has not been entirely accepted in the literature (see entry for P.G. III-41).
6. Gachet 1994, p. 245.

Vincent van Gogh (1853–1890)

Prints

23a Portrait of Dr. Gachet (*The Man with a Pipe*)

1890
Copper etching plate, 7¼ x 6 in. (18.3 x 15.1 cm)
Inscribed upper left: 25 Mai 90
Musée d'Orsay, Paris
Gift of Paul Gachet, 1951 (OD 39)

23b Portrait of Dr. Gachet (*The Man with a Pipe*)

1890
Etching, 7⅛ x 6 in. (18 x 15.1 cm)
Van Gogh Museum (Vincent van Gogh Foundation), Amsterdam
P.G. III-a

> P467 V/1962
> Heavily inked around sitter's head; laid paper (watermark: ED & Cie)
> Gachet monogram stamp lower right

> P468 V/1962
> Printed in yellow ocher, heavily inked at bottom; laid paper (watermark: ED & Cie)
> Gachet monogram stamp lower left

> P469 V/1962
> Printed in sanguine; laid paper (watermark: P L BAS)
> Gachet monogram stamp lower left

> P472 V/1962
> Printed in greenish blue, heavily inked at lower right; laid paper (watermark: P L BAS)
> Gachet monogram stamp lower left

23c In the Orchard

1883
Lithograph on transfer paper, 9⅝ x 12¾ in. (24.5 x 32.5 cm)
Signed lower left: Vincent. Annotated upper right, in pencil: first proof Vt
Bibliothèque Nationale de France, Paris, Département des Estampes et de la Photographie
Gift of Paul Gachet, 1953
P.G. III-b

23d The Potato Eaters

1885
Lithograph, 10⅜ x 12⅝ in. (26.5 x 32 cm)
Signed lower left: Vincent
Bibliothèque Nationale de France, Paris, Département des Estampes et de la Photographie
Gift of Paul Gachet, 1953
P.G. III-c

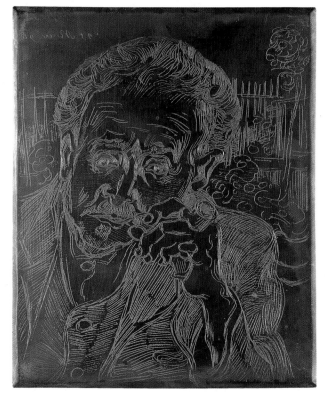

23a

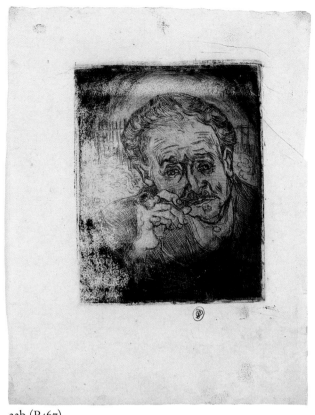

23b (P467)

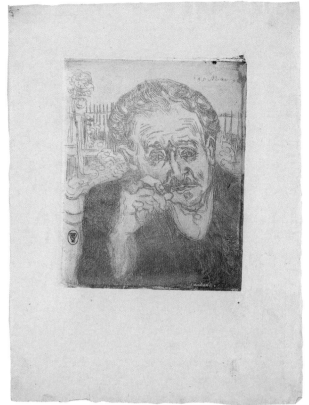

23b (P468)

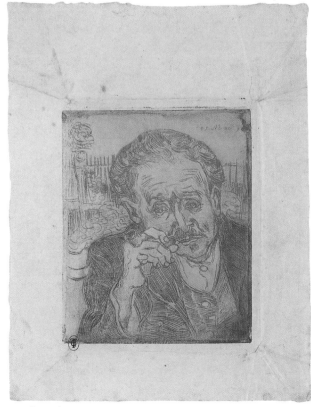

23b (P469)

23b (P472)

23c

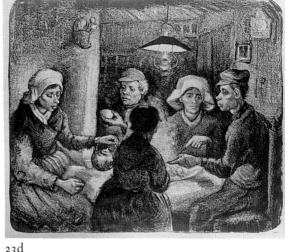

23d

In Auvers-sur-Oise, as we learn from the artist's letters to his brother Theo and to Paul Gauguin,[1] Van Gogh produced one etching and planned to make others, using materials that Dr. Gachet put at his disposal. In a reply on June 23, 1890, Theo van Gogh congratulated his brother for having created "a true painter's etching. No refinement in the technique, but a drawing made on metal."[2] Although Theo did not name the subject of the print, it is almost certain (a few critics have expressed some doubts) that he was referring to the *Portrait of Dr. Gachet (The Man with a Pipe)*. The work quickly became known because Lucien Pissarro, himself an enthusiastic creator and collector of prints, alluded to it in a letter to Dr. Gachet of May 12, 1891,[3] and a proof lent by Gachet was exhibited at the Salon des Indépendants in Paris in 1905.[4] Described by Julius Meier-Graefe in 1904,[5] mentioned by the print specialist Loys Delteil in 1925,[6] and included in J.-B. de la Faille's 1928 catalogue raisonné (F 1664), this work continues to be known as "Van Gogh's only etching."[7]

The copperplate for the print (cat. no. 23a) remained in the possession of Paul Gachet *fils*, who donated it to the national museums of France in 1951, thereby putting an end to the series of proofs that both he and his father had pulled from it; these impressions were either given away or sold, and, as Sjraar van Heugten notes in the most recent and complete study of the subject,[8] their exact number remains unknown. Dr. Gachet gave a proof of *The Man with a Pipe* to the Stedelijk Museum in Amsterdam in 1905, when he lent it to the Van Gogh retrospective.[9] The younger Gachet gave an example to the British Museum in London in 1923, one to the Bibliothèque d'Art et d'Archéologie Jacques Doucet in Paris in 1920,

and another to the Department of Prints at the Bibliothèque Nationale in Paris in 1929. The present exhibition features rarely shown impressions that originally belonged to Theo and that remained in the Van Gogh family: one heavily inked in black, and the others printed in yellow ocher, sanguine, and greenish blue. Regarded as experimental proofs, these etchings show the artist exploring—not always successfully—the different effects he was able to obtain by varying the surface tone or by introducing color. The yellow and greenish blue prints may be characterized by the unorthodox use of oil pigment.[10]

In 1953 Gachet *fils* published the story, which had been circulated many times before, of the print's genesis on Pentecost Sunday, May 25, 1890:

> After an outdoor lunch in the courtyard, once the men's pipes were lit, Vincent was handed an *etching needle* and a varnished copper; he enthusiastically took his new friend *as his subject*. As soon as it was sketched, the *drawing* was *bitten*—under the eye of Van Ryssel—just as Cézanne's had been seventeen years earlier. Thus was born *The Man with a Pipe*, Van Gogh's only etching. The operation was still not finished: the whole thing must have amused Vincent a great deal, as he immediately pulled several proofs that *came out muddy*, from not having been wiped thoroughly enough. He himself found them "a little dirty," too black, and readily agreed to try some prints in *sanguine*. Once started down that path, one could predict the rest: other colors were tried—yellow ocher, red ocher, gray, greenish black, orange. Their diversity pleased him no end.[11]

Nevertheless, the plate's precise date of execution has been a subject of debate: according to various authors, the inscription it carries, traced by a clumsy hand and difficult to decipher, reads "May 15, 1890," "May 25, 1890," or "May 15, 1896." On May 15, 1890, however, Van Gogh was still in Saint-Rémy, and in 1896 he was dead (leading Louis Anfray, in reference not to the original impression but to a reproduction published in 1923, to doubt the work's authenticity,[12] an ill-founded and unconvincing conclusion[13]). Sjraar van Heugten,[14] who noted with surprise that Vincent, in a letter to Theo dated that same day,[15] did not allude to the event and that Theo, who visited the Gachet house in Auvers on June 8, made no mention of a print until June 23, has suggested that the print was actually executed by Van Gogh on June (rather than May) 15 and that the inscription was added by Dr. Gachet after the fact, with a mistaken date. If so, we must add that the inscription did not come much later than the making of the etching, since no known impression of it lacks this notation. It may also be that the copper was in fact "bitten" on May 25 but not printed until several days later, which would explain Van Gogh's failure to mention his work before seeing the first proofs. The etching—with evident technical weaknesses in both execution and printing, which the printmaker Pierre Courtin has pointed out to me and described as being the result of Van Gogh's inexperience and Dr. Gachet's ("Van Ryssel's") mediocre technical skills—cannot be considered anything more than a first attempt. At the same time, there is no reason to doubt its authenticity.

Gachet *fils* also owned two earlier lithographs[16] by Van Gogh: *In the Orchard* from 1883 (cat. no. 23c) and *The Potato Eaters* from 1885 (cat. no. 23d). He gave both of them to the Bibliothèque Nationale in 1953.

1. Letters 642 and 643.
2. T 38. Quoted in a different translation in Excerpts from the Correspondence, June 23, 1890.
3. Archives, Van Gogh Museum, Amsterdam, b885 V/1975.
4. Paris 1905, no. 26: *L'Homme à la Pipe*, Van Gogh's only etching, Auvers 1889 [*sic*].

5. Meier-Graefe 1904, p. 120; in a letter to Dr. Gachet dated July 21, 1903 (Archives, Wildenstein Institute, Paris), Meier-Graefe invited the younger Gachet to visit him in Germany and asked him to bring along "the etching by Vincent that I absolutely intend to publish."
6. Delteil 1925, vol. 1, p. 298.
7. Hulsker 1996, no. 2028: *Portrait of Dr. Gachet with Pipe*, mid-June 1890.
8. Van Heugten and Pabst 1995.
9. The waybill from Gachet *fils* to Jo van Gogh (Archives, Van Gogh Museum, Amsterdam, b3374 V/1984) specified that the print was pulled by "Louis van Ryssel" (i.e., the younger Gachet) and was meant for the Stedelijk Museum in Amsterdam, where the Van Gogh exhibition had been held. It is mentioned in the catalogue under no. 432 at the end of the list of drawings. This print is now at the Rijksmuseum in Amsterdam.
10. Van Heugten and Pabst 1995, p. 84. These prints are catalogued there, pp. 99–100, as 10.2, 10.6, 10.7, and 10.8.
11. Gachet 1953a. The text is dated 1928, as is the entry on Van Gogh's etchings in Gachet Unpub. Cat., III, which gives no more information than the 1953 publication. The story already appears in Doiteau 1923–24. On May 11, 1905, Gachet *fils*, in a letter to Jo van Gogh, described the etching recently exhibited at the Salon des Indépendants simply as "a print that he made at my house in Auvers."
12. Anfray 1953; 1954b; 1954d; 1958a. De la Faille took up this debate by reproaching Gachet *fils* for not warning him in 1928 that he might be mistaken in reading the date as May *15*, 1890. One of his arguments concerned a rainstorm that occurred on May 25, which would have prevented any work from being done outdoors.
13. This thesis was refuted by Chatelet in Paris 1954–55, no. 66, and in Sablonière 1957, pp. 41–42. Anfray's thesis was recently revived by Jean-Marie Tasset in an interview with Benoît Landais for *Le Figaro* (Oct. 7, 1997). Landais used an exchange of letters between Theo's widow, Jo, and the younger Gachet in July 1912 (Archives, Van Gogh Museum, Amsterdam, b2156 and 2157 V/1982 and b3414 V/1984), in which Jo, who had seen the print exhibited in Cologne, asked Gachet for an explanation of the etching (which she took for a reproduction of Van Gogh's oil portrait of the doctor). She noted that she owned several impressions of the print (now in the Van Gogh Museum, Amsterdam) and asked if their author was Van Gogh or Dr. Gachet—proof simply of a memory lapse, since she herself had acted as go-between for the loan and gift of this print from Dr. Gachet in 1905 (see n. 9, above).
14. Van Heugten and Pabst 1995.
15. LT 637; see Excerpts from the Correspondence, May 25, 1890.
16. In a letter of Sept. 12, 1890 (Archives, Van Gogh Museum, Amsterdam, b2016 V/1982), Theo announced that he had sent Dr. Gachet a lithograph, which Van Heugten believes is *In the Orchard* (Van Heugten and Pabst 1995, pp. 66, 95). See also Faille 1928, nos. 1659, 1661.

Vincent van Gogh (1853–1890)

24 *Souvenirs of Van Gogh*

Photograph of an arrangement by Paul Gachet *fils*
Published in Gachet 1953a

Each of the objects shown in this photograph is linked to the memory of Vincent van Gogh. With the exception of the book—the novel *La fille Élisa* by Edmond and Jules de Goncourt, which Van Gogh had lent to Dr. Gachet—and the three first issues of the magazine *Le Japon artistique*, all of them were given to the Louvre by Paul Gachet in 1951, published in Florisoone 1952 and by Chatelet in Paris 1954–55, and are now housed in the Musée d'Orsay, Paris.

In the background at the left, framed together, are two Japanese crepe-paper cutouts (OD 34) that belonged to Van Gogh. Paul Gachet *fils*, who got them from Theo van Gogh, mounted them on a gilded background embellished with an inscription in Japanese stating that they were in Vincent van Gogh's room at Auvers in 1890. To the right of it is a three-color poster by Chéret (OD 32) for the restaurant Au Tambourin (the first Tambourin establishment on the rue de Richelieu, not the one that Vincent frequented on the boulevard de Clichy). In the foreground, from left to right, are tubes of paint, chromium yellow and geranium lake, from the firms of Tasset et Lhote and Tanguy (OD 31); the palette (OD 30) that, according to Paul Gachet *fils*, Van Gogh used for painting *Mademoiselle Gachet at the Piano* (fig. 87); a

Paul Gachet *fils*
24a Opening pages from the album of Japanese prints that belonged to Vincent van Gogh. 16⅛ x 11⅜ in. (41 x 29 cm)
Musée Nationalé des Arts Asiatiques-Guimet, Paris, acquired from Paul Gachet in 1958 (MA 2107)

This introduction, with calligraphy by Paul Gachet *fils*, precedes the fourteen prints depicting actors or familiar scenes (notably by Toyokuni I, Kunichika, Yoshitora, and Yoshikazu) that belonged to Vincent van Gogh. Theo van Gogh gave these sheets to the younger Gachet, who in 1921 gathered them in a Japanese-style album with a yellow and blue cover, calling the selection "Gogh-No-Omo-Ide" ("Souvenirs of Van Gogh").

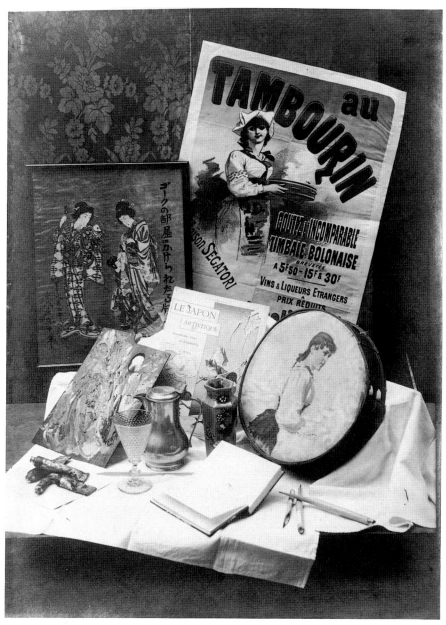

24

stemmed glass (OD 28) that had previously appeared in still lifes by Cézanne (see fig. 79); a pewter jug (OD 36) that Paul Gachet associated with a drawing attributed to Van Gogh (P.G. III-33); the Japanese stoneware vase (OD 37) from *Roses and Anemones* (cat. no. 16); bamboo pens that belonged to Van Gogh (OD 35); and a tambourine (signed by H. Tode in 1886; OD 33) from the restaurant of the same name, which was run by Agostina Segatori, a model and friend of Van Gogh.

Gachet *fils* stressed that to this group should be added his father's famous cap, given to the Louvre in 1951 (OD 38); the piano from Auvers, donated to the Musée Instrumental of Brussels in November 1952; the album of Japanese prints "Gogh-No-Omo-Ide" ("Souvenirs of Van Gogh"), acquired from Gachet by the Musée Guimet, Paris, in 1958; and two other large cutouts that had belonged to Van Gogh (present location unknown).

AD

The Discoloration of Pinks and Purples in Van Gogh's Paintings from Auvers

Preparation for the exhibition "Cézanne to Van Gogh: The Collection of Doctor Gachet" has provided an opportunity to reexamine the works that Van Gogh painted in Auvers-sur-Oise in May and June 1890. Thanks to various gifts and sales by the doctor's son, a number of canvases from this brief and final period of the artist's life are now housed at the Musée d'Orsay, which facilitates their study side by side and allows direct comparison of the materials and techniques used.

FADING DUE TO EXPOSURE

Similar evidence observed in three works suggests that some of the originally pink shades have now become so faded that they have completely disappeared. However, a museum visitor probably would not notice this discoloration, since it does not become apparent until the painting is removed from its frame.

The roof of the large thatched cottage at left in *Two Children* (cat. no. 18), for example, does not have an even hue: two noticeably pinker strips, of the same width as the rabbet of the frame, follow the edges of the painting in the

Fig. 60. *Two Children* (cat. no. 18), detail of the roof at upper left, where the original pink has faded to bluish gray through exposure to sunlight; some pink partially survives near the edge, which was protected by the frame.

upper left corner (fig. 60). With a loupe (magnifier), we can see that the brushstrokes continue uninterrupted from the pink strips into the rest of the bluish gray roof, and thus we can exclude the possibility that the painting was poorly retouched. The blue, black, and white pigments that compose the color of the roof have remained unchanged throughout, whereas the red pigment, which gave it its pink tint, has faded. As the same phenomenon did not occur on the edges, which are protected from direct and prolonged exposure to sunlight, we can conclude that light caused this red pigment to deteriorate. The surviving strips on the edges of the canvas therefore testify that the overall color of the roof was originally pink.

A comparable phenomenon can also be observed in a slightly different version of the same composition in which the two little girls are smiling.[1] During a restoration that exposed the edges of this canvas (which had been folded over the sides of the stretcher) it was noted that the colors in these areas did not match the other colors but instead formed pink strips. As with the painting in the Musée d'Orsay, these seemed to be the remnants of a faded red pigment that elsewhere had been exposed to sunlight.[2] It appears that this unstable pigment was used more abundantly here than in the painting at the Musée d'Orsay, for the pink strips are much wider in this version.

A less obvious but similar change in color can be observed in *The Church at Auvers* (cat. no. 17). Van Gogh provided a description of this painting in a letter to his sister Wil: "In the foreground some green plants in bloom, and sand with the pink glow of sunshine on it."[3] We can no longer see this pink: the path is colored only by small, pointillistic dabs of pale beige and white in the foreground (fig. 61). In fact, the dabs that are white in the uncovered portions are light pink near the lower extremity of the canvas, where the painting is protected from light by the edge of the frame—emphasizing the discoloration and showing that we have here a phenomenon comparable to the one observed in *Two Children*.

Dr. Gachet's Garden (cat. no. 14) also shows signs of fading (fig. 62), though less obvious ones than those in the preceding works: just two small, very slightly pinkish areas on the side edges suggest that the neighboring foliage initially had a slightly warmer tonality.

Fig. 61. *The Church at Auvers* (cat. no. 17), detail of the lower edge of the painting, where the primed canvas has not been painted over; above are two brown strokes and one white one that initially were entirely pink (a trace of this color, protected from light by the frame, survives at bottom).

Fig. 62. *Dr. Gachet's Garden* (cat. no. 14), detail of the yucca plants at the lower right edge, where the original color is still visible toward the right of the image. The pink progressively fades to the left, which had more exposure to light.

COMPARISON WITH WATERCOLOR COPIES

Further proof that Van Gogh's pinks have faded is afforded by comparing these three paintings in their present condition with watercolor copies made by Blanche Derousse at Dr. Gachet's house in or about 1901. The copies, which were initially intended to illustrate a work on Van Gogh that the doctor was planning to write, have been preserved in excellent condition, and one can see in them pinks and purples that today are absent from the oil paintings. It hardly seems likely that the copyist deliberately reinterpreted her models. Working at the Gachet home, she no doubt shared the doctor's respectful attitude toward the memory of the artists whom he had helped and whose work he actively promoted, and in all likelihood she labored to reproduce the originals as faithfully as possible. Moreover, we can judge her fidelity for ourselves: in comparing the blues, greens, and yellows, which have escaped discoloration, we see a good resemblance between the colors in the two versions. Clearly the watercolors were meant to be accurate witnesses to what the paintings looked like some ten years after their creation, at which point the slow fading of the pinks was not yet too pronounced.

A comparision of *Two Children* with its copy (cat. no. 18a) is quite instructive: the roof of the thatched cottage at left has an even pink-gray color in the copy that is comparable to the color in the strips along the sides of the two oil versions; while the edge of the roof in the watercolor is frankly purple, in place of the pale gray seen in the oil painting. The little girls' features are much clearer in the watercolor: the lips and nostrils of the girl on the left and the lips, fingers, and bonnet of the girl on the right are outlined in purple. These elements have largely vanished in the original (fig. 63). In the copy the eyes of the girl at right are also painted in purple; they remain visible in the oil version (because the thickness of the paint and the concentration of purple are much greater in the eyes than in other details of the faces and hands) but have become dull brown. This comparison between the painting at the Musée d'Orsay and its copy allows us to measure how significantly the painting's appearance has changed.

An examination of the original and the copy (cat. no. 14a) of *Dr. Gachet's Garden* leads to the same conclusions. Judging from the watercolor, the discoloration is

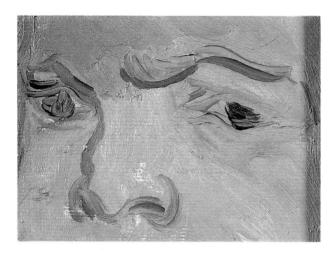

Fig. 63. *Two Children* (cat. no. 18), detail of the girl at right, whose features have faded from purple to beige; at her eyes, where the paint is thicker and more concentrated, we can still see a reddish tint.

not limited to the two areas first indicated by a few discreet signs on the edges of the oil painting: it also affects the potted flower in the foreground at left as well as numerous brushstrokes spread throughout the yuccas at right, the foliage at left, and the base of the dark green thujas (fig. 64).

The change in hue seems less drastic in *The Church at Auvers* when compared with its copy (cat. no. 17a). The pink has faded on the foreground path (fig. 65), although with relatively little effect on the painting's overall appearance; no other discolored areas are revealed.

Further comparison of Blanche Derousse's copies with the three originals confirms the conclusions first reached by simple visual observation. Van Gogh used, among other reds, a purple that he lightened with various whites to obtain tones ranging from violet red to very pale pink. This unstable pigment then slowly faded, and the pink tones paled or became invisible while the purples took on a dull beige color. The result is the disappearance of certain details of the composition or an imbalance in the relations between colors. These consequences, while always damaging, are of greater or lesser importance today depending on the amount of unstable pigment in each painting and the use to which Van Gogh put it. The other conclusion reached through these comparisons is that the discoloration is not limited to the peripheral parts of the composition.

QUESTIONS ON THE EXTENT OF THE DISCOLORATION

Would not other works painted in Auvers, though apparently unaltered, have been affected by similar discoloration? Further comparisons with Derousse's watercolors suggest that this is indeed the case. In her version of *Mademoiselle Gachet in the Garden* (cat. no. 15), the roses on the bush in the foreground at left, the roses behind the flowerpots, several roses at right, and the young girl's carnation are all tinted in pale pinks, colors absent from the original, where in their place we see only white or slight traces of beige. Were the flowers in this garden all white or ivory?

The *Portrait of Doctor Paul Gachet* (cat. no. 13) poses a similar question. On the table where his elbows rest, the doctor holds two stalks of foxglove (digitalis), a medicinal plant whose flowers have a purplish or pale yellow color in nature. Why, then, are these foxglove flowers blue in the painting at the Musée d'Orsay (figs. 72, 73)? The question might also be asked for Van Gogh's other version of this portrait,[4] in which the flowers are almost white with a few blue and pale pink reflections, entirely without the purple that Van Gogh, in describing the painting, specified as their color.[5] In Derousse's copy of this work at the Musée d'Orsay (cat. no. 13b), the foxgloves have their normal purplish tint. We may therefore wonder whether, in painting his two versions of the portrait, Van Gogh did not depict these flowers by mixing a blue pigment (the one we can still see unchanged today) with a purple that has since faded. The outlines of the right hand and of the lower part of the face, purple in the copy and beige in the painting, also indicate the presence of an unstable pigment in these areas.

Not all the works painted in Auvers are known to have been copied soon after their creation, leaving us in some cases without reliable references to detect and locate discolorations like those described above. We might nonetheless ask whether certain colors in the works not copied have not also evolved with time—for example, the tones of the oddly brownish flowers that appear in *Roses and Anemones* (cat. no. 16).

RED LAKE PIGMENTS USED BY VAN GOGH

The discoloration of pinks and reds has also been noted in works by Van Gogh that are not in the Musée d'Orsay

collections. In addition to its presence in the variant of *Two Children* mentioned above,[6] the phenomenon has been observed in three works from 1888 representing flowering fruit trees, *The Pink Orchard, Flowering Peach Trees,* and *The White Orchard,*[7] recently the subject of an in-depth study,[8] and in *Irises* in The Metropolitan Museum of Art in New York. Comparable fading was also noted in a painting by Gauguin.[9] The fragile red pigments, identified in the course of these studies, are of two types: various carmines, and eosin-based pigments. All of them are lake pigments obtained by making a previously dissolved organic color insoluble. Precipitation is accomplished by adding mineral salts—most commonly alum—to a watery solution of the coloring agent.

All carmines contain the same coloring agent, carminic acid, which is extracted from cochineal.[10] The intensity and nuance of the lake pigment can be modified according to the nature of the added minerals. Those containing tin produce a particularly intense scarlet color, but this aesthetic quality unfortunately goes hand in hand with great instability under light. The instability of tin carmines is more pronounced than that of aluminum carmines, which are themselves less solid than the red madder or alizarin lakes; these, among lake pigments, generally offer the most stability.[11]

In 1871 Caro produced the first synthetic red pigment, which, in reference to the first rays of dawn, he called eosin,[12] after Eos, the Greek goddess of dawn. Soon after that, paint manufacturers decided that this new, easily blended product could complement the traditional natural pigments that at the time were the only source of lake color. New lake reds began appearing under various labels, each manufacturer inventing his own brand name to indicate slight differences in formula.[13] Geranium lake was one of the eosin reds offered to artists at the end of the nineteenth century, and, based on orders he placed via his brother Theo,[14] we know that Van Gogh used it. Like the carmines, however, this new red was very unstable in daylight.

Artists of the time were aware that certain reds ran the risk of fading. Sixty years earlier, J.-F.-L. Mérimée[15] had warned against the use of cochineal carmines in oil painting because of their instability under light. J.-G. Vibert[16] made the same criticism and for similar reasons advised against using the synthetic reds that had recently been made available to artists. The discoloration was rapid enough for some painters to live to see it for themselves. The story goes that

Fig. 64. *Dr. Gachet's Garden* (cat. no. 14), cross section of a pink paint sample from the yuccas at right edge, which was protected from direct sunlight (see fig. 62). The grains of carmine have preserved the original intensity of their color throughout the thickness of the paint, except for a very thin surface layer.

Fig. 65. *The Church at Auvers* (cat. no. 17), cross section of a paint sample from the foreground path (see fig. 61); the grains of carmine scattered throughout the white retain their color in the deepest layers of paint (at bottom) but have nearly all become invisible toward the surface (at top).

when Renoir saw his *Ball at the Moulin de la Galette*[17] hanging in the Louvre after World War I, he joked, "This picture isn't mine. I painted it in pink; this one is blue."

IDENTIFICATION OF A CARMINE

To answer the questions raised by the preceding observations, we had to identify the pigments used in areas that have purportedly changed color or where a former pink has now become invisible.[18] The first step was to take several isolated samples[19] and to study the stratigraphy of successive layers of paint and their apparent color under a microscope. Next, the same samples were subjected to various kinds of chemical analysis.[20] We performed such analyses on the six Van Goghs from the Gachet collection discussed above.

An aluminum-and-tin carmine lake pigment was identified in the roof of the thatched cottage at upper left in *Two Children*. In 1890 the roof no doubt had a purplish color: lead white (the most abundant pigment) was

Fig. 66. Palette said to have been used by Van Gogh when painting *Mademoiselle Gachet in the Garden* (cat. no. 15)

colored by a little carmine, now faded, and by a small amount of cobalt blue and black that have remained stable. It is quite probably the same carmine, this time used in its pure form, that delineated some of the features, particularly the eyes, mouth, and outline of the hands, of the little girl at right—details that have now faded to pale beige and have become almost indistinguishable.[21] This result differs from the one obtained when the other version of *Two Children* was studied; that examination identified an eosin red lake in the painting.[22] Thus, despite the similarity of subject matter and the chronological proximity of the two versions, they vary in the nature of the red pigment used.

We find aluminum and tin red lake pigment on the path in the foreground of *The Church at Auvers,* confirming that the ground was initially pinker, in accord with Van Gogh's description, and on the side edges of *Dr. Gachet's Garden* (fig. 64), suggesting as well the disappearance of many pink highlights in the foliage. In these two works, carmine has faded—just as it did in *Two Children* at the Musée d'Orsay, which features the same type of carmine[23]—and has now vanished completely.

A palette used by Van Gogh (fig. 66) was among the "souvenirs" Paul Gachet *fils* donated to the Louvre. Now at the Musée d'Orsay, it has remained intact since the artist's death, having been carefully preserved by the doctor and then by his son, faithful guardians of the cult of Vincent's memory. According to Gachet *fils*, this palette actually belonged to the doctor[24] and had been lent to Van Gogh on June 29, 1890, to finish his portrait *Mademoiselle*

Gachet at the Piano (fig. 87), since the artist had left his own palette at Ravoux's Inn.[25] Examination and analysis of several colors on it[26] detected the presence of aluminum and tin carmine lake, mixed with other colored pigments. This carmine is the same as that identified in the three paintings at the Musée d'Orsay. It would be interesting to compare these results with a study of the material used for Mlle Gachet's slightly rose-tinted white dress, to learn whether at one time this garment was more heavily colored with the pigment found on the palette. In his description of this painting, Van Gogh said the dress was predominantly pink, reinforcing the hypothesis.[27]

IDENTIFICATION OF EOSIN REDS

The pale flowers depicted in *Mademoiselle Gachet in the Garden* (cat. no. 15), near the middle of the left edge and between the pots and thujas (fig. 67), contain an eosin red lake mixed with a little vermilion. This red is itself lightened by a large quantity of white.[28] It seems that the residual extremely light beige color is due to the vermilion, not very concentrated but unaltered, whereas the eosin pigment, which was the main component of the red, has completely faded. We find this very pale beige again in several flowered areas of the garden and in the girl's carnation, as already noted. We can therefore confirm that several more or less intensely pink blossoms disrupted the uniformity of the garden when Van Gogh first painted it.

Discolorations have also altered the chromatic equilibrium of *Roses and Anemones* (cat. no. 16). Analysis of the

Fig. 67. *Mademoiselle Gachet in the Garden* (cat. no. 15), detail of roses in front of the thujas at left, now only a residual pale beige

Fig. 68. *Roses and Anemones* (cat. no. 16), detail of table at lower left corner showing crosshatched white brushstrokes

Fig. 69. *Roses and Anemones* (cat. no. 16), detail of the pink at lower right. The garnet that outlines the petals and marks the shadow on the table has the same appearance and probably the same pigmentary composition as the line indicating the edge of the table (see fig. 71), suggesting it was once brighter.

pigments in this painting shows that fading has been particularly extensive, for it affects not only certain flowers but also the table and the background of the composition. This finding is particularly interesting because, in the absence of an available copy or a reliable documentary reference, there was until now no satisfactory explanation for the overall "aged" look of the colors.

The table in *Roses and Anemones* was painted in two layers (figs. 68, 70). Orange minium was laid down first. This color, visible beneath the white rose at right and near the corner of the table at left, is well preserved and seems to constitute the overall tone of the background. Above this a second color, painted in crosshatched strokes, a common practice of Van Gogh, softens the vivacity of the orange on a portion of the table surface. This second color seems to be white, particularly in the lower left corner, where it is thicker. Analysis has identified lead white, a stable and always visible pigment, and an eosin red lake that has now faded. Initially, therefore, the table was pink over orange.

The garnet red outline edging the table at left (fig. 71) contains an eosin red lake, vermilion, and zinc white. We find the garnet color in other elements of the composition, such as the shadows on the table and the outline of the white rose petals at right (fig. 69). Given the instability of one of the two red pigments used here, we can deduce that this color was much brighter in 1890. The rose with petals edged in blue at the top of the bouquet was also painted with the same mix of red pigments, pure

in the accents at the crest of the flower, lightened with lead white in the petals. The initial colors were thus more brilliant than the faded garnets and beiges we now see. However, alteration in the color of the flowers does not seem to be generalized; no unstable red pigment was detected in the white paint of the anemones or of the buttercups at the center of the bouquet, indicating that these flowers most likely retain their original appearance.

As with the surface layer on the table, the background of the composition is painted in perpendicular crosshatched strokes, clearly visible under X-ray photography. Its yellowish gray color is the result of a complex blend of pigments: lead white charged with barium sulfate is tinted with ultramarine, chromium oxide green, vermilion, and

Fig. 70. *Roses and Anemones* (cat. no. 16), cross section of a paint sample from the table at lower left (see fig. 68). The external layer of color (at top) has faded to white, while the deeper layers (at bottom) retain their original color.

Fig. 71. *Roses and Anemones* (cat. no. 16), cross section of a paint sample from the line defining the edge of the tabletop at left. The vermilion has retained its original color, while the eosin lake has faded.

Fig. 72. *Portrait of Doctor Paul Gachet* (cat. no. 13), cross section of a paint sample from the foxglove blossoms in front of the doctor's sleeve. The external layer (at upper right), now blue, is composed of zinc white mixed with ultramarine blue and eosin lake; the last pigment, here in a very low concentration, has almost completely faded. The flowers' darker initial color (at lower left) contains a bright red eosin lake, still well preserved, and a few grains of dark ultramarine blue.

eosin red lake. Given the presence of the last, this background color has no doubt changed since its creation, but it is difficult to determine accurately the shade of the original because many pigments were used. Moreover, it appears that Van Gogh hesitated over this background color, for under the current yellowish gray surface, stratigraphic examination has detected an older layer of lead white colored with eosin red lake, which, though protected from direct sunlight, has largely discolored.

The two sprays of foxglove in the *Portrait of Doctor Paul Gachet* (cat. no. 13) were carefully studied. The blue now visible is a zinc white mixed with synthetic dark ultramarine and a very small amount of eosin red lake, whose color is no longer visible near the surface of the layer but survives below as a very pale pink. Although it contained a strong dose of blue, the original color was closer to the purple reproduced by Blanche Derousse.

Under the top layer of paint of the flowers in front of the jacket we found another colored layer, composed of eosin aluminum red lake mixed with a little ultramarine. In the sample studied, the red pigment, abundantly applied and well protected from daylight, has retained its original bright color, which allows us to see, for the first time, the red actually used by Van Gogh, without the fading that has systematically occurred elsewhere.[29] The absence of white in the blend of pigments here means that this underlying color was a very dark purple (fig. 72). The foxglove flowers that stand out against the table differ from those on the other stem, for we can observe no dark purple underneath them (fig. 73). They are painted partly over the orange of the table and partly over the white

primer, because the artist rubbed the painted canvas with minium to remove the still-fresh color where he wanted to place the second flower. Even though this portrait is a replica, it seems that Van Gogh still hesitated when painting the foxglove flowers, whose arrangement is in fact different from that in the first version. After his first attempt, which consisted of sketching out a few flowers in dark purple near the doctor's sleeve, he chose to paint the group of flowers in a lighter purple, which today has faded to blue. The stalk outlined against the table was painted only with this second color, after he had partially suppressed the orange to create a lighter background.[30]

Moreover, closer analysis allows us to confirm that the pigments used here are identical to those the artist mentioned using for the first version of the portrait.[31] The blue behind the doctor, for example, is indeed cobalt blue, lightened with lead white (more heavily in the upper part than toward the bottom). And the doctor's jacket is painted in ultramarine, just as Van Gogh stated.

A few tubes of paint used by Van Gogh in Auvers were donated to the French national museums by Paul Gachet *fils*, along with the palette discussed above. One of them (fig. 74) carries a label mentioning the color (geranium lake) and the manufacturer (Tasset et Lhôte); its contents, barely used, are now dried out, but they have retained their vivid red color. Van Gogh often asked Theo to buy him paint of that name, which suggests that he used it fairly regularly.[32] He even specified the manufacturer's name in one of his letters.[33] An analysis of the red paint in this tube, conducted thirty years ago, identified eosin.[34] As

Fig. 73. *Portrait of Doctor Paul Gachet* (cat. no. 13), detail of the foxglove blossoms on the table; the eosin lake in them has faded, leaving visible only the blue pigment mixed in with it. Unlike the foxgloves in front of the doctor's sleeve, these were painted in a single layer.

part of the present study this analysis was recently redone, confirming the original results by finding that the paint is an aluminum red lake mixed with large amounts of lead.[35] The red in this tube is thus comparable to the eosin red lakes in Van Gogh's paintings, particularly those used for the foxglove flowers in the *Portrait of Doctor Paul Gachet*. The agreement of the older documentary data with recent analytical results suggests that this is most likely the very geranium lake that can be found in *Mademoiselle Gachet in the Garden, Roses and Anemones*, and the *Portrait of Doctor Paul Gachet*, all of which seem to have been painted in the first days of June 1890.

Fig. 74. Van Gogh's tube of geranium lake pigment made by Tasset et Lhôte, preserved by the Gachet family

Conclusions

From the study of six Van Goghs from the Gachet collection and the examination of a palette and tube of geranium lake paint used in Auvers, two types of organic red were identified in Van Gogh's paintings from this time: an aluminum-and-tin carmine lake and an aluminum eosin lake[36] mixed with lead.[37] These two pigments have a very intense color in their pure state, which is why they were almost always diluted with large amounts of white to form lighter or darker shades of pink. The second of the two was also sometimes mixed with other colors, such as vermilion. While it is possible that Van Gogh himself created this mixture of eosin lake and vermilion (found in both *Roses and Anemones* and *Mademoiselle Gachet in the Garden*), he might also have used a premixed composite red. The homogeneity of the mixture, visible under a microscope in the tested samples, and the absence of vermilion (either in its pure state or mixed with other pigments) in the studied paintings favor this hypothesis.[38]

The absence of pure vermilion may seem surprising, as this color figures on the shopping lists Vincent sent to his brother.[39] Still, high-quality vermilion was expensive, and Vincent repeatedly urged his brother to be economical. It is possible that the mix of vermilion and eosin lake detected by analysis was, in fact, a cheaper "vermilion," less expensive because less pure.

It is interesting to note that carmine and eosin lake pigments are not generally found in the same painting: for each of these works, the artist chose one color or the other. It would, of course, be risky to apply this observation too generally, especially since both an aluminum carmine lake and an eosin lake were found in a painting from the Arles period, *Flowering Peach Trees.*[40]

Both carmine and eosin red are very fragile; in all the paintings studied each has lost its color over time from the action of sunlight.[41] Van Gogh was not unaware of this risk. In using these pigments, did he succumb to the seduction of their particularly intense colors and throw caution to the winds, or did he simply not realize just how much the change in hue would affect his works? In a letter to his brother of April 1888, we read, "You were right to tell Tasset that he must put in the geranium lake all the same; he has sent it, I have just checked it. *All the colors that the Impressionists have brought into fashion are unstable,* so there is all the more reason not to be afraid to lay them on too crudely—time will tone them down only too much." And farther on: "They are only to be found in Delacroix, who had a passion for the two colors which are most condemned, and with most reason, citron-yellow and Prussian blue. All the same, I think he did superb things with them."[42] Apparently Van Gogh did not fully assess the danger: accentuating the strength and "rawness" of the colors was a vain precaution, because with the carmines and red lake pigments he used, the alteration was not limited to a lessening of the color's intensity but could continue to the point of its total disappearance, something he probably did not know. Van Gogh noted that Delacroix's paintings had held up well after several decades despite the use of supposedly dubious pigments such as Prussian blue and light chromium yellow. But even if that yellow and blue are not perfectly stable, they are incomparably more so than the two lake pigments Van Gogh used. It appears that he was not entirely cognizant of this difference.

Not all of Van Gogh's purples and reds are systematically unstable, however. We can find seemingly well-preserved pinks in *Pink Roses,*[43] painted in Auvers, and even in some earlier canvases. Although no example of a more stable red lake pigment, such as red madder or alizarin, has been found in the six paintings from the

Gachet collection, Van Gogh probably did use those colors at some time. Obviously, more paintings need to be analyzed before we can gain an accurate idea of how often he used the various organic reds in depicting different subjects and in various periods.

By partially upsetting the original harmony of the colors, the discoloration of pinks and purples brings about a loss of aesthetic quality that might have influenced the judgment of unsuspecting art critics. This phenomenon should henceforth be taken into account, since it is fairly widespread: at least six paintings from the Gachet collection can be added to those previously studied. Other instances may well come to light, including pictures by Paul Gauguin that he painted during the final years of Van Gogh's life and works by other contemporaries.

Speculations about the authenticity of certain Van Gogh paintings have generally not been backed up by verifiable data. New facts that may help answer these questions are therefore significant. Laboratory studies do not claim in themselves to directly resolve problems of attribution, or to constitute irrefutable proof, but they can highlight technical characteristics shared by several works; and such similarities are worth considering. This exploration has been one attempt in that direction, but other pertinent material aspects of Van Gogh's paintings also need to be compared. No such study can lead to reliable interpretations unless the number of works examined is large, and thus a cooperative effort among various museums to study Van Gogh's painting materials is required to help us determine which paintings are not genuine and to deepen our knowledge of those that are.

Jean-Paul Rioux

1. F 784; private collection.

2. Cadorin, Veillon, Mühlethaler 1987; Cadorin 1991.

3. Letter W 22 (to his sister Wil); see Van Gogh Letters 1958, vol. 3, p. 470.

4. F 753; private collection.

5. Letters LT 638 (to Theo) and W 22 (to Wil); see Excerpts from the Correspondence, June 3 and ca. June 5, 1890.

6. See notes 1 and 2.

7. F 555, F 404, F 403, respectively; Van Gogh Museum, Amsterdam (Vincent van Gogh Foundation).

8. Bang 1991; Hofenk de Graaff et al. 1991.

9. See note 2.

10. Schweppe and Roosen-Runge 1986.

11. Saunders and Kirby 1994.

12. Eosin is an alkaline salt derived from tetrabrominated fluorescein. See Langstroth 1973.

13. Coffignier 1924, pp. 316–21.

14. Letters LT 475, 541a, 551, 584, 629, 638.

15. Mérimée 1830.

16. Vibert 1892.

17. Musée d'Orsay, Paris (RF 2739).

18. The analyses were performed at the Research Laboratory of the Musées de France (LRMF).

19. The samplings were taken in a very limited number, preferably from the edges of the painted area and, in a few cases, from more central parts when it was necessary and possible.

20. Two methods of analysis were used: 1) A scanning electron microscope (SEM) with analyzer (EDX) allowed us to identify the chemical elements in a layer or fleck of the sample. The detection of tin, aluminum, and sulfur indicates a tin- and aluminum-based cochineal carmine lake. If the eosin molecule contains four atoms of bromine, the detection of the bromine indicates the presence of eosin, as bromine does not enter into the composition of other common pigments. EDX analysis can identify bright eosin reds, but it does not work for light pinks—that is, when the red lake pigment is mixed with a large quantity of white and thus is insufficiently concentrated. 2) A simple microchemical operation allowed us to extract eosin from the sample, which, put into a solution, displays a characteristic fluorescence under ultraviolet light (see n. 2). This method is very sensitive, making it possible to detect eosin even when its concentration is very weak. Carmines cannot be confused with eosin, since under these same conditions they do not become fluorescent.

21. No samples could be taken from such important elements as the eyes of the girl on the right. An analysis by X-fluorescence, which does not require samples to be taken and which can detect tin, the principal and characteristic chemical element of this carmine lake, will be performed the next time the painting is in the laboratory.

22. See note 2.

23. The only difference is that the pinks in *The Church at Auvers* and *Dr. Gachet's Garden* are a mix of carmine and zinc white, while the pink in *Two Children* is a mix of carmine and lead white.

24. Gachet *fils* did not specify whether this palette was new or if it had already been used by its owner. The first possibility seems the more likely, for over the entire surface it seems to reflect the free, rapid movements that correspond much more to Van Gogh's temperament than to the no doubt less fervent temperament of his host.

25. Gachet 1994, p. 166, pls. xxx, xxxii.

26. Analysis under scanning electron microscope conducted by A. Duval.

27. Letter LT 645 (to Theo); see Excerpts from the Correspondence, June 28, 1890.

28. The white contains lead white, a little zinc white, and a charge of barium sulfate.

29. The underlying color observed in a sample under the microscope is not the same color that would be seen by the naked eye if the same material were painted over a large surface. In the first case, one sees the juxtaposition of the different grains of pigment that compose the color; in the second, the eye effects a synthesis.

30. Judging from Blanche Derousse's watercolor copy, it seems that the outlines of the right hand and the face in the Van Gogh original may have been painted in purple. Since we cannot take samples from these areas, the presence of a discolored red has not been verified. Direct observation of the outlines reveals no visible sign of an altered color.

31. See note 5.

32. See note 14.

33. "Then (but at Tasset's) 2 geranium lake, medium-sized tube." LT 629 (Vincent to Theo, September 1889); see Van Gogh Letters 1958, vol. 3, p. 261.

34. Chemical analysis was performed in 1967 at the Research Laboratory of the Musées de France under the supervision of S. Delbourgo.

35. The backscattered electron image (composition mode) obtained under a scanning electron microscope allows us to distinguish a continuous matrix containing eosin lake (Br and Al) and dispersed grains that are very rich in lead.

36. Aluminum, the mineral support of eosin lake, was precisely identi-fied only in the *Portrait of Doctor Paul Gachet* and in the geranium lake.

37. We can compare these results with the ones obtained after analysis of the colors in the three works in the Van Gogh Museum *The Pink Orchard*, *Flowering Peach Trees*, and *The White Orchard*, painted two years earlier (see nn. 7, 8). An aluminum-and-tin crimson lake and an eosin lake mixed with vermilion were identified, as they were in the paintings from the Gachet collection. We nonetheless note two differences: an aluminum crimson lake without tin is also found in the paintings from Amsterdam; and the calcium carbonate or dolomite that charges the carmines in these paintings was not found in the carmine of the Gachet paintings.

38. There is a similar mixture in *Flowering Peach Trees;* see note 8.

39. LT 475, 584, 604.

40. See notes 7, 8.

41. Examination of cross-section cuts of samples under a microscope reveals the appearance of the deepest layers of the paint, parts beneath the surface discoloration that are only partially or not at all faded. In the pinks made from carmine, the pigment appears as very fine but discernible grains of dark purple. In the eosin pinks, the coloration, less purplish than in the previous example, is more uniform and shows few grains of red.

42. LT 476; Van Gogh Letters 1958, vol. 2, p. 545.

43. F 595; Ny Carlsberg Glyptotek, Copenhagen; see Summary Catalogue, P.G. III-4.

IMPRESSIONISTS AND CONTEMPORARIES

ARMAND GUILLAUMIN (1841–1927)

25 *Self-Portrait*

Ca. 1870–75
Oil on canvas, 28¾ x 23⅝ in. (73 x 60 cm)
Musée d'Orsay, Paris
Gift of Paul and Marguerite Gachet, 1949 (RF 1949-18)
P.G. IV-1

In adding this self-portrait by Guillaumin to his gift of two paintings by Vincent van Gogh, *Self-Portrait* and *Portrait of Doctor Paul Gachet* (cat. nos. 12, 13), Paul Gachet *fils* hoped to draw attention to the least well known of the Impressionists (he had already lent the picture several times, at least once, in 1937, under his name as owner).[1] He also wanted to commemorate the friendly relationship that his father and the artist maintained during the 1870s. Yet his strongest desire was most likely to put before the public this work that Van Gogh himself had admired in his father's house and had mentioned in a letter to his brother Theo, who considered Guillaumin one of "his" painters: "He [Gachet] also has a very old self-portrait by Guillaumin, very different from ours, dark but interesting."[2] Guillaumin's stature for the Gachets was probably strengthened by the esteem in which the Van Gogh brothers held the painter. "I think," wrote Vincent van Gogh to the painter Émile Bernard, "that Guillaumin the man is clearer in his head than the others and that if all were like him, we would be producing more good work and have less time and inclination to step on each other's toes."[3] This masterful canvas, which Paul Gachet dated "before 1870"[4] but which seems slightly later,[5] can without disfavor be compared with contemporary works by Guillaumin's closest friend, Paul Cézanne.

AD

1. Paris 1937a, no. 1: *Portrait de l'artiste par lui-même,* Gachet collection. The work was lent anonymously to the exhibitions "Guillaumin" (Paris 1938), no. 28, and the "Centenaire de A Guillaumin" (Paris 1941), no. 91.
2. LT 638; see Excerpts from the Correspondence, June 3, 1890. On Guillaumin's *Self-Portrait with Palette,* 1878, see Van Uitert and Hoyle 1987, p. 350, ref. I 267.
3. Van Gogh Letters 1911, p. 73, letter 1; and, in a somewhat different translation, Van Gogh Letters 1958, vol. 3, p. 474.
4. Paul Gachet *fils* to Michel Florisoone, Oct. 30, 1949 (Archives, Musée d'Orsay, Paris). Gachet *fils* believed that the picture entered the Gachet collection in 1873: Gachet Unpub. Cat., IV, P.G. 1.
5. Courières 1924, p. 72, about 1872; Chatelet (in Paris 1954–55, no. 72), dates it 1875, a dating upheld by Serret and Fabiani (1971, no. 39), and Gray (1972, no. 46).

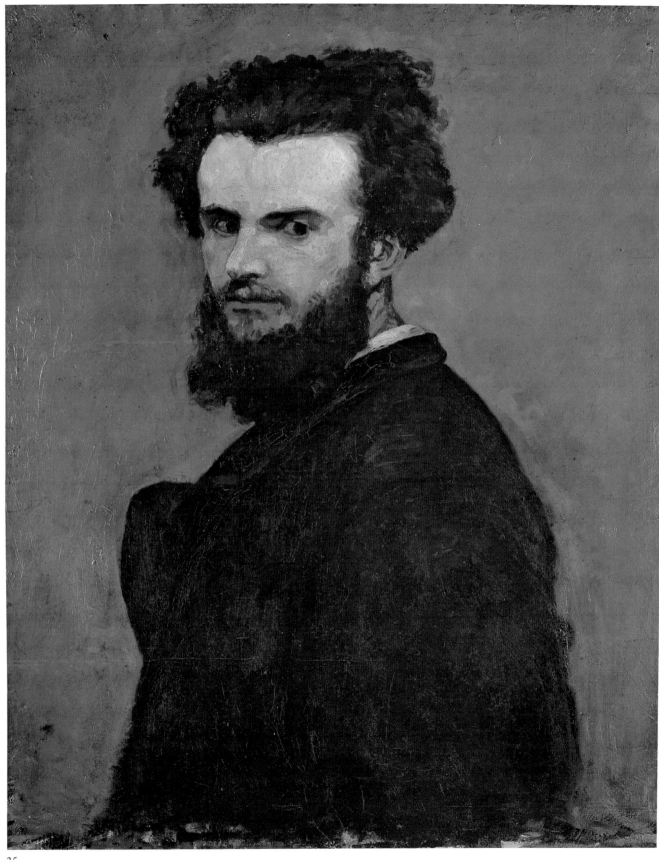

25

Armand Guillaumin (1841–1927)

26 *The Sunken Road, Snow Effect*

1869
Oil on canvas, 26 x 21⅝ in. (66 x 55 cm)
Signed and dated lower right: A Guillaumin / X 69 [A and G interlaced]
Musée d'Orsay, Paris
Gift of Paul Gachet, 1954 (RF 1954-10)
P.G. IV-9

According to Paul Gachet *fils*, this snowscape was painted at Arcueil, a small village just south of Paris, in the Bièvres Valley. That information had been written on the original stretcher, which was lost when the picture was transferred to a new canvas; it is repeated on the back of the watercolor copy executed in 1901 by the younger Gachet (cat. no. 26a).[1] Although the picture contains no precise topographical features that could verify the claim, it seems plausible, for Guillaumin often worked in the area and even took his friend Dr. Gachet there in 1873 to look for subjects for prints.

The date inscribed has usually been read as December 1869, which would make this snowy landscape with bluish shadows a respectable contemporary of Monet's splendid paintings treating the same theme. Gachet *fils* made no secret of owning this work, which is mentioned as being in his collection in the first monograph on Guillaumin, by Édouard de Courières (1924).[2] He lent it anonymously at least once, in 1938, for an exhibition in a Paris gallery,[3] before it entered the national museums of France in 1954.[4] Often mentioned in the literature on the artist,[5] this is a very popular work that pleases—despite a certain clumsiness of execution—because of its direct, spontaneous quality.

AD

Louis van Ryssel (Paul Gachet *fils*)
26a Copy after Guillaumin, *The Sunken Road, Snow Effect*, 1901
Watercolor, 15⅛ x 12¼ in. (38.4 x 31 cm)
Musée du Louvre, Paris, Département des Arts Graphiques, Fonds du Musée d'Orsay, acquired from Paul Gachet, December 1960 (RF 31 259)

1. Signed and dated lower right: Mars 901 / LVR. Inscribed (twice) on the back: Nach dem Gemald von Guillaumin / Arcueil 1869 / L. van Ryssel / Auvers / 6 mars 1901.
2. Courières 1924, p. 72, as "Arcueil—*Effet de neige*, Dec. 6, 1869."
3. "Guillaumin." Galerie Raphaël Gérard, 4, avenue de Messine, November 4–26, 1938, no. 29, according to a label on the back of the work (see Paris 1938).
4. Chatelet in Paris 1954–55, no. 67; Gachet Unpub. Cat., IV, P.G. 9.
5. Serret and Fabiani 1971, no. 5; Gray 1972, no. 14.

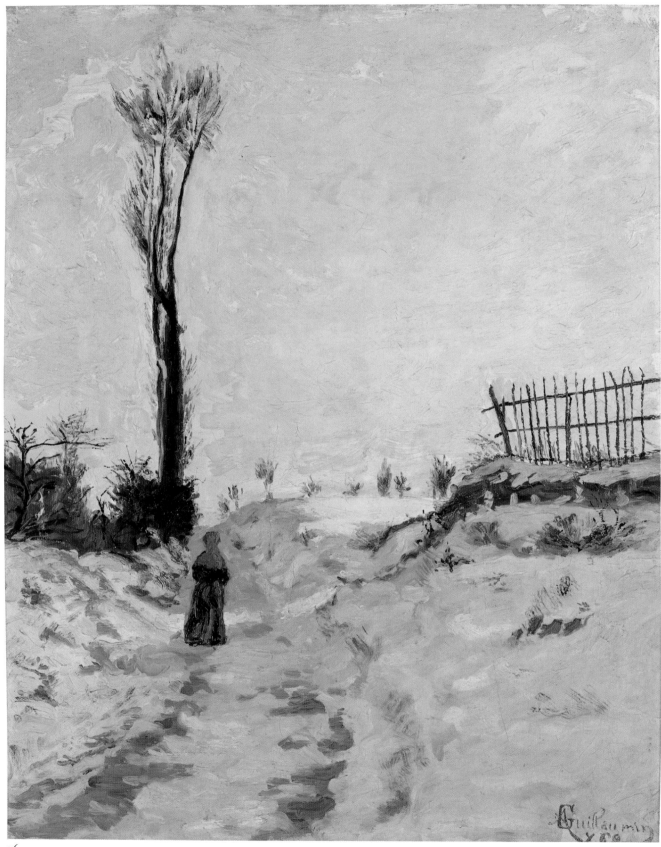

26

Armand Guillaumin (1841–1927)

27 Sailboats on the Seine at Bercy

1871
Oil on canvas, 20⅛ x 28¾ in. (51 x 73 cm)
Signed and dated lower left: A Guillaumin / 9 71 [A and G interlaced]
Musée d'Orsay, Paris
Gift of Paul Gachet, 1954 (RF 1954-11)
P.G. IV-14

This austere composition, executed in muted tones but with a sensitive and energetic touch, takes up a subject Guillaumin chose to paint often, in line with his and his fellow Impressionists' interest in industrial motifs. Guillaumin's system of dating was such that the numbers should be read as "November 1871" rather than "September 1871," a detail that has little effect on the chronology of the artist's work. Paul Gachet *fils* attached considerable importance to this picture,[1] for he also owned the only known proof of the print that reproduces it, in reverse, which is inscribed in the plate: After Armand Guillaumin Pictor. "More curious than beautiful," he commented,

seeing in it "something incomplete and dynamic peculiar to Cézanne" (see cat. no. 10a). Thus the work is one more testimony to the friendship that bound Cézanne and Guillaumin to Dr. Gachet's circle in Auvers. Since its entry into the French national collections in 1954, when, it seems, it was exhibited for the first time, it has been included in all the catalogues of Guillaumin's work.[2]

AD

1. Gachet 1952, repr., n.p.; Gachet Unpub. Cat., IV, P.G. 14.
2. Chatelet in Paris 1954–55, no. 68, pl. IX. Serret and Fabiani 1971, no. 11; Gray 1972, no. 25.

27

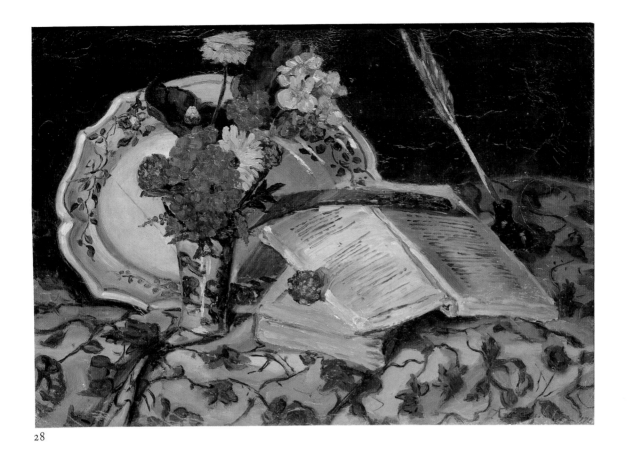

28

ARMAND GUILLAUMIN (1841–1927)

28 *Still Life with Flowers, Faience, and Books*

1872
Oil on canvas, 12¾ x 18⅛ in. (32.5 x 46 cm)
Signed and dated lower right in red: A Guillaumin 7 72 [A and G
interlaced]
Musée d'Orsay, Paris
Gift of Paul Gachet, 1954 (RF 1954-9)
P.G. IV-30

In 1924, in one of the first major studies devoted to
Guillaumin, Édouard des Courières called attention to
this painting in the Gachet collection.[1] According to
Paul Gachet *fils*,[2] who made a watercolor copy of it at the
beginning of the century (cat. no. 28a), the cloth with a
pattern of blue leaves that appears here is the same as the
one employed by Cézanne in his still life *Bouquet with
Yellow Dahlia* (cat. no. 5). This use of an accessory
belonging to the Gachet household implies that Guillaumin
painted his picture at the doctor's house in Auvers, a
possibility not contradicted by the date inscribed on
the picture, whether it is interpreted as July 1872 or, in

Louis van Ryssel (Paul Gachet *fils*)
28a Copy after Guillaumin, *Still Life with Flowers, Faience, and
Books*
Watercolor, 10 x 14⅜ in. (25.3 x 36.5 cm)
Musée du Louvre, Paris, Département des Arts Graphiques,
Fonds du Musée d'Orsay, gift of Paul Gachet, Dec. 1960
(RF 31 260)

accordance with what seems to be the artist's usual method of notation, September 1872. Although these factors point to no definitive conclusion, certainly the closeness of this work to Cézanne's of the same time highlights yet again the community of effort between the two artists. However, from the compact arrangement of this composition, with its thickly applied, colorful paint, Guillaumin appears a quite different painter from his friend; the most interesting aspect of this somewhat awkward endeavor is

that it shows us what Guillaumin was doing in 1872[3] and provides a basis for comparison with works attributed to Cézanne.

AD

1. Courières 1924, p. 72.
2. Gachet 1953b, n.p.; Gachet Unpub. Cat., IV, P.G. 30.
3. Since its publication by Chatelet (in Paris 1954–55, no. 69), this painting has been included in Guillaumin's oeuvre: see Serret and Fabiani 1971, no. 14; Gray 1972, no. 32.

Armand Guillaumin (1841–1927)

29 *Reclining Nude*

Ca. 1872–77
Oil on canvas, 19¼ x 25⅝ in. (49 x 65 cm)
Signed lower right: A Guillaumin [A and G interlaced]
Musée d'Orsay, Paris
Gift of Paul Gachet, 1951 (RF 1951-35)
P.G. IV-5

This type of subject is often represented in Impressionist works of the early 1870s (note the fan here, a touch of Japonism) but is rare in Guillaumin's oeuvre. The painting has been dated between 1872 and 1877,[1] a time frame based both on stylistic analysis and on the supposition that the picture was shown at the third Impressionist exhibition of 1877, since the catalogue of that show contains an entry for a work by Guillaumin called *Reclining Woman;* that the two are identical is, however, impossible to confirm.[2] What motivated Paul Gachet *fils* to donate this picture to the French national museums was the fact that, like Guillaumin's *Self-Portrait* (cat. no. 25), it had attracted the attention of Vincent van Gogh when he visited Dr. Gachet in 1890. "Gachet has a Guillaumin," Vincent wrote to his brother Theo, "a nude woman on a bed, that I think very fine."[3] There is an anecdote that has long been associated with the work and was related by, among others, Gustave Coquiot and Dr. Victor Doiteau, who both paid lengthy visits to the younger Gachet in the early 1920s:[4] Calling on Dr. Gachet one day, Vincent van Gogh is said to have

been irritated that this painting which he so admired was without a frame; in a fit of rage, he reached into his pocket as if for a pistol to threaten the doctor. Gachet remained calm and stared him down, and the artist finally left. Whether real or apocryphal, the incident contributes little to an understanding of this picture or of Van Gogh, but the story is too well known to leave unmentioned.

AD

1. Courières 1924, p. 72, *Femme demi-nue couchée,* ca. 1872, in the Paul Gachet collection. Gachet *fils,* who titled it *Nu couché à l'écran japonais,* dated it early in the painter's oeuvre: Gachet Unpub. Cat., IV, P.G. 5. See also Serret and Fabiani 1971, no. 51, ca. 1877; Gray 1972, no. 49, ca. 1876. A pastel that seems to be a sketchy study for this picture and bears the date 1873 recently appeared twice at public auction (Hôtel Drouot, Paris, Oct. 26, 1976, no. 43, and Nov. 22, 1996, no. 26).
2. Berson (1996, vol. 2, p. 74) cites Jacqueline Derbanne and points out that there are no references to the painting in the reviews. There was no inscription on the original makeshift stretcher or on the original canvas.
3. LT 638; see Excerpts from the Correspondence, June 3, 1890.
4. Coquiot 1923, pp. 256–57; Doiteau 1923–24 (Dec. 1923), pp. 278–79.

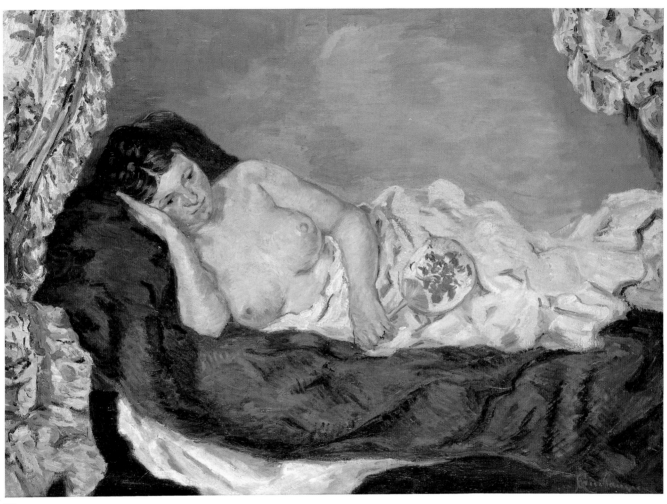

29

ARMAND GUILLAUMIN (1841–1927)

30 *Sunset at Ivry*

Ca. 1872–73
Oil on canvas, 25⅝ x 31⅞ in. (65 x 81 cm)
Signed lower left: A. Guillaumin [A and G interlaced]
Musée d'Orsay, Paris
Gift of Paul Gachet, 1951 (RF 1951-34)
P.G. IV-16

Remarkable for its starkly contrasting, heightened colors as well as for the originality and modernity of its subject, this painting was almost certainly lent by Dr. Gachet to the first Impressionist exhibition, in 1874,[1] from which it draws its justly merited fame.[2] Although the picture does not seem to have been discussed in any reviews at the time, it is the only Guillaumin in the Gachet collection that fits the title given in the exhibition catalogue. Contemporaneous critical reviews rule out the theory some authors have advanced that the picture appeared again in the eighth Impressionist exhibition, in 1886, under the title *Sunset*.[3] The painting bears no date, but, for stylistic reasons and because artists generally submitted recent works, we place it about 1872–73.[4] Christopher Gray's proposal[5] that it be dated about 1869 on the strength of a sketch with a similar subject so dated (Musée du Petit Palais, Paris, inv. D 1390) cannot reasonably be upheld: that is too early for a painting with a flavor so decidedly Impressionist.

In arranging to have his name printed with those of Cézanne (see cat. no. 1) and Guillaumin in the catalogue of the first Impressionist exhibition, Dr. Gachet made known not only his friendship with his protégés but also his commitment to them as an independent collector. In choosing to donate this painting, Paul Gachet *fils* sought to underscore the role played by his father in the avant-garde controversies of his day. Blanche Derousse, who at the doctor's request executed a watercolor copy of this painting in 1901 (cat. no. 30a),[6] referred to it as *The Seine at Charenton*, indicating that she, or her informant, was unaware of the title given in the 1874 catalogue.

AD

Blanche Derousse
30a Copy after Guillaumin, *Sunset at Ivry*, 1901
Watercolor, 9¼ x 12⅛ in. (23.5 x 30.7 cm)
Musée du Louvre, Paris, Département des Arts Graphiques, Fonds du Musée d'Orsay (RF 31 242)

1. Paris 1874, no. 66: *Soleil couchant à Ivry, appartenant au Dr Gachet.* A label on the back written in calligraphy by Paul Gachet *fils* recalls this fact, which is also mentioned by Chatelet in Paris 1954–55, no. 71.

2. Gachet Unpub. Cat., IV, P.G. 16. Gachet *fils* seems to have lent it only once under his name, to the exhibition "Guillaumin" (Paris 1937a, no. 4), where the fact that it was the picture exhibited in 1874 is mentioned .

3. Berson 1996, vol. 1, pp. 428, 454, and vol. 2, p. 8, quoting Jacqueline Derbanne.

4. See especially Serret and Fabiani 1971, no. 20.

5. Gray 1972, no. 12.

6. Signed at lower right: B. D. Annotated on the back in blue pencil, in the artist's hand(?): La Seine à Charenton. Tableau de Guillaumin / Février 01. Annotated in pencil, by Paul Gachet *fils*(?): La Seine à Charenton aquarelle de Blanche Derousse d'après Guillaumin.

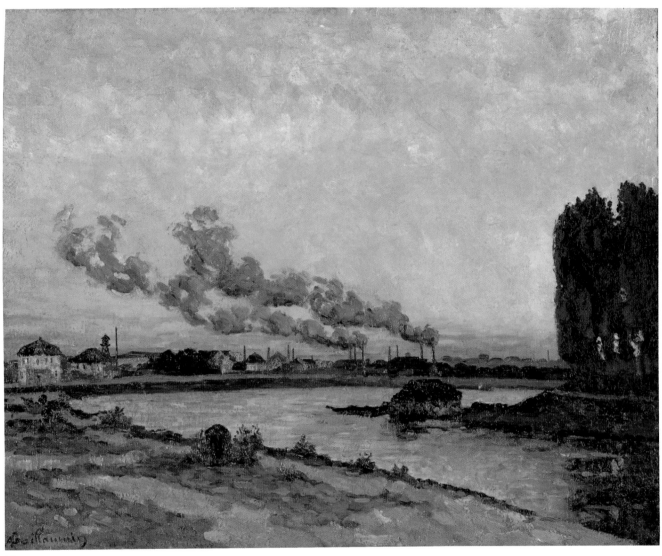

30

Armand Guillaumin (1841–1927)

Prints

Guillaumin's graphic works have only recently been cata-
logued.[1] Thanks to Paul Gachet *fils*,[2] the artist's first
efforts in the etching medium, made during the early
1870s, remain indissociable from those of his friend and
collector Dr. Gachet, and have not fallen into oblivion.
The doctor introduced the young painter to Richard
Lesclide, who as early as 1873 used some of Guillaumin's
etched vignettes for *Paris à l'eau-forte*, a magazine that
also published Gachet's own prints. One of Guillaumin's
works, *The Sunken Road, the Hautes-Bruyères* (cat. no. 31),
carries a dedication to Dr. Gachet in the plate and serves
as a fitting symbol for their association. The title refers to
a site in the Bièvres Valley, south of Paris; the younger
Gachet regarded his father's earliest plate, *The Hautes-
Bruyères*, as its companion piece and assigned the same
date, 1872, to both prints. Actually, the scene is so vague
that this claim is very difficult to confirm, and Guillau-
min's composition seems closer to the picture said to have
been painted in Arcueil in 1869—also in the Gachet col-
lection (cat. no. 26)—than to the tree-lined road depicted
by the doctor. Guillaumin's plate, as Gachet *fils* noted, is
marked at upper left with his emblem, a cat in profile.
His fellow printmakers at Auvers each had an emblem:
Gachet, a duck; Pissarro, a flower. Cézanne signed his
portrait of Guillaumin with the image of a hanged man,
which provided the name for this technically and graphi-
cally mediocre work (cat. no. 10e). Considered side by
side, the prints by Paul van Ryssel (Dr. Gachet), Cézanne,
and Guillaumin present clear affinities, and their respec-
tive attributions rely to a great extent on the younger
Gachet's documentation. The importance of the Auvers
group may seem exaggerated today, but the beginner's
enthusiasm of Dr. Gachet surely encouraged Guillaumin's
production of spontaneous and "modern" images, techni-
cally unpolished but direct.

AD

1. Kraemer 1997.
2. Gachet 1952; Gachet 1954a, pp. 13–21; see also Gachet 1957a,
 pp. 65–67, where he published a letter from Guillaumin to Dr. Gachet
 dated Sept. 6, 1873, which mentions prints being made by both men.

31 *The Sunken Road, the Hautes-Bruyères*

1872 or 1873
Etching, 5 x 3⅝ in. (12.7 x 9.3 cm)
Dedication lower right, in the copperplate: Au Docteeur [*sic*]
Gachet; dedication handwritten by Paul Gachet *fils:* à M. J. Lieure /
Souvenirs et remerciements / Sympathiquement / Paul Gachet
Bibliothèque Nationale de France, Paris, Département des Estampes
et de la Photographie

ATTRIBUTED TO CONSTANTIN GUYS (1802–1892)

32 *In the Street*

Ca. 1860?
Oil on canvas, 9½ x 12¾ in. (24 x 32.5 cm)
Musée d'Orsay, Paris
Gift of Paul Gachet, 1954 (RF 1954-17)
P.G. I-22

This small picture, formerly accepted as a work by Constantin Guys and now attributed to him, was given to the French national museums by Paul Gachet *fils* at a time when there were no other known oil paintings by this artist, who is noted for his watercolors and wash drawings. The canvas was executed, according to the younger Gachet, at the prompting of Manet, to whom it belonged until it was given to Dr. Gachet.[1] This information, however, remains unsubstantiated and was mentioned with caution in museum catalogues even during the younger Gachet's lifetime.[2] The present state of scholarship on this artist, who was once admired by Baudelaire and called "the painter of modernity" but is now out of favor and little shown, provides no further clues. The atypical character of this sketch, which displays a cursive style common to many painters of the mid-1800s, does not permit its attribution to any other known artist.

AD

1. Chatelet in Paris 1954–55, no. 73, ill. pl. II.
2. Sterling and Adhémar 1958–61, no. 1046.

32

Claude Monet (1840–1926)

33 Chrysanthemums

1878
Oil on canvas, 21½ x 25⅝ in. (54.5 x 65 cm)
Signed lower left: Claude Monet. Dated lower right: 1878
Musée d'Orsay, Paris
Gift of Paul Gachet, 1951 (RF 1951-36)
P.G. I-14

In publishing the letters written by Claude Monet to Dr. Gachet and to his friend the painter and collector Eugène Murer, the younger Gachet[1] helped to elucidate the relationship between Monet and his sponsors: on one side, the artist, hard-pressed, knowing how to apply pressure to secure a loan or the purchase of a work, then becoming more financially demanding as soon as the emergency had passed; on the other side, the collector—Dr. Gachet, introduced to Monet by his friend Murer, to whom Monet was beholden—readily disbursing funds while nursing the hope of acquiring a fine picture at a discount. After Gachet acquired this glorious still life from Monet in December 1878—let go, in order to repay a debt, at the bargain price of 50 to 100 francs (far less than was usually charged by the art dealer Durand-Ruel, who never went below 200 francs)—the result was clearly a falling-out. The still lifes that Monet painted and exhibited at this time were certainly meant, judging from their inoffensive subject matter, to reach a wide audience. Dr. Gachet chose an especially decorative work with an original composition, flat and friezelike—floral motifs and an Oriental vase intermingle with the patterns of the wallpaper and tablecloth—and splendid in its effects of color and texture.[2] Though often asked, Gachet *fils* consistently refused to sell this work or even to exhibit it. Yet despite the fact that Monet and Dr. Gachet had had only a distant relationship (which seems to have ended with this transaction),[3] the son made a point of including the still life in his first gift to the French national museums, to commemorate that connection.

AD

1. Gachet 1957a, pp. 113–20, 161–63.
2. Wildenstein 1974, no. 492.
3. Gachet 1956a, pp. 11, 77.

33

Francisco Oller y Cestero (1833–1917)

34 *The Student*

Ca. 1865 or 1874?
Oil on canvas, 25⅝ x 21⅜ in. (65.2 x 54.2 cm)
Signed lower left: F. Oller
Musée d'Orsay, Paris
Gift of Paul Gachet, 1951 (RF 1951-41)
P.G. I-25

Francisco Oller, a native of Puerto Rico, studied art in Madrid and Paris, where he lived for prolonged periods, specifically 1858–65, in 1874, and 1895–96. He had many contacts within French artistic circles, notably Cézanne and Pissarro.[1] It was probably through these two artists that Dr. Gachet came into possession of one of his works, which are rare in France. Paul Gachet *fils* identified the subject of this painting—a young bearded man absorbed in his reading, with his hand casually resting on a human skull—as the future Dr. Aguiar, a friend of his father: "[This] amateur Cuban painter . . . qualified as a doctor in 1884 and practiced at Saint-Germain-des-Fossés (Allier) about 1890."[2] Nothing more is known of Dr. Aguiar except that he is mentioned in connection with Oller in Cézanne's and Pissarro's letters and that in 1875 he painted a landscape, *Houses at Auvers,* which also belongs to the Musée d'Orsay.[3] These Caribbean connections at Auvers-sur-Oise seem plausibly to explain how Dr. Gachet came into possession of one of Oller's works. This engaging genre painter studied with Federico Madrazo and Thomas Couture, admired Courbet, and most likely was strongly influenced by literary naturalism; he stood at the fringes of Impressionism, like such painters as Alfred-Émile Stevens and Giuseppe de Nittis, also expatriates established in France and friends of the Impressionists. A number of authors, ignoring the younger Gachet's account, have considered identifying the sitter for this painting as some other friend of Oller, Pissarro or Francisco Mejia (a Puerto Rican student), if not as the artist himself.[4] The picture most likely represents a Parisian interior, which would suggest a date either about 1865, at the end of the artist's first stay in Paris, or about 1874.

AD

1. Cézanne Letters 1978, pp. 112–13, 246–47; Pissarro Letters 1980–91, vol. 1, letter 36, and vol. 3, letters 1181, 1201, 1203; letters from Oller in Drouot 1975, no. 137 (4).
2. Chatelet in Paris 1954–55, no. 82. See also Gachet Unpub. Cat., I, P.G. 25, a reference used in Monneret 1978–81, vol. 1, p. 35, and vol. 2, pp. 108–9.
3. With the dedication: à mon ami Martinez Aguiar 1875. Along with another work by Aguiar and one by Oller, it was donated to the French national museums in 1953 by R. J. Martinez (sometimes called Dr. Martinez), a Cuban and the son of the Martinez named in the dedication. The younger Martinez remembered having been taken care of in his childhood by Dr. Aguiar, who he thought was Puerto Rican (letter from R. J. Martinez to Michel Florisoone, Feb. 9, 1952, Archives, Musée d'Orsay, Paris). Also among Dr. Gachet's friends was Havana-born Nicolas Martinez Valdivielso, a man of private means and an amateur printmaker who lived at Auvers and who must have also been a friend of Aguiar.
4. Haydee Venegas in Ponce 1983, no. 10.

34

Camille Pissarro (1830–1903)

35 *The Ferry at La Varenne-Saint-Hilaire*

1864
Oil on canvas, 10⅝ x 16⅛ in. (27 x 41 cm)
Signed and dated lower right: C. Pissarro 64
Musée d'Orsay, Paris
Gift of Paul Gachet, 1951 (RF 1951-38)
P.G. I-2

This small, precisely dated painting of a very specific location is a prelude to the more ambitious compositions Pissarro later exhibited at the official salons during the 1860s. When his son Ludovic-Rodo Pissarro, in collaboration with Lionello Venturi, compiled the first catalogue of his work in 1939, Paul Gachet *fils* refused to provide a reproduction of this picture (among others), even though he had contributed a photograph of another study that could be considered its companion piece.[1] That may explain why this rather dark but dynamic composition was reproduced in full color when it entered the French national collections.[2] Since then it has been cited regularly in the literature on Pissarro's work. AD

1. Pissarro and Venturi 1939, no. 36, accurately described but not reproduced and with no indication of location. The companion piece is no. 40 in the same volume, described as in the Gachet collection and with photo credit to Paul Gachet (see entry for P.G. I-1 in the Summary Catalogue). Gachet Unpub. Cat., I, P.G. 2 (*Le bac de la Varenne*), without date of acquisition or further information.
2. Florisoone 1952, n.p. [p. 27], pl. IV.

36

CAMILLE PISSARRO (1830–1903)

36 *Chestnut Trees at Louveciennes*

Winter 1871–72
Oil on canvas, 16⅛ x 21¼ in. (41 x 54 cm)
Signed lower right: C. Pissarro
Musée d'Orsay, Paris
Gift of Paul Gachet, 1954 (RF 1954-18)
P.G. I-7

Before it was donated to the French national museums, this painting had never been reproduced or exhibited;[1] it was already celebrated, however, because Vincent van Gogh admired it during his first visit to Dr. Gachet at Auvers. "He has a *very* fine Pissarro, winter with a red house in the snow," Vincent wrote to his brother Theo.[2] Gachet *fils* reported that, according to Lucien Pissarro,

"the red house was located near the Pissarros' home [in Louveciennes]. It belonged to an old person, retired and enigmatic, who lived alone, isolated, mysterious."[3] Since it appears to be well established that the scene was painted at Louveciennes, logic dictates that this undated work was produced during either the winter of 1869–70 or that of 1871–72, years when the Pissarro family resided there. For

stylistic reasons the later dating, which is supported by Pissarro and Venturi in their catalogue of Pissarro's work as well as by Gachet, seems the more plausible.[4]

Rather exceptionally, this work, painted on coarse canvas, has never been relined and remains on its original makeshift stretcher. To give it a suitable frame, it seems that another painting in Dr. Gachet's collection was divested of its own, for the back of this frame carries the inscription: P. van Ryssel No. 2 Le Cochon. No doubt written by the doctor, these words probably refer to a now-lost picture exhibited by Dr. Gachet, under his pseudonym "Paul van Ryssel," at the Salon des Indépendants in 1906. AD

1. Pissarro and Venturi (1939, no. 146) give an exact description but no reproduction or location. See Chatelet in Paris 1954–55, no. 86, ill. pl. X.
2. LT 635; see Excerpts from the Correspondence, May 20, 1890.
3. Gachet Unpub. Cat., I, P.G. 7. For this motif, see also Marley-le-Roi, Louveciennes 1984, p. 92, where the site is identified as the rue du Parc de Marly.
4. See Pissarro and Venturi 1939, no. 146. Cooper (1955, p. 104), seems to be of the same opinion, questioning the date of 1870 advanced by Chatelet in Paris 1954–55, no. 86.

CAMILLE PISSARRO (1830–1903)

37 *Road at Louveciennes*

1872
Oil on canvas, 23⅝ x 28⅞ in. (60 x 73.5 cm)
Signed and dated lower left: C. Pissarro. 1872
Musée d'Orsay, Paris
Gift of Paul Gachet, 1951 (1951-37)
P.G. I-6

Jacques and Monique Lay recently identified the exact location of this scene as the Route de Versailles at Louveciennes, between the Grande-rue (today's rue du Général-Leclerc) and the Grille Royale (the Royal Gate).[1] Pissarro depicted the area several times starting in 1869, when he lived in Louveciennes, until the Franco-Prussian War of 1870 forced him to flee to the provinces and then to England. He returned briefly to Louveciennes in 1872 before settling in Pontoise, which brought him closer to Dr. Gachet, who had just bought his house in Auvers. This winter landscape is very likely among the last works he painted in Louveciennes.

Paul Gachet *fils* lent this picture, under his name, as owner, to the Pissarro exhibition organized by the French national museums in 1930 (possibly at the prompting of the artist's son, with whom he stayed in touch, or that of his friend Alfred Tabarant, who wrote the preface to the catalogue).[2] The painting was reproduced in Pissarro and Venturi's catalogue raisonné[3] and thus had already been published when it entered the French national collections.

AD

1. Marley-le-Roi, Louveciennes 1984, p. 84.
2. Paris 1930, no. 12; as documented by a label on the back.
3. Pissarro and Venturi 1939, no. 138 (reproduced, but without location). Gachet Unpub. Cat., I, P.G. 6; with no new information.

37

Camille Pissarro (1830–1903)
Prints

It was certainly not Dr. Gachet who suggested to Pissarro that he try his hand at printmaking: the painter had already executed several etchings during the 1860s, before ever meeting the doctor and amateur printmaker. Yet it is worth noting that two of Pissarro's early prints, both rare,[1] were given to Dr. Gachet, probably many years after their execution. These now belong to the Bibliothèque Nationale de France, thanks to a gift Paul Gachet *fils* made in February 1953. Without repeating the chronology of the two men's association, we can establish that where printmaking was concerned, Pissarro turned to Dr. Gachet to resolve problems pertaining to materials: "Please bring me a *large plate of copper*," he asked Dr. Gachet in a letter of October 30, 1873, and in late January 1889, "Would you please be so kind as to bring me the plates I left at your house. I would like to continue working on them."[2] Indeed, as Gachet *fils* pointed out, precisely three copper plates belonging to Pissarro—*Hills of Pontoise, The Oise at Pontoise,* and *Factory at Pontoise,* all datable to about 1873–74 and marked with the flower the artist had chosen as his printmaking emblem at the "Auvers studio"[3]—were found much later in the Gachet house and returned to Pissarro's heirs.[4] At one point Ludovic-Rodo Pissarro, the artist's son and cataloguer, drew up a list of nine etchings and three lithographs that he believed to be in the possession of the younger Gachet and asked him to confirm this.[5] Also remaining in Gachet's possession was another early work, the *Negress* of 1867, as well as the *Peasant Woman Feeding a Child* of 1874 (a meditation on the corresponding work by Millet, which must have interested Dr. Gachet, who had copied Millet himself; see cat. no. 46h) and the well-known portrait *Paul Cézanne*, dated 1874 on the plate.

AD

1. Delteil 1923, nos. 2, 5; Leymarie and Melot 1971, P2, P5.
2. Pissarro Letters 1980–91, vol. 1, letter 26, and vol. 2, letters 517, 518.
3. See Delteil 1923, nos. 7, 9, 10, and Gachet 1957a, p. 40 n. 1, where they are given more precise titles than in Delteil: *Dans la plaine d'Auvers, Péniche sur l'Oise au Pothuis,* and *L'Usine à Châlon.*
4. See Summary Catalogue, Pissarro prints, D10.
5. Archives, Wildenstein Institute, Paris; see also Delteil 1923, n. 1, nos. 2, 5, 6, 7, 9, 10, 12, 13, 126 (which Ludovic-Rodo Pissarro says he had recently given to Paul Gachet *fils*), 130, 134, 135; and Leymarie and Melot 1971, n. 1, pp. 2, 5, 6, 7, 9, 10, 12, 13, 127, 134, 138, 139.
6. See Summary Catalogue, Pissarro prints, D6, D12, D13.

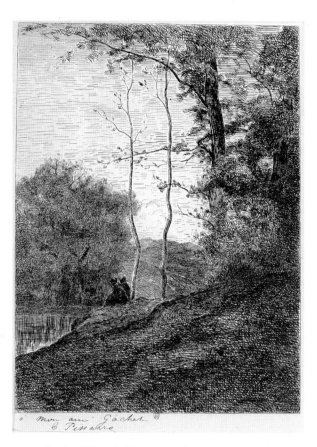

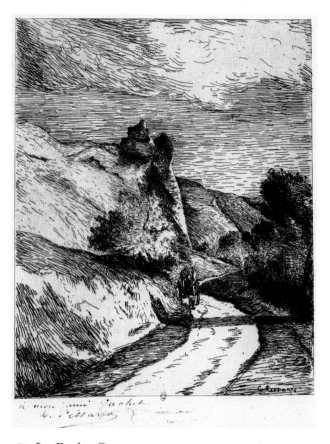

38a *At the Water's Edge*

Ca. 1863
Etching, single state, 11⅛ x 8⅜ in. (28.4 x 21.4 cm)
Inscribed lower left: à mon ami Gachet / C. Pissarro
Bibliothèque Nationale de France, Paris, Département des Estampes
et de la Photographie, gift of Paul Gachet, 1953. D 2

38b *La Roche-Guyon*

Ca. 1866
Etching, first state, 10⅝ x 8¾ in. (27.1 x 22.1 cm)
Inscribed lower left: à mon ami Gachet / C. Pissarro
Bibliothèque Nationale de France, Paris, Département des Estampes
et de la Photographie, gift of Paul Gachet, 1953. D 5

Auguste Renoir (1841–1919)

39 *Portrait of a Model*

Ca. 1878
Oil on canvas, 18⅛ x 15 in. (46 x 38 cm)
Signed upper left: Renoir
Musée d'Orsay, Paris
Gift of Paul Gachet, 1951 (RF 1951-39)
P.G. I-16

Renoir was well enough acquainted with Dr. Gachet in 1879 to ask him to make an urgent house call to an ailing young woman living on the rue Lafayette. An entire series of letters, published by Paul Gachet *fils*, chronicles the woman's illness up to her death, which Renoir announced to the doctor on February 25 of that year. The doctor's son was also in possession of a letter sent by Renoir to Eugène Murer on February 26 informing him of the death of "Margot."[1] Thus, following Renoir, who gave this sketch to Dr. Gachet as a token of thanks for his services, the younger Gachet referred to the sitter only as "Margot" and believed the likeness to be a portrait of the young woman who died, a traditional identification that has persisted.[2]

"Margot" was actually Henriette-Anna Leboeuf, who lived with her parents at 47, rue Lafayette, where she died at the age of twenty-three on February 18, 1879. Renoir called her "Mlle Leboeuf" in his first letter, but for the sake of discretion, Gachet *fils* published only the initial; and she has always been known by the first name given her by Renoir rather than by her real name.[3] Her great-grandson, Jean-Charles Leboeuf, who helped reconstruct these biographical facts, pointed out that the young blonde portrayed here bears little resemblance to Anna Leboeuf, who was a brunette. Her likeness is known from a copy, made at the turn of the century for her descendants, of a portrait of Anna by Renoir (the family sold the original, which is now in a private collection).[4] That picture has enabled us to recognize her features in many other works painted during this period, among them a painting exhibited at the 1878 Salon, *Le Café* (D 272; private collection). Of course, we also know that when not painting commissioned portraits, Renoir often freely interpreted the physical appearance of his models, as might be the case here. The style of this Gachet collection painting suggests that it was probably done no later than 1878. Blanche Derousse executed a watercolor copy of it in 1901 (cat. no. 39a).[5] AD

Blanche Derousse
39a Copy after Renoir, *"Portrait of a Model,"* 1901
Watercolor, 12⅝ x 9½ in. (32 x 24 cm)
Van Gogh Museum, Amsterdam, acquired in 1966
(D581 V/1966)

1. Gachet 1956a, p. 87; Gachet 1957a, pp. 81–85, 89–90. At the time of the painting's donation, this anecdote was told to André Malraux, who mentioned it in Malraux 1951.
2. Daulte 1971, no. 276: *Portrait de Margot;* sitter identified as Marguerite Legrand, another well-known model for Renoir (see also nos. 234–38).
3. Her birth certificate from Chenoise (Seine-et-Marne), dated January 11, 1856, gives her name as Alma; the birth certificate of her son, Georges-Jules, father's name not given, born on May 18, 1876, at 27, boulevard Rochechouart, identifies her as Henriette-Anna Leboeuf, seamstress, living at 29, rue Lepic.
4. Daulte 1971, no. 310.
5. Signed and dated lower right, in pencil: B.D. / 11 septembre 1901.

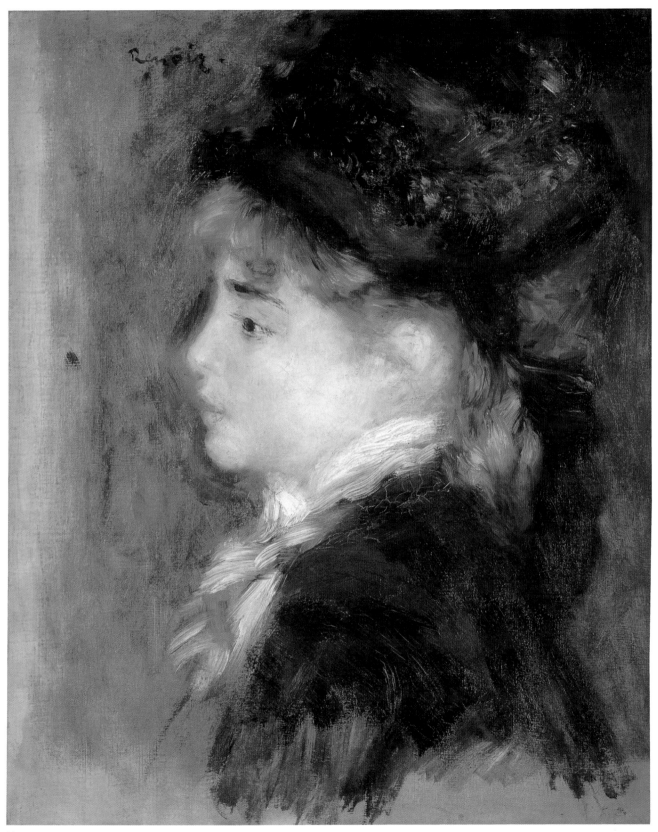

39

ALFRED SISLEY (1839–1899)

40 *View of Canal Saint-Martin*

1870
Oil on canvas, 19¾ x 25⅝ in. (50 x 65 cm)
Signed and dated lower right: Sisley 1870
Musée d'Orsay, Paris
Gift of Paul Gachet, 1951 (RF 1951-40)
P.G. I-18

The history of this picture is well established. We are fairly certain that it corresponds to the *Vue du canal Saint-Martin* that Sisley exhibited at the 1870 Salon (no. 2651), where it inspired no critical commentary, not even from "Blanche de Mézin," an alias used by Dr. Gachet in his pamphlet *Promenades en long et en large au Salon de 1870* (*Strolling To and Fro at the 1870 Salon*).[1] According to Paul Gachet *fils*, the painting was acquired by his father at an unknown date from Gandoin, a Paris art dealer and expert, for 170 francs.[2] In 1883, at Sisley's request, Pissarro wrote to Dr. Gachet asking him to lend it to the exhibi-

tion organized at Durand-Ruel's gallery that year.[3] This canal scene seems to be the only Sisley purchased by Dr. Gachet, who apparently did not maintain steady relations with the artist. The painting is still on its original stretcher and has not been relined; it is stamped on the back with the mark of Deforge and Carpentier, suppliers to the Impressionist artists in the period around 1870.

This depiction has been written about frequently since it entered the French national collections (where it became known to the public),[4] for it shows that Sisley turned at a very early date to "industrial" subject matter, a modern theme that interested the Impressionists. Marie-Thérèse Laureilhe, who is very familiar with the area, analyzed the composition using the only topographical feature identifiable today, the apse of the church of Saint-Joseph at left. Despite considerable changes to the location over time, she concluded that Sisley took some liberties with the site, probably to open up the view of the water in the foreground.[5] There is a watercolor copy of the painting signed by Louis van Ryssel (Paul Gachet *fils*) (cat. no. 40a).[6]

AD

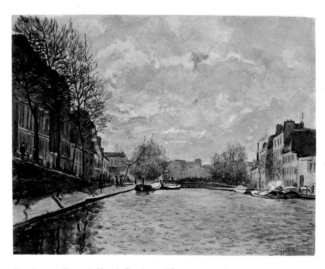

Louis van Ryssel (Paul Gachet *fils*)
40a Copy after Sisley, *View of Canal Saint-Martin*, 1901
Watercolor, 10⅝ x 13¾ in. (27 x 35 cm)
Musée du Louvre, Paris, Département des Arts Graphiques, Fonds du Musée d'Orsay, acquired from Paul Gachet, Dec. 1960 (RF 31 251)

1. Sisley also exhibited another painting, *Péniches sur le canal*, dated 1870 as well (Oskar Reinhart Foundation, Winterthur).
2. Located at 16, rue Saint-Georges, according to the Chamber of Commerce registry.
3. Gachet 1957a, pp. 37–38, n. 2. This work is not cited in the 1883 catalogue.
4. Daulte 1959, no. 16.
5. Written communication, Nov. 17, 1992; see also a recent photograph in Reidemeister 1963.
6. Inscribed on the back in ink, in the handwriting of Gachet *fils:* [illeg.] Der Canal Saint Martin [illeg.] Gemalde von Sysley (1870) / L. Van Ryssel 1901.

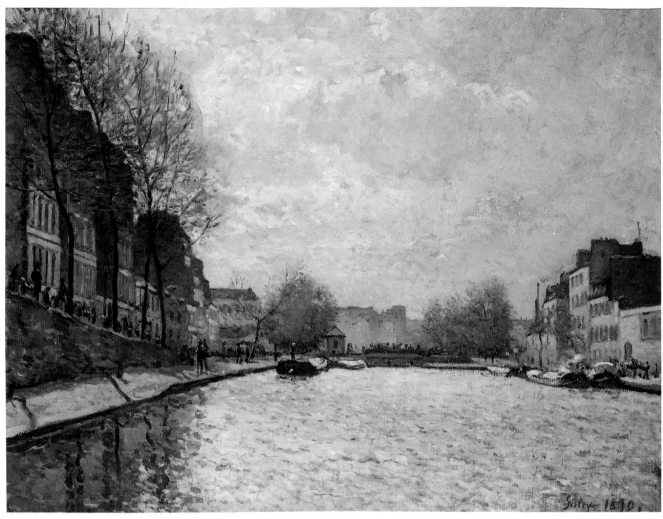

40

AMATEURS IN AUVERS

Paul van Ryssel
(Dr. Paul Gachet; 1828–1909)

41 *Vincent van Gogh on His Deathbed*

1890
Charcoal, 18⅞ x 16⅛ in. (48 x 41 cm)
Signed lower right with the monogram: PVR; annotated:
29 juillet 90 / V. Van Gogh
Musée du Louvre, Paris, Département des Arts Graphiques,
Fonds du Musée d'Orsay
Gift of Paul Gachet, 1951 (RF 29 928)

While still suffering from the emotional shock of Vincent
van Gogh's suicide, Dr. Gachet appears to have done a
quick charcoal sketch of the artist on his deathbed. There
are two known versions of this drawing: one that was ded-
icated to Theo, who immediately showed it to his mother,[1]
now at the Van Gogh Museum in Amsterdam (cat. no.
41a);[2] and this one, presented by Paul Gachet *fils* to the
French national museums. The regular woven pattern that
appears on its yellowed paper suggests that the drawing
was placed on a caned chair seat, possibly in the process of
fixing the charcoal. This version must be the drawing that
was shown at the Salon des Indépendants in 1891 as num-
ber 534, *Le Peintre Vincent van Gogh sur son lit de mort*,
charcoal after life, which the critic Eugène Tardieu repro-

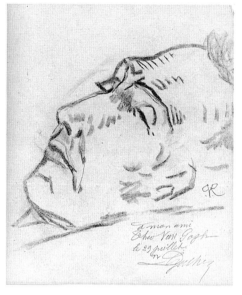

Paul van Ryssel (Dr. Paul Gachet)
41a *Vincent van Gogh on His Deathbed*, 1890
Charcoal, 10¾ x 9 in. (27.3 x 22.8 cm)
Van Gogh Museum, Amsterdam (D753 V/1962)

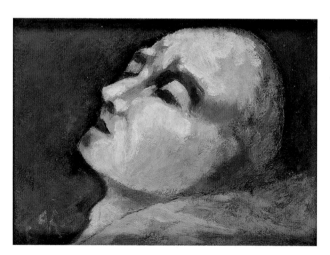

Paul van Ryssel (Dr. Paul Gachet)
41b *Vincent van Gogh on His Deathbed*, 1890
Oil on cardboard, 4⅜ x 6½ in. (11 x 16.5 cm)
Van Gogh Museum, Amsterdam (S362 V/1962)

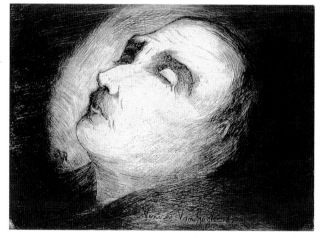

Paul van Ryssel (Dr. Paul Gachet)
41c *Vincent van Gogh on His Deathbed*, 1890
Etching, 4¾ x 6¾ in. (12.2 x 17 cm)
Musée du Louvre, Paris, Département des Peintures, Service de
Documentation, Étienne Moreau-Nélaton file

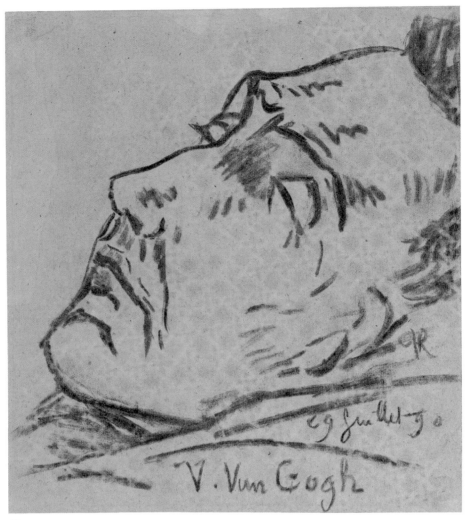

41

duced in a review of the exhibition published in the April 25, 1891, issue of the *Magazine illustré français*. Another, more elaborate charcoal drawing (private collection)[3] seems more closely linked to other works treating the same subject, a painting given to Johanna van Gogh in 1905 (cat. no. 41b)[4] and an etching of which nine states are known (cat. no. 41c).[5] First Dr. Gachet and then his son printed a large number of proofs of the etching, which they liberally distributed.[6]

AD

1. Letter, Theo van Gogh to Dr. Paul Gachet; see Excerpts from the Correspondence, August 12, 1890.

2. Signed lower right with the monogram: PVR. Inscribed: À mon Ami / Theo Van Gogh / le 29 juillet P. Gachet.

3. Dimensions: 12¼ x 10¼ in. (31 x 26 cm). Dated lower right: 23 juillet 1890. Inscribed on the back, in pencil: Vincent van Gogh 1890 / à son lit de mort.

4. Signed lower left with the monogram: PVR. Inscribed on the back: V. Van Gogh 29 juillet 1890—Le peintre V. Van Gogh à son lit de mort par P. Van Ryssel, offert à Mme Gosschalk [at that time the married name of Johanna van Gogh] par l'auteur P. Van Ryssel Auvers-sur-Oise, 12 juin 1905.

5. Signed on the plate with the monogram: PVR. Inscribed on the back: Juillet 1890 Le Peintre Vincent Van Gogh à son lit de mort d'après le dessin original de Van Ryssel. Stamped with the cat's-head emblem of the Gachets.

6. In 1873 Dr. Gachet had etched a deathbed portrait of his nephew André Gachet.

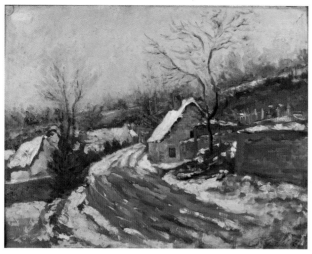

42

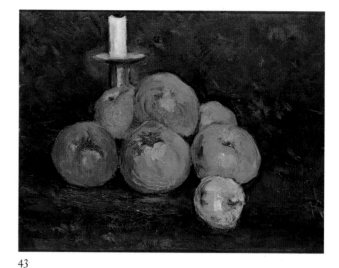

43

Paul van Ryssel
(Dr. Paul Gachet; 1828–1909)

42 The Old Road at Auvers-sur-Oise, Snow Effect

Ca. 1878–81
Oil on canvas, 15¾ x 21¼ in. (40 x 54 cm)
Signed and dated lower right: P. Gachet 81
Musée d'Orsay, Paris
Gift of Paul Gachet, 1954 (RF 1954-28)

Although this work is dated 1881 and was exhibited in
1882 at the Salon in Niort, Paul Gachet *fils* maintained
that his father painted it in 1878; we have no explanation
for the discrepancy.[1] The title referring to the countryside
around Auvers seems to have been applied to quite diverse
locales; there is, for example, a painting with the same
title but depicting a different site, at the Van Gogh
Museum, Amsterdam. Several pictures exhibited at the
Salon des Indépendants in 1891, 1892, and 1909 also car-
ried the title. Surely one of the best paintings by Dr.
Gachet, this work displays his modest gift, that of
an amateur heavily influenced by the Impressionists he
admired. While his subject is very much an Impressionist
one, the dull palette and a certain weakness of form sepa-
rate this effort from Gachet's models, works by Cézanne,
Guillaumin, and Pissarro. AD

Paul van Ryssel
(Dr. Paul Gachet; 1828–1909)

43 Apples

Oil on cardboard, 10⅝ x 13¾ in. (27 x 35 cm)
Signed lower right with the monogram: PVR
Musée d'Orsay, Paris
Acquired from Paul Gachet, 1958 (RF 1958-16)

This modest painting has been identified as the one
shown as number 4477 at the Salon des Indépendants of
1907, the next-to-last in which the artist participated.
According to a label on the back, it was also exhibited at
the Salon of the Société Artistique de Pontoise. It is
undated, and while logic suggests a late dating, the style is
too vague for it to be ascribed to any particular period of
Van Ryssel's hypothetical development. In fact, the paint-
ing's greatest interest is its provision of a basis for compar-
ing, and for making distinctions between, Gachet's works
and the works of his painter friends.

AD

1. Chatelet in Paris 1954–55, no. 100, pl. XXX.

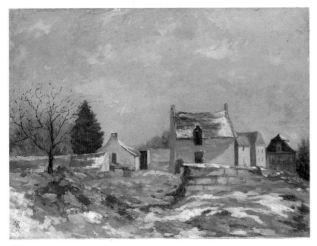

44

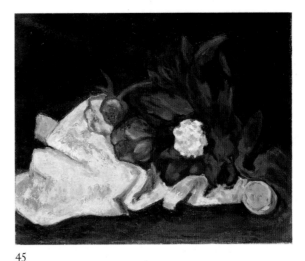

45

PAUL VAN RYSSEL
(DR. PAUL GACHET; 1828–1909)

44 Copy after Pissarro, *Study at Louveciennes, Snow*

1877
Oil on canvas, 15¾ x 21¼ in. (40 x 54 cm)
Signed with monogram and dated, lower left: PVR/I 77
Musée d'Orsay, Paris
Gift of Paul Gachet, 1958 (RF 1958-18)

The interesting thing about this copy of a painting by
Camille Pissarro entitled *Study at Louveciennes, Snow*
(1872)[1] is that it carries the date 1877, which, if accurate,
gives us an idea of Dr. Gachet's artistic ability at this
time. It also tells us that he had access to a painting by
Pissarro that he seems not to have owned. In a letter to
Dr. Gachet that from the context can be dated to late
October 1873, Pissarro writes that, since he has collectors
interested in a snowscape, he would like the doctor to
return to him—via Cézanne—the painting he had lent
him.[2] This message confirms that there was a lively
exchange of works between Dr. Gachet, Pissarro, and
Cézanne, who, incidentally, also copied a Pissarro, a copy
that ended up in the doctor's collection.[3]

AD

1. Pissarro and Venturi 1939, no. 132.
2. Pissarro Letters 1980–91, vol. 1, letter 25.
3. Rewald 1996, no. 184; and see Summary Catalogue, P.G. II-2.

PAUL VAN RYSSEL
(DR. PAUL GACHET; 1828–1909)

45 Copy after Cézanne, *Flowers and Fruits*

Oil on canvas, 15 x 18⅛ in. (38 x 46 cm)
Musée d'Orsay, Paris
Gift of Paul Gachet, 1958 (RF 1958-19)

This picture entered the French national collections
identified, according to a label on the back, as a copy of a
Cézanne painting of 1873. However, Cézanne's original,
formerly in the Gachet collection, had merely been men-
tioned by Lionello Venturi as one of the works owned
by Dr. Gachet; not until recently was it located and
reproduced.[1]

AD

1. Rewald 1996, no. 212 and vol. 1, p. 15; and see Summary Catalogue, P.G. II-9.

PAUL VAN RYSSEL (DR. PAUL GACHET; 1828–1909)
PRINTS

In 1954, shortly after Paul Gachet *fils* donated his father's prints to the Bibliothèque Nationale, he published a study that he had written in 1928, *Paul van Ryssel, le docteur Gachet graveur*. This booklet retraced the career of the amateur artist and his contacts with many different print-makers, some of them well known, including François Bonvin, Félix Bracquemond, Rodolphe Bresdin, Félix Buhot, Marcelin Desboutin, Léopold Flameng, Norbert Goeneutte, Henri Guérard, Charles Jacque, Édouard Manet, Charles Meryon, and Frédéric and Félix Regamey, as well as such graphic technicians as Auguste and Eugène Delâtre, Alphonse Leroy, and the Cuban artist (living at Auvers) Nicolas Martinez Valdivielso. Gachet *fils* concentrated on two subjects: the doctor's joint endeavors at Auvers with Cézanne, Guillaumin, and Pissarro in 1872–73 and the part he played in the genesis of Vincent van Gogh's unique etching in 1890 (see cat. nos. 10, 23, 31, 38).

Through this publication, the personal oeuvre of the doctor, which until then had been given only the briefest mention in his biographies, was drawn from the obscurity of attics in the rue du Faubourg-Saint-Denis in Paris and in the house at Auvers and brought into the light. A list of one hundred works considered to be finished (elsewhere the author claimed 103), constituting the graphic work of Dr. Gachet, was included. (The same list was used in organizing the two albums devoted to Paul van Ryssel in the Department of Prints at the Bibliothèque Nationale.) The selection we have made here should suffice to give the measure of the modest talent of this "Maître au canard," whose earliest prints are signed with the silhouette of a duck. These works—often associated with the publication of *Paris à l'eau-forte* by Dr. Gachet's friend, and beneficiary of his largesse, Richard Lesclide or with the convivial activities of the "Éclectiques" (see pp. 7, 9)— also attest to links with Cézanne, Pissarro, and Blanche Derousse as well as to his admiration for Millet and Monticelli, which Van Gogh shared.

AD

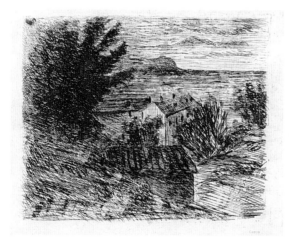

46a Copy after a drawing attributed to Cézanne, *L'Estaque*

Etching, 8⅜ x 10⅝ in. (21.2 x 27 cm)
Signed upper left with duck emblem and signed and dated lower right, in the plate: PVR / 1873
Bibliothèque Nationale de France, Paris, Département des Estampes et de la Photographie, gift of Paul Gachet, 1953 (DO 8775; PG 4 1873)

According to Paul Gachet *fils,* there were only two impressions of this print. For the drawing attributed to Cézanne, see Summary Catalogue, P.G. II-31.

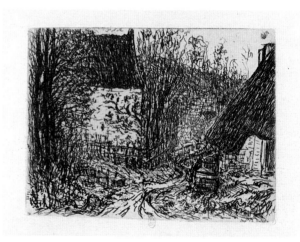

46b *Sunken Path at Auvers, House of the Hanged Man*

Etching, first and second states, 4⅛ x 5½ in. (10.5 x 14 cm)
Signed upper right with duck emblem and at top, in the plate: PVR.
Faintly annotated on the back: 1872 [or 1873]
Bibliothèque Nationale de France, Paris, Département des Estampes et de la Photographie, gift of Paul Gachet, 1953 (DO 8775; PG 9 1873)

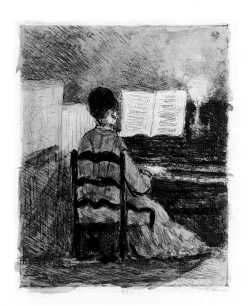

46c *Madame Gachet at the Piano*

Etching, first state, colored, 6⅞ x 5½ in. (17.5 x 14 cm)
Signed upper right with duck emblem and signed and dated upper left, in the plate: P. V. Ryssel / ıbre 1873
Bibliothèque Nationale de France, Paris, Département des Estampes et de la Photographie, gift of Paul Gachet, 1953 (DO 8775; PG 8 1873)

46e *Old Community House at Auvers,* also called *View of Auvers-sur-Oise*

Etching, 4⅜ x 5⅞ in. (11 x 15 cm)
Signed upper left with duck emblem and lower left, in the plate: PVR
Bibliothèque Nationale de France, Paris, Département des Estampes et de la Photographie, gift of Paul Gachet, 1953 (DO 8775; PG 12 1873)

46d Copy after Pissarro, *Saint Stephen's Church by Moonlight*

Etching, one of four subjects on one plate, 9⅛ x 10⅝ in. (23.3 x 27 cm)
Signed with duck emblem and signed and dated, in the plate: P. Van Ryssel 1873
Bibliothèque Nationale de France, Paris, Département des Estampes et de la Photographie, gift of Paul Gachet, 1953 (DO 8775; PG 11 1873)

46f *Murer's Walnut Tree, Old Road at Auvers*

Etching, 3¾ x 5⅛ in. (9.5 x 13 cm)
Signed upper left with duck emblem and upper right, in the plate: PVR. Annotated in ink: P. Gachet; marked with Moreau-Nélaton's collection stamp
Musée du Louvre, Paris, Département des Peintures, Service de Documentation, bequest of Étienne Moreau-Nélaton, 1927 (PG 15 1874)

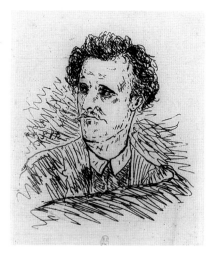

46g *Portrait of Doctor Gachet*

Etching, second state, 5¼ x 4⅜ in. (13.5 x 11 cm)
Bibliothèque Nationale de France, Paris, Département des Estampes
et de la Photographie, gift of Paul Gachet, 1953 (DO 8775; PG 20
1874)

According to Paul Gachet *fils*, this work was done after a
photograph by Alphonse Leroy.

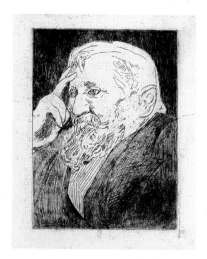

46i *Portrait of Ernest Hoschedé*

Etching, first state, 4¼ x 5 in. (10.7 x 12.7 cm)
Bibliothèque Nationale de France, Paris, Département des Estampes
et de la Photographie, gift of Paul Gachet, 1953 (DO 8775; PG 54
1890)
See fig. 8 and, on Hoschedé, p. 8.

46h Copy after Millet, *Woman Weaving*

Etching, 5¼ x 3 in. (13.5 x 7.5 cm)
Signed and dated lower right, in the plate: PVR/75. Annotated:
J. F. Millet
Bibliothèque Nationale de France, Paris, Département des Estampes
et de la Photographie, gift of Paul Gachet, 1953 (DO 8775; PG 29
1875)
(Published in *Paris à l'eau-forte*, March 7, 1875)

46j *All Saints' Day*

Etching, 4½ x 3⅜ in.(11.5 x 8.5 cm)
Dated at bottom, in the plate: 3 novembre 1890. Annotated in pencil
in the handwriting of Paul Gachet *fils:* 3 novembre 1890
Bibliothèque Nationale de France, Paris, Département des Estampes
et de la Photographie, gift of Paul Gachet, 1953 (DO 8775; PG 56 1890)

This work is an allegory of the Feast of the Dead in the year of Van
Gogh's death. There exists a proof of it in faded green (recalling the
trial proofs in color of *The Man with a Pipe* by Van Gogh, cat. no. 23b).

46k *Monticelli Pictor*

Etching, first state with text, 9 x 5⅞ in. (23 x 15 cm)
Bibliothèque Nationale de France, Paris, Département des
Estampes et de la Photographie, gift of Paul Gachet, 1953
(DO 8775; PG 62 1892)

46m *Sukrop (Blanche Derousse), Head and Shoulders, in Right Profile*

Two-color etching, 5½ x 4⅜ in. (14 x 11 cm)
Signed and dated lower right: PVR / 98
Bibliothèque Nationale de France, Paris, Département des Estampes
et de la Photographie, gift of Paul Gachet, 1953 (DO 8775; PG 88 1898)

On Blanche Derousse (1873–1911), see cat. no. 53.

46l *Windmill at Haarlem*

Etching, 4⅞ x 4 in. (12.5 x 10 cm)
Annotated in ink: Moulin du Nord / Dessin et eau-forte de / Van
Ryssel / Tirage de l'auteur
Musée du Louvre, Paris, Département des Peintures, Service de
Documentation, bequest of Étienne Moreau-Nélaton, 1927
(PG 71 1895)

46n *Sukrop (Blanche Derousse), Head Resting on Her Hand*

Etching, two states, 7⅛ x 5¾ in. (18 x 14.5 cm)
Signed and dated lower left: 1901 PVR
Bibliothèque Nationale de France, Paris, Département des Estampes
et de la Photographie, gift of Paul Gachet, 1953 (DO46l 8775; PG 95
1901)

Louis van Ryssel (Paul Gachet *fils*; 1873–1962)

47 *Medallion of Vincent van Gogh*

1904 (cast 1905)
Bronze, diam. 15¾ in. (40 cm)
Signed: L. Van Ryssel. Inscribed: VAN GOGH 1853–1890
Musée d'Orsay, Paris
Gift of Paul Gachet, 1951 (RF 3464)

In addition to making copies (see cat. nos. 5a, 6a, 8a, 8b, 9a, 26a, 28a, 40a), Paul Gachet *fils* tried, under the name Louis van Ryssel, to establish an independent career for himself as a painter, sculptor, and printmaker. On the back of a photographic reproduction of this medallion, the artist penned the following note: "Louis van Ryssel, *Vincent Van Gogh* (1853–1890). Phot. of the (unique) bronze cast. Modeled at Auvers in 1904; cast in Paris by Aubert and Fallachon, January 28, 1905; Salon des Artistes Indépendants, Paris, March 24–April 30, 1905, no. 4109, *Homage to My Master: Sculpture;* "Sint Lucas," Amsterdam, Salon, May–June 1905; "Secession," Munich, May 1907, no. 176, *Vincent Van Gogh—Bronze Relief. Rejected!* [underlined twice], Auvers-Paris. Given to the Musée d'Art Moderne, November 1952 [corrected to 1951]."[1]

A letter to Theo van Gogh's widow, Jo, from Gachet *fils* confirms the significance of this work for him: "I will be happy to learn that you have seen my bronze and that you are satisfied with it; I have already received numerous congratulations on the manner of its treatment, and this has deeply gratified me."[2] In a note added to another letter to Jo, he indicates that the medallion was "intended for the monument to be erected on Vincent van Gogh's grave at Auvers-sur-Oise, France (project of Dr. Gachet)."[3] Indeed, that is how it is listed in the supplement to the catalogue of the Van Gogh exhibition held at the Stedelijk Museum, Amsterdam, in July–August 1905[4]—a reference that the younger Gachet omitted in his notation. That the bronze was shown at the "Sint Lucas" exhibition is confirmed by a label on its back. The planned monument was never executed. In 1906, according to another letter to Jo,[5] Gachet sent the plaster model for the medallion to Van Gogh's nephew in Amsterdam, but no trace of it has been found.

AD

47

1. Communicated by Michael Pakenham.
2. May 11, 1905; Archives, Van Gogh Museum, Amsterdam (b3363 V/1984).
3. Van Gogh Museum, Amsterdam (b3374 V/1984).
4. *Portretten Vincent van Gogh* ref. *d;* see Amsterdam 1905.
5. June 17, 1906; Archives, Van Gogh Museum, Amsterdam (b3381 V/1984).

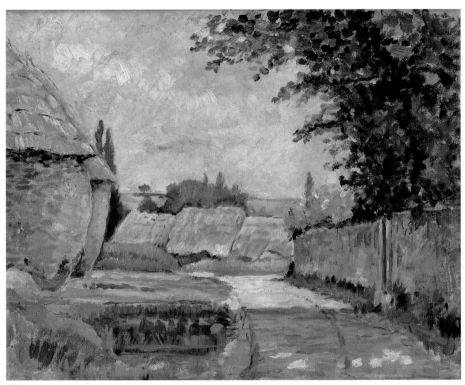

48

Louis van Ryssel (Paul Gachet *fils*; 1873–1962)

48 *Auvers, from the Spot Where Vincent Committed Suicide*

1904
Oil on canvas, 10¼ x 13¼ in. (26 x 33.5 cm)
On the reverse, label inscribed by the artist, in calligraphy: L. Van Ryssel. / Auvers. 1904. / De l'endroit où Vincent s'est suicidé.
Musée Tavet-Delacour (Musée Camille Pissarro), Pontoise
Anonymous gift, 1974 (P. 1976-1-1)

The title of this study testifies to the documentary quest to which Paul Gachet *fils* unceasingly devoted himself. The exact spot at which Vincent van Gogh's suicide took place has never been established with certainty, and is in any case of little importance. However, the Gachets, beset from all sides by curiosity seekers, and justly considering themselves privileged witnesses, went out of their way to provide material evidence in what today seems a futile exercise.

AD

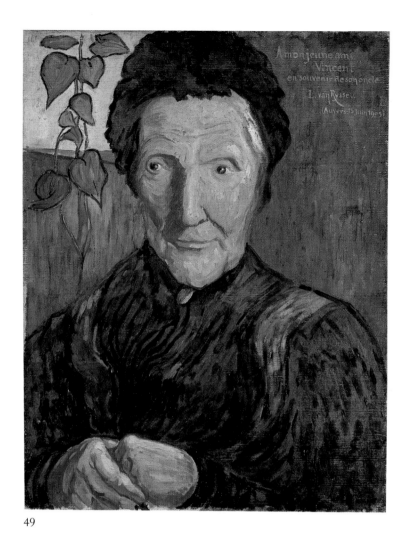

49

Louis van Ryssel (Paul Gachet *fils*; 1873–1962)

49 *Portrait of Vincent van Gogh's Mother*

1905
Oil on canvas, 21⅝ x 16⅞ in. (55 x 43 cm)
Signed, dated, and dedicated at upper right: A mon jeune ami
Vincent en souvenir de son oncle L. Van Ryssel (Auvers 13 juin
1905)
Van Gogh Museum, Amsterdam (S376 V/1982)

To my young friend Vincent, in memory of his uncle. I
made this portrait from the photograph you sent me,
and although it may not be a good likeness, it is, I
believe, very original. I painted it in Vincent's favorite
colors, yellow and blue, in remembrance of him and in
memory of your visit to Auvers. I take the liberty of
giving it to your son and, with your and Mme Van
Gogh's permission, ask that you make a little room for
it next to my medallion of Vincent.[1]

Thus did Paul Gachet *fils* write in early July 1905 to Jo van
Gogh, Theo's widow and mother of young Vincent, the
artist's nephew.

Gachet *fils* wanted the portrait to be exhibited along-
side Van Gogh's works in the retrospective exhibition
devoted to the artist that was held at the Stedelijk
Museum, Amsterdam, in July–August 1905. However, his
wish does not seem to have been honored, although the
exhibition did include the medallion he made (cat. no. 47).
We see here an example of the painting style used by
the younger Gachet when he was trying to approximate
Van Gogh's approach. AD

1. Archives, Van Gogh Museum, Amsterdam (b3374 V/1984).

Louis van Ryssel
(Paul Gachet *fils*; 1873–1962)

50 *Bouquet of Roses*

1907
Oil on canvas, 13¾ x 10⅝ in. (35 x 27 cm)
Signed and dated lower right: L. Van Ryssel 1907
Van Gogh Museum, Amsterdam (S286 V/1963)

From May 1 to 20, 1908, Louis van Ryssel held an exhibition at 39, rue Victor-Massé. On this occasion Betsy Bonger, sister of Theo van Gogh's widow, Jo, and a friend of hers passing through Paris, Mme Seelig, each selected a painting by the artist; as a family friend, he invited them to set the price.[1] A label on the back indicates that this work belonged to Betsy Bonger. That explains why this still life demonstrating the modest talent of Louis van Ryssel can be found in the collections of the Van Gogh Museum.

AD

1. Letter from Paul Gachet *fils* to Jo van Gogh, Archives, Van Gogh Museum, Amsterdam (b3390 V/1984); and Jo's reply dated June 2, 1908 (b2145 V/1982).

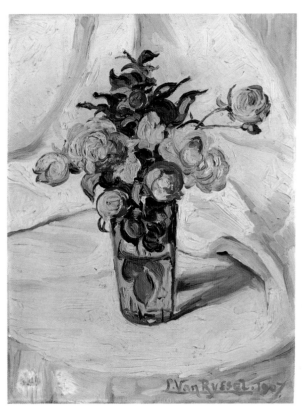

50

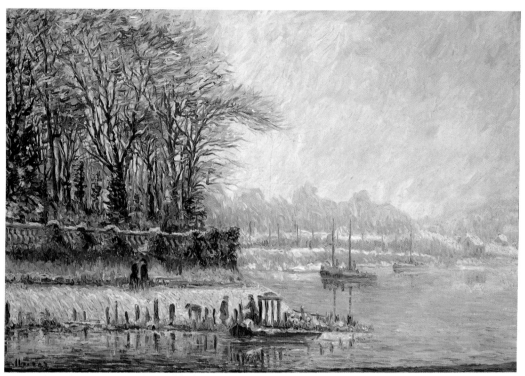

51

EUGÈNE MURER (1841–1906)

51 *The Oise River at L'Isle-Adam*

Ca. 1903
Oil on canvas, 18⅛ x 25⅝ in. (46 x 65 cm)
Signed lower left: Murer
Musée d'Orsay, Paris
Gift of Paul Gachet, 1955 (RF 1955-8)

Not content with having immortalized through his writings the baker, restaurant owner, writer, painter, and collector of Impressionist pictures Eugène Meunier—known as Eugène Murer—Paul Gachet *fils* also wished to bring his friend's work into the Louvre.[1] Gachet's endeavor was met with cautious assent from the museum's curators; they were intrigued by Murer because he was an original figure, but most of them relegated this canvas to the storerooms.

Murer may be remembered as an enthusiastic, though not especially wealthy, art lover. Introduced by chance into the Impressionist circle because he had been a childhood friend of Guillaumin, he knew enough to recognize as early as the 1870s the talents of not only Monet, Pissarro, Renoir, and Sisley, but also Cézanne and, later, Van Gogh. His work as a painter, however, remains a curiosity; the Musée d'Orsay landscape, which shows a clear debt to the painters he admired, may be counted among his more successful efforts. (Ambroise Vollard, who hoped to profit from the paintings in his collection, was the only dealer to organize an exhibition of Murer's work requiring an admission fee.) AD

1. Gachet 1956a.

PIERRE OUTIN (1840–1899)

52 *Eugène Murer*

1864
Black chalk highlighted with white on cream-colored paper,
8⅝ x 6¾ in. (22 x 17 cm)
Signed and dated lower right: P. Outin 1864
Musée du Louvre, Paris, Département des Arts Graphiques, Fonds
du Musée d'Orsay
Gift of Paul Gachet, 1951 (RF 1951-924)

By 1956, when Paul Gachet *fils* published his study *Le doc-
teur Paul Gachet et Murer: Deux amis des impressionnistes,*
Eugène Meunier, known as Eugène Murer (1841–1906),
had long fallen into oblivion—despite his writings, paint-
ings, and splendid collection of Impressionist art. Painted
by an obscure artist—who, like his sitter, came from
Moulins—this portrait of the baker-artist as a poet or art
student escaped from a longhaired bohemia is consistent
with the image that Murer liked to present of himself.
Along with Dr. Gachet, Murer was among the earliest
admirers of Van Gogh; he owned the still life *Fritillaries
in a Copper Vase* (Musée d'Orsay, Paris), which after
Murer's death was sold to Count Isaac de Camondo and
in 1911 became the first Van Gogh to enter the French
national museums. Murer worshiped the Dutch artist to
such an extent that he expressed the wish in his will that
Van Gogh be buried at his side,[1] and planned to donate
land in Auvers for the erection of a monument to him.

AD

1. Letter from Paul Gachet *fils* to Jo van Gogh, May 9, 1906; Archives,
 Van Gogh Museum, Amsterdam (b3779 V/1984).

52

BLANCHE DEROUSSE (1873–1911)

53 *Irises in a Vase*

Watercolor, 25¼ x 19⅛ in. (64 x 48.5 cm)
Signed and dated lower right: BD 03
Van Gogh Museum, Amsterdam
Acquired in 1966 (Gachet coll. inv. D.577/1966)

Paul Gachet *fils* paid homage to the talent of Blanche
Derousse in his writings[1] and by selling to the Louvre, in
1960,[2] a series of watercolor copies that she had made of
paintings in his father's collection. The copies were
intended to be a contribution to the doctor's great project,
a book on Van Gogh, which, however, was never finished.
These fresh and faithful watercolors proved to be valuable
aids in the study of the paintings in the collection, espe-
cially those by Van Gogh. (For copies by Derousse, see
the Checklist of Copies and cat. nos. 1c, 1d, 6b, 12a, 13b,
14a, 15a, 17a, 18a, 18b, 20b, 30a, 39a.)

"The eldest daughter of an old friend," wrote Paul
Gachet *fils*, "Blanche is twenty years of age; she has musi-
cal ability but knows practically nothing about the plastic

Fig. 75. Anonymous, *Blanche Derousse and
Dr. Paul Gachet,* ca. 1900–1905. Photograph
provided by M. Bonnenfant in May 1992.
Musée d'Orsay, Paris, Documentation

arts; she scribbles like a six-year-old who has not learned
to draw. Quite suddenly, the collection in Auvers and the
old canvases in Paris are a revelation to her . . . and inspire
in her an irresistible desire to attempt the same." Of all
Dr. Gachet's "pupils," Blanche was unquestionably the
most gifted. Nonetheless, except for her regular submis-
sions of watercolors and prints (and probably of oil paint-
ings as well, although the catalogues are not very explicit)
to the Salons des Indépendants from 1903 to 1910, her
work remained on an amateur level. Her death certificate,
dated April 10, 1911,[3] described her as a seamstress. The
certificate of her birth, on July 28, 1873, in Neuilly-sur-
Marne, specified that her father was an accountant and
her mother a piano teacher. That is all we know about
her,[4] aside from the fact that Dr. Gachet gave her the
puzzling pseudonym "Sukrop" (see cat. nos. 46m, 46n).[5]

A dozen original prints by Derousse have come down
to us, all executed with great care. They were inspired by

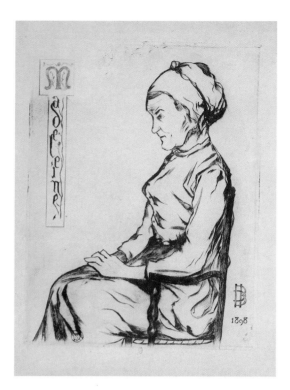

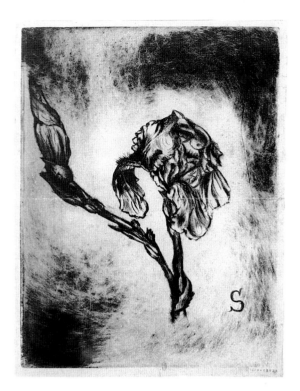

53a *Madeleine*

1898
Two-color etching, 12¾ x 10⅜ in. (32.3 x 26.5 cm).
Signed and dated on the copper plate, lower right: BD 1898
Bibliothèque Nationale de France, Paris, Département des Estampes et de la Photographie

53b *The Blue Iris*

1900
Etching, 9⅞ x 7⅝ in. (25 x 19.5 cm); sheet, 10⅜ x 8⅛ in.
(26.3 x 20.6 cm)
Signed on the plate, lower right. Inscribed on the back in ink: L'Iris bleu / eau-forte de Sukrop / tirage de Van Ryssel / VR / février 1900
Bibliothèque Nationale de France, Paris, Département des Estampes et de la Photographie

the style of the turn of the century, like the graphic works of her fellow "student" Louis van Ryssel (Paul Gachet *fils*). They were printed in very small editions, by Dr. Gachet or by the printer Alphonse Leroy; the examples known today belonged to Paul Gachet *fils* and to his estate and are now in the Bibliothèque Nationale de France, Paris, and the Van Gogh Museum, Amsterdam. Derousse also produced about twenty etching and dry-point copies of paintings in the Gachet collection; they are noted in the entries for the original works and in the Checklist of Copies. AD

1. Gachet 1956a, p. 130 and figs. 61–63.
2. See the minutes of the curators' committee meeting of October 10, 1960 (Archives, Musée du Louvre, Paris): "M. Bazin wishes to inform the committee confidentially that M. Paul Gachet, whose state of health gives cause for much concern, is extremely troubled at the thought of the use that might be made after his death of the copies of works by Van Gogh executed by his father, himself, and

Blanche Derousse, of which thirty are still in his possession. At M. Bazin's suggestion, the committee agreed to purchase this group for 10,000 NF." The works were shown during the meeting held on December 1, 1960, and their acquisition was ratified. The selection did not include copies by Dr. Gachet, which had been donated earlier.
3. She died at 27, rue Beaurepaire, where she lived with her mother.
4. Since her mother's maiden name was Chevalier, Blanche may have been related to Mme Chevalier, Dr. Gachet's governess, a possibility that has not been confirmed.
5. Backward it reads "Porkus," a rather unseemly name for a young woman.

The Greater Gachet Collection

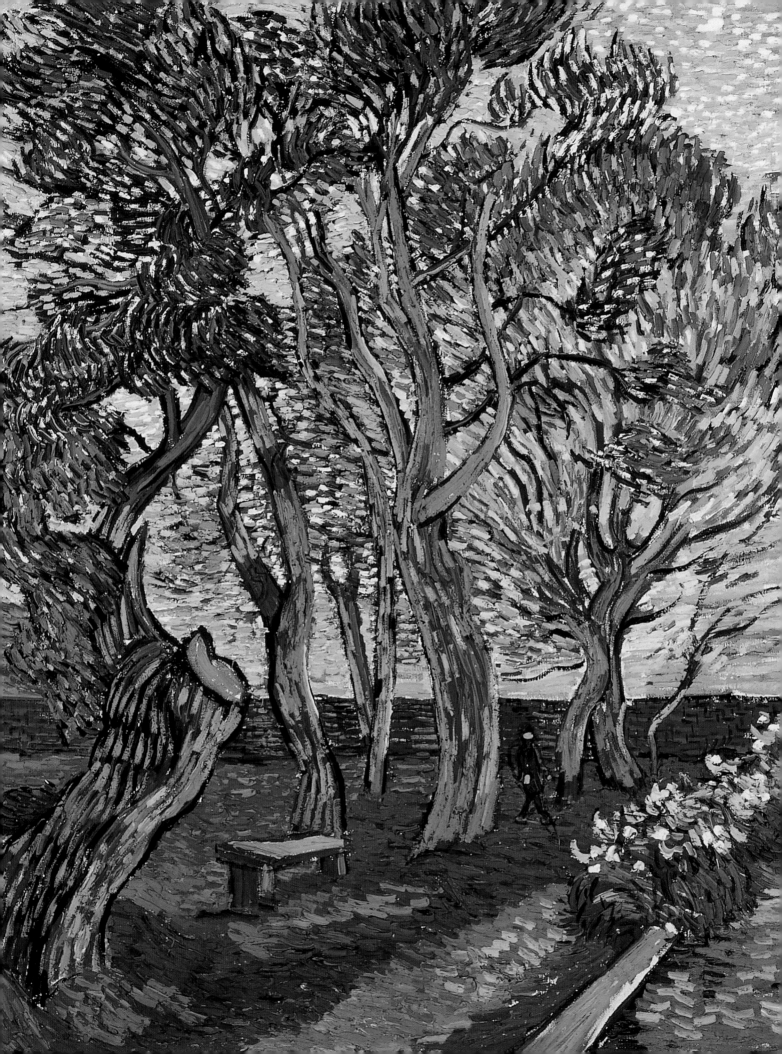

The Gachet Donation in Context:
The Known and Little-Known Collections of Dr. Gachet

SUSAN ALYSON STEIN

I begin with *big news*," Paul Gachet announced to a friend in July 1949. "My sister and I have donated to the Musée du Louvre: the *Self-Portrait* by Vincent [van Gogh], the *Portrait of Dr. Gachet* by Vincent, and the *Self-Portrait* by Guillaumin. Three portraits, very curious, very important, that symbolize the reciprocal friendship of three great individuals."[1] So commenced the donation to the French state of a notable group of paintings, drawings, prints, and cherished objects that for more than half a century had been kept in near-obscurity, in a house that was a shrine to the memory of Dr. Gachet and the illustrious artists he had known. When, between 1949 and 1954, the works emerged from this cloistered collection, they came as a revelation.

Only a privileged few had ever seen the mesmerizing cobalt blue sky of Van Gogh's 1890 *Church at Auvers* (cat. no. 17) before it left the Gachet collection and entered the Louvre in 1951. For more than six decades the painting had been sequestered in the three-story stone house in Auvers, never photographed and never exhibited, kept behind shuttered windows in a room on an upper floor, where it was protected from the ill effects of sunlight or exposure of any kind. Smoking was not permitted. Before they were presented to the Louvre, four of the seven paintings by Van Gogh and four of the seven by Paul Cézanne—from his bright green study of apples (cat. no. 6), an immediate favorite with the press, to his darker, moodier *Bouquet with Yellow Dahlia* (cat. no. 5)—had never left the premises or even been reproduced. Readers of Van Gogh's correspondence could only imagine from his descriptions of them the views that he had painted in Dr. Gachet's garden (cat. nos. 14, 15) or the *Chestnut Trees at Louveciennes* by Camille Pissarro (cat. no. 36) and *Reclining Nude* by Armand Guillaumin (cat. no. 29) that he had admired on the walls of the house.

Fig. 76. Detail of Vincent van Gogh, *The Garden of the Asylum in Saint-Rémy*, 1889 (see fig. 89)

A small number of paintings had enjoyed an early celebrity: Cézanne's *A Modern Olympia* (cat. no. 1) and Guillaumin's *Sunset at Ivry* (cat. no. 30), which Dr. Gachet boldly lent to the first Impressionist exhibition of 1874, and the Van Goghs that (this time with some trepidation) he lent to exhibitions held in Paris and Amsterdam in 1905.[2] These were the hypnotic *Self-Portrait* (cat. no. 12), *Thatched Huts at Cordeville, Auvers* (cat. no. 19), *Two Children* (cat. no. 18), and the much-debated *Portrait of Doctor Paul Gachet* (cat. no. 13)—the authenticity of which was doubted in 1954, then accepted, and since 1996 doubted again.

At the 1954–55 exhibition held at the Musée de l'Orangerie, "Van Gogh et les peintres d'Auvers-sur-Oise," the thirty paintings were showcased together for the first time along with the rest of the contents of the donation: drawings (often of more documentary than artistic interest), prints (dedicated "to my friend Gachet"), and the so-called souvenirs, which ranged from painters' palettes to the household objects represented in their still lifes. Seen *ensemble*, the donation gave a vivid sense of Dr. Gachet's close relationships with artists—notably Cézanne, Pissarro, Guillaumin, and Van Gogh—who had set up their easels in his house or made use of the printing press installed in his alchemist-like attic studio. It was a fitting hommage to the doctor's role as collector, lender, supporter, muse, and fellow artist, and to the mutual admiration that existed among the group of artists whose work he had patronized. As one reviewer put it, "The unique charm of the Gachet collection today is its homely, connecting intimacy."[3]

Yet there is another aspect of the donation that perhaps explains its "unique charm": it is the only part of the Gachet legacy that was kept intact for posterity. While often thought to represent the bulk of the collection, the "Gachet donation" represents only a fraction, or rather a choice selection, from the considerably larger, more heterogeneous, and somewhat disconcerting assemblage of

works owned by Dr. Gachet. The rest of the contents—which can be established from the documentation now at hand and is published in this book in the sections that follow—remained quite private.[4] Since only a small part of the collection became widely known, numerous mistaken assumptions joined the scholarly literature. Now, one can reassess former evaluations: of the donation, of Dr. Gachet's activities as a collector, and of his son's role as curator-guardian of the collection, which extended to cataloguing and deaccessioning works and presumably to establishing the selection that now occupies the Gachet galleries at the Musée d'Orsay.

THE LITTLE-KNOWN, GREATER COLLECTION

The group of works that constitute the Gachet donation is rather like the little *matoshka*, or Russian nesting doll, that one finally discovers after opening first a very large doll and then a succession of smaller and smaller ones. Dr. Gachet's entire collection must have been enormous. It contained more than a thousand prints ranging in date from the fifteenth to the twentieth century, a "confused mass of old paintings, Flemish, for the most part,"[5] some one hundred works by Amand Gautier, thirty-odd oil panels by Paul Guigou, and an occasional Daumier; but it was dominated mostly by hoards of drawings, prints, and other efforts of little distinction, by artists who were the doctor's friends. The smaller but still sizable core collection, made up of Impressionist and Postimpressionist works, included, according to the younger Gachet's unpublished account, forty-four paintings and drawings by Van Gogh, forty-three by Cézanne, thirty-four by Guillaumin, thirteen by Pissarro, and a few examples by Monet, Renoir, Sisley, and other late-nineteenth-century painters. Of these, only a third of the paintings and a tenth of the drawings were donated to the French state.

No one ever recognized the full extent of Dr. Gachet's passion for collecting or knew the entire contents of his collection, which seems to have been more or less intact at the time of his death in 1909 and was inherited by his children, Marguerite and Paul. It was Paul who assumed the role of keeper and, as it were, gatekeeper as well. The visitors who over the years came to his door in a steady stream were selectively welcomed or more routinely denied access to the collection. The interested and the curious were kept at bay by a hand-printed sign at the top of the stairs that read "Ne reçoit pas" (No admittance).

Paul Gachet's legendary refusal to allow the paintings even to be photographed meant that they were little known and could not be considered in the context of other relevant works. In illustrated publications that surveyed the oeuvre of an artist—such as Lionello Venturi's catalogue raisonné *Cézanne* (1936) and the 1939 edition of Jacob-Baert de la Faille's *Van Gogh*—many of the pictures owned by Gachet were relegated to a separate section of "works not reproduced." The contents of the collection became increasingly inaccessible to scholars as time went on. This was in part because the younger Gachet felt that his earlier generosity had not been repaid by those he had helped, "for often they put their own and completely false interpretations on what he so kindly told them"; and in part because of his own scholarly ambitions.[6]

De la Faille, who was introduced to Gachet *fils* in 1923, did obtain permission to examine the collection. He seems to have been able to study the Van Gogh works closely at first hand, since he made notes about both recto and verso of drawings and transcribed color annotations written on them by the artist. He also was given information about the entire Van Gogh holdings, even the nine pictures that by then had been sold. In fact, except for the lack of illustrations—only half the paintings and none of the drawings were reproduced[7]—De la Faille's 1928 publication provided a complete account of Gachet's Van Goghs, cataloguing twenty-six paintings and eighteen drawings, just as (we now know) Gachet *fils* did.

A decade later, Venturi was not accorded the same privileges. Of his 1934 visit to Paul Gachet he recalled, "I was obliged to work from memory, since the owner did not allow me to take notes at the time."[8] His documentation of the Cézannes in the Gachet collection is partial at best. While twenty-six paintings are named in the Gachet *fils* inventory,[9] only thirteen Cézannes are catalogued by Venturi as works that belonged to Gachet (six of them merely listed and not reproduced); three more appear but with no mention of their Gachet provenance; and eight paintings are not included at all. In addition, three paintings that the Gachets never owned are described as having belonged to their collection.[10]

For the next sixty years, Venturi's catalogue raisonné remained the authoritative study of Cézanne's works. Needless to say, for more than a generation, scholars had little sense of the contents of the Gachet collection. It was not until 1996 that John Rewald published many of the Gachet Cézannes for the first time.[11]

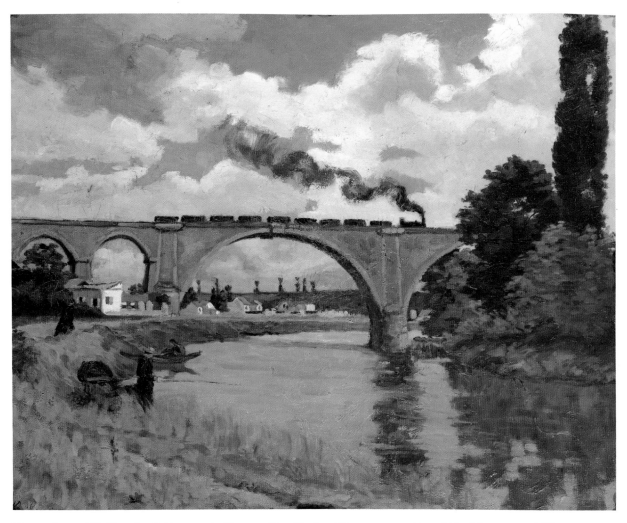

Fig. 77. Armand Guillaumin, *Bridge over the Marne at Joinville*, 1871. Oil on canvas, 23⅛ x 28⅜ in. (58.7 x 72.1 cm). The Metropolitan Museum of Art, New York, Robert Lehman Collection, 1975 (1975.1.180). P.G. IV-13

About Gachet's paintings by Pissarro, very little has been gleaned by scholars from the catalogue raisonné published by Ludovico Pissarro and Venturi in 1939. Of the twelve Pissarros that Gachet owned, only four were fully catalogued and illustrated; seven others were described but with no indication of their Gachet provenance; and one painting was not included at all, apparently because its authorship by Pissarro was rejected (P.G. I-11).[12] With Guillaumin, the state of knowledge has been even worse. Gachet owned a total of thirty paintings by Guillaumin, but only six (those now in the Musée d'Orsay) are catalogued as coming from the Gachet collection in the catalogue raisonné by G. Serret and D. Fabiani (1971), and nine in the one by Christopher Gray (1972).[13]

Drawings and prints owned by the Gachets have suffered equal obscurity, as is evident from the documentation in the Summary Catalogue below; some are published

or illustrated here for the first time. Although many of the paintings can be documented because they were either exhibited, mentioned in correspondence, published, photographed, or copied during Dr. Gachet's lifetime, the early history of the works on paper, as is usually the case, is less securely established.

What became of the artworks making up the original collection? While Gachet *fils* was protectively guarding the collection's contents from would-be viewers, photographers, and scholars, he was also selectively selling off large numbers of pictures. Perhaps this is less paradoxical than it seems. Certainly he was concerned with preserving the Gachet legacy, and this interest, undoubtedly shared by his sister, inspired the donations made at mid-century to the Louvre, the Musée de Lille, and the Vincent van Gogh Foundation. Yet the legacy of artworks was also the source of Paul and Marguerite's livelihood, and therefore paint-

ings were sold discreetly and piecemeal over the years. After Paul's death in 1962, hoards of drawings and prints were bought from his estate in large lots by dealers. As a consequence there are many Gachet-owned pictures now dispersed in public and private collections throughout the world, and often their provenance is unknown—as was the case until recently with the Metropolitan Museum's *Bridge over the Marne at Joinville* by Guillaumin (fig. 77)—or long forgotten. A great number of works, some never published and others untraceable, remain as obscurely hidden away today as they were in Dr. Gachet's three-story stone house at Auvers.

It was by means of a permanent record that Paul Gachet intended to preserve the art his father had collected. He spent much of his adult life closeted with the works, assiduously studying, researching, and cataloguing them. While information about the collection was hard to come by in the outside world, his own knowledge of the subject was formidable. But, although he planned to donate his multi-volume catalogue of the most important contents of the collection to the Bibliothèque Nationale, he never made a specific provision to that effect. The catalogue became part of his estate, and in 1962 it was sold to the private dealer Georges Wildenstein. (His son, Daniel Wildenstein, generously allowed us to consult the albums, now in the archives of the Wildenstein Institute, Paris, while conducting this study.)

By neither preserving the collection intact nor ensuring the future of his documentation, Gachet *fils* became as formidable a keeper in death as he had been in life. Perhaps the saddest irony is that he did not anticipate the inevitable consequences of his lifelong effort to safeguard his legacy from exposure and misinterpretation. He left us with merely the pieces of a puzzle, not a framework for understanding how they fit together. Moreover, with his closed-door policy, refusal to provide photographs, and seemingly secretive behavior, he no doubt evoked suspicion and resentment from scholars whose efforts he effectively thwarted. They naturally based their assessments of the collection on the small part of it that became known, while drawing sundry conclusions from its having been curiously hidden away. Ultimately this laid the foundation for a half-century's worth of doubts about the integrity of the Gachets and the works they owned.

When the Gachet donation emerged into the light of day at mid-century, the reception was mixed. The pictures were little known and of uneven quality. The connection with Van Gogh in the final months of his life inevitably carried a potential for sensationalism. Although many appreciated Paul Gachet as the faithful guardian and chronicler of his father's collection, some suspected the donor of wrongdoings behind closed doors and between the lines of his writings. The latter view was largely instigated by retired-naval-officer-turned-Van-Gogh-researcher Louis Anfray, who between 1953 and 1954 published a series of incendiary articles of dubious art-historical merit in which he contrived a case against the authenticity of the etched and oil portrait of Dr. Gachet, based on "inconceivable omissions" in Van Gogh's letters.[14] He insinuated that the Gachets, father and son, had perpetrated a hoax on an unsuspecting art world by fabricating works in their studio and passing them off as genuine, and that these deceptions, together with the donations made at mid-century, were part of a self-serving "master plan" to ensure the posthumous glory of the Gachet name.

Anfray's accusations surfaced in the press, took on added momentum as journalists entered the fray, and gained some credence as scholars fell in tow. At mid-century a new Doctor Gachet emerged: no longer an amateur artist, friend, and patron but instead a forger, exploiter, and inept physician who eventually, as the idea caught on, became a murderer as well. Although Dr. Gachet has now been "vindicated" (at least of the most heinous crimes),[15] a number of pictures remain disputed, and some of the older charges have been revived in recent publications. The integrity of Gachet *fils* is still an open question, one that has often been a linchpin in determining (or debating) questions of authenticity.[16]

It was because of the doubts cast on the Gachet pictures that Georges Wildenstein, who had bought even more works from the collection than had been donated to the French state, convinced the heirs of the estate to sell him the massive unpublished catalogue by Gachet *fils*, "to have proof in case the authenticity of certain canvases is contested later on."[17] And while ultimately the catalogue does not offer proof of the works' authenticity, it does establish the contents of the collection according to the younger Gachet's intimate knowledge and intensive study of them. It is from this knowledge, from his sense of the contents, that certain decisions were made over the years regarding the disposition of the collection. In the end, only a small, albeit select, part from considerably larger holdings was kept intact and donated to the French state. The rest was dispersed.

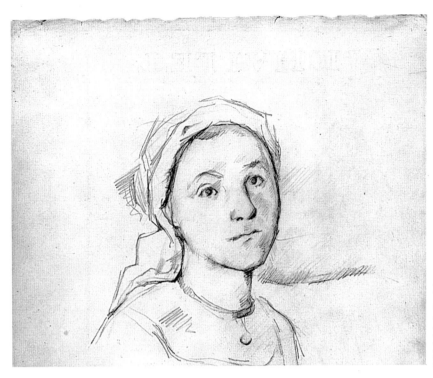

Fig. 78. Paul Cézanne, *Peasant Girl Wearing a Fichu*, ca. 1873 or ca. 1890-93. Pencil on white laid paper, 8⅝ x 6¾ in. (22 x 17 cm). Philadelphia Museum of Art, The Henry P. McIlhenny Collection, in memory of Francis P. McIlhenny (1986-26-2). P.G. II-37

THE DISPERSAL OF THE COLLECTION

What pictures were sold, and when? The younger Gachet's activity selling artworks, which has now been established by research undertaken for this catalogue, can in its highlights be summarized as follows. Only one sale, of a Cézanne still life, *Dahlias* (cat. no. 9), is documented during Dr. Gachet's lifetime. Immediately after his death, in the period before World War I, several of the finest paintings by both Cézanne and Van Gogh were sold;[18] the Gachet provenance of those works has since then in many cases eluded scholars. Few, if any, further Cézannes were sold until mid-century. However, a half-dozen Van Goghs left the collection between 1919 and 1928, often going to foreign dealers and collectors,[19] and before 1930 one Pissarro (P.G. I-5) was sold, although the rest remained in the collection until at least the end of the decade. (Only limited observations can be made about works by Pissarro and Guillaumin, owing to a paucity of information.) In the mid-1930s, two more Van Goghs—of significant artistic and art-historical significance as well as personal value—were sold, as was the first Van Gogh drawing.[20] Thereafter, only a small number of relatively minor works left the collection, until the time of the donations: the vast majority of pictures by Cézanne, the remaining Van Goghs, presumably most of the Pissarros, and all the Guillaumins that can be documented

were sold between 1949 and 1960, largely to Wildenstein. Essentially, Gachet *fils* divested himself of his holdings at this time, mostly by sale but also by means of a few well-placed gifts. He had intended to donate a group of additional drawings by Cézanne and Van Gogh to the Louvre, but these intentions were never realized. Some were sold to Wildenstein, and others, including Cézanne's charming *Peasant Girl Wearing a Fichu* (fig. 78), simply ended up in the estate.[21] Indeed, this was the fate of most of the collection, for he had made no provision for the lion's share of its contents—the hundreds of drawings, prints, and assorted items left at his death in 1962.

If large numbers of works were sold from the Gachet collection over the years, it would surely be interesting to know what principles dictated the selling of certain pictures and the keeping of others. However, the pattern is by no means always a clear one. We know that by mid-century more than half the paintings by Van Gogh had already been sold, but only a few Cézannes. Then, as part of his donation to the state, between 1949 and 1954 Gachet *fils* gave seven paintings by each artist to the Louvre and facilitated its acquisition of *The Church at Auvers* by significantly reducing the purchase price. The other paintings—a dozen or so Cézannes and the three remaining Van Goghs—went to the marketplace, along with the "outtakes" from his selection of three Pissarros and a half-dozen

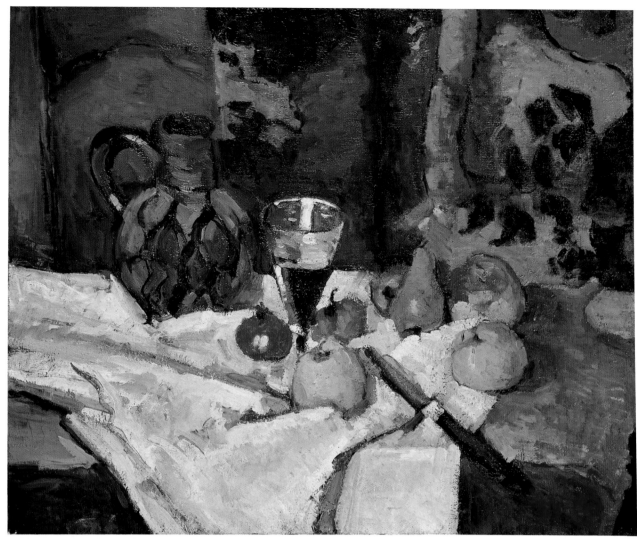

Fig. 79. Paul Cézanne, *Pitcher, Glass, Fruit, and Knife*, ca. 1873. Oil on canvas, 24 x 28¾ in. (61 x 73 cm). Fondation Angladon-Dubrujeaud, Avignon. P.G. II-16

Fig. 80. Photograph of a reconstitution of Cézanne's still life by Paul Gachet *fils*. Archives, Musée du Louvre, Paris.

Guillaumins. Thus, at the end, he was clearly divvying up the pictures: some were for the Louvre, others for the dealer; some had more lasting, others more pragmatic value.[22]

Yet several of the best Cézannes and Van Goghs had already left the collection decades earlier, undoubtedly before any thought was given to posterity. The sale of four Cézannes between 1907 and 1912 depleted the collection of some of its finer still lifes and landscapes from the start. Moreover, those were pictures that one might have expected to be kept for personal reasons. The still lifes, including the evocative *Pitcher, Glass, Fruit, and Knife* (fig. 79)—amply documented by the objects themselves, among them such "souvenirs" in the Louvre as the Gachets' ebony-handled knife and "verre Flamand" (fig. 80)—are part of the series Cézanne painted in the Gachet's house;

Fig. 81. Paul Cézanne,
View of Louveciennes,
ca. 1872. Oil on canvas,
28¾ x 36¼ in. (73 x
92 cm). Private collec-
tion. P.G. II-2

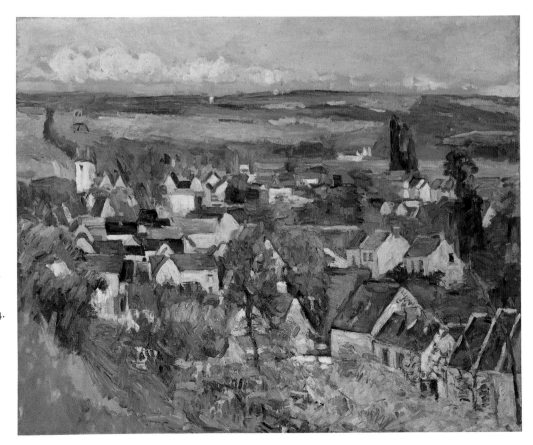

Fig. 82. Paul Cézanne,
*Panoramic View of
Auvers-sur-Oise,* 1873–74.
Oil on canvas,
25½ x 31½ in. (64.8 x
80 cm). The Art
Institute of Chicago,
Mr. and Mrs. Lewis
Larned Coburn
Memorial Collection
(1933.422). P.G. II-4

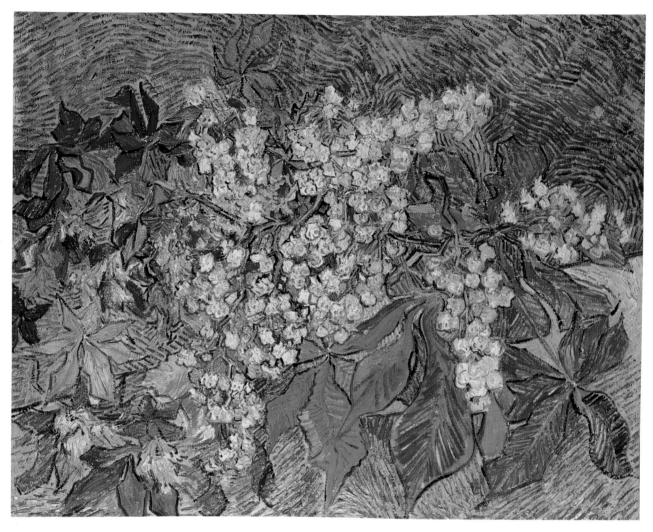

Fig. 83. Vincent van Gogh, *Blossoming Chestnut Branches,* late May 1890. Oil on canvas, 28½ x 35⅞ in. (72.5 x 91 cm). Foundation E. G. Bührle Collection, Zurich. P.G. III-13

and the landscape *View of Louveciennes* (fig. 81), which Cézanne had copied after Pissarro, had also inspired a copy by Dr. Gachet. In the group as well were *Dahlias* (cat. no. 9) and *Panoramic View of Auvers-sur-Oise* (fig. 82), which it seems were, respectively, one of the "two beautiful bouquets by Cézanne" and "another Cézanne, of the village" that Van Gogh had admired at Gachet's house and described in a letter to his brother Theo of May 20, 1890. Perhaps those four sales—made before Van Gogh's correspondence was published in 1914—were later regretted, since no Cézannes seem to have left the collection for the next forty-odd years.[23]

Nor did Gachet *fils* keep all the paintings most intimately associated with the seventy-day period during which Van Gogh worked in Auvers. Among the first to leave the collection (sold in 1912, to Bernheim-Jeune) was

Blossoming Chestnut Branches (fig. 83), rightfully considered one of "the most important, even in size," of the artist's late still lifes.[24] Less surprising, perhaps, are the sales of two other still lifes prior to the First World War, *Pink Roses* (P.G. III-4)—whose date and relationship to a similar flower piece owned by Dr. Gachet's friend and neighbor, the collector Eugène Murer, are still unresolved—and the Paris-period *Cornflowers and Poppies* (P.G. III-2), quite possibly the "large painting of flowers" that Théodore Duret had been eager to buy more than a decade earlier.[25]

After the war, in the years between 1919 and 1928, a half-dozen Van Gogh paintings, mostly Saint-Rémy landscapes, left the collection,[26] along with an important Auvers flower piece painted in Gachet's house, *Wildflowers and Thistles* (fig. 86). Then, after a hiatus of six years, two other major works were sold: *Mademoiselle Gachet at the*

Piano, to the Kunstmuseum Basel in 1934 (fig. 87), and *The Man Is at Sea (after Demont-Breton)*, to Paul Cassirer in 1937/38 (fig. 88). The sale of these works—the former a portrait done when Paul's then middle-aged sister was twenty-one years old and the latter one of the few loans his father had chosen for the 1905 Indépendants exhibition—seems surprising, if only because of their sentimental value. One might think, especially after the next sale (to Dr. Victor Doiteau in 1941), of a small, quickly brushed study, *Branches of Flowering Acacia* (P.G. III-21), that Gachet *fils* had depleted most of his stock. But even after his gifts of 1949–54 to the Louvre, the Musée de Lille, and the Vincent van Gogh Foundation, he still had three pictures left: *Chrysanthemums* (fig. 85); *Cottages at Jorgus* (P.G. III-24); and *The Little Stream* (fig. 84), which Meier-Graefe had coveted in 1909; they were sold to Wildenstein, along with several drawings, during the same period.[27]

What prompted Gachet and his sister (who assumed a less active role in these transactions) to alternately relinquish and retain paintings by Van Gogh? There does not seem to have been a single predominant criterion, at least early on, or any operative "master plan" that would have ensured the family's posthumous fame. Why would the son have agreed to sell at the very outset *Blossoming Chestnut Branches* (fig. 83), one of the finest paintings from Van Gogh's Auvers period, when he had so many other works made in Paris, Arles, or Saint-Rémy that had no historical connection with his father? And why did he keep until 1949 Van Gogh's *Chrysanthemums*, even though he had expressed an opinion, in a letter of 1921 to Johanna van Gogh-Bonger, of works "from the Paris period" such as this still life of 1886: "despite all its interest, this period of Vincent's is not his most typical, most characteristic, or most valuable."[28] (Regrettably, the picture was not among his gifts to the French state; it would have made an instructive comparison to Monet's painting of the same subject.) Why, sometime before 1928, did Gachet *fils* sell off *Wildflowers and Thistles*, which has the distinction of being the only Auvers still life clearly recorded in the correspondence, only to hold on to and later donate to the Louvre the unremarkable *Roses and Anemones* (cat. no. 16)—particularly if little credence is given to his claim that it was presented to him by Theo for sitting vigil at Vincent's deathbed? Why not palm off the less distinguished picture on an unsuspecting art market and attach one's name to an undisputed work? Likewise, if "the entire Gachet collection is riddled with fakes," as one writer contends,[29] was it prudent for Gachet *fils* to keep, publish, and later donate to the Musée de Lille the only picture that De la Faille wrote "does not greatly recall Vincent's hand"? Perhaps not—unless *Cows* (cat. no. 20) was, as Gachet claimed, based on an etching his father had made after Jordaens's painting in Lille.

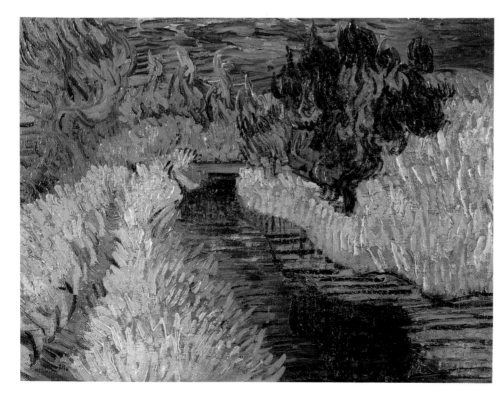

Fig. 84. Vincent van Gogh, *The Little Stream*, 1889-90. Oil on canvas, 10 x 13⅜ in. (25.5 x 34 cm). American International Group, Inc. P.G. III-12

Finally, how do we account for the sale of *Mademoiselle Gachet at the Piano*? In 1934, sixty-five-year-old Marguerite was encouraged to part with the remarkable portrait Van Gogh had done of her as a young woman. Purportedly painted with a palette lent to the artist by her father (later donated as a "souvenir" to the Louvre) and inspired by an etching Dr. Gachet made in 1873, *Mademoiselle Gachet at the Piano* (fig. 87) had hung in her bedroom for more than four decades. It left its timeworn spot between two Japanese prints to find a new home on the walls of the Kunstmuseum Basel. The sale of this great portrait, some twenty years prior to the donations made to the French state, has been viewed as odd enough to evoke a range of dubious speculations.[30] Yet one crucial distinction has been overlooked: the work was not simply sold off but was, in effect, placed in a museum, where it could be appreciated by the public.[31]

In fact, this sale may signal the first time that thought was given to posterity. It was during the same period, between 1936 and 1938, that the Gachets lent works from the collection—including some that had never left the house before—to Paris exhibitions devoted to Cézanne, Van Gogh, and Guillaumin. Those paintings were among the group later donated to the French state. After this

period, very few pictures, and none of distinction, left the collection until the time the donations were made; the interim sales that did take place, with the exception of a smallish study (P.G. III-21), excluded works made in Auvers. While the Auvers pictures had not always been valued in and of themselves for their historical or personal associations, ultimately those associations seem to have been a determining factor in choosing—from the dozen or so paintings by Van Gogh that the Gachets had long cherished and refused to sell—which ones went to the Louvre and which ones were sold. The handful of pictures that Dr. Gachet lent to exhibitions during his lifetime surely had a particular personal importance, since all but one of them were included in the donation. The one that was not, Van Gogh's *The Man Is at Sea (after Demont-Breton)* (fig. 88), painted in Saint-Rémy, stands apart from the others because it is the only one not made in Auvers or known (like the *Self-Portrait*) to have been brought there by the artist.[32]

It is clear from Paul Gachet's brief account of the contents of the 1954 donation, given in a letter to longtime family friend V. W. van Gogh (the artist's namesake and nephew), that he had selected an Auvers group, one that included "five canvases by Vincent painted in Auvers" and

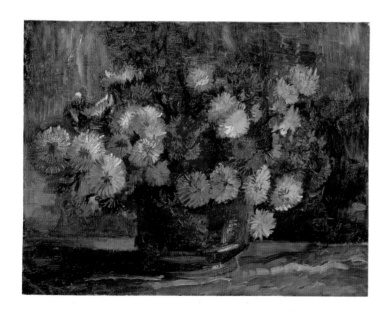

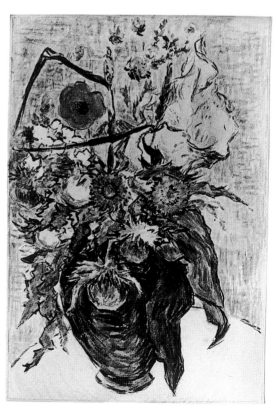

Fig. 85. Vincent van Gogh, *Chrysanthemums*, 1886. Oil on canvas, 18⅛ x 24 in. (46 x 61 cm). Private collection. P.G. III-1

Fig. 86. Vincent van Gogh, *Wildflowers and Thistles*, mid-June 1890. Oil on linen, lined with canvas, 26 x 17¾ in. (66 x 45 cm). Location unknown. P.G. III-18

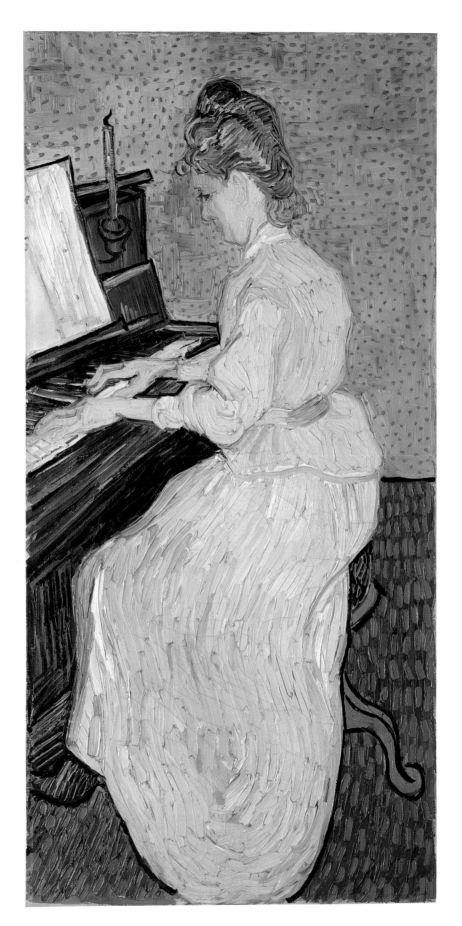

Fig. 87. Vincent van Gogh,
Mademoiselle Gachet at the Piano,
late June 1890. Oil on canvas,
40⅜ x 19¾ in. (102.5 x 50 cm).
Oeffentliche Kunstsammlung
Basel, Kunstmuseum (no. 1635).
P.G. III-20

"4 Cézannes (from Auvers)." While he had set aside this key group of works for the Louvre, having chosen the best examples then at his disposal, he also wanted to see the "Gachet name figure at Amsterdam in the [Vincent van Gogh] Foundation." To this end he proposed donating to the Foundation "a very beautiful and important canvas," but one that, as its title reveals, was an earlier work: *The Garden of the Asylum in Saint-Rémy* (fig. 89).[33]

By mid-century, the Gachet collection, which had not contained a surplus of museum-quality works to begin with, boasted few paintings describable as "very beautiful and important" to draw upon for donations that would carry the family name. One might say, then, that from the contents of the collection still intact, the younger Gachet chose well for posterity. But it should be recognized that he had been making choices all along. Responding to dealers' interest over the years and at the same time initiating offers for sales on his own, Gachet had let go of a number of masterpieces; however, he had not parted with certain works,

some of considerably lesser quality than those he sold, presumably for reasons often dismissed as fables. In making these determinations, he did not place a premium on pictures because they were documented in Van Gogh's correspondence, nor did he defer to the opinions of experts: while he donated *Cows* (cat. no. 20), a work disparaged by De la Faille, he sold Cézanne's *Three Bathers* (P.G. II-24), which Venturi had praised as the "most perfect" of the bathing scenes made by the artist in the mid-1870s.

To a great extent, Paul Gachet's sense of the relative importance of works in the collection seems[34] to have been predicated on choices his father made earlier, for the donation includes both the Cézanne and the Guillaumin that Dr. Gachet had lent to the Impressionist exhibition in 1874 as well as most of the Van Goghs lent in 1905.[35] Gachet *fils* obviously attached importance to the works Van Gogh had singled out for admiration in his letters: of them, the two paintings by Guillaumin and the Pissarro landscape were part of the donation, as was one of the Cézannes, *Bouquet in a Small Delft Vase* (cat. no. 8), although the others, having been sold peremptorily before the artist's correspondence was published, apparently were not.[36] The son gave preference to the "tokens of fellowship and gratitude" that his father had acquired over the years, whether the model's portrait received from Renoir (cat. no. 39) or the painting supposedly by Constantin Guys (its attribution now doubted; see cat. no. 32) that came from Manet. Such choices tend to carry out the theme of "reciprocal friendship" that Gachet *fils* had ascribed to the trio of portraits initiating the donation in 1949.

Ultimately, the group of paintings now in the Musée d'Orsay—with its three Pissarros, half-dozen Guillaumins, fifteen Cézannes and Van Goghs, and works by other Impressionist colleagues—succeeds as a fitting *hommage* to Dr. Gachet as patron, friend, and fellow artist. While the pictures are often (though not always) the best examples of what the Gachets owned by each artist who worked in and around Auvers, perhaps other considerations—anticipated by the father, and respected by his children—played a more decisive role in determining their fate.

For many years the donation has been thought of as constituting the entirety of Dr. Gachet's collection, whereas it actually represents a choice, carefully edited selection. Therefore, certain long-standing views are sorely tested by the revelation of works sold over the years or weeded out from the final group that do not display expected characteristics of style, quality, and date, or do not reflect the

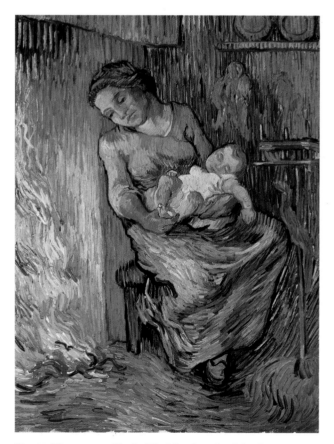

Fig. 88. Vincent van Gogh, *The Man Is at Sea (after Demont-Breton),* October 1889. Oil on canvas, 26 x 20⅛ in. (66 x 51 cm). Location unknown. P.G. III-6

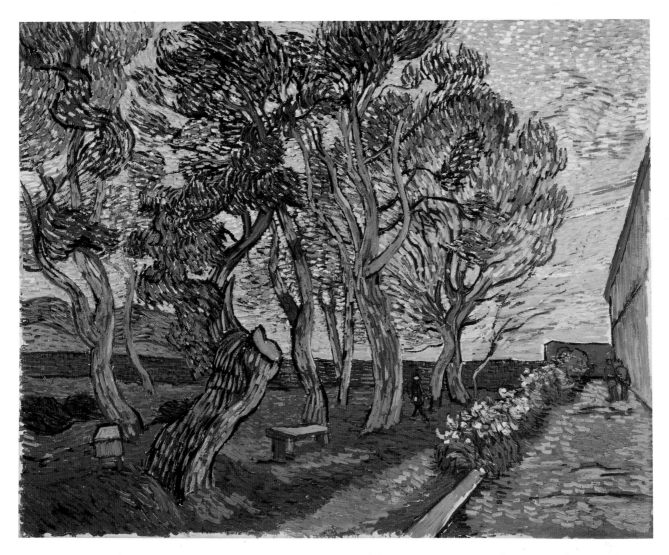

Fig. 89. Vincent van Gogh, *The Garden of the Asylum in Saint-Rémy,* 1889. Oil on canvas, 28⅛ x 35⅝ in. (71.5 x 90.5 cm). Van Gogh Museum (Vincent van Gogh Foundation), Amsterdam (S196 V/1962). P.G. III-7

close personal relationships that have been understood as the basis for their ownership by Gachet. One common assumption has been that all the works he collected date from the periods when their makers were friendly with him and were acquired directly from the artists themselves (in the case of Van Gogh, from the artist or from his brother Theo immediately after the funeral). Yet certain pictures do not fit this profile, as John Rewald discovered when he wrestled to reconcile Gachet's ownership of various unpublished works by Cézanne with the fact that they predate the artist's two-year (1872–74) sojourn in Auvers (see P.G. II-1 bis). As for the Van Goghs in the collection, even though they were correctly established seventy years ago in De la Faille's catalogue raisonné, curiously, no Van Gogh scholar has tackled the issue of non-Auvers works among

them: at least eight pictures, including two Paris-period still lifes (1886–87) and several Saint-Rémy landscapes and copies, clearly challenge conventional assumptions. However, not only have those assumptions gone unchallenged, but the provenance of the pictures has been virtually ignored.[37]

Various questions that have long gone unasked in the Van Gogh literature, and that Rewald recently raised in reference to Cézanne, deserve further thought. How do we account for Dr. Gachet's ownership of pictures by both artists that predate the periods they worked in Auvers? Can we dismiss the possibility, as Van Gogh scholars have for years, that at least some of the works were brought to Auvers?[38] Perhaps not: witness Van Gogh's double-sided drawing *Workers in the Fields* (P.G. III-30) and the paintings

called *Huts in the Sunshine: Reminiscence of the North* (P.G. III-8 and 8 bis). Nor can we ignore the possibility of other sources for Dr. Gachet's acquisitions. Ironically, we now know more about the later history of works in the Gachet collection than we do about the original provenance of works for which there is not a familial history.

DR. GACHET AS A COLLECTOR

The Gachet donation to the French state gives only a partial sense of the range and quality of works in the collection by individual artists, such as Cézanne and Van Gogh, and almost no sense of the larger, more diverse and eclectic collection as a whole.[39] Essentially it distorts the perception of Dr. Gachet's activity as a collector. Paul Gachet *fils* tried to correct this misperception, shortly after the donation was made, by publishing a few pages of description that are reprinted in this catalogue (see p. 177–78). His father, he wrote, was not an ordinary collector, nor was he exclusively a collector of "Impressionist Painting—including Vincent." He possessed neither the resources nor the incentive to acquire works that were "costly, beautiful, or rare." Instead he seems to have been a passionate, not always discriminating, and somewhat accidental collector. We now know that he owned several hundred works by artist friends whose names are "completely forgotten today." Most of them, as his son reminds us, were of no interest to anyone. But some 150 works—those documented in the Summary Catalogue that follows—became of considerable interest, once others as well realized the genius of their makers: Cézanne and Van Gogh, for whom recognition was slow in coming, and, among the Impressionists, most notably Pissarro and Guillaumin. Given Dr. Gachet's acquisitive spirit and wide-ranging, often progressive and peculiar interests, perhaps it was inevitable that some of the works he enthusiastically collected—frequently from artists whom he enthusiastically encouraged—would later become valuable. He was not a speculator, as his son was quick to make clear, but rather an art lover in the broadest sense of the term, and a man who kept everything.

During the course of his long and interesting life, his son tells us, he accumulated a host of "souvenirs," largely from artists he met and befriended over the years and who left behind "tokens of fellowship and gratitude," or, one suspects, sometimes simply left works behind. Dr. Gachet willingly accepted paintings in exchange for his services and appears to have been satisfied with whatever he received. He also bought works. But he almost never sold anything. These practices could doubtless account for the relative dearth of masterpieces and the unedited character of his holdings of individual artist's works. Not only was Gachet attracted to artworks that no one else cared for (and in 1890 this was especially true of Van Gogh's); he kept and treasured the whole lot of them, including items that others might well have discarded and perhaps some that the artists themselves wished he had.[40]

This perspective on Dr. Gachet's collection (which derives from his son's understanding of it), while it does not discount the possibility of misattribution, does offer an explanation for the disconcertingly uneven nature of the holdings and the inferior or atypical qualities of certain works that have provoked puzzlement and doubt. We know that Dr. Gachet took in a river view by Pissarro that the artist had originally intended to destroy (P.G. I-8). He did not mind choosing from works that painters did not consider their best, as in the case of the few pictures Monet was able to show him in 1878 (cat. no. 33). Nor did he always receive the pictures he admired, as we realize from Van Gogh's correspondence (see entry for P.G. III-5). Some of the unfinished or abandoned exercises by Cézanne, including perhaps some experiments that went awry, may simply have been left behind, as surely was the case with the handful of sketchbook drawings by Van Gogh that the doctor owned (cat. no. 22). Perhaps no one, with the exception of Vincent's family, would have cherished this lot of dashed-off jottings on a page that Gachet, and in turn his children, kept for more than half a century. In fact, no other collection of the Dutch artist's works—and Gachet's was the largest of his generation—remained intact for so long.

The works by Cézanne, Van Gogh, and other artists that Dr. Gachet's children kept and later donated to the Louvre are the only part of the collection still intact. They don't tell the whole story—just a chapter, in fact—but perhaps a second reading, with all the excerpts now back in place, will allow us to better assess the overall contents of a collection that to date has been known in only a very abridged form.

1. Letter from Paul Gachet *fils* to Eduard Buckman, July 2, 1949 (Buckman papers, VGM Archives, folder 293); in content it is almost identical to one that Gachet sent to V. W. van Gogh on April 29, 1949 (VGM Archives, b3072 V/1962). Throughout these notes, the abbreviation VGM signifies the Van Gogh Museum, Amsterdam.

2. Dr. Gachet's need for assurances and his general anxiety about lending to the Amsterdam retrospective are recorded in a series of letters between Johanna van Gogh-Bonger, who organized the exhibition, and the younger Gachet, written in July 1905. In one she writes: "But if it causes Dr. Gachet too much vexation [*trop d'ennuie*] to part with [the pictures], then it is not necessary for him to do so." Johanna van Gogh-Bonger to Paul Gachet *fils*, July 1, 1905 (VGM Archives, b2171 VF/1982).

3. Flanner 1955, p. 53.

4. Citations of works in the Gachet collection by P.G. number refer to entries in the Summary Catalogue, below.

5. Distel 1990, p. 181.

6. Eduard Buckman, "I Found the Real Vincent van Gogh at Auvers," unpublished manuscript, ca. 1952, p. 2 (Buckman papers, VGM Archives).

7. The only Van Goghs still in Gachet's possession that were illustrated in the 1928 and 1939 editions of the De la Faille catalogue were the five paintings that Dr. Gachet had lent to the Indépendants exhibition in 1905, which the dealer Druet had photographed without permission.

8. Venturi 1956, p. 270.

9. Gachet Unpub. Cat., II.

10. *Pastoral* (V104 [R166]), *Flowers in a Green Vase* (V748 [R875]), *Geraniums and Larkspur in a Small Delft Vase* (V180 [R226]); see the Summary Catalogue, non-Gachet section, pp. 240. These wrong identifications can probably be attributed to Venturi's bad guesswork from his notes. The subjects depicted, bathers in a landscape and flower pieces, appear in paintings in the Gachet collection that could have been similarly described. *Pastoral* was published as a Gachet-owned picture even in 1996, albeit for the last time. (Working "from memory" inevitably led to other inaccuracies, from Venturi's description of *Game Birds* [P.G. II-20] as a single bird on a red background to his misidentification of a drawing as a painting [see P.G. II-35]).

Among the pictures Venturi never knew had been in the collection, since they had left it before his arrival in Auvers in 1934, are *Dahlias* (P.G. II-14) and *Panoramic View of Auvers-sur-Oise* (P.G. II-4), which Van Gogh had presumably seen in 1890. Unfortunately, and surprisingly, the provenance of these works eluded even John Rewald, who also mistakenly gave a Gachet provenance to the bouquet in the small Delft vase (Rewald 1996, no. 226).

11. Rewald 1996. In almost all respects (see n. 10), Rewald presents an accurate account of the collection, filling in the blanks left by the absence of photographs and correcting the blind spots and oversights caused by the dearth of information at Venturi's disposal. Only one of the Gachet-owned pictures was rejected by Rewald (P.G. II-18), or perhaps two (see P.G. II-1), though many of them challenged his sensibilities.

12. Readers are advised in a note, "Dr. Gachet, Pissarro's friend who lived at Auvers, had a dozen or so works by the artist, of which we have been able to obtain two or three photos, thanks to the kindness of his son, Mr. Paul Gachet." The cataloguers actually succeeded in obtaining photographs of five of the paintings owned by Gachet (perhaps only two or three of them from the owner himself); of the seven that were catalogued with no indication of their Gachet provenance, one (P.G. I-6) was illustrated.

13. The six now in the Musée d'Orsay were the only ones whose Gachet provenance was recorded in the early literature. Four were listed by Édouard des Courières in 1924, and two others were published by Paul Gachet *fils* just before and just after they were donated to the French state. Together, the current catalogues raisonnés by Serret and Fabiani (1971) and by Gray (1972; revised in 1991) include less than half the Gachet-owned Guillaumins; the other works have never been published.

14. For these articles, published in *Art-Documents*, see bibliographical entries for Anfray.

15. Anfray's supposition that Dr. Gachet had been implicated in Van Gogh's death (see Anfray 1954f), which prompted further speculation—for example, by the writer Antonin Artaud, who cast Gachet in the role of murderer—was based on missing passages in the artist's correspondence. The last two lines of Dr. Gachet's letter of June 27, 1890, to Theo van Gogh had been omitted by Theo's widow, Johanna van Gogh, when she first published the correspondence in 1914. In addition, Dr. Gachet's letter of about August 15, 1890, had been lost, although passages were quoted from it in Johanna's introduction. It later emerged that the omitted two lines were innocent, and when the lost letter was rediscovered, Gachet was "vindicated," to use Ronald Pickvance's phrase (see Pickvance 1992, pp. 13, 27); but it is sad to think that without "letter evidence," Dr. Gachet's integrity would still be impugned. Yet that is essentially the reason why a number of pictures remain in dispute. See Excerpts from the Correspondence in this catalogue.

16. Sometimes contrary views on Gachet's integrity vie for equal attention in one publication, as is the case in the new Cézanne catalogue raisonné (Rewald 1996); or they are expressed in two versions of the same book, as in the editions of Jan Hulsker's Van Gogh catalogue raisonné, where the once "seemingly reliable" Gachet *fils* (1980, p. 485) has now become a "totally unreliable" source (1996, p. 460).

17. Letter from Paule Lizot to M. and Mme Marc Edo Tralbaut, [June] 27 [1962], VGM Archives.

18. Cézannes: P.G. II-2, 4, 16; Van Goghs: P.G. III-2, 4, 13.

19. P.G. III-3, 8, 9, 11, 18, 22.

20. The paintings are P.G. III-6, 20; the drawing is P.G. III-29.

21. Only one Van Gogh drawing was donated to the Louvre (P.G. III-34), but Gachet *fils* had contemplated giving three more in 1955; instead, two of them were sold to Wildenstein (P.G. III-28, 32) and the third (P.G. III-37) became part of his estate. Similarly, only two Cézanne drawings were included in the donation to the French state (P.G. II-39, 40), but he had considered presenting five more: a

watercolor view of Pontoise (P.G. II-26), which was sold to Wildenstein, and four drawings (P.G. II-31, 37, 38, 41), at least three of which were acquired by dealers from his estate; the subsequent provenance of P.G. II-31 is unknown.

22. Not all the pictures had been kept over the previous decades for the same reasons. Some works Gachet had tried unsuccessfully to sell earlier, such as Cézanne's *Still Life with Bottle, Glass, and Lemons* (P.G. II-6), which was offered to Victor Doiteau in 1941. However, he had held on to Van Gogh's *The Little Stream* (P.G. III-12) despite the interest Meier-Graefe expressed in buying it as early as 1909.

23. Among the artist's works kept and later donated, perhaps only *A Modern Olympia* and *Dr. Gachet's House at Auvers* rival those canvases in quality or historical importance. One consequence of these early sales is that the provenance of three of the pictures (P.G. II-2, 4, 14) eluded Venturi, whose 1936 catalogue raisonné was the voice of authority on Cézanne's works for more than a generation. Clearly, omissions like these unfavorably skewed the overall sense scholars had of the Gachet holdings.

24. Hulsker 1980, p. 462. His observation that "had it been part of a public collection, it might very well have become just as famous as, for example, *Branches of an Almond Tree*"—the glorious picture now in the Van Gogh Museum in Amsterdam—is worth noting, since various assessments have been made about the Gachet holdings based exclusively on the eight Van Gogh paintings now in the Musée d'Orsay. Although no mention is made of its early provenance, Hulsker associates *Blossoming Chestnut Branches* with other pictures in the Gachet collection, remarking on the "related" study of *Branches of Flowering Acacia* (P.G. III-21) and adding that the "deep ultramarine blue of the background links it to works such as *The Church at Auvers* and the *Portrait of Dr. Gachet*."

25. *Pink Roses* has been variously but inconclusively dated (see P.G. III-4). What is its relationship to the two grand bouquets, *Roses* (F 681, 682), that were painted in Saint-Rémy in May 1890 and included in a shipment of pictures Van Gogh received in Auvers about June 22? Is there a comparable relationship between the great *Fritillaries in a Copper Vase* (F 213; formerly owned by Eugène Murer, now in the Musée d'Orsay, Paris) and *Still Life with Fritillaries* (F 214; possibly also owned by Murer, formerly with Théodore Duret, now location unknown)? Lacking the exuberance and painterly qualities of the bouquets to which they are related, the Gachet-owned *Pink Roses* and the *Fritillaries* study (F 214) betray certain similarities in composition and in their spatial ambiguity: the flowers, no longer in vases, seem to have been abstracted from the bouquets and placed in a somewhat indeterminate space, to which more leaves have been added as filler.

It is unfortunate that we know so little about the contents of Eugène Murer's collection of works by Van Gogh; like the Gachets, he owned Paris-period still lifes, but when were they acquired, and from whom? What pictures were at Van Gogh's disposal in Auvers? Was the *Fritillaries in a Copper Vase* sold to the banker Isaac de Camondo (after Murer's death in 1906) by Gachet *fils*, who sold the Gachets' *Dahlias* (P.G. II-14) to the banker in 1907? Both were part of the Camondo bequest to the Louvre in 1908.

26. See note 19.

27. A half-dozen drawings by Van Gogh were sold to Wildenstein between 1952 and 1958; see P.G. III-27, 28, 30, 32, 33, 35. Other drawings were dispersed, by gift or sale, during the same period; see P.G. III-38, 39, 40, 41. The drawings by Van Gogh that became part of Paul Gachet's estate in 1962 (which included P.G. III-37 and perhaps P.G. III-31 and 36) were the subject of closed-door meetings among the experts and dealers involved.

28. Paul Gachet *fils* to Johanna van Gogh-Bonger, January 10, 1921 (VGM Archives, b3402 V/1984).

29. Landais 1997, p. 114.

30. Some writers, seeing the sale as part of a premeditated plan or in relation to the donations at mid-century, have offered reasons why it did not figure in that group. According to one supposition, there had been an unrequited love affair between Marguerite Gachet and Vincent; according to another, Gachet *fils*, the only member of the family whose portrait Van Gogh never painted, was motivated by jealousy.

31. It is possible that correspondence or other documentation is present in the archives of the Kunstmuseum Basel (information not made accessible for this study) that could shed further light on the circumstances that led to the painting's placement in this particular museum; for example, the initiator of the sale. We can note that in Basel the picture could be appreciated in relation to another double-square Auvers painting by Van Gogh, *Daubigny's Garden*; it had been owned since 1917 by the Basel collector Rudolf Staechlin, whom Gachet described as "an acquaintance, almost a friend" in a letter written four years after the sale (Paul Gachet *fils* to Eduard Buckman, Dec. 27, 1938 [Buckman archives, VGM]).

32. On this subject, see notes 35, 37.

33. Paul Gachet *fils* to V. W. van Gogh, April 12, 1954 (VGM Archives, b3439 V/1984).

34. Without the benefit of knowing the contents of a formal testimony or will, if one exists.

35. The donation did not include all five of the Van Gogh paintings that Dr. Gachet lent to exhibitions in 1905. *The Man Is at Sea (after Demont-Breton)* (P.G. III-6), as noted, was instead sold to the dealer Paul Cassirer in 1937/38. I have proposed that this is because, unlike the other four pictures, it was not made in Auvers or known to have been brought there by the artist—although it may have been: Van Gogh brought to Auvers other Saint-Rémy copies that are recorded in the artist's correspondence with mentions of Dr. Gachet's admiration for them, and it is not inconceivable that he brought this copy as well. It appears that Gachet *fils* knew little about the provenance of works by Van Gogh and Cézanne that predate the artists' working periods in Auvers.

The one Van Gogh drawing donated to the French state (P.G. III-34) was also lent by Dr. Gachet to the Indépendants exhibition in 1905. Of several drawings lent, it was the only one individually described in the catalogue by title and media; the others were called simply "Dessins fait à Auvers," in two separate entries. Gachet *fils* seems to have been unable to identify these works; he devoted a

publication to the subject of his father's loans (see Gachet 1953b) in which he included a footnote about the erroneous date assigned them (1889 as opposed to 1890), but no further information. Although in 1905, at age thirty-two, he had definitely been aware of and involved in the lending of these works, as is documented in his correspondence with Johanna van Gogh-Bonger, when he sat down to write about his father's loans a half-century later, he apparently did not recall or have documentation at his disposal about the "dessins." Might the group have included the three drawings he earmarked for the Louvre but did not donate (P.G. III-28, 32, 37)? De la Faille identified one of those as having been included in the 1905 exhibition (see P.G. III-28, comments).

Paul Gachet's knowledge of the early history of his father's collection was limited. Generally, the donation was restricted to those works that he was able to document as significant purchases, gifts, loans, or acquisitions, made in (or brought to) Auvers by the artists represented.

36. According to Gachet *fils*, only one of the three Cézannes that Van Gogh admired, *Bouquet in a Small Delft Vase* (P.G. II-15), was included in the donation. He identified the others as *Dahlias* (P.G. II-14) and *Panoramic View of Auvers* (P.G. II-4); as noted, both were sold from the collection early on, before Van Gogh's correspondence was published in 1914, and their Gachet provenance has since eluded scholars. It is likely but not absolutely certain that these are the three works that took Van Gogh's fancy, since we now know that Gachet owned three views of Auvers (see also P.G. II-3, 5) and four floral still lifes (see also P.G. II-9, 11). Among the previous candidates for Van Gogh's admiration that can no longer be considered is the still life *Geraniums and Larkspur in a Small Delft Vase* (R226; see Summary Catalogue, p. 240); it was mistakenly identified as belonging to Gachet by Venturi (and also by Rewald) and has always been thought to be one of the "deux beaux bouquets de Cézanne" Van Gogh's mentioned, but it was never part of the Gachet collection.

37. Without recourse to the original, 1928 edition of De la Faille— which in many ways determined the future course of Van Gogh scholarship by relying on a distinction between pictures "mentionné dans les lettres" and those "non mentionnés"—it is almost impossible to ascertain what works were in the Gachet collection. The revised edition of 1970 has no index of former owners, and information pertaining to the provenance of works has been relegated to small type at the back of the book, where it could well escape notice. Priority goes to quotations from the letters, which appear next to the illustrations and basic cataloguing information. Jan Hulsker's catalogue raisonné of 1980, recently revised to include unexplained question marks liberally sprinkled on its pages (presumably calling into question the authenticity and/or given dates of works), contains no provenance information whatsoever, making it perhaps unique among books of this type. Nor have any of the recent catalogues accompanying major Van Gogh exhibitions provided provenance documentation.

Ultimately, this vacuum of knowledge explains much of the current "fakes" controversy. After years of neglect, researchers are start-ing to examine the early provenances of Van Gogh's pictures, something that should have been studied all along hand-in-hand with factors such as style and the artist's letters. In the absence of much solid knowledge, bits and pieces of recently discovered information about owners are seized upon, or even the fact that a work not documented in the artist's correspondence cannot be traced to an early owner becomes grounds for suspicion. At their worst, these researches are no more than witch hunts for possible forgers.

One of the long-standing reasons for doubting pictures in the Gachet collection—going back to the observations made in 1954—is the need to bring down the number of works regarded as having been made by the artist during his sixty-six working days in Auvers to one possible for a genius (as opposed to a superhero). Current catalogues raisonnés still assign more than seventy paintings, some thirty drawings, a sketchbook, and some twenty-five letters to this period. Serious provenance research might help weed out misattributions and misdatings of works, problems caused by neglect of this area for so long.

38. Despite misleading statements to the contrary, we do not know precisely how many works Van Gogh retrieved in Paris during his brief visit there en route from Saint-Rémy and brought with him to Auvers. He never said. Yet because no drawings are mentioned in the correspondence and only four paintings are described (three early on in Van Gogh's letters from Auvers, and a fourth in Émile Bernard's description of the funeral [see Stein 1986, pp. 219–22]), Ronald Pickvance concluded: "As far as is known, Van Gogh did not take any drawings to Auvers-sur-Oise on 20 May 1890. But he took four paintings" (Pickvance in Otterlo 1990, p. 317; Pickvance in New York 1986–87, p. 197). His inference, narrowly based on the letters, considered neither the provenances of pictures in Auvers (in the collections of Gachet, Murer, and others) nor other primary documentation. For example, if Van Gogh did not take any Saint-Rémy drawings to Auvers, how do we account for double-sided drawings in Gachet's collection and elsewhere, including the Van Gogh Museum, that have on their recto and verso drawings from both periods? The question of what works Van Gogh may have had on hand in Auvers, and other issues regarding the dating and attribution of works raised by a reconsideration of their provenance, will be discussed at length in a forthcoming article.

39. Paul Gachet *fils* did not catalogue the greater part of the collection, owing to its size and the negligibility of its contents. Apparently those works were sold off from his estate in large lots and acquired by dealers, among them Alfred Daber, Wildenstein, and Curt Valentien (who was the source for the large group of drawings, prints, and copies acquired by the Van Gogh Museum in 1966). More than one thousand prints were auctioned off at the Hôtel Drouot, Paris, in 1993. (See Checklist of Artists and Works, n. 2.)

40. In this context, it is worth noting the remarks made by Gachet *fils* on Cézanne's *Still Life with Italian Faience* (P.G. II-12). He described it as "falling quite short of Cézanne's ideal" and added that "it is highly probable that had it not been left at the [Gachet] house, it would no longer exist today" (Gachet Unpub. Cat., II, P.G. 12).

Paul Gachet Characterizes His Father's Collection

In documenting the contents of Dr. Gachet's collection we have maintained the distinction Paul Gachet *fils* made between works "by Pissarro, Cézanne, Guillaumin, Renoir, Monet, Sisley, and especially Van Gogh" that were valued by artists and connoisseurs (see the Summary Catalogue) and other artworks that were known only to "a few old friends who could appreciate their simplicity and curious origins." As his son reminds us in the excerpt that follows, Dr. Gachet did not limit himself to collecting "Impressionist Painting—including Vincent" but had "encyclopedic aspirations"; or, one might say, eclectic tastes.

The younger Gachet's description of his father's possessions, reprinted below, does not pretend to be in any order either chronological, alphabetical, or by historical importance. This makes it somewhat hard to follow but probably gives the truest sense of the assorted mix of artworks and "souvenirs"; indeed, the text's unedited character invites comparison with the contents of the collection itself. The nonhierarchical listing of the items owned by Dr. Gachet effectively conveys his son's point, which is that all these works, whether by known artists or by those "completely forgotten," were of value to their owner.

Following the description we provide a checklist of the artists and works in the collection.

SAS

From *Deux amis des Impressionistes**

PAUL GACHET

Ultimately, the doctor-artist is still ranked—especially today—among the "collectors."

Already during his lifetime, Paul Alexis, Hoschedé, and Tabarant had, in friendship and without further explanation, bestowed on him that *label*, really the only thing that prepared for his fragile renown.

It is valid but at the same time false and inadequate, for by implicitly limiting *the collecting* to Impressionist Painting—including Vincent—it creates, *ipso facto*, some "exclusions" that give his passion a false air of moral speculation, which is not the case.

Being badly informed, the critics could not accurately treat this question, which—as always with Gachet—takes some peculiar and often complex turns.

At that time—as indeed in all times—a *Collector* was a wealthy individual, whether knowledgeable or not, a sincere admirer or a mere speculator, motivated by idleness or by vanity; but possessing the resources to acquire works that are costly, beautiful, or rare.

This was not the case with Dr. Gachet, who was never wealthy.

In that, he reminds us of Vincent: the Vincent who was a fervent collector of illustrated documents, which constituted for him—at the beginning—a kind of *contemporary* artistic encyclopedia, quite rare for artists even of his generation.

But the doctor, who was better off, did not limit himself to documentary illustrations, though he admired them.

For him, *collecting* was a passion that was almost hereditary, instinctive, spontaneous, often dependent on circumstance.

In general, the child breaks and demolishes even the things that amuse him; the young Paul, on the contrary, loved, cared for, and preserved what people gave him.

Later he discovered a curious side to everything, an interesting character, even when he didn't know the object's price or value.

Circumstances often put him on the trail of artists, but his encyclopedic aspirations kept him from limiting himself to a single form of beauty, to one kind of interest: he broadened his collection.

Whatever the case, we must, in this regard, eradicate the word *speculation* and leave aside *"collector's nose"* and *"on the watch"*—terms not only offensive but contrary to the truth.

In that *lunatic* house—as Coquiot said of Dr. Gachet's residence, which he *knew nothing about*—one could nonetheless ponder an important Landscape by *Van Coxie* (a souvenir of a stay in Malines [Belgium]), a handsome panel by *Klas Molenaer*, Flowers by *Nicolas Boschaert*, a

Shipwreck by *Peters Bonaventure*, two curious marine views by *Pieter Vogelaer*, and two beautiful Van Helmonts.

Some *Cows in Pasture* by *Van Stry* hung next to a *Bull* by *Brascassat*.

Since the Collector had a weakness for portraits, we can cite, among so many others, a very good portrait of a man by *Zuberlein*, a very curious portrait of Hortense Mancini attributed to *Joseph Werner*, two beautiful pastels by *Louis Vigée*, a portrait of a man painted by Meyer (18th century), and two by *Heinsius* (1810).

Two odd figures, composed of fruits, are attributed to *Guiseppe* [sic] *Arcimboldo*, and a very good old copy depicts Titian's *Salome*.

These are only a few names among many, *Anonymous and without official value* but constituting so many interesting documents, done with an honest and very honorable technique.

With the contemporaries, it is the life of the "collector" himself that is illustrated, by works almost all of which were offerings of friendship. Well before the Impressionists, the names of his artist friends—even if they are completely forgotten today—figured prominently on the list: Souchon, Detrez, Lobbedez, Schanne, Daumier, Ed. Sain, Guigou, Bonvin, Monticelli, De Los Rios, Célestin Nanteuil, Oller, Quost, L. Latouche, de Specht, Piette, Beauverie, Daubigny, Perret, Delpy, Viollet-le-Duc, Goeneutte, Giran-Max, Émile Bernard, Loiseau, Murer, Buhot, Thévenot, Léandre, Cordey.

All of them, or nearly all, are represented in the Gachet Collection, not by a dearly bought work but by one given as a humble token of fellowship or gratitude.

For the drawings and prints, apart from numerous older pieces, certain names recur among the Contemporaries and the Moderns: Daumier, Bresdin, Régamey, Desboutin, Buhot, Rajon, Guérard, André Proust, Goeneutte, Taiée, Paillard, Decisy, Émile Bernard, Chahine, and Osterlind, to whom we must now add the names of the Impressionist painter-printmakers, some of whose beautiful proofs were to P. van Ryssel [Dr. Gachet] a delight: Manet, Pissarro, Guillaumin, and Cézanne.

Moreover, they go very well with Méryon, Jongkynd, Fantin-Latour, Edmond Morin, Charles Maurin, and Auguste and Eugène Delatre.

If the name of Amand Gautier does not figure in the above lists, it is because his paintings and prints—very important in the Gachet Collection—are the subject of a special catalogue[1] that reminds us that the doctor was the painter's useful and helpful friend well in advance of his rich collectors, Gustave Félu and Gaudibert.

As for Vincent, he who once knew how to give an interesting physiognomy to a pair of old shoes, to some flasks, glasses, or birds' nests, he had at his disposal, in the Gachet household, a host of *more elevated* objects on which to apply his final technique: apart from two or three pieces, he ignored the rest almost entirely.[2]

When it came to prints, he did not speak at all of his own etching and singled out—in quite different ways—only two prints: a *Portrait of Auguste Comte* by Bracquemond, which he considered a masterpiece, and *The Cows*, an etching by P. van Ryssel, which so *carried him away* that he transposed it onto canvas to end up with the fantastic composition visible today at the Musée de Lille, not far from the painting by Jordaens, the original model.

In reality, Vincent, in Auvers, did not know the collections of Dr. Gachet that would so greatly have interested him several years earlier.

Apart from his Impressionist paintings, all the collections formed by the doctor have remained unknown, except by a few old friends who could appreciate their simplicity and curious origins.

The old and contemporary paintings, the prints, posters, books, ceramics, copperware, pewters, ironware, plasters, Barye bronzes, periodicals illustrated or not, fabrics, old furniture, and various art objects made up an important body of documentation and an inexhaustible source of studio materials, which several of P. van Ryssel's friends and students made use of even more than he did.

But the paintings by Pissarro, Cézanne, Guillaumin, Renoir, Monet, Sisley, and especially Van Gogh soon constituted the only collection known—first by artists and foreign collectors.

Mme Theodore van Gogh was not mistaken when she wrote that Dr. Gachet would *last* primarily as the collector and friend of Vincent: indeed, after Cézanne, it was Vincent who launched the venerable and silent renown of their doctor friend.

* See Gachet 1956a, pp. 135–38.

1. "Paul Gachet, Catalogue raisonné des oeuvres d'Amand Gautier formant la collection de son ami le Dr P. Gachet" (unpublished), Auvers, 1928. See also "Lettres du peintre Amand Gautier à son ami le Dr P.-F. Gachet" (unpublished), Auvers, 1940.

2. The three pieces were a pewter pot, a goblet, and a Japanese stoneware vase. We might also add the piano, which appears only in the portrait of Mlle Gachet.

Checklist of Artists and Works in the Gachet Collection

JULIE STEINER

This list serves as an index to the artists and works that Paul Gachet *fils* mentioned in writings as having belonged to his father's collection or that additional sources indicate were represented in the Gachet collection.[1] The checklist supplies full names and life dates for the less elusive artists and further information about the artworks, when known.

All works designated VGM—that is, in the collection of the Van Gogh Museum, Amsterdam—belong to a group of drawings, prints, and copies purchased in 1966 from the dealer Curt Valentien, Stuttgart, who had acquired them from the estate of Gachet *fils*. Abbreviations used are explained in the reader's note to the Summary Catalogue.

For a more comprehensive sense of Gachet's holdings, the present checklist should be supplemented by the information given in the 1993 Hôtel Drouot catalogue, which names over one thousand prints and drawings that were sold from the Gachet collection.[2] Some of these, however, were probably personal acquisitions made by Paul Gachet *fils*.

Adrion, Lucien (French, 1889–1953)
Six Nude Studies of Women, drawing; VGM (D573 V/1966)

Andreas, Ernest-André (French, 1868–1899)
Standing Woman and *Woman on a Balcony*, pastels; VGM (D455, 456 V/1966)
Lithograph; VGM (P270 V/1966)

Arcimboldo, Giuseppe, attributed to (Italian, 1527–1593)
Listed as represented in the collection: "two curious figures, made of fruit" (Gachet 1956a, p. 137)

Barcinski, Casimir
See Portraits, p. 33.

Bargue, Charles (French, 1825/26–1883)
Lithograph; VGM (P223 V/1966)

Beauverie, Charles-Joseph (French, 1839–1924)
Listed as represented in the collection (Gachet 1956a, p. 137)

Bernard, Émile (French, 1868–1941)
See fig. P18.
Additional prints: see Drouot 1993, nos. 218, 293–96.

Bin, Émile (French, 1825–1897)
Listed as an artist with whom Dr. Gachet exchanged etchings (Gachet 1956a, p. 77)
See *Still Life*, painting (Gachet 1956a, fig. 44, p. 84; possibly from Gachet's collection).

Blanche, Jacques-Émile (French, 1861–1942)
Lithograph; VGM (P222 V/1966)

Bonaventure, Peters
Listed as represented in the collection: *Shipwreck* (painting?) (Gachet 1956a, p. 136)

Bonvin, François (French, 1817–1887)
Listed as represented in the collection: *Cat* (probably an engraving?) (Gachet 1956a, p. 39; see also p. 137)

Bosschaert, Jean-Baptiste (Flemish, 1667–1746)
Listed (as Nicolas Boschaert) as represented in the collection: paintings of flowers (Gachet 1956a, p. 136)

Bouilly, Joseph (French, 1831–1894)
Listed among artists from whom Dr. Gachet received gifts (Gachet 1956a, p. 79)

Bourgeois, Alfred (French, 19th century)
See fig. AD8.

Bourges, Léonide-Pauline-Élisa (French, 1838–1909)
See Gachet 1956a, p. 73, and Drouot 1993, no. 297 (drawings and prints dedicated to Dr. Gachet).

Bouvenne, Aglaüs (French, 1829–1903)
Listed as an artist with whom Dr. Gachet exchanged etchings (Gachet 1956a, p. 77)

Bracquemond, Félix (French, 1833–1914)
Portrait of Auguste Comte, after Joseph Guichard, 1851, etching; 18.8 x 13.5 cm
REFERENCES: Gachet 1956a, p. 138; Bouillon 1987, pp. 138–39, repr.

LETTER: LT 638
Additional prints; VGM (P149–51 V/1966)

Brascassat, Jacques-Raymond (French, 1804–1867)
Listed as represented in the collection: *Bull* (Gachet 1956a, p. 137)

Bresdin, Rodolphe (French, 1822–1885)
Listed as represented in the collection (Gachet 1956a, p. 137; see also Gachet 1954a, n.p., where Dr. Gachet's friendship with the artist is described)

Buhot, Félix-Hilaire (French, 1847–1898)
Listed as represented in the collection (Gachet 1956a, p. 137)

Burne-Jones, Edward (English, 1833–1898), after
Lithograph; VGM (P224 V/1966)

Carabin, Rupert (French, 1862–1952)
This recently "rediscovered" Art Nouveau sculptor, who exhibited with the Indépendants, was a friend of the two Paul Gachets. A drypoint by Blanche Derousse (VGM, P187–89 V/1966) reproduces a decoration from a stairway railing in the shape of a crouching woman, of which one version exists in the Musée Félix Ziem, Martigues; see also the plaster ornaments on the mantelpiece at Auvers, visible in fig. 18.

Cézanne, Paul (French, 1839–1906)
See Summary Catalogue, P.G. II-1–42 and unnumbered prints that follow.
See also **Clodion**.

Chahine, Edgar (French, 1874–1947)
Listed as represented in the collection (Gachet 1956a, p. 137)

Checa y Sanz, Ulpiano (Spanish, 1860–1916)
Print; VGM (P225 V/1966)

Clodion, Claude-Michel (French, 1738–1814)
Naiads and *Triton with Conch*, low-relief sculptures, polychromed by Paul Cézanne; 19 x 46 cm and 18 x 36 cm

PROVENANCE: Dr. Paul Gachet, Auvers; Marius Delpiano collection sale, Galerie Robiony, Nice, April 21–22, 1965, no. 462, as ex coll. Paul Gachet; sale, Versailles, Dec. 3, 1995, no. 116; acquired by the Conseil Général du Val d'Oise

Cordey, Frédéric-Samuel (French, 1854–1911)
Listed as represented in the collection (Gachet 1956a, p. 137)

Courbet, Gustave (French, 1819–1877)
Amand Gautier, 1867, oil on canvas, 55 x 46.5 cm; Musée des Beaux-Arts, Lille
PROVENANCE: Acquired from Wildenstein, Paris, by Paul Gachet *fils*, ca. 1952, and donated to the Musée des Beaux-Arts, Lille, 1952
REFERENCES: Chatelet in Paris 1954–55, no. 26; Fernier 1977–78, no. 624

Coxie, Anthonie van
(Flemish, after 1650–1720)
Listed as represented in the collection: "An important landscape—remembrance of a stay in Malines" (Gachet 1956a, p. 136)

Daubigny, Charles-François
(French, 1817–1878)
Listed as represented in the collection (Gachet 1956a, p. 137)

Daumier, Honoré (French, 1808–1879)
Madame Honoré Daumier (formerly *The Artist's Mother*), ca. 1863–66, oil on canvas, 34 x 28 cm, inscribed on reverse of stretcher in Dr. Gachet's hand: H. Daumier (sa mère)
PROVENANCE: Said to have been given by Daumier to Dr. Gachet, after 1872, when the artist moved to Valmondois, until 1909; sold by Paul Gachet *fils* to Louis Sergent, ca. 1950; present location unknown
REFERENCES: Sergent 1950 (sitter identified as the artist's mother); Adhémar 1954, no. 152; Cherpin 1972, pp. 30, 74 n. 15 (as a "portrait of Daumier's mother or wife")

Profile of a Man, pen with brown and black wash; 15.3 x 13.7 cm; location unknown (formerly J.-P. Sergent, Paris)
REFERENCES: Gachet 1956a, fig. 12; Maison 1968, no. 78, pl. 13

Additional prints: see Drouot 1993, nos. 202–16, prints after no. 217.

Decisy, Eugène (French, 1866–1936)
Listed as an artist with whom Dr. Gachet exchanged etchings (Gachet 1956a, pp. 77, 136–37)

Delacroix, Eugène (French, 1798–1863)
Hamlet Contemplating the Head of Yorick, 1828, lithograph. Copied by Cézanne: see Summary Catalogue, P.G. II-21 (R 232), II-41 (Chappuis 325), II-42 (Chappuis 326).

PROVENANCE: Given by Amand Gautier to Dr. Gachet [?–1909]; Paul Gachet *fils*, until his death in 1962; possibly included in one of two lots of lithographs after Delacroix in the sale "Collection du Docteur Gachet" (see Drouot 1993, nos. 218, 225)
REFERENCE: Chappuis 1973, fig. 49
COMMENTS: On Nov. 20, 1954, and Dec. 4, 1955, Paul Gachet *fils* listed this lithograph among works he intended to give to the Musée du Louvre "in case of sudden death," but this intention was not realized (VGM Archives).

Listed as an artist represented in the collection by drawings (Gachet 1956a, p. 79)

Delâtre, Eugène (French, 1864–?)
Print; VGM (P165 V/1966)

Delpy, Hippolyte-Camille (French, 1842–1910)
See Summary Catalogue, P.G. I-24.

Derousse, Blanche (French, 1875–1911)
See cat. no. 53 and Checklist of Copies.
Numerous drawings; VGM (D460–62, 507, 508, 575–82 V/1966)
Prints; VGM (P161–64, 166–213, 215–18 V/1966)
Additional prints: see Drouot 1993, no. 298.

Deroy, Auguste-Victor (French, ca. 1825–1906)
Two etchings, invitations to meetings of the Éclectiques, dedicated to Dr. Gachet; private collection
COMMENTS: These prints are part of a group of thirteen etchings by minor or unknown artists (G. Horscher, A. Ringotz?) bearing dedications to Dr. Gachet and now in a private collection. Undoubtedly, the Gachet collection included many drawings and prints by little-known artists and contemporaries of Dr. Gachet that were not part of the Drouot 1993 sale but were probably dispersed from the estate of Paul Gachet *fils* after his death in 1962.

Desboutin, Marcelin-Gilbert (French, 1823–1902)
Madame Horace de Callias, 1879, drypoint, signed and inscribed: à mon ami Gachet
REFERENCE: Gachet 1956a, p. 45; also see p. 137.

Detrez, Ambroise (French, 1811–1863)
See fig. 20.
Listed as an artist represented in the collection by a watercolor (Gachet 1956a, p. 39; see also p. 137)

Duvivier, Albert (French, 1842–?)
Listed as an artist with whom Dr. Gachet exchanged etchings (Gachet 1956a, p. 77)

Fantin-Latour, Henri (French, 1836–1904)
Prints; VGM (P226–29 V/1966)

Forain, Jean-Louis (French, 1852–1931)
Listed as an artist with whom Dr. Gachet exchanged etchings (Gachet 1956a, p. 77)

Frère, Charles-Théodore (French, 1814–1888)
Listed as represented in the collection (Gachet 1956a, p. 79)

Fugère, Henry (French, 1872–1944)
See Portraits, p. 33.

Gabriel, (Paul-Joseph-Constantin?)
(Dutch, 1828–1903)
Listed as an artist with whom Dr. Gachet exchanged etchings (Gachet 1956a, p. 77)

Gauguin, Paul (French, 1848–1903)
Although Dr. Gachet did not know the artist personally, a zincograph, *Baigneuses bretonnes*, 1889, annotated "exemplaire de Van Gogh," was sold at the "Collection du Docteur Gachet" sale (Drouot 1993, no. 307, repr.).

Gautier, Amand-Désiré (French, 1825–1894)
The unpublished "Catalogue raisonné des oeuvres d'Amand Gautier formant la collection de son ami le Dr P. Gachet" by Paul Gachet *fils* lists 62 paintings, 40 watercolors, a pastel, and numerous drawings and prints. Some of these works must have been purchased from the Parisian dealer Pierre-Firmin Martin (Gachet 1994, p. 93) and others from a sale organized by the artist (Hôtel Drouot, Paris, March 2, 1872). See figs. 19, 21, 22. Other notable examples are:

The Reader, oil on canvas, copied by Blanche Derousse (copy exhibited 1905, Societé des Artistes Indépendants, no. 1210)

Asiatic Cholera in the Jura; see fig. 23.
REFERENCE: Gachet 1956a, p. 18, fig. 10

Madwomen of La Salpêtrière; Patients' Courtyard, Fifth Division, ca. 1855 (after his painting for the Salon of 1857), lithograph
REFERENCES: Doiteau 1923 (repr.); Gachet 1956a, p. 39

The Princess of La Salpêtrière, lithograph; Wellcome Museum of Medical Science, London (Gachet 1956a, p. 19)

Additional prints: see Drouot 1993, nos. 299, 300.

Prints after Gautier
Portrait of Professor Falret, after a drawing by Gautier (Gachet 1956a, p. 18)
See also under Vernier.

Gill, André (French, 1840–1885)
Listed as an artist with whom Dr. Gachet exchanged etchings (Gachet 1956a, p. 77)

Giran-Max, Léon (French, ?–1927)
Listed as represented in the collection (Gachet 1956a, p. 137)
Murer at Work and *Old Woman with a Prayer Book*, drawings; VGM (D500, 510 V/1966)
According to Faille 1930 (*Les faux van Gogh*), p. 42, all the drawings numbered FF 165–74 can be attributed to this artist.

Godmer, Émile (French, 1839–1892)
See Portraits, p. 33.

Goeneutte, Norbert (French, 1854–1894)
See figs. 28, 29.
The Beautiful Flower Vendor, ca. 1888 or earlier, pastel, 55 x 45 cm, signed, dated, and inscribed lower left: À son ami le docteur Gachet/ Norbert Goeneutte/1888. Musée du Petit Palais, Paris (Paul Gachet *fils* donation to the Musée du Louvre, Paris, 1955; entered Petit Palais 1958)

Prints: four prints in the Bibliothèque Nationale de France, Paris, Paul Gachet *fils* donation, 1953 (see Portraits, figs. 00, 00, n. 9); VGM (P214, 219, 220 V/1966)

Additional prints: see Drouot 1993, nos. 301, 302.

Gogh, Vincent van (Dutch, 1853–1890)
See Summary Catalogue, P.G. III-1–41 and unnumbered works that follow.

Gonzalès, Éva (French, Mme Henri Guérard, 1849–1883)
See Summary Catalogue, P.G. I-19–20.

Guérard, Henri-Charles (French, 1846–1897)
Listed as an artist with whom Dr. Gachet exchanged etchings (Gachet 1956a, pp. 77, 136–37)

Guigou, Paul-Camille (French, 1834–1871)
Dr. Gachet purchased some thirty oil sketches by Guigou at the posthumous sale of the artist's studio in 1872 (Daulte 1960, pp. 70–72; Miquel 1985, p. 279), probably as part of lot 14: "Approximately 230 paintings and studies after nature, for the most part representing sites of Provence" (*Tableaux, études d'après nature, aquarelles, fusains, croquis, eaux-fortes, etc. laissés par feu Paul Guigou, Paysagiste*, March 22, 1872, Hôtel Drouot, Paris). He is also said to have purchased Guigou sketches from the dealer Pierre-Firmin Martin, Paris (Gachet 1994, p. 93). Gachet *fils* referred to these works as "curious little panels—which [Dr. Gachet] regards as even more characteristic than his best canvases" (Gachet 1956a, p. 28). The Paris dealer Alfred Daber later bought them from Gachet *fils* (Miquel 1985 p. 279), presumably before 1950, when many of them were exhibited.

In two catalogues raisonnés, Bonnici 1989 and Lamort de Gail 1989, nineteen small-scale oil studies from the Gachet collection are catalogued, largely landscapes from about 1860–65. The locations of almost all of them are unknown. The works are listed here in order of Bonnici catalogue number:
The Farmhouse behind the Trees: Miquel 1985, p. 278; Bonnici 16; Lamort de Gail 12
Study of Trees: Twilight: Bonnici 17; Lamort de Gail 215
Forest Path, Seaside: Bonnici 40; Lamort de Gail 18
Landscape: Meadow Bordered with Trees: Bonnici 55
L'Estaque: Bonnici 59
Path on the Hill: Bonnici 64; Lamort de Gail 33
The Nerthe Path (or *Peasant Woman on the Road*): Rowland, Browse and Delbanco collection, London; Bonnici 65
Harnessed White Horse by a Tree: Bonnici 69
Village in a Hilly Landscape: Bonnici 70
Meadow with Trees at the Foot of the Mountains: Bonnici 71; Lamort de Gail 213
La Durance, Flowing on the Banks: Bonnici 78
Port of Marseilles, Dock with Setting Sun: Bonnici 88; Lamort de Gail 218
Port of Marseilles, Dock with Setting Sun: Bonnici 88 bis
The Artist's Dog Curled in a Ball: Bonnici 106
Two Studies of a Dog: Bonnici 107 bis
Thatched Cottage at Sunset—Île de France: Bonnici 117
Washerwomen on the Banks of the Loire at Moret, Seine-et-Marne: Bonnici 169; Lamort de Gail 108
Fruit Harvest: Bonnici 357
Fields and Trees, Autumn Study: private collection, Great Britain; Lamort de Gail 209

Guiguet, François-Joseph (French, 1860–1937)
Print; VGM (P230 V/1966)

Guillaumin, Jean-Baptiste-Armand (French, 1841–1927)
See Summary Catalogue, P.G. IV-1–34 and unnumbered works that follow.

Guillemet, Jean-Baptiste-Antoine (French, 1843–1918)
Listed as represented in the collection (Gachet 1956a, p. 79)

Guys, Constantin (French, 1802–1892)
See Summary Catalogue, P.G. I-22, 23.

H.G. (?)
Print; VGM (P153 V/1966)

Heinsius, Johann Ernst (German, 1740–1812)
Hippolyte Gabriel Joseph Merché-Marchand, Engraver and Maker of Heraldry, 1810, oil on canvas, 64 x 54 cm; Musée des Beaux-Arts, Lille, Paul and Marguerite Gachet donation, 1946 (RF 1946-11)
REFERENCE: Gachet 1956a, p. 137

Madame Merché-Marchand, 1810, oil on canvas, 64 x 54 cm; Musée des Beaux-Arts, Lille, Paul and Marguerite Gachet donation, 1946 (RF 1946-12)
REFERENCE: Gachet 1956a, p. 137

Helmont, Mattheus van (Flemish, 1623–after 1679)
Listed as represented in the collection by two paintings: "two beautiful Van Helmonts" (Gachet 1956a, p. 136)

Jongkind, Johan Barthold (Dutch, 1819–1891)
Listed as represented in the collection (Gachet 1956a, p. 138)

Kono, Micao (Japanese)
See Portraits, p. 33.

Latouche, Louis (French, 1829–1884)
Listed as represented in the collection: "paintings by Louis Latouche (who sold colors to [Gachet], as he did to Gautier and Pissarro)" (Gachet 1956a, pp. 79, 137)

Lavieille, Jacques-Adrien (French, 1818–1862)
Prints; VGM (P245–54 V/1966)

Léandre, Charles-Lucien (French, 1862–1930)
See fig. 27.

Legrand, Louis-Auguste-Matieu (French, 1863–1901)
Print; VGM (P154 V/1966)

Lemoine, Edmond (French, 19th century)
See Portraits, p. 33.

Letourneau, Édouard (French, d. 1907)
See Portraits, p. 33.

Lobbedez, Charles-Auguste-Romain (French, 1825–1882)
Listed as represented in the collection by at least one painting (Gachet 1956a, pp. 79, 137)

Loiseau, Gustave (French, 1865–1935)
Listed as represented in the collection (Gachet 1956a, p. 137)

Longuet, Jules
Woman, black ink and watercolor on paper, 32 x 17 cm; VGM (D587 V/1966)
REFERENCE: Van Uitert and Hoyle 1987, no. 2.733

Los Rios, Ricardo de (Spanish, 1846–1929)
Listed as represented in the collection (Gachet 1956a, pp. 79, 137)

Manet, Édouard (French, 1832–1883)
Le fleuve (*The River*), series of printed illustrations for the book of that title by Charles Cros (Richard Lesclide, ed., Paris, 1874); dedicated: à mon ami le Dr Gachet
REFERENCES: Guerin 1944, no. 63; Gachet 1956a, p. 63 (as a gift from Manet to Dr. Gachet); Harris 1970 no. 79

Le corbeau (*The Raven*), series of five printed illustrations for the poem by Edgar Allan Poe, translated by Stéphane Mallarmé (Richard Lesclide, ed., Paris, 1873); dedicated: à mon ami le Dr Gachet
REFERENCES: see Guerin 1944, nos. 84–86; Gachet 1956a, p. 63 (as a gift from Manet to Dr. Gachet); Harris 1970, no. 83
LETTER: Paul Gachet *fils* to Edward Buckman, Oct. 25, 1949 (VGM Archives)

Portrait of Courbet, transfer lithograph, dedicated: à mon ami le Dr Gachet; Musée Gustave Courbet, Ornans
REFERENCE: Gachet 1956a, p. 63 (as a transfer lithograph [of Rouart and Wildenstein 1975, no. 477] given by Manet to Dr. Gachet)

Maurin, Charles (French, 1856–1914)
Listed as represented in the collection (Gachet 1956a, p. 137)

Méryon, Charles (French, 1821–1868)
San Francisco, 1855–56, etching, 24 x 99.8 cm
REFERENCES: Gachet 1956a, p. 30 (notes that the artist gave an impression of this print to Amand Gautier, who later gave it to Gachet); Schneiderman 1990, no. 54
Dr. Gachet already owned works by Méryon by July 20, 1861, when the artist offered him two Parisian landscape etchings (see letter reprinted in Gachet 1957a, p. 181; see Schneiderman 1990, p. 211, for Méryon's Parisian landscape series). A year later, Méryon also offered Dr. Gachet a chance to purchase the print *Pont-au-Change* (see Schneiderman 1990, nos. 40, 52) for 10 francs; it is not known which, if any, of these other works Gachet acquired (letter from Méryon to Dr. Gachet, March 14, 1862, reprinted in Gachet 1957a, pp. 182–83). Dr. Gachet's friendship with the artist is described in Gachet 1954a, p. 9.

Meyer, Alfred (French, 1832–1904)
Anatomical Study and *Seated Woman Seen in Left Profile*, drawings; VGM (D583, 512 V/1966)
Listed as an artist from whom Dr. Gachet received gifts: *Portrait of a Man* (Gachet 1956a, pp. 79, 136–37)

Molenaer, Klaes (Dutch, 1630–1676)
Listed as represented in the collection: "a pretty panel" (Gachet 1956a, p. 136)

Monet, Claude (French, 1840–1926)
See Summary Catalogue, P.G. I-14, 15.

Monticelli, Adolphe-Joseph-Thomas (French, 1824–1886)
See Summary Catalogue, P.G. I-21.

Morin, Charles-Camille (French, 1846–1919)
Landscape near Auvers, oil on canvas, 24 x 33 cm; VGM (S334 V/1966)
REFERENCE: Van Uitert and Hoyle 1987, no. I.318

Landscape, ca. 1911, oil on canvas, 38 x 46 cm signed lower right: Morin; inscribed on stretcher: à Mlle Gachet; VGM (S335 V/1966)
REFERENCE: Van Uitert and Hoyle 1987, no. I.319

Landscape, ca. 1909, oil on canvas, 46 x 55 cm, inscribed on stretcher: à Mlle Gachet de la part de Morin, 24 Nov. 1909; VGM (S349 V/1966)
REFERENCE: Van Uitert and Hoyle 1987, no. I.320

Morin, Edmond (French, 1824–1882)
Listed as an artist with whom Dr. Gachet exchanged etchings (Gachet 1956a, p. 77)

Mouclier, Marc-Marie-Georges (French, 1866–1948)
Print; VGM (P232 V/1966)

Murer (Eugène-Hyacinthe Meunier) (French, 1841–1906)
See cat. no. 51.

Drawings in VGM: *Portrait of Jeanne* (D464 V/1966), *Two Nudes in a Landscape* (D465 V/1966), *Jack, with Oranges* (D466 V/1966), *Woman Listening* (D467 V/1966), *City and Countryside* (D468 V/1966), *Traveler in a Forest* (D469 V/1966), *Landscape* (D470 V/1966), *View of the Sea with City and Sailboats* (D471 V/1966), *Vase with Flowers* (D472 V/1966), *Jack on the Balcony* (D473 V/1966), *Jeanne* (D474 V/1966), *Walking Man with Hand in His Pocket* (D501 V/1966), *Standing Man with Hand in His Pocket* (D502 V/1966), *Man with a Staff, with Weight over His Shoulder* (D503 V/1966), *Five Figures Carrying Weights* (D504 V/1966), *Man and Woman Carrying Branches* (D505 V/1966), *Woman Standing Next to a Tree* (D513 V/1966), *Head of a Woman* (D514 V/1966), *Standing Woman* (D515 V/1966), *Figure Carrying Weight over Shoulder* (D516 V/1966), *Three Figures Carrying Weights on Their Shoulders* (D517 V/1966), *Boat on a Shore* (D584 V/1966), *Fisherman by the River* (D585 V/1966; Van

Uitert and Hoyle 1987, no. 2.746), *Murer's House* (D586 V/1966)
Gouache: see Drouot 1993, no. 311.
Prints; VGM (P233, 234 V/1966)

Nanteuil, Célestin (French, 1813–1873)
Listed as represented in the collection (Gachet 1956a, p. 137)
Prints; VGM (P155, 235, 236 V/1966)
Additional prints: see Drouot 1993, nos. 218, 225.

Nanteuil, Paul (French, 1837–?)
Listed as an artist with whom Dr. Gachet exchanged etchings (Gachet 1956a, p. 77)

Nittis, Giuseppe de (Italian, 1846–1884)
Print; VGM (P156 V/1966)

Oller y Cestero, Francisco (Puerto Rican, 1833–1917)
See Summary Catalogue, P.G. I-25.

Osterlind, Anders (French, 1887–1960)
Listed as represented in the collection (Gachet 1956a, p. 137)

Outin, Pierre (French, 1840–1899)
See cat. no. 52.

Paillard, Henri-Pierre (French, 1844–1912)
Listed as an artist with whom Dr. Gachet exchanged etchings (Gachet 1956a, pp. 77, 136–37)

Perret, Aimé (French, 1847–1927)
Listed as represented in the collection (Gachet 1956a, p. 137)

Piette, Ludovic (French, 1826–1877)
See Summary Catalogue, P.G. I-26, 27.

Piguet, Rodolphe (Swiss, 1840–1915)
See fig. 26.
Listed as an artist with whom Dr. Gachet exchanged etchings (Gachet 1956a, p. 77)

Pilon, Pierre (French, 1824–1912)
Bathers, oil on paper lined with canvas, 49 x 60 cm
PROVENANCE: Possibly purchased from the artist by Dr. Paul Gachet, Auvers, ca. 1895; sold by Paul Gachet *fils* to Wildenstein, Paris and New York, before 1954
REFERENCES: Paul Gachet, *Un peintre méconnu, Pierre Pilon* (Paris, 1953); Chatelet in Paris 1954–55, no. 84; Gachet 1956a, pp. 74, 130 (recounts that Dr. Gachet took an interest in Pilon's work at the Société Française Artistique de Pontoise, about 1895, and purchased several paintings from him)

Pirodon, Louis-Eugène or **Eugène-Louis** (French, 1824–?)
Listed as an artist with whom Dr. Gachet exchanged etchings (Gachet 1956a, p. 77)

Pissarro, Camille (French, 1830–1903)
See Summary Catalogue, P.G. I-1–13 and unnumbered prints that follow.

Pissarro, Lucien (French, 1863–1944)
Print: see Drouot 1993, no. 314 (this work was possibly given to Dr. Gachet by Lucien Pissarro about 1891 in exchange for a proof of the Van Gogh etching P.G. III-a [F 1664]; see Gachet 1957a, pp. 51–52).

Proust, André
Listed as represented in the collection (Gachet 1956a, p. 137)

Quost, Ernest (French, 1844–1931)
Listed as represented in the collection by still lifes "of which Vincent knew, and admired the flowers" (Gachet 1956a, p. 79; see also p. 137)

Raffet, Auguste (French, 1804–1860)
Napoleon at Saint-Jean d'Acre, oil on canvas, 37.5 x 45.7 cm
PROVENANCE: Acquired from Gachet *fils* by a private collector, 1953

Rajon, Paul-Adolphe (French, 1843–1888)
Listed as represented in the collection (Gachet 1956a, p. 137)

Rassenfosse, André-Louis-Armand (Belgian, 1862–1934)
Prints; VGM (P157, 271 V/1966)

Redon, Georges (French, 1869–1943)
Print; VGM (P237 V/1966)

Régamey, Félix-Élie (French, 1844–1931)
Listed as an artist with whom Dr. Gachet exchanged etchings (Gachet 1956a, pp. 77, 136–37)

Régamey, Frédéric (French, 1849–1925)
Listed as an artist with whom Dr. Gachet exchanged etchings (Gachet 1956a, pp. 77, 136–37)
See Portraits, p. 33.
See Gachet 1956a, fig. 37, *Le Dr P. F. Gachet des "Éclectiques,"* 1875, chalk (?), possibly ex coll. Gachet, and an etching for "Les Chats de Gachet" album (Gachet 1956a, p. 65), for which Gachet may have owned proofs.

Rembrandt Harmensz van Rijn (Dutch, 1606–1669)
See "Paul Gachet *fils* Remembered," p. 272; and see Drouot 1993, no. 88.

Renoir, Pierre-Auguste (French, 1841–1919)
See Summary Catalogue, P.G. I-16, 17 and unnumbered print that follows.

Rivelin, L.
Prints; VGM (P238 V/1966, P239 V/1966)

Robin, Léopold (French, 19th century)
See fig. 12 and Portraits, p. 33.

Portrait of Blanche Derousse, 1903, charcoal (Gachet 1956a, fig. 61; possibly ex coll. Gachet)

Wheat Sheaves, watercolor; VGM (D589 V/1966)
REFERENCE: Van Uitert and Hoyle 1987, no. 2.770

Old Cottages at Chaponval, 1903, watercolor; VGM (D590 V/1966)
REFERENCE: Van Uitert and Hoyle 1987, no. 2.771

"Rue des Vessenots" at Auvers, drawing; VGM (D535 V/1966)
REFERENCE: Van Uitert and Hoyle 1987, no. 2.769

Additional drawings in VGM: *Portrait of a Woman* (D531 V/1966), *Head of a Man* (D532 V/1966), *Seated Male Nude* (D533 V/1966), *Woman at the Piano* (D534 V/1966), *Rue des Vessenots, Auvers* (D535 V/1966), *Rue Victor Hugo, Chaponval* (D588 V/1966)

Ruprecht, Erich
Schwartzwald, drawing; VGM (D536 V/1966)

Ryssel, Paul van (Dr. Paul-Ferdinand Gachet; French, 1828–1909)
See cat. nos. 41–46, and Checklist of Copies, and "Gachet, Father and Son," n. 100.
Additional works in public collections include:
Drawings; VGM (D774 V/1962; D518–30, 591–603, 753 V/1966; D806 V/1982)
Prints; VGM (P440–60, 462, 481 V/1962; P846, 847, S/1995)
For prints, see Gachet 1954; Adhémar and Lethève 1954, pp. 294–300.

Ryssel, Louis van (Paul-Louis Gachet; French, 1873–1962)
See fig. 30, cat. nos. 47–50, and Checklist of Copies.
Additional works in public collections include:
Prints; VGM (P461, 640 V/1962; P145, 272, 273 V/1966, P526 M/1988)
See also New York 1954, nos. 1–29; Drouot 1993, nos. 227–88, 290.

S.T. (?)
Print; VGM (P244 V/1966)

Sain, Édouard Alexandre (French, 1830–1910)
Listed as represented in the collection (Gachet 1956a, pp. 79, 136–37)

Sarolta
Print; VGM (P158 V/1966)

Schann, Alexandre (French, 19th century)
Study of a Woman, oil on canvas (Gachet 1956a, fig. 28, as by "Schanne," ex colls. Gachet and Doiteau; see also pp. 39, 137)

Seguin, Armand (French, 1869–1903)
Print; VGM (P159 V/1966)

Sisley, Alfred (French, 1839–1899)
See Summary Catalogue, P.G. I-18 and unnumbered print that follows.

Some, Yuki
See Portraits, p. 33.

Somm, Henry (French, 1844–1907)
Print; VGM (P221 V/1966)
Listed as an artist with whom Dr. Gachet exchanged etchings (Gachet 1956a, p. 77)

Souchon, François (?) (French, 1787–1857)
Listed as represented in the collection (Gachet 1956a, p. 137)

Specht, Wilhelm-Émile-Charles-Adolphe de (French, 1843–?)
See Portraits, p. 33.
Listed as an artist from whom Dr. Gachet received gifts (Gachet 1956a, pp. 79, 137)

Doctor Gachet, 1896, drawing (copied by Dr. Gachet; see Adhémar and Lethève 1954, vol. 8, p. 298, no. 80)

Figure Studies and *Female Nude*, drawings; VGM (D537, 538 V/1966)

Steinlen, Théophile-Alexandre (French, 1859–1901)
Lithograph, VGM (P240 V/1966)

Stry, (Jacob?) van (Dutch, 1756–1815)
Listed as represented in the collection: *Cows in the Pasture* (Gachet 1956a, pp. 136–37)

Taiée, Alfred or **Jean-Alfred** (French, 1820–?)
Listed as represented in the collection (Gachet 1956a, p. 137)

Thévenot, François (?) (French, 1856–?)
Listed as represented in the collection (Gachet 1956a, pp. 79, 136–37)

Thomsen, Constant (French, active 1887–1907)
See fig. 34.

Titian (Tiziano Vecelli) (Italian, ca. 1487–1576), after
Copy after *Salomé* (Gachet 1956a, p. 137)

Toulouse-Lautrec, Henri de (French, 1864–1901)
Hunting, ca. 1879–80, watercolor and pencil on paper, 29.2 x 21.9 cm, signed lower right with the artist's monogram; inscribed: d'après Princeteau; stamped lower left with red monogram
PROVENANCE: Dr. Paul Gachet, Auvers; Paul Gachet *fils*; Frank W. Packard, New York, 1971; sale, Sotheby's, New York, Feb. 17, 1999, no. 17
REFERENCE: Dortu 1971, vol. 6, pp. 472–73, no. A.80

Verner
View of Auvers-sur-Oise, watercolor on paper, 27 x 35 cm; VGM (D604 V/1966)
REFERENCE: Van Uitert and Hoyle 1987, no. 2.785

Vernier, Émile
Copy after Gautier, *Dr. Paul Gachet* (see fig. 19), lithograph, 42.5 x 15.5 cm; VGM (P241, 242 V/1966)
COMMENTS: This print has been dated about 1862, although Paul Gachet *fils* records that his father purchased an impression of the print from Vernier for 100 francs on Feb. 9, 1860 (see Chronology).

Vigée, Louis (French, 1715–1767)
Portrait of a Man, Waist-Length, pastel, 65 x 54 cm; Musée d'Orsay, Paris, Paul Gachet *fils* donation to Musée du Louvre, 1951 (RF 29 930)
REFERENCE: Gachet 1956a, p. 137

Portrait of a Woman, Waist-Length, pastel, 65 x 54 cm; Musée d'Orsay, Paris, Paul Gachet *fils* donation to Musée du Louvre, 1951 (RF 29 931)
REFERENCE: Gachet 1956a, p. 137

Vinçotte, Thomas-Jules, Baron de (Belgian, 1850–1925)
See "Gachet, Father and Son," n. 100.

Viollet-le-Duc, Adolph-Étienne (?) (French, 1817–1878)
Listed as represented in the collection (Gachet 1956a, p. 137)

Vogelaer, Pieter (Flemish, 1641–1720)
Listed as represented in the collection: "Two curious seascapes" (Gachet 1956a, p. 136)

Werner, Joseph, attributed to (Swiss, 1637–1710)
Listed as represented in the collection: "a very peculiar portrait of Hortense Mancini" (Gachet 1956a, p. 136)

Zuberlein (German, 1556–1607)
Listed as represented in the collection: *Portrait of a Man* (Gachet 1956a, pp. 136–37)

Anonymous Artists
Drawings in VGM (D447–54, 457, 463, 475–99, 506, 509, 539–72, 574 V/1966)
Prints in VGM (P144, 146–48, 160, 231, 243, 268, 269, 274–80, 282, 283 V/1966)
See also works after Burne-Jones, Gautier, Titian.

Additional Items
Donations to the Wellcome Museum of Medical Science, London (per Gachet 1956a, p. 19)
Assorted books, including a first edition of *L'auscultation médiate, l'atlas anatomique* by Vicq-d'Azyr, with anatomical engravings of the brain by Angélique Allais (née Briceau)
Laënnec stethoscope
Anatomical plates, drawings, and photographs, and human bones used in anatomy courses for artists taught by Dr. Gachet
Portraits of doctors
Models after heads of famous guillotined assassins, which Cézanne purportedly found very exciting in 1873
The medical satchel formerly belonging to the head doctor of the Garde Nationale
Various electrical apparatuses: "Ruhmkorff" bobbins, electromagnetic machines, "rhéophores," probes, speculums, forceps, etc.
Fifty-six signed letters from the patients of the fifth division at La Salpêtrière (1853–55)

For other donations, see "Gachet, Father and Son," n. 100.

1. The inventory taken after the death of Mme Gachet in 1875 (see pp. 289–91) lists approximately 160 paintings and a number of engravings found in the house. They are mentioned only as groups of works by room (e.g., two paintings in the vestibule, an un-numbered group of *toiles peintes* in the attic). Thus, although individual works cannot be identified, the inventory gives an idea of the scale of Gachet's collection at that date.

2. Some 300 lots of prints and drawings from the Gachet collection, by nearly 400 artists, were auctioned at the Hôtel Drouot, Paris, on May 15, 1993. They included works from the French, Italian, and Northern schools and ranged in date from the fifteenth to the twentieth century. In the interest of brevity, this checklist does not include the works whose ownership by Gachet is documented only by that sale. Readers are encouraged to consult the indexed sale catalogue, *Collection du Docteur Gachet, estampes et dessins* (Drouot 1993).

Summary Catalogue of Works by Major Artists

SUSAN ALYSON STEIN

With the assistance of Julie Steiner

Introduction: The Catalogue Raisonné by Paul Gachet *fils*

Paul Gachet *fils* prepared a catalogue of the most important contents of Dr. Gachet's collection. Never published, it consisted of at least six volumes, now in the archives of the Wildenstein Institute, Paris. Measuring 11 by 8¾ inches each, they are bound in red moroccan leather (except for the two Van Gogh volumes, which are dark blue), with marbled endpapers. Each volume has a title page hand printed in black and red calligraphic capital letters, followed by a second, typed title page. The entries are mostly typed and are accompanied by numbered photographs pasted on heavy paper.

One volume, devoted to the substantial holdings of works by Amand Gautier, is titled "Catalogue raisonné des oeuvres d'Amand Gautier formant la collection de son ami le Dr P. Gachet illustré de plusieurs reproductions" and dated "Auvers-sur-Oise 1928" (see the Checklist of Artists for a description of its contents). There is also an album entitled "Le Passé," in which the death announcements and funeral engravings related to Dr. Gachet's death in 1909 are bound together. The other volumes are dedicated to the core collection of nineteenth-century, largely Impressionist and Postimpressionist works owned by Dr. Gachet. These works are the subject of the present Summary Catalogue, which is organized to follow the sequence of the Gachet *fils* volumes.[1] That sequence and transcriptions of the title pages are given here:

Volume I, Pissarro and others:
Paul Gachet / Collection du Dr. Gachet / I / Pissarro / Monet – Renoir – Sisley / Éva Gonzalès – Monticelli / Guys – Delpy – Oller – Piette / Catalogue raisonné / Illustré de 27 / reproductions / Auvers-sur-Oise / 1928.
Includes entries numbered 1–27, handwritten, except for those devoted to Gonzalès (19, 20), Delpy (24), and Oller and Piette (25–27), and which are typed.

Volume II, Cézanne:
Paul Gachet / Collection du Dr. Gachet / II / Cézanne peintures – aquarelle – pastels – dessins / Catalogue raisonné / Illustré de 46 / reproductions / Auvers-sur-Oise / 1928.
Includes entries numbered 1–42, a reproduction of Pissarro's *View of Louveciennes* (P.G. 2 bis), and a description and photograph of the "souvenirs."

Volume III, part 1, Van Gogh:
Paul Gachet / Collection du Dr. Gachet / III / Van Gogh / première partie: / Peintures / Catalogue raisonné / Illustré de 27 / reproductions / Auvers-sur-Oise / 1928.
Includes entries numbered 1–26 and also a reproduction of a work owned by Gachet's housekeeper (P.G. 8 bis).

Volume III, part 2, Van Gogh:
Paul Gachet / Collection du Dr. Gachet / III / Van Gogh / seconde partie: / Dessins et estampes / Catalogue raisonné / Illustré de 30 / reproductions / et des souvenirs / de Van Gogh / Auvers-sur-Oise / 1928.
A second, typed title page is dated "Auvers-sur-Oise 1920–1940." Includes entries numbered 27–41, three prints labeled a, b, and c, and a description and photograph of the souvenirs. A note states: "Par suite d'une erreur le no. 40 P.G. I verso n'a pas été reproduit."

Volume IV, Guillaumin:
Paul Gachet / Collection du Dr. Gachet / IV / Guillaumin / Peinture – pastel – aquarelle / Catalogue raisonné / Illustré de 34 / reproductions / Auvers-sur-Oise / 1940.
A second, typed title page is dated "Auvers-sur-Oise 1928–1940." Includes entries numbered 1–34.

Apparently Gachet *fils* made various manuscript and typed versions of his documentation before a definitive

edition of the multivolume catalogue was bound in the early to mid-1950s. Although almost all the bound entries are typed, the original pages seem to have been handwritten. Several handwritten Cézanne entries, identical in content to the typed pages in the bound volume, have come to light; they were acquired from the younger Gachet's estate, and presumably other pages, photographs, and papers were also sold from his estate and dispersed. Though the volumes are dated between 1920 and 1940, Gachet must have continued to make additions until mid-century, since notes in the bound volumes concern the first donations made to the French state.[2] It seems that he worked longest—through the early 1950s—on the entries devoted to Cézanne and Van Gogh, replacing handwritten manuscript pages with typed texts, in some cases slightly revised and extended.

Almost all the works are reproduced. The photographs are of differing quality and from different sources, suggesting that the author used whatever images were available as illustrations. Often the photographs came from the dealers Vollard or Druet; some were made at the Louvre. In two cases Gachet included photographs of copies rather than of the original works.[3]

The rediscovery of these long-lost volumes, which were located in the Wildenstein Institute, came late in the preparation of the present catalogue—after much of the documentation had already been compiled from various sources, including a list of the contents of the collection (Archives, Musée du Louvre), the published writings of Gachet *fils*, catalogues raisonnés, monographs, exhibition catalogues, and the copies (see the Checklist of Copies), which provided crucial leads. The exercise proved instructive: without access to Paul Gachet's documentation, which has been the unfortunate plight of two generations of scholars, any effort to reconstruct the contents of the Gachet collection would have been partial at best.

Many works catalogued by Gachet *fils* are entirely unknown or known only from descriptions of them; they are published or reproduced here for the first time. There are a surprising number of works, including major pictures in public collections, that were never recognized as having belonged to the Gachets, and others that were wrongly thought to have been part of the collection. The research we conducted was also revealing because it made evident the varying extent to which Dr. Gachet's holdings of works by individual artists had been accounted for in the literature: fully in the case of Van Gogh, but incompletely and inaccurately otherwise. The entries in the Summary Catalogue provide information on when works were first recorded, reproduced, and exhibited.

For this project the unpublished Gachet *fils* catalogues were used primarily to establish the contents of the collection. They were consulted at first hand by my colleague Anne Distel, who took careful notes and provided me, to the extent that she was able, with the pertinent factual information and, eventually, photographs of the pages themselves. She also arranged for reproductions to be made of the photographs used by Gachet *fils*. Further study and publication of these catalogues will no doubt amplify our knowledge of Dr. Gachet's collection as it was understood by his son.

Gachet's catalogue entries are descriptive, largely stylistic evaluations of the works from an artist's point of view; they are often sentimental in content and anecdotal in nature. Except in a personal context, he provides no factual, concrete information on the early provenances of works in the collection. Nor does he deal with the subsequent provenances of works that left the collection, except to mention those that ended up in museums, whether as donations or otherwise.[4] Essentially no firm dates of ownership are established. He does, however, give exhibition histories of the works lent from the collection.[5]

It was by means of a permanent record that Gachet *fils* endeavored to preserve the works of art his father had collected. From his forthright remarks on the relative merits of individual works to the sometimes obsessive details provided about the state of conservation,[6] Gachet's commentaries leave little doubt as to his familiarity with the collection or his intention to present a faithful and complete account of its contents. Yet it is not always clear to what extent the information is based on intimate, first-hand knowledge and primary source material and to what extent it is the result of intensive scholarly research and connoisseurship.[7] Nor can we be certain that the documentation is comprehensive: does it account for all the works his father owned by the artists in question? And is it exclusive—limited solely to the works his father acquired, not incorporating others added to the collection later?

These are important considerations. Although no one (except his father, who seems not to have been much of a writer or record-keeper himself) knew the contents of the collection as intimately as Paul Gachet *fils*, his knowledge was still imperfect. Single-mindedly, he dedicated himself to studying the works in the collection, striving to fill the gaps in his own knowledge by gathering information from innumerable sources, including individuals most familiar with the artists (his correspondence with Johanna van Gogh-Bonger and V. W. van Gogh spans five decades). Not surprisingly, he offers an abundance of detail about pictures made in or brought to Auvers, which presumably

were those best known to him at first- or second hand; but he provides no information, or only frustrating generalities, on the provenances of pictures for which there is no familial history.[8] Perhaps he simply did not know precisely when or how his father had acquired them. Given the quantity of paintings and the brimming portfolios of drawings and prints that he combed through (and attempted to sort out) over the years, some misattribution is certainly possible. Undoubtedly there are also lapses in his dating of works and identification of subjects. To some degree the documentation raises as many questions as it answers about the contents of Dr. Gachet's collection, but it is hoped that the information now at hand will provide a starting point for further study, factual corroboration, and reassessment.

This Summary Catalogue builds on the monographic studies of previous scholars, who have made significant contributions to our knowledge about the works Dr. Gachet owned and their provenances. That essential literature may be found in the Selected Bibliography. Limitations of space and format preclude complete bibliographic and exhibition histories in the entries.

The generous cooperation of a number of individuals and institutions, especially the firm of Wildenstein, made it possible to locate, illustrate, and trace the provenances of works formerly owned by Dr. Gachet. Owners graciously provided documentation and photographs, and many colleagues contributed the benefit of their knowledge, expertise, and resources. Their names are recorded in the Acknowledgments.

Reader's Note to the Summary Catalogue

Order

This Summary Catalogue is arranged in the same order as the catalogue prepared by Paul Gachet *fils*, following its sequence of volumes (I–IV) and numeration of individual works by Paul Gachet collection (or P.G.) number. As a rule, works are grouped by medium, with entries for oil paintings first, then original works on paper (pastels, watercolors, drawings), and lastly prints.[9] The prints were not assigned P.G. numbers, and only those by Van Gogh were catalogued (under letters a, b, c). Supplementary information pertaining to prints and other noncatalogued works owned by Gachet has been added at the end of each artist's section.

Numbers and Abbreviations

Most Summary Catalogue entries have a P.G. number consisting of the Roman numeral of the volume and the Gachet collection number, linked by a hyphen (e.g., P.G. III-5). The P.G. number appears in boldface type and is followed by the title and date that Gachet *fils* assigned to each work; standard catalogue raisonné citations are provided in abbreviated form directly below.

When a Gachet collection work is mentioned in a discussion, both its P.G. number and, if there is one, its primary catalogue raisonné reference number are cited: e.g., P.G. II-5 (F 627). Works not in the Gachet collection are cited by catalogue raisonné numbers. Works by Van Gogh have an F number, referring to the catalogue raisonné by J.-B. de la Faille (Faille 1970), and works by Cézanne have an R number,

referring to the catalogue by John Rewald (Rewald 1996). See the Selected Bibliography for complete citations of these and other abbreviated references.

Entry Contents

Each entry contains descriptive information; identifying information, i.e., the Gachet collection and catalogue raisonné references; documentary information from unpublished sources when that exists; and the recorded history of the work of art, including provenance, exhibitions, published references, letters, and comments. These categories are further described below.

Descriptive information: The heading includes the work's title, date, medium, dimensions, and inscriptions. This information was obtained from the current owner; from the catalogue raisonné or latest reference; or from the Gachet *fils* catalogue, which was the primary source for details concerning original support of paintings, type of paper (including watermarks), and inscriptions on the reverse and in Dr. Gachet's hand. Attributions are those provided by Gachet *fils* except for ones that have been changed by the current owner. Information regarding the present locations of works is included, when known, in the form of credit lines provided by owners. Dimensions are given in centimeters, height preceding width. Differences of opinion about attributions, dates, titles, and other issues are recorded under References and Comments.

Identifying information: The Gachet collection number (in boldface type) is given together with the title and date assigned by Gachet *fils*. Below them appear abbreviated catalogue raisonné references. See the explanation under NUMBERS AND ABBREVIATIONS above.

Documentary information from unpublished sources: There are two possible sources in this category. One is a group of photographs, taken about 1905 by Ambroise Vollard, which provide early documentation, during Dr. Gachet's lifetime, for certain paintings by Cézanne. The other consists of copies after works of art in the Gachet collection, many dated between 1900 and 1903 and all presumably made during Dr. Gachet's lifetime. Whenever there is a reference to a copy, the reader will find the work described and illustrated in the Checklist of Copies.

RECORDED HISTORY

Provenance: The circumstances and date of Dr. Gachet's acquisition of a work of art are recorded whenever documentation exists; the source of the information is noted below that under References, Letters, or Comments. In the absence of specific documentation, presumed or generally accepted dates of ownership are indicated within brackets []. Supplementary information that helps establish the existence of the work and/or Gachet's ownership of it by a given date is provided under Copies, References, Exhibitions, or Letters. The intention has been to avoid constant recourse to qualifiers, such as "presumably acquired from the artist," and potentially misleading language, especially because assumptions have been questioned and doubts have been raised about acquisitions made by Gachet.

Exhibitions: An exhibition is cited here only when the work was lent from the Gachet collection, either by Dr. Gachet or by his children. Other exhibition catalogues of interest appear under References; the abbreviated citation refers to both an exhibition and its catalogue.

References: Citations are limited to authoritative catalogues and to publications that address specific issues concerning Gachet's ownership of a work of art, including dating, provenance, and authenticity. Every effort has been made to include the earliest published sources for works in the collection and to give currency to matters of debate.

Letters: References are to both published and unpublished correspondence. Those to Van Gogh's correspondence employ standard numerical designations for the letters as they appear in *The Complete Letters of Vincent van Gogh* (Van Gogh Letters 1958) and other editions. The abbreviations are LT: Letter to Theo van Gogh, Vincent's brother; W: Letter to Wilhelmina (Wil), his sister; T: Letter from Theo. The abbreviation VGM stands for the Van Gogh Museum, Amsterdam.

DESIGNATION OF WORKS EXHIBITED
An asterisk (*) preceding an entry indicates that the work is shown in the New York and Amsterdam venues of the exhibition.
Works exhibited in New York only are designated by double asterisk (**) and those shown in Amsterdam only by a triple asterisk (***).
A dagger (†) indicates that the work is represented in New York and Amsterdam by a surrogate impression; for a list of these loans, see page 292.

1. At the front of the volume devoted to Guillaumin, Gachet *fils* includes a "Notice importante" in which he remarks that "this volume—the last completed—is no. IV in the series 'Collection du Dr. Gachet,'" but that were it to reflect the chronology of Dr. Gachet's relationships with the artists in question, "its place [would be] second, between 'Pissarro' and 'Cézanne.'"
2. He inserted notes—in the form of either a separate typed page, a line of text added in darker type, or a handwritten addition at the end of an entry—recording donations made between 1949 and 1951, but there is no reference to those made in 1954.
3. The photographs used to illustrate two paintings by Van Gogh, P.G. III-4 and P.G. III-19, were of watercolors by Blanche Derousse (see Checklist of Copies).
4. In addition to noting the donations made to the French state prior to 1954, he mentioned that P.G. II-4 was in the Art Institute of Chicago and that P.G. III-20 was acquired by the Kunstmuseum Basel in 1934.
5. Gachet presents a fairly complete record, although he does not identify all the drawings by Van Gogh that were shown at the Indépendants exhibition of 1905, presumably because he is unable to do so; see "The Gachet Donation in Context," above, n. 35.
6. For example, he records—and sometimes enumerates—little tears, pinholes, paper folds, smudges, accidental pencil marks, and the like in his descriptions of drawings.
7. One of the clearest indications that Gachet *fils* relied on attributions provided by his father comes from the inscriptions of artists' names he records as being in Dr. Gachet's hand. These notations, generally in blue pencil on the reverse, are cited for the following works: P.G. I-23; P.G. II-8, 15, 17, 18, 27, 30, 31, 37, 38, 41; P.G. IV-29, 34.
8. He remarks of Guillaumin's *Sailboats on the Seine at Bercy* (P.G. IV-14) that it is one of the paintings Gachet owned by 1872, but he does not tell us what the others were. Likewise, he states that Van Gogh's drawing *Snowy Landscape with Cottages and Figures* (P.G. III-28 [F 1648]) was "among the drawings given to the doctor by Theo," but he never refers to the others, leaving uncertainty as to the contents of the group. Similarly, he advises us only in the most general terms of Dr. Gachet's transactions with the Parisian dealer Pierre-Firmin Martin; he notes that in addition to Sisley's *View of the Canal Saint-Martin* (P.G. I-18), the dealer sold him "Guillaumins, some Pissarros, watercolor-gouaches by Piette, sketches by Paul Guigou, and, of course, works by Amand Gautier." Sometimes the provenance information is contradictory—ironically so in the case of this Sisley (see P.G. I-18).
9. For Cézanne (vol. II) and Guillaumin (vol. IV), the paintings are grouped by subject (as is revealed in Gachet's table of contents) and within these groups are listed in roughly chronological order. Works by Cézanne are arranged as follows: landscapes (P.G. II-1–5), still lifes (6–20), genre (21–25); then, watercolor (26), pastels (27–29), drawings (30–42). Works by Guillaumin are arranged as follows: figures (P.G. IV-1–5), landscapes (6–28), still lifes (29, 30); pastels (31–33), watercolor (34).

P.G. I-2

PROVENANCE: Dr. Paul Gachet, Auvers [?–1909]; donated by Paul Gachet *fils* to the Musée du Louvre, Paris, 1951
REFERENCES: Pissarro and Venturi 1939, no. 36 (as 1864; no mention of Gachet in provenance; not repr.); Florisoone 1952, p. 27, pl. IV; Chatelet in Paris 1954–55, no. 85; Cooper 1955, p. 103 (as 1864, ex Gachet collection)
COMMENTS: See comments for P.G. I-8 (P&V 187).

Landscape with a Road, ca. 1870
Oil on canvas, 40 x 31 cm
Signed lower left: Pissarro.
Private collection

P.G. I-3: *Paysage* (antérieur à 1870)
P&V 103

PROVENANCE: Dr. Paul Gachet, Auvers [?–1909]; sold by Paul Gachet *fils* sometime between 1939 and 1950; sold by the Galerie de L'Élysée to the Alex Reid and Lefevre Gallery, London, Oct. 27, 1950; sold to the Hon. W. S. Phillips, Nov. 28, 1950; sale, Galerie Motte, Geneva, May 23, 1964; sale, Christie's, London, Nov. 27, 1989, no. 6
REFERENCE: Pissarro and Venturi 1939, no. 103 (as ca. 1870; no mention of Gachet in provenance; not repr.)

PAUL GACHET

COLLECTION DU DR. GACHET

I

PISSARRO

MONET · RENOIR · SISLEY
EVA GONZALÈS · MONTICELLI
GUYS · DELPY · OLLER · PIETTE

CATALOGUE RAISONNÉ
ILLUSTRÉ DE 27
REPRODUCTIONS

AUVERS-SUR-OISE
1928

Camille Pissarro
(French, 1830–1903)

Landscape at La Varenne-Saint-Hilaire, 1864
Oil on canvas, 27 x 38 cm
Signed and dated lower right: C. Pissarro/1864
Location unknown

P.G. I-1: *La Varenne, paysage au bord de la Marne,* 1864
P&V 40

P.G. I-1

PROVENANCE: Dr. Paul Gachet, Auvers [?–1909]; sold by Paul Gachet *fils* sometime between 1939 and 1950; sale, Galerie Fischer, Lucerne, June 13–17, 1950, no. 2250; sale, Galerie Charpentier, Paris, June 10, 1955, no. 93
REFERENCE: Pissarro and Venturi 1939, no. 40 (as 1864, Gachet collection; repr.; with the notation: "Dr. Gachet, Pissarro's friend who lived at Auvers, had a dozen or so works by the artist, of which we were able to obtain two or three photos, thanks to the kindness of his son, M. Paul Gachet.")

The Ferry at La Varenne-Saint-Hilaire, 1864
(cat. no. 35)
Oil on canvas, 27 x 41 cm
Signed and dated lower right: C. Pissarro. 64
Musée d'Orsay, Paris, RF 1951-38

P.G. I-2: *Le bac de la Varenne,* 1864
P&V 36

P.G. I-3

P.G. I-4

Saint Stephen's Church by Moonlight, 1872
Oil on panel, 12 x 17 cm
Signed and dated lower right: C. Pissarro/1872
Location unknown

P.G. I-4: *St. Stephen's Church—Lower Norwood (Angleterre)*, 1872
P&V 145
Copied (etched) by Dr. Gachet in 1873
(cat. no. 46d)

PROVENANCE: Dr. Paul Gachet, Auvers [1872–1909]; Paul Gachet *fils,* until at least 1939
REFERENCES: Pissarro and Venturi 1939, no. 145 (as 1872, Gachet collection, repr.; notes that "there exists an etching by Dr. Gachet after this painting"); Gachet 1954a, p. 21 (mentions the Gachet etching *Clair de lune* made after this work); Reid 1977, p. 255, and Reid 1986, p. 63 (disputes Lower Norwood as location)
COMMENTS: Gachet's etching after this work was one of "four subjects on a single plate" made in Aug.–Sept. 1873 (see Adhémar and Lethève 1954, p. 295, no. 12).

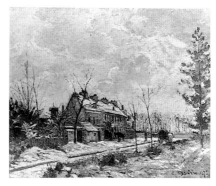

P.G. I-5

Road at Louveciennes, Snow Effect, 1872
Oil on canvas, 46 x 55 cm
Signed and dated lower right: C. Pissarro. 1872
Private collection

P.G. I-5: *Route de Louveciennes (effet de neige),* 1872
P&V 149
Copied by Derousse, 1901 (RF 31 241)

PROVENANCE: Dr. Paul Gachet, Auvers, [1872–1909]; sold by Paul Gachet *fils,* before 1930; Paul Rosenberg, Paris; René Gaston Dreyfus, Paris, by 1930; sale, Sotheby's, London, March 30, 1966, no. 49; Albert J. Dreitzer, from 1966 until 1985; his sale, Sotheby's, New York, Nov. 13, 1985, no. 7; with Hall Galleries, Dallas, 1986; private collection, Texas?; Galerie Art Point, Tokyo; private collection, Japan; private collection
REFERENCE: Pissarro and Venturi 1939, no. 149 (as 1872, ex Gachet collection; repr.)
LETTER: Camille Pissarro to Dr. Gachet, April 1, 1872 (reprinted in Gachet 1957a, p. 27; Pissarro Letters 1980–91, no. 16). Pissarro writes of bringing a "snow scene" to Dr. Gachet along with a "Sunrise" and a work by Gautier.

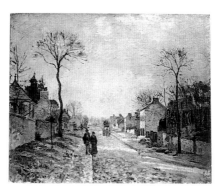

P.G. I-6

* *Road at Louveciennes*, 1872
(cat. no. 37)
Oil on canvas, 60 x 73.5 cm
Signed and dated lower left: C. Pissarro. 1872
Musée d'Orsay, Paris, RF 1951-37

P.G. I-6: *Route de Louveciennes (Seine-et-Oise)*, 1872
P&V 138

PROVENANCE: Dr. Paul Gachet, Auvers [1872–1909]; donated by Paul Gachet *fils* to the Musée du Louvre, Paris, 1951
EXHIBITION: Paris 1930, no. 12
REFERENCES: Pissarro and Venturi 1939, no. 138 (as 1872; no mention of Gachet in provenance; repr.); Chatelet in Paris 1954–55, no. 87

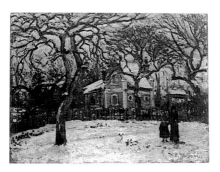

P.G. I-7

Chestnut Trees at Louveciennes, winter 1871–72
(cat. no. 36)
Oil on canvas, 41 x 54 cm
Signed lower right: C. Pissarro
Musée d'Orsay, Paris, RF 1954-18

P.G. I-7: *Les châtaigniers à Louveciennes (effet de neige)*, vers 1871–72
P&V 146

PROVENANCE: Dr. Paul Gachet, Auvers [ca. 1872–1909]; donated by Paul Gachet *fils* to the Musée du Louvre, Paris, 1954
REFERENCES: Pissarro and Venturi 1939, no. 146 (as ca. 1872; no mention of Gachet in provenance; not repr.); Chatelet in Paris 1954–55, no. 86 (as ca. 1870); Cooper 1955, p. 104 (as ca. 1872, ex Gachet collection)
LETTER: LT 635
COMMENTS: This work was first exhibited and reproduced in Paris 1954–55, no. 86.

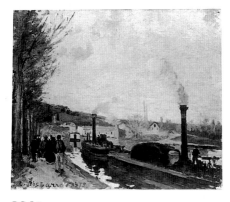

P.G. I-8

The Seine at Port Marly, 1872
Oil on canvas, 46 x 55 cm
Signed and dated lower left: C. Pissarro, 1872
Staatsgalerie Stuttgart, no. 2727

P.G. I-8: *La Seine à Port-Marly (S. & O.),* 1872
P&V 187

PROVENANCE: Dr. Paul Gachet, Auvers [1877–1909]; sold by Paul Gachet *fils* to Wildenstein, Paris and New York, 1953, until 1958; sold to Mrs. Thornycroft Ryle, New York, 1958; sale, Sotheby's, London, April 19, 1964, lot 40; Marlborough Fine Art, Ltd., London, until 1965; sold to Staatsgalerie Stuttgart, 1965

REFERENCE: Pissarro and Venturi 1939, no. 187 (no mention of Gachet in provenance; not repr.)

LETTERS: Eugène Murer to Dr. Gachet, Oct. 22, 1877; Dr. Gachet to Eugène Murer, Oct. 24, 1877 (reprinted in Gachet 1957a, pp. 164–66, 177–78)

COMMENTS: This is presumably the work described (in letters cited above) as "the water's edge with boats, and some houses in the background" that Gachet persuaded Pissarro to give him in 1877 (instead of destroying it) and that led to a dispute later, when Pissarro wanted it to serve as repayment of an outstanding debt. See also P.G. I-2 (P&V 36), another possible candidate.

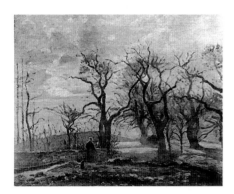

P.G. I-9

Chestnut Trees at Louveciennes, Fog Effect, ca. 1872
Oil on canvas, 50 x 61.5 cm
Location unknown

P.G. I-9: *Les châtaigniers à Louveciennes (effet de brume),* 1872
P&V 147

PROVENANCE: Dr. Paul Gachet, Auvers [ca. 1872–1909]; Paul Gachet *fils,* until at least 1939

REFERENCE: Pissarro and Venturi 1939, no. 147 (as ca. 1872; no mention of Gachet in provenance; not repr.)

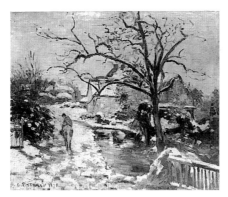

P.G. I-10

Winter at Montfoucault, 1875
Oil on canvas, 46 x 56 cm
Signed and dated lower left: C. Pissarro 1875
Michael and Henry Jaglom

P.G. I-10: *Hiver à Montfoucault (Mayenne) (effet de neige),* 1875
P&V 327

PROVENANCE: Dr. Paul Gachet, Auvers [1875–1909]; sold by Paul Gachet *fils* to Wildenstein, Paris and New York, 1953; sold to Mrs. Pamela Woolworth, New York, 1954; Simon Jaglom, New York, by 1965; by descent to Michael and Henry Jaglom

REFERENCES: Pissarro and Venturi 1939, no. 327 (as 1875; no mention of Gachet in provenance; not repr.); Pissarro and Rachum in Jerusalem 1994–95, no. 52, repr.

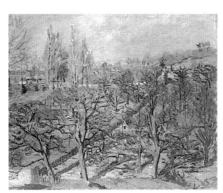

P.G. I-11

Autumn Landscape, 1880?
Oil on canvas, 50 x 61 cm
Location unknown

P.G. I-11: *Paysage d'automne,* 1880?

PROVENANCE: Dr. Paul Gachet, Auvers, from 1880–1909; Paul Gachet *fils,* until at least 1948

COMMENTS: Following his catalogue entry for this work, Gachet *fils* added a typed

note, dated May 1948, in which he recorded that Camille Pissarro's son Rodo Pissarro (Ludovic Rodolphe Pissarro, 1878–1952), said the work was not by his father. Gachet *fils* then remarked: "My father held on to this canvas by Pissarro, claiming it to be by him. Either Rodo is mistaken or Dr. Gachet's words are to be doubted . . . unless Pissarro had given a painting he hadn't made." He also noted that in color it looks like a Guillaumin and that it was in Dr. Gachet's collection from 1880.

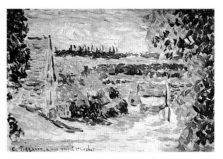

P.G. I-12

Landscape at Éragny, ca. 1886
Oil on panel, 16 x 23.5 cm
Signed and inscribed lower left: C. Pissarro, à mon ami Le Dr Gachet
Private collection

P.G. I-12: *Éragny-Bazincourt (Eure),* 1887?
P&V 705

PROVENANCE: Given by the artist to Dr. Paul Gachet, Auvers, 1888, until 1909; sold by Paul Gachet *fils* to Michel Fert, Geneva, 1962; sold to Mme D. H. Vermulen, Hilversum (Netherlands), 1962; sold to P. A. Swier, Bergen (Netherlands), 1973; sold to Baron B. W. van Dedem, Boskoop (Netherlands), 1976; sale, Germann, Zurich, May 22, 1980, no. 53 [presumably bought in]; sold by Baron van Dedem's heirs, through E. J. van Wisselingh and Co., to a private collector, Amsterdam, 1981; private collection

REFERENCE: Pissarro and Venturi 1939, no. 705 (as ca. 1886, Gachet collection; repr.)

LETTER: Camille Pissarro to Dr. Gachet, May 26, 1888 (reprinted in Gachet 1957a, p. 39)

COMMENTS: Paul Gachet *fils* identified this panel as the one "painted precisely according to the 'new technique' (pointillism)" that was given to Dr. Gachet by the artist in 1888, of which Pissarro wrote: "I was so very preoccupied . . . that I forgot your panel, which I had, however, set aside. I will send it or bring it to you" (Gachet 1957a, p. 39).

P.G. I-13

The Hay Harvest, ca. 1880?
Gouache, 24.7 x 15.5 cm
Signed lower right: C. Pissarro
Location unknown

P.G. I-13: *La fenaison,* 1880?

PROVENANCE: Dr. Paul Gachet, Auvers
[?–1909]; Paul Gachet *fils*

Prints by Pissarro
(not catalogued by Gachet *fils*)

† *At the Water's Edge,* ca. 1863
(cat. no. 38a)
Etching, unique state, 28.4 x 21.4 cm
Dedication lower left: à mon ami Gachet/
C. Pissarro
Bibliothèque Nationale de France, Paris,
Département des Estampes et de la
Photographie

D 2

D 2

PROVENANCE: Given, with a dedication, to
Dr. Paul Gachet, Auvers [after 1871, until
1909]; donated by Paul Gachet *fils* to the
Bibliothèque Nationale, Paris, 1953
REFERENCES: Delteil 1923, no. 2 (as a very
rare etching and variant in reverse of D 1,
owned by Gachet; reproduces Gachet's
inscribed impression); Leymarie and Melot
1971, no. 2
LETTER: Paul Gachet *fils* to V. W. van Gogh,
Feb. 13, 1953 (b3079 V/1962, VGM Archives)

D 5

La Roche-Guyon, ca. 1866
(cat. no. 38b)
Etching, first state, 27.1 x 22.1 cm
Dedication lower left: à mon ami Gachet
C. Pissarro
Bibliothèque Nationale de France, Paris,
Département des Estampes et de la
Photographie

D 5

PROVENANCE: Given, with a dedication, to
Dr. Paul Gachet, Auvers [after 1871, until
1909]; donated by Paul Gachet *fils* to the
Bibliothèque Nationale, Paris, 1953
REFERENCES: Delteil 1923, no. 5 (lists
Gachet as the owner of a very rare, if not
unique, first state; 2nd state repr.); Leymarie
and Melot 1971, no. 5
LETTER: Paul Gachet *fils* to V. W. van
Gogh, Feb. 13, 1953 (b3079 V/1962, VGM
Archives)

Negress, 1867
Etching, first state, 30.5 x 21 cm
Location unknown

D 6

REFERENCES: Delteil 1923, no. 6 (lists
Gachet as an owner of first state, repr.);
Leymarie and Melot 1971, no. 6

D 6

† *Hills at Pontoise,* 1873
Etching, 12.1 x 15.8 cm
Gachet collection stamp
Location unknown

D 7

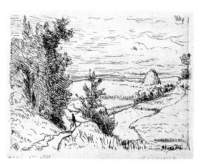

D 7

PROVENANCE: Dr. Paul Gachet, Auvers
[ca. 1873–1909]; sold by Paul Gachet *fils* to
Philip Jones, Esq., London, 1961, until 1971;
sale of his property, Sotheby's, London,
Nov. 4, 1971, lot 40
REFERENCES: Delteil 1923, no. 7 (as
Coteaux à Pontoise, 1873; lists Gachet as an
owner of this print; repr.); Gachet 1952, n.p.;
Gachet 1957a, p. 40 n. 1 (as *Dans la plaine
d'Auvers*); Leymarie and Melot 1971, no. 7
(as 1874); Cherpin 1972, p. 35 (as *Coteaux à
Pontoise,* 1873)
COMMENTS: See comments for Pissarro
print D 10, below.

† *The Oise at Pontoise,* 1874
Etching, 7.9 x 11.9 cm
Gachet collection stamp
Location unknown

D 9

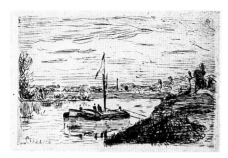

D 9

PROVENANCE: Dr. Paul Gachet, Auvers [1874–1909]; sold by Paul Gachet *fils* to Philip Jones, Esq., London, 1961, until 1971; sale of his property, Sotheby's, London, Nov. 4, 1971, lot 41
REFERENCES: Delteil 1923, no. 9 (as *L'Oise à Pontoise;* lists Gachet as an owner of this print; repr.); Gachet 1952, n.p. (as *Péniche sur l'Oise*); Gachet 1957a, p. 40 n. 2 (as *Péniche sur l'Oise, au Pothuis*); Leymarie and Melot 1971, no. 9 (as *L'Oise à Pontoise*); Cherpin 1972, p. 35
COMMENTS: See comments for Pissarro print D 10, below.

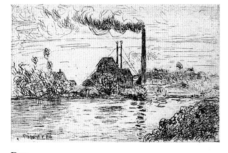

D 10

Factory at Pontoise, 1874
Etching, 12 x 7.9 cm
Gachet collector stamp
Location unknown

D 10

PROVENANCE: Dr. Paul Gachet, Auvers [1874–1909]; sold by Paul Gachet *fils* to Philip Jones, Esq., London, 1961, until 1971; sale of his property, Sotheby's, London, Nov. 4, 1971, lot 42
REFERENCES: Delteil 1923, no. 10 (lists Gachet as an owner of this print; repr.); Gachet 1952, n.p. (as *L'usine à Châlon*); Gachet 1957a, p. 40 n. 3; Leymarie and Melot 1971, no. 10; Cherpin 1972, p. 35
COMMENTS: In a letter to Dr. Gachet of 1889, Pissarro wrote, "Would you be so kind as to bring me the copper plates I left at your house. I would like to continue [working on] them. . . ." (reprinted in Gachet 1957a,

pp. 39–40). According to Gachet *fils,* three plates (D 7, 9, 10) were found among Van Ryssel plates in 1922 and returned to Pissarro's heirs (Gachet 1957a, p. 40 n. 1). The three plates have been alternatively identified as Delteil 8, 9, and 10, and a possible fourth print in this group (D 192; see below) has also been named (see Leymarie and Melot 1971, no. 9).

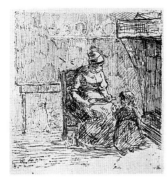

D 12

Peasant Woman Feeding a Child, 1874
Etching, first state, 12.2 x 12.1 cm
Gachet collection stamp
Location unknown

D 12

PROVENANCE: Dr. Paul Gachet, Auvers [1874–1909]; sold by Paul Gachet *fils* to Philip Jones, Esq., London, 1961, until 1971; sale of his property, Sotheby's, London, Nov. 4, 1971, lot 43
REFERENCES: Delteil 1923, no. 12 (lists Gachet as an owner of first state; repr.); Gachet 1952, n.p. (as *La bouillie*); Leymarie and Melot 1971, no. 12; Cherpin 1972, p. 35

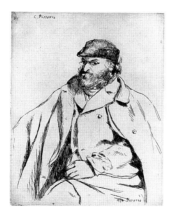

D 13

† *Paul Cézanne,* 1874
Etching, 27 x 21.4 cm
Location unknown

D 13

REFERENCE: Delteil 1923, no. 13 (lists Gachet as an owner of this print; repr.)

D 85

Peasant Woman with Buckets, 1889
Etching and aquatint, seventh and final state, 14.9 x 11 cm
Location unknown

D 85

PROVENANCE: Sale, "Collection du Docteur Gachet," Hôtel Drouot, Paris, May 15, 1993, no. 313
REFERENCE: Delteil 1923, no. 85 (no mention of Gachet in provenance; repr.); Drouot 1993, no. 313

D 97

Vegetable Market, Pontoise, 1891
Etching and aquatint, second and final state, 22.5 x 20 cm
Location unknown

D 97

PROVENANCE: Sale, "Collection du Docteur Gachet," Hôtel Drouot, Paris, May 15, 1993, no. 313
REFERENCES: Delteil 1923, no. 97 (no mention of Gachet in provenance; second state repr.); Drouot 1993, no. 313

D 126

Harvesting the Hay, 1900
Etching, seventh state, 11.7 x 8 cm
Location unknown

D 126

PROVENANCE: Dr. Paul Gachet, Auvers
[?–1909]; sold by Paul Gachet *fils* to Philip
Jones, Esq., London, 1961, until 1971; sale of
his property, Sotheby's, London, Nov. 4,
1971, lot 44
REFERENCE: Delteil 1923, no. 126 (lists
Gachet as an owner of seventh state; fourth
state repr.)

D 130

Road at Pontoise, 1874
Lithograph, 26.5 x 22 cm
Signed lower left: C. Pissarro
Location unknown

D 130

REFERENCE: Delteil 1923, no. 130 (lists
Gachet as an owner of one of four known
impressions; repr.)

Women Carrying Hay on a Rack, ca. 1874
Lithograph, 21.5 x 29.2 cm
Signed lower left: C. Pissarro
Location unknown

D 134

D 134

REFERENCE: Delteil 1923, no. 134 (lists
Gachet as an owner of one of four known
impressions; repr.)

Woman and Child in the Fields, ca. 1874
Lithograph, 13.9 x 19.2 cm
Signed lower left: C. Pissarro
Location unknown

D 135

REFERENCE: Delteil 1923, no. 135 (lists
Gachet as an owner of one of seven or eight
known impressions; repr.)

D 135

Convalescence: Lucien Pissarro
Lithograph, 32.2 x 23.1 cm
Signed lower left with artist's initials: C.P.;
and edition notation: 10/11
Location unknown

D 192

D 192

PROVENANCE: Sale, "Collection du
Docteur Gachet," Hôtel Drouot, Paris, May
15, 1993, no. 312
REFERENCES: Delteil 1923, no. 192 (as ca.
1900, made in thirteen impressions; does not
list owners of the print; repr.); Leymarie and
Melot 1971, no. 191 (dates the plate to 1879,
but notes that the zinc was found in 1922
[conceivably along with three other plates;
see comments for D 10, above] and that an
edition of eleven impressions was printed
then); Drouot 1993, no. 312 (as ca. 1930, repr.)

D 194

The Plow (frontispiece for *Les temps
nouveaux*), 1901
Lithograph, printed in colors, second state;
22.5 x 15.1 cm
Location unknown

D 194

PROVENANCE: Dr. Paul Gachet, Auvers
[?–1909]; sold by Paul Gachet *fils* to Philip
Jones, Esq., London, 1961, until 1971; sale of
his property, Sotheby's, London, Nov. 4,
1971, lot 45
REFERENCES: Delteil 1923, no. 194 (lists
Gachet as an owner of this print; repr.);
Leymarie and Melot 1971, no. 192 (as *Le
labour* or *La charrure*)

Claude Monet
(French, 1840–1926)

Chrysanthemums, 1878
(cat. no. 33)
Oil on canvas, 54.5 x 65 cm
Signed lower left: Claude Monet. Dated
lower right: 1878
Musée d'Orsay, Paris, RF 1951-36

P.G. I-14: *Chrysanthèmes*, 1878
W 492

P.G. I-14

PROVENANCE: Acquired from the artist by Dr. Paul Gachet, Auvers, in 1878, as repayment of a loan, until 1909; donated by Paul Gachet *fils* to the Musée du Louvre, Paris, 1951
REFERENCES: Florisoone 1952, p. 27, pl. V; Chatelet in Paris 1954–55, no. 79; Wildenstein 1974, no. 492; Paris 1980, no. 72; Lacambre et al. 1990, vol. 2, p. 335
COMMENTS: Between Dec. 1877 and Feb. 1878, Dr. Gachet extended several loans to Monet which he intended to repay in artwork. This painting is undoubtedly the work Gachet accepted as repayment for this debt. (See the series of letters between Dr. Gachet and Monet, 1877–78 [reprinted in Gachet 1957a, pp. 113–15], and Monet's letter to Eugène Murer of Dec. 16, 1878 [Gachet 1957a, pp. 119–20], in which the artist bemoaned the fact that he had very few paintings to offer Gachet.)

P.G. I-15

Path in the Forest, ca. 1864?
Pastel on gray Ingres paper, 26.7 x 20.7 cm
Signed lower left: C. Monet
Location unknown

P.G. I-15: *L'orée du bois*, avant 1870
W P17

PROVENANCE: Dr. Paul Gachet, Auvers [?–1909]; sold by Paul Gachet *fils* to Wildenstein, Paris and New York, ca. 1953, until at least 1962; private collection, United States, ca. 1963

REFERENCES: Minneapolis, New York 1962, no. 84 (as 1864); Wildenstein 1991, no. P 17 (undated, as ex Gachet collection)

Pierre-Auguste Renoir
(French, 1841–1919)

Portrait of a Model, ca. 1878
(cat. no. 39)
Oil on canvas, 46 x 38 cm
Signed upper left: Renoir
Musée d'Orsay, Paris, RF 1951-39

P.G. I-16: *Portrait de modèle (Margot)*, vers 1878
Daulte 276
Copied by Derousse, Sept. 1901 (cat. no. 39a)

P.G. I-16

PROVENANCE: Given by the artist to Dr. Paul Gachet, Auvers, after the model's death in 1879, until 1909; donated by Paul Gachet *fils* to the Musée du Louvre, Paris, 1951
REFERENCES: Florisoone 1952, p. 27, pl. VI; Chatelet in Paris 1954–55, no. 98 (as *Portrait de modèle*); Gachet 1956a, pp. 81, 87–88, fig. 48 (as *Portrait de Margot*); Daulte 1971, no. 276 (as *Portrait de Margot*, 1878, subject Marguerite Legrand, called Margot); Distel in London, Paris, Boston 1985–86, pp. 209, 299 (identifies model as Alma-Henriette Leboeuf; records her death date as Feb. 18, 1879, at age twenty-three); Bailey in Ottawa, Chicago, Fort Worth 1997, pp. 13, 289 n. 4 (discusses Renoir's relationship with his model and mistress Alma-Henriette Leboeuf, known as Margot)
LETTER: Auguste Renoir to Dr. Gachet, Feb. 25, 1879 (reprinted in Gachet 1957a, pp. 81–85)
COMMENTS: Renoir had urged Dr. Gachet several times to look after his model during her illness. She was treated instead by another homeopath, Dr. de Bellio, and Dr. Gachet saw her only once, shortly before her death from smallpox in February 1879. Nevertheless, Renoir made a gift of this painting to Dr. Gachet in appreciation of "the care you were able to give her, although we both were convinced that it was in vain" (Gachet 1957a, pp. 81–85).

Landscape with Bathers, Guernsey, 1883
Oil on canvas, 54 x 65 cm
Ny Carlsberg Glyptotek, Copenhagen, 2755

P.G. I-17: *Les baigneurs*, 1879?
Copied by Derousse, 1902 (RF 31 249)

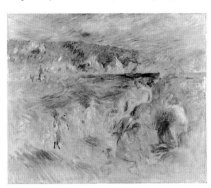

P.G. I-17

PROVENANCE: Dr. Paul Gachet, Auvers [?–1909]; sold by Paul Gachet *fils*, before 1953; Fritz Nathan, Zurich, until 1953; sold to Ny Carlsberg Foundation, 1953, and donated to Ny Carlsberg Glyptotek the same year
REFERENCE: Munk 1993, pp. 84–85 (as 1883, ex Gachet collection)

At the Beach, Berneval, 1892?
Drypoint, 14 x 9.5 cm
Location unknown

D 5

PROVENANCE: Sale, "Collection du Docteur Gachet," Hôtel Drouot, Paris, May 15, 1993, no. 315
REFERENCES: Delteil 1923 (Renoir), no. 5 (as 1892?; no mention of Gachet in provenance); Drouot 1993, no. 315

D 5

Alfred Sisley
(French, 1839–1899)

View of Canal Saint-Martin, 1870
(cat. no. 40)
Oil on canvas, 50 x 65 cm
Signed and dated lower right: Sisley 1870.
Musée d'Orsay, Paris, RF 1951-40

P.G. I-18: *Vue du Canal St Martin,* 1870
Daulte 16
Copied by Gachet *fils,* 1901 (cat. no. 40a)

P.G. I-18

PROVENANCE: Purchased by Dr. Paul
Gachet, Auvers, from the dealer Gandoin,
Paris (or from Pierre-Firmin Martin, Paris),
before 1883, until 1909; donated by Paul
Gachet *fils* to the Musée du Louvre, Paris, 1951
REFERENCES: Paris 1870, no. 2651;
Florisoone 1952, p. 27, pl. II; Chatelet in
Paris 1954–55, no. 105; Gachet 1957a,
pp. 37–38 n. 2 (as P.G. I-18, purchased by
Dr. Gachet from Gandoin for 170 francs);
Daulte 1959, no. 16 (as purchased by
Dr. Gachet from Gandoin for 170 francs);
Gachet 1994, p. 93 (as purchased by Dr.
Gachet from the dealer Pierre-Firmin Mar-
tin, Paris, who also sold him "Guillaumins,
several Pissarros, watercolor-gouaches by
Piette, sketches by Paul Guigou, and, of
course, works by Amand Gautier")
LETTER: Camille Pissarro to Dr. Gachet,
May 26, 1883 (reprinted in Gachet 1957a,
pp. 37–38, and Pissarro Letters 1980–91,
no. 154), advises of Sisley's interest in bor-
rowing "the painting depicting the Canal
Saint-Martin" for an exhibition.
COMMENTS: Gachet *fils* originally identified
this work as the one Dr. Gachet purchased
from the dealer Gandoin (Gachet 1957a), but
in his posthumously published manuscript
(Gachet 1994) he recorded that it was instead
purchased from Pierre-Firmin Martin.

Banks of the Loing: The Cart, 1890
Etching
Location unknown
D 1

D 1

PROVENANCE: Paul Gachet *fils,* until at least
1961 (when it was listed as "Paysage—Épreuve
de la Gazette des Beaux-Arts" in a typescript
inventory of prints in his collection)
REFERENCE: Delteil 1923 (Sisley), no. 1 (as
1890; no mention of Gachet in provenance;
cites publication of third state in the *Gazette
des Beaux-Arts,* 1899)

Éva Gonzalès
(French, 1849–1883)

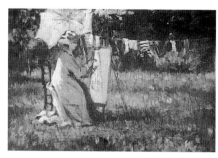

P.G. I-19

Woman at an Easel, Painting Outdoors, 1880?
Oil on panel, 15.5 x 24 cm
Location unknown

P.G. I-19: *"En plein air,"* 1880?

PROVENANCE: Dr. Paul Gachet, Auvers
[?–1909]; Paul Gachet *fils*

P.G. I-20

Camellias, 1874?
Oil on canvas, 24 x 19 cm
Location unknown

P.G. I-20: *Camélias,* 1874?

PROVENANCE: Dr. Paul Gachet, Auvers
[?–1909]; Paul Gachet *fils*

Adolphe-Joseph-Thomas Monticelli
(French, 1824–1886)

Undergrowth, ca. 1868
Oil on panel, 30.5 x 35 cm
Location unknown

P.G. I-21: *Sous-bois,* 1868?

P.G. I-21

PROVENANCE: Dr. Paul Gachet, Auvers
[?–1909]; Paul Gachet *fils*
REFERENCES: Gachet 1956a, p. 79 (lists "a
badly painted Monticelli" in Gachet's col-
lection); Sheon in New York, Columbus
1987, n.p.
COMMENTS: According to Aaron Sheon,
Dr. Gachet owned several works by
Monticelli. Paul Gachet *fils,* however, lists
only this painting in his catalogue.

Constantin Guys
(French, 1802–1892)

In the Street, ca. 1860?
(attributed to Guys)
(cat. no. 32)
Oil on canvas, 24 x 32.5 cm
Musée d'Orsay, Paris, RF 1954-17

P.G. I-22: *Dans la rue,* 1860?

PROVENANCE: Purportedly given by Manet
to Dr. Paul Gachet, Auvers [?–1909]; donated
by Paul Gachet *fils* to the Musée du Louvre,
Paris, 1954
REFERENCES: Chatelet in Paris 1954–55,
no. 73 (observes that Guys, while a notable
watercolorist and draftsman, is not known for
painting in oil, and that this work was made
exceptionally at Manet's urging, according
to Gachet *fils*); Cooper 1955, p. 104 ("an

P.G. I-22

unpublished and quite exceptional oil by
Constantin Guys . . . given to the Doctor by
Manet"); Gachet 1956a, p. 63 (as a gift from
Manet to Dr. Gachet, and, as a painting,
"surely unique?"); Lacambre et al. 1990,
vol. 1, p. 222 (as Guys?)
COMMENTS: This work was first exhibited
and reproduced in Paris 1954–55, no. 73, as
Constantin Guys, *Dans la rue*, not dated. It
was subsequently downgraded by the
museum and is now listed as "Guys (?)."

At the Brothel, ca. 1860?
Ink wash and pen on white paper, 18.5 x 23.5 cm
Annotated (per Gachet *fils*) on reverse in
blue pencil, in Dr. Gachet's hand: donné par
Manet; in pencil: Guys
Location unknown

P.G. I-23: *Au lupanar,* 1860

P.G. I-23

PROVENANCE: Purportedly given by
Manet to Dr. Paul Gachet, Auvers [?–1909];
Paul Gachet *fils,* Auvers
REFERENCE: Gachet 1956a, p. 63 (as a gift
from Manet to Dr. Gachet)

Hippolyte-Camille Delpy
(French, 1842–1910)

Snow at Montmartre, 1869
Oil on canvas, 24 x 39 cm
Signed and dated lower right: C. Delpy 69
Musée Carnavalet, Paris, P. 1927 E.18.770

P.G. I-24: *Montmartre (emplacement du Sacré-
Coeur—effet de neige),* or *Sur la "butte,"* 1869

P.G. I-24

PROVENANCE: Dr. Paul Gachet, Auvers
[?–1909]; donated by Paul Gachet *fils* to the
Musée Carnavalet, Paris, 1953
REFERENCE: Lannoy-Duputel 1989, p. 143
COMMENTS: Gachet *fils* included in his
catalogue two entries for this work (one
handwritten, the other typed), in which he
provides different titles and different
descriptions of the same painting.

Francisco Oller y Cestero
(Puerto Rican, 1833–1917)

P.G. I-25

The Student, ca. 1865, or 1874?
(cat. no. 34)
Oil on canvas, 65.2 x 54.2 cm
Signed lower left: F. Oller
Musée d'Orsay, Paris, RF 1951-41

P.G. I-25: *L'étudiant,* vers 1873?

PROVENANCE: Dr. Paul Gachet, Auvers
[?–1909]; donated by Paul Gachet *fils* to the
Musée du Louvre, Paris, 1951
REFERENCE: Chatelet in Paris 1954–55, no. 82
COMMENTS: Gachet *fils* provided two sug-
gested dates for this work: "vers 1873?" in his
entry and "vers 1868?" in his table of contents.

Ludovic Piette
(French, 1826–1877)

View of Mans, 1870
Watercolor and gouache over Conté crayon
sketch on gray paper, 30.5 x 18.5 cm

P.G. I-26

Signed lower left: L. Piette. Signed and
dated lower right: L. Piette/Le Mans 1870
Location unknown

P.G. I-26: *Vue du Mans,* 1870

PROVENANCE: Presumably purchased from
the dealer Pierre-Firmin Martin, Paris, by
Dr. Gachet, Auvers [?–1909]; Paul Gachet *fils*
REFERENCES: Gachet 1956a, pp. 79, 136;
Gachet 1994, p. 93 (notes that the Parisian
dealer Martin sold Dr. Gachet "watercolor-
gouaches by Piette")

P.G. I-27

Street in Mans, 1870
Watercolor and gouache, 37 x 23 cm
Signed lower right: L. Piette. Inscribed
lower right, in pencil: un coin de rue
Location unknown

P.G. I-27: *Une rue au Mans,* 1870

PROVENANCE: Presumably purchased from
the dealer Pierre-Firmin Martin, Paris, by
Dr. Gachet, Auvers [?–1909]; Paul Gachet *fils*
REFERENCES: Gachet 1956a, pp. 79, 136;
Gachet 1994, p. 93 (notes that the Parisian
dealer Martin sold Dr. Gachet "watercolor-
gouaches by Piette")

P.G. II-1 bis

PAUL GACHET

COLLECTION DU DR. GACHET
II
CEZANNE

PEINTURES - AQUARELLE
PASTELS - DESSINS

CATALOGUE RAISONNÉ
ILLUSTRÉ DE 46
REPRODUCTIONS

AUVERS-SUR-OISE
1928

1865; wrestles with the seeming contradiction between its early style and its acquisition by Gachet); Feilchenfeldt in Rewald 1996, p. 15 (questions its authenticity because the picture lacks early documentation in the form of a Vollard photograph); Reff 1997, p. 801 (finds Rewald's attribution unconvincing) COMMENTS: Rewald accepts this picture as an early work but acknowledges that this makes Gachet's ownership "puzzling," since the picture would predate Cézanne's arrival in Auvers by seven years; speculates that perhaps Guillaumin brought it to Auvers; but is not entirely convinced that the figure depicted is "really Guillaumin." (He does not consider the possibility that Cézanne himself brought it.) Reff writes that "the whole work seems so 'vaguely brushed' and spurious in execution, so blatant in its coloring and obvious grid-like design, that it is hard to accept."

Gachet *fils* notes, "The original canvas was slightly larger and kept unmounted; the edges were virtually nonexistent; they had to undergo a relining." Unlike the other works by Cézanne catalogued by Gachet *fils*, this one is not listed in the table of contents for volume II. It is numbered "1 bis," and the entry is in darker type than the others, further suggesting that it was a late addition to the catalogue, presumably made when notes (also in darker type; see p. 188 n. 2) were added recording the 1951 donations to the Louvre. No mention is made of Guillaumin.

Paul Cézanne
(French, 1839–1906)

Brushstrokes, before 1870
Oil on cardboard, 17.8 x 23.8 cm
Location unknown

P.G. II-1: *Coups de pinceaux,* avant 1870

PROVENANCE: Dr. Paul Gachet, Auvers, from 1873 [until 1909]; subsequent provenance unknown

P.G. II-1

COMMENTS: Gachet *fils* notes that this work was painted quite some time before Cézanne brought it to Auvers in 1873.

Landscape, with Guillaumin Seated under a Tree, ca. 1865
Oil on canvas, mounted on fiberboard, 24.4 x 31.4 cm
Michael Werner, Cologne

P.G. II-1 bis: *Sur la route,* avant 1870
R 59; not in V

PROVENANCE: Dr. Paul Gachet, Auvers [?–1909]; sold by Paul Gachet *fils* to Wildenstein, Paris and New York, 1956; sold to Dallas Museum of Art (Foundation for the Arts) by 1961, until 1986; sale, Christie's, New York, Nov. 20, 1986, no. 309; Michael Werner, Cologne, from 1988
REFERENCES: Rewald 1996, no. 59 (as *Paysage—Guillaumin assis sous un arbre,* ca.

** *View of Louveciennes,* ca. 1872
Oil on canvas, 73 x 92 cm
Private collection (fig. 81)

P.G. II-2: *Vue de Louveciennes (d'après Pissarro),* 1872
R 184; V 153
Vollard photograph no. 208, annotated by Cézanne's son: Auvers 1875 [per Rewald].

P.G. II-2

A print is in the Musée d'Orsay, Vollard archives.
Copied by Gachet *fils*, Jan. 1900 (RF 31 253)

PROVENANCE: Given by the artist to
Dr. Paul Gachet, Auvers [ca. 1872/74–1909];
sold by Paul Gachet *fils* to Bernheim-Jeune,
Paris, March 9, 1912; Ambroise Vollard,
Paris; Auguste Pellerin, Paris; by descent to
M. René Lecomte and Mme Lecomte (née
Pellerin), Paris, by 1936; her sale, "Mme X.,"
Galerie Charpentier, Paris, June 8, 1956,
no. 5; private collection, United States;
private collection, Tokyo, by 1983; private
collection
REFERENCES: Rivière 1923, p. 202 (as 1875),
repr. p. 181; Venturi 1936, no. 153 (as
Louveciennes, 1872, copied after an 1871
Pissarro [formerly owned by Caillebotte, in
the collection of Albert Chardeau, Paris];
provenance begins with Pellerin, does not
mention Gachet); Paris 1936, no. 23 (as 1872;
no mention of Gachet in provenance);
Gachet 1956a, pp. 76, 93, 128 (described as a
gift from Cézanne to Dr. Gachet, who, he
notes, borrowed Pissarro's *Louveciennes*
[P&V 123] to study and copy in 1874);
Gachet in Cherpin 1972, p. 12; Bensusan-
Butt in London 1977, p. 21 (quotes Lucien
Pissarro; see below); Feilchenfeldt in Paris,
London, Philadelphia 1995–96, p. 570 (notes
its sale to Bernheim-Jeune in 1912); Rewald
1996, no. 184 (as *Vue de Louveciennes, d'après
Pissarro*, ca. 1872, made in Pontoise prior to
Cézanne's arrival in Auvers; names Gachet
as original owner)
LETTER: Lucien Pissarro to Paul Gachet
fils, Nov. 4, 1927 (reprinted in Gachet 1957a,
pp. 53–54), describing the origin of Cézanne's
copy: "My father was beginning then to do
lighter paintings, he had banished black,
ochers, etc., from his palette . . . he explained
his ideas on this subject to Cézanne, who, in
order to understand, asked him to lend him
a canvas so that he could, by copying it, try
out the possibilities of this new theory."

COMMENTS: There is some question as to
whether Cézanne made this copy of
Pissarro's *Louveciennes* (P&V 123) before
leaving Pontoise for Auvers in 1872 or after
his arrival there. As noted by Rewald (1996,
p. 144) and others, Lucien Pissarro recalled
seeing Cézanne's version and the original
"hanging together in the collection of
Dr. Gachet." The Pissarro, illustrated in the
Gachet catalogue as P.G. II-2 bis, did not
belong to Dr. Gachet; according to Gachet
fils, his father borrowed it from Pissarro in
1874 to make his own copy. This information
does not resolve where the picture was
made, or when; it only reintroduces both
possibilities. Nor can one be certain which
two pictures of the three (the Pissarro, the
Cézanne version, the Gachet version)
Lucien Pissarro saw hanging together; the
date of his visit is not recorded.

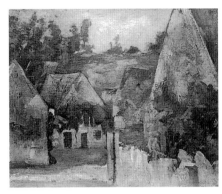

P.G. II-3

Crossroad of Rue Rémy, Auvers, 1872
(cat. no. 3)
Oil on canvas, 38 x 45.5 cm
Musée d'Orsay, Paris, RF 1954-8

P.G. II-3: *Carrefour de la rue Rémy*, Auvers
1873
R 185; not in V
Vollard photograph no. 334, annotated by
Cézanne's son: Auvers 1873 [per Rewald].
A print is in the Musée d'Orsay, Vollard
archives.

PROVENANCE: Dr. Paul Gachet, Auvers
[ca. 1872/73–1909]; donated by Paul Gachet
fils to the Musée du Louvre, Paris, 1954
REFERENCES: Cooper 1955, p. 103 (as 1872,
painted in Auvers); Rewald 1996, no. 185
(ca. 1872; lists Gachet as original owner)
LETTER: LT 635? See P.G. II-4 [R 221].
COMMENTS: Gachet *fils* notes that this
work had been relined. It was first exhibited
and reproduced in Paris 1954–55, no. 5. See
comments for P.G. II-5 (R 192).

Panoramic View of Auvers-sur-Oise,
1873–74 (fig. 82)
Oil on canvas, 64.8 x 80 cm
The Art Institute of Chicago, Mr. and
Mrs. Lewis Larned Coburn Memorial
Collection, 1933.422

P.G. II-4: *Panorama (Auvers)*, 1873
R 221; V 150
Vollard photograph no. 209, annotated by
Cézanne's son: Auvers 1875 [per Rewald]
Copied by Gachet *fils*, Feb. 1900 (RF 31 252)

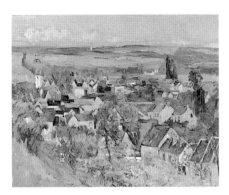

P.G. II-4

PROVENANCE: Dr. Paul Gachet, Auvers
[ca. 1873/74–1909]; sold by Paul Gachet *fils*,
before 1912; Ambroise Vollard, Paris; with
Manzi, Joyant et Cie, Paris, by 1912; Georges
Viau, Paris(?); Alfred Strolin, Paris, until
1921; his sale, Hôtel Drouot, Paris, July 7,
1921, no. 7; Hector Brame, Paris; Durand-
Ruel, Paris and New York; sold to Mr. and
Mrs. Lewis L. Coburn, Chicago; her
bequest to the Art Institute of Chicago, 1933
REFERENCES: Venturi 1936, no. 150 (as
1873–75; names its first owner as Georges
Viau, with no mention of Gachet or Choc-
quet in provenance); Chatelet in Paris
1954–55, no. 12; Cooper 1955, p. 103 (as sum-
mer 1873); Gachet 1956a, p. 56 n. 2, p. 93
(identifies the painting by title, Gachet and
Venturi numbers, and current location in the
Art Institute of Chicago); Brettell in Los
Angeles, Chicago, Paris 1984–85, no. 69 (as
1873–75, and a work "certainly owned by
Gachet" that because of its "unfinished"
state and thin handling has led some recent
scholars to doubt its authenticity; refutes
this, in part, on the basis of Gachet's owner-
ship); Gachet 1994, p. 45 (states that of the
paintings in the Gachet collection men-
tioned by Van Gogh in letter 635, only
Cézanne's *Panorama d'Auvers* ["4 P.G."] did
not go to the Louvre); Mothe in Gachet
1994, p. 80 n. 15, p. 86 n. 41 (proposes this
work and P.G. II-5 [R 192] as two possible

candidates for Cézanne's view "of the village" admired by Van Gogh); Loyrette in Paris, London, Philadelphia 1995–96, no. 31 (as ca. 1873; describes it as a sketch for a landscape, noting that its first documented owner was Vollard but that it may have been owned by Gachet); Rewald 1996, no. 221 (as 1873–74; does not mention Gachet in the provenance, which begins with Vollard, but in his text—undercut by Feilchenfeldt's misleading editor's note—suspects that the picture was owned by Gachet; he notes wrongly that Venturi said it belonged to Victor Chocquet)

LETTER: LT 635 (as "another Cézanne, of the village"); see also P.G. II-3 and II-5.

COMMENTS: Gachet's ownership of this landscape, which depicts his house at far left, has never been clearly established. Several scholars (including Brettell, Loyrette, Rewald) have suspected that it belonged to him and have identified it as the "Cézanne, of the village" admired by Van Gogh at Gachet's in 1890 (LT 635). This was the contention of Gachet *fils*, who also confirmed their suspicions about its provenance, albeit in a footnote, which read: "Panorama (Auvers), no. 4 P.G.—Vent[uri] 150. Aujourd'hui à l'Institut of Art de Chicago." The painting was sold before Van Gogh's correspondence was published in 1914. See also comments for P.G. II-5.

* *Dr. Gachet's House at Auvers*, 1872–73 (cat. no. 2)
Oil on canvas, 46 x 38 cm
Musée d'Orsay, Paris, RF 1951-32

P.G. II-5: *Paysage—la maison du Dr. Gachet*, Auvers 1873 R 192; V 145
Vollard photograph no. 159, annotated: Gachet [per Rewald]. A print is in the Musée d'Orsay, Vollard archives.

PROVENANCE: Dr. Paul Gachet, Auvers [ca. 1872/73–1909]; donated by Paul Gachet *fils* to the Musée du Louvre, Paris, 1951

REFERENCES: Venturi 1936, no. 145 (as 1873, Gachet collection, citing mention by Van Gogh in letter 635); Florisoone 1952, pp. 14–15, repr.; Chatelet in Paris 1954–55, no. 6; Gachet in Cherpin 1972, repr. p. 10; Mothe in Gachet 1994, p. 80 n. 15, p. 86 n. 41 (proposes this work and P.G. II-4 [R 221] as two possible candidates for the Cézanne landscape admired by Van Gogh in 1890); Rewald 1996, no. 192 (as 1872–73)

LETTER: LT 635? See P.G. II-4 (R 221).

COMMENTS: Venturi was the first to identify this as the picture cited by Van Gogh in

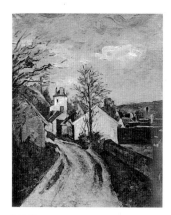

P.G. II-5

letter 635 ("another Cézanne, of the village"). Of the Cézanne paintings Venturi catalogued as being in the Gachet collection (in an incomplete account), only this work could be called a view of Auvers. As a consequence Van Gogh's quote has traditionally been identified with this work. Yet, as certain scholars have suspected more recently, Gachet also owned a panoramic view of Auvers (see P.G. II-4 [R 221]), as well as the not-yet-considered view of thatched cottages (see P.G. II-3 [R 185]). All three landscapes are presumably viable candidates for Van Gogh's admiration.

Still Life with Bottle, Glass, and Lemons, ca. 1867–69
Oil on canvas, 35.5 x 27.3 cm
Collection of Mr. and Mrs. Paul Mellon, Upperville, Virginia

P.G. II-6: *Nature morte (fiole, verre, citrons, etc.)*, vers 1870
R 129; V 63
Vollard photograph no. 201, annotated by Cezanne's son: 1875 [per Rewald]. A print is in the Musée d'Orsay, Vollard archives.

PROVENANCE: Dr. Paul Gachet, Auvers [?–1909]; sold by Paul Gachet *fils* to Wildenstein, Paris and New York, 1953; Steven Juvelis, Lynn, Mass.; Hirschl & Adler Galleries, New York; acquired by Mr. and Mrs. Paul Mellon, Upperville, Va., 1966

REFERENCES: Venturi 1936, no. 63 (as *Nature morte [flacon, verre et citron]*, 1864–66, Gachet collection); Rewald 1996, no. 129 (as ca. 1867–69 or "possibly later"; notes that painting was originally owned by Dr. Gachet, "to whom the artist may have presented it")

LETTER: Paul Gachet *fils* to Victor Doiteau, July 7, 1941 (reprinted in Tralbaut 1967, p. 93), probably the "Still life by Cézanne (before 1870), canvas, 27 x 33" that

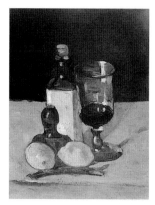

P.G. II-6

he was willing to sell for 20,000 francs. (Instead, Doiteau chose a small Van Gogh [see P.G. III-21 (F 821)] for the same price.)

COMMENTS: Rewald, like Venturi and Gachet *fils*, dates the painting prior to Cézanne's sojourn in Auvers and suggests that the artist brought it, and the wooden pepper mill depicted in it, with him in 1872; he notes that the same motif was incorporated in a Gachet-owned still life painted in Auvers that "poses surprising stylistic problems" (P.G. II-10 [R 211]).

Apples and Glass, ca. 1873
Oil on cardboard, remounted on canvas(?), 26.7 x 40 cm
Private collection

P.G. II-7: *Nature morte (deux pommes sur une assiette)*, vers 1872
R 208; V p. 347

PROVENANCE: Dr. Paul Gachet, Auvers [ca. 1873–1909]; sold by Paul Gachet *fils* to Alfred Daber, Paris, before 1953; Sam Salz, New York, by 1953; Mr. and Mrs. Leigh B. Block, Chicago; Fairweather-Hardin Gallery, Chicago, until 1958; sold to M. Knoedler and Co., New York, Nov. 1958, until June 1960; sold to Mr. and Mrs. Norman B. Woolworth, Monmouth, Me.,

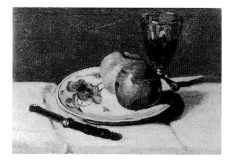

P.G. II-7

June 1960; sale, Parke-Bernet Galleries, New York, Oct. 31, 1962, no. 11; Mr. and Mrs. Arnold Askin, Katonah, N.Y.; sale, Christie's, New York, May 16, 1977, no. 26, bought in; Brain Trust, Inc., Tokyo; private collection, Japan; private collection
REFERENCES: Venturi 1936, p. 347 (under "Unpublished works," Gachet collection, as "Still life: Apple and glass. Two large, spherical apples, one red and the other yellow, on a faience plate decorated with a flower. To the right, a glass, to the left, a knife"; not repr.); Rewald 1996, no. 208 (as ca. 1873, oil on canvas, "one of the best constructed" still lifes painted in Auvers); Feilchenfeldt in Rewald 1996, p. 15 (questions its authenticity because the picture lacks early documentation in the form of a Vollard photograph)
COMMENTS: Gachet *fils* describes the support as cardboard. This work was first exhibited at the Musée Granet in Aix-en-Provence 1953, as no. 3.

Three Apples, ca. 1877 (possibly earlier)
Oil on cardboard, transferred to canvas, 24.8 x 34.3 cm
On reverse (per Gachet *fils*), annotation in Dr. Gachet's hand: P. Cézanne 1871; and two pencil sketches of boats by Cézanne
Private collection

P.G. II-8: *Nature morte (pommes, linge, draperie)*, 1871
R 355; V p. 347
Copied by Gachet *fils*, Feb. 1900 (RF 31 258)

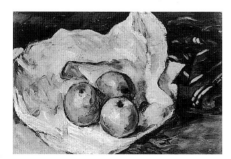

P.G. II-8

PROVENANCE: Dr. Paul Gachet, Auvers [?–1909]; sold by Paul Gachet *fils* to Wildenstein, Paris and New York, 1954; Mr. and Mrs. William Goetz, Los Angeles, by 1959; private collection, Philadelphia; sale, Christie's, London, June 29, 1976, no. 218, bought in; Wildenstein, New York; private collection, Japan; private collection

REFERENCES: Venturi 1936, p. 347 (under "Unpublished works," Gachet collection, as "Still life: Three apples. Small canvas: three yellow apples on a crumpled white tablecloth. Thickly painted, with particularly vivid colors"; not repr.); Rewald 1996, no. 355 (as ca. 1877, possibly earlier, oil on canvas); Feilchenfeldt in Rewald 1996, p. 15 (questions its authenticity because the picture lacks early documentation in the form of a Vollard photograph)
COMMENTS: Gachet *fils* describes the support as cardboard.

Flowers and Fruits, 1872–73
Oil on canvas, 38 x 46 cm
Private collection, Switzerland

P.G. II-9: *Pivoines*, vers 1871
R 212; V p. 347
Vollard photograph no. 176 [per Rewald]
Copied by Dr. Gachet (cat. no. 45) and by Bigny, Jan. 1900 (RF 31 262)

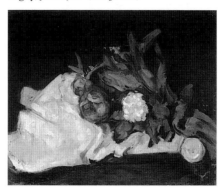

P.G. II-9

PROVENANCE: Dr. Paul Gachet, Auvers [ca. 1873–1909]; sold by Paul Gachet *fils* to M. B. Pellet, Paris, after 1936; Wildenstein, Paris, by 1953; sold to Emil Georg Bührle, Zurich, 1953; private collection, Switzerland
REFERENCES: Venturi 1936, p. 347 (under "Unpublished works," Gachet collection, as "Still life: Flowers and fruit. Flowers and apples; particular influence of Manet"; not repr.); Rewald 1996, no. 212 (as 1872–73 and betraying Manet's influence)

* *The Accessories of Cézanne: Still Life with Medallion of Philippe Solari*, 1872
(cat. no. 4)
Oil on cardboard, transferred to canvas, 60 x 81 cm
Musée d'Orsay, Paris, RF 1954-7

P.G. II-10: *Les accessoires de Cézanne*, Auvers 1873
R 211; V 67

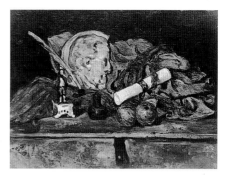

P.G. II-10

Vollard photograph (per Reff). A print is in the Musée d'Orsay, Vollard archives. (fig. 46).

PROVENANCE: Purportedly left behind by Cézanne with Dr. Paul Gachet, Auvers, 1874–1909; donated by Paul Gachet *fils* to the Musée du Louvre, Paris, 1954
REFERENCES: Rivière 1923, p. 199 (as *Nature morte—encrier: Sphinx à tête d'Adolphe Thiers*, ca. 1870); Venturi 1936, no. 67 (as *Nature morte: bas-relief, parchemin, encrier*, 1870–72, Gachet collection, and as dating prior to Cézanne's stay in Auvers; describes the medallion as a portrait of Dr. Gachet by Solari); Florisoone 1952, p. 24 (repr., with photograph of medallion); Gachet 1953a, n.p., repr. (writes: "Baptized the 'Accessories of Cézanne' by Dr. Gachet, this still life was painted not at the [Gachet] house but at Cézanne's house, and in addition brushed on a dreadful piece of spongy and disintegrated cardboard, which the humidity of the walls at Auvers did not spare . . . it was necessary to undertake a relining"; notes that Cézanne gave the broken plaster to Dr. Gachet and that it was glued together sometime later); Cooper 1955, p. 103 (as early 1872); Gachet 1956a, pp. 56, 103, 111 (clarifies that the medallion is a self-portrait by Solari); Gachet in Cherpin 1972, p. 12 (as typical of Cézanne's dark paintings of this period); Rewald 1996, no. 211 (as ca. 1872; wrestles with the picture's dating, stylistic problems, and clumsiness of execution, but hesitates to deny Cézanne's authorship, given evidence of similar failings in other Auvers still lifes and the "formal testimony" of Gachet *fils*); Feilchenfeldt in Rewald 1996, p. 15 (questions the authenticity of the picture because it lacks early documentation in the form of a Vollard photograph); Reff 1997, p. 801 (notes that the painting is, in fact, documented by a Vollard photograph and credits the picture's "disappointing appearance" to its condition, caused by the transfer of warped cardboard to canvas)

COMMENTS: The Solari medallion, dated 1870 and broken in 1872, was, according to Gachet *fils*, left behind along with the painting when Cézanne departed for Paris; later restored by Dr. Gachet, it was among the "souvenirs" presented to the Louvre. The painting was first exhibited in Paris 1954–55, no. 3.

P.G. II-11

Bouquet with Yellow Dahlia, 1873? (cat. no. 5)
Oil on canvas, 54 x 64 cm
Signed lower right in red: P. Cézanne
Musée d'Orsay, Paris, RF 1954-5

P.G. II-11: *Bouquet au dahlia jaune avec cruche de grès*, Auvers 1873
R 214; V p. 347
Vollard photographs nos. 177 and 428, annotated by Cézanne's son: 1875 [per Rewald].
Several prints are in the Musée d'Orsay, Vollard archives.
Copied by Paul Gachet *fils*, Feb. 1900 (RF 31 257) (cat. no. 5a)

PROVENANCE: Dr. Paul Gachet, Auvers [ca. 1873–1909]; donated by Paul Gachet *fils* to the Musée du Louvre, Paris, 1954
REFERENCES: Venturi 1936, p. 347 (under "Unpublished works," Gachet collection, as "Still life: Two vases. Dark brown vase with flowers arranged on a gray-blue tablecloth, which falls diagonally from left to right, against a black background"; not repr.); Florisoone 1952, p. 23 (repr., with photograph of pitcher); Gachet 1953a, n.p.; Cooper 1955, p. 103 (as summer/autumn 1872); Gachet 1956a, p. 56; Gachet in Cherpin 1972, p. 12; Adhémar and Sérullaz in Paris 1974, no. 12 (as having been purchased from Cézanne by Dr. Gachet); Rewald 1996, no. 214 (as *Bouquet du dahlia jaune*, 1872–73)
COMMENTS: Rewald, who finds this work "almost as dark and clumsy" as P.G. II-10 (R 211), states that it "must have been painted at Dr. Gachet's house," since it

incorporates objects (e.g., the pitcher and tablecloth) that belonged to him. The same fabric appears in an 1872 Guillaumin still life (P.G. IV-30 [S&F 14]). This painting was first exhibited in Paris 1954–55, no. 4.

In his catalogue entry, Gachet *fils* records that Cézanne, at Dr. Gachet's request, added his signature after the painting was dry.

Still Life with Italian Faience, ca. 1872–73
Oil on canvas, 46 x 55 cm
Private collection

P.G. II-12: *Nature morte au vase d'Urbino (esquisse)*. Peinte à l'atelier du Dr. Gachet—Auvers 1873
R 204; not in V

P.G. II-12

PROVENANCE: Dr. Paul Gachet, Auvers [ca. 1872/73–1909]; sold by Paul Gachet *fils* to Wildenstein, Paris and New York, 1953; private collection, Switzerland; private collection
REFERENCES: Gachet 1953a, n.p. (as an unfinished sketch of 1873; discusses origins of vase; repr.); Rewald 1996, no. 204 (as 1872–73; accepts the assessment of the work by Gachet *fils* as an unfinished or abandoned sketch); Feilchenfeldt in Rewald 1996, p. 15 (questions the picture's authenticity because it lacks early documentation in the form of a Vollard photograph)
COMMENTS: The vase used for this still life and for P.G. II-13 (R 205) was among the "souvenirs" later donated to the Louvre. Doubts have been raised about the authenticity of both works (as noted by Rewald and Feilchenfeldt). In his description of this one, Rewald defers to Gachet *fils*'s assessment of it as showing "a phase of Cézanne's work due to an accidental neglect and not to a voluntary stopping of a sketch considered sufficiently finished" (from Gachet 1953a, n.p.).

In his catalogue entry, Gachet *fils* credits his father with setting up the motif and encouraging Cézanne to paint, "at the atelier of Dr. Gachet," the second version (P.G. II-13) based on this "sketch."

Still Life with Italian Faience, 1872–73
Oil on canvas, 40 x 53 cm
Private collection

P.G. II-13: *Nature morte au vase d'Urbino*. Peinte à l'atelier du Dr. Gachet, Auvers 1873
R 205; V 189
Vollard photograph no. 172 (per Rewald). A print is in the Musée d'Orsay, Vollard archives.
Copied by Bigny (RF 31 263)

PROVENANCE: Dr. Paul Gachet, Auvers [ca. 1873–1909]; sold by Paul Gachet *fils* to Wildenstein, Paris and New York, 1951; Charles Engelhard, Far Hills, N. J., until 1959; consigned to M. Knoedler and Co., New York, Feb. 1959; sold to Galerie des Arts Anciens et Modernes, Geneva, Oct. 1959, and owned jointly with M. Knoedler and Co., New York, from Dec. 1960 until Feb. 1967; sale, Sotheby's, London, Dec. 6, 1961, no. 71 (withdrawn); Galerie des Arts Anciens et Moderns, Geneva, from Feb. 1967; Galerie de l'Élysée (Alex Maguy), Paris; sale, Parke-Bernet Galleries, New York, April 3, 1968, no. 54; Michael F. Drinkhouse, New York; sale, Christie's, London, April 14, 1970, no. 44; Bernard Solomon, Los Angeles; sale, Christie's, New York, May 19, 1978, no. 8; private collection, Japan; private collection

P.G. II-13

REFERENCES: Rivière 1923, p. 209 (as *Le pot à tabac*, ca. 1880; not repr.); Venturi 1936, no. 189 (as *La faïence italienne*, 1873–74, Gachet collection); Florisoone 1952, p. 24 (repr., with photograph of vase); Gachet 1953a, n.p. (repr.); Rewald 1996, no. 205 (as 1872–73)

COMMENTS: Rewald acknowledges that this and similar works have been doubted and attributed to Dr. Gachet or his son (Feilchenfeldt in Rewald 1996, p. 154, cites as examples Paul Rosenberg's doubts and the picture's withdrawal from a Sotheby's sale in 1961). Challenging, on the basis of both character and artistic ability, the notion that the Gachets were capable of forgery, Rewald concludes that the picture was painted in a period "during which the artist was groping, not always successfully, for a new mode of expression." A similar painting of the same subject by Paul Gachet *fils* was exhibited in New York at Wildenstein, in "Exhibition of Paintings by L. van Ryssel," 1954, as no. 17, *Apples and Anemones*, 1906, 15 x 18¼ in. (see New York 1954).

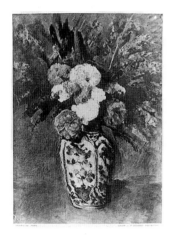

P.G. II-14

*
Dahlias, 1873
(cat. no. 9)
Oil on canvas, 73 x 54 cm
Signed lower left in red: P. Cézanne
Musée d'Orsay, Paris, RF 1971

P.G. II-14: *Bouquet de dahlias*. Peinte chez le Dr. Gachet—Auvers 1873
R 223; V 179
Vollard photograph no. 183, annotated by Cézanne's son: circa 1873–75; annotated in another hand: Gachet [per Rewald]. Several prints are in the Musée d'Orsay, Vollard archives.
Copied by Gachet *fils*, 1900 (RF 31 254) and 1906 (RF 1958-20) (cat. no. 9a)

PROVENANCE: Possibly Armand Rondest, Pontoise, from ca. 1873(?); Dr. Paul Gachet, Auvers, by 1890, until 1907; sold by Paul Gachet *fils*, through the dealer Moline, to Isaac de Camondo, Paris, May 11, 1907, until 1908; his bequest to the Musée du Louvre, 1908, accepted 1911; entered the Louvre, 1914

REFERENCES: Paris 1877(?), possibly no. 20 or 21, (*Étude de fleurs*); Rivière 1923, p. 206 (as ca. 1877); Venturi 1936, no. 179 as *Dahlias dans un pot de Delft*, 1873–75; notes that it was painted at Gachet's and that the vase is still in their house; gives the first owner as private collection, Pontoise; no mention of Gachet in provenance); Florisoone 1952, p. 25 (repr., with photograph of vase); Gachet 1953a, n.p. (as part of the Camondo collection in the Louvre; describes it as first in the series of four still lifes that Cézanne painted at Dr. Gachet's house in Auvers; repr.); Chatelet in Paris 1954–55, no. 14 (as ex Gachet collection); Cooper 1955, p. 103 (as 1873, ex Gachet collection); Gachet 1956a, p. 56 (as in the Camondo collection in the Louvre; describes its origin and relationship to "the three bouquets [au Petit Delft]" Cézanne subsequently made, p. 59; dates to August 1873); Reff 1962, p. 225, n. 17 (proposes that this still life and others signed in red [see R 226, p. 228] were shown in the 1877 Impressionist exhibition); Gachet in Cherpin 1972, p. 12; Brettell in San Francisco, Washington 1986, pp. 203–4 (names this work and R 226 as possible, but not the most likely, candidates for the "Étude de fleurs" shown as nos. 20 and 21 in the 1877 Impressionist exhibition); Gachet 1994, p. 45 (identifies this work and P.G. II-15 [R 227] as the still lifes Van Gogh admired at Gachet's house in 1890); Rewald 1996, no. 223 (as 1873; records original owner as Rondest, does not include Gachet in provenance; describes work as "supposedly the first of a series of flowers in a Delft vase" painted at Gachet's house, and relates the rest of Gachet *fils*'s account, but says that the series included two subsequent paintings, whereas Gachet *fils* says there were three; states that the painting may be referred to in Cézanne's draft letter of early 1874 [see below]; does not include the 1877 Impressionist show under exhibitions, though he gives some credence to the idea, despite general reservations about Reff's theory [Reff 1962, p. 225])
LETTERS: LT 635, as one of "two beautiful bouquets by Cézanne" that Van Gogh saw at Gachet's house in 1890 (see also P.G. II-15 [R 227]). Perhaps draft of a letter from Cézanne "to a collector in Pontoise" (reprinted in Cézanne Letters 1937, XXIX), presumably written in early 1874 to Rondest, in which Cézanne offers, "If you wish me to sign the picture you spoke to me about, please have it sent to M. Pissarro where I shall add my name," which may refer to this

picture or to R 226, R 191, or an unidentified work. Paul Gachet *fils* to Gustave Coquiot, April 1, 1922, referring to this picture as the "marvelous *Bouquet of Dahlias* in the Louvre that I sold to Camondo" (b3310 V/1966 VGM Archives).
COMMENTS: Gachet *fils* records that his father had set up the still life with the intention of painting it himself but allowed Cézanne, who had come by, to paint it instead. Dr. Gachet thereafter encouraged the slow-working Cézanne to paint three still lifes on a smaller scale (the origin of R 226, R 227, and an unidentified picture; see entries for R 226 [p. 240] and P.G. II-15 [R 227]). Gachet's ownership of this painting has been overlooked. Neither Venturi nor Rewald mentions Gachet in his provenance for the work, and Gachet *fils* always refers to it as a Camondo picture. It may be that Armand Rondest owned the picture originally, as Venturi and Rewald propose; but it was not, as Rewald seems to assume, one of the "three fine Cézannes" with Rondest in 1904 (see Gachet 1956a, p. 59). Gachet *fils* copied it in 1900 and 1906. Only in his unpublished catalogue and in his posthumously published manuscript (Gachet 1994, p. 45) did he identify it as one of the paintings Van Gogh saw at Gachet's in 1890 (see letter citation LT 635 above). The still life was sold seven years before that letter from Van Gogh to Theo was first published in 1914 (see comments for P.G. II-4 [R 221]).

*
Bouquet in a Small Delft Vase, 1873?
(cat. no. 8)
Oil on canvas, 41 x 27 cm
Signed lower left: P. Cézanne. Annotated (per Gachet *fils*) on original stretcher bar, in Dr. Gachet's hand: P. Cézanne, Août 1873.
Musée d'Orsay, Paris, RF 1951-33

P.G. II-15: *Bouquet dans un vase de Delft*. Peinte à la maison d'Auvers, Août 1873
R 227; V 183
Vollard photograph no. [353] [per Rewald]
Copied by Gachet *fils*, 1900/01 (RF 31 255) and 1906 (RF 1958-21) (cat. nos. 8b, 8a)

PROVENANCE: Purportedly acquired from the artist, upon completion, by Dr. Paul Gachet, Auvers, 1873, until 1909; donated by Paul Gachet *fils* to the Musée du Louvre, Paris, 1951
REFERENCES: Venturi 1936, no. 183 (as *Vase de fleurs*, 1873–75; identifies it as one of the "two beautiful bouquets by Cézanne" that Van Gogh mentioned [LT 635] seeing in

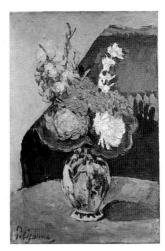

P.G. II-15

Gachet's collection in 1890 [the other was V 180]); Florisoone 1952, p. 25 (repr., with photograph of vase), p. 27, pl. III; Gachet 1953a, n.p., repr. (describes it as the "smallest" of the three still lifes in Delft vases painted at Gachet's house [a no. 6 canvas], signed, and the one that remained in the "house where he was born" for the longest period of time); Chatelet in Paris 1954–55, no. 7; Cooper 1955, p. 103 (as 1873, ex Gachet collection); Gachet 1956a, pp. 56, 59 (describes as the first of the "three bouquets [in the small Delft vase]" painted at Gachet's house in August 1873 and says that it was hung immediately upon completion "on the wall of the salon" and later donated to the Louvre); Gachet in Cherpin 1972, p. 12 (describes as one of four marvelous still lifes that Cézanne painted at their house); Gachet 1994, p. 45 (identifies this work and P.G. II-14 [R 223] as the two still lifes that Van Gogh admired at Gachet's house in 1890); Rewald 1996, no. 227 (as *Bouquet au petit vase de Delft*, 1873; seems to question whether the small scale of this work [and of R 226; see p. 228] was contingent on Dr. Gachet's advice)
LETTER: LT 635, as one of "two beautiful bouquets by Cézanne" that Van Gogh saw at Gachet's house in 1890 (see also P.G. II-14 [R 223])
COMMENTS: Gachet *fils* often described the "three paintings of flowers (in the small Delft [vase])" that Cézanne painted at their house in Auvers, and he always distinguished this work as the still life that remained in the house, as opposed to the other two, which did not. Of those, one, he said, belonged to the grocer Rondest; he most fully described it in Gachet 1956a, p. 59, as "a bouquet of zinnias or coreopsis—harmony

in copper [tones]" (this is an unidentified work, size 8 canvas, not in Rewald or Venturi). His description of the other makes it readily identifiable as R 226 (V 180); see p. 240. The series initiated, according to Gachet *fils*, with the *Bouquet de dahlias (au grand Delft)* (P.G. II-14 [R 223]), was followed by the "three paintings of flowers (in the small Delft)," making "four marvelous paintings made at the house" in all (Gachet in Cherpin 1972, p. 12). Venturi (V 179, 180, 183) and Rewald (R 223, 226, 227), account for only three of the four. The two that were part of the Gachet collection, the present painting and P.G. II-14 (R 223), were identified by Gachet *fils* as the "bouquets by Cézanne" that Van Gogh saw at their house in 1890 (LT 635; see Letter, above). The only other possible candidates for Van Gogh's admiration are *Bouquet with Yellow Dahlia* (P.G. II-11 [R 214]) and *Flowers and Fruits* (P.G. II-9 [R 212]). The present work was first exhibited in Paris 1953, no. 16.

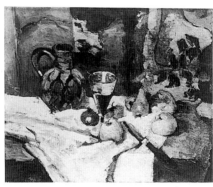

P.G. II-16

Pitcher, Glass, Fruit, and Knife, ca. 1873
Oil on canvas, 61 x 73 cm (fig. 79)
Fondation Angladon-Dubrujeaud, Avignon

P.G. II-16: *Nature morte (pichet, verre, fruits, couteau, tapisserie).* Peinte à l'atelier Gachet—Auvers 1873
R 203; V 185
Vollard photograph no. 174, annotated by Cézanne's son: 1875–80 [per Rewald]. Several prints are in the Musée d'Orsay, Vollard archives.
Copied by Gachet *fils,* Jan. 1900 (RF 31 256)

PROVENANCE: Dr. Paul Gachet, Auvers [ca. 1873–1909]; sold by Paul Gachet *fils* to Bernheim-Jeune, Paris, March 9, 1912; collection Jacques Doucet, Paris, by 1914, until his death in 1929; to his widow, Jeanne Doucet, until at least 1950; by succession to her nephew, Jean Dubrujeaud; Jean and Paulette Angladon-Dubrujeaud collection, until 1988; Fondation Angladon-Dubrujeaud, Avignon, from 1993

REFERENCES: Rivière 1923, p. 206 (as ca. 1877); Venturi 1936, no. 185 (as *Nature morte,* 1873, painted at Dr. Gachet's house in Auvers, ex Gachet collection); Florisoone 1952, p. 22 (repr., with photograph of pitcher, glass, and knife); Gachet 1953a, n.p., repr.; Feilchenfeldt in Paris, London, Philadelphia 1995–96, p. 570 (notes its 1912 sale to Bernheim-Jeune); Rewald 1996, no. 203 (as ca. 1873, one of a series of still lifes painted at the doctor's house based on objects his son later donated to the Louvre)
COMMENTS: Rewald, like Gachet *fils,* describes this work as belonging to a series of still lifes Cézanne painted at Dr. Gachet's house with "objects his host put at his disposal," and identifies the others as P.G. II-7 (R 208), P.G. II-11 (R 214), P.G. II-12 (R 204), P.G. II-13 (R 205), P.G. II-14 (R 223), P.G. II-15 (R 227) and R 226 (see p. 228).

* *Green Apples,* ca. 1872–73?
(cat. no. 6)
Oil on canvas, 26 x 32 cm
Musée d'Orsay, Paris, RF 1954-6

P.G. II-17: *Pommes vertes.* Peinte à la maison Gachet—1873
R 213; V 66
Vollard photograph no. 184, annotated by Cézanne's son: 1875 [per Rewald]
Copied by Gachet *fils* (RF 1958–22) and Derousse (RF 31 238), 1900 (cat. nos. 6b, 6a)

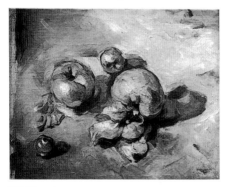

P.G. II-17

PROVENANCE: Dr. Paul Gachet, Auvers [ca. 1873–1909]; donated by Paul Gachet *fils* to the Musée du Louvre, Paris, 1954
REFERENCES: Venturi 1936, no. 66 (as *Nature morte: pommes et feuilles,* 1870–72, with no provenance given); Cooper 1955, p. 103 (as summer 1873); Cooper 1975, p. 83 (questions its authenticity, thinks it may be by Gachet); Rewald 1996, no. 213 (as 1872–73)
COMMENTS: In his catalogue entry, Gachet *fils* specifies that this work was painted "at the Gachet house, 1873." It was first exhibited in Paris 1954–55, no. 9.

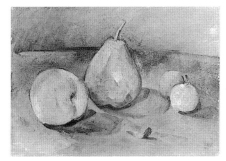

P.G. II-18

Still Life with Fruit
(attributed to Cézanne)
(cat. no. 7)
Oil on cardboard, 22 x 32 cm
Annotated on reverse at top and bottom, in
black pencil (in Dr. Gachet's hand, per Gachet
fils): Auvers/Septembre 1873/Paul Cézanne
Musée de l'Orangerie, Paris, RF 1963-10

P.G. II-18: *Nature morte (fruits)*, Auvers 1873
Not in R, illustrated and cited as a rejected
work under R 209; not in V
Vollard photograph (per Reff). Several prints
are in the Musée d'Orsay, Vollard archives.

PROVENANCE: Dr. Paul Gachet, Auvers
[?–1909]; sold by Paul Gachet *fils* to an
intermediary (Mathey or Methey) who
ceded it in April 1951 to Mme Jean Walter,
Paris, in exchange for two paintings by
Chaim Soutine; Jean Walter and Paul
Guillaume collection, Paris, until 1963; their
collection acquired by the Musées
Nationaux, 1963
REFERENCES: Rewald 1996, p. 155, under
no. 209 (illustrated as a copy after Cézanne
and cited by the editor as a work not
accepted by Rewald); Reff 1997, p. 800
(notes the existence of a Vollard photograph
and Rewald's rejection of the painting
nevertheless)
COMMENTS: This work was first published
and exhibited in Paris 1966, no. 1, and then in
Paris 1974, no. 7, as a Cézanne of ca. 1873–74.
It was subsequently downgraded by the
museum to "attributed to Cézanne" and was
rejected by Rewald. It is documented by a
Vollard photograph and is similar to other
Gachet-owned works (e.g., P.G. II-19
[R 209]) that Rewald accepted, as noted by
Reff (1997, p. 800), who remarks on inconsis-
tencies in Rewald's attributions and questions
the methodology "based on documentary evi-
dence or its absence" that led Feilchenfeldt to
doubt pictures in the Gachet collection not
represented by Vollard photographs.

Gachet *fils* describes the support as card-
board and states that the annotations on the
reverse were written by his father.

P.G. II-19

Peach and Pear, ca. 1873
Oil on cardboard, 13.8 x 17 cm
Private collection

P.G. II-19: *Pêche et poire*, Auvers 1873
R 209; not in V

PROVENANCE: Dr. Paul Gachet, Auvers
[ca. 1873–1909]; presented by Paul Gachet
fils to M. and Mme Philippe Huisman, Paris
REFERENCES: Rewald 1996, no. 209 (as
Pêche et poire, ca. 1873); Warman in Rewald
1996, p. 155 (notes that the composition is
"nearly identical" to a still life also owned by
Gachet that Rewald rejected [see P.G. II-18];
Feilchenfeldt, in the same source, p. 155,
points to its lack of early documentation in
the form of a Vollard photograph as reason
to be dubious of its authenticity); Reff 1997,
p. 800 (notes that the similar, but rejected,
work is represented by a Vollard photograph)

P.G. II-20

Still Life with Game Birds, 1872–73
Oil transferred to linen, on honeycomb
panel, 25.5 x 39.6 cm
Fogg Art Museum, Harvard University Art
Museums, Cambridge, Massachusetts, Gift
of David Rockefeller

P.G. II-20: *Gibier*, Auvers 1873
R 206; V p. 347
Vollard photograph no. 378 [per Rewald]
Copied by Bigny, Feb. 1900 (RF 31 264)

PROVENANCE: Dr. Paul Gachet, Auvers
[ca. 1873–1909]; sold by Paul Gachet *fils* to
Wildenstein, Paris and New York, 1951, until
1960; donated to benefit auction for the
Museum of Modern Art, New York, Parke-
Bernet Galleries, April 27, 1960, no. 24;
acquired at the sale by David Rockefeller,
New York, until 1976; donated to Fogg Art
Museum, Harvard University, Cambridge,
Mass., 1976
REFERENCES: Venturi 1936, p. 347 (under
"Unpublished works," Gachet collection, as
"Still life: a bird on a red background"; not
repr.); Gachet 1953a, n.p. (describes how
Cézanne reused the drapery from P.G. II-10
[R 211] for "the red background of a still life,
Gibier, painted on cardboard, then trans-
ferred to canvas"); Cooper 1975, p. 83; Potter
1984, no. 46, pp. 148–49 (as Cézanne?, ca.
1873?; full discussion; reprints the Gachet
catalogue entry for this work); Rewald 1996,
no. 206 (as 1872–73)
COMMENTS: Rewald notes the unusual red
background and that Gachet *fils* recorded
that the same fabric was used for another
still life (see P.G. II-10 [R 211]). As Feilchen-
feldt remarks (in Rewald 1996, p. 154), the
picture was first challenged by Cooper (1975)
and then by Potter (1984); attributions to
Dr. Gachet and to Guillaumin have been
proposed. David Rockefeller states (in Potter
1984, p. 149) that he bought the work at
Alfred Barr's recommendation and, in light
of the "interesting controversy" sparked by
Cooper, gave it to the Fogg Art Museum "as
a painting to be used for study purposes."

According to Gachet *fils,* the original card-
board support was of poor quality, and after
"twenty-five or thirty years" this made the
"transfer to canvas obligatory." Although the
work has been reproduced in the literature
as a horizontal composition, in the Gachet
household it was hung vertically (see fig. 13).

Hamlet and Horatio (after Delacroix),
1873–74
Oil on paper mounted on canvas, 21.9 x
19.4 cm
Private collection

P.G. II-21: *Hamlet (esquisse d'après
Delacroix)*, vers 1870
R 232; V p. 347

PROVENANCE: Dr. Paul Gachet, Auvers
[1874–1909]; sold by Paul Gachet *fils* some-
time between 1936 and 1953; private collection,
New York; sale, William Doyle Galleries,
New York, Sept. 22, 1982, no. 47; Sydney
Rothberg, Philadelphia; private collection

P.G. II-21

REFERENCES: Venturi 1936, p. 347 (under "Unpublished works," Gachet collection, as *Hamlet et Horatio, d'après Delacroix;* not repr.); Venturi 1956, pp. 270–71, fig. 1 (remarks that this picture, which he "had the good fortune to trace in the market," was in the Gachet collection when he saw it in 1934 and is based on Delacroix's 1839 painting in the Louvre); Rewald 1996, no. 232 (as 1873–74); Feilchenfeldt in Rewald 1996, p. 15 (questions its authenticity because the picture lacks early documentation in the form of a Vollard photograph)

COMMENTS: This is one of three works in Gachet's collection based on a Delacroix lithograph he owned, *Hamlet Contemplating the Skull of Yorick.* (For the two related drawings, see P.G. II-41 [Chappuis 325] and P.G. II-42 [Chappuis 326].)

P.G. II-22

Bathers, ca. 1870
Oil on canvas, 33 x 40 cm
Private collection, Paris

P.G. II-22: *Baigneuses (noires),* vers 1870
R 159; not in V
Vollard photograph no. 516 (per Rewald).
A print is in the Musée d'Orsay, Vollard archives.
Copied by Derousse (RF 31 239)

PROVENANCE: Dr. Paul Gachet, Auvers [?–1909]; sold by Paul Gachet *fils* before 1959; Wildenstein, Paris; Jacques Dubourg, Paris; sale, Chapelle et Martin, Versailles, Dec. 12, 1959, no. 60; sale, Floralies, Versailles, June 2, 1982, no. 45; private collection, Paris

REFERENCES: Not in Venturi; Gachet in Cherpin 1972, p. 12 (probably the *Bathers* described as having been painted at Dr. Gachet's house); Rewald 1996, no. 159 (as ca. 1870)

COMMENTS: In his catalogue entry, Gachet *fils* indicates that the work was stamped on the reverse: Chabod, Sucr de Bovard. Md. de Couleurs & toiles à tableaux.—Rue de Bucy. 15. On the supplier Chabod, see cat. no. 2.

Although Gachet *fils* dates this work and P.G. II-23 to ca. 1870, he mentions (in Cherpin 1972) the artist's reliance on black in canvases painted at the Gachet house (i.e., 1872–74), such as "the *Bathers* and a splendid still life" (P.G. II-11).

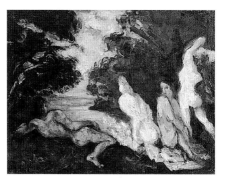

P.G. II-23

Reclining Man with Bathers, ca. 1870
Oil on cardboard, transferred to canvas, 26.7 x 35 cm
Private collection

P.G. II-23: *Baigneuses (sombres—fond bleu),* vers 1870
R 160; not in V
Vollard photograph no. 525, annotated by Cézanne's son: ca. 1870 [per Rewald]
Copied by Derousse (RF 31 240, VGM P170)

PROVENANCE: Dr. Paul Gachet, Auvers [?–1909]; sold by Paul Gachet *fils* to Wildenstein, Paris and New York, 1953; private collection, Milan; private collection

REFERENCES: Not in Venturi; Gachet in Cherpin 1972, p. 12; Rewald 1996, no. 160 (as ca. 1870, oil on canvas)

COMMENTS: According to Gachet *fils,* this work was painted on poor-quality cardboard and was transferred to canvas. He notes that the etched copy by Derousse was made on July 9, 1899.

P.G. II-24

Three Bathers, 1876–77 (possibly earlier)
Oil on canvas, 24.8 x 34.3 cm
Collection Elliot K. Wolk, Scarsdale, New York

P.G. II-24: *Baigneuses (claires)*
R 358; V 269
Vollard photograph no. 28, annotated by Cézanne's son: 1877 [per Rewald]. A print is in the Musée d'Orsay, Vollard archives. Copied by an anonymous artist (VGM D570)

PROVENANCE: Dr. Paul Gachet, Auvers [?–1909]; sold by Paul Gachet *fils* to Wildenstein, Paris and New York, 1960; sold to Mr. and Mrs. Roy O. Chalk, New York and Palm Beach, Fla., ca. 1960; sale, Parke-Bernet, New York, Oct. 19, 1977, no. 29, bought in; sale, Christie's, New York, Nov. 19, 1986, no. 7; Elliot K. Wolk, Scarsdale, N.Y.

REFERENCES: Bernard 1926, repr. opp. p. 86; Venturi 1936, no. 269 (as *Trois baigneuses,* 1875–77, a "masterpiece" belonging to Gachet); Krumrine 1990, pp. 144, 146, repr. (as one of a series of related compositions depicting three bathers); Rewald 1996, no. 358 (as 1876–77, possibly earlier); Feilchenfeldt in Rewald 1996, p. 15 (suspects that the work is a spurious copy after a drawing [Chappuis 366]); Reff 1997, p. 801 (refutes Feilchenfeldt's assessment, finding qualities of the picture characteristic and "hardly conceivable in an imitation")

COMMENTS: A related drawing by Cézanne also in Gachet's collection (P.G. II-30) was described by Venturi (p. 347) as "Sketches . . . five bathers, of which the first on the left is a study for no. 269."

Gachet *fils* points out that in this work "One notes . . . the existence of a pencil [layout] sketch, which proves that Cézanne did not, as some have insisted, paint without a preparatory drawing."

P.G. II-25

A Modern Olympia (Sketch), 1873–74
(cat. no. 1)
Oil on canvas, 46 x 55 cm
Musée d'Orsay, Paris, RF 1951-31

P.G. II-25: *Une moderne Olympia,* Auvers 1872
R 225; V 225
Vollard photographs nos. 269 and [264], anno-
tated by Cézanne's son: 1875 [per Rewald]. A
print is in the Musée d'Orsay, Vollard archives.
Copied by Dr. Gachet in oil (RF 1958-17) and
in ink (VGM D599); by Derousse in water-
color, March 21, 1901 (RF 31 237), and in dry-
point (VGM P210) (cat. nos. 1b, 1a, 1c, 1d)

PROVENANCE: Acquired from the artist by
Dr. Paul Gachet, Auvers, by 1874, until 1909;
donated by Paul Gachet *fils* to the Musée du
Louvre, Paris 1951
EXHIBITIONS: Paris 1874, no. 43; Paris 1936,
no. 28; Paris 1939, no. 7
REFERENCES: Vollard 1914, pp. 32–33, pl. 10;
Rivière 1923, p. 198 (as 1868, but possibly
retouched 1872); Venturi 1936, no. 225 (as
1872–73); Florisoone 1952, pp. 19–20, repr.;
Chatelet in Paris 1954–55, no. 8; Gachet
1956a, pp. 57–58, 93 (as a "'marvelous sketch'
that Gachet immediately took away for safe-
keeping, fearing that Cézanne might destroy
it by trying to *push* it further"; recounts that
Dr. Gachet gave Cézanne another canvas to
make a copy of it, which was never realized);
Gachet 1956b; Andersen 1970, p. 42 n. 2 (dis-
putes Gachet's part in the work's origin,
since the artist had first treated the subject in
1869–70, before he knew Gachet); Gachet in
Cherpin 1972, p. 12 (as a surprisingly bright
work done in a period marked by dark paint-
ings); Cooper 1975, p. 83 (as 1873); Paris,
London, Philadelphia 1995–96, no. 28 (as
1873); Rewald 1996, no. 225 (as 1873–74)
COMMENTS: According to Gachet *fils,* this
work was painted in 1872 and was inspired
by a discussion between his father and
Cézanne about Manet's *Olympia.* Most
scholars have dated the work later, about
1873, and Rewald leans toward 1874.

P.G. II-26

View of Pontoise (?), ca. 1877–82
Graphite and watercolor on white laid
paper, 23.5 x 30.5 cm
Location unknown

P.G. II-26: *Paysage,* vers 1870
Rewald 1983, no. 87
Vollard photograph no. 180 (per Rewald)

PROVENANCE: Dr. Paul Gachet, Auvers
[?–1909]; sold by Paul Gachet *fils* to
Wildenstein, Paris and New York, 1957,
until 1959; sold to Mrs. Dunbar Bostwick,
1959; consigned by her to Wildenstein, New
York, by 1971–72; sold to Hirschl and Adler
Galleries, New York; Jan Krugier, New
York; sale, Christie's, London, Dec. 6, 1977,
no. 116; Japanese art market; private collec-
tion, Boston (?); sale, Christie's, London,
Dec. 3, 1985, no. 409
REFERENCE: Rewald 1983, no. 87 (as 1877–82;
tentatively proposes as a view of Pontoise)
COMMENTS: On Nov. 20, 1954, Gachet *fils*
listed this watercolor among works he
intended to give to the Musée du Louvre; at
some later point (before 1957, when he sold
it to Wildenstein) he evidently changed his
mind, crossed out the entry, and wrote next
to it "canceled" (VGM Archives).

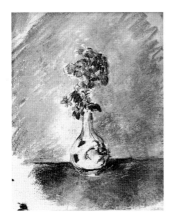

P.G. II-27

Vase of Flowers, 1873–74
Pastel and graphite on white paper, 19.5 x
15.5 cm
Annotated on reverse (per Gachet *fils*), in
Dr. Gachet's hand :P. Cézane [*sic*]
Location unknown

P.G. II-27: *"Simplicité" (petit bouquet),*
Auvers 1873
Chappuis 297; V p. 347

PROVENANCE: Dr. Paul Gachet, Auvers
[1873/74–1909]; sold by Paul Gachet *fils* to
Wildenstein, Paris and New York, 1955; sold
to Mr. and Mrs. Dunbar W. Bostwick,
New York, 1955, until 1962; sold to Wilden-
stein, New York, 1962, until ca. 1966–67;
sold to Galerie Beyeler, Basel; private
collection, Switzerland (by 1973)
REFERENCES: Venturi 1936, p. 347 (under
"Unpublished works," Gachet collection,
"Pastels," as *Vase de fleurs;* not repr.); Reff 1960,
p. 118, fig. 25; Chappuis 1973, no. 297 (as
1873–74)
COMMENTS: This work was first exhibited
and reproduced in New York at Wilden-
stein, in "Loan Exhibition Cézanne,"
Nov. 5–Dec. 5, 1959, no. 58, lent by Mr. and
Mrs. Dunbar W. Bostwick, New York (see
New York 1959).

P.G. II-28

Sunset, ca. 1873
Pastel, 21.6 x 33 cm
Location unknown

P.G. II-28: *Coucher de soleil,* Auvers 1873
Chappuis 742; V p. 347

PROVENANCE: Dr. Paul Gachet, Auvers
[ca. 1873–1909]; Paul Gachet *fils,* until at
least 1936; Jacques O'Hana, London; Mau-
rice Harris, London, by 1973
REFERENCES: Venturi 1936, p. 347 (under
"Unpublished works," Gachet collection,
"Pastels," as *Paysage avec maisons;* not repr.);
Chappuis 1973, no. 742 (as ca. 1873, and with
P.G. catalogue number)

P.G. II-29

The Quarry, ca. 1873
Graphite and pastel on gray-blue laid paper
(with watermark: P.L. Bas), 27 x 46 cm
Location unknown

P.G. II-29: *La carrière,* Auvers 1873
Chappuis 742a; V p. 347

PROVENANCE: Dr. Paul Gachet, Auvers
[ca. 1873–1909]; Paul Gachet *fils,* until at
least 1936

REFERENCES: Venturi 1936, p. 347 (under
"Unpublished works," Gachet collection,
"Pastels," as *Paysage avec collines,* ca. 1873;
subject described as an abandoned quarry
near Gachet's house; not repr.); Chappuis
1973, no. 742a; not repr.

COMMENTS: This lost drawing, first
recorded in 1936, is here reproduced for the
first time.

P.G. II-30 (recto)

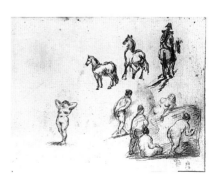

P.G. II-30 (verso)

Sketches: Three Boats (recto); *Two Horses with
a Rider, Five Bathers* (verso), before 1872
Graphite with black chalk heightened with
white on slightly yellowed white paper (with
Canson watermark), 35 x 22.5 cm
Annotated lower left, in Dr. Gachet's hand
(per Gachet *fils*): P. Cézane [*sic*]
Location unknown

P.G. II-30: *Tartanes et barques* (recto);
Baigneuses, chevaux, gendarme (verso)
V p. 347

PROVENANCE: Dr. Paul Gachet, Auvers
[?–1909]; Paul Gachet *fils,* until at least 1936

REFERENCE: Venturi 1936, p. 347 (under
"Unpublished works," Gachet collection, as
"Sketches: Recto: Three boats. Verso: Two
horses with a rider in the center [study for
Don Quixote?]; five bathers, of which the first
on the left is a study for no. 269"; not repr.)

COMMENTS: See P.G. II-24 (R 358).

L'Estaque (recto); *Hand* (verso), 1872–73
Black chalk with traces of blue pencil on
white paper (with watermark: Whatman
Turkeymill 1866), 24.5 x 31 cm
Annotated in blue pencil on recto and verso,
lower right, in Dr. Gachet's hand (per
Gachet *fils*): P. Cézane [sic]
Location unknown

P.G. II-31: *L'Estaque* (recto); *Main de femme*
(verso), avant 1873
Chappuis 124a
Vollard photographs of recto and verso
(per Anne Distel); prints are in the Musée
d'Orsay, Vollard archives.
Copied by P. van Ryssel (Dr. Paul Gachet),
1873 (cat. no. 46a)

PROVENANCE: Dr. Paul Gachet, Auvers
[1872/73–1909]; Paul Gachet *fils,* until at
least 1955

REFERENCES: Gachet 1952, n.p.; Chappuis
1973, no. 124a (as 1872–73, a lost work
documented by Dr. Gachet's etched copy of
1873 [repr.])

COMMENTS: This work, here reproduced for
the first time, was previously known only from
Dr. Gachet's copy of it, which was described
by his son (Gachet 1952, n.p.) and illustrated
in Chappuis, albeit recto only (see cat. no. 46a).
In his catalogue entry, Gachet *fils* records that
the traces of blue pencil on the bottom and
along the sides enframe the part of the draw-
ing (22.5 x 28.4 cm) etched by Dr. Gachet.
On Dec. 4, 1955, Gachet *fils* listed the drawing
among works he intended to give to the Musée
du Louvre; at some later point he evidently
changed his mind, crossed out the entry, and
wrote next to it "canceled" (VGM Archives).

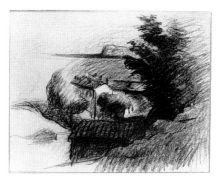

P.G. II-31 (recto)

P.G. II-31 (verso)

Seated Male Nude Leaning on His Elbow,
ca. 1863
Black crayon on gray-blue paper, 30 x 45 cm
Location unknown

P.G. II-32: *Académie (Jeune homme à terre),*
Académie Suisse, Paris 1863?
Chappuis 101; V 1165

PROVENANCE: Dr. Paul Gachet, Auvers
[?–1909]; Paul Gachet *fils,* until at least
1936; James Lord, New York; J. K. Thann-
hauser, New York, 1973

REFERENCES: Vollard 1914, p. 5, repr.;
Venturi 1936, no. 1165 (as *Étude du nu,*
1860–65, Gachet collection); Chappuis 1973,
no. 101 (as ca. 1863)

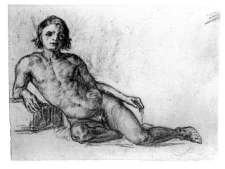

P.G. II-32

P.G. II-33

Male Nude Leaning on His Elbow, 1863–66
Charcoal on thin blue paper, 31.2 x 40.8 cm
Bridgestone Museum of Art, Ishibashi
Foundation, Tokyo

P.G. II-33: *Académie (Homme à terre, d'après nature)*, Académie Suisse, Paris, 1863?
Chappuis 100; V 1165

PROVENANCE: Dr. Paul Gachet, Auvers
[?–1909]; presumably sold by Paul Gachet
fils to Ryūichi Ishiwara (Kyūryūdō), Tokyo,
before 1954; Shōjirō Ishibashi, 1954; donated
to the Ishibashi Foundation, Tokyo, 1961
REFERENCES: Venturi 1936, no. 1165 and
p. 347 (under "Unpublished works," Gachet
collection, as *Nu couché*. Pencil on blue paper
[corresponds to no. 1165]; not repr.); Chappuis 1973, no. 100 (as 1863–66)

P.G. II-34

Standing Male Nude Seen from the Back
and *Two Studies for "The Abduction,"*
ca. 1861; studies, 1866–67
Graphite on paper (with Michallet watermark), 43 x 29 cm
On reverse (per Gachet *fils*): Conté crayon
sketch of a standing (female?) nude
Ohara Museum of Art, Kurashiki,
Okayama, Japan

P.G. II-34: *Académie (Homme debout) et recherches pour "Un enlèvement,"* Académie
Suisse, Paris 1863
Chappuis 200; V p. 347

PROVENANCE: Dr. Paul Gachet, Auvers
[?–1909]; sold by Paul Gachet *fils* between
1936 and 1954; with the noted Japanese
painter Sotaro Yasui, Tokyo (1888–1955), by
1954; Minami Gallery, 1966; Ohara Museum
of Art, Kurashiki, Okayama, Japan
REFERENCES: Venturi 1936, p. 347 (under
"Unpublished works," Gachet collection, as
"Standing nude, back view; with two studies
for the *Enlèvement* on the side [no. 101]";
not repr.); Chappuis 1973, no. 200 (as
ca. 1861; studies 1866–67)
COMMENTS: Gachet *fils* notes that on the
reverse, in addition to the sketch, there are a
few pencil marks and strokes of blue and
gray watercolor.

P.G. II-35

Landscape with Viaduct and Railway
Black crayon on white, finely grained, handmade paper, 25 x 32 cm
Location unknown

P.G. II-35: *Le viaduc*, vers 1870
V p. 347

PROVENANCE: Dr. Paul Gachet, Auvers
[?–1909]; Paul Gachet *fils*, until at least 1936
REFERENCE: Venturi 1936, p. 347 (under
"Unpublished works," Gachet collection,
"Paintings," as *Paysage: viaduc et chemin de
fer*; not repr.)
COMMENTS: Although this work is listed
in Venturi under paintings, Rewald recognized it as a drawing, according to Jayne
Warman (oral communication, Dec. 10,
1997). It is reproduced here for the first time.

Les Vessenots
Graphite on paper, 23.5 x 31 cm (sheet); 18.8
x 25.7 cm (image)
Location unknown

P.G. II-36: *Les Vessenots*, Auvers 1873–74

P.G. II-36

PROVENANCE: Dr. Paul Gachet, Auvers
[ca. 1874–1909]; subsequent provenance
unknown
COMMENTS: Gachet *fils* records that this
drawing hung in a guest room on the third
floor that "Dr. Gachet 'modestly' called
'Le Petit Louvre,' because that was where he
enjoyed hanging his favorite paintings and
the prints he was partial to."

** *Peasant Girl Wearing a Fichu*, ca. 1873 or
ca. 1890–93 (fig. 78)
Graphite on white laid paper (with
Michallet watermark), 22 x 17 cm
Annotated (per Gachet *fils*) in blue pencil on
reverse, in Dr. Gachet's hand: P. Cézane [*sic*]
Philadelphia Museum of Art, The Henry P.
McIlhenny Collection, in memory of
Francis P. McIlhenny, 1986-26-2

P.G. II-37: *Jeune paysanne (Tête de jeune
fille)*, Auvers 1873 [in pencil, after title:
Almyre]
Chappuis 273; V p. 347

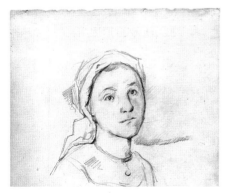

P.G. II-37

PROVENANCE: Dr. Paul Gachet, Auvers
[ca. 1873?–1909]; Paul Gachet *fils*, until his
death in 1962; acquired from his estate by
the Galerie Daber, Paris, 1962; sold to
Henry McIlhenny, Philadelphia, 1962; his
bequest to the Philadelphia Museum of Art,
1986
EXHIBITION: Paris 1936, no. 145

REFERENCES: Venturi 1936, p. 347 (under "Unpublished works," Gachet collection, as "*Paysanne coiffée d'une marmotte* [graphite drawing, 22 x 17 cm]. Exposition OR. C. 36, no. 145"; not repr.); Gachet 1952, n.p. (observes that the same sitter is represented in a Cézanne etching [V 1160]); Andersen 1970, no. 257 (as 1873–74; proposes that the same model posed for a Guillaumin pastel [repr. as a comp. ill.]; not repr.); Chappuis 1973, no. 273 (as ca. 1873; associates image with Cézanne's etching and proposes that the same sitter is represented); Clark 1974, pp. 79–80 (argues for a date of ca. 1893 and disputes the drawing's relationship to the etching); Reff 1975, p. 490 (disputes 1873 date and previous identifications of the model with Cézanne's etching and the [stylistically] "related" Guillaumin pastel); Rishel in Paris, London, Philadelphia 1995–96, no. 33 (as ca. 1873; calls the drawing a unique image of this face and a work probably first owned by Dr. Gachet)

LETTER: Mme Paule Lizot to Mr. and Mrs. Marc Edo Tralbaut, July 20, 1962, writes that "Daber is offering 5 million for the group of drawings" in the estate of Gachet *fils*, but "only the Cézanne *Head of a Young Girl* is worth that amount."

COMMENTS: Gachet *fils*'s contention that the model for this drawing also posed for Cézanne's etching of 1873 (see V 1160, p. 200) has not been widely accepted. The drawing has been variously dated, to about 1873 and to about 1890–93. On Dec. 4, 1955, Gachet *fils* listed this drawing among works he intended to give to the Musée du Louvre "in case of sudden death" (VGM Archives); perhaps the document was superseded by another, for the drawing was part of his estate and was purchased from it.

Dr. Gachet, Seen from the Back, 1873
Graphite on faded gray-blue paper, 23.5 x 20 cm
Annotated lower margin, in Dr. Gachet's hand (per Gachet *fils*): P. Cézanne
Location unknown

P.G. II-38: *Le Docteur Gachet (vu de dos)*, Auvers 1874
Chappuis 296; V p. 347

PROVENANCE: Dr. Paul Gachet, Auvers [1873–1909]; Paul Gachet *fils*, until his death in 1962; acquired from his estate by the Galerie Daber, Paris, 1962, until at least 1973
REFERENCES: Venturi 1936, p. 347 (under "Unpublished works," Gachet collection,

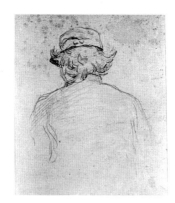

P.G. II-38

as "*Portrait du Docteur Gachet*. Back view, half-length. Pencil on blue paper"; not repr.); Gachet 1956a, p. 105; Andersen 1970, no. 224; not repr. (as a lost work; confuses it with Venturi's description of P.G. II-39 [Chappuis 295]); Chappuis 1973, no. 296 (as Dr. Gachet, seen back view, 1873, pencil on gray-blue paper, signed [*sic*] by Cézanne)
COMMENTS: On Dec. 4, 1955, Gachet *fils* listed this drawing among works he intended to give to the Musée du Louvre "in case of sudden death" (VGM Archives); perhaps the document was superseded by another, for the drawing was part of his estate and was purchased from it.

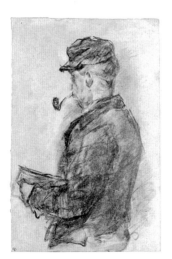

P.G. II-39

Dr. Paul Gachet, ca. 1872–73
(fig. 25)
Charcoal on gray paper (now discolored), with traces of yellow fixative(?) 32.2 x 21.5 cm
Musée du Louvre, Paris, Département des Arts Graphiques, Fonds du Musée d'Orsay, RF 29 926

P.G. II-39: *Le Docteur Gachet dans son atelier*, Auvers 1873
Chappuis 295; V p. 347

PROVENANCE: Dr. Paul Gachet, Auvers [ca. 1873–1909]; donated by Paul Gachet *fils* to the Musée du Louvre, Paris, 1951
REFERENCES: Venturi 1936, p. 347 (under "Unpublished works," Gachet collection, as "*Portrait du Docteur Gachet*. Charcoal"; not repr.); Florisoone 1952, p. 7, repr.; Chatelet in Paris 1954–55, no. 18; Gachet 1956a, pp. 61, 105, fig. 3; Andersen 1970, no. 222 and pp. 9–10, 12–14 (as "Portrait of Dr. Paul Gachet painting," ca. 1873–74, but with some erroneous remarks pertaining to its description in Venturi); Chappuis 1973, no. 295 (as "Portrait of Dr. Gachet," ca. 1873, charcoal on gray-brown paper)
COMMENTS: Gachet *fils* comments that "the fixative has given a yellowish tint" to the gray paper. This work was first exhibited in Paris 1954–55, no. 18.

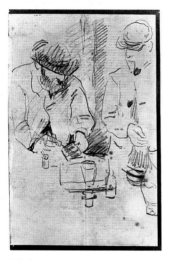

P.G. II-40

Dr. Gachet and Cézanne Making an Etching, ca. 1872–73
(fig. 24)
Graphite on laid writing paper with a faded black border, 20.5 x 13 cm
Musée du Louvre, Paris, Département des Arts Graphiques, Fonds du Musée d'Orsay, RF 29 925

P.G. II-40: *La morsure*, Auvers 1873
Chappuis 292; V p. 347

PROVENANCE: Dr. Paul Gachet, Auvers [1873–1909]; donated by Paul Gachet *fils* to the Musée du Louvre, Paris, 1951
REFERENCES: Venturi 1936, p. 347 (under "Unpublished works," Gachet collection, as "Doctor Gachet and Cézanne, preparing the acid bath for an etching"; not repr.; also described under no. 1159); Florisoone 1952, p. 23, repr.; Gachet 1952, n.p., repr. (identifies the etching being made as *Head of a Young*

Girl [V 1160]; see p. 200); Gachet 1954a, p. 15 (as made "as if to leave an irrefutable testimony of those curious and magnificent debuts [in etching]"); Chatelet in Paris 1954–55, no. 19; Gachet 1956a, pp. 53, 105 (as "*La morsure*, pencil sketch, where the artist has depicted himself in the process of biting a plate, under the eye of his friend Van Ryssel, who surveys the operation [40 P.G.]"); Andersen 1970, catalogued twice, as nos. 28 and 225 (as "Dr. Gachet and Cézanne preparing the acid bath for etching a plate"; notes "Although it does suggest Cézanne's style . . . examination of the details reveals major dissimilarities"; suggests a possible alternative attribution to Pissarro); Chappuis 1973, no. 292 (as 1873); Adhémar and Sérullaz in Paris 1974, no. 52 (as 1873, possibly executed after a photograph; notes the similarity in style to Pissarro); Cooper 1975, p. 83 (suggests attribution to Guillaumin)
COMMENTS: Reservations have been expressed about Gachet *fils*'s identification of the subject of this drawing and its attribution to Cézanne. The idea that the drawing could be both of Cézanne and by Cézanne was first challenged by Andersen, who found it "unlikely, if not impossible, that Cézanne would have executed this spontaneous drawing as if he were an onlooker rather than the subject." Alternative attributions to Pissarro and Guillaumin have been proposed.

P.G. II-41

Hamlet and Horatio (after Delacroix), 1873
Conté crayon on bister paper, 25.5 x 34 cm
Annotated on reverse in blue pencil, in
Dr. Gachet's hand (per Gachet *fils*):
P. Cézanne
Location unknown

P.G. II-41: *Le grand "Hamlet" (d'après Delacroix)*, Auvers 1873
Chappuis 325; V. p. 347

PROVENANCE: Dr. Paul Gachet, Auvers [1873–1909]; Paul Gachet *fils*, until his death in 1962; acquired from his estate by Galerie Daber, Paris, 1962, until at least 1973
REFERENCES: Venturi 1936, p. 347 (under "Unpublished works," Gachet collection, as one of the works "Faust and Mephistopheles, after the Delacroix lithograph. Two drawings of different sizes"; not repr.); Berthold 1958, no. 244; Chappuis 1973, no. 325 (as 1873)
COMMENTS: On Nov. 20, 1954, and on Dec. 4, 1955, Gachet *fils* listed this drawing and a lithograph of the subject by Delacroix (which he called the "model for the drawing") among works he intended to give to the Musée du Louvre "in case of sudden death," but this intention was not realized (VGM Archives).

P.G. II-42

Hamlet and Horatio (after Delacroix), 1873
Conté crayon on bister paper, 12.4 x 17 cm
David and Constance Yates

P.G. II-42: *Le petit "Hamlet" (d'après Delacroix)*, Auvers 1873
Chappuis 326; V p. 347

PROVENANCE: Dr. Paul Gachet, Auvers [1873–1909]; Paul Gachet *fils*, until his death in 1962; acquired from his estate by the Galerie Daber, Paris, 1962, until at least 1973; private collection, Paris; David and Constance Yates, New York
REFERENCES: Venturi 1936, p. 347 (under "Unpublished works," Gachet collection, as one of the works "Faust and Mephistopheles, after the Delacroix lithograph. Two drawings of different sizes"; not repr.); Gachet 1952, n.p. (repr.); Andersen 1970, pp. 11–12, fig. 11 (as *Hamlet Contemplating the Skull of Yorick*, 1873); Chappuis 1973, no. 326 (as 1873)
COMMENTS: According to Paul Gachet *fils*, Cézanne originally intended to make an engraving of this subject, but it was never realized (Gachet 1952, n.p.).

Prints by Cézanne
(not catalogued by Gachet *fils*)

** *Sailboats on the Seine at Bercy (after Guillaumin)*, 1873
(cat. no. 10a)
Etching, 21.5 x 26.5 cm
Inscribed in the plate, in reverse: d'apres Armand Guillaumin Pictor
Bibliothèque Nationale de France, Paris, Département des Estampes et de la Photographie

Cherpin 1

Cherpin 1

PROVENANCE: Dr. Paul Gachet, Auvers [1873–1909]; donated by Paul Gachet *fils* to the Bibliothèque Nationale, Paris, 1953
REFERENCES: Gachet 1952, n.p., repr.; Gachet 1956a, p. 55 (described as Cézanne's first etching); Chatelet in Paris 1954–55, no. 20; Cherpin 1972, no. 1
LETTER: Paul Gachet *fils* to V. W. van Gogh, Feb. 13, 1953 (b3079 V/1962, VGM Archives)
COMMENTS: This proof from the Gachet collection of a print after Guillaumin's *Sailboats on the Seine at Bercy* (see P.G. IV-14 [cat. no. 27]) seems to be unique.

† *Guillaumin at the House of the Hanged Man*, 1873
(cat. no. 10e)
Etching, 14.5 x 11 cm
Annotated at the top margin in ink, by Gachet(?): P. Cézanne / Auvers Sept. 1873
Location unknown

Cherpin 2; V 1159

PROVENANCE: Dr. Paul Gachet, Auvers [1873–1909]; sold by Paul Gachet *fils* to Philip Jones, Esq., London, 1961, until 1971; sale of his property, Sotheby's, London, Nov. 4, 1971, lot 39

Cherpin 2

REFERENCES: Coquiot 1919, p. 62; Venturi 1936, no. 1159 (as 1873, 26 x 20.5 cm, and as made at Dr. Gachet's suggestion, but with no mention of Gachet in provenance); Gachet 1952, n.p., repr.; Gachet 1954a, p. 17; Andersen 1970, no. 227 (as *Portrait of Armand Guillaumin Seated on the Ground*, 1873); Cherpin 1972, no. 2

Cherpin 3

** *View of a Garden at Bicêtre*, 1873
(cat. no. 10d)
Etching, 10.6 x 13 cm
Bibliothèque Nationale de France, Paris,
Département des Estampes et de la
Photographie

Cherpin 3

PROVENANCE: Dr. Paul Gachet, Auvers [1873–1909]; donated by Paul Gachet *fils* to the Bibliothèque Nationale, Paris, in 1953
REFERENCES: Gachet 1952, n.p., repr.; Cherpin 1972, no. 3
LETTERS: Paul Gachet *fils* to V. W. van Gogh, Feb. 13, 1953 (b3079 V/1962, VGM Archives); Paul Gachet *fils* to Jean Cherpin, Feb. 2, 1956 (reprinted in Cherpin 1972, p. 15)

Cherpin 4

† *Head of a Young Girl*, 1873
(cat. no. 10b)
Etching, 12 x 9.5 cm
Signed and dated lower right, in the plate: 73/Paul Cézanne
Bibliothèque Nationale de France, Paris,
Département des Estampes et de la
Photographie

Cherpin 4; V 1160

PROVENANCE: Dr. Paul Gachet, Auvers [1873–1909]; donated by Paul Gachet *fils* to the Bibliothèque Nationale, Paris, 1953. Another impression was donated to the Bibliothèque Doucet, Paris, in 1920.
REFERENCES: Vollard 1914, frontispiece; Coquiot 1919, p. 62; Venturi 1936, no. 1160 (as *Tête de femme*, 1873, 32 x 23 cm; no mention of Gachet in provenance); Gachet 1952, n.p. (as "after the model who had posed for the admirable graphite drawing" [P.G. II-37]); Andersen 1970, no. 256 and pp. 10, 12, 13; Cherpin 1972, no. 4; Courthion 1976, p. 62; Gachet 1994, p. 142 (as *Tête d'Almyre*)
LETTERS: John Rewald to Eduard Buckman, Nov. 6, 1952, mentions that both Gachets printed numerous unnumbered proofs of this etching in various colors (VGM Archives); Paul Gachet *fils* to V. W. van Gogh, Feb. 13, 1953 (b3079 V/1962, VGM Archives)
COMMENTS: The model for this etching has been identified as Almyre Roger, daughter of one of Dr. Gachet's neighbors. See P.G. II-37.

† *Entrance to a Farm, Rue Rémy in Auvers*, 1873
(cat. no. 10c)
Etching, 13 x 10.5 cm
Inscribed in Dr. Gachet's hand: P. Cézanne, juillet 1873
Bibliothèque Nationale de France, Paris,
Département des Estampes et de la
Photographie

Cherpin 5; V 1161

Cherpin 5

PROVENANCE: Dr. Paul Gachet, Auvers [1873–1909]; donated by Paul Gachet *fils* to the Bibliothèque Nationale, Paris, 1953
REFERENCES: Coquiot 1919, p. 62; Venturi 1936, no. 1161 (as *Paysage à Auvers*, 1873, 37 x 28 cm, with no mention of Gachet in provenance); Gachet 1952, n.p. (as *Paysage*; repr.); Chatelet in Paris 1954–55, no. 21; Cherpin 1972, no. 5
LETTER: Paul Gachet *fils* to V. W. van Gogh, Feb. 13, 1953 (b3079 V/1962, VGM Archives)

Vincent van Gogh
(Dutch, 1853–1890)

Chrysanthemums, 1886 (fig. 85)
Oil on canvas, 46 x 61 cm
Private collection

P.G. III-1: *Chrysanthèmes*, Paris 1889 [*sic*]
F 217; JH 1164

P.G. III-1

PROVENANCE: Dr. Paul Gachet, Auvers [1890–1909]; sold by Paul Gachet *fils* to Wildenstein, Paris and New York, 1949; private collection, France; private collection, Japan; private collection

PAUL GACHET

COLLECTION DU DR. GACHET
III
VAN GOGH

PREMIÈRE PARTIE:
PEINTURES

CATALOGUE RAISONNÉ
ILLUSTRÉ DE 27
REPRODUCTIONS

AUVERS·SUR·OISE
1 9 2 8

PAUL GACHET

COLLECTION DU DR. GACHET
III
VAN GOGH

SECONDE PARTIE:
DESSINS ET ESTAMPES

CATALOGUE RAISONNÉ
ILLUSTRÉ DE 30
REPRODUCTIONS
ET DES SOUVENIRS
DE VAN GOGH

AUVERS·SUR·OISE
1 9 2 8

REFERENCES: Faille 1928, no. 217 (as Paris; not repr.); Faille 1939, p. 557 (listed among works not repr.); Faille 1970, no. 217 (as Paris, autumn 1886); Hulsker 1980 and 1996, no. 1164 (as Paris, summer 1886)

COMMENTS: This still life was first exhibited in 1955 in Paris at the Galerie Beaux-Arts, in "Tableaux de collections parisiennes, 1850–1950," April 22–May 31, 1955, as no. 128. In the Gachet collection, the subject was also represented by Monet's painting of 1878 (see P.G. I-14 [RF 1951-36]); in 1905, under the pseudonym Louis van Ryssel, Paul Gachet fils showed a work described as "Les chrysan-thèmes (peinture)" at the Salon des Indépen-dants in Paris, no. 4105 (see Paris 1905).

Cornflowers and Poppies, 1887
Oil on canvas, 80 x 67 cm
Signed upper left: Vincent
Private collection

P.G. III-2: *Fleurs des champs*, Paris 1889 [*sic*]
F 324; JH 1293

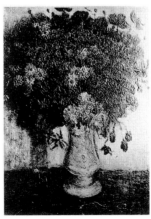

P.G. III-2

PROVENANCE: Dr. Paul Gachet, Auvers [1890–1909]; sold by Paul Gachet *fils* before 1912; G. Camentron, Paris, until Feb. 1912; sold to Paul Cassirer, Berlin, 1912; sold to C. Harries-von Siemens, Berlin, by 1914; with his widow until at least 1928; private collection, Belgium; private collection

REFERENCES: Faille 1928, no. 324 (as Paris); Faille 1939, no. 332 (as Paris); Faille 1970, no. 324 (as Paris, summer 1887); Welsh-Ovcharov 1976, pp. 227, 237 (tentatively dated to summer 1886 but listed under "undecided attributions" because it is "known only from a weak reproduction" in Faille); Hulsker 1980 and 1996, no. 1293 (as Paris, summer 1887); Feilchenfeldt 1988, p. 88

LETTER: Théodore Duret to Dr. Paul Gachet, April 4, 1900, possibly, because of its relative size, the "large painting of flowers" in which he had expressed interest (as cited by Anne Distel above, p. 22 n. 75); the only other candidate is P.G. III-13.

Roses, 1889
Oil on canvas, 33 x 41.3 cm
Matsukata Collection, The National Museum of Western Art, Tokyo, P.1959-193

P.G. III-3: *Rosiers en fleurs*, Arles 1889?
F 580; JH 1679

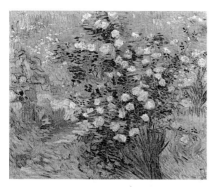

P.G. III-3

PROVENANCE: Dr. Paul Gachet, Auvers [1890–1909]; sold by Paul Gachet *fils* before 1923; Paul Rosenberg, Paris; Kojiro Matsukata, Kobe, by 1923; detained in Paris by the customs authorities and subsequently confiscated by the French government as enemy property during World War II; given by the French government to the National Museum of Western Art, Tokyo, 1959
REFERENCES: Faille 1928, no. 580 (as Arles); Faille 1939, no. 592 (as Arles 1888); Faille 1970, no. 580 (as Arles 1888); Hulsker 1980 and 1996, no. 1679 (as Saint-Rémy, April 1889)

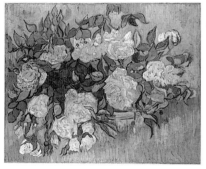

P.G. III-4

Pink Roses, 1890
Oil on canvas, 32 x 40.5 cm
Ny Carlsberg Glyptotek, Copenhagen, I.N. 1836

P.G. III-4: *Les roses*, Arles 1889
F 595; JH 2009
Copied by Derousse (RF 31 234)

PROVENANCE: Dr. Paul Gachet, Auvers [1890–1909]; sold by Paul Gachet *fils*, by 1913; G. F. Reber, Barmen (Germany), by 1913; Jos Hessel, Paris; Paul Rosenberg, Paris, by 1918; Helge Jacobsen, Copenhagen, 1918–27; her gift to the Ny Carlsberg Glyptotek, Copenhagen, 1927
REFERENCES: Faille 1928, no. 595 (as Arles); Faille 1939, no. 595 (as Arles, 1888); Faille 1970, no. 595 (as Saint-Rémy-Auvers, May 1890); Hulsker 1980 and 1996, no. 2009

(as Auvers, early June 1890); Feilchenfeldt 1988, p. 106
COMMENTS: The editors of Faille 1970 note (no. 595, p. 310) that "since [this picture] belonged to Gachet, we can assume that it . . . was painted in Auvers"; this led them to assign to Auvers a "whole group" of stylistically related pictures (F 597, 748, 749).

* *Self-Portrait,* early September 1889 (cat. no. 12)
Oil on canvas, 65 x 54 cm
Musée d'Orsay, Paris, RF 1949-17

P.G. III-5: *Son portrait,* Saint-Rémy 1889
F 627; JH 1772
Copied by Derousse, 1902 (RF 31 222) (cat. no. 12a)

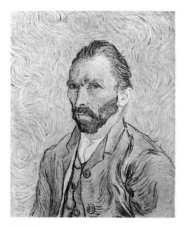

P.G. III-5

PROVENANCE: Dr. Paul Gachet, Auvers [1890–1909]; donated by his children, Paul and Marguerite Gachet, to the Musée du Louvre, Paris, 1949
EXHIBITIONS: Paris 1905, no. 20; Paris 1907–08, no. 52; Paris 1925, no. 50; Paris 1937b, no. 42
REFERENCES: Meier-Graefe 1904, p. 119 n. 1 (as "Selbst-porträt blau auf blau von 1890," Gachet collection); Faille 1928, no. 627 (as Saint-Rémy, Sept. 1889); Faille 1939, no. 748 (as Auvers, May 1890); Florisoone 1949, p. 150 (as purchased from Theo by Dr. Gachet); Florisoone 1952, pp. 9–11, repr.; Gachet 1953c, n.p. (as "conceivably his last self-portrait, surely painted at Saint-Rémy in late 1889 or early 1890," a work lent by Dr. Gachet to the 1905 Indépendants exhibition); Chatelet in Paris 1954–55, no. 42; Faille 1970, no. 627 (as Saint-Rémy, Sept. 1889); Hulsker 1980 and 1996, no. 1772 (as Saint-Rémy, early Sept. 1889); Pickvance in New York 1986–87, p. 121, fig. 19, p. 197 (as one of four Saint-Rémy canvases that Van Gogh brought to Auvers); Van Uitert

et al. in Amsterdam 1990, pp. 226, 228, 230, no. 100 (as Saint-Rémy, Aug.–Sept. 1889); Landais 1997, pp. 110–11 (as one of "two works of quality accompanying the portrait of the Doctor in the first donation [to the Louvre]")
LETTERS: LT 604, W 14, LT 607, LT 638, W 22; Johanna van Gogh-Bonger to Paul Gachet *fils,* Dec. 22, [1924] (b1528 V/1962, VGM Archives); PG *fils* to V. W. van Gogh, April 29, 1949 (b3072 V/1962, VGM Archives); VWvG to PG *fils,* May 16, 1949 (b2842 V/1982, VGM Archives)
COMMENTS: This work was among the Saint-Rémy canvases that Van Gogh brought to Auvers in May 1890, as can be established from Van Gogh's mentioning Dr. Gachet's enthusiasm for it in a letter written shortly after his arrival (LT 638). Van Gogh also records Gachet's admiration of an *Arlésienne* (F 540?) and a *Pietà* after Delacroix (F 640), both from Saint-Rémy, as well as an Auvers landscape (F 762)— none of which Dr. Gachet acquired. Whether the *Self-Portrait* was received from Vincent or from Theo (after the funeral) is not known (but that it was *purchased* seems unlikely). Included in four exhibitions and reproduced in a number of early publications, this portrait and the one of Dr. Gachet (P.G. III-16 [F 754]) were the two best-known Van Goghs in the Gachet collection.

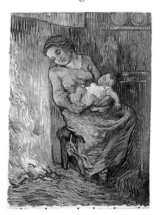

P.G. III-6

The Man Is at Sea (after Demont-Breton), October 1889 (fig. 88)
Oil on canvas, 66 x 51 cm
Location unknown

P.G. III-6: *L'homme est en mer,* Saint-Rémy 1889
F 644; JH 1805

PROVENANCE: Dr. Paul Gachet, Auvers [1890–1909]; sold by Paul Gachet *fils* to Paul Cassirer, Amsterdam, 1937/38; Caeser R. Diorio, New York, by 1943; Errol Flynn, Hollywood, until 1964; sale of property from

his estate, Sotheby's, London, April 29, 1964, lot 52 (withdrawn); sold by Acquavella Galleries, New York, to John T. Dorrance Jr., Nov. 16, 1964, until 1989; sale, Sotheby's, New York, Oct. 19, 1989, lot 27; purchased by Yashumichi Morishita, Tokyo, 1989; subsequently sold; present location unknown

EXHIBITION: Paris 1905, no. 22

REFERENCES: Meier-Graefe 1904, p. 120 n. 1 (as *Die Frau mit dem Kind am Feuer*, Gachet collection); Faille 1928, no. 644 (as Saint-Rémy, Oct. 1889); Faille 1939, no. 654 (as Saint-Rémy, Oct. 1889); Gachet 1953c, n.p. (as a work lent by Dr. Gachet to the 1905 Indépendants exhibition, repr. with caption *"L'Homme est en mer* [Salon de 1905]," as 1889; cites LT 610); Faille 1970, no. 644 (as Saint-Rémy, Oct. 1889); Hulsker 1980 and 1996, no. 1805 (as Saint-Rémy, early Oct. 1889)

LETTER: LT 610

COMMENTS: Of the handful of paintings by Van Gogh that Dr. Gachet lent to exhibitions in 1905, this is the only one that was not later donated to the Louvre.

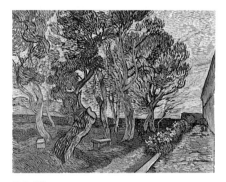

P.G. III-7

*** *The Garden of the Asylum in Saint-Rémy*, 1889 (fig. 89)
Oil on canvas, 71.5 x 90.5 cm
Van Gogh Museum (Vincent van Gogh Foundation), Amsterdam, S196 V/1962

P.G. III-7: *Parc de la maison de santé*, Saint-Rémy, Déc. 1889
F 659; JH 1850
Copied by Derousse (RF 31 228)

PROVENANCE: Dr. Paul Gachet, Auvers [1890–1909]; given by Paul Gachet *fils* to V. W. van Gogh, 1954, for the Vincent van Gogh Foundation, Amsterdam

REFERENCES: Meier-Graefe 1904, p. 120 n. 1 (conceivably the work described as "from the Arles period . . . a large, relatively dark painting, *Les Oliviers*," in Gachet's collection [since the author could have mistaken the trees for olives and not recognized the asylum's facade; see also entry for F 586, p. 241]); Faille 1928, no. 659 (as Saint-Rémy,

Dec. 1889; not repr.); Faille 1939, p. 557 (as Saint-Rémy, Oct. 1889); Faille 1970, no. 659 (as Saint-Rémy, Oct. 1889); Hulsker 1980, no. 1850 (as Saint-Rémy, Nov. 1889); Pickvance in New York 1986–87, p. 147 (erroneously, as a copy of F 660 made for the artist's mother and sister); Dorn in Essen and Amsterdam 1990, pp. 155–58 (persuasively argues that this studio replica [after F 660] is documented in letter B21; notes that Theo seems not to have included either version in the informal memorial exhibition he held in 1890, but that "Dr. Gachet . . . was impressed and Theo gave him the duplicate"); Van Uitert et al. in Amsterdam 1990, no. 105, pp. 234–35, 237 (as Dec. 1889); Hulsker 1996, no. 1850, pp. 423–24 (as Saint-Rémy, Nov. 1889?; describes as an "almost exact copy" of F 660 sent by Gachet *fils* to V. W. van Gogh, who did not consider it an authentic work; adds [p. 6] that "Dr. V. W. van Gogh . . . opened the hunt for forgeries by refusing to accept as authentic [this] painting.")

LETTERS: B21 (see Dorn in Essen, Amsterdam 1990, p. 155); Paul Gachet *fils* to V. W. van Gogh, April 12, 1954 (b3439 V/1984, VGM Archives), proposes the idea of donating this "very beautiful and important" canvas to the Van Gogh Foundation; VWvG to PG *fils*, April 28, 1954 (b3440, VGM Archives), formally acknowledges the donation, for which Gachet *fils* is named "Councillor of Honor"; PG *fils* to VWvG, April 30, 1954 (b3441, VGM Archives); PG *fils* to VWvG, June 12, 1954 (b3442, VGM Archives), notes fragility of canvas, adding, "however, for nearly sixty-six years its color has remained very fresh."

COMMENTS: V. W. van Gogh, the artist's nephew, was the first to question the authenticity of this work, shortly after he received it as a gift from Gachet *fils* in 1954. More recently it has been doubted by Hulsker (1996, no. 1850), though many scholars feel it is documented in the correspondence (see Pickvance, Dorn, Van Uitert et al.) and accept it as a second version of the painting sold by Johanna van Gogh-Bonger in 1906 (F 660, now Folkwang Museum, Essen).

Huts in the Sunshine: Reminiscence of the North, 1890
Oil on canvas, 50 x 39 cm
The Barnes Foundation, Merion, Pennsylvania, BF #136 Gallery VIII

P.G. III-8: *Chaumes au soleil (réminiscence du nord)*, Saint-Rémy, Mars–Avril 1890
F 674; JH 1920
Copied by Derousse (RF 31 233, VGM P161, P162)

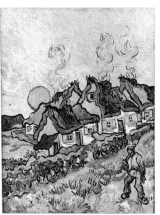

P.G. III-8

PROVENANCE: Dr. Paul Gachet, Auvers [1890–1909]; sold by Paul Gachet *fils* to an agent for Albert C. Barnes (probably Alfred Maurer), who was instructed to deliver the painting to Paul Guillaume, the "foreign secretary" for the Barnes collection; acquired from him in 1922 for 17,200 francs (Archives, Barnes Foundation, Merion, Pa., courtesy of Nicholas King)

REFERENCES: Meier-Graefe 1904, p. 119 n. 1 (presumably counted among "a quantity of beautiful, mostly small views of the village" in Gachet's collection); Faille 1928, no. 674 (as Saint-Rémy, April 1890); Faille 1939, no. 692 (as Saint-Rémy, April 1890); Faille 1970, no. 674 (as Saint-Rémy, March–April 1890); Hulsker 1980 and 1996, no. 1920 (as Saint-Rémy, March–April 1890)

LETTERS: LT 629, 629a

COMMENTS: See comments for P.G. III-8 bis.

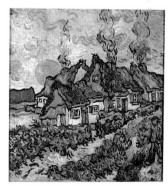

P.G. III-8 bis

Huts in the Sunshine: Reminiscence of the North, 1890
Oil on canvas, 45.5 x 43 cm
Private collection

P.G. III-8 bis: *Chaumes au soleil*, toile carrée

NOTE: This work was not owned by Gachet or catalogued as part of the Gachet collection, but it was assigned a collection number

(P.G. III-8 bis), illustrated in the catalogue, and discussed under Gachet *fils*'s entry for P.G. III-8. Of the two, only this version was published by Gachet *fils* (Gachet 1956a).
F 673; JH 1919

PROVENANCE: Gift of Theo van Gogh to Mme Chevalier, Auvers, 1890, until her death in 1904; subsequently sold—possibly by Paul Gachet *fils*—to the dealer Moline, Paris, before 1911; Hugo van Tschudi, Munich (d. 1911); Carl and Thea Sternheim, La Hulpe-Brussels, by 1914, until 1919; her sale, F. Muller, Amsterdam, Feb. 11, 1919, no. 11; G. Ribbius Peletier, Utrecht; by descent to Mrs. D. van Wely-Ribbius Peletier, The Hague; by descent to H. van Wely, by 1955; E. J. Van Wisselingh and Co., Amsterdam, until March 1956; sold to M. Knoedler and Co., New York, from March 1956, until April 1956; sold to Zannis L. Cambranis, London, April 1956; sold to a private collection, Switzerland, April 1956; private collection

REFERENCES: Faille 1928, no. 673 (as Saint-Rémy, April 1890); Faille 1939, no. 691 (as Saint-Rémy, April 1890); Gachet 1956a, pp. 71–72, fig. 56 (notes that it was painted in Saint-Rémy, March 1890, "during a crisis," and establishes its early provenance); Faille 1970, no. 673 (as Saint-Rémy, March–April 1890); Hulsker 1980 and 1996, no. 1919 (as Saint-Rémy, March–April 1890); Feilchenfeldt 1988, p. 112 (erroneously, as the *Huisjes te Auvers* that was sold by Johanna van Gogh-Bonger in 1908); Gachet 1994, pp. 231, 270 n. 159 (dates the picture to the Auvers period, describes it as Theo's gift to Mme Chevalier and as a replica or "*duplicata*," in smaller format, of the Saint-Rémy picture P.G. III-8 [F 674]); Mothe in Gachet 1994, p. 270 n. 159 (observes how surprising it is that Gachet *fils* subsequently dated this painting [which is documented in LT 629 and 629a] to Auvers, since Gachet had earlier published it with a Saint-Rémy date)
LETTERS: LT 629, 629a, as "a memory of Brabant, hovels with moss-covered roofs and beech hedges on an autumn evening with a stormy sky, and the sun setting amid ruddy clouds."
COMMENTS: According to Gachet *fils* (1956a, 1994), Theo gave this picture to the Gachets' housekeeper, Mme Chevalier, and it was sold after her death to the dealer Moline. The other version (see P.G. III-8 [F 674]) belonged to Dr. Gachet. Both have always been dated to Saint-Rémy and associated with Van Gogh's letter of April 29, 1890 (LT 629a), in which he describes the

subject (see above). Only Gachet *fils* studied the pictures in relation to their subsequent provenance, and in his posthumously published manuscript (Gachet 1994, p. 231) he concluded that Mme Chevalier's gift [F 673] is a replica, painted in Auvers, after the Saint-Rémy picture in the Gachet collection (P.G. III-8 [F 674]). He observed that "*Huts in the Sunshine*, painted at Auvers, like some of the drawings [made there], are reminiscences of the North" (Gachet 1994, p. 270 n. 159). There seems evidence, especially in the double-sided drawings, to support Gachet's contention that Van Gogh may have continued to explore the subject further in Auvers. It is certainly plausible, in light of the pictures' provenance, that one of the two versions was brought to Auvers by Van Gogh and the other was made there (perhaps more likely than the idea that he brought both versions). This is the only instance in which two versions of the same subject remained in Auvers for an extended period of time.

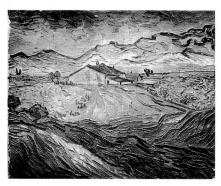

P.G. III-9

Landscape with House and Mountains, Saint-Rémy, spring 1890 (or December 1889)
Oil on canvas, 33 x 41 cm
Location unknown

P.G. III-9: *Paysage aux environs de St-Rémy*, Saint-Rémy 1890
F 726; JH 1874
Copied by Derousse (VGM D508)

PROVENANCE: Dr. Paul Gachet, Auvers [1890–1909]; sold by Paul Gachet *fils* to J. Seidenberg of Frans Buffa & Zonen, Amsterdam, Jan. 1926; sold to A. C. Goodyear, Buffalo, N.Y., July 1926, until 1949; his gift to the Museum of Modern Art, New York, 1949, until 1955; sold to Wildenstein, New York, 1955; subsequently sold by Wildenstein, Paris, to A. Levy; stolen on Dec. 7, 1980; present location unknown

REFERENCES: Meier-Graefe 1904, p. 119 n. 1 (presumably counted among "a quantity of beautiful, mostly small views of the village" in Gachet's collection); Faille 1928, no. 726 (as Saint-Rémy); Faille 1939, no. 733 (as Saint-Rémy, Jan. 1898 [*sic*]); Faille 1970, no. 726 (as Saint-Rémy, spring 1890, mentioned in letter 644); Hulsker 1980 and 1996, no. 1874 (as Saint-Rémy, Dec. 1889)
LETTER: LT 644(?)
COMMENTS: This is perhaps the "little canvas with mountains" (LT 644) included in the shipment of Saint-Rémy canvases that arrived in Auvers on June 24 or 25, 1890 (see Faille 1970). The theft of the painting from an unnamed collection in 1980 was reported in Drouot 1989 (repr.).

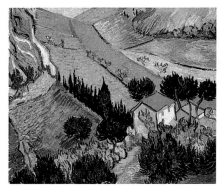

P.G. III-10

Landscape with House and Plowman, Saint-Rémy, spring 1890 (or December 1889)
Oil on canvas, 33 x 41 cm
Otto Krebs collection, on deposit at the State Hermitage Museum, Saint Petersburg

P.G. III-10: *Paysage à St-Rémy*, Saint-Rémy 1890
F 727; JH 1877

PROVENANCE: Dr. Paul Gachet, Auvers [1890–1909]; sold by Paul Gachet *fils* to Paul Cassirer, Amsterdam, Oct. 24, 1928; sold to Otto Krebs, Holzdorf, 1928; his collection, on deposit at the State Hermitage Museum, Saint Petersburg

REFERENCES: Meier-Graefe 1904, p. 119 n. 1 (presumably counted among "a quantity of beautiful, mostly small views of the village" in Gachet's collection); Faille 1928, no. 727 (as Saint-Rémy; not repr.); Faille 1939, p. 557 (as Saint-Rémy, Sept.–Oct. 1889; listed among works not reproduced); Faille 1970, no. 727 (as Saint-Rémy, early spring 1890); Hulsker 1980 and 1996, no. 1877 (as Saint-Rémy, Dec. 1889); Kostenevich 1995, pp. 236–38, pl. 60 (provides provenance)

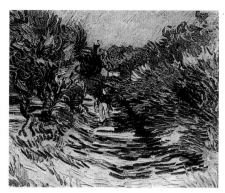

P.G. III-11

Road at Saint-Rémy, with a Figure, spring
1890 (or December 1889)
Oil on canvas, 33.5 x 41.1 cm
Kasama Nichido Museum of Art, Ibaraki,
Japan

P.G. III-11: *Route à St-Rémy,* Saint-Rémy
1890
F 728; JH 1875
Copied by Derousse (RF 31 235)

PROVENANCE: Dr. Paul Gachet, Auvers
[1890–1909]; sold by Paul Gachet *fils*
before 1923; Paul Rosenberg, Paris; J. K.
Thannhauser gallery, Munich and New
York, by 1923; Georges Bigar, New York;
Mr. and Mrs. Guy A. Weill, Scarsdale,
N.Y., by at least 1955–57; private collection,
Lausanne, by 1967; private collection, New
York; Richard L. Feigen, New York, until
1987; sold to Kasama Nichido Museum of
Art, 1987
REFERENCES: Meier-Graefe 1904, p. 119
n. 1 (possibly counted among "a quantity of
beautiful, mostly small views of the village"
in Gachet's collection, although similar in
style to P.G. III-12 [F 740], which he dates
to Arles); Faille 1928, no. 728 (as Saint-
Rémy); Faille 1939, no. 735 (as Saint-Rémy,
May 1890); Faille 1970, no. 728 (as Saint-
Rémy, May 1890); Hulsker 1980 and 1996,
no. 1875 (as Saint-Rémy, Dec. 1889)

The Little Stream, 1889–90
Oil on canvas, 25.5 x 34 cm
American International Group, Inc.

P.G. III-12: *Petit cours d'eau,* Saint-Rémy
1890 (fig. 84)
F 740; JH 2022

PROVENANCE: Dr. Paul Gachet, Auvers
[1890–1909]; sold by Paul Gachet *fils* to
Wildenstein, Paris and New York, 1951;
sold to C. V. Starr, New York; with his heirs
by 1970; American International Group

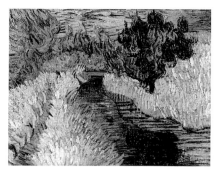

P.G. III-12

REFERENCES: Meier-Graefe 1904, p. 120
n. 1 (as a painting "from the Arles period . . . a
blue brook with a blue sky and yellow river-
bank," in Gachet's collection); Faille 1928,
no. 740 (as Saint-Rémy; not repr.); Faille
1939, p. 557 (as Saint-Rémy, April 1890;
listed among works not repr.); Faille 1970,
no. 740 (as Auvers, May 1890); Hulsker
1980, no. 2022 (as Auvers, June 1890);
Hulsker 1996, no. 2022 (as Saint-Rémy,
Oct. 1889)
LETTER: Julius Meier-Graefe to Paul
Gachet *fils,* Jan. 14, 1909 (cited above by
Anne Distel, p. 23 n. 77)
COMMENTS: This work has been variously,
and inconclusively, dated. Most recently,
Hulsker (1996, p. 491) was persuaded to
reassign the painting from Auvers to Saint-
Rémy because of the supposed discovery of
the stream in Saint-Rémy and its documen-
tation in recent photographs, which, however,
were not published. The painting was first
exhibited and reproduced by Wildenstein in
New York 1955, no. 67, lent anonymously.

Blossoming Chestnut Branches, late May
1890 (fig. 83)
Oil on canvas, 72.5 x 91 cm
Foundation E. G. Bührle Collection, Zurich

P.G. III-13: *Branches de marronniers en fleurs,*
Auvers, Mai–Juin(?) 1890
F 820; JH 2010
Copied by Derousse (RF 31 229, VGM D578)

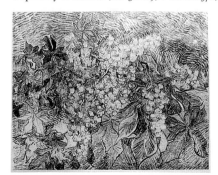

P.G. III-13

PROVENANCE: Dr. Paul Gachet, Auvers
[1890–1909]; sold by Paul Gachet *fils* to
Bernheim-Jeune, Paris, March 9, 1912; Franz
von Mendelssohn, Berlin, by 1914, until at
least 1928; subsequently his heirs; Dr.
F. Nathan, Saint Gall; purchased by Emil
G. Bührle, Zurich, 1951
REFERENCES: Meier-Graefe 1904, p. 120 n.
1 (as *Feuilles et fleurs de marronnier,* in
Gachet's collection); Faille 1928, no. 820 (as
Auvers); Faille 1939, no. 747 (as Auvers, May
1890); Faille 1970, no. 820 (as Auvers, before
May 25, 1890); Hulsker 1980 and 1996,
no. 2010 (as Auvers, early June 1890);
Feilchenfeldt 1988, p. 123; Gachet 1994, p. 53
(as ca. May 24, 1890, and in the Gachet
collection for about twenty years)

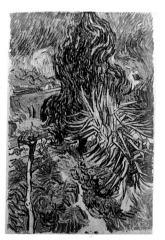

P.G. III-14

* *Dr. Gachet's Garden,* late May 1890
(cat. no. 14)
Oil on canvas, 73 x 51.5 cm
Musée d'Orsay, Paris, RF 1954-15

P.G. III-14: *Dans le jardin du Dr. Gachet,*
Auvers, 27 Mai 1890
F 755; JH 1999
Copied by Derousse (RF 31 226) (cat. no. 14a)

PROVENANCE: Given by the artist to
Dr. Paul Gachet, end of May 1890, until
1909; donated by Paul Gachet *fils* to the
Musée du Louvre, Paris, 1954
REFERENCES: Faille 1928, no. 755 (as *Le
jardin du docteur Gachet,* Auvers, June 1890;
not repr.); Faille 1939, p. 557 (as Auvers, May
1890; listed among works not repr.); Gachet
1956a, p. 112 (as May 27, 1890, one of the
more notable works in the collection; cites
letter reference); Faille 1970, no. 755 (as
Auvers, end of May 1890); Hulsker 1980 and
1996, no. 1999 (as Auvers, late May 1890);
Gachet 1994, pp. 63–64 (as May 27, 1890)

LETTERS: LT 638 (as a gift to Gachet); W 22; Paul Gachet *fils* to V. W. van Gogh, April 12, 1954 (b3439 V/1984, VGM Archives)
COMMENTS: Of the forty-four works by Van Gogh in the Gachet collection, only this work and P.G. III-15 (F 756), the two studies Van Gogh painted in Dr. Gachet's garden shortly after his arrival in Auvers, are explicitly described in the artist's correspondence as gifts (see letter 638). The two paintings were first reproduced and exhibited in Paris 1954–55 (nos. 43, 44), forty years after the first definitive edition of Van Gogh's letters to Theo was published in 1914.

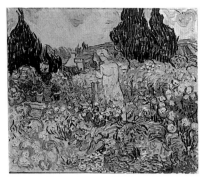

P.G. III-15

* *Mademoiselle Gachet in the Garden,*
June 1, 1890
(cat. no. 15)
Oil on canvas, 46 x 55 cm
Musée d'Orsay, Paris, RF 1954-13

P.G. III-15: *Mlle Gachet au jardin,* Auvers—Dimanche 1er Juin 1890
F 756; JH 2005
Copied by Derousse (RF 31 225) (cat. no. 15a). An unattributed chalk drawing of the subject also came from Gachet's estate (see Mothe 1987, p. 49; Mothe in Gachet 1994, p. 172 n. 45). See p. 241, below.

PROVENANCE: Given by the artist to Dr. Paul Gachet, Auvers, June 1890, until 1909; donated by Paul Gachet *fils* to the Musée du Louvre, Paris, 1954
REFERENCES: Meier-Graefe 1904, p. 119 n. 1 (possibly counted among "a quantity of beautiful, mostly small views of the village" in Gachet's collection); Doiteau 1923–24, p. 254 (names Mlle Gachet as the subject, in her father's garden); Faille 1928, no. 756 (as *Mademoiselle Gachet dans son jardin,* Auvers, June 1890; not repr.); Faille 1939, p. 557 (as Auvers, June 1890; listed among works not repr.); Gachet 1956a, p. 112 (as May 27, 1890, one of the more notable works in the collection; cites letter reference); Outhwaite 1969, p. 38; Faille 1970, no. 756 (as Auvers, June 1, 1890); Hulsker 1980 and 1996, no. 2005 (as

Auvers, June 1, 1890); Cabanne 1992, p. 30 (questions the origin of the picture's title and whether the "white figure" described by Van Gogh [LT 638] actually represents Mlle Gachet); Gachet 1994, pp. 91–92 (records that the picture was painted in the afternoon of June 1, 1890)
LETTERS: LT 638 (establishes date of June 1, 1890, and picture as gift to Gachet); W 22; Paul Gachet *fils* to V. W. van Gogh, April 12, 1954 (b3439 V/1984, VGM Archives)
COMMENTS: See comments for P.G. III-14.

* *Portrait of Doctor Paul Gachet,* June 1890
(cat. no. 13)
Oil on canvas, 68 x 57 cm
Musée d'Orsay, Paris, RF 1949-16

P.G. III-16: *Portrait du Docteur Gachet (Duplicatum),* Auvers, 3, 4 Juin 1890
F 754; JH 2014
Copied by Derousse, 1901 (RF 31 223 [cat. no. 13b], VGM P203)

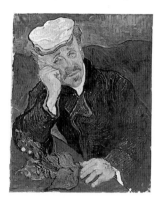

P.G. III-16

PROVENANCE: Dr. Paul Gachet, Auvers [1890–1909]; donated by his children, Paul and Marguerite Gachet, to the Musée du Louvre, Paris, 1949
EXHIBITIONS: Paris 1905, no. 19; Amsterdam 1905, no. 229a; Paris 1907–8, no. 54; Paris 1925, no. 49; Paris 1937b, no. 48
REFERENCES: Meier-Graefe 1904, p. 120 n. 1 (as the painting *Homme à la pipe [Porträt des Dr. G.]* in Gachet's collection); Faille 1928, no. 754 (as Auvers, June 1890); Faille 1939, no. 753 (as Auvers, June 1890); Florisoone 1952, p. 21 (repr., with photograph of Gachet's cap); Gachet 1953a, n.p. (notes that it was painted in the courtyard at Auvers and depicts the Gachets' red table "of pure vermilion"); Gachet 1953c, n.p. (as a work lent by Dr. Gachet to the 1905 Indépendants exhibition); Anfray 1954c (questions its authenticity; argues that only one portrait of Dr. Gachet was made);

Chatelet in Paris 1954–55, no. 46, pp. 41–44 (defends authenticity); Cooper 1955, p. 105 (defends authenticity); Gachet 1956a, pp. 101–2, 112, fig. 54 (describes it as the second, lesser known of two versions [both reproduced]; says that this one, made at the sitter's request and completed on June 7, 1890, was "quite superior from all points of view"); Graetz 1963, pp. 259–68 (rejects authenticity of picture; enumerates, among other faults, its lack of psychological expression); Tralbaut 1967, pp. 90–91 (relates Gachet *fils*'s account of the genesis of the work, based on author's interview); Outhwaite 1969, p. 23 (suggests it may be a work by Derousse); Faille 1970, no. 754 (as Auvers, early June 1890; the editors record, but do not accept, Faille's reservations about this "weak replica") and p. 703 (defends authenticity of work on basis of recent x-ray and technical analysis of canvas); Hulsker 1980, no. 2014 and p. 460 (as June 1890; notes that its authenticity "is difficult to disprove, as Dr. Gachet's son . . . has stated that he saw it being painted when he was seventeen years old"); Van Uitert et al. in Amsterdam 1990, no. 123, p. 268 (as June 1890 and as the second version of the portrait); Gachet 1994, pp. 102–5 (as Auvers, June 4 and 7, 1890, a "*duplicata* without books" and "a work highly superior to the first version"); Hulsker 1996, no. 2014 (as Auvers, June 1890?) and p. 460 (finds problematic the absence of a mention of this variant in Van Gogh's correspondence and questions the firsthand knowledge of the making of this work by Paul Gachet *fils,* "the totally unreliable son of Dr. Gachet"); Landais 1997, pp. 109–14 (disputes authenticity); Défossez 1997, pp. 7, 9
LETTERS: Paul Gachet *fils* to Johanna van Gogh-Bonger, June 6, 1905 (b3374, VGM Archives), July 5, 1905 (b3368, VGM Archives); JvGB to PG *fils,* Aug. 15, 1905 (b2134, VGM Archives); PG *fils* to JvGB, Aug. 29, 1905 (b2134, VGM Archives); JvGB to PG *fils,* Dec. 22, [1924] (b1528 V/1962, VGM Archives); PG *fils* to V. W. van Gogh, April 29, 1949 (b3072 V/1962, VGM Archives); VWvG to PG *fils,* May 16, 1949 (b2842 V/1982, VGM Archives)
COMMENTS: The authenticity of this work has been debated. Detractors have argued that only one portrait of Dr. Gachet (F 753; see fig. 56) is recorded in the correspondence, and that in comparison this appears a weak replica that seems uncharacteristic in terms of its style, facial expression, and omissions (of books, glass, and buttons); they have suggested it is a copy by Gachet

or Derousse. Supporters consider this portrait to be a second version or variant by Van Gogh that, in keeping with his practice, was made for the sitter, incorporating changes that reflect a rethinking, or improvement, of the original composition. It was first doubted by Louis Anfray in 1954.

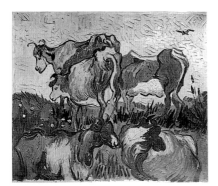

P.G. III-17

* *Cows (after Van Ryssel and Jordaens)*,
May–July 1890
(cat. no. 20)
Oil on canvas, 55 x 65 cm
Musée des Beaux-Arts, Lille, RF 1950-49

P.G. III-17: *Les vaches*, Auvers 1890
F 822; JH 2095
Copied by Derousse (RF 31 232) (cat. no. 20b)

PROVENANCE: Purportedly given by the artist to Dr. Paul Gachet, Auvers, May 27, 1890, until 1909; donated by Paul Gachet *fils* to the Musée des Beaux-Arts, Lille, 1950
REFERENCES: Meier-Graefe 1904, p. 120 n. 1 (as "*Les boeufs*, free [copy] after an etching that Dr. Gachet had made after a painting by Jordaens," in Gachet's collection); Faille 1928, no. 822, not repr. (with the comment: "The painting described here does not greatly recall Vincent's hand, but Dr. Gachet strongly assured me that Vincent made this work during his stay at Auvers"); Faille 1939, p. 557 (as Auvers, June 1890, but with same disclaimer as Faille 1928; listed among works not repr.); Gachet 1954b, p. 45 (in-depth study, describes genesis of picture; repr.); Chatelet in Paris 1954–55, no. 49; Perruchot 1955, p. 14 (recaps doubts expressed in 1954 and earlier by Faille); Gachet 1956a, p. 98; Faille 1970, no. 822 (as Auvers, June–July 1890; the editors accept the work as authentic but note that Faille rejected it for the revised edition); Hulsker 1980, no. 2095 (as Auvers, July 1890); Stein in New York, Paris 1992–93/ 1995, pp. 174–77 n. 42 (accepts the work as authentic but notes curious discrepancies between print and painting); Gachet 1994, pp. 57–58 (adds to earlier description a precise date:

May 25–27, 1890); Hulsker 1996, no. 2095 and p. 474 (as Auvers, July 1890?, and as a work that cannot be dated with certainty and that is documented only by Gachet *fils*)
COMMENTS: According to Gachet *fils* (1954, 1994), Van Gogh asked Dr. Gachet for a copy of his 1873 etching *Cows (after Jordaens)* (cat. no. 20a) on May 25, 1890, and returned two days later with his oil copy in hand. The authenticity of this work was first challenged by Faille in 1928 (no. 822). Various doubts were expressed at the time of the Paris 1954–55 exhibition and more recently in Hulsker 1996, no. 2095.

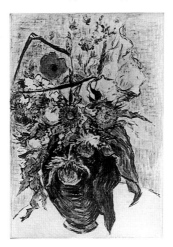

P.G. III-18

Wildflowers and Thistles, mid-June 1890
Oil on linen, lined with canvas, 66 x 45 cm
Location unknown (fig. 86)

P.G. III-18: *Bouquet des champs*, Auvers,
17 Juin 1890
F 763; JH 2030
Copied by Derousse (RF 31 250)

PROVENANCE: Dr. Paul Gachet, Auvers [1890–1909]; sold by Paul Gachet *fils* before 1928; Paul Rosenberg, Paris, before 1928; H. J. Laroche, Paris, before 1928, until at least 1955; Jacques Lindon, Paris; Mr. and Mrs. André Meyer, New York, by 1962, until 1980; his sale, Sotheby's, New York, Oct. 22, 1980, lot 28; purchased at that sale by Juan Alvarez de Toledo, Paris; his sale, Christie's, New York, Nov. 12, 1985, lot 26 (bought in), until 1987; sold to International Finance Company, S. A. Group, London, 1987; with Nanci Fisher, New York, April 1989; present location unknown
REFERENCES: Meier-Graefe 1904, p. 120 n. 1 (as *Vase aux fleurs* [painted on a dish towel], Gachet collection); Faille 1928, no. 763 (as Auvers, June 1890); Faille 1939, pl. xv (as Auvers, June 1890); Chatelet in Paris

1954–55, no. 48; Faille 1970, no. 763 (as Auvers, June 1890); Hulsker 1980 and 1996, no. 2030 (as June 17, 1890); Pickvance in New York 1986–87, no. 67, p. 240 (describes the support as a red-striped linen tea towel, obscured by later relining); Gachet 1994, pp. 139–40 (as June 17, 1890)
LETTER: LT 642
COMMENTS: This is the only Auvers still life by Van Gogh that is unequivocally documented in his correspondence.

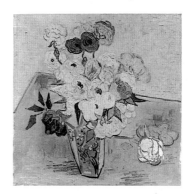

P.G. III-19

* *Roses and Anemones*, 1890
(cat. no. 16)
Oil on canvas, 51.5 x 52 cm
Musée d'Orsay, Paris, RF 1954-12

P.G. III-19: *Roses et anémones*, Auvers 1890
F 764; JH 2045

PROVENANCE: Purportedly given by Theo van Gogh to Paul Gachet *fils* for sitting vigil at Van Gogh's deathbed on July 27, 1890; donated by Gachet *fils* to the Musée du Louvre, Paris, 1954
REFERENCES: Faille 1928, no. 764 (as Auvers, June 1890; not repr.); Faille 1939, p. 557 (as Auvers; listed among works not repr.); Gachet 1953a, n.p. (repr., with photograph of the "Japanese stoneware vase"; describes painting as a cherished souvenir received from Theo for "spending the first night at Vincent's side after his injury"; notes that in this oil and in a drawing [P.G. III-33 (F 1650)], Van Gogh depicted objects Dr. Gachet put at his disposal); Chatelet in Paris 1954–55, no. 50; Faille 1970, no. 764 (as Auvers, June 1890); Hulsker 1980 and 1996, no. 2045 (as Auvers, June 1890); Gachet 1994, p. 94 (as Auvers, ca. June 2, 1890, and as Theo's gift to Gachet *fils*)
LETTER: Paul Gachet *fils* to V. W. van Gogh, April 12, 1954 (b3439 V/1984, VGM Archives)
COMMENTS: According to Gachet *fils*, this still life was painted at the Gachet house in one session, set up on the same table that

appears in the portraits of Dr. Gachet (see P.G. III-16 [F 754; cat. no. 13] and fig. 56), and was "barely dry" when Theo gave it to him, "upon Vincent's death," for spending the "first night at Ravoux's, at the time of his brother's suicide." The work was first exhibited in Paris 1954–55, no. 50. The Japanese vase is among the souvenirs that Gachet *fils* donated to the Louvre.

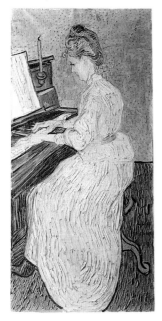

P.G. III-20

Mademoiselle Gachet at the Piano, late June 1890 (fig. 87)
Oil on canvas, 102.5 x 50 cm
Oeffentliche Kunstsammlung Basel, Kunstmuseum, no. 1635

P.G. III-20: *Mlle Gachet au piano*, Auvers, 28 et 29 Juin 1890
F 772; JH 2048
Copied by Derousse, 1901 (RF 31 224, VGM P167)

PROVENANCE: Given by the artist to Marguerite Gachet, Auvers, end of June 1890, until 1934, when it was sold to the Kunstmuseum Basel
REFERENCES: Meier-Graefe 1904, p. 120 n. 1 (as *Porträt des Fräulein G. am Pianino*, Gachet collection); Faille 1928, no. 772 (as Auvers, June 1890; not repr.); Faille 1939, no. 769 (as Auvers, June 1890); Gachet 1953a, n.p. (notes that it was painted in the parlor at their house in Auvers with a palette borrowed from Dr. Gachet, and describes colors used); Gachet 1953b, n.p. (as painted June 28–29, 1890, and part of the family's collection until 1934; in-depth study); Gachet 1956a, p. 113; Outhwaite 1969,

pp. 9, 27, 91 (discusses the motif in relation to prints owned by Gachet); Faille 1970, no. 772 (as Auvers, late June 1890); Hulsker 1980 and 1996, no. 2048 (as Auvers, June 26–27, 1890); Pickvance in New York 1986–87, no. 81, pp. 266–68; Cabanne 1992, p. 30 (finds the sale of this picture during the sitter's lifetime curious; speculates on her relationship with Van Gogh); Gachet 1994, pp. 164–65 (as Auvers, June 28–29, 1890)
LETTERS: LT 638; W 22; LT 644; LT 645 (suggests that the picture was given to the sitter, since Vincent writes Theo that he will [also] do one for him); T 39; T 40
COMMENTS: According to Gachet *fils*, the motif was inspired by the 1873 etching *Madame Gachet at the Piano* (cat. no. 46c) by P. van Ryssel (Dr. Gachet) and completed with a palette lent to the artist by Dr. Gachet, which is among the souvenirs given to the Louvre. Gachet *fils* also notes that Van Gogh gave the portrait to Mlle Gachet on June 29, 1890, upon its completion, and that it was framed in white and hung in her bedroom between two Japanese prints of the same size and format ("*mousmés*" by Kesai Yesen that had belonged to Van Gogh), until 1934, when it was "ceded" to the Basel Kunstmuseum, having never previously left Auvers.

L. van Ryssel (the pseudonym of Gachet *fils*) painted Mlle Gachet at the harmonium, in homage to Van Gogh, and exhibited the work with the Indépendants in Paris 1908a, no. 6045, as *À l'orgue*. See entry for F 1873 (sketch in letter 645) below, p. 230.

P.G. III-21

Branches of Flowering Acacia, June 1890
Oil on canvas, 33 x 24 cm
Nationalmuseum, Stockholm, NM 5939

P.G. III-21: *Fleurs et feuillages*, Auvers 1890
F 821; JH 2015

PROVENANCE: Dr. Paul Gachet, Auvers [1890–1909]; sold by Paul Gachet *fils* to Dr. Victor Doiteau for 20,000 francs, 1941; by inheritance to Mrs. Yvonne Doiteau, Péronne, Somme, 1960–66; sale, Sotheby's, London, June 22, 1966, lot 26; purchased by the Nationalmuseum Stockholm, 1966
REFERENCES: Faille 1928, no. 821 (as Auvers; not repr.); Faille 1939, p. 557 (as Auvers, May 1890; listed among works not repr.); Tralbaut 1967 (in-depth study); Tralbaut 1969, pp. 312, 314, repr. p. 317 (recounts Gachet *fils*'s description to him of the making of this painting on June 7, 1890, accepting its verity but disputing that Van Gogh painted it from beneath the tree); Faille 1970, no. 821 (editors accept the work as authentic but note that Faille rejected it for the revised edition); Hulsker 1980 and 1996, no. 2015 (as Auvers, ca. June 7, 1890); Pickvance in New York 1986–87, p. 206 (attributes the June 7, 1890, date to Tralbaut); Gachet 1994, pp. 114–15 (as June 7, 1890); Landais 1997, p. 113 (describes as "a 'Van Gogh' which must be regarded as a pure Gachet-*fils*")
LETTER: Paul Gachet *fils* to Victor Doiteau, July 7, 19, 29, 1941 (reprinted in Tralbaut 1967, pp. 93–96), regarding the purchase of this work
COMMENTS: Tralbaut reconstructs the provenance and defends the authenticity of this work in a 1967 publication that relies in part on conversations he had with Paul Gachet *fils* after World War II. The date June 7, 1890, comes from Gachet *fils*. See comments under P.G. III-33 (F 1650).

* *Les Vessenots, Auvers,* May–July 1890
Oil on canvas, 55 x 65 cm
Museo Thyssen-Bornemisza, Madrid, 1978.41

P.G. III-22: *Les Vessenots*, Auvers 1890
F 797; JH 2003
Copied by Derousse (RF 31 230)

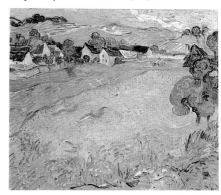

P.G. III-22

PROVENANCE: Dr. Paul Gachet, Auvers [1890–1909]; sold by Paul Gachet *fils* to Paul Rosenberg, Paris, 1919; Emil Hahnloser, Zurich, by 1922; Mrs. Robert Hahnloser, Zurich, by 1954–55; Mrs. Dora Hahnloser-Gassman, Zurich, by 1970; Galerie Nathan, Zurich, until 1978; Thyssen-Bornemisza Collection, Lugano-Castagnola, 1978

REFERENCES: Meier-Graefe 1904, p. 119 n. 1 (presumably counted among "a quantity of beautiful, mostly small views of the village" in Gachet's collection); Faille 1928, no. 797 (as *Les Vessenots à Auvers*, July 1890); Faille 1939, no. 784 (as Auvers, July 1890); Chatelet in Paris 1954–55, no. 56; Faille 1970, no. 797 (as Auvers, early July 1890); Hulsker 1980 and 1996, no. 2003 (as Auvers, late May); Gachet 1994, p. 149 (as Auvers, ca. June 20, 1890; observes that the subject is atypical of Van Gogh's landscape views)

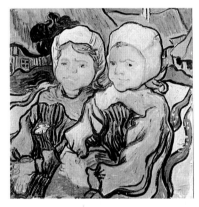

P.G. III-23

Two Children, June 1890
(cat. no. 18)
Oil on canvas, 51.2 x 51 cm
Musée d'Orsay, Paris, RF 1954-16

P.G. III-23: *Les deux fillettes,* Auvers 1890
F 783; JH 2051
Copied by Derousse, 1901 (cat. nos. 18a,18b, VGM D461, P205)

PROVENANCE: Dr. Paul Gachet, Auvers [1890–1909]; donated by Paul Gachet *fils* to the Musée du Louvre, Paris, 1954
EXHIBITION: Paris 1905, no. 18
REFERENCES: Meier-Graefe 1904, p. 120 n. 1 (as *Deux petites filles,* Gachet collection); Faille 1928, no. 783 (as Auvers); Faille 1939, no. 773 (as Auvers, June 1890); Gachet 1953c, n.p. (as Auvers 1890 and a work lent by Dr. Gachet to the 1905 Indépendants exhibition); Chatelet in Paris 1954–55, no. 51; Outhwaite 1969, p. 23 (suggests that the painting may be by Derousse in light of "disconcerting" similarities, in its "flatness of design," to her copies [see, e.g., cat. nos. 18a, 18b]);

Faille 1970, no. 783 (as Auvers, June 1890, and less finished than F 784); Hulsker 1980 and 1996, no. 2051 (as Auvers, June–July 1890, and one of two versions of the subject); Gachet 1994, pp. 194–96 (as Auvers, ca. July 5, 1890; considers this the first version and F 784 the "*duplicata*")

LETTERS: Théodore Duret to Dr. Paul Gachet, April 4, 1900 (cited above by Anne Distel, p. 22 n. 75); Paul Gachet *fils* to V. W. van Gogh, April 12, 1954 (b3439 V/1984, VGM Archives)

COMMENTS: According to contemporaneous newspaper accounts, the authenticity of this work was questioned when it was exhibited in Paris 1954–55, but these doubts (including Outhwaite's suggestion that it may be a work by Derousse) have not been recorded in the catalogues raisonnés, where the painting is accepted as one of two versions, with the order/relationship between the two not critically addressed. The other version, F 784 (fig. 58), was included in the Van Gogh memorial exhibition arranged by Theo in his Montmartre apartment at the end of 1890 and was sold by Johanna van Gogh in 1907; ironically, it was also the basis for several copies (made in 1907–8 by Cuno Amiet and Giovanni Giacometti).

P.G. III-24

Cottages at Jorgus, late May–June 1890
Oil on canvas, 33 x 40.5 cm
Private collection

P.G. III-24: *Les chaumes de Jorgus,* Auvers, Juin 1890
F 758; JH 2016
Copied by Derousse, 1901 (RF 31 236; VGM P172)

PROVENANCE: Dr. Paul Gachet, Auvers [1890–1909]; sold by Paul Gachet *fils* to Wildenstein, Paris and New York, before 1951; sold to Erwin Swan, Riegelsville, Pa., until 1951; sold to the Reader's Digest Association, Pleasantville, N.Y., 1951, until 1998; their sale, Sotheby's, New York, Nov. 16, 1998, no. 17

REFERENCES: Meier-Graefe 1904, p. 119 n. 1 (presumably counted among "a quantity of beautiful, mostly small views of the village" in Gachet's collection); Faille 1928, no. 758 (as Auvers, June 1890; not repr.); Faille 1939, p. 557 (as Auvers, June 1890; listed among works not repr.); Outhwaite 1969, p. 20 (as late Saint-Rémy, 1890); Faille 1970, no. 758 (as Auvers, June 1890); Hulsker 1980 and 1996, no. 2016, p. 462 (as Auvers, June 1890, and as probably referred to in LT 640); Dorn in Essen, Amsterdam 1990, p. 172 (as Auvers, late May 1890); Gachet 1994, pp. 118–19, 176 n. 70 (as ca. June 9, 1890)

LETTER: LT 640(?)

COMMENTS: Faille and Gachet *fils* associated this picture with Van Gogh's description (LT 640) of "two studies of houses with greenery," identifying the other study as F 759 (see also comments for P.G. III-26 [F 792]). Hulsker identified this picture and F 806 as the "most probable" candidates for the two studies. The painting was first reproduced and exhibited at Wildenstein in New York 1955, no. 74, lent by the Reader's Digest.

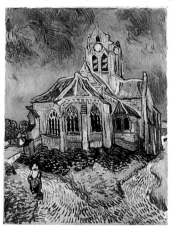

P.G. III-25

The Church at Auvers, early June 1890
(cat. no. 17)
Oil on canvas, 94 x 74 cm
Musée d'Orsay, Paris, RF 1951-42

P.G. III-25: *Église d'Auvers,* Auvers 1890
F 789; JH 2006
Copied by Derousse, 1901 (RF 31 227 [cat. no. 17a], VGM D460, P211)

PROVENANCE: Dr. Paul Gachet, Auvers [1890–1909]; Paul Gachet *fils,* from 1909, until 1951; acquired by the Musée du Louvre, Paris, in 1951 for 8 million francs, with the help of an anonymous Canadian donation and in cooperation with Paul Gachet, who reduced the price by 7 million francs, bringing it to approximately half the 15-million-franc estimate

REFERENCES: Meier-Graefe 1904, p. 119 n. 1 (as *Die Kirche von Auvers*, Gachet collection); Faille 1928, no. 789 (as Auvers, under "Paintings not mentioned in his letters"; not repr.); Faille 1939, p. 557 (as Auvers, June 1890; listed among works not repr.); Malraux 1951, repr.; Florisoone 1952, pp. 13, 16, 27, repr. pl. 1; Rewald 1952, repr. p. 19 (as "reproduced for the first time, and in color"); Chatelet in Paris 1954–55, no. 45; Outhwaite 1969, pp. 23–24; Faille 1970, no. 789 (as Auvers, first week of June 1890); Hulsker 1980 and 1996, no. 2006 (as ca. June 5, 1890); Gachet 1994, pp. 108–9 (as Auvers, June 5, 1890)
LETTER: W 22
COMMENTS: Van Gogh's correspondence with his sister Wil, which contains the only reference to this picture, was first published in 1953, two years after the work entered the Louvre from the Gachet collection; previously, scholars had assumed that it was among the pictures "not mentioned in the letters." The painting was first reproduced in 1951.

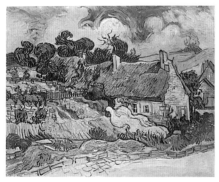

P.G. III-26

** Thatched Huts at Cordeville, Auvers,*
late May or early June 1890
(cat. no. 19)
Oil on canvas, 72 x 91 cm
Musée d'Orsay, Paris, RF 1954-14

P.G. III-26: *Chaumes à Cordeville,*
Auvers 1890
F 792; JH 1987

PROVENANCE: Dr. Paul Gachet, Auvers [1890–1909]; donated by Paul Gachet *fils* to the Musée du Louvre, Paris, 1954
EXHIBITIONS: Paris 1905, no. 21 (as *Chaumes du Montcel,* Auvers 1889 [*sic*]); Amsterdam 1905, no. 229b
REFERENCES: Meier-Graefe 1904, p. 119 n. 1 (presumably counted among "a quantity of beautiful, mostly small views of the village" in Gachet's collection, albeit larger than most of the views); Faille 1928, no. 792 (as *Chaumes de Montcel,* Auvers); Faille 1939, no. 779 (as Auvers, June 1890); Gachet 1953c, n.p, repr. (as 1890, depicting Cordeville at Auvers, a work

lent by Dr. Gachet to the 1905 Indépendants exhibition); Chatelet in Paris 1954–55, no. 47; Outhwaite 1969, p. 38; Faille 1970, no. 792 (as Auvers, June 1890); Hulsker 1980 and 1996, no. 1987 (as Auvers, late May 1890); Pickvance in New York 1986–87, p. 206 (as probably one of the "two studies of houses among the trees" made in early June and recorded in letter 640, with the other as probably F 759); Van Uitert et al. in Amsterdam 1990, no. 118, pp. 261–62, 264 (as May 1890); Gachet 1994, pp. 239–40 (as Auvers, ca. July 24, 1890)
LETTERS: LT 640(?); Paul Gachet *fils* to Johanna van Gogh-Bonger, June 6, 1905 (b3374, VGM Archives); JvGB to PG *fils,* Aug. 15, 1905 (b2134, VGM Archives); PG *fils* to JvGB, Aug. 29, 1905 (b3369, VGM Archives); PG *fils* to V. W. van Gogh, April 12, 1954 (b3439 V/1984, VGM Archives)
COMMENTS: Both this picture and P.G. III-24 (F 758) have been proposed as candidates for one of the "two studies of houses with greenery" described by Van Gogh (LT 640); the other study has generally been identified as F 759.

P.G. III-27 (recto)

P.G. III-27 (verso)

Landscape with Two Figures (recto); *Figures on a Road* (verso), January–April 1890 (Saint-Rémy)
Graphite (recto) and black chalk (verso) on bister paper, 29.5 x 20.5 cm
Location unknown

P.G. III-27: *Paysages (du Midi),* double face
F 1647 (recto and verso); JH 1950 (recto), 1968 (verso)

PROVENANCE: Dr. Paul Gachet, Auvers [1890–1909]; sold by Paul Gachet *fils* to Wildenstein, Paris and New York, 1952; Mr. and Mrs. Sydney M. Schoenberg, Saint Louis, by 1970; sale, Sotheby Parke-Bernet, New York, May 17, 1979, lot 414a (sold for $22,000); present location unknown
REFERENCES: Faille 1928, no. 1647 (as Auvers; not repr.); Faille 1970 and 1992, no. 1647, recto and verso (as Saint-Rémy, Jan.–April 1890); Hulsker 1980 and 1996, no. 1950 (recto), no. 1968 (verso) (as Saint-Rémy, March–April 1890)
COMMENTS: This drawing was first exhibited at Wildenstein in New York 1955, no. 107, no lender listed (presumably for sale).

Snowy Landscape with Cottages and Figures (recto); *Cottages and Trees* (verso), 1890
Graphite on yellow ocher paper, 23.5 x 31 cm
Location unknown

P.G. III-28: *Effet de neige (réminiscence du nord),* double face, Midi
F 1648 (recto and verso); JH 1913 (recto), 1914 (verso)

PROVENANCE: Purportedly given by Theo van Gogh to Dr. Paul Gachet, Auvers, 1890, until 1909; sold by Paul Gachet *fils* to Wildenstein, Paris and New York, 1954; sold to Ernesto Blohm, Caracas, ca. 1955–56; present location unknown
EXHIBITION: (?)Paris 1905, possibly no. 24 or 25
REFERENCES: Faille 1928, no. 1648 (recto) (as Saint-Rémy; not repr.), no. 1648 (verso) (as Auvers; not repr.); Faille 1970 and 1992, no. 1648 (recto and verso) (as Saint-Rémy, Jan.–April 1890); Hulsker 1980 and 1996, no. 1913 (recto), no. 1914 (verso) (as Saint-Rémy, March–April 1890); Gachet 1994, pp. 185–86 (as Auvers, ca. July 1, 1890, "among the drawings given to the doctor by Theo")
COMMENTS: According to Faille (1928, 1970, 1992), this drawing was exhibited in Paris 1905 as no. 23, "*Les Vessenots,* Auvers 1889 [*sic*], pencil and reed pen drawing," a description that undoubtedly refers to F 1653 (see entry for P.G. III-34 [F 1653]), as Gachet

fils maintained. Perhaps it was among the other Van Gogh drawings lent by Gachet, which were listed simply as no. 24, "Dessins faits à Auvers 1889," and no. 25, "Dessin fait à Auvers 1889." Gachet *fils*'s remark that this drawing was among those given by Theo to Dr. Gachet is his only mention of such a group, leaving uncertainty about what other drawings were included.

On Dec. 4, 1955—a year after the drawing had been sold to Wildenstein—Gachet *fils* listed it among works he intended to give to the Musée du Louvre as "1 Landscape drawing (Snow Scene) graphite—double sided." At some point he must have realized his error; the entry was crossed out and next to it was written "canceled" (VGM Archives).

P.G. III-28 (recto)

P.G. III-28 (verso)

Sowers and Diggers (recto); *Study of Cottages and Figures* (verso), 1890
Graphite (recto) and black chalk (verso) on white paper, 23 x 30.5 cm
Private collection

P.G. III-29: *Croquis (laboureurs, semeurs, etc.)*, double face, Midi
F 1649 (recto and verso); JH 1926 (recto), 1904 (verso)

PROVENANCE: Dr. Paul Gachet, Auvers [1890–1909]; sold by Paul Gachet *fils* to Paul Cassirer, Amsterdam, 1937; sold to Estella

P.G. III-29 (recto)

P.G. III-29 (verso)

Katzenellenbogen, Berlin and Santa Monica, 1937, until 1973; sold to Walter Feilchenfeldt, Zurich, 1973, until 1977; sold to Reid and Lefevre, London, 1977; sold to a private European collector, 1977, until 1992; sale, Christie's, New York, June 30, 1992, lot 107; purchased by a private collector, Paris, until ca. 1993; private collection
REFERENCES: Faille 1928, no. 1649 (as Auvers; not repr.); Faille 1970 and 1992, no. 1649 (recto) (as Saint-Rémy, Jan.–April 1890), no. 1649 (verso) (as Saint-Rémy, spring 1890); Hulsker 1980 and 1996, no. 1926 (recto), no. 1904 (verso) (as Saint-Rémy, March–April 1890)

* *Workers in the Fields* (recto); *A Man Digging, Two Seated Children, and Other Sketches* (verso), 1890
Graphite and black chalk on white paper, 23.5 x 30.6 cm
Thaw Collection, The Pierpont Morgan Library, New York

P.G. III-30: *Effet de neige et croquis*, double face, Midi
F 1620 (recto and verso); JH 1911 (recto), 1934 (verso)
Copied by Derousse: detail, recto (VGM D462, P213); detail, verso (VGM P163)

PROVENANCE: Dr. Paul Gachet, Auvers [1890–1909]; sold by Paul Gachet *fils* to Wildenstein, Paris and New York, 1958; sold

to T. Edward Hanley, Bradford, Pa., by 1960, until at least 1968; Eugene V. Thaw, New York, by 1975; Thaw Collection, The Pierpont Morgan Library, New York
EXHIBITION: Paris 1937b, no. 81 (not repr.)
REFERENCES: Faille 1928, no. 1620 (as Saint-Rémy; not repr.); Faille 1970 and 1992, no. 1620 (recto and verso) (as Saint-Rémy, Jan.–April 1890); Hulsker 1980 and 1996, no. 1911 (recto), no. 1934 (verso) (as Saint-Rémy, March–April 1890); Denison in New York 1994, p. 253, repr.
COMMENTS: This drawing has always been assigned to Saint-Rémy; the verso, however, must have been made in Auvers, since there is an obvious relationship between its sketch of a seated child and Van Gogh's well-known painting of the subject, *Child with Orange* (F 785). This telling detail was copied in drypoint by Derousse (see Checklist of Copies).

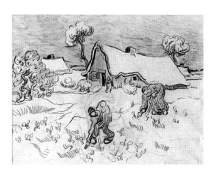

P.G. III-30 (recto)

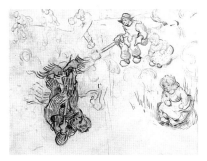

P.G. III-30 (verso)

Studies of Figures and Wooden Shoes (recto); *Studies of Figures and Hands* (verso), 1890
Black chalk on white paper, 23 x 31 cm
Location unknown

P.G. III-31: *Page de croquis (avec la main de Vincent)*, double face, Midi
F 1651 (recto and verso); JH 1955 (recto), 1956 (verso)

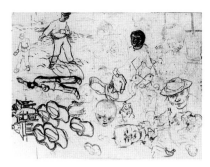

P.G. III-31 (recto)

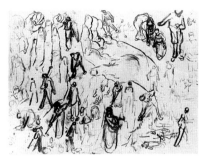

P.G. III-31 (verso)

PROVENANCE: Dr. Paul Gachet, Auvers [1890–1909]; sold at an unknown date by Paul Gachet *fils* or by his estate; private collection, New York, before 1970; with L'Oeil, Galerie d'Art, Paris, Nov. 1970; present location unknown
REFERENCES: Faille 1928, no. 1651 (as Auvers; not repr.); Faille 1970 and 1992, no. 1651 (recto) (as Arles, late 1888; the editors trace certain motifs [shoes, models] to the Arles period and suggest that the sower and figures around the table were added at Saint-Rémy, Jan.–April 1890), no. 1651 (verso) (as Saint-Rémy, April–May 1890); Hulsker 1980 and 1996, no. 1955 (recto), no. 1956 (verso) (as Saint-Rémy, March–April 1890); Gachet 1994, pp. 227–28 (as Auvers, ca. July 19, 1890, "Page of sketches [with Vincent's hand]"; inverts recto and verso)
COMMENTS: The verso drawing may have prompted Gachet *fils* to ask Johanna van Gogh-Bonger in 1905 for a photograph showing Vincent's hands; in lieu of one she sent him a photograph of Gauguin's *Portrait of Van Gogh Painting Sunflowers* (now Van Gogh Museum, Amsterdam), in which part of the artist's right hand, mainly his thumb and index finger, is seen holding a brush (see letters between Gachet *fils* and Jo in the VGM Archives: b399, Aug. 10, 1905; b2134, Aug. 15, 1905; b2136, Oct. 18, 1905).

Studies of Men, Women, and Children (recto); *Study of a Young Woman and Other Figures* (verso), 1890
Graphite on white Hallines paper, 43.5 x 27 cm
Private collection

P.G. III-32: *Croquis d'étude*, double face, Auvers 1890
F 1652 (recto and verso); JH 2071 (recto), 2074 (verso)

PROVENANCE: Dr. Paul Gachet, Auvers [1890–1909]; sold by Paul Gachet *fils* to Wildenstein, Paris and New York, by 1957, until 1960; sold to Mr. and Mrs. Harry Goldblatt, New York, 1960; sale, Sotheby's, New York, Nov. 15, 1984, lot 113; sale, Christie's, New York, May 11, 1989, lot 110; private collection, Japan; private collection
REFERENCES: Faille 1928, no. 1652 (as Auvers; not repr.); Faille 1970 and 1992, no. 1652 (recto and verso) (as Auvers, July 1890); Hulsker 1980 and 1996, no. 2071 (recto), no. 2074 (verso) (as Auvers, June–July 1890); Gachet 1994, p. 228 (as Auvers, ca. July 19, 1890)

P.G. III-32 (recto)

P.G. III-32 (verso)

COMMENTS: On Dec. 4, 1955, Gachet *fils* listed this drawing among works he intended to give to the Musée du Louvre; at some later date (by 1957, when he sold it to Wildenstein) he evidently changed his mind, crossing out the entry and writing next to it "canceled" (VGM Archives).

P.G. III-33 (recto)

P.G. III-33 (verso)

Still Life and Figure Studies (recto); *Sketch of a Couple Walking in a Landscape* (verso), 1890
Graphite (recto) and graphite and black chalk (verso) on white Dambricourt frères paper, 43.7 x 26.7 cm
Annotated (recto): rose, groseille, point orangé, blanc
Mr. and Mrs. Ralph M. Wyman

P.G. III-33: *Croquis (verre, pot d'étain, etc.),* double face, Auvers 1890
F 1650 (recto and verso); JH 2073 (verso only)

PROVENANCE: Dr. Paul Gachet, Auvers [1890–1909]; sold by Paul Gachet *fils* to Wildenstein, Paris and New York, 1953, until 1960; sold to a private collector, London, 1960; sale, Sotheby's, London, June 22, 1966, no. 4; Richard Feigen Gallery, New York; sale, Sotheby's, New York, Oct. 23, 1980, no. 304; purchased at that sale by the present owners

REFERENCES: Faille 1928, no. 1650 (as Auvers; not repr.); Florisoone 1952, p. 22 (repr. with a photograph of the glass and other "souvenirs" depicted here and in Cézanne's still life [P.G. II-16]); Gachet 1953a, n.p. (repr., with photograph of glass and pewter pot; discusses the objects depicted in relation to Cézanne's earlier still life [P.G. II-16]); Faille 1970 and 1992, no. 1650 (recto) (as Auvers, May–June 1890); no. 1650 (verso) (as Auvers, June–July 1890; editors comment that "the two women and a girl were probably added sometime after the still life had been completed"); Hulsker 1980 and 1996, no. 2073 (verso) (as Auvers, June–July 1890; recto not included); Gachet 1994, pp. 95, 98–99 (as Auvers, June 3, 1890) COMMENTS: Gachet *fils* (1994, pp. 95, 114) records that Van Gogh made the recto drawing and Dr. Gachet's portrait (F 753; see fig. 56) "in close to five hours" on June 3, 1890; he associates the "two accessories" in the sketch—the glass and the pewter stein—with the afternoon of June 7, when, after Van Gogh had completed the second portrait of Dr. Gachet (P.G. III-16 [F 754]) and an oil sketch of acacias (P.G. III-21 [F 821]), he and the doctor relaxed in the garden, smoking their pipes and drinking beer. The two objects are among the "souvenirs" that Gachet *fils* donated to the Louvre; the glass also appears in a still life by Cézanne (see P.G. II-16 [R 203]). The editors of Faille (1970, 1992) leave vague the matter of attributing the later figure drawings on the recto; Hulsker (1980, 1996) did not include this side of the drawing.

The Farm of Père Eloi, 1890 (cat. no. 21)
Graphite, reed pen, and brown ink on pink Ingres paper (with watermark: CF [Catel et Farcy]), 48 x 61.7 cm
Musée du Louvre, Paris, Département des Arts Graphiques, Fonds du Musée d'Orsay, RF 30 271

P.G. III-34: *La ferme du Père Eloi*, Auvers 1890
F 1653; JH 1993

PROVENANCE: Dr. Paul Gachet, Auvers [1890–1909]; donated by Paul Gachet *fils* to the Musée du Louvre, Paris, 1954
Exhibitions: Paris 1905, no. 23, "*Les Vessenots*, Auvers 1889 [*sic*], pencil and reed pen drawing"; Paris 1937b, no. 80

P.G. III-34

REFERENCES: Faille 1928, no. 1653 (as Auvers; not repr.); Gachet 1953a, n.p. (describes Van Gogh's technique, in particular his use of a bamboo pen, which he gave to Dr. Gachet); Faille 1970 and 1992, no. 1653 (as Auvers, June 1890); Hulsker 1980 and 1996, no. 1993 (as Auvers, May 1890); Pickvance in Otterlo 1990, pp. 317, 319, 324, no. 243 (as June 1890); Gachet 1994, pp. 67–68 (as Auvers, ca. May 29, 1890, and as a work lent by Dr. Gachet to the 1905 Indépendants exhibition)
LETTERS: Paul Gachet *fils* to Johanna van Gogh-Bonger, Dec. 1909 (b3396 V/1984, VGM Archives), describes the subject and notes that the drawing hangs in his office in Paris beneath a Guillaumin and next to two Daumiers; PG *fils* to VWvG, April 12, 1954 (b3439 V/1984, VGM Archives)
COMMENTS: This work was first reproduced in Paris 1954–55, no. 59.

P.G. III-35

The Sowers, 1890
Black chalk on bister paper, 28.5 x 22 cm
Location unknown

P.G. III-35: *Semeurs*, Auvers 1890
F 1618; JH 1901

PROVENANCE: Dr. Paul Gachet, Auvers [1890–1909]; sold by Paul Gachet *fils* to Wildenstein, Paris and New York, 1955, until 1957; sold to Mrs. Gregor Piatigorski, 1957;

by descent to Mr. and Mrs. Joram Piatigorski, by 1970; present location unknown
REFERENCES: Faille 1928, no. 1618 (as Saint-Rémy; not. repr.); Faille 1970 and 1992, no. 1618 (as Saint-Rémy, Jan.–April 1890); Hulsker 1980 and 1996, no. 1901 (as Saint-Rémy, March–April 1890); Gachet 1994, p. 170 (as Auvers, ca. June 30, 1890)
COMMENTS: Mothe (in Gachet 1994, p. 182 n. 120) finds it odd that Gachet *fils* placed this drawing and P.G. III-36 (F 1645) in Auvers, since they arguably belong to a series of works made in Saint-Rémy. The close relationship between the two drawings is deserving of further study; this sketch, the more deliberate or less spontaneous of the two, repeats in reverse the proportions and positions of the two figures depicted in F 1645.

P.G. III-36 (recto)

P.G. III-36 (verso)

Study of a Sower and a Man with a Spade (recto); *Study of Two Sowers* (verso), 1890
Black chalk (recto) and graphite (verso) on bister paper, 31 x 25 cm
Location unknown

P.G. III-36: *Études (semeurs, laboureur)* double face, Auvers 1890
F 1645 (recto and verso); JH 1902 (recto), 1903 (verso)

PROVENANCE: Dr. Paul Gachet, Auvers [1890–1909]; sold by Paul Gachet *fils* or by his estate at an unknown date before 1965; Jacques Dubourg, Paris, by 1965; present location unknown

REFERENCES: Faille 1928, no. 1645 (as Auvers; not repr.); Faille 1970 and 1992, no. 1645 (recto and verso) (as Saint-Rémy, Jan.–April 1890, and as stylistically close to F 1618); Hulsker 1980 and 1996, no. 1902 (recto), no. 1903 (verso) (as Saint-Rémy, March–April 1890); Gachet 1994, pp. 170–71 (as Auvers, ca. June 30, 1890)

COMMENTS: See comments under P.G. III-35.

P.G. III-37 (recto)

P.G. III-37 (verso)

Three Studies of Women in Landscapes (recto); *Sketches of Boats and Figures* (verso), 1890
Graphite on white laid Dambricourt frères paper, 44 x 27.5 cm
Annotated recto, upper left: figures roses, chapeau paille, ruban rose, ruban vin rouge ceinture; upper right: figures noires, fond vert, faces et mains rouges; bottom: bleu
Marina Picasso collection, Courtesy Galerie Jan Krugier, Ditesheim & Cie, Geneva

P.G. III-37: *Feuille de croquis*, double face, Auvers 1890
F 1646 (recto and verso); not in JH

PROVENANCE: Dr. Paul Gachet, Auvers [1890–1909]; Paul Gachet *fils,* until his death in 1962; acquired from his estate by the Galerie Daber, Paris, 1963; sold to Philip and Aimée Goldberg, London, Jan. 1963, until 1986; her estate sale, Christie's, London, Dec. 2, 1986, lot 128; purchased at that sale by Galerie Jan Krugier, Geneva; acquired by the present owner, 1987

REFERENCES: Faille 1928, no. 1646 (as Auvers; refers to the sketch at upper left [recto] as a "study for the stairway at Auvers"; not repr.); Faille 1970, no. 1646 (recto and verso) (as Auvers 1890; not repr.); Faille 1992, no. 1646 (recto and verso), pl. ccxciii; Gachet 1994, p. 125 (as Auvers, ca. June 11, 1890)

COMMENTS: Gachet associates this "page of good and curious sketches" with Van Gogh's few depictions of the Oise (e.g., F 798 and F 1639). The drawing was not accepted by Hulsker (1980, 1996); it was first reproduced in the Van Gogh literature in 1992. On Dec. 4, 1955, Gachet *fils* listed this drawing among works he intended to give to the Musée du Louvre "in case of sudden death"; perhaps the document was superseded by another, for the drawing was later purchased from his estate (VGM Archives).

* *Study of Two Women* (recto); *Study of a Woman Standing, Two Heads, and Another Figure* (verso), 1890
Graphite on pink Ingres paper, 22 x 18.5 cm
Annotated recto: rouge gris et noir cravate rose/chapeau pourpre et noir; verso: ocre jaune, bleu, cobalt
Frances Lehman Loeb Art Center, Vassar College, Poughkeepsie, New York, Gift of Alastair B. Martin, 1959.10

P.G. III-38: *Croquis d'étude*, double face, Auvers 1890
F 1619 (recto and verso); JH 2072 (recto only)

PROVENANCE: Dr. Paul Gachet, Auvers [1890–1909]; sold by Paul Gachet *fils* before 1954; Justin K. Thannhauser, New York, by 1955; Alastair B. Martin, until 1959; his gift to the Vassar College art gallery, Poughkeepsie, N.Y., 1959

REFERENCES: Faille 1928, no. 1619 (as Saint-Rémy; not repr.); Faille 1970 and 1992, no. 1619 (recto and verso) (as Auvers, June–July 1890); Hulsker 1980 and 1996, no. 2072 (recto) (as Auvers, June–July 1890; verso not included); Gachet 1994, p. 235 (as Auvers, ca. July 22, 1890)

P.G. III-38 (recto)

P.G. III-38 (verso)

COMMENTS: This little-known drawing was first exhibited at Wildenstein in New York 1955, no. 106, lent by Mr. Justin K. Thannhauser. Its verso was not accepted by Hulsker (1980, 1996).

Women in a Field (recto); *Sketch of a Landscape with Trees* (verso), 1889–90
Graphite on pink Ingres paper, 20.7 x 23.6 cm
Annotated recto: jaune, rose, violet, vert, vert clair, vert bleu; verso: violet
Galerie Siegfried Billesberger

P.G. III-39: *Cueilleuses de pois*, double face, Auvers 1890
F 1621 (recto and verso); not in JH

PROVENANCE: Dr. Paul Gachet, Auvers [1890–1909]; sold by Paul Gachet *fils* to an anonymous collector, 1954; Zdenko Bruck, by 1959; sale, Gutekunst & Klipstein, Bern, June 20, 1990, lot 36; acquired at that sale by the present owner

REFERENCES: Faille 1928, no. 1621 (as Saint-Rémy; not repr.); Faille 1970 and 1992, no. 1621 (recto and verso) (as Saint-Rémy 1889–90, though the editors comment that

the "paper seems to indicate Auvers"; not repr.); Gachet 1994, pp. 132–33 (as Auvers, ca. June 14, 1890)

COMMENTS: Gachet *fils* notes that Van Gogh depicts the gathering of the crop during the pea season "by a rapid, very lively sketch." Presumably Faille's 1928 description of "nine peasants busy picking peas" comes from the same source. This drawing, which has never been reproduced in the Van Gogh literature, is virtually unknown; it was not accepted by Hulsker (1980, 1996).

P.G. III-39 (recto)

P.G. III-39 (verso)

*** *Woman with Striped Skirt* (recto); *Woman in Checked Dress and Hat* (verso), June–July 1890
(cat. no. 22c)
Graphite on faded blue-lined graph paper, 13.2 x 8.5 cm
Musée du Louvre, Paris, Département des Arts Graphiques, Fonds du Musée d'Orsay, RF 29 883

P.G. III-40 (1): *Six petits croquis*, Auvers 1890—feuillet I [verso not repr. "on account of error"]
F 1644 (recto and verso); JH 2065 (recto), 2066 (verso)

PROVENANCE: Dr. Paul Gachet, Auvers [1890–1909]; sold by Paul Gachet *fils* to Mme Walter, Paris, before 1951; sold by her

to the Musée du Louvre, 1951
REFERENCES: Faille 1928, no. 1644, not repr. (Auvers); Faille 1970 and 1992, no. 1644 (recto and verso) (as Auvers, June 1890; the editors suggest that the woman in a checked dress may be one of the Americans mentioned in letter 640); Hulsker 1980 and 1996, no. 2065 (recto), no. 2066 (verso) (Auvers, June–July 1890); Van der Wolk 1987, no. 243, SB 7/68 (recto); no. 242, SB 7/67 (verso); Gachet 1994, p. 245 (as one of "six small sketches"; under ca. July 26, 1890)

COMMENTS: Gachet *fils* described P.G. III-40 (this drawing together with F 1616, 1617, 1622), and P.G. III-41 (F 1654) as pages from an Auvers sketchbook "that are now detached" and noted that "the paper of these sketches is yellowed by fixative and by time." The original sketchbook (Van Gogh Museum, Amsterdam) was recently reconstituted from bound and loose sheets and is partially intact; the only displaced pages that have been recovered are those formerly owned by Gachet (see Van der Wolk 1987, SB 7, pp. 212–64).

P.G. III-40 (1) (recto)

P.G. III-40 (1) (verso)

P.G. III-40 (2) (recto)

P.G. III-40 (2) (verso)

** *Hind Legs of a Horse* (recto); *Head of a Young Man with a Hat* (verso), June–July 1890
(cat. no. 22d)
Crayon and graphite on faded blue-lined graph paper, 13.2 x 8.5 cm
Musée du Louvre, Paris, Département des Arts Graphiques, Fonds du Musée d'Orsay, RF 29 884

P.G. III-40 (2): *Six petits croquis*, Auvers 1890—feuillet II
F 1622 (recto and verso); JH 2061 (recto), 2075 (verso)

PROVENANCE: Dr. Paul Gachet, Auvers [1890–1909]; sold by Paul Gachet *fils* to Mme Walter, Paris, before 1951; sold by her to the Musée du Louvre, 1951

REFERENCES: Faille 1928, no. 1622 (as Saint-Rémy; not repr.); Faille 1970 and 1992, no. 1622 (recto and verso) (as Auvers, June 1890); Hulsker 1980 and 1996, no. 2061 (recto), 2075 (verso) (as Auvers, June–July 1890); Van der Wolk 1987, no. 263, SB 7/138 (recto), no. 262, SB 7/137 (verso) (as *Head of a Woman*); Gachet 1994, p. 245 (as one of "six small sketches"; under ca. July 26, 1890)
COMMENTS: See comments under P.G. III-40 (1), above.

P.G. III-40 (3)

Seated Woman with Child, June–July 1890
(cat. no. 22a)
Crayon on faded blue-lined graph paper,
13.2 x 8.5 cm
Musée du Louvre, Paris, Département des Arts Graphiques, Fonds du Musée d'Orsay, RF 29 885

P.G. III-40 (3): *Six petits croquis*, Auvers 1890—feuillet III
F 1617; JH 2076

PROVENANCE: Dr. Paul Gachet, Auvers [1890–1909]; sold by Paul Gachet *fils* to Mme Walter, Paris, before 1951; sold by her to the Musée du Louvre, 1951
REFERENCES: Faille 1928, no. 1617 (as Saint-Rémy; not repr.); Faille 1970 and 1992, no. 1617 (as Auvers, June 1890); Hulsker 1980 and 1996, no. 2076 (as Auvers, June–July 1890); Van der Wolk 1987, no. 239, SB 7/35; Gachet 1994, p. 245 (as one of "six small sketches"; under ca. July 26, 1890)
COMMENTS: See comments under P.G. III-40 (1), above.

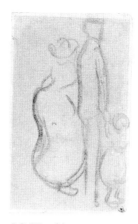

P.G. III-40 (4)

Woman, Man, and Child Walking, June–July 1890
(cat. no. 22b)
Crayon on faded blue-lined graph paper,
13.2 x 8.5 cm
Musée du Louvre, Paris, Département des Arts Graphiques, Fonds du Musée d'Orsay, RF 29 886

P.G. III-40 (4): *Six petits croquis*, Auvers 1890—feuillet IV
F 1616; JH 2077

PROVENANCE: Dr. Paul Gachet, Auvers [1890–1909]; sold by Paul Gachet *fils* to Mme Walter, Paris, before 1951; sold by her to the Musée du Louvre, 1951
REFERENCES: Faille 1928, no. 1616 (as Saint-Rémy; not repr.); Faille 1970 and 1992, no. 1616 (as Auvers, June 1890); Hulsker 1980 and 1996, no. 2077 (as Auvers, June–July 1890); Van der Wolk 1987, no. 235, SB 7/23; Gachet 1994, p. 245 (as one of "six small sketches"; under ca. July 26, 1890)
COMMENTS: See comments under P.G. III-40 (1), above.

**Café Scene*, also called *Counter at Ravoux's Inn* (recto); *Two Chickens* (verso), June–July 1890
(cat. no. 22e)
Graphite on faded blue-lined graph paper,
8 x 13.3 cm
Van Gogh Museum (Vincent van Gogh Foundation), Amsterdam, D384 m/1975

P.G. III-41: *Au comptoir, chez Ravoux*, double face, Auvers 1890
F 1654 (recto and verso); JH 2069 (recto), 2070 (verso)

PROVENANCE: Dr. Paul Gachet, Auvers [1890–1909]; sent as a gift from Paul Gachet *fils* to Eduard Buckman, Richmond, Va.,

Oct. 24, 1951, until his death in 197[4]; acquired from his estate by the Van Gogh Museum, Amsterdam, 1975
REFERENCES: Faille 1928, no. 1654 (recto) (as Auvers; not repr.; verso not included); Faille 1970 and 1992, no. 1654 (recto and verso) (as Auvers, June–July 1890); Hulsker 1980 and 1996, no. 2069 (recto), no. 2070 (verso) (as Auvers, June–July 1890); Van der Wolk 1987, no. 229, SB 7/11 (recto), no. 230, SB 7/12 (verso); Gachet 1994, pp. 245–46 (as Auvers, ca. July 26, 1890)
LETTERS: Paul Gachet *fils* to Eduard Buckman, Oct. 24, 1951 (b1215 M/1975, VGM Archives); EB to PG *fils*, Oct. 26, 1951 (VGM Archives); PG *fils* to EB, Nov. 7, 1951 (b1216 M/1975, VGM Archives); PG *fils* to EB, Jan. 15, 1952 (VGM Archives); EB to PG *fils*, Feb. 7, 1952 (VGM Archives)
COMMENTS: Faille identified the subject on the recto as Ravoux's Inn, in accordance with (and presumably relying on) Gachet *fils* (1994, and letters); other scholars (Hulsker, Van der Wolk) have preferred a generic ("Café") title. This is the only double-sided drawing in Gachet's collection for which Faille 1928 did not record the verso. See comments under P.G. III-40 (1), above.

P.G. III-41 (recto)

P.G. III-41 (verso)

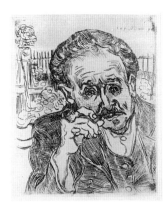

P.G. III-a

† *Portrait of Dr. Gachet (The Man with a Pipe)*, 1890
(cat. no. 23b)
Etching, 18 x 14.7 cm
Dated upper right, in the plate: 25 Mai 90
Bibliothèque Nationale de France, Paris,
Département des Estampes et de la
Photographie

P.G. III-a: *L'homme à la pipe
(Dr. Gachet)*, Auvers, 25 Mai, 1890
F 1664; JH 2028

PROVENANCE: An undetermined number
of these prints were made in several editions
(see Van Heugten and Pabst 1995, no. 10).
Most existing impressions bear Gachet col-
lector stamps. Paul Gachet *fils* donated the
plate to the Musée du Louvre in 1951 and
impressions of the print to the Bibliothèque
Nationale, Paris, in 1929 and to the
Bibliothèque Doucet, Paris, in 1920.
EXHIBITIONS (impressions lent from the
Gachet collection): Paris 1905, no. 26, as
"*L'homme à la pipe* (eau-forte unique de Van
Gogh, Auvers, 1889 [*sic*]"; Amsterdam 1905,
no. 432; Paris 1907–8, no. 55; Paris 1925,
no. 56; Paris 1937b, no. 206
REFERENCES: Meier-Graefe 1904, p. 120 n. 1
(notes that "Dr. G. owns the unique etching
that Van Gogh had made from the copper-
plate which is still on hand: an independent
Portrait of Dr. Gachet"); Faille 1928,
no. 1664 (as May 15, 1890); Gachet 1947,
repr.; Florisoone 1952, p. 4, repr.; Gachet
1952, n.p.; Gachet 1953a, n.p.; Gachet 1953c,
n.p. (as May 25, 1890, a work lent by Dr.
Gachet to the 1905 Indépendants exhibi-
tion); Anfray 1953; Anfray 1954b, pp. 1, 8–11;
Anfray 1954c, no. 43, pp. 4–6, no. 44, pp.
4–6; Anfray 1954d, pp. 8–9 (as May 15, 1890;
questions authenticity); Chatelet in Paris
1954–55, no. 66; Cooper 1955, p. 105; Perru-
chot 1955, p. 14; Gachet 1956a, pp. 101, 112,
fig. 55; Sablonière 1957–58, pp. 41–42;
Anfray 1958; Faille 1958, pp. 4–7; Outhwaite
1969, pp. 49–50 (as seen by Theo on June 8,
1890); Hulsker 1980 and 1996, no. 2028 (as
mid-June 1890); Pickvance in New York
1986–87, p. 229, no. 61; Dorn in Essen,
Amsterdam 1990, no. 57, pp. 176–77 (as May
25, 1890); Faille 1992, no. 1664, pp. 442–44;
Gachet 1994, pp. 55–57, 82–83 n. 25, 142; Van
Heugten and Pabst 1995, no. 10, pp. 30–31,
79–86, 99–106 (as June 15, 1890; proposes
that the date is in Dr. Gachet's hand)
LETTERS: T 38; Paul Gauguin to Vincent
van Gogh, ca. June 24, 1890 (reprinted in
Cooper 1983, no. 42, pp. 321–27); Lucien
Pissarro to Dr. Paul Gachet, May 12, 1891
(b885, VGM Archives); Paul Gachet *fils* to
Johanna van Gogh-Bonger, June 6, 1905
(b3374, VGM Archives); PG *fils* to JvGB,
July 5, 1905 (b3368, VGM Archives); PG *fils*
to JvGB, Aug. 29, 1905 (b3369, VGM
Archives); JvGB to PG *fils*, July 15, 1912
(b2156, VGM Archives); PG *fils* to JvGB,
July 17, 1912 (b3414, VGM Archives), and
[spring 1913] (b3415 V/1984, VGM Archives);
JvGB to PG *fils*, June 16 and 18, 1913 (b2160
V/1982, VGM Archives); PG *fils* to JvGB,
Dec. 22, 1920 (b3401 V/1984, VGM Archives);
PG *fils* to Gustave Coquiot, Dec. 28, 1921
(b3307, VGM Archives); PG *fils* to V. W.
van Gogh, Feb. 13, 1953 (b3079 V/1962,
VGM Archives); PG *fils* to VWvG, June 22,
1953 (b3082, VGM Archives)
COMMENTS: There has been considerable
controversy over the authorship and date of
this work. Anfray was the first to question
its attribution to Van Gogh and propose
instead Dr. Gachet (or his son) as artist. By
those who accept the work as authentic, the
inscribed date has been variously read as 15
or 25 and interpreted as May or June. Gachet
fils (even in a letter to Jo of 1912 [b3414])
maintained it was done on May 25, 1890.

In the Orchard, mid-July 1883
(cat. no. 23c)
Transfer lithograph on wove paper, height-
ened with black ink on roller, 24.5 x 32.5 cm
Signed lower left: Vincent. Inscribed upper
right, in pencil: première épreuve/Vt.
On the reverse, graphite sketch of the sun
Bibliothèque Nationale de France, Paris,
Département des Estampes et de la
Photographie, D 8581

P.G. III-b: *Dans le verger*, La Haye 1883
F 1659; JH 379
Copied by Gachet *fils* in 1920 (letter sketch,
b3401 V/1984, VGM Archives)

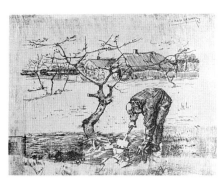

P.G. III-b

PROVENANCE: Sent as a gift by Theo van
Gogh to Dr. Paul Gachet, Auvers, Sept. 12,
1890, until 1909; donated by Paul Gachet *fils*
to the Bibliothèque Nationale, Paris, 1953
REFERENCES: Faille 1928, no. 1659 (as The
Hague, June 1883); Vanbeselaere 1937,
pp. 109–10, 137 (as Aug. 1883; this is the first
reference to a proof in Gachet's collection);
Faille 1970 and 1992, no. 1659 (as after July 13
or 14, 1883; listed as impression IV); Mont-
fort 1972, no. 7; Hulsker 1980 and 1996,
no. 379 (as mid-July 1883); Van Heugten and
Pabst 1995, no. 7.2, pp. 65–66, p. 95 (as The
Hague, mid-July 1883; describes the prove-
nance of the Gachet-owned lithograph and
discusses letters [b2015 and b3401 below] in
this connection)
LETTERS: LT 300, 301, 303; Theo van
Gogh to Dr. Paul Gachet, Sept. 12, 1890
(b2015 V/1982, VGM Archives; reprinted in
Gachet 1957a, pp. 153–55); Paul Gachet *fils* to
Johanna van Gogh-Bonger, [spring 1913]
(b3415 V/1984, VGM Archives); JvGB to
PG *fils*, June 16 and 18, 1913 (b2160 V/1982,
VGM Archives); PG *fils* to JvGB, Dec. 22,
1920 (b3401 V/1984, VGM Archives); JvGB
to PG *fils*, Dec. 31, 1920 (b1518, VGM
Archives); PG *fils* to V. W. van Gogh,
Feb. 13, 1953 (b3079 V/1962, VGM Archives)
COMMENTS: In a letter to Dr. Gachet of
Sept. 12, 1890, Theo included the lithograph,
unmounted, so that Dr. Gachet could make
an etching of it if he wished.

The Potato Eaters, ca. April 16, 1885
(cat. no. 23d)
Lithograph on wove paper, 26.5 x 32 cm
Signed lower left, on the stone (printed in
reverse): Vincent f. Signed in ink: Vincent
Bibliothèque Nationale de France, Paris,
Département des Estampes et de la
Photographie, D 8581

P.G. III-c: *Les mangeurs de pommes de terre*,
Nuenen 1885
F 1661; JH 737

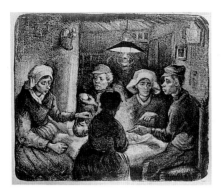

P.G. III-c

PROVENANCE: Dr. Paul Gachet, Auvers [received as a gift from Theo van Gogh, Sept. 1890, until 1909]; donated by Paul Gachet *fils* to the Bibliothèque Nationale, Paris, 1953

REFERENCES: Faille 1928, no. 1661 (as Nuenen, April 1885); Montfort 1972, no. 9; Faille 1970 and 1992, no. 1661 (as Nuenen, mid-April 1885; not listed among the known impressions); Hulsker 1980 and 1996, no. 737 (as Nuenen, April 1885); Van Heugten and Pabst 1995, no. 9.14, pp. 66, 98 (as Nuenen, ca. April 16, 1885, citing Theo van Gogh as owner prior to Dr. Gachet in 1890)

LETTERS: LT 400-2, 404, 405, 413, 418; R 51a, 52, 53, 57; Paul Gachet *fils* to Johanna van Gogh-Bonger, [spring 1913] (b3415 V/1984, VGM Archives); JvGB to PG *fils*, June 16 and 18, 1913 (b2160 V/1982, VGM Archives); JvGB to PG *fils*, Sept. 27, 1923 (b1523 V/1962, VGM Archives); PG *fils* to V. W. van Gogh, Feb. 13, 1953 (b3079 V/1962, VGM Archives); PG *fils* to VWvG, March 15, 1955 (b3443, VGM Archives)

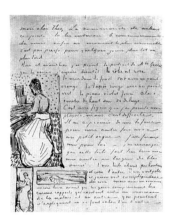

F 1873 (LT 645)

Letter from Vincent to Theo van Gogh with Sketch of "Mlle Gachet at the Piano," June 28, 1890
Pen on writing paper, two pages
Location unknown

F 1873 (LT 645)

PROVENANCE: Sent by the artist (letter 645) to Theo van Gogh, Paris, on June 28, 1890, with him until his death in 1891; by descent to his widow, Johanna van Gogh-Bonger, Amsterdam, 1891–1905; sent by her as a gift to Dr. Paul Gachet, June 14, 1905, until 1909; Paul Gachet *fils,* until his death in 1962; acquired from his estate by Georges Wildenstein, Paris, ca. March 1963; subsequently sold; present location unknown

EXHIBITION: Paris 1937b, no. 213

REFERENCES: Van Gogh Letters 1914, vol. 3, p. 453 (repr.); Van Gogh Letters 1952–54, vol. 3, no. 645, p. 288, repr.; Gachet 1953b, figs. 9, 10; Van Gogh Letters 1977, vol. 2, no. 645 (facsimile of Johanna van Gogh-Bonger's transcription of the original letter, annotated by her, "copy of a letter that I gave to M. Gachet"); Hulsker 1980 and 1996, no. 2049 (as letter sketch, June 28, 1890); Pickvance in New York 1986–87, p. 267, fig. 64; Faille 1992, no. 1873 (as letter sketch); Gachet 1994, p. 165 (as a gift from Johanna van Gogh-Bonger to Dr. Gachet)

LETTERS: LT 645 (reprinted in Gachet 1957a, pp. 139–40); Johanna van Gogh-Bonger to Dr. Paul Gachet, June 14, 1905 (b2131 V/1982, VGM Archives); PG *fils* to JvGB, June 20, 1905 (b3413 V/1984, VGM Archives); JvGB to PG *fils*, Feb. 15, [1912] (b2151 V/1982, VGM Archives); Paule Lizot to Mr. and Mrs. Marc Edo Tralbaut, March 18, 1963 (VGM Archives)

COMMENTS: Before Johanna van Gogh-Bonger sent letter 645 to the Gachets as a gift in June 1905, she transcribed the text (as she advised Gachet *fils* in b2151), but she did not photograph the sketches. Later, wanting to reproduce all the drawings in her upcoming publication of Van Gogh's correspondence, she asked in Feb. 1912 to borrow "the letter from Vincent which I had sent at the time to Monsieur your father" that included the "portrait of Mlle Gachet." The latter description makes it possible to identify her 1905 gift, then called simply "a letter from Vincent" (b2131). Likewise, it was described only as a "signed letter from V.G." when Mme Lizot recorded its 1963 purchase by Wildenstein. See P. G. III-20.

Armand Guillaumin
(French, 1841–1927)

* *Self-Portrait*, ca. 1870–75
(cat. no. 25)
Oil on canvas, 73 x 60 cm
Musée d'Orsay, Paris, RF 1949-18

P.G. IV-1: *Son portrait,* vers 1870
S&F 39; Gray 46

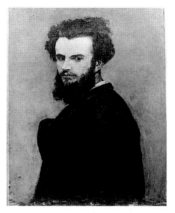

P.G. IV-1

PROVENANCE: Dr. Paul Gachet, Auvers [?–1909]; donated by Paul Gachet *fils* to the Musée du Louvre, Paris, 1949

EXHIBITIONS: Paris, Galerie de l'Élysée, "Guillaumin," Nov. 9–27, 1937, no. 1; Paris, Galerie Raphaël Gérard, "Sélection d'oeuvres de Guillaumin," Nov. 4–26, 1938, no. 28 (as *Son portrait par lui-même*, ca. 1873); Paris, Galerie Raphaël Gérard, "Centenaire de A. Guillaumin," May 24–June 7, 1941, no. 91 (as *Portrait de A. Guillaumin par lui-même*, ca. 1873)

REFERENCES: Courières 1924, p. 72 (as *Portrait du peintre*, ca. 1872, 58 x 73 cm, P. Gachet collection; not repr.); Florisoone 1952, p. 18, repr.; Chatelet in Paris 1954–55, no. 72 (as ca. 1875); Serret and Fabiani 1971, no. 39 (as ca. 1875); Gray 1972, no. 46, pl. 4 (as ca. 1875); Landais 1997, pp. 110–11 (as one of "two works of quality accompanying the portrait of the doctor in the first donation [to the Louvre]")

LETTERS: LT 638; Paul Gachet *fils* to V. W. van Gogh, April 29, 1949 (b3072 V/1962, VGM Archives); VWvG to PG *fils*, May 16, 1949 (b2842 V/1982, VGM Archives); PG *fils* to VWvG, June 26, 1949 (b3073 V/1962, VGM Archives)

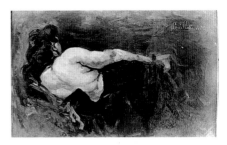

P.G. IV-3

COMMENTS: Paul Gachet *fils* describes the fragility of the original support with its prepared red-brown ground and remarks that the "only way to save" this and other works [P.G. II-10, P.G. IV-2] painted on poor-quality cardboard was to give them "a new and solid support: it was necessary to transfer them to canvas, [an] operation that was carried out about fifty years after their execution."

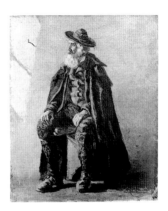

P.G. IV-4

PAUL GACHET

COLLECTION DU DR. GACHET
IV
GUILLAUMIN

PEINTURE · PASTEL · AQUARELLE

CATALOGUE RAISONNÉ
ILLUSTRÉ DE 34
REPRODUCTIONS

AUVERS-SUR-OISE
1 9 4 0

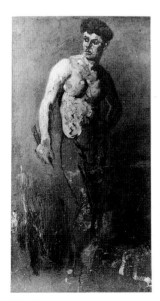

P.G. IV-2

Life Study of a Man
Oil on cardboard remounted on canvas, 71 x 38 cm
Location unknown

P.G. IV-2: *Académie (homme)*, ébauche, Atelier Suisse

PROVENANCE: Dr. Paul Gachet, Auvers [?–1909]; Paul Gachet *fils*

Reclining Nude Seen from the Back
Oil on cardboard remounted on canvas, 44 x 71 cm
Signed upper right, in vermilion: Guillaumin
Location unknown

P.G. IV-3: *Nu couché (dos)*, époque de l'Académie Suisse

PROVENANCE: Dr. Paul Gachet, Auvers [?–1909]; Paul Gachet *fils*

Italian Model
Oil on canvas, 55 x 46 cm
Signed lower right, in red: A Guillaumin [A and G interlaced]
Location unknown

P.G. IV-4: *Vieux modèle italien*

PROVENANCE: Dr. Paul Gachet, Auvers [?–1909]; Paul Gachet *fils*

Reclining Nude, ca. 1872–77 (cat. no. 29)
Oil on canvas, 49 x 65 cm
Signed lower right: A Guillaumin [A and G interlaced]
Musée d'Orsay, Paris, RF 1951-35

P.G. IV-5: *Nu couché, à l'écran japonais*
S&F 51; Gray 49

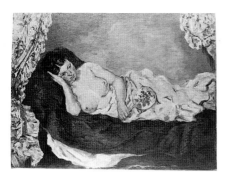

P.G. IV-5

PROVENANCE: Dr. Paul Gachet, Auvers [?–1909]; donated by Paul Gachet *fils* to the Musée du Louvre, Paris, 1951

REFERENCES: Doiteau 1923–24 (Dec. 1923), pp. [278]–79 (recounts story of Van Gogh's anger over the work's unframed state and the ensuing dispute with Dr. Gachet); Coquiot 1923, pp. 256–57; Courières 1924, p. 72 (as *Femme demi-nue couchée*, ca. 1872, 65 x 49 cm, P. Gachet collection, ; not repr.); Florisoone 1952, p. 18 (as ca. 1877; repr.); Gachet 1956a, pp. 95, 113 (notes that Meier-Graefe mistakenly catalogued it as a Pissarro in 1904); Tralbaut 1969, pp. 322–24, 328 (gives account of the dispute over the unframed picture as retold to Tralbaut by Paul and Marguerite Gachet); Serret and Fabiani 1971, no. 51 (as ca. 1877); Gray 1972, no. 49, pl. 5 (as ca. 1876)

LETTER: LT 638

COMMENTS: This work was first exhibited in Paris 1954–55, no. 70.

P.G. IV-6

Quay at Bercy
Oil on canvas, 39 x 56 cm
Musée Carnavalet, Paris (P 2163.E.21280)

P.G. IV-6: *La Seine à Bercy*, avant 1870
S&F 28

PROVENANCE: Dr. Paul Gachet, Auvers [?–1909]; sold by Paul Gachet *fils* to Wildenstein, Paris and New York, ca. 1952; sold to William B. Jaffe, New York, 1952,

until 1959; consigned by him to M. Knoedler and Co., New York, April–Nov. 1959; sold to Marion Fitzhugh, New York, Nov. 1959; J. Perry (or Percy) Fitzhugh, by 1967; consigned by him to M. Knoedler and Co., New York, April 1967, and returned unsold June 1968; Hammer Galleries, New York, by 1971; consigned by them to M. Knoedler and Co., New York, Dec. 1971, and returned unsold May 1974; sale, Sotheby's, London, Dec. 5, 1979, no. 27; purchased at that sale by the Musée Carnavalet, Paris

REFERENCES: Serret and Fabiani 1971, no. 28 (as ca. 1874, ex Gachet collection); Montgolfier 1992, p. 120 (as *La Seine à son entrée dans Paris*, ca. 1875)

P.G. IV-7

Fog Effect
Oil on canvas, 38 x 46 cm
Location unknown

P.G. IV-7: *Effet de brouillard*

PROVENANCE: Dr. Paul Gachet, Auvers [?–1909]; Paul Gachet *fils*

Canal Saint-Denis, or *Canal Saint-Martin*, 1869
Oil on canvas, 32.7 x 46 cm
Signed and dated lower left (per Gachet *fils*): 69 [signature not visible on photograph]
Location unknown

P.G. IV-8: *Canal Saint-Denis*, 1869
Copied by Gachet *fils*, March 1901 (RF 31 261)

PROVENANCE: Dr. Paul Gachet, Auvers [?–1909]; Paul Gachet *fils*

COMMENTS: On a list of works that Paul Gachet *fils* gave to the Musée du Louvre, (Archives du Louvre), he titled this painting *Canal Saint-Martin*, whereas in the catalogue he identified the site depicted as Canal Saint-Denis.

P.G. IV-8

The Sunken Road, Snow Effect, 1869 (cat. no. 26)
Oil on canvas, 66 x 55 cm
Signed and dated lower right: A Guillaumin [A and G interlaced]/X 69
Musée d'Orsay, Paris, RF 1954-10

P.G. IV-9: *Chemin creux (effet de neige) (Arcueil)*, 1869
S&F 5; Gray 14
Copied by Gachet *fils*, March 1901 (RF 31 259) (cat. no. 26a)

PROVENANCE: Dr. Paul Gachet, Auvers [?–1909]; donated by Paul Gachet *fils* to the Musée du Louvre, Paris, 1954

EXHIBITION: Paris, Galerie Raphaël Gérard, "Sélection d'oeuvres de Guillaumin," Nov. 4–26, 1938, no. 29 (as *Chemin creux sous la neige*)

REFERENCES: Courières 1924, p. 72 (as Arcueil—*Effet de neige*, Dec. 6, 1869, 54 x 64 cm, P. Gachet collection; not repr.); Chatelet in Paris 1954–55, no. 67; Serret and Fabiani 1971, no. 5 (as ca. 1869); Gray 1972, no. 14, fig. 11 (as 1869)

COMMENTS: According to Gachet *fils*, "After relining, the flimsy stretcher was *no longer strong enough*, and the inscription on the back, by Guillaumin, disappeared along with it; it had read—in fact—on the top crossbar: Arcueil, 6 Xbre 1869."

P.G. IV-9

P.G. IV-10

Quay in the Snow
Oil on canvas, 49 x 65 cm
Signed lower left, in red: A Guillaumin
[A and G interlaced]
Location unknown

P.G. IV-10: *Quai à la neige*

PROVENANCE: Dr. Paul Gachet, Auvers
[?–1909]; Paul Gachet *fils*

View of the Seine, 1874
Oil on canvas, 45.5 x 61.5 cm
Signed lower left: Guillaumin
The Fine Arts Museums of San Francisco,
Gift of Mr. and Mrs. Louis A. Benoist,
1956.17

P.G. IV-11: *Péniches à Bercy,* 1870
S&F 36

PROVENANCE: Dr. Paul Gachet, Auvers
[?–1909]; sold by Paul Gachet *fils* to a pri-
vate collection, Germany, before 1956; sold
to Mr. and Mrs. Louis A. Benoist; their
donation to the Fine Arts Museums of
San Francisco, 1956
REFERENCE: Serret and Fabiani 1971, no. 36
(as ca. 1874; no mention of Gachet in
provenance)

P.G. IV-11

P.G. IV-12

Snowy Route near Paris, 1871
Oil on canvas, 33 x 46 cm
Signed and dated lower left: A Guillaumin
71 [A and G interlaced]
Location unknown

P.G. IV-12: *Effet de neige,* 1871
S&F 12

PROVENANCE: Dr. Paul Gachet, Auvers
[ca. 1872–1909]; Paul Gachet *fils*
REFERENCE: Serret and Fabiani 1971, no. 12
(as ca. 1871; no mention of Gachet in
provenance)

P.G. IV-13

* *Bridge over the Marne at Joinville,* 1871
(fig. 77)
Oil on canvas, 58.7 x 72.1 cm
Signed and dated lower left: A Guillaumin
[A and G interlaced] 1871. Annotated on
reverse, on stretcher bar: La Marne à
Joinville le Pont (Seine); on label, in Paul
Gachet *fils*'s hand: Ad. Guillaumin, Le Pont
de Joinville
The Metropolitan Museum of Art, New
York, Robert Lehman Collection, 1975,
1975.1.180

P.G. IV-13: *La Marne à Joinville,* 1871
Gray 301
Copied by Derousse, March 1901
(RF 31 243)

PROVENANCE: Dr. Paul Gachet, Auvers
[ca. 1872–1909]; presumably sold by Paul
Gachet *fils* to Wildenstein, Paris and New
York, by 1954; sold to Robert Lehman, Nov.
1954, until his death in 1969; his bequest to
The Metropolitan Museum of Art,
New York, 1975
REFERENCE: Gray 1991, no. 301 (as an
addition to Gray 1972; no mention of
Gachet in provenance)

* *Sailboats on the Seine at Bercy,* 1871
(cat. no. 27)
Oil on canvas, 51 x 73 cm
Signed and dated lower left: A Guillaumin
[A and G interlaced]/9 71
Musée d'Orsay, Paris, RF 1954-11

P.G. IV-14: *Péniches sur la Seine, à Bercy,*
1871
S&F 11; Gray 25
Copied by Cézanne, ca. 1872 (Cherpin 1)
(cat. no. 10a)

PROVENANCE: Dr. Paul Gachet, Auvers, by
1872–1909; donated by Paul Gachet *fils* to
the Musée du Louvre, Paris, 1954
REFERENCES: Gachet 1952, n.p. (as *Vue de
la Seine,* Sept. 1871, one of the paintings by
Guillaumin that Gachet owned by 1872;
repr.); Serret and Fabiani 1971, no. 11 (as
ca. 1871); Gray 1972, no. 25, fig. 20
COMMENTS: Gachet *fils* dates this painting
to Sept. 1871 and notes that Cézanne's first
etching (cat. no. 10a) was copied after it.
The painting was first exhibited in Paris
1954–55, no. 68.

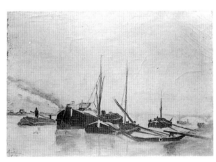

P.G. IV-14

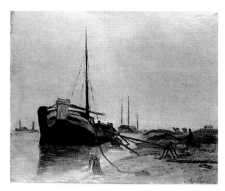

P.G. IV-15

Sailboats on the Seine, 1872
Oil on canvas, 38 x 46 cm
Signed lower right: A Guillaumin [A and G interlaced]. Dated on reverse, in blue pencil: 21 février 72
Location unknown

P.G. IV-15: *Péniches sur la Seine*, 1872
Copied by Derousse, 1901 (RF 31 248)

PROVENANCE: Dr. Paul Gachet, Auvers [1872–1909]; Paul Gachet *fils*

Sunset at Ivry, ca. 1872–73
(cat. no. 30)
Oil on canvas, 65 x 81 cm
Signed lower left: A Guillaumin [A and G interlaced]
Musée d'Orsay, Paris, RF 1951-34

P.G. IV-16: *Soleil couchant à Ivry*, vers 1872
S&F 20; Gray 12
Copied by Derousse, Feb. 1901 (RF 31 242)
(cat. no. 30a)

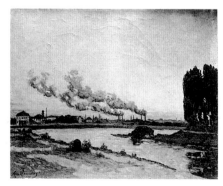

P.G. IV-16

PROVENANCE: Dr. Paul Gachet, Auvers, by 1874–1909; donated by Paul Gachet *fils* to the Musée du Louvre, Paris, 1951
EXHIBITIONS: Paris 1874, no. 66; Paris 1937a, no. 4

REFERENCES: Chatelet in Paris 1954–55, no. 71 (as 1873); Serret and Fabiani 1971, no. 20 (as ca. 1873); Gachet in Cherpin 1972, p. 13; Gray 1972, no. 12, fig. 10 (as ca. 1869); Welsh-Ovcharov in Paris 1988, no. 82 (as ca. 1869–71)

Path at Auvers, 1872
Oil on cardboard, remounted on canvas, 19 x 24 cm
Annotated on reverse, in Dr. Gachet's hand (per Gachet *fils*): Auvers—Septembre 1872. Guillaumin.
Private collection

P.G. IV-17: *Un coin d'Auvers*, 1872
S&F 3

P.G. IV-17

PROVENANCE: Dr. Paul Gachet, Auvers [1872–1909]; sold by Paul Gachet *fils* to Wildenstein, Paris and New York, 1955, until 1959; sold to S. Weir, Canada, 1959; private collection
REFERENCE: Serret and Fabiani 1971, no. 3 (as ca. 1869, oil on canvas, 19 x 24 cm, ex Gachet collection)
COMMENTS: Paul Gachet *fils* describes this work as oil on good-quality cardboard, 22 x 32 cm. The photograph in his catalogue (reproduced here) shows a painting wider on both sides than that depicted in the Serret and Fabiani 1971 catalogue raisonné; presumably the work had been transferred to canvas and cropped at the same time. The fragility of other works in the Gachet collection painted on cardboard supports had necessitated remounting; see P.G. IV-3 and P.G. II-10 (R 211).

Hillside at Auvers, 1872
Oil on canvas(?)
Location unknown

P.G. IV-18 [not repr.]: *La côte (Auvers)*, 1872

PROVENANCE: Dr. Paul Gachet, Auvers [?–1909]; Paul Gachet *fils*
COMMENTS: Although *La côte (Auvers)*, 1872, is listed as P.G. 18, with reference to a photograph, in the table of contents of the Gachet *fils* catalogue, there is no entry for it; the catalogue skips from P.G. 17 to P.G. 19.

Corner at Auvers: The Garden Path, 1872
Oil on cardboard, 21.5 x 23 cm
Location unknown

P.G. IV-19 [not repr.]: *Pochade*, Auvers 1872

PROVENANCE: Dr. Paul Gachet, Auvers [?–1909]; Paul Gachet *fils*
COMMENTS: Paul Gachet *fils* gives the following description of this work, which he does not illustrate with a photograph: "A path winds through tall, gray, yellowish grass, up to the wall of a shed in the background at right. Two figures—two '*quilles*' [literally, ninepins or skittles]—animate this 'scrap' of landscape, bleak in spite of the effect of sunlight and a light sky of pale cobalt. Except as an experiment in canvas, brush, and colors, the interest of such a sketch escapes us today—the site appears ordinary, without charm, it is—perhaps—without history. Worth noting from a technical point of view is the drawing, unusual for Guillaumin, of some twigs traced in the paint with the paintbrush handle."

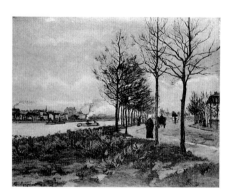

P.G. IV-20

The Seine at Charenton, 1873
Oil on canvas, 65 x 81 cm
Signed and dated lower left: A Guillaumin [A and G interlaced] 2.73
Location unknown

P.G. IV-20: *La Seine à Charenton*, 1873
Copied by Derousse, March 1901 (RF 31 244)

PROVENANCE: Dr. Paul Gachet, Auvers [1873–1909]; Paul Gachet *fils*

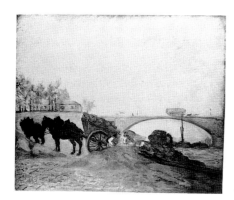

P.G. IV-21

Unloading Cargo on the Banks of the Seine,
1873
Oil on canvas, 54 x 65 cm
Signed with initials and dated lower right:
AG [interlaced] 11.73.
Location unknown

P.G. IV-21: *Quai de la Rapée (brouillard),* 1873
S&F 23
Copied by Derousse, 1901 (RF 31 246)

PROVENANCE: Dr. Paul Gachet, Auvers
[1873–1909]; sold by Paul Gachet *fils* before
1959; Hirschl and Adler Galleries, New York;
Pedro Vallenillo, Caracas, by 1959; sale,
Sotheby's, London, April 30, 1969, no. 43;
sale, Sotheby's, London, Dec. 6, 1979, no. 533
REFERENCE: Serret and Fabiani 1971, no. 23
(as ca. 1873, ex Gachet collection)

*Path in the Île de France (Vallée de la
Bièvre),* 1873
Oil on canvas, 59.4 x 73.3 cm
Signed and dated lower left: A Guillaumin
[A and G interlaced] 11–73
Museo de Bellas Artes, Caracas, Venezuela,
59.38

P.G. IV-22: *Vallée de la Bièvre (gelée blanche),*
1873
S&F 22
Copied by Derousse, 1901 (RF 31 247)

P.G. IV-22

PROVENANCE: Dr. Paul Gachet, Auvers
[1873–1909]; sold by Paul Gachet *fils* to
Wildenstein, Paris and New York, 1954,
until 1959; sold to Fundacion Museo de
Bellas Artes, Caracas, 1959
REFERENCE: Serret and Fabiani 1971, no. 22
(as ca. 1873; no mention of Gachet in
provenance)

P.G. IV-23

Road at Sèvres
Oil on canvas, 65 x 81 cm
Signed lower right: A Guillaumin [A and G
interlaced]
Location unknown

P.G. IV-23: *Une rue à Sèvres (paysage
d'automne)*
Copied by Derousse, 1901/2 (RF 31 245)

PROVENANCE: Dr. Paul Gachet, Auvers
[?–1909]; Paul Gachet *fils*

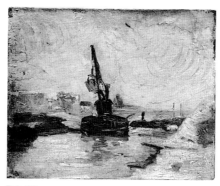

P.G. IV-24

The Pontoon Crane, ca. 1873
Oil on canvas, 22 x 27 cm
Location unknown

P.G. IV-24: *Le ponton-grue,* 1873

PROVENANCE: Dr. Paul Gachet, Auvers
[?–1909]; Paul Gachet *fils*

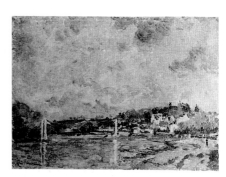

P.G. IV-25

Suspension Bridge, ca. 1873–74
Oil on canvas, 33 x 46 cm
Signed lower left: A Guillaumin [A and G
interlaced]
Location unknown

P.G. IV-25: *Le pont suspendu (Villeneuve St-
Georges?),* vers 1874
S&F 21

PROVENANCE: Dr. Paul Gachet, Auvers
[?–1909]; sold by Paul Gachet *fils* to
Wildenstein, Paris and New York, 1954,
until 1955; sold to a private collector; Hirschl
and Adler Galleries, New York; Denmann
collection, United States, by 1971
REFERENCE: Serret and Fabiani 1971, no. 21
(as ca. 1873; no mention of Gachet in
provenance)

Landscape in the Île de France, Frost Effect,
ca. 1874
Oil on canvas, 46 x 55 cm
Signed lower right: A Guillaumin [A and G
interlaced]
Location unknown

P.G. IV-26: *Paysage (gelée blanche),* 1874

PROVENANCE: Dr. Paul Gachet, Auvers
[?–1909]; Paul Gachet *fils*

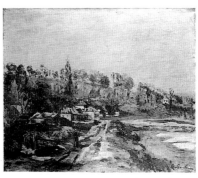

P.G. IV-26

LETTER: Paul Gachet *fils* to Victor Doiteau, July 7, 1941 (reprinted in Tralbaut 1967, p. 93), probably the "*Landscape (Frost Effect)*, 46 x 54 cm by Guillaumin" that he was willing to sell for 20,000 francs. Instead Doiteau chose a small Van Gogh (see P.G. III-21 [F 821]) for the same price.

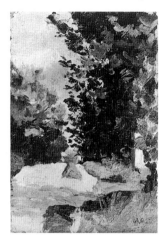

P.G. IV-27

Landscape at Auvers, 1874
Oil on cardboard, 26 x 18 cm
Signed lower right: A.G. Dated in brown (per Gachet *fils*; not visible in photograph): 74
Location unknown

P.G. IV-27: *Paysage (Auvers)*, 1874

PROVENANCE: Dr. Paul Gachet, Auvers [1874?–1909]; Paul Gachet *fils*

Field at Auvers, 1874
Oil on canvas, 16 x 24 cm
Signed and dated lower right, in red:
A Guillaumin [A and G interlaced]/74.
Stamped on reverse of canvas (per Gachet *fils*): Donnet, Fabt de Toiles pour Tableaux, 4, quai des Orfèvres, Paris
Location unknown

P.G. IV-28: *Plaine d'Auvers*, 1874

PROVENANCE: Dr. Paul Gachet, Auvers [1874–1909]; Paul Gachet *fils*

P.G. IV-28

P.G. IV-29

Still Life with Faience, Brioche, Lemons, 1872
Oil on cardboard, 31 x 39.7 cm
Signed lower right: A Guillaumin [A and G interlaced]. Annotated on reverse (per Gachet *fils*), in Dr. Gachet's hand:
Guillaumin—1872
Location unknown

P.G. IV-29: *Nature-morte (faïence, brioche, citrons, etc.)*, 1872

PROVENANCE: Dr. Paul Gachet, Auvers [1872–1909]; Paul Gachet *fils*

P.G. IV-30

* *Still Life with Flowers, Faience, and Books,* 1872
(cat. no. 28)
Oil on canvas, 32.5 x 46 cm
Signed and dated lower right: A Guillaumin [A and G interlaced] 7 72
Musée d'Orsay, Paris, RF 1954-9

P.G. IV-30: *Nature morte (fleurs, faience, livres, etc.)*
S&F 14; Gray 32
Copied by Gachet *fils* (RF 31 260)
(cat. no. 28a)

PROVENANCE: Dr. Paul Gachet, Auvers [1872–1909]; donated by Paul Gachet *fils* to the Musée du Louvre, Paris, 1954
REFERENCES: Courières 1924, p. 72 (as "Still life. Flowers, books, inkwell, faience dish," 47 x 33 cm, P. Gachet collection; not repr.);

Gachet 1953a, n.p. (notes Guillaumin's use of the same fabric that appears in Cézanne's similar still life, *Bouquet with Yellow Dahlia,* P.G. II-11 [R 214]); Chatelet in Paris 1954–55, no. 69 (as painted at Dr. Gachet's house, using the same fabric as Cézanne in P.G. II-11 [R 214]); Serret and Fabiani 1971, no. 14 (as ca. 1872); Gray 1972, no. 32, fig. 22
COMMENTS: This work was first exhibited in Paris 1954–55, no. 69.

P.G. IV-31

The Hautes-Bruyères, 1872
Pastel on gray laid paper (with watermark), 31 x 46 cm
Dated on reverse, in red-brown pastel (per Gachet *fils*): 25 8bre 72.
Location unknown

P.G. IV-31: *Les Hautes-Bruyères,* 1872

PROVENANCE: Dr. Paul Gachet, Auvers [1872–1909]; Paul Gachet *fils*

The Seine at Bercy, 1872
Pastel on gray laid paper (with Michalet watermark), 31.7 x 43.8 cm
Dated lower left, in pencil (per Gachet *fils*; not visible in photograph): 25 Fév. 72.
Location unknown

P.G. IV-32: *Péniches à Bercy,* 1872

P.G. IV-32

PROVENANCE: Dr. Paul Gachet, Auvers [1872–1909]; Paul Gachet *fils*; Charles E. Slatkin Galleries, New York, by 1959–62
REFERENCE: Minneapolis, New York 1962, no. 53 (as *The Seine at Bercy*, formerly owned by Dr. Gachet; repr.)

P.G. IV-33

Suburban Landscape, ca. 1872
Pastel on blue paper, 23 x 27.5 cm
Location unknown

P.G. IV-33: *Paysage de Banlieue*, vers 1872

PROVENANCE: Dr. Paul Gachet, Auvers [?–1909]; Paul Gachet *fils*

P.G. IV-34

Banks of the Seine
Watercolor on graph paper, 13.5 x 20.5 cm
On reverse (per Gachet *fils*), annotation in blue pencil, in Dr. Gachet's hand: Guillaumin; and ink drawing of a tethered horse
Location unknown

P.G. IV-34: *Bords de la Seine*

PROVENANCE: Dr. Paul Gachet, Auvers [?–1909]; Paul Gachet *fils*

Two Men at a Round Table (recto); *Figure Study* (verso)
Pencil on paper, 21 x 13.5 cm
Van Gogh Museum (Vincent van Gogh Foundation), Amsterdam, D511 V/1966

PROVENANCE: Dr. Paul Gachet, Auvers [?–1909]; Paul Gachet *fils* until his death in 1962; acquired from his estate by Galerie Valentien, Stuttgart; purchased by the Vincent van Gogh Foundation, 1966
REFERENCE: Van Uitert and Hoyle 1987, no. 2.707

VGM D511 V/1966 (recto)

Prints by Guillaumin
(not catalogued by Gachet *fils*)

Three Men at a Table, or *At the Cabaret at Montrouge*
Etching, 8.3 x 16 cm
Signed with cat emblem lower right, in plate
Private collection

Kraemer 4
PROVENANCE: Dr. Paul Gachet, Auvers [?–1909]; sold by Paul Gachet *fils* to present owner, fall 1961
REFERENCES: Clermont-Ferrand 1995, no. 4; Kraemer 1997, no. 4

Kraemer 4

Bièvre, rue Croulebarbe, or *Rue Croulebarbe*, ca. 1874?
Etching
Inscribed on reverse, in blue crayon: Guillaumin
Private collection

Kraemer 5

PROVENANCE: Dr. Paul Gachet, Auvers [?–1909]; sold by Paul Gachet *fils* to present owner, fall 1961
REFERENCE: Kraemer 1997, no. 5 (as 1871? 1874?)

* *The Sunken Road, the Hautes-Bruyères*, 1872 or 1873
(cat. no. 31)
Etching, 12.7 x 9.3 cm
Signed lower left, in plate, with initials: A.G. cat emblem upper left, in plate.
Inscribed lower margin, in plate: au Docteeur [*sic*] Gachet
Private collection

Kraemer 6

Kraemer 6

PROVENANCE: Given (with a dedication, presumably in several exemplars) to Dr. Paul Gachet, Auvers [1873–1909]; one impression was donated by Paul Gachet *fils* to the Bibliothèque Nationale, Paris, 1953, another was sold to a private collector, fall 1961, and a third remained with Paul Gachet *fils* until his death in 1962; sale, "Collection du Docteur Gachet," Hôtel Drouot, Paris, May 15, 1993, no. 304
REFERENCES: Gachet 1952, n.p. (notes that the sketch for Dr. Gachet's first etching was made in Guillaumin's company and depicted the same site as this print, which Guillaumin dedicated to Dr. Gachet in 1873); Gachet 1954a, p. 13 (dates the work to 1872; states that it was made on the same day as Gachet's own first etching, of the same site); Gachet 1957a, p. 66 n. 1 (dates the work to

March 1873 and clarifies that it was also Guillaumin's first etching); Cherpin 1972, p. 25 (as *Chemin à Auvers*, 1873, after a sketch made on a walk with Dr. Gachet); Gray 1972, no. 39, pl. 67 (as ca. 1873); Courthion 1976, pp. 61, 71; Drouot 1993, no. 304; Melot 1994, p. 103 (as 1873); Clermont-Ferrand 1995, no. 6 (as 1873); Kramer 1997, no. 6 (as 1873)

COMMENTS: Gachet *fils*, the primary source for the history of this work, provides slightly differing accounts (Gachet 1952, 1954a, 1957a) of its genesis, dating, and relationship to Dr. Gachet's own first etching of the same site.

Kraemer 10a

La ruelle Barrault, ca. 1873
Etching, 9.4 x 17.5 cm
Inscribed with title lower left. Signed lower right, in the plate. Annotated on reverse mount, in pencil, by Gachet *fils*: Tirage Dr. Gachet / Guillaumin
Private collection

Kraemer 10a

PROVENANCE: Dr. Paul Gachet, Auvers [ca. 1873–1909]; sold by Paul Gachet *fils* to present owner, fall 1961
REFERENCES: *Paris à l'eau-forte*, no. 23 (Aug. 31, 1873), p. 56; Gray 1972, no. 35A (as 1873, one of four etchings on a plate); Clermont-Ferrand 1995, no. 10a; Kraemer 1997, no. 10a (as an impression of one motif from a larger plate with four subjects)

Path of the Barons, Bicêtre, 1873
Etching, 9.7 x 17.3 cm
Signed lower right, in the plate: Guillaumin. Inscribed center margin, in plate: Bicêtre et chemin des Barons. Annotated in pencil: Tirage / Guillaumin / Dr. Gachet
Location unknown

Kraemer 10b

Kraemer 10b

PROVENANCE: Sale, "Collection du Docteur Gachet," Hôtel Drouot, Paris, May 15, 1993, no. 305
REFERENCES: Gray 1972, no. 35B, pl. 63 (as 1873, one of four etchings on a plate); Drouot 1993, no. 305 (as an impression of one motif from a larger plate with four subjects); Clermont-Ferrand 1995, no. 10b (like impression); Kraemer 1997, no. 10b

The Quarry, or *L'Île de Casseuil (Gironde)*, ca. 1873
Etching, 7.3 x 10 cm
Signed lower left, in the plate: AG
Private collection

Kraemer 10c

Kraemer 10c

PROVENANCE: Dr. Paul Gachet, Auvers [ca. 1873–1909]; sold by Paul Gachet *fils* to present owner, fall 1961
REFERENCES: *Paris à l'eau-forte*, no. 27 (Sept. 28, 1873), p. 113; Gray 1972, no. 35D (as 1873, an unidentified subject, represented on a plate with four subjects); Kraemer 1997, no. 10c (as an impression of one motif from a larger plate with four subjects)

Path in the Hautes-Bruyères, 1872 or 1873
Etching, 7.2 x 10.4 cm
Signed lower left: AG
Private collection

Kraemer 10d

Kraemer 10d

PROVENANCE: Dr. Paul Gachet, Auvers [ca. 1873–1909]; sold by Paul Gachet *fils* to present owner, fall 1961
REFERENCES: *Paris à l'eau-forte*, no. 23 (Aug. 31, 1873), p. 61, repr.; Gray 1972, no. 33, pp. 12–13, fig. 23 (erroneously described as Guillaumin's first plate, inscribed with a dedication to Gachet and dated to March 1873), and no. 35B, pl. 63 (as 1873, one of four etchings on a plate); Clermont-Ferrand 1995, no. 10d; Kraemer 1997, no. 10d (as an impression of one motif from a larger plate with four subjects)
COMMENTS: Christopher Gray (1972) confused this print with the version of the subject in vertical format that is dedicated to Dr. Gachet and was identified by his son as Guillaumin's first etching (cat. no. 31a; Kraemer 6).

Plate with Two Subjects: Landscape with Trees, Cabaret at Ivry, 1870s
Etching, 14.8 x 25.7 cm
Signed with cat emblem upper left, in the plate. Signed and inscribed lower right: à mon ami Gachet / A Guillaumin
Private collection

Kraemer 11

Kraemer 11

PROVENANCE: Given (with a dedication) to Dr. Paul Gachet, Auvers [?–1909]; sold by Paul Gachet *fils* to present owner, fall 1961
REFERENCES: Gray 1972, no. 34, pl. 62 (as ca. 1873); Gray 1991, pl. 62, p. 198; Clermont-Ferrand 1995, no. 11; Kraemer 1997, no. 11

Kraemer 11b

Cabaret at Ivry
Etching, 14.8 x 14.9 cm
Signed lower right, in plate: Guillaumin.
Cat emblem upper left, in plate.
Annotated on reverse: Cabaret à Ivry
Musée des Beaux Arts, Ville de Clermont-
Ferrand

Kraemer 11b

PROVENANCE: Sale, "Collection du
Docteur Gachet," Hôtel Drouot, Paris,
May 15, 1993, no. 306
REFERENCES: Gray 1972, no. 34A (as ca.
1873); Drouot 1993, no. 306 (as a unique
impression of the left part of a plate with
two subjects; repr.); Clermont-Ferrand 1995,
no. 11b (as *Paysage au cabaret* or *Cabaret à
Ivry*, unique proof of this subject); Kraemer
1997, no. 11b

Kraemer 12

Port of Charenton, or *Sailboats at Bercy*,
1870s
Etching, 10.9 x 18.2 cm
Signed with cat emblem upper right, in the
plate. Signed and inscribed lower right: à
mon ami Gachet/A Guillaumin
Private collection

Kraemer 12

PROVENANCE: Given (with a dedication)
to Dr. Paul Gachet, Auvers [?–1909]; sold
by Paul Gachet *fils* to present owner, fall
1961
REFERENCES: Coquiot 1917, p. 4; Melot
1996, p. 107; Clermont-Ferrand 1995, no. 12;
Kraemer 1997, no. 12

Kraemer 13

Les Galeciennes, Ivry, 1870s
Etching, 14.9 x 25.6
Inscribed lower margin, on the plate:
Les Galeciennes IVRY
Private collection

Kraemer 13

PROVENANCE: Dr. Paul Gachet, Auvers
[?–1909]; sold by Paul Gachet *fils* to present
owner, fall 1961
REFERENCES: Clermont-Ferrand 1995,
no. 13; Kraemer 1997, no. 13

Kraemer 15

Bridge at Bercy, 1873
Etching, 15.6 x 25.5 cm
Signed with cat emblem upper left, in the
plate. Inscribed with title in lower margin:
Le pont de Bercy. Dated lower left: 7 br 1873
Annotated on reverse, in pencil, by Gachet
fils: 7bre 1873
Private collection

Kraemer 15

PROVENANCE: Dr. Paul Gachet, Auvers
[ca. 1873–1909]; sold by Paul Gachet *fils* to
present owner, fall 1961
REFERENCES: Coquiot 1917, p. 3; Clermont-
Ferrand 1995, no. 15; Kraemer 1997, no. 15

Daybreak, 1870s
Etching, 16.2 x 23.3 cm
Signed with cat emblem upper left, in the
plate. Annotated on reverse, in pencil, by
Gachet *fils*: Quai d'Austerlitz [1873]
Private collection

Kraemer 16

Kraemer 16

PROVENANCE: Dr. Paul Gachet, Auvers
[ca. 1873–1909]; sold by Paul Gachet *fils* to
present owner, fall 1961
REFERENCES: Clermont-Ferrand 1995,
no. 16; Kraemer 1997, no. 16, and see
Kraemer 1997, no. 1 (possibly also catalogued
as *Quai d'Austerlitz*; not repr.)
COMMENTS: An impression of this etching
is catalogued and reproduced as Kraemer 16:
Le point de jour. However, the title inscribed
on the reverse of the present print corre-
sponds to that of an unidentified etching
that was listed, unillustrated, as Kraemer 1:
Quai d'Austerlitz [a work known only from
its mention under this title in a 1927 sale
catalogue]. Kraemer 1 and Kraemer 16 may
refer to the same print.

Route d'Allemagne, Paris
Etching, 5.5 x 10.9 cm
Private collection

PROVENANCE: Dr. Paul Gachet, Auvers
[?–1909]; sold by Paul Gachet *fils* to present
owner, fall 1961
REFERENCE: Not in Kraemer 1997; for a
related print, see Kraemer 1997, no. 7d.
COMMENTS: This print represents the
same subject as the etching catalogued as
Kraemer 7d and is quite similar to it in
composition, although it depicts the scene
in reverse. Gachet *fils*, in a letter of Oct. 4,
1961, to the present owner, commented,
"You will find in the collection of etchings
by Guillaumin a small piece, *Canal géle(?)*
[*Frozen Canal (?)*], that is neither signed
nor marked with 'a cat.' This is why it was
not originally included in my inventory [of
the artist's prints]. When you have the
chance, try to find it in *Paris à l'eau-forte.*"

Roll Call
Etching, 8 x 15 cm
Signed with cat emblem, in plate
Private collection

PROVENANCE: Dr. Paul Gachet, Auvers [?–1909]: sold by Paul Gachet *fils* to present owner, fall 1961
REFERENCE: not in Kraemer 1997
COMMENTS: Titled *L'appel* on a list of Guillaumin prints prepared by Gachet *fils* (ca. 1961), this etching depicts six people on a quay, five standing in a line and a seated man, writing, at the far right.

Note on Guillaumin prints:

It is entirely likely that Gachet owned impressions of other prints by Guillaumin beyond those noted above, but his ownership is difficult to establish in the absence of sufficient provenance documentation. We do know from a letter to Dr. Gachet of September 6, 1873, that Guillaumin was interested in having proofs of Gachet's etchings and in return intended to send him those he had made since their last visit together (letter reprinted in Gachet 1957a, pp. 65–67).

Appendix: Works Formerly Thought to Be Part of the Gachet Collection but Not Catalogued by Paul Gachet *fils*

Paul Cézanne

Pastoral (also called *Idyll*), 1870
Oil on canvas, 65 x 81 cm
Dated lower right: 1870
Musée d'Orsay, Paris, RF 1982-48

R 166; V 104

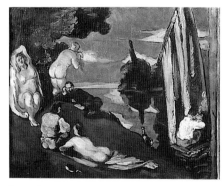

R 166; V 104

PROVENANCE: With Ambroise Vollard, Paris, until 1910; sold to Bernheim-Jeune, Paris, Dec. 24, 1910; ceded to Auguste Pellerin, Paris, for three watercolors and an

additional payment, Dec. 27, 1910; by descent to Jean-Victor Pellerin, Paris; acquired by *dation* by the Musée d'Orsay, Paris, 1982
REFERENCES: Paris 1899, no. 23 (as *Fete au bord de la mer*); Venturi 1936, no. 104 (as formerly owned by Gachet, then Pellerin); Loyrette in Paris, London, Philadelphia 1995–96, no. 23 (relying on Venturi, erroneously names Gachet as its original owner [from ca. 1872]); Rewald 1996, no. 166 (as 1870; provenance begins with Vollard)

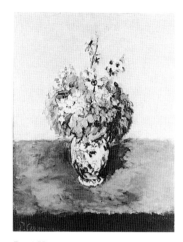

R 226; V 180

Geraniums and Larkspur in a Small Delft Vase, 1873
Oil on canvas, 52 x 39 cm
Signed lower left: P. Cézanne
Private collection

R 226; V 180
Vollard photograph no. 574 (per Rewald)

PROVENANCE: Original owner unknown (possibly Armand Rondest, Pontoise); Ambroise Vollard, Paris; Josse and Gaston Bernheim-Jeune, Paris, from 1910; private collection
REFERENCES: Venturi 1936, no. 180 (as *Géraniums et coreopsis*, 1873–75; lists Dr. Gachet as its first owner, then Vollard; cites it as one of the "two beautiful bouquets by Cézanne" at Gachet's that Van Gogh described in letter 635 [for the other, see P.G. II-15 (R 227)]); Gachet 1953a, n.p. (as one of three signed still lifes in Delft vases that Cézanne painted at Gachet's house; notes it was exhibited in Paris 1936, no. 31); Gachet 1956a, p. 59; Gachet in Cherpin 1972, p. 12; Rewald 1996, no. 226 (as 1873; lists Dr. Gachet as owner subsequent to Armand Rondest; describes it and P.G. II-15 (R 227) as the two small flower pieces that Cézanne painted at Gachet's and that Van Gogh admired there in 1890 [LT 635])

LETTER: (?)Draft of a letter from Cézanne "to a collector in Pontoise" (reprinted in Cézanne Letters 1937, XXIX), presumably written in early 1874 to Rondest, in which Cézanne offers: "If you wish me to sign the picture you spoke to me about, please have it sent to M. Pissarro where I shall add my name." The reference may be to this picture or to P.G. II-14 (R 223), R 191, or an unidentified work.
COMMENTS: According to Gachet *fils*, the size of this still life and of P.G. II-15 (R 227) followed from Dr. Gachet's advice to Cézanne that he work on a smaller scale. The vase, also depicted in P.G. II-15 (R 227), is among the "souvenirs" later presented to the Louvre. See comments under P.G. II-14 (R 223) and P.G. II-15 (R 227).

Flowers in a Green Vase, date uncertain
Oil on canvas, 57.5 x 65.5 cm
Private collection

R875; V 748

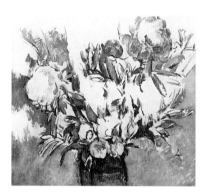

R875; V 748

REFERENCES: Venturi 1936, no. 748 (erroneously identified as belonging to Gachet); Rewald 1996, no. 875 (as *Bouquet de pivoines dans un pot vert*, ca. 1898; corrects provenance in Venturi, noting that the picture actually belonged to Georges Bracque)

House at Auvers
Drawing
Location unknown

V p. 347

REFERENCE: Venturi 1936, p. 347 (under "Unpublished works," Gachet collection, as "*Maison à Auvers:* rather close to the painting no. 145" [i.e. P.G. II-5]; not repr.)
COMMENTS: See P.G. II-31 and P.G. II-36.

Vincent Van Gogh

Olive Grove, Saint-Rémy, 1889
Oil on canvas, 74 x 93 cm
Göteborgs Konstmuseum, Göteborg

F 586; JH 1854

F 586; JH 1854

PROVENANCE: Earliest whereabouts
unknown: possibly Gachet collection until
at least 1904; with Bernheim-Jeune, Paris,
from Sept. 29, 1916, until Nov. 25, 1917; sold
to the Göteborgs Konstmuseum, 1917
REFERENCES: Meier-Graefe 1904, p. 120
n. 1 (possibly the work described as "from
the Arles period . . . a large, relatively dark
painting, *Les Oliviers*," in Gachet's collec-
tion; see also P.G. III-7 [F 659]); Faille 1928,
no. 586 (as Arles; provenance begins with
Bernheim-Jeune, Paris); Faille 1939, no. 651
(as Saint-Rémy, Sept.–Oct. 1889); Faille
1970, no. 586 (as Saint-Rémy, Sept.–Dec.
1889); Hulsker 1980 and 1996, no. 1854 (as
Saint-Rémy, second half of Nov. 1889); Dorn
in Essen, Amsterdam 1990, pp. 158–60, no. 47
Letters: LT 615, W 16
COMMENTS: Roland Dorn (1990, p. 160)
identifies this painting as *Les Oliviers*, seen
by Meier-Graefe at Dr. Gachet's house, and
states that "presumably Theo van Gogh had
given it to him." Though it is arguably the
only plausible candidate among Van Gogh's
pictures of the subject, there is no other
documentation for Gachet's ownership of
the painting. (According to Bernheim-Jeune
records, it was not acquired from Paul
Gachet *fils*, although he had sold other
paintings to the gallery in 1912 [see P.G. II-2
(R 184), P.G. II-16 (R 203), P.G. III-13
(F 820)]; there are no labels, inscriptions, or
other distinguishing marks on the reverse of
the canvas to clarify its provenance.) It is
entirely conceivable that Meier-Graefe was
referring to F 659, which fits the general
description of a large dark picture of trees.
See P.G. III-7 [F 659]).

Formerly attributed to Vincent van Gogh

Mademoiselle Gachet in the Garden
Black chalk heightened with white chalk,
31 x 34 cm
Private collection

PROVENANCE: Dr. Paul Gachet, Auvers
[?–1909]; Paul Gachet *fils*, until his death in
1962; acquired from his estate, March 1963,
by present owner
REFERENCES: Mothe 1987, p. 49, repr.
(attributes this previously unpublished
drawing to Van Gogh and describes it as a
study for P.G. III-15 [F 756]; provides prove-
nance); Mothe in Gachet 1994, p. 172 n. 45
(reconsiders attribution, as the drawing was
not recorded by Gachet *fils*)
COMMENTS: See Checklist of Copies.

Illustrated Checklist of Copies
after Works by Cézanne, Van Gogh, and Other Nineteenth-Century Artists in the Gachet Collection

SUSAN ALYSON STEIN

HISTORY AND PROVENANCE OF THE COPIES

Dr. Gachet intended to devote a publication to Vincent van Gogh, but it was never realized. In mid-August 1890 he informed Vincent's brother Theo that he had already "started writing down" some of his thoughts with the idea in mind "to make, not a catalogue, but a complete biography—for a man who was so *exceptional*."[1] In 1904 Julius Meier-Graefe's pioneering study on the development of modern art included at the end of its chapter on Van Gogh this footnote: "Dr. Gachet is presently preparing a monograph on Van Gogh, which will be accompanied by etchings that reproduce the work of the master. In addition to his son, he has a group of young and eager people who first assiduously copied each work in color line by line, then etched it on the copperplate. From what has been presently accomplished, we can only hope that the rest will be the same. Cézanne's will be handled in the same manner."[2] After Dr. Gachet's death in 1909, Johanna van Gogh-Bonger contributed a brief obituary to the *Nieuwe Rotterdamsche Courant* in which she remarked that "the book on Vincent that he was in the process of writing, and that was to have been illustrated with watercolors after his paintings, has not been finished."[3]

No manuscript pages nor even scribbled notes in Dr. Gachet's hand have come to light. But, fortunately, many of the illustrations do survive: copies made in large part by Blanche Derousse (1875–1911), a neighbor's daughter to whom Gachet gave art lessons. Copies after works by Cézanne and other artists were made by Derousse, by the Gachets—father and son—and by another "student" known as E. Bigny. The last, whose full name was Théophile Éléonore Bigny (1866–1952), lived in Auvers until his death; late in life he was described as the "oldest friend" of Gachet *fils*.[4] An employee of the Chemin de Fer du Nord, Bigny was the son-in-law of the Gachets' housekeeper, Louise-Anne-Virginie Chevalier (1847–1904). Since Chevalier was the maiden name of Blanche Derousse's mother, Blanche may have been Mme Chevalier's niece.

The copies were neither surreptitiously made nor covertly kept. Those now in the Musée d'Orsay were donated and sold to the French state by Paul Gachet *fils* in 1958 and 1960. The copies now in the Van Gogh Museum were purchased in 1966 from the Galerie Curt Valentien, Stuttgart, along with other prints and drawings from the estate of Gachet *fils*.

An asterisk (*) preceding an entry indicates that the work is shown in the New York and Amsterdam venues of the exhibition.

1. Letter, Dr. Paul Gachet to Theo van Gogh (Archives, Van Gogh Museum, Amsterdam, b3266 V/1966); see Excerpts from the Correspondence, ca. Aug. 15, 1890.
2. Meier-Graefe 1904, p. 129 n. 1.
3. Jan. 14, 1909 (Archives, Van Gogh Museum, Amsterdam).
4. See "À travers sa grille, j'ai arraché a Paul Gachet le vieillard sans fortune qui vient de léguer au Louvre pour cent millions de tableaux des souvenirs qu'il ne publiera jamais," *Samedi-soir*, no. 341 (Jan. 12–18, 1952), p. 2: "Every week, [Paul Gachet *fils*] dines at the home of his oldest friend, the only one in Auvers, M. Bigny. He is an octogenarian, still spry, but whose memory sometimes fails." This article includes an interview with Bigny. The biographical details were kindly provided by Anne Distel.

Copies after Paul Cézanne

In order by the Gachet collection (P.G.) numbers of the originals

After Cézanne, *View of Louveciennes* (P.G. II-2; R 184; private collection), fig. 81

Louis van Ryssel (Paul Gachet *fils*). Watercolor, 50.5 x 64.5 cm
Signed and dated lower left: L. Van Ryssel / Janv. 1900. Annotated on reverse, in pencil: (91 x 72) Nach dem Gemalde von P. Cézanne / Auvers 10 Januar 1900 / L. Van Ryssel
Musée du Louvre, Paris, Département des Arts Graphiques, Fonds du Musée d'Orsay, RF 31 253

After Cézanne, *Panoramic View of Auvers-sur-Oise* (P.G. II-4; R 221; The Art Institute of Chicago), fig. 82

Louis van Ryssel (Paul Gachet *fils*). Watercolor, 50.5 x 63 cm
Signed and dated lower left: L. Van Ryssel / Fev. 1900. Annotated on reverse, in pencil: Nach dem Gemalde von P. Cézanne / 65 x 81 / L Van Ryssel / Auvers Janvier 1900 / Panorama d'Auvers s/Oise / Peint par P. Cézanne en 1874
Musée du Louvre, Paris, Département des Arts Graphiques, Fonds du Musée d'Orsay, RF 31 252

After Cézanne, *Three Apples* (P.G. II-8; R 355; private collection)

Louis van Ryssel (Paul Gachet *fils*). Watercolor, 24 x 33.5 cm
Signed and dated lower right, in blue-green: L. Van Ryssel / Fev 1900. Annotated on reverse, in pencil: P [. . .] Cézanne
Musée du Louvre, Paris, Département des Arts Graphiques, Fonds du Musée d'Orsay, RF 31 258

After Cézanne, *Flowers and Fruits* (P.G. II-9; R 212; private collection, Switzerland)

Paul van Ryssel (Dr. Paul Gachet). Oil on canvas, 38 x 46 cm
Musée d'Orsay, Paris, RF 1958-19
Cat. no. 45
REFERENCES: Lacambre et al. 1990, p. 469 (as a copy after an unidentified painting; repr.); Rewald 1996, p. 157, repr.
NOTE: This copy is identical in size to Cézanne's painting. A work by P. van Ryssel entitled *Les pivoines* (possibly this copy) was exhibited in Paris 1906, as no. 4113.

E. Bigny. Watercolor, ca. 34 x 45.5 cm
Annotated on reverse, in pencil, in the hand

of Paul Gachet *fils*(?): Nach dem Gemalde von P. Cézanne /38 x 46 / E. Bigny / Januar 1900
Musée du Louvre, Paris, Département des Arts Graphiques, Fonds du Musée d'Orsay, RF 31 262

After Cézanne, *Bouquet with Yellow Dahlia* (P.G. II-11; R 214; Musée d'Orsay, Paris, RF 1954-5), cat. no. 5

*Louis van Ryssel (Paul Gachet *fils*). Watercolor, 33.5 x 40.5 cm
Signed and dated lower right, in blue: L. Van Ryssel / Fev. 1900. Annotated on reverse, in pencil, in the hand of Paul Gachet *fils* (?): Nach dem Gemalde von P. Cézanne 53½ x 64 L. Van Ryssel / Fev 1900
Musée du Louvre, Paris, Département des Arts Graphiques, Fonds du Musée d'Orsay, RF 31 257
Cat. no. 5a

After Cézanne, *Still Life with Italian Faience* (P.G. II-13; R 205; private collection)

E. Bigny, Watercolor, 27.2 x 37.4 cm
Annotated on reverse, in pencil, in the hand of Paul Gachet *fils*(?): Nach dem Gemalde von P. Cézanne / 53½ x 40½ / E. Bigny
Musée du Louvre, Paris, Département des Arts Graphiques, Fonds du Musée d'Orsay, RF 31 263

After Cézanne, *Dahlias* (**P.G. II-14**; R 223; Musée d'Orsay, Paris, RF 1971), cat. no. 9

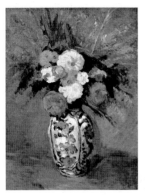

*Louis van Ryssel (Paul Gachet *fils*). Oil on canvas, 73 x 54 cm
Signed and dated lower right, in red: L. Van Ryssel 06; inscribed lower left with a copy of the signature: P. Cézanne
Musée d'Orsay, Paris, RF 1958-20
Cat. no. 9a
REFERENCES: Lacambre et al. 1990, p. 468, repr.; Rewald 1996, p. 163, repr.
NOTE: This copy is identical in size to Cézanne's painting.

Louis van Ryssel (Paul Gachet *fils*). Watercolor, 44 x 32.7 cm

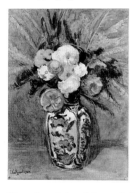

Signed and dated lower left, in blue: L. Van Ryssel 1900. Annotated on reverse: 53½ x 72 [dimensions of Cézanne's painting]
Musée du Louvre, Paris, Département des Arts Graphiques, Fonds du Musée d'Orsay, RF 31 254

After Cézanne, *Bouquet in a Small Delft Vase* (**P.G. II-15**; R 227; Musée d'Orsay, Paris, RF 1951-33), cat. no. 8

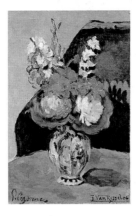

*Louis van Ryssel (Paul Gachet *fils*). Oil on canvas, 41 x 27 cm
Signed and dated lower right: L. Van Ryssel 06; inscribed lower left with a copy of the signature: P. Cézanne
Musée d'Orsay, Paris, RF 1958-21
Cat. no. 8a
REFERENCES: Lacambre et al. 1990, p. 468, repr.; Rewald 1996, p. 166, repr.
NOTE: This copy is identical in size to Cézanne's painting.

Louis van Ryssel (Paul Gachet *fils*). Watercolor, 38.5 x 25.4 cm

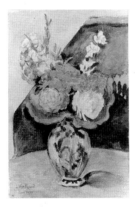

Signed and dated lower left, in red: L. Van Ryssel / Janv. 1900. Annotated on reverse, in pencil, in the hand of Paul Gachet *fils*(?):
Nach Dem Gemalde von P. Cézanne / 40½ x 27 / L. Van Ryssel Pontoise 1901
Musée du Louvre, Paris, Département des Arts Graphiques, Fonds du Musée d'Orsay, RF 31 255
Cat. no. 8b

After Cézanne, *Pitcher, Glass, Fruit, and Knife* (**P.G. II-16**; R 203; Fondation Angladon-Dubrujeaud, Avignon), fig. 79

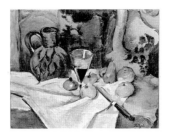

*Louis van Ryssel (Paul Gachet *fils*). Watercolor, 33.6 x 43 cm
Signed and dated lower right: L. Van Ryssel Jan. 1900. Annotated on reverse, in pencil, in the hand of Paul Gachet *fils* (?): d'après le tableau de P. Cézanne / 59 x 72 / L. Van Ryssel / Janv. 1900
Musée du Louvre, Paris, Département des Arts Graphiques, Fonds du Musée d'Orsay, RF 31 256

After Cézanne, *Green Apples* (**P.G. II-17**; R 213; Musée d'Orsay, Paris, RF 1954-6), cat. no. 6

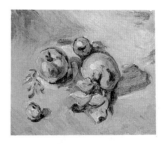

*Louis van Ryssel (Paul Gachet *fils*). Oil on canvas, 26 x 52 cm
Musée d'Orsay, Paris, RF 1958-22
Cat. no. 6a
REFERENCES: Lacambre et al. 1990, pp. 468–69, repr.; Rewald 1996, p. 157, repr.
NOTE: This copy is identical in size to Cézanne's painting.

*Blanche Derousse. Watercolor over a faint graphite sketch on white paper, 23.3 x 32 cm

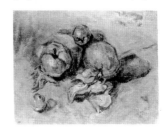

Signed and dated lower right, in blue: BD. / 7bre 1900. Annotated on reverse in calligraphic script, probably by Paul Gachet *fils*: Aquarelle de Blanche Derousse d'après Cézanne grandeur de l'original
Musée du Louvre, Paris, Département des Arts Graphiques, Fonds du Musée d'Orsay, RF 31 238
Cat. no. 6b

After Cézanne, *Still Life with Game Birds* (**P.G. II-20**; R 206; Fogg Art Museum, Harvard University Art Museums, Cambridge, Massachusetts)

*E. Bigny. Watercolor, ca. 26 x 39.4 cm
Annotated on reverse, in pencil, in the hand of Paul Gachet *fils*(?): Nach dem Gemalde von / P. Cézanne / 25½ x 39½ / E. Bigny / Fev 1900
Musée du Louvre, Paris, Département des Arts Graphiques, Fonds du Musée d'Orsay, RF 31 264

After Cézanne, *Bathers* (**P.G. II-22**; R 159; private collection)

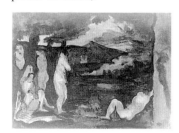

Blanche Derousse. Watercolor over a faint graphite sketch, 13.5 x 19 cm
Musée du Louvre, Paris, Département des Arts Graphiques, Fonds du Musée d'Orsay, RF 31 239

After Cézanne, *Reclining Man with Bathers* (**P.G. II-23**; R 160; private collection)

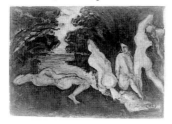

Blanche Derousse. Watercolor on vellum, 6.3 x 9.2 cm
Musée du Louvre, Paris, Département des Arts Graphiques, Fonds du Musée d'Orsay, RF 31 240

Blanche Derousse. Drypoint and etching, 18 x 13.5 cm

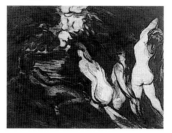

Signed lower right, in pencil: B. Derousse; annotated: No. 147. Annotated on reverse: Les baigneurs d'après Cézanne / Le collection du Dr. Gachet
Van Gogh Museum (Vincent van Gogh Foundation), Amsterdam, P170 V/1966

Other known impressions:
Van Gogh Museum (Vincent van Gogh Foundation), Amsterdam, P168, P169, P270 V/1966
NOTE: According to Gachet *fils* (Unpub. Cat., II, no. 23), the etched copy was made on July 9, 1899.

After Cézanne, *Three Bathers* (**P.G. II-24**; R 358; Elliot K. Wolk, Scarsdale, New York)

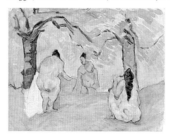

Anonymous. Watercolor on paper, 25 x 32 cm
Van Gogh Museum (Vincent van Gogh Foundation), Amsterdam, D570 V/1966

After Cézanne, *A Modern Olympia* (**P.G. II-25**; R 225; Musée d'Orsay, Paris, RF 1951-31), cat. no. 1

*Paul van Ryssel (Dr. Paul Gachet). Oil on canvas, 45.5 x 55 cm
Musée d'Orsay, Paris, RF 1958-17
Cat. no. 1b
REFERENCE: Lacambre et al. 1990, pp. 468–69, repr.
NOTE: This copy is almost identical in size to Cézanne's painting.

*Paul van Ryssel (Dr. Paul Gachet). Ink and wash on paper, 20 x 26 cm

Inscribed lower left, in ink: L'Olympia de Cézanne. Annotated on reverse, in pencil, in the hand of Paul Gachet *fils*: Dessin de P. van Ryssel (Dr. Gachet)
Van Gogh Museum (Vincent van Gogh Foundation), Amsterdam, D599 V/1966
Cat. no. 1a
REFERENCE: Van Uitert and Hoyle 1987, p. 491, no. 2.763, repr.

*Blanche Derousse. Watercolor over a faint graphite sketch, 26.5 x 36 cm (image: 23.5 x 27 cm)
Signed lower right, in blue: B.D. Annotated

in the margins at left, in pen: H= 23 + 6 =/29; L=27 + 6 = / 33; at lower left, in pencil: h 23 / 27; at lower right: 21 mars 01. Annotated on reverse, in blue pencil, in the hand of Blanche Derousse(?): L'Olympia d'après le tableau de P. Cézanne /21 mars 1901
Musée du Louvre, Paris, Département des Arts Graphiques, Fonds du Musée d'Orsay, RF 31 237
Cat. no. 1c

*Blanche Derousse. Drypoint, 23 x 27.6 cm (image)

Inscribed lower right, in pencil: No. 130
Van Gogh Museum (Vincent van Gogh Foundation), Amsterdam, P210 V/1966
Cat. no. 1d

Other known impressions:
Van Gogh Museum (Vincent van Gogh Foundation), Amsterdam, P209 V/1966. Signed lower right, in blue: Blanche Derousse.
EXHIBITION: An impression of this print was exhibited in Paris 1907, no. 1514, as *La Nouvelle Olympia,* pointe sèche, d'après le tableau de P. Cézanne (Collection du Dr Gachet)."

After Cézanne, *L'Estaque* (**P.G. II-31**; Chappuis 124a; location unknown)

Paul van Ryssel (Dr. Paul Gachet). Etching, 21 x 27 cm (composition reversed)
Signed upper left with duck emblem; signed and dated lower right, in the plate: PVR/1873

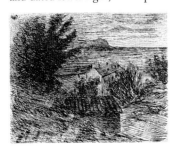

Bibliothèque Nationale de France, Paris, Département des Estampes et de la Photographie, DO 8775; PG 4 1873
Cat. no. 46a
REFERENCES: Gachet 1954a, no. 4, repr. facing p. 9; Adhémar and Lethève 1954, p. 295, no. 4; Chappuis 1973, no. 124a, repr.

COPIES AFTER VINCENT VAN GOGH

In order by the Gachet collection (P.G.) numbers of the originals

After Van Gogh, *Pink Roses* (**P.G. III-4**; F 595; Ny Carlsberg Glyptotek, Copenhagen)

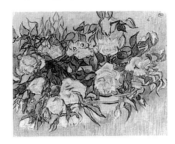

*Blanche Derousse. Watercolor over a faint graphite sketch, 12.5 x 16 cm (image: 12.3 x 15.7 cm)
Verso, in graphite: small study of a woman's head and detail of an eye
Musée du Louvre, Paris, Département des Arts Graphiques, Fonds du Musée d'Orsay, RF 31 234

After Van Gogh, *Self-Portrait* (**P.G. III-5**; F 627; Musée d'Orsay, Paris), cat. no. 12

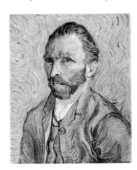

*Blanche Derousse. Watercolor over a faint graphite sketch, 60 x 49 cm (image: 58 x 48 cm)
Signed and dated lower right, in blue: B.D. Juillet 02

Musée du Louvre, Paris, Département des Arts Graphiques, Fonds du Musée d'Orsay, RF 31 222
Cat. no. 12a
EXHIBITION: Possibly Paris 1903, no. 691, "V. Van Gogh (aquarelle)"

Other documented copies:
Blanche Derousse. Drypoint. Sent as a gift, on the artist's behalf, by Paul Gachet *fils* to Johanna van Gogh-Bonger in June 1905, at the time of the Van Gogh retrospective in Amsterdam, so that it could be exhibited as a "document of Vincent's work"; described as "*Portrait de Vincent van Gogh* (pointe sèche)." Location unknown.
REFERENCE: Letter, Paul Gachet *fils* to Johanna van Gogh-Bonger, [June 6], 1905 (b3374 V/1984, VGM Archives)
EXHIBITION: Presumably an impression of this print was exhibited in Paris 1905, no. 1211, as "*Vincent van Gogh* (eau forte, d'après son tableau)."

After Van Gogh, *The Garden of the Asylum in Saint-Rémy* (**P.G. III-7**; F 659; Van Gogh Museum, Amsterdam), fig. 89

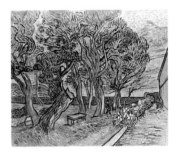

*Blanche Derousse. Watercolor over a faint graphite sketch on white paper (pinkish salmon verso), 17.3 x 20.7 cm (image: 17 x 20.5 cm)
Annotated on reverse, in pencil: 4351
Musée du Louvre, Paris, Département des Arts Graphiques, Fonds du Musée d'Orsay, RF 31 228

After Van Gogh, *Huts in the Sunshine: Reminiscence of the North* (**P.G. III-8**; F 674; The Barnes Foundation, Merion, Pennsylvania)

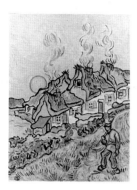

*Blanche Derousse. Watercolor over a faint graphite sketch on white paper (pinkish salmon verso), 15.8 x 12 cm (image: 15.5 x 11.9 cm)
Annotated on reverse, in pencil: 3747
Musée du Louvre, Paris, Département des Arts Graphiques, Fonds du Musée d'Orsay, RF 31 233

Blanche Derousse. Drypoint and etching on paper, 15.5 x 12 cm

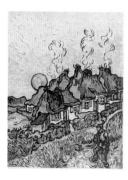

Annotated on reverse, in pencil: 5 janvier 1903. Gachet collection stamp, bottom center
Van Gogh Museum (Vincent van Gogh Foundation), Amsterdam, P162 V/1966

Other known impressions:
Van Gogh Museum (Vincent van Gogh Foundation), Amsterdam, P161 V/1966

After Van Gogh, *Landscape with House and Mountains, Saint-Rémy* (**P.G. III-9**; F 726; location unknown)

Blanche Derousse. Graphite on paper, 15 x 20 cm
Van Gogh Museum (Vincent van Gogh Foundation), Amsterdam, D508 V/1966
REFERENCE: Van Uitert and Hoyle 1987, p. 379, no. 2.80, repr.

After Van Gogh, *Road at Saint-Rémy, with a Figure* (**P.G. III-11**; F 728; Kasama Nichido Museum of Art, Ibaraki, Japan)

*Blanche Derousse. Watercolor over a faint graphite sketch on white paper, 11.5 x 14 cm (image: 11.1 x 13.7 cm)
Musée du Louvre, Paris, Département des Arts Graphiques, Fonds du Musée d'Orsay, RF 31 235

After Van Gogh, *Blossoming Chestnut Branches* (**P.G. III-13**; F 820; Foundation E.G. Bührle Collection, Zurich), fig. 83

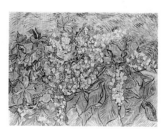

*Blanche Derousse. Watercolor over a faint graphite sketch on white paper (salmon-colored verso), 19.6 x 26.1 cm (image: 19.3 x 26 cm)
Annotated on reverse: 4351
Musée du Louvre, Paris, Département des Arts Graphiques, Fonds du Musée d'Orsay, RF 31 229

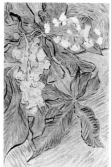

Blanche Derousse. Copy of a detail of the original. Watercolor on paper, 50 x 32.5 cm
Annotated on reverse, in pencil, by Gachet *fils*: B. Derousse/ Aquarelle/ Vincent van Gogh/ Partie de la toile: Marronniers en Fleurs (grandeur nature de l'original)
Van Gogh Museum (Vincent van Gogh Foundation), Amsterdam, D578 V/1966
REFERENCE: Van Uitert and Hoyle 1987, p. 379, no. 2.83, repr.

After Van Gogh, *Dr. Gachet's Garden* (**P.G. III-14**; F 755; Musée d'Orsay, Paris), cat. no. 14

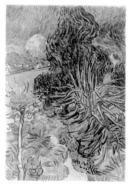

Blanche Derousse. Watercolor over a faint graphite sketch on white paper, 17 x 12 cm
Musée du Louvre, Paris, Département des Arts Graphiques, Fonds du Musée d'Orsay, RF 31 226
Cat. no. 14a

After Van Gogh, *Mademoiselle Gachet in the Garden* (**P.G. III-15**; F 756; Musée d'Orsay, Paris), cat. no. 15

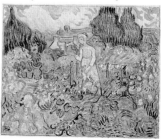

*Blanche Derousse. Watercolor over a faint graphite sketch on white paper (salmon-color verso), 11.5 x 14.1 cm (image: 11.2 x 13.9 cm)
Musée du Louvre, Paris, Département des Arts Graphiques, Fonds du Musée d'Orsay, RF 31 225
Cat. no. 15a

Anonymous. Black chalk heightened with white chalk on paper, 31 x 34 cm

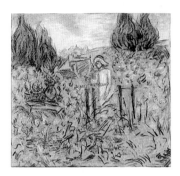

Private collection, France (acquired from the estate of Paul Gachet *fils*, March 1963)
REFERENCES: Mothe 1987, p. 49 (as a preparatory study by Van Gogh; repr.); Mothe in Gachet 1994, p. 172 n. 45 (reconsiders attribution to Van Gogh, since the drawing is not recorded in Gachet *fils*'s account of the collection)

After Van Gogh, *Portrait of Doctor Paul Gachet* (**P.G. III-16**; F 754; Musée d'Orsay, Paris), cat. no. 13

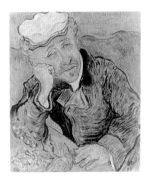

*Blanche Derousse. Watercolor over a faint graphite sketch, 15.9 x 13.4 cm (image: 15.6 x 13 cm)
Signed and dated lower right: B.D. /01
Musée du Louvre, Paris, Département des Arts Graphiques, Fonds du Musée d'Orsay, RF 31 223
Cat. no. 13b

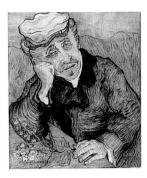

Blanche Derousse. Drypoint, 15.5 x 13.5 cm
Signed and dated lower right: B.D./ 01
Annotated on reverse: Blanche Derousse / Pointe sèche. Portrait de Dr. Gachet par Vt Van Gogh. Gachet collection stamp at bottom center
Van Gogh Museum (Vincent van Gogh Foundation), Amsterdam, P203 V/1966

Other known impressions:
Van Gogh Museum (Vincent van Gogh Foundation), Amsterdam, P204 V/1966
EXHIBITION: An impression of this print may have been exhibited in Paris 1903, no. 694, as "*Portrait du docteur G... (eau-forte).*"

Other documented copies:
According to Paul Gachet *fils* (Gachet 1994, p. 96), "There exists in Japan—in Tokyo or Kyoto—a very good copy made with my authorization by my friend Katuso Satomi, in Auvers, in 1921."

After Van Gogh, *Cows* (**P.G. III-17**; F 822; Musée des Beaux-Arts, Lille), cat. no. 20

*Blanche Derousse. Watercolor over a faint graphite sketch on cream paper, 13.4 x 15.5 cm (image: 13 x 15 cm)
Musée du Louvre, Paris, Département des Arts Graphiques, Fonds du Musée d'Orsay, RF 31 232
Cat. no. 20b

After Van Gogh, *Wildflowers and Thistles* (**P.G. III-18**; F 763; location unknown), fig. 86

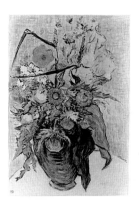

*Blanche Derousse. Watercolor over a faint graphite sketch, 26.5 x 18.4 cm (image: 26 x 18 cm)
Annotated on reverse, in black pencil: 47 x 67
Musée du Louvre, Paris, Département des Arts Graphiques, Fonds du Musée d'Orsay, RF 31 250

After Van Gogh, *Mademoiselle Gachet at the Piano* (**P.G. III-20**; F 772; Kunstmuseum Basel), fig. 87

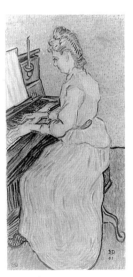

*Blanche Derousse. Watercolor over a faint graphite sketch on cream paper, 21.8 x 10.8 cm (image: 21.5 x 10.4 cm)
Signed and dated lower right: B.D. / 01
Musée du Louvre, Paris, Département des Arts Graphiques, Fonds du Musée d'Orsay, RF 31 224

EXHIBITION: Possibly shown in Paris 1903, no. 690, as *Mlle G…* (aquarelle), appartient au docteur G…"

Blanche Derousse. Drypoint, etching, and aquatint, 21 x 10 cm (image)

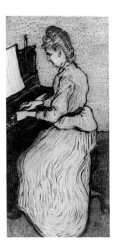

Annotated on reverse, in pencil: 4ᵉ état. 28 mai 901. Tirage Leroy
Van Gogh Museum (Vincent van Gogh Foundation), Amsterdam, P167 V/1966

Other known impressions:
Van Gogh Museum (Vincent van Gogh Foundation), Amsterdam, P178 V/1966
Signed lower right: BD. Annotated on reverse, in pencil: 2eme Etat. 28 mai 901 Tira. Leroy.

After Van Gogh, *Les Vessenots, Auvers* (**P.G. III-22**; F 797; Museo Thyssen-Bornemisza, Madrid)

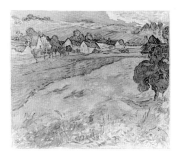

*Blanche Derousse. Watercolor over a faint graphite sketch on white paper, 14.2 x 16.8 cm (image: 14.2 x 16.8 cm)
Musée du Louvre, Paris, Département des Arts Graphiques, Fonds du Musée d'Orsay, RF 31 230

After Van Gogh, *Two Children* (**P.G. III-23**; F 783; Musée d'Orsay, Paris), cat. no. 18

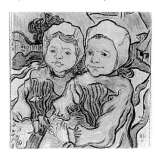

*Blanche Derousse. Watercolor over a faint graphite sketch on white paper, 11.8 x 16 cm (image: 11.8 x 12.5 cm)
Signed and dated lower right: B.D./01; in the margin, in pencil: B.D. 01
Musée du Louvre, Paris, Département des Arts Graphiques, Fonds du Musée d'Orsay, RF 31 231
Cat. no. 18a

*Blanche Derousse. Watercolor and drypoint on paper, 12 x 13 cm

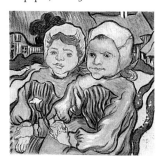

Signed and dated lower right: BD / [o]1
Van Gogh Museum (Vincent van Gogh Foundation), Amsterdam, D461 V/1966
REFERENCE: Van Uitert and Hoyle 1987, p. 379, no. 2.81, repr.

*Blanche Derousse. Drypoint, 12 x 13 cm
Signed and dated lower right: B.D. /01
Gachet collection stamp, at bottom, left of center, in red. Annotated on reverse: Blanche Derousse / Pointe sèche d'après "Les deux Filettes" par Vincent van Gogh.

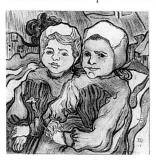

Van Gogh Museum (Vincent van Gogh Foundation), Amsterdam, P205 V/1966

Other known impressions:
Van Gogh Museum (Vincent van Gogh Foundation), Amsterdam, P173, P206, P207, P208 V/1966
Private collection (cat. no. 18b)

After Van Gogh, *Cottages at Jorgus* (**P.G. III-24**; F 758; private collection)

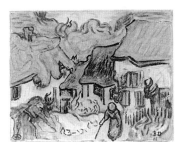

*Blanche Derousse. Watercolor, 13 x 16 cm (image: 8.6 x 11 cm)
Signed and dated lower right: B.D. /01
Musée du Louvre, Paris, Département des Arts Graphiques, Fonds du Musée d'Orsay, RF 31 236

Blanche Derousse. Drypoint and etching, 20.7 x 31.4 cm (image: 8.5 x 10.5 cm)

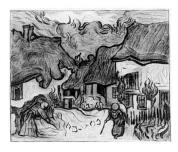

Signed lower right: B D; annotated lower right, in pencil: no. 144. Annotated on reverse, in blue chalk: Tirage Leroy
Van Gogh Museum (Vincent van Gogh Foundation), Amsterdam, P172 V/1966

Other known impressions:
Van Gogh Museum (Vincent van Gogh Foundation), Amsterdam, P171 V/1966

After Van Gogh, *The Church at Auvers*
(**P.G. III-25**; F 789; Musée d'Orsay, Paris),
cat. no. 17

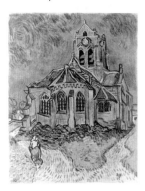

*Blanche Derousse. Watercolor over a faint
graphite sketch on white paper, 28.3 x 22 cm
(image: 20.4 x 16 cm)
Signed and dated lower right: B.D. / 01
Musée du Louvre, Paris, Département des
Arts Graphiques, Fonds du Musée d'Orsay,
RF 31 227
Cat. no. 17a

Blanche Derousse. Watercolor and drypoint
on paper, 20.4 x 16 cm

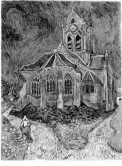

Signed and dated lower right: BD / 01
Van Gogh Museum (Vincent van Gogh
Foundation), Amsterdam, D460 V/1966
REFERENCE: Van Uitert and Hoyle 1987,
p. 379, no. 2.82, repr.

Blanche Derousse. Drypoint, 20.5 x 16 cm
Signed and dated lower right: B.D. / 01.;

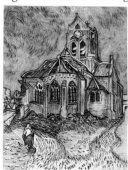

annotated lower right, in pencil: no. 162.
Annotated on reverse, in pencil: 4e état. 28
n. le 901. Tirage Leroy
Van Gogh Museum (Vincent van Gogh
Foundation), Amsterdam, P211 V/1966

After Van Gogh, *Workers in the Fields* (recto)
(**P.G. III-30**; F 1620r; Thaw Collection,
The Pierpont Morgan Library, New York)

*Blanche Derousse. Detail of figure and
cottage (reversed). Watercolor and drypoint
on paper, 10 x 9 cm (image)
Annotated on reverse, in pencil: Tir. Leroy
Van Gogh Museum (Vincent van Gogh
Foundation), Amsterdam, D462 V/1966
REFERENCE: Van Uitert and Hoyle 1987,
p. 380, no. 2.84, repr.

Blanche Derousse. Detail of figure and
cottage (reversed). Drypoint, 10 x 9 cm
Annotated lower right: No 137

Van Gogh Museum (Vincent van Gogh
Foundation), Amsterdam, P213 V/1966

Other known impressions:
Van Gogh Museum (Vincent van Gogh
Foundation), Amsterdam:
P166 V/1966. Annotated on reverse: Tirage
Leroy
P212 V/1966. Annotated lower right: No 135;
on reverse: Blanche Derousse / Pointe Sèche
d'après un Dessin (partie) de Van Gogh /
Tirage Leroy
Private collection:
Annotated on reverse, in pencil: Tir. Leroy

After Van Gogh, *Workers in the Fields* (verso)
(**P.G. III-30**; F 1620v; Thaw Collection,
The Pierpont Morgan Library, New York)

*Blanche Derousse. Detail of seated child
(from verso). Drypoint, 13 x 11 cm
Van Gogh Museum (Vincent van Gogh
Foundation), Amsterdam, P163 V/1966

After Van Gogh, *In the Orchard*
(**P.G. III-b**; F 1659; Bibliothèque Nationale
de France, Paris), cat. no. 23c

*Paul Gachet *fils*. Letter sketch sent to
Johanna van Gogh-Bonger, Dec. 22, 1920
Van Gogh Museum (Vincent van Gogh
Foundation), Amsterdam, b3401 V/1984
REFERENCE: Van Heugten and Pabst 1995,
p. 66, fig. 7b

After Van Gogh, *Portrait of Trabuc* (F 629;
Kunstmuseum Solothurn). Not owned by
Gachet

Paul van Ryssel (Dr. Paul Gachet). Pen and
ink on tracing paper, 11.5 x 10 cm
Annotated lower right: Mr. van der
Kerkhoven
Van Gogh Museum (Vincent van Gogh
Foundation), Amsterdam, D806 V/1982
REFERENCE: Van Uitert and Hoyle 1987,
p. 492, no. 2.768, repr.
NOTE: Undoubtedly this drawing prompted
Paul Gachet *fils* to ask Johanna van Gogh-

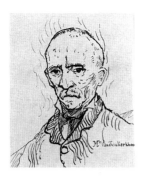

Bonger in late May 1908: "Do you know of a portrait of Mr. Van der Kerkhoven made by Vincent? Is this portrait the same as the one entitled *Gardien de Fous* (exhibited last January at Druet's in Paris)? Do you know Mr. W. de Heymel, to whom this picture belonged? Whether this is the same work, or if this Mr. Van der Kerkhoven was an [asylum] guard? Was this simply a friend of Vincent's? When did Vincent paint this portrait?" (Letter b3390 V/1984, VGM Archives). In her reply of June 2, 1908 (b2145 V/1982, VGM Archives), Johanna quoted from the two Saint-Rémy letters in which Vincent mentioned the picture (LT 604, 605) and added: "I've never heard the name of v.d. Kerkhoven—we have always called this portrait 'the attendant.' I sold this painting in 1907 to Mr. Bernheim—I don't know the name Mr. Heymel." (The portrait was lent to the exhibition "Vincent van Gogh" [Paris 1908b], no. 15, *Gardien de fous*, from the collection of M. W. de Heymel.)

After Van Gogh, *The Raising of Lazarus*
(F 677; Van Gogh Museum, Amsterdam).
Not owned by Gachet

Louis van Ryssel (Paul Gachet *fils*). Etching and drypoint, 27.1 x 33.5 cm (image: 15 x 19 cm)
Van Gogh Museum (Vincent van Gogh Foundation), Amsterdam, P145 V/1966

Other known impressions:
Van Gogh Museum (Vincent van Gogh Foundation), Amsterdam, P461 V/1966

Paul van Ryssel (Dr. Paul Gachet). Graphite and watercolor on paper, 11.5 x 15 cm
Van Gogh Museum (Vincent van Gogh Foundation), Amsterdam, D545 V/1966
REFERENCE: Van Uitert and Hoyle 1987, p. 366, no. 2.1 (as anonymous; repr.)

Paul van Ryssel (Dr. Paul Gachet). Graphite, pen and brown ink on paper, 11.5 x 15 cm
Van Gogh Museum (Vincent van Gogh Foundation), Amsterdam, D546 V/1966
REFERENCE: Van Uitert and Hoyle 1987, p. 366, no. 2.2 (as anonymous; repr.)

NOTE: Originally the ink drawing and the watercolor above seem to have been part of a portfolio assembled by Paul Gachet *fils* in 1923, which he called: "*Vincent van Gogh—Documents originaux—Autographs—Illustrations. Gravures—Notes—Aquarelles-&. . . réunis par L. van Ryssel (Gachet fils).*" The items it contained were dispersed at the time of the Gachet *fils* estate sale in 1963 but the paper jacket and table of contents are preserved (Michael Packenham collection). In the contents, under the heading "Dessin de P. van Ryssel (Dr. Gachet), works are described that correspond to those now in the Van Gogh Museum: "Resurrection de Lazare. (Réminiscence des Indépendants (1891). (un dessin à encre et une aquarelle)." This document allows us to assign authorship to two previously unattributed works.

The painting by Van Gogh, exhibited with the Indépendants in 1891, was the first work by the artist ever reproduced; an engraving of it appeared in Tardieu 1891. Also reproduced were two original works by Dr. Gachet: a deathbed drawing (see cat. no. 41) and a snow scene.

COPIES AFTER OTHER ARTISTS

In order alphabetically by artists of the originals, then by Gachet collection (P.G.) numbers of the originals

After Norbert Goeneutte, *Portrait of Dr. Gachet* (Musée d'Orsay, Paris, RF 757), fig. 28

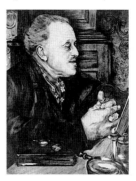

Blanche Derousse. Drypoint on Japanese paper, 26 x 20 cm
Signed lower right: B. Derousse.
Van Gogh Museum (Vincent van Gogh Foundation), Amsterdam, P201 V/1966

Other known impressions:
Van Gogh Museum (Vincent van Gogh Foundation), Amsterdam, P202 V/1966
Inscribed: Souvenir affectueuse à Clémentine. BD.
EXHIBITION: An impression of this print was exhibited in Paris 1906, no. 1444, as "*Portrait de Dr. G...* pointe sèche (état définitif), d'après Norbert Goeneutte (Musée du Luxembourg)."

After Goeneutte, *The Smoker (Portrait of Dr. Gachet)* (location unknown; repr. in Gachet 1956a, fig. 1)

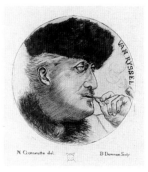

*Blanche Derousse. Drypoint and etching, 15 x 11 cm (image)
Inscribed in the plate: N. Goeneutte del. B. Derousse sculpt. Gachet collection stamp lower center, in red

Van Gogh Museum (Vincent van Gogh Foundation), Amsterdam, P218 V/1966

Other known impressions:
Van Gogh Museum, Amsterdam (Vincent van Gogh Foundation), P215, 216, 217 V/1966
Wellcome Museum of Medical Science, London (per Gachet 1956a, p. 19)

After Armand Guillaumin, *Canal Saint-Denis* (or *Canal Saint-Martin*) (**P.G. IV-8;** location unknown)

Louis van Ryssel (Paul Gachet *fils*). Watercolor, 21 x 30.5 cm

Annotated on reverse, in pencil, by Paul Gachet *fils*(?): Aquarelle d'après Guillaumin / L. Van Ryssel / Mars 1901
Musée du Louvre, Paris, Département des Arts Graphiques, Fonds du Musée d'Orsay, RF 31 261

After Guillaumin, *The Sunken Road, Snow Effect* (**P.G. IV-9;** Musée d'Orsay, Paris, RF 1954-10), cat. no. 26

*Louis van Ryssel (Paul Gachet *fils*). Watercolor, 38.4 x 31 cm
Signed and dated lower right, in gray-blue: Mars 901 / LVR [monogram]. Annotated on reverse, upper left, in pencil, and upper right, in blue (the same inscription, appearing twice): Nach dem Gemalde von Guillaumin /Arcueil 1869 / L. van Ryssel /

Auvers /6 mars 1901
Musée du Louvre, Paris, Département des Arts Graphiques, Fonds du Musée d'Orsay, RF 31 259
Cat. no. 26a

After Guillaumin, *Bridge over the Marne at Joinville* (**P.G. IV-13;** The Metropolitan Museum of Art, New York, 1975.1.180), fig. 77

*Blanche Derousse. Watercolor over a faint graphite sketch on white paper, 25 x 29 cm (image: 25 x 28.7 cm)
Signed lower right, in blue: B.D.
Annotated on reverse, in blue pencil, in the artist's hand (?): La Marne à Joinville d'après le tableau Guill [cut off] Mars 1901; in black pencil: Pontoise 1909; in black pencil in calligraphic script, probably by Paul Gachet *fils*: La Marne à Joinville...Aquarelle de B. Derousse d'après Ad Guillaumin.
Musée du Louvre, Paris, Département des Arts Graphiques, Fonds du Musée d'Orsay, RF 31 243

After Guillaumin, *Sailboats on the Seine* (**P.G. IV-15;** location unknown)

Blanche Derousse. Watercolor over a faint graphite sketch on white paper, 16.3 x 24.5 cm
Verso, in the same technique: *Landscape with Cows, on a Riverbank*
Musée du Louvre, Paris, Département des Arts Graphiques, Fonds du Musée d'Orsay, RF 31 248

After Guillaumin, *Sunset at Ivry* (**P.G. IV-16;** Musée d'Orsay, Paris, RF 1951-34), cat. no. 30

*Blanche Derousse. Watercolor over a faint graphite sketch on white paper, 23.5 x 30.7 cm
Signed lower right: B.D. Annotated on reverse, in blue pencil, by Derousse (?): La Seine à Charenton. Tableau de Guillaumin / Février 01; in pencil in calligraphic script, probably by Paul Gachet *fils*: La Seine à Charenton aquarelle de Blanche Derousse d'après Guillaumin
Musée du Louvre, Paris, Département des Arts Graphiques, Fonds du Musée d'Orsay, RF 31 242
Cat. no. 30a

After Guillaumin, *The Seine at Charenton* (**P.G. IV-20;** location unknown)

Blanche Derousse. Watercolor over a faint graphite sketch on white paper, 30 x 36.7 cm
Signed lower right, in blue pencil: B.D.
Annotated on reverse, in blue pencil, by Derousse(?): Vue de la Seine (Bercy) (tableau) d'après Guillaumin/Mars 1901; in black pencil in calligraphic script, probably by Paul Gachet *fils*: Vue de la Seine à Bercy. aquarelle de Blanche Derousse d'après Ad. Guillaumin.
Musée du Louvre, Paris, Département des Arts Graphiques, Fonds du Musée d'Orsay, RF 31 244

After Guillaumin, *Unloading Cargo on the Banks of the Seine* (**P.G. IV-21**; S&F 23; location unknown)

Blanche Derousse. Watercolor over a faint graphite sketch, 23 x 25.5 cm
Signed lower right, in blue: B.D.
Annotated on reverse, in blue pencil, by Derousse(?): Quai de la Rapée [illegible] d'après le tableau de Guillaumin /Avril 1901; in black pencil in calligraphic script, probably by Paul Gachet *fils*: Quai de la Rapée (Bercy)
Musée du Louvre, Paris, Département des Arts Graphiques, Fonds du Musée d'Orsay, RF 31 246

After Guillaumin, *Path in the Île de France (Vallée de la Bièvre)* (**P.G. IV-22**; S&F 22; Museo de Bellas Artes, Caracas)

Blanche Derousse. Watercolor over a faint graphite sketch on white paper, 24.6 x 28.5 cm
Signed and dated lower right, in blue: BD 01. Annotated on reverse, in blue pencil, by Derousse (?): Vallée de la Bièvre (d'après Guillaumin) Avril 1901
Verso, a sketchy reprise of the motif done in wash and graphite in a smaller format, 22 x 24 cm
Musée du Louvre, Paris, Département des Arts Graphiques, Fonds du Musée d'Orsay, RF 31 247

After Guillaumin, *Road at Sèvres* (**P.G. IV-23**; location unknown)

Blanche Derousse. Watercolor over a faint graphite sketch on white paper, 25.3 x 20 cm
Signed and dated lower right: B.D. 1901.
Annotated on reverse, in blue pencil, by Derousse(?): Vue de Sèvres (d'après le tableau de Guillaumin / 20 avril 01; and in black: Pontoise 1902
Musée du Louvre, Paris, Département des Arts Graphiques, Fonds du Musée d'Orsay, RF 31 245

After Guillaumin, *Still Life with Flowers, Faience, and Books* (**P.G. IV-30**; Musée d'Orsay, Paris, RF 1954-9), cat. no. 28

Louis van Ryssel (Paul Gachet *fils*). Watercolor, 25.3 x 36.5 cm
Musée du Louvre, Paris, Département des Arts Graphiques, Fonds du Musée d'Orsay, RF 31 260
Cat. no. 28a

After Camille Pissarro, *Saint Stephen's Church by Moonlight* (**P.G. I-4**; P&V 145; private collection)

*Paul van Ryssel (Dr. Paul Gachet). Etching, one of four subjects on a plate, 23.3 x 27 cm
Signed with duck emblem upper left, in the plate; signed, dated, and inscribed in the plate: Pissarro pinx P. V. Ryssel 1873.

Three states, printed in four impressions, one of which is dedicated to Buhot
Bibliothèque Nationale de France, Paris, Département des Estampes et de la Photographie, Gift of Paul Gachet, 1953, DO 8775, PG 2 1873
Cat. no. 46d
REFERENCES: Gachet 1954a, n.p., no. 11; Adhémar and Lethève 1954, p. 295, no. 12

After Pissarro, *Road at Louveciennes, Snow Effect* (**P.G. I-5**; P&V 149; private collection)

Blanche Derousse. Watercolor over a faint graphite sketch on white paper, 30.5 x 37 cm
Signed and dated lower right: B.D. 1901.
Annotated on reverse, in calligraphic script, probably by Paul Gachet *fils*: Aquarelle de Blanche Derousse d'après Camille Pissarro
Musée du Louvre, Paris, Département des Arts Graphiques, Fonds du Musée d'Orsay, RF 31 241

After Pissarro, *View of Louveciennes* (P&V 123; private collection). Not owned by Gachet

Paul van Ryssel (Dr. Paul Gachet). Oil on canvas, dimensions unknown, 1874
Location unknown
REFERENCE: Gachet 1956a, pp. 76 n. 1, 128

After Pissarro, *Study at Louveciennes, Snow* (P&V 132; private collection). Not owned by Gachet

*Paul van Ryssel (Dr. Paul Gachet). Oil on canvas, 40 x 54 cm
Signed and dated lower left: PVR I-77
Annotated on stretcher bar upper right, in pen: P. Van Ryssel d'après C. Pissarro; on stretcher bar at center: 40/54 [the second number originally 59, but 9 crossed out and replaced by 4]. Oval stamp on reverse of canvas: 4, Quai des Orfèvres, 4 à Paris Donnet Fab: de Toiles des Tableaux
Musée d'Orsay, Paris, RF 1958-18
Cat. no. 44
REFERENCES: Pissarro and Venturi 1939, p. 98, no. 132 (mention); Gachet 1956a, fig. 51; Lacambre et al. 1990, p. 469, repr.
NOTE: This copy is almost exactly the size of Pissarro's painting (38 x 55 cm).

After Pierre-Auguste Renoir, *Portrait of a Model* (P.G. I-16; Musée d'Orsay, Paris, RF 1951-39), cat. no. 39

*Blanche Derousse. Watercolor on paper, 32 x 24 cm
Signed and dated lower right, in pencil: B.D. 11 septembre 1901
Van Gogh Museum (Vincent van Gogh Foundation), Amsterdam, D581 V/1966

Cat. no. 39a
REFERENCE: Van Uitert and Hoyle 1987, p. 380, no. 2.86, repr.

After Renoir, *Landscape in Guernsey with Bathers* (P.G. I-17; Ny Carlsberg Glyptotek, Copenhagen)

Blanche Derousse. Watercolor over a faint graphite sketch, 23.7 x 29 cm
Signed and dated lower right, in blue: B.D. /F 1902. Annotated on reverse, in black pencil in calligraphic script, probably by Paul Gachet *fils*: Les Baigneurs— aquarelle de Blanche Derousse d'après Renoir
Musée du Louvre, Paris, Département des Arts Graphiques, Fonds du Musée d'Orsay, RF 31 249

After Alfred Sisley, *View of the Canal Saint-Martin* (P.G. I-18; Musée d'Orsay, Paris, RF 1951-40), cat. no. 40

*Louis van Ryssel (Paul Gachet *fils*). Watercolor, 27 x 35 cm
Annotated on reverse, in pen, probably by Paul Gachet *fils*: [illeg.] Der Canal Saint Martin [illeg.] / Gemalde von Sysley (1870) / L. Van Ryssel 1901
Musée du Louvre, Paris, Département des Arts Graphiques, Fonds du Musée d'Orsay, RF 31 251
Cat. no. 40a

ADDITIONAL DOCUMENTATION

Other copies by **Blanche Derousse** include:

A copy after Gautier's painting *The Reader* (location unknown). Exhibited in Paris 1905, no. 1210, as *"Le liseur* (d'après le tableau d'A. Gautier, de la collection du Dr. Gachet)"

A copy after Gautier's drawing *Asiatic Cholera in the Jura* (Wellcome Museum of Medical Science, London [fig. 23]). Exhibited in Paris 1908a, no. 1778, as *"Le Choléra dans le Jura* (1854), d'après le dessin original de Amand Gautier (Collection du docteur Gachet, Paris)"
NOTE: Paul van Ryssel (Dr. Gachet) also exhibited a version of this subject in Paris 1908a, no. 6040, *Le Choléra dans le Jura.*

A drypoint copy after Rupert Carabin's *Woman Crouching* (a stairway decoration in stone or plaster). Impressions in the Van Gogh Museum, Amsterdam, P187–89 V/1966

Other copies by **Paul van Ryssel (Dr. Paul Gachet)** include:

A watercolor and gouache copy after Gautier's *Les demoiselles de Campagne,* 1854 (Gachet 1956a, fig. 64)

Several etchings after works by other artists are listed in the "Catalogue de L'Oeuvre Gravé de P. Van Ryssel" published in Gachet 1954a, n.p. They are cited as follows:
6. *Les vaches* (d'après J. Jordaens). 1873 [cat. no. 20a]
13. *Le canard* (Amand Gautier pinx. — P. Gachet 1854). 1873
29. *La fileuse,* d'après un dessin de Millet. 1875 (repr.) [cat. no. 46h]
43. *Une invasion chasse l'autre* (d'après Daumier). 1880 (repr.)
63. *Trois femmes dans un bois.* 1893 [after Monticelli: per Adhémar and Lethève 1954, p. 298, no. 66. This etching, since it depicts the same subject, may be based on P.G. I-21.]
64. *Marine,* d'après Monticelli. 1893
77. *Le Docteur Gachet.* 1896 [after a drawing by Specht: per Adhémar and Lethève 1954, vol. 8, p. 298, no. 80]

Documents

Mon cher Theo, déjà depuis plusieurs jours j'aurais désiré t'écrire à tête reposée mais ai été absorbé par le travail. Ce matin arrive ta lettre de laquelle je te remercie et du billet de 50 fr. qu'elle contenait. Oui je crois que pour bien des chôses il sera bien que nous fussions encore ensemble tous ici pour une huitaine de tes vacances si plus longtemps n'est pas possible. Je pense souvent à toi à Jo et au petit, et je vois que les enfants ici au grand air sain ont l'air de bien se porter. Et pourtant c'est déjà ici aussi difficile assez de les élever à plus forte raison est ce plus ou moins terrible à de certains moments de les garder sains-saufs à Paris dans un quatrième étage. Mais enfin il faut prendre les chôses comme elles sont. M. Gachet dit qu'il faut que père et mère se nourrissent bien naturellement il parle de prendre 2 litres de bière par jour &c. dans ces mesures là. Mais tu feras certes avec plaisir plus ample connaissance avec lui et il y compte déjà en parle toutes les fois que je le vois que vous tous viendrez. Il me paraît certes aussi malade et ahuri que toi ou moi et il est plus âgé et il a perdu il y a quelques années sa femme, mais il est très médecin et son métier et sa foi le tiennent pourtant. Nous sommes déjà très amis et par hasard il a connu encore Brias de Montpellier et a les mêmes idées sur lui que j'ai que c'est quelqu'un d'important dans l'histoire de l'art moderne. Je travaille à son portrait

la tête avec une casquette blanche très blonde très claire les mains aussi à carnation claire un frac bleu et un fond bleu cobalt appuyé sur une table rouge sur laquelle un livre jaune et une plante de digitale à fleurs pourpres. Cela ~~faiblis~~ est dans le même sentiment que le portrait de moi que j'ai pris lorsque je suis parti pour ici. ~~Il n'attendait que pas~~ M. Gachet est absolument fanatique pour ce portrait et veut que j'en fasse un de lui si je peux absolument comme cela ce que je désire faire aussi. Il est maintenant aussi arrivé à comprendre le dernier portrait d'arlésienne ~~et~~ dont tu en as une encore. Il revient lorsqu'il vient voir les études toujours le temps sur ces deux portraits et il les admet en plein mais en plein tels qu'ils sont

Excerpts from the Correspondence, 1889–91: Vincent van Gogh, Theo, Dr. Gachet, and Others

The letters reprinted below provide a firsthand account of Dr. Gachet's relationship with Vincent van Gogh and his family during the period 1889–91. This selection contains all the known references to Gachet in the Van Gogh correspondence, as well as all known references in other letters written during the same period that have some bearing on the relationship. For passages extracted from the published correspondence, citations are provided that will enable the reader to consult the excerpts in their original context. Previously unpublished letters, which have been newly translated, are reprinted in their entirety.

The dates of the letters are those assigned in Hulsker 1993. Alternative translations of certain passages given in brackets are by Hulsker or the editors of this catalogue.

SAS

Theo van Gogh to Vincent, October 4, 1889, excerpt T 18
(Van Gogh Letters 1958, vol. 3, p. 554)

I spoke to Pissarro. . . . he knows somebody at Auvers who is a doctor and does painting in his spare moments. He tells me the gentleman in question has been in contact with all the impressionists. He thinks that you might possibly stay with him. He has to look him up, and will speak about the matter. If you could find something in that neighborhood, it would be a very good thing for you. . . .

Vincent to Theo, October 5, 1889, excerpt LT 609
(Van Gogh Letters 1958, vol. 3, p. 221)

What you say of Auvers is nevertheless a very pleasant prospect. . . . If I come North, even supposing that there were no room at this doctor's house, it is probable that after your recommendation and old Pissarro's he would find me board either with a family or quite simply at an inn. The main thing is to know the doctor, so that in case

Fig. 90. Page of a letter from Vincent van Gogh to his brother Theo, June 3, 1890 (LT 638). Archives, Van Gogh Museum, Amsterdam

of an attack I do not fall into the hands of the police and get carried off to an asylum by force.

Theo to Vincent, October 22, 1889, excerpt T 19
(Van Gogh Letters 1958, vol. 3, p. 555)

Pissarro has gone away, and I suppose he is now occupying himself with that worthy man at Auvers. I hope he will succeed, and that we are going to see you next spring if not earlier.

Theo to Camille Pissarro, November 14, 1889, excerpt
(Rewald 1978, p. 357 n. 51)

I thank you very much for being so kind as to take the trouble to find out if there is some pension in which my brother would be comfortable; Mme Pissarro is most gracious to look into the matter also. It seems to me that if he could stay at Auvers close to that doctor you mentioned, that would be an excellent thing.

Theo to Vincent, November 16, 1889, excerpt T 20
(Van Gogh Letters 1958, vol. 3, p. 557)

Pissarro wrote me that his wife and he have been looking around the country for a boardinghouse for you, but he tells me he thinks that it will be better for you to go to stay with that doctor in Auvers. He will have to go to him very soon.

Theo to Vincent, December 22, 1889, excerpt T 22
(Van Gogh Letters 1958, vol. 3, p. 559)

So far [Pissarro] has not seen that gentleman at Auvers, at least he does not write anything on the subject. . . .

Theo to Vincent, March 29, 1890, excerpt T 31
(Van Gogh Letters 1958, vol. 3, p. 567)

My dear brother, how sad it is for us to be at such a distance from one another, and to know so little what the

other one is doing. For this reason I am very happy to be able to tell you that I met Dr. Gachet, that physician Pissarro mentioned to me. He gives the impression of being a man of understanding. Physically he is a little like you. As soon as you come here we are going to see him; he comes to Paris several times a week for consultations. When I told him how your crises came about, he said to me that he didn't believe it had anything to do with madness, and that if it was what he thought he could guarantee your recovery, but that it was necessary for him to see you and to speak with you in order to be able to make a more definite statement. He is a man who may be of use to us when you come here. Have you spoken about it to Dr. Peyron, and what did he say?

Theo to Dr. Paul Gachet, May 9, 1890 b2014 VF/1982,
(Newly translated and published) VGM Archives[1]

Dear Sir,

Allow me to bring up the conversation we had when I had the honor of making your acquaintance. We were speaking of my brother the painter, who is currently at St-Rémy, in the house run by Dr. Peyron. You gave me reason to hope that under your care he might return to his normal state. He is doing very well at the moment and writes me very reasonable letters. He greatly desires to come to Paris for a few days, and then to go to the countryside to work. But he is prepared, if you felt he would be better off under treatment in a sanatorium, to return to St-Rémy or to go to another institution. If you would kindly consent to treat him, I would greatly appreciate your telling me what days you come to Paris, so that you can see him as soon as he arrives in Paris. If it were possible for you to tell me of an inn or boardinghouse where he would be comfortable if he came to Auvers, I would be very grateful. Do you think it would be wise to have someone with him during the voyage? He himself has a horror of having to be watched & has begged me to let him make the trip alone. I would very much like to have your views on this. To meet his needs, he cannot allow himself any extravagance, but if he leads a simple life he can have what is necessary.

In hopes of receiving a reply, I extend
my sincere good wishes,
T. van Gogh
8 cité Royale or 19 boul. de Montmartre

1. Throughout, the abbreviation VGM Archives stands for Archives, Van Gogh Museum, Amsterdam.

Theo to Vincent, May 10, 1890, excerpt T 34
(Van Gogh Letters 1958, vol. 3, p. 570)

I wrote to Dr. Gachet yesterday to ask him when he is coming to Paris, for then he will sit for consultations, and I asked him at the same time to look for a boardinghouse for you. A change of country might certainly do you good. . . . I also wrote to Dr. Peyron to tell him . . . to let you go.

Theo to Dr. Gachet, May 19, 1890 b2012 V/1982,
(Newly translated and published) VGM Archives

Dear Sir,

My brother arrived only last Saturday, so we were unable to come to your office. As he doesn't wish to tire himself out in Paris, he has decided to leave for Auvers and to go see you there. You will see that at the moment he is doing very well. I would be very grateful if you could treat him & give him any recommendations you might have regarding lodgings. I will take the liberty of coming to see you on a Friday to ask for your instructions & impressions. Please accept, dear Doctor, my sincere good wishes.

T. van Gogh
8 cité Pigalle

Vincent to Theo, May 20, 1890, excerpt LT 635
(Van Gogh Letters 1958, vol. 3, p. 273)

I have seen Dr. Gachet, who gives me the impression of being rather eccentric, but his experience as a doctor must keep him balanced enough to combat the nervous trouble from which he certainly seems to me to be suffering at least as seriously as I.

He piloted me to an inn where they ask 6 francs a day. All by myself I found one where I shall pay 3.50 fr. a day.

. . . Probably you will see Doctor Gachet this week—he has a *very* fine Pissarro, winter with a red house in the snow [cat. no. 36], and two fine flower pieces [two beautiful bouquets] by Cézanne [see cat. nos. 8, 9].

Also another Cézanne, of the village [see P.G. II-4]. And I in my turn will gladly, very gladly, do a bit of brushwork here.

I told Dr. Gachet that for 4 francs a day I should think the inn he had shown me preferable, but that 6 was 2 francs too much, considering the expenses I have. It was useless for him to say that I should be quieter there, enough is enough.

His house is full of black antiques, black, black, black, except for the impressionist pictures mentioned. The impression I got of him was not unfavorable. When he spoke of Belgium and the days of the old painters, his grief-hardened face grew smiling again, and I really think that I shall go on being friends with him and that I shall do his portrait.

Then he said that I must work boldly on, and not think at all of what went wrong with me.

Vincent to Wil, ca. May 20, 1890, excerpt W 21
(Van Gogh Letters 1958, vol. 3, p. 469)

I think that the doctor to whose care I am entrusted will absolutely leave me to my own devices, as if there were nothing the matter with me. . . .

Vincent to Theo, May 23, 1890, excerpt LT 648
(Van Gogh Letters 1958, vol. 3, p. 294)

. . . Now about Dr. Gachet. I went to see him the day before yesterday, I did not find him in. . . .

I think we must not count on Dr. Gachet *at all*. First of all, he is sicker than I am, I think, or shall we say just as much, so that's that. Now when one blind man leads another blind man, don't they both fall into the ditch?

Vincent to Theo, May 25, 1890, excerpt LT 637
(Van Gogh Letters 1958, vol. 3, p. 275)

Today I saw Dr. Gachet again, and I am going to paint at his house on Tuesday morning; then I shall dine with him, and afterward he will come to see my painting. He seems very sensible, but he is as discouraged about his job as a doctor as I am about my painting. Then I told him that I would gladly swap jobs with him. Anyway, I am ready to believe that I shall end up being friends with him. He said to me besides that if the melancholy or anything else became too much for me to bear, he could easily do something to lessen its intensity, and that I must not feel awkward about being frank with him. Well, the moment when I need him may certainly come, however, up to now all is well. And it may yet improve, I still think that it is mostly a disease of the South that I have caught and that returning here will be enough to dissipate the whole thing.

Theo to Vincent, June 2, 1890, excerpt T 35
(Van Gogh Letters 1958, vol. 3, p. 571)

What you write me about Dr. Gachet interests me a good deal. I hope you will become friends.

I should like very much to have a friend who is a doctor, for one wishes to know at any given moment, especially on account of the little one, the cause of those fits of depression and indisposition.

Vincent to Theo, June 3, 1890, excerpt LT 638
(Van Gogh Letters 1958, vol. 3, pp. 276–78)

M. Gachet says that a father and mother must naturally feed themselves up, he talks of taking 2 liters of beer a day, etc., in those circumstances. But you will certainly enjoy furthering your acquaintance with him, and he already counts on all of you coming, and talks about it every time I see him. He certainly seems to me as ill and distraught as you or me and he is older and lost his wife several years ago, but he is very much the doctor, and his profession and faith still sustain him. We are great friends already, and as it happens, he already knew Brias [*sic;* the collector Alfred Bruyas] of Montpellier and has the same idea of him that I have, that there you have someone significant in the history of modern art.

I am working at his portrait, the head with a white cap, very fair, very light, the hands also a light flesh tint, a blue frock coat and a cobalt blue background, leaning on a red table, on which are a yellow book and a foxglove plant with purple flowers [fig. 56; F 753]. It has the same sentiment as the self-portrait I did when I left for this place [cat. no. 12].

M. Gachet is absolutely *fanatical* about this [that] portrait, and wants me to do one for [of] him, if I can, exactly like it. I should like to myself. He has now got so far as to understand the last portrait of the Arlésienne [F 540?], of which you have one in pink [F 542]; he always comes back to these two portraits when he comes to see the studies, and he understands them exactly, exactly [and he accepts them, totally, but (really) totally as they are], I tell you, as they are.

I hope to send you a portrait of him soon. Then I have painted two studies at his house, which I gave him last week, an aloe with marigolds and cypresses [cat. no. 14], then last Sunday some white roses, vines and a white figure in it [cat. no. 15].

I shall most probably also do the portrait of his daughter, who is nineteen years old [*sic*], and with whom I imagine Jo would soon be friends.

. . . And I also hope that this feeling I have of being much more master of my brush than before I went to Arles will last. And M. Gachet says that he thinks it most improbable that it will return, and that things are going on quite well.

But he too complains bitterly of the state of things everywhere in the villages where he has gone as a total stranger, that living there gets so horribly expensive. He says he's amazed that the people I am with give me board and lodging for that amount, and that compared with others who have been here and whom he has known I am even comparatively lucky. . . . Now nothing, absolutely nothing, is keeping us here but Gachet—but he will remain a friend, I should think. I feel that I can do not too bad a picture every time I go to his house, and he will continue to ask me to dinner every Sunday or Monday.

But till now, though it is pleasant to do a picture there, it is rather a burden for me to dine and lunch there, for the good soul takes the trouble to have four- or five-course dinners, which is as dreadful for him as for me—for he certainly hasn't a strong digestion. The thing that has somewhat prevented me from protesting against it is that it recalls the old times to him when there were those family dinners which we ourselves know so well. But the modern idea of eating one—or at most two—courses is certainly progress, as well as a remote return to real antiquity. Altogether father Gachet is very, yes very like you and me.

. . . Gachet has a Guillaumin, a nude woman on a bed [cat. no. 29], that I think very fine; he also has a very old self-portrait by Guillaumin [cat. no. 25], very different from ours, dark but interesting.

But you will see that his house is full, full like an antique dealer's, of things that are not always interesting. But nevertheless there is this advantage, there is always something for arranging flowers in or for a still life. I did these studies for him to show him that if it is not a case for which he is paid in money, we will still compensate him for what he does for us.

Gachet also told me, that if I wished to give him great pleasure, he would like me to do again the "Pietà" by Delacroix [F 630] for him, he looked at it for a long time. In the future he will probably lend me a hand in getting models; I feel that he understands us perfectly and that he will work with you and me to the best of his power, with-

out any reserve, for the love of art for art's sake. And he will perhaps really get me portraits to do.

Vincent to his mother, ca. June 4, 1890, excerpt
(Van Gogh Letters 1958, vol. 3, p. 279) Letter 639

The physician here has shown me much sympathy, I may come to his house as often as I want, he has a good knowledge of what is being done these days among the painters. He himself is very nervous, which I suppose has not improved since his wife's death. He has two children, a girl of nineteen [*sic*] and a boy of sixteen [*sic*]. He tells me that in my case work is the best thing to keep my balance.

. . . Unfortunately it is expensive here in the village, but Gachet, the physician, tells me that it is the same in all the villages in the vicinity, and that he himself suffers much from it compared with before. And for some time to come I shall have to stay near a physician I know. And I can pay him in pictures, and I could not do that with anyone else if anything happened and I needed help.

Vincent to Wil, ca. June 5, 1890, excerpt W 22
(Van Gogh Letters 1958, vol. 3, pp. 469–70)

. . . I have found a true friend in Dr. Gachet, something like another brother, so much do we resemble each other physically and also mentally. He is a very nervous man himself and very queer in his behavior; he has extended much friendliness to the artists of the new school, and he has helped them as much as was in his power. I painted his portrait the other day, and I am also going to paint a portrait of his daughter, who is nineteen years old [*sic*]. He lost his wife some years ago, which greatly contributed to his becoming a broken man. I believe I may say we have been friends from the very first, and every week I shall go stay at his house one or two days in order to work in his garden, where I have already painted two studies, one with southern plants, aloes, cypresses, marigolds [cat. no. 14]; the other with white roses, some vines and a figure [cat. no. 15], and a cluster of ranunculuses besides [then a bouquet of wild buttercups] [work unknown; see cat. no. 16]. Apart from these I have a larger picture of the village church—an effect in which the building appears to be violet-hued against a sky of a simple deep blue color, pure cobalt [cat. no. 17]. . . .

My friend Dr. Gachet is *decidedly enthusiastic* about the latter portrait of the Arlésienne, which I have made a

copy of for myself [see F 540–43]—and also about a self-portrait [cat. no. 12], which I am very glad of, seeing that he will urge me to paint figures, and I hope he is going to find some interesting models for me to paint.

. . . So the portrait of Dr. Gachet shows you a face the color of an overheated brick, and scorched by the sun, with reddish hair and a white cap, surrounded by a rustic scenery with a background of blue hills; his clothes are ultramarine—this brings out the face and makes it paler, notwithstanding the fact that it is brick-colored. His hands, the hands of an obstetrician, are paler than the face. Before him, lying on a red garden table, are yellow novels and a foxglove flower of a somber purple hue [fig. 56; F 753].

My self-portrait is done in nearly the same way; the blue is the blue color of the sky in the late afternoon [but the blue is the fine blue of the Midi], and the clothes are a bright lilac [light lilac]. . . .

Theo to Vincent, June 5, 1890, excerpt T 36
(Van Gogh Letters 1958, vol. 3, pp. 571–72)

Dr. Gachet came to see me yesterday, but unfortunately there were customers, which prevented me from talking with him very much, but at any rate he told me that he thought you entirely recovered, and that he did not see any reason for a return of your malady. He invited us to visit him next Sunday, when you will also be there.

. . . Will you be so kind as to go to Dr. Gachet and tell him that, if the weather is fine, we shall accept his invitation with great pleasure, but that we cannot absolutely promise it, and that, if we should come, we should like to be home again in the evening. There is a train at 5:58 which we might take.

Vincent to Theo, ca. June 10, 1890, excerpt LT 640
(Van Gogh Letters 1958, vol. 3, p. 280)

. . . [P]lease ask old Tanguy to set to work instantly, taking the nails out of all the canvases that are on stretchers up there in the attic. He must make rolls of the canvases, and packages of the stretchers.

Then either I will send the carrier from Pontoise, or else I will come some time during the next fortnight with M. Gachet to get some of them.

I also saw at your home in the heap under the bed a lot that I can touch up, I think, to advantage.

Vincent to M. and Mme Ginoux, ca. June 12, 1890,
excerpt Letter 640a
(Van Gogh Letters 1958, vol. 3, p. 281)

. . . The doctor here says that I ought to throw myself into my work with all my strength, and so distract my mind.

This gentleman knows a good deal about painting, and he greatly likes mine; he encourages me very much, and two or three times a week he comes and visits me for a few hours to see what I am doing.

Vincent to his mother, ca. June 12, 1890, excerpt
(Van Gogh Letters 1958, vol. 3, pp. 282–83) Letter 641a

Last Sunday Theo, his wife and their child were here, and we lunched at Doctor Gachet's. There my little namesake made the acquaintance of the animal world for the first time, for at that house there are 8 cats, 8 dogs, besides chickens, rabbits, ducks, pigeons, etc., in great numbers.

Vincent to Wil, ca. June 12, 1890, excerpt W 23
(Van Gogh Letters 1958, vol. 3, p. 472)

I painted a portrait of Dr. Gachet with an expression of melancholy, which would seem to look like a grimace to many who saw the canvas. And yet it is necessary to paint it like this, for otherwise one could not get an idea of the extent to which, in comparison with the calmness of the old portraits, there is expression in our modern heads, and passion—like a waiting for things as well as a growth. Sad and yet gentle, but clear and intelligent—this is how one ought to paint many portraits.

Vincent to Theo, June 14, 1890, excerpt LT 641
(Van Gogh Letters 1958, vol. 3, p. 282)

I have a vineyard study [F 762], which M. Gachet liked very much the last time he came to see me.

Vincent to Paul Gauguin, ca. June 17, 1890, excerpt
(Van Gogh Letters 1958, vol. 3, pp. 284–87) Letter 643

And it gives me enormous pleasure when you say the Arlésienne's portrait, which was based strictly on your drawing, is to your liking [See F 540–43]. . . . My friend Dr. Gachet here has taken to it altogether after two or three hesitations, and says, "How difficult it is to be simple." Very well—I want to underline the thing again by etching it, then let it be. Anyone who likes can have it.

. . . Meanwhile I have a portrait of Dr. Gachet with the heart-broken expression of our time. *If you like*, something like what you said of your "Christ in the Garden of Olives" not meant to be understood, but anyhow I follow you there, and my brother grasped that nuance absolutely.

Vincent to Theo, June 17, 1890, excerpt　　LT 642
(Van Gogh Letters 1958, vol. 3, p. 284)

. . . [V]ery well that [Gauguin] thinks well of the Arlésienne in question. I hope he does some etching [I hope to make some etchings] of Southern subjects, say six, since I can print them without cost at M. Gachet's, who is kind enough to print them for nothing if I do them. That is certainly something that ought to be done, and we will do it in such a way that it will form a sort of sequel to the Lauzet-Monticelli publication, if you approve. And Gauguin will probably engrave some of his canvases in conjunction with me. His picture that you have, for instance, and for the rest, the Martinique things especially. M. Gachet will print these plates for us too. Of course he will be at liberty to print copies for himself. M. Gachet is coming to see my canvases in Paris someday and then we could choose some of them for engraving.

At the moment I am working on two studies, one a bunch of wild plants, thistles, ears of wheat, and sprays of different kinds of leaves—the one almost red, the other bright green, the third turning yellow [P.G. III-18]. . . .

Theo to Vincent, June 23, 1890, excerpt　　T 38
(Van Gogh Letters 1958, vol. 3, pp. 573–74)

And now I must tell you something about your etching [cat. no. 23b]. It is actually an etching done by a painter. There is no refinement of process, but it is a drawing on metal. I like that drawing very much—De Bock liked it too.

It's funny that Dr. Gachet has that printing press; the etchers are forever complaining that they have to go to a printer to get proofs.

Vincent to Theo, June 24 or 25, 1890, excerpt　　LT 644
(Van Gogh Letters 1958, vol. 3, p. 288)

. . . I hope to do the portrait of Mlle Gachet next week, and perhaps I shall have a country girl to pose too. [. . . Gachet is coming today to see the canvases from the Midi.] [Preceding sentence omitted from Van Gogh Letters 1958]

Paul Gauguin to Vincent, June 27, 1890, excerpt
(Cooper 1983, no. 42, pp. 321–27; newly translated)

Upon my return from a short trip [to Pont-Aven], I found your letter and the proof of your etching. . . . I see that you haven't wasted your time in Auvers. . . . I do not know Dr. Gachet, but I have often heard Father Pissarro talk of him. And it must be nice for you to have someone near you who sympathizes with your work and your ideas.

Vincent to Theo, June 28, 1890, excerpt　　LT 645
(Van Gogh Letters 1958, vol. 3, p. 288)

Yesterday and the day before I painted Mlle Gachet's portrait, which I hope you will see soon; the dress is red [pink], the wall in the background green with orange spots, the carpet red with green spots, the piano dark violet; it is 40 inches high by 20 inches wide [1 meter high by 50 wide] [P.G. III-20].

It is a figure that I enjoyed painting—but it is difficult. He has promised to make her pose for me another time at the small organ. I will do one for you—I have noticed that this canvas goes very well with another horizontal one of wheat [F 775], as one canvas is vertical and in pink tones, the other pale green and greenish-yellow, the complementary of pink; . . .

Theo to Vincent, June 30 or July 1, 1890, excerpt　　T 39
(Van Gogh Letters 1958, vol. 3, p. 575)

Your portrait of [Mlle] Gachet must be admirable, and I shall be happy to see it with those spots of orange in the background.

Vincent to Theo, July 2, 1890, excerpt　　LT 646
(Van Gogh Letters 1958, vol. 3, p. 289)

It is a great pity that M. Gachet's house is so encumbered with all sorts of things. But for that, I think that it would be a good place to come and stay here—with him—with the little one, for a full month at least. I think that country air has an enormous effect. In this very street there are youngsters who were born in Paris and were really sickly—who, however, are doing well now.

. . . And as for Jo—so that she should have some company in the daytime—well, she could stay right opposite old Gachet's house, perhaps you remember that there is an inn just across the way at the bottom of the hill?

Theo to Vincent, July 22, 1890, excerpt
(Van Gogh Letters 1990, vol. 4, no. 906, p. 2092;
newly translated)

. . . I hope, my dear Vincent, that your health is good, and since you say that you write with difficulty and you tell me nothing about your work, I am a little concerned that something troubles you or isn't going well. In this case, why not drop by to see Dr. Gachet, perhaps he will give you something to make you feel better.

Dr. Gachet to Theo, July 27, 1890 b3265 V/1966,
(Pickvance 1992, p. 27) VGM Archives

Dear Monsieur Vangogh,

It is with the utmost regret that I intrude on your privacy, however I regard it as my duty to write to you immediately, today, Sunday, at nine o'clock in the evening I was sent for by your brother Vincent, who wanted to see me at once. I went there and found him very ill. He has wounded himself. . . .

Not having your address which he refused to give me, this letter will reach you through Goupil.

I would advise you to take the greatest precautions with your wife who is still breast feeding.

I would not presume to tell you what to do, but I believe that it is your duty to come, in case of any complications that might occur. . . .

> Ever yours
> Gachet
> Auvers-sur-Oise

Theo to his wife, Johanna, July 28, 1890, excerpt
(Pickvance 1992, p. 28) b2066 VF/1982, VGM Archives

This morning a Dutch painter [Anton Hirschig, 1867–1939] who is also in Auvers came to bring me a letter from Dr. Gachet who had bad news about Vincent and requested me to come. . . .

Émile Bernard to Albert Aurier, July 31, 1890, excerpt
(Pickvance 1992, pp. 32–35) b3052 V/1985, VGM Archives

. . . Our dear friend Vincent died four days ago . . . on Monday evening still smoking his pipe which he refused to let go of explaining that his suicide had been absolutely deliberate and that he had done it in complete lucidity. A typical detail that I was told about his wish to die was

that when Doctor Gachet told him that he still hoped to save his life, he said, "Then I'll have to do it over again." But, alas, it was no longer possible to save him. . . .

On Wednesday 30 July, yesterday that is, I arrived in Auvers at about 10 o'clock. His brother, Theodore Van ghohg [*sic*], was there together with Doctor Gachet. Also Tanguy. . . . Charles Laval accompanied me. . . . Many people arrived, mainly artists. . . .

We reached the cemetery. . . . Doctor Gachet (who is a great art lover and possesses one of the best collections of impressionist painting at the present day) wanted to say a few words of homage about Vincent and his life, but he too was weeping so much that he could only stammer a very confused farewell . . . (perhaps it was the most beautiful way of doing it). . . .

He gave a short description of Vincent's struggles and achievements, stating how sublime his goal was and how great an admiration he felt for him (though he had only known him a short while). He was, Gachet said, an honest man and a great artist, he had only two aims, humanity and art. It was art that he prized above everything and which will make his name live. . . .

July 31, 1890
On this day, Van Gogh's mother and his sister Wil sent letters of condolence to Theo in which they thank him "for all [he] did" for Vincent. The postscript to Wil's letter reads: "Thank Dr. Gachet on our behalf too" (b1009 V/1962, VGM Archives; Pickvance 1992, pp. 48–49).

Theo to Johanna, August 1, 1890, excerpt b2067 VF/1982,
(Pickvance 1992, pp. 39–40) VGM Archives

. . . The two doctors were so very good. Dr. Gachet had summoned the village doctor as he did not trust himself, but it was nevertheless he in fact who did everything. Later, he did not leave me alone for a second, almost, and was so very kind. . . . There were masses of bouquets and wreaths. Dr. Gachet was the first to bring a magnificent bouquet of sunflowers because he loved them so dearly. . . . Dr. Gachet spoke beautifully [at the funeral]; I gave a few words of thanks & then it was over. . . .

Theo to his mother, August 1, 1890, excerpt
(Pickvance 1992, pp. 56–57) b934 V/1962, VGM Archives

. . . Dr. Gachet and the other doctor were excellent and

looked after him well, but they realized from the very first moment that there was nothing one could do. Vincent said: This is how I would like to go and half an hour later he had his way. . . .

Theo to Dr. Gachet, August 12, 1890
(Pickvance 1992, pp. 142–43)

b2016 VF/1982,
VGM Archives

Amsterdam, 12 August 1890
My dear Doctor,

I have been meaning to write to you for several days now, but I have felt so weary that I have been completely incapable of doing so, probably as a result of these days of great stress.

However, it has done me good to be with my mother and to talk with her about my brother, about whom she has told me countless of those little things that go to make up the life story of a man. Also we have found a packet of letters that he sent me from 1873 to 1877, some of which I read and which moved me once again.

At that time he was going through his period of religious preoccupations and he wrote to me about his experiences.

These letters could be enormously useful, if we wanted to describe how one becomes a painter and how the idea takes root that one cannot do anything else but follow this path.

Most of these letters are written in Dutch, but I will translate a few so that you may know their contents. In them I found many fascinating details of his life in Paris which should also interest you.

As soon as I get back, I intend to visit Durand-Ruel to see if it is possible to hold an exhibition in one of his rooms.

As soon as I returned from Auvers, I had the canvases stretched so that I am already able to show them to some people who might be interested.

I have received numerous tokens of appreciation of my brother's talent, and several people have told me that they felt that he had something of absolute genius about him.

My mother has particularly asked me to tell you of her deep gratitude—which she herself has difficulty in expressing in French—for all that you have done for her poor son whom you have shown as much devotion and affection as if you were a member of the family.

When I described to her all that had happened and the events of the final day when the burial took place, she was very moved by all the kindness you have shown me.

I join her in telling you once again that the warmth and friendship that you offered me were beyond anything I could have hoped for.

Dear Doctor, I can assure you that words are quite inadequate to convey my feelings, but I will never forget what you have done for me. I don't know what I would have done without you. My wife also asks me to send you her kind regards. She and the baby are fairly well, but she has not yet regained her strength. She had to stop feeding the baby for lack of milk. Since then, she has been feeling much better.

I must also tell you that it gave my mother immense pleasure to see the drawing you have made of our dear Vincent [cat. no. 41a].

A number of people have seen and admired it.

We are planning to return to Paris at the end of this week, and if you happen to be free to dine with us one evening next week, we should be really delighted.

Send us a note, if it suits you, stating on what day you can come, and we shall look forward to seeing you with the greatest pleasure.

Please remember me to your family. With much affection and respect, I remain

Yours truly
T. van Gogh.

Dr. Gachet to Theo, ca. August 15, 1890
(Pickvance 1992, pp. 144–45)

b3266 V/1966,
VGM Archives

My dear friend,

This is how I will refer to you from now on, with your permission. Vincent has brought us together. It has to be so. . . .

Your letter has done me a great deal of good. I must tell you that my health has not been too good since the tragic event, the day after the funeral I caught an unpleasant bout of laryngitis which makes me cough terribly, especially at night. Not only that but I have been thinking about your brother the whole time. . . . I have turned this train of thought to advantage and started writing down the things I told you about—I have a whole series of ideas that I shall tell you about at our next meeting, a meeting that I am eagerly looking forward to, even though I am feeling rather poorly.

I am glad to hear that you now have all the additional information you need to make, not a catalogue but a com-

plete biography—for a man who was so *exceptional* something commonplace would be inappropriate. . . .

The more I think of it, the more I regard Vincent as a *giant*. Not a day goes by without my looking at his canvases. I always find a new idea in them, something different from the day before, and I return by the mental phenomenon of thought to the man himself whom I think of as a Colossus. . . .

He was, moreover, a philosopher of the same type as Seneca.

This sovereign disdain that he felt for life which was surely a product of his passionate *love* for art, is extraordinarily suggestive. In my view, it was a sort of mental transposition in which the religious side of his character played an important role.

The word *love* of art is not right—*Faith* is the proper word. Faith to the point of martyrdom!!!!

A strange idea has occurred to me that I will tell you of while putting a question mark after it.

Had Vincent lived, it would still be years and years before the triumph of the *art of humanity*. His death however means a kind of consecration that results from the struggle between two opposing principles, light and darkness, life and death.

I don't mean that he got the idea for his suicide from this or because of it, but he knew mankind and what man is worth and he must certainly have had moments when he glimpsed this idea of the void not in order to stay put in that place, but at least to entertain it energetically as offering some sort of certainty beyond death. . . .

All this is so bizarre that I have to pull myself up short on this slope down which when I think of him (Vincent), he surely lures me. . . .

Good-bye my dear friend, fondest regards from all the family, to you, your wife and baby.

Yours

Dr. Gachet

P.S. Barring anything unexpected I will come to dinner with you next Thursday, 21 August, between 7 and 7:30.
P.S. Keep this letter.

Theo to his mother and Wil, August 24, 1890, excerpt
(Stein 1986, pp. 233–34)

. . . Then we had Dr. Gachet to dinner last Wednesday. I will send you a letter one of these days which you should read to see something of what he thinks of him. After the funeral he has been ill from emotion, but he was some-

what better then. While he was ill he wrote about Vincent and he will let it appear some time in a magazine. It may be good. . . . Dr. Gachet brought me a sketch in pencil after a portrait of Vincent, which he had made as an exercise for the etching he wanted to make later on, as well as a small drawing of a sunflower. He stayed that evening till twelve and there came no end to his admiration for the things of Vincent I was able to show him. He promised to return in a fortnight or so. . . .

September 8, 1890

Theo sent his mother and Wil several condolence letters, commenting, "The one by Dr. Gachet I think is the most remarkable." They ended up misplacing the letter and were quite upset. On September 16, 1890, Theo wrote them: "I am sorry that you were worried about Dr. Gachet's letter. It is nothing, you know. I read the letter many times and know what is in it and he will write again sometime. It doesn't matter at all and please do not look for it any more for it is nothing if it is not found, really *nothing*" (Pickvance 1992, p. 145 n. 7).

Theo to Dr. Gachet, September 12, 1890 b2015 V/1982, *(Stein 1986, pp. 235–36)* VGM Archives

My dear Doctor,

It seems that it has been too long since I have written you to keep you abreast of what concerns us both.

This is because I do not yet feel completely well; my head spins, and writing anything makes me somewhat dizzy.

My nerves have again taken the upper hand.

I hope with all my heart that you, at least, are entirely recovered.

I have heard from Bernard that he saw you and that you went together to the grave, where there were already sunflowers (I do not need to ask from whom—thank you, thank you!) and where the stone had been set.

He said that the stonecutter's work was well done.

I have promised myself to pay a visit as soon as I can to the little corner where he rests.

As for the exhibition, I saw Durand-Ruel, senior, who came by my house and found the drawings and several paintings "very interesting"; this was his expression. But when I spoke of the exhibition, he told me that the public would hold him forever responsible if anybody were to laugh, so he was postponing his decision until he had seen the canvases at Tanguy's. He promised to come and get me the following week, but he didn't show up.

Later, I saw the son, who told me that he didn't think his father was reluctant and that in the winter he would have no objection to lending the gallery for this purpose.

I hope this can be done, because by permitting these masterpieces to go ignored I would hold myself to blame, nor could I ever forgive myself if I did not do everything in my power to try to bring this about.

I also received a visit from M. Aurier, who came by one evening to discuss the book that has to be done. He appears entirely determined to do a book on the one for whom we still mourn, and M. Manzi told me that he would be happy to etch the plates for it.

I am sending you a proof of the lithograph you like. I am sending it unmounted because if you want to make an etching of it, you might prefer to retrace it on the back so that the etching comes out in the same direction as the original.

Now I must also tell you that I had a visit from Antoine, the actor's brother, who is an editor at *Art et critique* and appears to have some influence there. If you want to publish something on Vincent, as you were intending to do, he says that there would always be a place for it in his paper and he is sure that you could have all the space you might want.

Needless to say, I would be as happy as can be to read what you thought of him in print, and what you already say so well in your letter that I sent to my mother so that she might see the opinion certain people hold of him. If you have continued your study of him, you really mustn't leave it in a drawer, where only a privileged few would know of it.

Which seems preferable to you, the exhibition at Durand-Ruel's, if one were able to obtain it, [or] a separate gallery in the Pavillon de la Ville de Paris at the time of the Indépendants exhibition?

Signac suggested the latter idea and said that it would not be impossible to obtain it, since it is almost certain that they will do so for Dubois-Pillet.

I would be so glad to be able to chat with you again; you would give us great pleasure if, as soon as you are able, you would come for a simple dinner and we had another evening to chat of almost nothing but Vincent.

My wife has already reproached me several times for letting you wait too long for news, and she sends her best regards.

Please be so good as to remember me to everyone at home, and believe in my sincerest friendship. . . .

T. van Gogh

Dr. Gachet to Theo, October 4, 1890
(Newly translated and published)
b3267 V/1966, VGM Archives

My Dear Friend,
> Received your letter
> Very happy!
> [Illeg.], and arms are [illeg.]!
> Regards to Madame Vhèndan
> a smile to Baby
> > Yours,
> > P. F. Gachet
> > Saturday 4 Oct., 90

Andries Bonger to Dr. Gachet, October 10, 1890
(Gachet 1994, pp. 290–91; newly translated)

Dr. Gachet Paris, October 10, 1890
Auvers 54 rue Blanche
Dear Sir:
Since yesterday my brother-in-law Van Gogh has been in an overexcited state that has left us seriously concerned. If it is at all possible for you, we would be extremely grateful if you could go see him tomorrow, claiming simply to be paying an unexpected social call.

Everything irritates him and puts him in a rage.

The overexcitement was caused by a dispute with his employers, as a result of which he wants to set up his own shop without delay.

The memory of his brother haunts him, so much so that he becomes infuriated with anyone who doesn't see things his way.

My sister is at her wit's end and doesn't know what to do.

I hope it will be possible for you to come; if not, please be so kind as to write me a word of advice.

With my apologies for disturbing you and my deepest respect,

Sincerely yours,
A. Bonger

Johanna van Gogh to Dr. Gachet, October 12, 1890
(Gachet 1994, pp. 290–91; newly translated) b2013 VF/1982, VGM Archives

Dear Monsieur Gachet,
My husband is very ill at the Maison Dubois. Please come by one time to see him, if you can.

Anxiously,
Mme Theo van Gogh

Andries Bonger to Dr. Gachet, October 16, 1890

(Gachet 1994, pp. 291–92; newly translated) b887 V/1975, VGM Archives

Paris, October 16, 1890
54 rue Blanche

Dear Doctor,

Dr. Meuriot could not give permission yesterday to see v. Gogh, as he feels that his condition requires the utmost calm. His physical state has improved greatly; at 10 o'clock in the morning, he was able to walk in the garden.—Dr. Blanche had not examined him yet. We hope that he can still give us some hope of a cure.

With cordial wishes from all of us to you and yours,

Sincerely,
A. Bonger

Albert Aurier to Dr. Gachet, October 22, 1890

(Gachet 1994, p. 292; newly translated) b888 V/1975, VGM Archives

Dear Sir,

An absence of some days prevented me from replying earlier to your letter of last Friday. Please forgive this tardiness and accept my thanks for the tickets that you sent me but that I have not, unhappily, been able to make any use of.

The misfortune you had foreseen has occurred just as you wrote me, and nothing remains but to do our duty as friends—perhaps also to hope, because Dr. Blanche himself reportedly has said that all hope of recovery is still not absolutely lost; let us wish that the Future makes good on these words.—

Please accept, dear sir, my most devoted respects.

G. Albert Aurier

Lucien Pissarro to Dr. Gachet, May 12, 1891

(Newly translated) b885 V/1975, VGM Archives

28 Cornwall Road
Bayswater
London
Dear Dr. Gachet,

I have friends here, artists, who are very interested in our poor friend Vincent van Gogh; they have seen the etching he did at your home and they would be very pleased to have a print of it; if you agree, we could make a trade. I will send you either proofs of my latest woodcuts or a drawing or a watercolor, whichever you prefer. I saw in your catalogue that you have had a fairly complete exhibition. The "Indépendants" must have been very interesting this year—I was rather pleased with the minor success of my woodcuts, but it doesn't get me very far, as no publisher will ask me for a drawing or etching only on the strength of that.

Kindly extend my best wishes to your family, as well as to M. and Mlle Murer.

Your young friend,
Lucien Pissarro

Andries Bonger to Dr. Gachet, August 26, 1891

(Gachet 1994, p. 294; newly translated)

Dear Doctor,

It is with great pleasure that we accept your kind invitation for next Sunday.

I would have written you well before this to tell you of our visit, as I had promised, but my wife was in Holland for several weeks.

Our friend Bernard will not be able to join us: he has been in Saint-Briac for nearly two months, and intends to stay there until the beginning of October.

As you suggested, we will take the 10:25 train and get off in Chaponval.

With our cordial best wishes for you and yours, I remain,

Yours truly,
A. Bonger

Paul Gachet *fils* Remembered

MICHAEL PAKENHAM

As a student I was fortunate to be introduced to Van Gogh by a magnificent exhibition of his drawings held in Manchester. Of Auvers and Dr. Gachet I knew next to nothing.

The first time I ever learned anything of consequence about the doctor was during a conversation with a Chinese artist and friend, Tseng Yu, during the academic year 1957–58, which I spent in Paris on a French government scholarship. The research I had begun there for a thesis on an avant-garde journal called *La Renaissance littéraire et artistique* (1872–74) would not necessarily have taken me to Auvers, although the last issue of the review did contain an article hostile to the Impressionists. That I went there I owe to Richard Lesclide, managing editor of *La Renaissance* in 1873, who subsequently published *Le corbeau* (Poe's *The Raven*) illustrated by Manet, and to Ernest Cabaner, a legendary bohemian who became the poet Rimbaud's first biographer. To my surprise they were both mentioned in Paul Gachet's biography of his father, a work I came across during a visit to the Jeu de Paume museum. Excerpts of letters from Lesclide to the doctor intrigued me. A correspondence therefore still existed! The sequel is too long a story to tell; suffice it to say that in the end M. Surirey de Saint Rémy, chief curator of the Bibliothèque Historique de la Ville de Paris, readily agreed to acquire Lesclide's letters for the library. He informed me that the doctor's son was still alive and even gave me his address. However, I did not contact him straightaway; I preferred to wait until this precious package became the property of the Bibliothèque. It was on December 10, 1960, that I finally wrote to M. Gachet.

I quickly received some very interesting news. "To sum up," Paul Gachet replied, "the only information I have bears upon friends of my father whom I myself knew: Cabaner, Richard Lesclide, Amand Gautier." This meant that I was corresponding with someone who had actually seen Cabaner, a man seventy-nine years in his grave! I think what M. Gachet liked about my overture was the fact that I was not one of the many curiosity seekers who

wanted to visit his house, if only to boast about it afterward, and that I was the odd duck concerned with something other than the painters of Auvers! In due course I submitted my text on Cabaner[1]—an eccentric if ever there was one—to M. Gachet for his approval; he was kind enough to answer that the pleasure of reading it had prepared him to make my acquaintance. I certainly could not turn down an invitation to visit him once the weather turned warm.

In May 1961 a surprising literary event led me to contact Gachet immediately. The *Mercure de France* had just published excerpts from the *Album zutique*, a parodic collection of poems written for the most part by Rimbaud, Charles Cros, Verlaine, Léon Valade, Cabaner, and Germain Nouveau. They included an unpublished sonnet by Valade dedicated to Cabaner. M. Gachet thanked me for sending it to him and proposed to assemble, with me in mind, his documentation on Lesclide, *Paris à l'eau-forte*, and several Impressionist prints that he thought might interest me. At the time I knew nothing, alas, about the history of printmaking, which is why, en route to Dr. Gachet's house on Saturday, July 15, 1961, I was more preoccupied with Richard Lesclide than with the aforementioned prints. I arrived at Auvers early, since the familiar postmark on Gachet's letters—"AUVERS-SUR-OISE / ses Sites / ses Monuments / ses PEINTRES," with a reproduction of the church painted by Van Gogh—had incited me to do some artistic touring. When I finally found myself at the gate of his residence, half hidden from the road, I wondered what awaited me on the other side, for very much in evidence on the flight of steps was the famous sign "NE REÇOIT PAS" (No Admittance); it sent cold shivers down my spine, and I hesitated before ringing the bell, even though I had a two o'clock appointment! Obviously the sign had been forgotten, an oversight that rather embarrassed M. Gachet, who came out to unlock the gate himself, accompanied by his secretary, Mme Lizot.

I won't describe in any detail this curious personage wearing a military-style jacket. He ushered me into his

living room, where the visitor's eye was drawn in every direction. What struck me most about my host, an old man who had just spent the winter mostly bedridden, was his verve, his sprightliness. No doubt he was performing his "song and dance act," as Mme Lizot put it, the same routine served up to all visitors, but I choose to believe that he was motivated by the desire to help a young foreign scholar.

Still, I could never have foreseen that I would leave Auvers laden with such gifts as a sketch of Cabaner, his visiting card, information about his movements, and the *Album de douze eaux-fortes* by Van Ryssel *père* (Dr. Gachet), or that I would be shown early impressions of several prints, my favorite being Cézanne's *Head of a Young Girl.* M. Gachet showed me other treasures besides the Cézanne—five Camille Pissarros, a Sisley—while indicating that these were for sale and proposing a very modest price. Unfortunately, even a modest price was beyond the means of an impecunious English instructor, but I could spare fifty francs to purchase a copy of Georges Rivière's *Renoir et ses amis*, annotated and with additional illustrations inserted, which was a boon for my research. Lest there be any misunderstanding, M. Gachet explained himself in a letter of July 19:

> I feel somewhat apologetic about having shown you so many things that fall outside your present domain. I'm sure you will understand, my motivation wasn't that of an antique dealer but of someone who seeks to complete honorably a work devoted to the memory of a poor sick artist, a work well worth doing—the way I conceive it should be done—because it is, above all, sincere and serious.

Sincerity combined with exactitude was the particular mix of virtues that had won me over when I read *Deux amis des impressionnistes*. There was also the fascination of entering a world in which the likes of Cabaner, Nina de Callias, and Lesclide, colorful characters now forgotten or neglected, had known Manet, Cézanne, and Hugo, among other famous people.

Despite his excellent memory, Gachet could not recall every last detail, but unquestionably he knew inside out the vast documentation accumulated by his father. He had spent years classifying it, transcribing it, annotating it, and availing himself of it to write his own booklets and the biography of Dr. Paul Gachet. He also produced the catalogue of the Gachet collection.

His diligence in checking and researching never slack-ened. The best example I can give occurred six weeks before his death, when he asked me to unearth some information about a certain Demirgien, a friend of Toulouse-Lautrec. I was unable to enlighten him, but he thanked me anyway, and, writing from his bed, to which he had been confined for three weeks, added: "It's really quite sad! I have work to do and can't contemplate it." This did not prevent him, at our last meeting, a week before he died, from asking me as soon as I appeared how my research was progressing. Had I made any important finds?

During my visits he obviously often spoke of Van Gogh—about his loathing for the Zadkine monument to Vincent, which he considered a betrayal of the man, about Theo's reburial in 1914, about his book on Vincent, which was already four hundred pages long and which he wanted to publish with a hundred illustrations.[2] He never doubted his value as a witness and even maintained that he was the only one who had really known Vincent. He would say, mysteriously, that he could not reveal everything because of the Van Gogh family. One day, trembling with indignation, he inveighed against *Les cahiers Vincent van Gogh* for casting doubt on the authenticity of Vincent's only known etching.

He spoke as well of his forty or so donations: costumes to Sceaux, his grandfather's medals to the Mint, Mlle Gachet's piano to the Musée Instrumental de Bruxelles, etc. It wasn't braggadocio but his way of saying, in a familiar refrain, that everything had been "honorably" placed. He had even bought Courbet's portrait of Amand Gautier to give it to the Musée de Lille. For him, sentimental value transcended even aesthetic value. He no longer visited the cemetery, but he confided to me that not a day or an hour passed without his sparing a thought for the departed.

He was reluctant to speak about himself, but I found out that his father had prevented him from going to the Congo with the explorer Clauzel, a family friend. Like other survivors of the First World War, he would say that he had been lucky to come through. All I knew is that he had been a machine gunner at Amiens and had spent ten days without rations, then days more on a forced march of sixty kilometers. He told me how, between 1914 and 1918, his wife and sister had no choice but to climb a ladder to their bedrooms because he had not had time to finish rebuilding the staircase before leaving for the front.

On one occasion he summoned up memories of his friend the English artist Tony Aryton, who knew him well enough to call him "Uncle Paul." I believe that this friend-

ship had predisposed him in my favor. Anyway, I had the honor of being invited twice in December 1961: on the twenty-second, then on the twenty-fifth.

On the twenty-second, during a desultory conversation, he spoke of Dr. Victor Doiteau, of John Rewald, whose most recent book presented nothing new, of the political situation, which he judged to be dismal; and he showed me a lot of things, including composite albums of original documents concerning Félix Buhot, Manet, and Norbert Goeneutte, which he himself had bound. I noticed once again his light blue eyes, the whites still very white.

A surprise treat lay in store for me on Christmas Day. As soon as I arrived I was led up to the third floor, where a feast of colors greeted me. Canvases were all around: paintings by the Van Ryssels *père* and *fils*—still lifes, portraits of M. Gachet's sister at the organ and with a pet bitch (*Les deux miss*), a portrait of himself, his own pastel of a cat's head, several snowy landscapes, a pig's carcass—two Rembrandt etchings, including *Dr. Faustus* (both modern impressions, he told me), a pastel by Armand Guillaumin, the famous print of *The Man with a Pipe*, a drawing by Cézanne, and the large canvas by Dr. Gachet called *Railway Accident* (1879), known previously only from a lithograph. Most of these works were sold at auction in Pontoise in 1963. That I, a foreigner alone in Paris, had been invited on a family day to share his Christmas repast moved me deeply.

At Eastertime he had to receive me in his room, where he lay bedridden, with a portrait of his father on the wall behind him. Nothing felt right, he said; if this was really the end, he wanted it to come straightaway. But he also wanted another year or two. Finding a publisher for his big book on Vincent preoccupied him, since he could no longer afford to do what he had done for the *Lettres impressionnistes*[3] and bring it out at his own expense. He was a little sorry that he had been so generous to the State. "I shouldn't have given away *everything*" was his final comment.

That Easter day in 1962 I sat alone at table. The dining room seemed terribly empty without the spirited presence of the master of the house. But when I went upstairs again to M. Gachet's bedroom, my gloom evaporated: despite his greatly weakened condition, he showed the same vivacity, the same alertness, the same keen desire to resume his labors.

In a letter of May 10, 1960, to Pierre Ripert, twelve years his junior, Gachet exclaimed: "Just think, most of my correspondents are young people whom I address as if they were contemporaries, yet regale with stories about times they never knew!" However odd it may seem, I think I was already enough of a nineteenth-century scholar for him to consider me an old hand. In any event, our common concern with the forgotten and the scorned, with painters labeled "secondary," secured our affinity. That was how Paul Gachet expressed it on July 19, 1961:

> The word telepathy is not meaningless between two men who understand one another so well. You doubled the dose [i.e., price], a gesture whose sensitivity touched me. Since it's out of print, the Renoir book may be worth as much as your estimate, but I didn't want to profit from a young man studying some out-of-the-way Frenchmen. As a rule, I'm drawn especially to obscure people, obscure people who have something in their *belly*—(belly = head plus heart).

According to Odette Barenne, a friend of mine, who wrote to me on October 19, 1961, after visiting Auvers at my request, it may have been more than an affinity: "We saw *absolutely nothing* outside the room in which we were received, which I took to be his dining room. It became clear in subsequent conversation that you've won the *affection* of M. Gachet (you win the hearts of everyone!), who sees in you what I would call a kind of spiritual son!"

One can imagine how moved I was to learn from Mme Lizot that I had been the last *friend* to see him alive. Perhaps the memory that stirs me more than any other is the remark he made at the end of my visit of December 25, 1961, when he was still vigorous: "It was damned good to see you again, Pakenham."

1. Who could have foreseen that this text would provide the basis for *Cabaner poète au piano*, written in collaboration with Jean-Jacques Lefrère, published by L'Échoppe in 1994?
2. It was published posthumously (Gachet 1994).–Ed.
3. Gachet 1957a.–Ed.

Chronology

PAUL GACHET

Paul Gachet *fils* compiled a chronology/biography of his father in a number of versions. Published here in full is a manuscript entitled "Dr. P. F. Gachet, Curriculum Vitae composé d'après souvenirs et documents par Paul Gachet, Auvers 1928," which was made available by Dr. Michael Pakenham. It is the oldest and most complete version, to which we have added some very brief notes, without systematically making reference to the documents Paul Gachet used. He later gave the documents to the Musée d'Histoire de la Médecine in Paris, where they can be consulted.

AD

1828
July 30
Birth of Paul-Ferdinand Gachet in Lille (North) at 6 in the morning, at 19, rue du Priez. That same evening, his mother attends a family dinner.[1]

Amand Gautier,[2] who will later have a marked influence on his artistic life, is three years old (born in Lille on June 19, 1825).

1830
The future "Citizen of '48" is only two years old.

1833
The family lives in Lille, on rue des Canonniers, in the private *hôtel* of the Marquis d'Aigremont.

1836
At the Collège de Lille, in 8th (Latin).

From this period is a composition book for writing (calligraphy) for New Year's Day.

1840
At the age of twelve, his portrait is painted in oils by Edmond Lemoine.

Jumps into a ditch from a rampart on the old Lille fortifications; this act of daring earns him a bad sprain, the effects of which he will feel for the rest of his life.

1842
In Lille he learns watercolor painting with his friend Ambroise Detrez,[3] who is at the time a student at the Écoles Académiques; Detrez will later be a painter of historical scenes, genre scenes, and portraits and a painting teacher at the Académie de Valenciennes.

1843
Distinguishes himself during a fire in Lille, when he manages to save several horses; as he brings the last one out, the roofs of the blazing structures collapse behind him.

1844–45
Monsieur Bernard, an industrialist in Lille, sends Louis Gachet (his father) to Belgium to start a new branch of the textile house.

The family moves to Malines.

P. Gachet's earliest oil painting is inscribed on the verso, "Malines, August 25, 1845 (No. 2 canvas—*La lecture?* after Teniers?)."

He learns Flemish.

1848
August 2
Applies for the post of student military surgeon. One must hold a Bachelor of Arts [*lettres*] degree, which he does not.

1848
He goes to Paris.

November 13
Bachelor of Arts (University of Paris).

November 15
Enrolls for the first time at the Faculté de Médecine (medical school) in Paris (4th trimester, 1848).

November 24
Authorized to take courses at the military hospital in Lille.

December 20
Charles-Louis-Napoléon Bonaparte vows to uphold the Constitution.

1849
January 2
Second enrollment at the Faculté de Médecine in Paris.

April 4
Third enrollment.

April 14
Bachelor of Science [*sciences physiques*], University of Paris.

May 16
In Lille he requests the candidacy requirements for the rank of naval surgeon, 3rd class.

May
Signs up for two years of voluntary military service (as a student of military medicine).

June 4
His father gives written consent for a two-year engagement with the 7th Light Cavalry regiment.

June 6
Enlisted in the military (army record).

June 7
Draft board at Prefecture Headquarters in Lille; housed at the time at 46, rue des Fossés-Neufs.

June 15
Attached to the 4th squadron of the 7th Light Cavalry regiment, in Arras. (Serial no. 2647. His horse is named Cupid, no. 2437.)[4]

1849
Fights a duel with swords against an old veteran, whom he wounds.

July 6
Fourth enrollment at the Faculté de Médecine in Paris.

His address is Passage Colbert, stairway E, no. 1 bis, although he has not been discharged.

October 31
The Faculté notifies him that his enrollments will be canceled if he is absent for another academic year.[5]

December 9
Replaced in the Corps after roughly six months of service by the infantryman Potier (Replacement and Good Conduct certificates).

1850
January 3
Lives at the Hôtel des Thermes, 66, rue de la Harpe, with his cousin Émile Sailly, who is also a medical student in Paris.

For the sake of economy, his mother recommends that he and his cousin "together rent and buy 4 or 6 chairs, a table, a washstand, a pan, which should all be chosen with Petronilla."

January 11
Fifth enrollment at the medical school.

April 15
Sixth enrollment.

April 23
Closing of the military medical schools.

Based on a report from the minister of war (d'Hautpoul), the president of the Republic decrees the closing of military finishing hospitals at the Val de Grâce and of teaching hospitals in Lille, Metz, and Strasbourg.

July 15
Seventh enrollment.

October 21
Certificate of six enrollments obtained in order to be admitted as a student in the hospitals.

October 22
Certificate of vaccination obtained for the same purpose.

October
Leaves rue de la Harpe and goes to live at 36, rue Dauphine, where he will stay until October 1851.

November 15
Eighth enrollment.

1851
June (?)
Extern in the hospitals and hospices.

Appointed to the Hôpital Sainte-Marguerite.

July 8
Ninth enrollment.

September 5
Hunting license (North prefecture).

October
Address: 47, rue de Seine.

December 2
Coup d'état.

Extern at the Hôpital Sainte-Marguerite (children's division).

Studies under Trousseau. Entry pass from the director of the hospital.

Death of Baudin.

December 3
His friend is Marc Sée. Letter to the concierge[6] at 47, rue de Seine (De Chintreuil house), today at the corner of rue Jacques-Callot.

December 16
Ballot on the plebiscite submitted to the French citizenry.
Election card: Gachet, student, 46, rue Dauphine. (The card
is addressed to his former lodging and erroneously gives
no. 46 instead of 36.)

1852
January 21
Admission card to the anatomy amphitheater.

April
Lives at 10, rue de Seine (Saint-Germain), in a building that
houses the Imprimerie Lenormand, his landlord.

April 8
Having come to Paris in January 1852, Amand Gautier[7]
enters the École des Beaux-Arts in the studio of Léon
Cogniet.

August
Extern at the National Health Services (Maison Dubois),
then located at 110, rue du Faubourg-Saint-Denis (director:
M. Brau).

Student of Vigla (physician) and Monod (surgeon), both
licensed professors at the Faculté de Médecine.

His friends among the interns: Vidal, Perrier de la Pelterie,
Tailhardat.

1852
Ambroise Detrez paints a portrait of him at age twenty-four
(oil, Gachet collection).[8]

1853
Becomes friendly with the painter Édouard Sain,[9] a friend of
Gautier's.

Member of the Paris medical hydrology society.

Bronze medal; former student of the Paris Hospitals.

Tenth enrollment (4th trimester) in Paris.[10]

1854
January 14
Eleventh enrollment.

March 2
His friend Perrier de la Pelterie writes to invite him to
Bicêtre, so that he can introduce him to the director and get
him a position as intern for supplemental duty.

April 3
Twelfth enrollment.

August 22
Voluntary mission to fight the cholera epidemic, commissioned by the Ministry of Agriculture and Commerce.

Order of departure.

Amand Gautier accompanies his friend Gachet, whose
cousin (Dr. Sailly) leaves at the same time to fight the plague
in the Aube region.

Curious sketches by Amand Gautier.

Dr. Durieux from Paris is also in the Jura.

Death of Drs. Fuands (at Lons-le-Saunier) and Bouvier (in
Messia). See the *Almanach de la santé* for 1874.

P. Gachet himself comes down with the plague.

Lons-le-Saunier arrondissement (Vicomte de Chambrun,
prefect):

September 26
Gatey.

September 28
Asnans.

October 3
Peseux.

October 6–10
Frébuans, Chilly, Saint-Georges.[11]

Dôle arrondissement (M. de Toulangeon, sub-prefect):

October 1
Damparis, Foucherans, Labergement, La Ronce, Bellevoye,
Laborde.

1854
Meets a cousin, Édouard Petit, a lieutenant in the 5th
Dragoons regiment in Dôle.

October 6
End of his mission to combat cholera in the Jura. He leaves
Lons-le-Saunier with his colleague (Dr. Durieux from Paris).
He returns via Lyons, where he stays for two days, then
Chanaz, Aix-les-Bain (Savoie), sometimes down the Rhône
on a steamer, sometimes in a coach.

October 11
He writes to friends from aboard the *Hirondelle*, "in port at
Hières."

October 13
In Geneva he crosses the lake in a boat and visits Lausanne.

October 15
Paid 24.10 francs for two seats in the coach from Nevey to
Bern.

October 16
Paid 26.50 francs for the Soleure coach to Basel from Bern(?).

1854
Visits Strasbourg.

Amand Gautier does a portrait of his friend[12] (painting: 32.5 x 27 cm).

Year 1854 (?)
He makes the acquaintance of the Baron de Monestrol, the leading homeopathist.

December 5
Extern at La Salpêtrière on this date (see the thesis by Jules Renaul du Mottey).

At around the same time, Dr. Blondel is also his comrade in the 5th Division. Later, he will be the doctor who delivers Mme P. Gachet's children.

1855
Year
Extern at La Salpêtrière (under M. Trélan).

Year
Extern at the Old People's Hospice (for women) at La Salpêtrière (under Dr. Falret).[13]

1855
Requested by Dr. Falret (psychiatrist at La Salpêtrière) as extern in 1856.

Amand Gautier, introduced at La Salpêtrière by his friend Gachet, makes numerous life studies for his painting *The Madwomen of La Salpêtrière* (Salon of 1857).

He paints the portrait of Dr. Falret, psychiatrist at La Salpêtrière (5th Division, 1st Section).

"A princess at La Salpêtrière."

February 1
Silver Medal in Epidemiology (from the Ministry of Agriculture, Commerce, and Industry) for Cholera, 1854. His cousins Émile Sailly and Alfred Petit are awarded the same distinction.[14]

July 16
Thirteenth enrollment.

September 12
Travels inland (from Lille to Paris).

September 15
Through an old friend of his father's, he is introduced to the Baron Michel de Trétaigne (on rue Marcadet in Clignancourt, near Paris), the owner of a well-endowed gallery of paintings, sculptures, drawings, and art objects—

and who, moreover, has a number of connections that could prove useful to the student (the gallery is sold after 1870).[15]

October
In Bordeaux he meets Richard Lesclide[16] and the painter Brascassat[17] (Jacques-Raymond, 1804–1867), whom he looks up on the recommendation of his friend Tailhardat, also from Bordeaux; Tailhardat temporarily takes over some of his patients in Paris, at 10, rue de Seine (Saint-Germain).

November 8
Fourteenth enrollment.

1855
In Lille he meets Dr. Jean Cabrol,[18] the head physician (2nd class), appointed to Lille Hospital on December 15, 1854, and remaining there until May 14, 1855.

Physician to the Maréchal de Saint-Arnaud, head physician of the Staff Major of the Eastern Armies; Cabrol will later become Gachet's friend and mentor.

1856
January 11
Fifteenth enrollment.

February
Extern at the Old People's Hospice (for men) in Bicêtre, under M. Voisin; must switch with an extern in the service of Dr. Andral from La Charité.

March 4
Note signed by Maisonneuve "to authorize M. Gachet, extern in Bicêtre, to serve as an extern in my wards" (Hôpital de la Pitié).

March 12
Recommended to the Ministry of War by the Ministry of Agriculture, Commerce, and Public Works for a mission in Constantinople. Nothing comes of this.

April 4
Sixteenth enrollment.

June 5
Portrait in graphite by Amand Gautier, during a reunion in Paris of the three friends, Gautier, E. Delergue, and Gachet.

1856
Friendly relations with the painter Paul Guigou, a friend of Gautier's.

1857
Extern in Lourcine (under Mozel-Lavallée).

June 14
Charles-Henri-Théodore Ferru, born in Lille, a childhood friend of Gautier and Gachet, writes him from Montpellier,

where he has defended his thesis for his doctorate in medicine (1857), to suggest he take his exams at the medical school in Montpellier.

June 20
Gachet leaves to earn his doctorate in Montpellier, bearing a letter from Dr. Falret for Lordat, a professor of physiology at the Faculté de Médecine, and a letter of recommendation from Courbet for Alfred Bruyas,[19] the patron of Montpellier's art museum.

He first lodges in Mme Mossart's house at 8, rue Barville, then boards with Mme Renault (the mother of Mme Pouget) on rue de la Barallerie.

1858
March
The Comte de Toulongeon (15, rue d'Isly), former sub-prefect of Dôle, tries to have him decorated for his actions during the cholera epidemic.[20]

June 16
Corresponding member of the Société Médicale d'Émulation of Montpellier.

June 18
Authorization to leave Montpellier after obtaining his doctorate.

June 21
Doctor of Medicine (University of Montpellier).

October 16
He signs a lease[21] for an apartment at 9, rue Montholon, effective January 1, 1859, but leaves 10, rue de Seine and moves in before that date. He announces a "special treatment of nervous ailments in women and children." His office hours are Monday, Wednesday, and Friday from 3 to 5 p.m. Price of a visit: 5 francs.

1858
In the company of his positivist friend Dr. Eugène Semerie, then an intern at Charenton, he visits Charles Méryon.[22]

He considers an apartment in Passage Saulnier for his medical offices.

1859
January 8
Receives his medical diploma.

August 18
After Alfred Delvau, the author of *Cafés et cabarets de Paris* and a journalist at *Le Figaro,* writes "Les dessous de Paris: la 5ème division à la Salpêtrière" (Aug. 9, 1859), Dr. Gachet responds with an article of rebuttal in the same newspaper (Aug. 18, 1859).

August 25
Pays 23 francs for the canvas on which Amand Gautier paints his full-length portrait[23] (Troyes Exhibition, 1860; Salon of 1861). After long figuring in the Gachet collection, this work is now in the Musée de Lille.

1859
Amand Gautier exhibits a pencil drawing, *Asiatic Cholera in the Jura,* 1859.[24] The number 243, still visible on the glass mount, is from an unidentified exhibition. The drawing is a recollection of an episode from the epidemic of 1854, depicting Dr. Gachet, whom Gautier had accompanied to the Jura. It is now housed at the Wellcome Museum of Medical Science in London (Gachet collection).

1860
April 23
Appointed commissioner of the Public Assistance Bureau for the 9th arrondissement (until 1861), 1st subdivision of the 11th Division.

June
The portrait painted by Gautier (*Portrait of Dr. G.*) is shown at the Fine Arts Exhibition in Troyes.

1861
May 1
The same portrait is accepted for the Salon of 1861 (*Portrait of Dr. G.,* no. 1227). It has been at the Musée de Lille since December 31, 1909.

May 14
Having fallen ill, his friend and colleague from the hospitals, Perrier de la Pelterie, names him executor of his will (letter of June 20, 1861).

August 20
Letter from J. M. Guardia, librarian of the Académie de Médecine, a friend of Tailhardat and an acquaintance of Dr. Falret, regarding a paper sent to the Académie (see below).

August 27
Paper presented to the Académie Impériale de Médecine by Dr. P. F. Gachet concerning a case of cardiovascular ectopia: Mlle Ernestine Elie (21 years old), one of Gautier's models[25] (*Bulletin de l'Académie de Médecine,* session of Aug. 27, 1861, p. 1174).

November
He visits Courbet in his studio on rue Notre-Dame-des-Champs, where he sees the famous live ox that serves as the painter's model.

1861
Member of the Société de Secours des Amis des Sciences, founded by Baron Thénard on March 5, 1857, to which his famous friend, the chemist Dubrunfaut, is a major donor.

1862

He is house doctor of the Théâtre des Délaissements Comiques, whose director is Cassanova, a friend of Jean de la Rocca's.

The full-length portrait of Dr. Gachet is made into a lithograph by Émile Vernier, completed by Gautier.

January 15
Publishes several articles in *L'avenir de la Corse* (a Bonapartist magazine edited by De la Rocca), including pieces on "the medical topology of Corsica" and "eating habits."

February 18
Accepted as M.: (L.: Sincere Friendship; O.: from Paris). Diploma signed by the Maréchal Magnan, Grand Master of the O. M.

June 15
Review of Mattéï's book *L'art des accouchements* in *L'avenir de la Corse,* signed Dr. P. F. Gachet.

July 4
Member of the Association des Médecins de la Seine (?). His sponsors are Drs. Destouches and Orfila, the association's general secretary.

July 10
In Lille to treat his sister-in-law, who dies of pulmonary congestion on July 10, 1862, at 16, rue de l'Arc. Tailhardat fills in for him at his office on rue Montholon.

August 19
In Boulogne-sur-Mer, 31, rue du Pot-d'Étain.

October 31
His landlord on rue Montholon, M. Héron de Villefosse, agrees to cancel his lease as of January 15, 1863.

1863

January 1
Moves his medical offices from 9, rue Montholon to 78, rue du Faubourg Saint-Denis[26] (building owned by Mlle Carlotta Grisi). Circular letter of January 1, 1863: "Electro-medical practice—Nervous ailments—Chronic ailments—Treatment by electricity. Free consultations on Wednesday and Saturday at noon, at the Saint-Martin Clinic, 31, rue du Vert-Bois. Paid consultations on Monday, Wednesday, and Friday at 3 p.m., 78, rue du Faubourg Saint-Denis (see green card)."

January 14
Travels to Monaco, then to Nice, where he meets up with Dr. Cabrol.

April 15
Death of his mother, Clémentine-Thérèse-Joséphine Cuvillon (wife of Louis Gachet), in Lille.

May 23
As he has not declared his change of address, an electoral card lists his residence as 9, rue Montholon.

May 28
Doctor at the thermal spa of Évaux (Creuse). Leaves Paris (via the Gare d'Orléans) for Montluçon at 8:30 p.m. on Thursday (May 28, 1863), then boards a coach at Évaux. Takes lodgings with Mme Picaud (letter from the Marquis de La Rocheaymon).

His friend Tailhardat temporarily takes over his practice on rue du Faubourg Saint-Denis.

October
End of the season at Évaux.

1864

January 1
Registers for a course with his friend Achille Ricourt, a professor of diction at the Théâtre d'Application (Théâtre des Jeunes Artistes) at 16, rue de la Tour-d'Auvergne.

January
He presents the Duc de Saxe-Coburg-Gotha with his report on ophthalmia in the armed forces.

April 9
Free consultations for nervous and chronic ailments at the Saint-Martin clinic now take place at noon at 78, rue du Faubourg Saint-Denis.

June
Trip to London. His address is 2 Little Stanhope Street, Mayfair. He visits the National Gallery and the British Museum, the College of Medicine and the College of Surgery. He meets Drs. Fergusson, Lindsay, Pardrige, and Dickson.

September 19
R.: C.: brief, signed by the Maréchal Magnan.

November 14
"I confirm that for my service in the 1st Co. of the 9th Battalion of the Paris National Guard, I was issued a rifle with bayonet no. 729," etc.

1865

He owns a small house in Berck, a cabin in the sand; this allows him to paint a number of watercolors from nature and later to do several etchings.

Unremunerated courses in anatomy for artists at the École Municipale de Dessin et de Sculpture [Municipal Drawing and Sculpture School] at 19, rue des Petits-Hôtels in the 10th arrondissement (1865–67).[27] Some classes feature live models. The director is Justin Lequien.

July 31
Imperial decree: Nominated to the rank of Assistant Surgeon-Major for the 9th Battalion of the Seine National Guard (5th, 6th, 7th, and 8th Cos.) (letter from the Staff Major General, signed by General Mélinet).

Letter from Major Allain.[28]

Vow: "I pledge allegiance to the Constitution and fidelity to the Emperor."

August 11
An article, "Hygiène, le choléra," published in *La science pittoresque.*

August 15
Nominated for the Legion of Honor (Désiré Risard).

1866
March

Wedding of Amand Gautier (at the time, the two friends have fallen out). See letter from Ferru.

Under the pen name Chironidès, he writes a presentation article "to the doctors" for specimen R of the little magazine *La médecine pour tous.*

May 17
Series of articles, "Variétés, le café," in *La médecine pour tous.*

May 23
Doctor and honorary member of the Société de Secours Mutuels for the Saint-Vincent de Paul quarter (10th arrondissement).

1867
Member of the Association des Médecins de la Seine.

November 13
Research on ophthalmia in the military, specifically on ophthalmia in Belgium. His study is presented to the king of Belgium.[29]

1868
May (?), until August 1870!
In the spring of 1868 he plans to explore the Paris area (accompanied by his fiancée) to find a country home. Soon afterward, he rents a private house from M. Chaignet at 14, rue des Trois-Frères in Villemomble (rented until April 1, 1871). He meets Pierre Lachambaudie.[30]

September 24, 1868
He marries Blanche-Élisabeth Castets (marriage certificate of the 2nd arrondissement, September 22).

1869
April 1
Founding doctor of the Société de Secours Mutuels for delivery men, employees, and clerks of Paris stores.

June 21
Birth of a daughter, Clémentine-Élisa-Marguerite, at 78, rue du Faubourg Saint-Denis in Paris.

1870
May 12
In *Le vélocipède illustré,* a sports magazine edited by "The Great Jacques" (Richard Lesclide), he publishes a series of articles, "Le Salon de 1870," signed "Bleu du Ciel." Gathered together, they form a pamphlet entitled *Promenades en long et en large au Salon de 1870,* by B. de Mézin.

May 26
Death of his father, Louis-Eugène-Joseph Gachet, former mill owner and member of the city council of Lille, at 12, rue de la Piquerie. Buried in that city on the 29th, in the Cimetière de l'Est.

1870
Silver medal: "Token of gratitude to Doctor Gachet, from the students of M. Lequiem *fils,* 1870" (for his course on anatomy for artists).

May 28
The 9th Battalion of the National Guard is inspected by the Supreme Commander (7:45, boulevard Bonne-Nouvelle); the doctor is in Lille for his father's funeral.

August
In Berck-sur-Mer with his family, at the Hôtel des Bains.

1870
Moves to Villemomble under Prussian fire.

The piano is brought back to Paris.

Later, in Auvers, his friends, the celebrated Belgian musicians Gevaert and Pieter Benoît, will compose several of their works on this instrument.

September
Billet for one soldier (8 days) at 78, rue du Faubourg-Saint-Denis.

September 24
Doctor in the 2nd Ambulance Corps of the Grand Orient de France during the Siege of Paris (armband card).

October 27
Creates "Dr. Gachet's antiseptic liquid," which he successfully uses in the ambulances to treat gunshot and saber wounds. Prepared by Christen, 31, rue du Caire, then by Barral and Dalmon, and finally by Dubat, 80, rue du Faubourg-Saint-Denis.

November 4
He is a founding member of a positivist club created by
Dr. Eugène Sémérie. Dr. Robinet and Gustave Pradeau also
belong.

November 18
(14 Frédéric 82)
Positivist subsidy. Receipt for 5 francs.

1871
January 30
Billet for one soldier (1 month).

January 30
Orders to serve from the Staff Officer of the National Guard
(9th Battalion) for the month of February (Porte de Flandre,
on the 4, 8, 12, 16, 20, 24, and 28).

May 1–June 5
Doctor on call at the Saint-Martin military hospital (head
doctor: Dr. Cabrol, former physician to the Maréchal de
Saint-Arnaud, head doctor of the Eastern Army); section
head of the 2nd Division.

May 8–9
Doctor called upon by the "Commune" to examine skeletons
discovered in the church of Saint-Laurent (Paris, 10th
arrondissement).[31]

May 11
"Paid rent country Chaignet: 300 f." This is the rent for the
house in Villemomble (stay interrupted by the war).

June 26
Saint-Martin hospital (sale), receipt for 208.90 francs.

July 2
Bronze cross from the Société de Secours aux Blessés des
Armées de Terre et de Mer (for service in the ambulance
corps, 9th Battalion).

Same honor (service to the ambulance corps of the Grand
Orient).

July 3
Saint-Martin hospital (sale), receipt for 34.80 francs.

July 18
Foreign passport[32] (Switzerland and Belgium) to visit Henri
Nestlé in Vevey (plan not realized).

1871
Congratulations and thanks from the City Commission of
the 10th arrondissement for services rendered during the
Siege of Paris in 1870–71.

Nominated for the Legion of Honor (Quartermaster
Blaizot).[33]

Late 1871
In Wissant (Pas-de-Calais).

1872
April 8
Aglaüs Bouvenne (a student of Diaz), foreman at
Lemercier's, founds the Société des Éclectiques.

April 9
Dr. Gachet buys the house in Auvers from M. and Mme
Lemoine. He is a retired housepainter, she a schoolmistress;
she ran a boardinghouse on the premises, and even toward
the end of the doctor's life one could still read a sign saying
"Boarding Day School for Young Ladies, headmistress Mme
Lemoine."

Summer
A. Guillaumin is the first to work in the Auvers house: views
of the garden, still lifes, and prints.

June 26
Buys paintings from Guillaumin, buys a Pissarro from F.
Martin (known as "Père" Martin), an art dealer and auction
appraiser at 52, rue Laffitte.[34]

September
Paul van Ryssel (Dr. Gachet) creates if not his first etching,
at least the earliest known one, after a sketch made from life
in the company of Guillaumin: *Sunken Path in the Hautes-
Bruyères.*

October
In Wissant with his family.

1873
Buys paintings by Cézanne (see Note Tanguy Martin).[35]

P. Cézanne works in Auvers. He often paints at the home of
his friend Gachet, rue Rémy, notably still lifes (bouquet,
Dahlias in a Delft Vase [at the Louvre], other flowers in vases,
Urbino Faience, A Modern Olympia, etc.).

Returning from a visit to Pissarro in Pontoise, Cézanne is
accosted on the road by gendarmes; he invokes the name of
his friend Gachet and takes the police to the house.

Richard Lesclide introduces him to Manet. The doctor has
long admired the master's independence and technique,
having followed his efforts, notably since his one-man
exhibition in 1867 on avenue de l'Alma, and even earlier,
since the famous Salon des Refusés of 1863.

April
His friend Richard Lesclide, alias Gabriel-Richard, "The
Great Jacques," founds *Paris à l'eau-forte,* a news magazine
including contributions from P. Van Ryssel (etchings and text).

May 11
Richard Lesclide publishes in *Paris à l'eau-forte* (no. 7, May 11, 1878) an article by Dr. Gachet called "Les chats" (which he reworks), signed G, with nine etchings by Frédéric Régamey.

June 21
Birth of his son, Paul-Louis-Lucien Gachet, in the Auvers house.

Summer
Cézanne rents a small house in Auvers, near Dr. Gachet's, where he often sees Pissarro and Guillaumin. The four of them work on etchings, even Cézanne. Cézanne is going through a difficult period; he paints frequently on innumerable pieces of cardboard. Dr. Gachet intercedes on his behalf with his father, who increases his allowance.[36]

September
In Auvers, Cézanne works on etchings with his friend Gachet; he has even left a sketch showing the two of them during the "biting" process.[37] Several of his rare plates include: *Guillaumin at the House of the Hanged Man, Head of a Young Girl, Landscape, Sailboats on the Seine* after a painting by Guillaumin in the Gachet collection.

November 3
Presented by the Régameys,[38] Van Ryssel (Dr. Gachet) receives his diploma as a member of the Société des Éclectiques.

1874
April 15–May 15
First Impressionist exhibition held at 35, boulevard des Capucines, at the studio of the ex-photographer Nadar. Dr. Gachet lends two paintings: *A Modern Olympia* by Cézanne and *Sunset at Ivry* by Guillaumin. The two other canvases by Cézanne are two views of Auvers, including *The House of the Hanged Man*. Among the other exhibitors, we can cite Astruc (Z.), Bordin, Bracquemond, Cals, Degas, Lépine, Meyer (Alfred), Monet, Morisot (Berthe), C. Pissarro, Renoir, and Sisley.

(December 6)
Mme Gachet, in poor health, leaves for Pau with her two children.

1874
He publishes an *Almanac of Health and Hygiene for 1874* (published by R. Lesclide).

August 31
The mayor of the 10th arrondissement requests that academic honors be conferred for Gachet's courses in anatomy for artists at the École Municipale de Dessin et de Sculpture in the 10th arrondissement (director M. Lequien): not granted.

1875
March 7
The Spinner, an etching by Paul van Ryssel after the drawing by Millet, appears in *Paris à l'eau-forte*, along with an article on the death of the Norman painter and his engraved portrait.

May 25
Death of Mme Blanche Gachet, at 78, rue du Faubourg Saint-Denis in Paris.

1875
He authors a *Yearbook of Health and Hygiene* (published by Richard Lesclide).[39]

Dr. Gachet publishes a "musical meditation" by the late Mme Gachet, *Espérance*,[40] and himself composes a piece of music under the name Van Ryssel, in collaboration with Mlle Jeanne Dutro. He names the piece *Night*, in memory of their first black cat in Auvers.

1877
March 9
Death in the Auvers house of his friend Eletsier, born in Lille in 1825, whom he had taken in for treatment (ex-flautist with the Paris Guard; timpanist at the Théâtre de l'Opéra-Comique).

May
Félix Buhot comes to Auvers.[41]

October
Émile-Jean-Baptiste Godmer models a bust of Dr. Gachet (Salon of 1878).

1877
Dr. Gachet buys the land and thatched cottages in Four [in Auvers] on behalf of his friend Murer.[42]

1878
January 6
He runs for Municipal Council of Auvers-sur-Oise. Listed on a Republican ballot alongside Charles Daubigny. Neither one is elected.

May
The bust by Godmer is exhibited at the Salon (no. 4294; begun in October 1877).

December 8
An article, "Everyday Medicine: The Curability of Chest Ailments," published in the *Patriote de Pontoise*.

1878
Via the Société des Éclectiques, Ernest Cousin, accountant at Lemercier's, Rodolphe Bresdin gets Dr. Gachet's address and writes to him about his children.

1878–79
The "Wednesdays on boulevard Voltaire" are held at the home of the pastry chef Eugène Murer, 94, boulevard Voltaire. The dinners sometimes reunite Pissarro, Sisley, Monet, Renoir, Cabaner, Eug. Gru, and Dr. Gachet.

1879
January 19
Under the pen name Dr. Pangloss, he publishes an article, "Everyday Medicine: Rabies," in *L'avenir de Pontoise.*

January 17
Accident. The evening train from Paris to Auvers is broadsided by a runaway locomotive at La Chapelle. The car in which the doctor is sitting is heavily damaged, and he receives contusions around his liver.

February 16
Under the initials P.V.R. (Paul Van Ryssel) he publishes in the *Patriote de Pontoise* an account of the civil burial of Honoré Daumier, who died on February 10 and was buried on Thursday, February 13, 1879.[43]

1879
Murer, feeling very poorly, comes to spend the summer at the house. He is treated by his friend free of charge.

At Four, a quarter of Auvers, the contractor Joseph Louis, known as "The Truffle," builds him a house under the direction of the architect Perrin.

July 16
New request for academic honors (again refused).

1880
July 14
First and splendid National Festival of the Third Republic. We spend the evening at boulevard Voltaire. Murer has brilliantly lit everything.[44]

1880
Renewed nomination for the Legion of Honor (Faidherbe).

Murer settles definitively in Auvers, where he installs his magnificent collection of Impressionist paintings.

1882
Dr. Paul Gachet exhibits at the Société des Beaux-Arts in the city of Niort. The *député* Antonin Proust, a friend of Manet's, is mayor of that city.

Nominated for the Legion of Honor.

1883
June 26
Appointed deputy physician of the Northern Railway Company for the region stretching from Herblay to Auvers.[45]

1883
Aglaüs Bouvenne publishes *Notes et souvenirs de Charles Méryon,* with four portraits by Dr. Gachet.

1884
March 16
Medical inspector for the Paris public school system (3rd district of the 18th arrondissement).[46]

August 10
Saves the life of Anthony Abrassard, who nearly drowned in the Oise. The family gives him a silver medallion.

1884
He contributes to the *Almanach du vieux Paris* for 1884, edited by the Société des Éclectiques (published by Lemerre), featuring two illustrations by two artists.

The drypoint artist Rodolphe Piguet engraves his portrait for Alexis Martin's *Sonnets Éclectiques* [fig. 26].

October 9
Lifetime member of the Animal Protection Society.

1885–87
Ernest Hoschedé[47] spends several seasons in Auvers.

1887
April 7
Elected president of the Éclectiques.

May
Amand Gautier exhibits *Asiatic Cholera in the Jura* at the Salon, no. 1004, depicting Dr. Gachet when he was a medical student [see fig. 23]. The painter, who accompanied the doctor on his mission (see above, 1854), has portrayed himself as his friend's assistant.

June
The Spinner, an etching after a drawing by Millet, is published in *L'artiste.*

June 15
Active member of the Société Fraternelle des Sauveteurs Médaillés de Seine et Oise (honorary diploma).

November 12
Lecture at the Société Fraternelle des Sauveteurs Médaillés de Seine et Oise, published in *Progrès de Seine et Oise.*

1887
As a transformist and admirer of the scientist Lamarck, Dr. Gachet is a founding member of the Société du Dîner Lamarck with Gabriel de Mortillet, Émile Bin (painter and former mayor of the 18th arrondissement), and Dr. Thulié.[48]

Member of the Société d'Histoire et d'Archéologie of the 18th arrondissement, "Old Montmartre," founded in 1886.

Ca. 1887
Charles Léandre, like Paul Signac a student of Émile Bin (painter and mayor of the 18th arrondissement), sketches a caricature of Dr. G.[49] in the studio (in pencil).

1888
Renewed candidacy for the Legion of Honor (nominated by Testelin).

1890
May 21
Vincent van Gogh, arriving in Auvers, appears at the Gachet house bearing a letter from his brother Theodore for Dr. Gachet (dated May 19).[50]

May 25
At the house, Vincent creates his only etching, *The Man with a Pipe* (a portrait of Dr. Gachet).[51]

June 4
Vincent paints a portrait of Dr. Gachet in the courtyard at Auvers (at the Städelsches Museum, Frankfurt). He makes a copy of it for the doctor (Gachet collection).[52]

June 8
Vincent, along with Theodore van Gogh and his wife and child, are welcomed at Dr. Gachet's house. Two days later Vincent writes to his brother, "The day we spent on Sunday has left a wonderful memory," etc. [LT 640].

June 22
Vincent lunches at the house with his brother Theo, his sister-in-law, and his six-month-old nephew.

July 27
Vincent shoots himself near the heart with a revolver. Ravoux, the innkeeper, comes to get Dr. Gachet. The doctor writes to Theodore.

July 29
Vincent dies at one o'clock in the morning, at the age of thirty-seven.

July 30
Burial of Vincent van Gogh, "artist-painter," in the Auvers cemetery. Fifteen-year lease.

October 13
Dr. Gachet goes to see Theodore van Gogh at the Dubois Sanatorium, Faubourg Saint-Denis.

November 6
Honorary member of the Société Nationale de Sauvetage.

1891
January 25
Death of Theodore van Gogh in Utrecht at the age of thirty-four.

March 20–April 27
Exhibits at the Société des Artistes Indépendants under the name Gachet (Paul): 8 paintings, 1 drawing (a portrait of Van Gogh on his deathbed), and 7 etchings.[53]

1891
Joins the Association Amicale des Enfants du Nord et du Pas-de-Calais.

Norbert Goeneutte is treated in Auvers in his friend's home, where he does his portrait.[54]

1892
March–April

At the "Indépendants": 4 paintings, 1 etching (a portrait of Monticelli) [cat. no. 46k].

1892
Member of the Société Historique d'Auteuil et de Passy since its founding.

December 16
He donates Norbert Goeneutte's portrait of him to the Musée du Luxembourg.

1893
At the "Indépendants": 4 paintings, 1 etching (Hoschedé) [cat. no. 46i].

1894
January
Death of his childhood friend, the painter Amand Gautier, in Paris.

Gachet writes an "artistic chronicle" on the painter Amand Gautier, which appears in *Le spectateur* (Feb. 17, 1894).

April 11
Death of his cousin Dr. Émile Sailly at the age of sixty-seven (silver medal for service during the cholera epidemic of 1854).

October 9
Death of Norbert Goeneutte in Auvers, at the age of forty.

1896
July
"Salon des Indépendants" in *L'artiste contemporain*, signed Van Ryssel.

1897
June
Renewed candidacy for the Legion of Honor.

1898
Henry Fugère creates a medallion of Dr. Gachet, no. 2209 at the Salon of 1900 (left profile); 18.2 cm in diameter.

July 13
He also models a right profile (plaster).

December 1898
-------------d°-------------d°-----------d°-----------

1901
January 15
Replaced as medical inspector for the Paris public school system (18th arrondissement):[55] letter from the mayor (see below).

March 28
Finally, an officer of the Académie.

June 6
Honorary physician for the Paris public school system.

June 30
Special medal of honor from the Société Nationale d'Encouragement au Bien (for outstanding service to humanity).

1902
Under the name Gachet, he sends a painting to a signage contest at the Paris city hall: *At the Good Pig's Head* (sign for a butcher shop).

1904
March 19
Death of the poet Alexis Martin; end of the "Éclectiques."

March 12
Death of Mme L. Chevalier, after thirty years in Dr. Gachet's service.

1905
April 2
Death of his brother, Louis-Eugène Gachet; buried on the 4th.

1905
At the "Indépendants" he exhibits 3 paintings under the name Paul van Ryssel.[56]

Participates in the Liège Medical Conference.

June 10–11
Exhumation and reburial of the remains of Vincent van Gogh in the Auvers cemetery. The fifteen-year lease becomes permanent. Those present include Mme Theodore van Gogh, Mlle Betsy Bonger, Dr. Gachet, and his son.

September 20
Gift to the Rijksmuseum (Prentenkabinet) in Amsterdam of a proof of *The Man with a Pipe (Portrait of Dr. Gachet)* by Vincent van Gogh.

1906
At the "Indépendants," Paul van Ryssel exhibits 2 paintings.

April 26
Death of Eugène Murer in Auvers.

1907
January 23
Officer of Public Education.

1907
At the "Indépendants": Paul van Ryssel, 5 paintings.

1908
At the "Indépendants": Paul van Ryssel, 6 paintings.

1909
January 9
Death of Dr. Paul-Ferdinand Gachet in Auvers, in his 81st year; he succumbs suddenly to cardiac arrest.

January 14
Burial in Père Lachaise cemetery at 3 o'clock.

POST MORTEM

1909
March–April
At the "Indépendants," 2 paintings by the late Paul van Ryssel (Dr. Gachet).

December 31
The full-length portrait by Amand Gautier (Salon of 1861) is donated to the Musée de Lille [fig. 19].

1920
November
A proof of *The Man with a Pipe*, etched by Vincent van Gogh, is given to the Bibliothèque Doucet on rue Spontini in Paris.

1923
July 11
A proof of *The Man with a Pipe*, etched by Vincent van Gogh, is donated to the British Museum in London.

August 1923–January 1924
Dr. Victor Doiteau publishes a study in *Aesculape*, "La curieuse figure du Docteur Gachet" (nos. 8, 9, 11, 12, 1).

1924
September 19
A proof of the portrait of Monticelli is donated to the Musée de Pont-de-Vaux, Ain, via Dr. Doileau [*sic*], who is treating Chintreuil, born in the region.

1926
January 26
Gift to the Musée de l'Armée (Invalides) of surgical equipment from the Staff Office of the National Guard of Paris (1865–70): cocked hat, kepi, sword, uniform belt, sword sling, shoulder strap, and cartridge pouch (letter from General Mariaux, March 24, 1926). Salle Chanzy, window XII.

1927
February 8
The Wellcome Museum of Medical Science in London buys Laënnec's stethoscope and the treatise on mediate auscultation used by Dr. Gachet.

1928
January
The Wellcome Museum of Medical Science in London acquires for "The Gachet Collection" the drawing by Amand Gautier, *Asiatic Cholera in the Jura, 1854,* in which the painter depicts his friend Gachet . . . and himself.

The Wellcome Museum of Medical Science, having dedicated a vitrine to Dr. Gachet's "souvenirs," purchases the electric (electro-medical) bone machine from his course on anatomy for artists (1865–76), his Assistant Surgeon-Major's surgical kit from the National Guard, a proof of *The Man with a Pipe* by Van Gogh, Vicq d'Azyr's treatise on anatomy, etc., etc.; to which are added free of charge a proof of the print by B. Derousse reproducing the portrait by N. Goeneutte in the Luxembourg [see Checklist of Copies], his thesis "Étude sur la mélancholie," his yearbook of health for 1875, his bronze medal by Fugère, a doorplate, etc., etc.

The Japanese periodical *Bijutsu Shinron* (Tokyo) publishes a study, "Paul van Ryssel or Dr. Gachet, Printmaker" by Paul Gachet *fils,* translated by Macao Ishiwara, illustrated with 8 etchings by Van Ryssel and a print portrait by B. Derousse after the drawing by N. Goeneutte (first article: January 1928, or third Year of Showa).

Addenda and Corrections

1848
August 19
Reply to his request of August 2 to compete for training as a military surgeon is addressed to "Citizen Gachet, 46, rue des Fossés-Neufs, in Lille."

1854
March 2
The letter from Perrier de la Pelterie bears the address, "Monsieur Gachet—rue de Seine 8, 10, 12 or 14, a building with a large portal and shaped like a horseshoe—almost adjoining the Bibliothèque Mazarine."

June 9
Amand Gautier is making sketches of madwomen at the Salpêtrière for his painting, executed and exhibited in Lille in 1855 and at the Salon of 1857. He paints a *Princess of the Salpêtrière* and does a portrait of M. Falret.

October 6
End of the mission to combat the cholera epidemic—Departure from Lons-le-Saunier. October 7 and 8: at Lyons; October 11: Hyère, Chanaz, Aix-les-Bains. October 13: Geneva; October 14: Lauzanne [*sic*]—Bern—Basel—Strasbourg.

1855
April 5
His cousin Émile Sailly substitutes for him at the Hôtel Dieu during his sojourn in Lille.

1855
It is through Cabrol that he will later make the acquaintance of the scholar Hippolyte Walferdin, an 1848 republican, bibliophile, and collector of eighteenth-century paintings, drawings, and engravings, particularly of Fragonard.

1857
June 20
Not wanting to importune Courbet or Champfleury, Paul Gachet made the acquaintance of M. Bruyas through M. Kunholtz; the recommendation came later, thus too late.

Addresses in Montpellier, corrected: 1. Chez Madame Bonnard, 8, rue Basville; 2. Rue de la Barallerie.

1858
June 21
"Étude sur la mélancholie," thesis, presented and publicly defended at the Montpellier Faculté [de Médecine].

July
He visits Aix and sees M. Auguste Cézanne, to whom he is introduced by friends of Mme Renaud of Montpellier.

1858
There is some question of renting an apartment in passage Saunier (put on page 9).

1860
February 9
He pays Émile Vernier the sum of 100 francs for the lithograph of his full-length portrait by Amand Gautier.

1860–61
Numerous notes—philosophical, artistic, and medical: nervous maladies (September 1861).

1864
Reprinting of his thesis on melancholy (Paris, 1864).

He cares for Madame Rachel Pissarro (rue de l'Échiquier).

1868
September 24
The newlyweds visit Hippolyte Walferdin, who offers them a reduced copy of Houdon's bust of Diderot. The old scholar also owned busts of Franklin and Washington: he gave the three originals to the Louvre.

May
He resided in Villemomble until August 1870 and moved when Prussian guns approached.

1870
First days of August: at Berck with Madame Gachet and his daughter, at the Hôtel des Bains.

1871
At the dressing station, 100, rue du Château d'Eau. Expressions of gratitude from the mayor of the 10th arrondissement, M. Dubail.

August–September
Dates of sketches, paintings, pastels: W. 27. August 71; September 1, 2, 3, 13, 20, 1871. (Etchings: *Road in Wissant, Pigs Resting, Dr. Gachet, Duval House at Wissant* (P. de Ci.).

1872
Cares for the family of Camille Pissarro, at Louveciennes.

1873
Continues to care for the Pissarro family, now at Pontoise.

1875
Publication of the health annual—to be put at the beginning of the year.

September 24
Visits Daumier at Valmondois and examines his eyes.

1882
L'almanach du vieux Paris for 1882 publishes an illustration after Dr. Gachet's drawing: *Promenade.*

1879
January 26
Dinner of the Survivors!!! of the Catastrophe of January 17, 1879, at Caffin's (Café de la Station) in Auvers: bill, 6.40 francs.

CURRICULUM VITAE
ADDENDA AND CORRECTIONS

[This text is typewritten, which suggests that it was compiled in the 1950s. The page numbers are Gachet's internal references.]

1854
August 22–23 (page 6)
Cholera—departure by railroad: Melun, Troyes, Dijon; then: the stagecoach to Lons-le-Saunier.

1854
First recommended for the Legion of Honor.

1858 (page 9)
"There is some question of renting an apartment in the passage Saunier, etc..." this paragraph on page 10 should be put on page 9, after June 21, 1858.

1861
June 20 (page 10)
"I appoint Doctor GACHET, residing at 9, rue Montholon, the executor of my will and testament as it bears upon my little one-act play to be staged at the Théâtre Lyrique. He will receive the royalties and from them pay 1000 francs straightaway to M. Paul Godfrin; as for what remains, he will make the best possible use of it. Paris, June 20, 1861. (Signed) Perrier de la Pelterie."

1862
June (page 11)
Death of Clémence Gachet, his sister-in-law, in Lille.

1868
A steam generator explodes at the plant in Hallennes-les-Haubourdin (north), which, according to Louis-Eugène-Joseph, will not greatly delay the marriage of his son Paul Gachet.

1870
May 20 (page 14)
Louis Gachet, the father, sick; trials and tribulations suffered during a long career. Dyspepsia, anorexia.

(page 15)
At the dressing station, 100, rue du Château d'Eau. Certificate and thanks from the mayor, M. Dubail.

Member of the Grand Orient of France: two years.

Worshipful Master: five years.

1870–71
He is in Paris during the Siege and the Commune.

After 1870 his favorite neighborhood is Montmartre. He knows the mayor, Georges Clemenceau, whom he comes to admire fervently. He also knows several of his successors at the Town Hall of the 18th: the painter Émile Bin, Wiggishoff, and Édouard Kleinmann, later a print dealer (friend of Steinlen, Willette, Lautrec, Forain, etc.).

He is particularly close to Bin, whose wife he treats.

It is in Émile Bin's studio that Léandre does his caricature of the doctor [fig. 27].

He often climbs the rue Lepic, where the engraver-printer Auguste Delâtre resides, whose family is in his care. Auguste and his son Eugène Delâtre print his numbered editions.

1872
November 3 (page 18)
His "Éclectique" friends are preponderantly Montmartrois: Émile Bin, Amédée Burion and the Secretary General, poet, Alexis Martin, who resides on the rue Gabrielle.

He socializes with Burion, Causin, Norbert Goeneutte, and many others at the "Vieux Montmartre." He also belongs to another such group, located farther away: the Société Historique d'Auteuil et de Passy.

On place Pigalle, at the Nouvelle Athènes, he regularly meets up with Manet, Degas, Goeneutte, Desboutin, Duranty. At the Château des Brouillards (rue Girardon) he goes to see Paul Alexis and Auguste Renoir.

1873
June (page 17)
Death of his nephew André-Théry-Joseph Gachet (son of Clémence and Louis Gachet), born in Lille on June 1, 1854.

1875
March 7 (page 18)
Madame Blanche Gachet is ill in Pau.

1878
June
Sale of the factory at Haubourdin.

Ca. 1883–84
Opening of a dispensary on the rue Stephenson, with Drs. Decours and Deschamps.

1884
January 20 (page 20)
Letter from Boll, municipal councillor, announcing that the Cantonal Delegation has ratified the prefect's nomination and appointed Dr. Gachet Physician of Schools in the 18th arrondissement.

1890
May 20 (page 22)
Vincent van Gogh arrives at Auvers and pays his first visit to Dr. Gachet (Dr. Gachet's appointment book).

1891
(page 22)
Émile Bin, mayor of the 18th arrondisement, is relieved of his duties (Boulangiste).

1894
February 12 (page 23)
Paul Gachet's lottery for military service (No. 100).

February (page 23)
Death of Amand Gautier in February, not in January.

1897
June (page 23)
Repeal of his nomination for the Legion of Honor.

1903
(page 24)
Long obsessed by Hahnemann's example, he observes the effect of medications on himself and his family and continues to prepare the T.M., whose herbal ingedients are readily available in the garden at Auvers: Bryum. Bellad. Chelad. Carbo. veg. Lappa. Major. Solanum. Dulcam. Tropaeolum.

1. His father, Louis-Eugène Gachet (Lille 1796–Lille 1870), owned a linen-spinning mill; his mother, Clémentine-Thérèse Cuvillon (d. 1863), was the daughter of a merchant who also signed his name as a witness to the birth; he had an older brother, Louis-Eugène Gachet (1825–1905).
2. On Amand Gautier, see ["Gachet, Father and Son,"], p. 4.
3. 1811–1863; see fig. 20.
4. Gachet's description indicates that he had brown hair and eyebrows and stood 5 feet 6 inches tall; other descriptions (on his hunting license, his 1855 and 1871 passports) put him as tall as 5 feet 8½ inches and give him blond hair, never red, as noted by those who knew him.
5. This letter (Musée d'Histoire de la Médecine, Paris) is addressed "to Monsieur Dutilleux, painter, rue Saint Jean at Arras, to be transmitted to M. Paul Gachet," which attests to a connection between the future physician and amateur painter and this friend of Camille Corot, a relationship overlooked by Paul Gachet *fils*, probably out of ignorance of Dutilleux's personality.
6. In this letter (Musée d'Histoire de la Médecine, Paris), Paul Gachet asks his concierge to care for his cat because he is detained at the Sainte-Marguerite hospital; Jean-Baptiste Baudin, shot on a barricade, was transported to this hospital. Baudin, a physician, was a representative in the Assembly of 1849.
7. Gautier, who lived at 12, rue de Seine, took up again with Gachet during this period.

8. Annotated: Donné au Musée de Valenciennes. See fig. 20.

9. Édouard Sain (1830–1910), portraitist and genre painter.

10. Paul Gachet's schooling was not without its rocky moments. In a "report on character and scholarship" addressed to his father on January 3, 1853, it is noted that he took an examination in the second semester of 1852, the only one he had taken since November 1848, but that he failed a second examination six times (Musée d'Histoire de la Médecine, Paris).

11. An article in *La sentinelle du Jura*, Oct. 1, 1854, calls attention to the "admirable conduct" of Gachet and his colleagues (Musée d'Histoire de la Médecine, Paris).

12. See fig. 21.

13. Dr. Jean-Pierre Falret (1794–1870), psychiatrist, chief physician at La Salpêtrière, member of the Académie de Médecine.

14. Dr. Gachet kept no. 137 of *L'écho du Nord* (May 17, 1855), citing the presentation of medals by the minister of Commerce, Agriculture, and Public Works in the name of the emperor (Musée d'Histoire de la Médecine, Paris).

15. See the sale of Baron Michel de Trétaigne, Hôtel Drouot, Paris, Feb. 19, 1872.

16. On Richard Lesclide (1825–1892), see p. 7.

17. It was not in 1855 but probably after July 17, 1857, the date of a letter from Tailhardat to Dr. Gachet giving him Brascassat's address, which was reconfirmed on June 6, 1858 (correspondence between A. Gautier and Dr. Gachet, transcription typed by Paul Gachet; Archives, Wildenstein Institute, Paris).

18. Dr. Jean Cabrol (1813–1889), chief physician of the armies, commander of the Legion of Honor, founder of the Nice Observatory, author of numerous works on hygiene.

19. On Paul Gachet's contacts with Alfred Bruyas, see "Gachet, Father and Son," p. 4 and n. 4.

20. According to letters from a friend of A. Gautier to Gachet (March 6, 1858) and from Gautier himself to Gachet, as well as those from the Count de Toulongeon (March 14, 1858), it was only a question of his being exempted from examination fees in exchange for services rendered (Musée d'Histoire de la Médecine, Paris).

21. The lease was for an apartment on the fourth floor: vestibule, dining room, living room, two bedrooms, kitchen, cellar, and a small room on the seventh floor, for 1,300 francs a month (Musée d'Histoire de la Médecine, Paris).

22. On his contacts with Méryon, see p. 4.

23. See fig. 19.

24. See fig. 21.

25. Ernestine's heart was on the right side.

26. On this apartment, which Paul Gachet *fils* still occupied in the 1950s, see the Inventory. His annual rent was 1,200 francs.

27. Handwritten notes for this course, dated 1867–68, are preserved at the Musée d'Histoire de la Médecine, Paris.

28. Major Allain transmitted the nomination and the oath-of-office form on August 10, 1865. He later sent Dr. Gachet an invitation to a ball at the Tuileries in January 1866 (Musée d'Histoire de la Médecine, Paris).

29. The acknowledgment of receipt from the Royal Household informed him that the work had been deposited in the palace library (Musée d'Histoire de la Médecine, Paris).

30. Pierre Lachambaudie (1806–1872), French *chansonnier* and author of fables.

31. See Gachet 1956a, appendix.

32. This passport also mentions Dr. Gachet's wife and daughter. Mme Henri Nestlé offered refuge to Mme Gachet and her daughter in Vevey (letters of Sept. 2 and 4, 1871, published in the *Bulletin Nestlé*, no. 2 [Feb. 1952]).

33. A memoir accompanied by a warm note from Dr. Cabrol supports this candidacy.

34. These purchases from P. F. Martin are not confirmed independently.

35. This mention is not confirmed independently.

36. Letter from Cézanne's father to Dr. Gachet, Aug. 10, 1873, in Rewald 1978, p. 143.

37. See fig. 24.

38. Guillaume Régamey (1837–1875) and Frédéric Régamey (1849–1925).

39. This collection of advice and addresses of physicians and pharmacists contains a chapter on the subject of mental derangement, signed by Dr. Gachet, in which he recalls his experiences at the Bicêtre and Salpêtrière hospitals (Musée d'Histoire de la Médecine, Paris).

40. These scores were donated to the Bibliothèque Nationale by Paul Gachet *fils* in 1954.

41. Félix Buhot (1847–1898), printmaker.

42. The first mention of the famous pastry cook, man of letters, and collector of Impressionist works, Eugène Meunier, called Murer (1841–1906), who encouraged Dr. Gachet in his acquisitions.

43. Article reprinted in Gachet 1956a, pp. 22–23.

44. Murer sold the collection housed on the boulevard Voltaire in 1881.

45. The letter from the chief physician accompanying this nomination specifies that it "involves no remuneration but that you will be given a first-class rail pass between Paris and Creil" (Musée d'Histoire de la Médecine, Paris).

46. The order of February 29, 1884, specifies that he is assigned to the girls' school at 11, rue Cave, to the nursery school at 8, rue Saint-Mathieu, and to the boys' school at 13, rue Richomme in the Goutte-d'Or neighborhod (Musée d'Histoire de la Médecine, Paris).

47. Paul Gachet was probably basing this assertion on Trublot 1887.

48. Dr. Thulié (b. 1832, psychiatrist and friend of Duranty, Champfleury, and Courbet). On the Lamarck dinners, see p. 9.

49. See fig. 27.

50. On the discussion on whether this date is May 20 or 21, see "Curriculum Vitae, Addenda and Corrections" and p. 21 n. 61.

51. See cat. no. 23b.

52. See fig. 56 and cat. no. 13.

53. See cat. no. 41.

54. See fig. 28.

55. By an order issued on December 24, 1897, Doctor Paul Gachet had been named physician-inspector of public primary and nursery schools in the 18th arrondissement, 8th ward of the City of Paris, the appointment to last three years beginning January 1, 1898 (Musée d'Histoire de la Médecine, Paris).

56. He also participated, through the loan of his paintings, in the Vincent van Gogh retrospective organized by the Indépendants.

Inventory Taken after the Death of Mme Gachet

Maître H. Megret, Notary, Paris, November 13, 1875, AN MC ET XXXI/1105

APARTMENT IN THE FAUBOURG SAINT-DENIS, EVALUATION OF THE CONTENTS

In the Cellar

1. One cask of wine containing two hundred twenty-eight liters of red wine and one hundred bottles of wine containing seventy-five liters, the lot valued at one hundred fifty francs.

In the Kitchen

2. Seven items of copperware, twenty items of wrought iron, a marble cistern, a pinewood buffet, assorted pottery, the lot valued at forty francs.

In the Vestibule

3. A bookcase of carved old oak, three caned chairs, and two banquettes, valued at one hundred fifty francs.
4. A chandelier made of several materials and two paintings, valued at twenty francs.

In a Parlor

5. A set of ebony furniture covered in velvet, consisting of a couch, four armchairs, and four chairs, valued at one hundred seventy francs.
6. An upright piano made of rosewood, a piano stool, a table in the center also of rosewood, and a music rack, valued at five hundred francs.
7. An ebony pedestal table, a bronze statuette, two Carcel lamps, and two copper candlesticks, valued at one hundred twenty francs.
8. A piece of rosewood furniture, two shelves, two hearth rugs, a copper fire screen with andirons, shovel, and tongs, the lot valued at one hundred ten francs.
9. Twenty paintings in gilded frames, valued at four hundred francs.
10. Twenty-five shelf objects of Japanese porcelain and unglazed earthenware, vases, and other knickknacks, valued at one hundred francs.
11. A gilded bronze chandelier, valued at forty francs.

In a Dining Room with a Window on the Courtyard

12. A table, four caned chairs, a piece of carved oak furniture, and a small copper chandelier, the lot valued at one hundred fifty francs.
13. Twenty canvases, a lamp, an ebony worktable, and a set of dishes and glassware, valued at one hundred ten francs.

In a Bathroom

14. A mirrored wardrobe of ebony and a dressing table with accessories, valued at one hundred fifty francs.
15. An ebony file cabinet and twenty-five canvases with and without frames, valued at one hundred francs.

In a Bedroom

16. A small oak bed, a mattress, and a pallet, valued at eighty francs.
17. A Louis XV rosewood commode with marble top, valued at one hundred fifty francs.
18. A marble clock, a bronze statuette, two cups, and an ebony night table, valued at seventy francs.
19. Two tub chairs, a rosewood gaming table, two chairs, valued at fifty francs.
20. Twelve canvases, a bedside rug, shovels and tongs, valued at ninety francs.

In a Study with a Window on the Courtyard

21. A carved oak desk, three oak chairs with moroccan leather trim, a chaise longue with velvet trim, and two large rep curtains, valued at one hundred seventy francs.
22. A carved oak bookcase containing approximately four hundred volumes of various kinds, valued at three hundred francs.
23. A pendulum clock of Siena marble with a bronze statuette, two copper candlesticks, a mirror, and six paintings, the lot valued at one hundred twenty francs.

Linen

24. Ten pairs of linen sheets, twelve pillowcases, twenty-four napkins, and twelve towels, valued at one hundred fifty francs.

Gentleman's Wardrobe

25. Four pairs of trousers, three waistcoats, two overcoats, a frock coat, twelve shirts, fourteen handkerchiefs, and ten pairs of socks, valued at sixty francs.
26. A gold watch, valued at sixty francs.

Lady's Wardrobe

27. Six dresses including one of silk, six white petticoats, six camisoles, a silk overcoat, a French cashmere shawl, fourteen chemises, ten pairs of stockings, twelve pairs of drawers, an assortment of detachable collars, sleeves, and bonnets, the lot valued at one hundred eighty francs.

Jewelry

28. A gold watch and chain, valued at one hundred francs.
29. Two necklaces, a coral bracelet, six rings, one of them mounted with a rose-cut diamond, valued at one hundred twenty francs.

Silverware

30. Sixteen place settings weighing 1,760 grams, valued at three hundred fifty-two francs on the basis of twenty centimes the gram.

A total of four thousand three hundred sixty-two francs.

COUNTRY HOUSE AT AUVERS-SUR-OISE, EVALUATION OF THE CONTENTS

In the Cellar

1. A cask of red wine containing approximately one hundred sixty liters, valued at forty francs.

In a Room on the Ground Floor, with a Window

2. A rosewood piano in disrepair and a piano stool, valued at sixty francs.
3. A dresser of carved old oak valued at forty francs.
4. An oak buffet, valued at forty francs.
5. A banquette covered in red velvet, three armchairs, and a chair covered in leather, all in bad condition, valued at sixty francs.
6. A clock, valued at ten francs.
7. A framed mirror and two caned chairs, valued at ten francs.
8. In the buffet, thirty-seven pieces of porcelain and crockery, glassware including Bohemian vases, valued at twenty francs.
9. Eighteen canvases, valued at fifty francs.

In the Vestibule

10. A glass lantern, valued at ten francs.

In the Kitchen

11. A cast-iron stove, valued at five francs.
12. Seventy-two items of copper and tin kitchenware, cooking pots and saucepans, a scale and weights, valued at fifty francs.
13. A kitchen table and a pine buffet, valued at ten francs.

In the Dining Room

14. A bronze and Siena marble pendulum clock (motif of a woman reading), valued at sixty francs.
15. A buffet and a walnut table, valued at twenty-five francs.
16. In the buffet: approximately sixty pieces of glassware and crockery, valued at twenty-five francs.
17. An armchair covered in leather and six rush-bottomed chairs, valued at thirty-five francs.
18. Two large curtains and a door curtain of Algerian stripe, two muslin curtains, and a worn table cover, the lot valued at twenty francs.
19. Eight earthenware plates and sixteen canvases, valued at ten francs.

On the Second Floor, in the Children's Room

20. Two iron bedsteads, each with a pallet and a mattress, and a wool cover, valued at forty francs.
21. A commode and a small mirrored wardrobe of ebony, valued at sixty francs.
22. Fifteen canvases and two chintz curtains in bad condition, valued at fifty francs.

In a Bedroom

23. A walnut bedstead, valued at twenty francs.
24. A gaming table and a walnut commode, valued at forty francs.
25. A banquette covered in rep, valued at five francs.
26. Four framed engravings and five canvases, valued at twenty francs.
27. A large rep curtain and two more of muslin, valued at fifty francs.

In Another Bedroom

28. A large iron bedstead with pallet and mattress, valued at fifteen francs.
29. A Louis XIII commode of ebony, valued at thirty francs.
30. Two cretonne curtains, two rush-bottomed chairs, and twelve engravings and canvases, the lot valued at twenty francs.

In a Large Bathroom

31. A couch in poor condition, two cushions, two curtains and a door curtain, all in red rep, valued at twenty francs.
32. An ebony chest of drawers and an ebony dressing table with toilet requisites, valued at twenty francs.

33. A set of shelves with some fifty bound volumes, valued at twenty-five francs.

On the Third Floor, in the Vestibule
34. A hanging wall clock with weights, valued at five francs.

In a Bedroom with a Window
35. A rosewood bed [illegible], a box spring, two mattresses, and a cover, valued at one hundred francs.
36. A small buffet of carved oak, valued at fifty francs.
37. Two old armchairs, a caned chair, and a small pine dressing table with pitcher, valued at thirty francs.
38. An assortment of plaster casts, trumpet vases and others, and a chandelier of silvered bronze, valued at twenty-five francs.

In Another Bedroom
39. An ebony Louis XIII commode and a gaming table, valued at fifty francs.
40. A bedstead and eiderdown, a commode, and a night table painted in the style of Louis XVI, the lot valued at eighty francs.

In Another Bedroom
41. A curved, boat-shaped bed of ebony, a box spring, a mattress, a pillow, a bolster, and a wool cover, valued at forty francs.
42. A commode, a dressing table, and an ebony night table, valued at fifty francs.
43. Two old armchairs, two rep curtains, two trumpet vases of crystal, two copper candlesticks, two terracottas, and twelve canvases, the lot valued at twenty francs.

In a Large Study
44. A small commode with marble top, valued at fifteen francs.
45. An assortment of stone and clay pots and various other objects, valued at ten francs.

On the Fourth Floor, in a Maid's Room
46. An iron bedstead, a pallet, an old commode, and a rush-bottomed chair, the lot valued at twenty-five francs.

In the Attic
47. Two old armchairs, two tables, two screens, a pedestal table, two easels, a ladder, a stool, and a miscellany of small objects, plaster casts, canvases, dishes, and oddments, the lot valued at fifteen francs.
48. A secretary with marble top, a stool, two wardrobes, a set of shelves with approximately one hundred volumes, the lot valued at forty francs.

In the Shed
49. A wheelbarrow, a ladder, a bathtub, a shower appliance, a doghouse, and a collection of agricultural implements, the lot valued at twenty francs.
50. Approximately half a cubic meter of firewood, valued at ten francs.

Total value of the contents at Auvers: fifteen hundred fifty francs.

Note on Works Exhibited

All the major works in the Gachet donation are exhibited in the New York and Amsterdam showings of "Cézanne to Van Gogh: The Collection of Doctor Gachet" with the exception of *The Church at Auvers* (cat. no. 17) and *The Farm of Père Eloi* (cat. no. 21), which are too fragile to travel. (The following works in the section of Auvers amateurs are not shown: cat. nos. 41, 45, 50, 52, 53.) For specific information on the showing at both locations of paintings, drawings, prints, and copies, including additional loans, see the Summary Catalogue and the Checklist of Copies, where the works exhibited are identified by asterisks. Other works lent to the exhibition are listed below.

Portraits of Dr. Gachet
New York and Amsterdam: figs. 12, 19, 28, 33, 34
New York: figs. 26, 27
Amsterdam: figs. 22, 30

Documents and Souvenirs
Figs. 2, 3, 9

Dr. Gachet's visiting card (78, rue Faubourg-Saint-Denis). Paper, 6.5 x 10 cm. Musée d'Histoire de la Médecine, Paris (99.1.10)

Diploma, Paul-Ferdinand Gachet, Doctor of Medicine, August 2, 1858. Parchment, 37 x 40 cm. Musée d'Histoire de la Médecine, Paris (99.01.1)

Homeopathic case imprinted with Dr. Gachet's name. Leather, wood, and glass, 7 x 12 cm. Musée d'Histoire de la Médecine, Paris (90.173.2)

Paul-Ferdinand Gachet, "Étude sur la Mélancholie," 1864. Leather-bound doctoral thesis, 22 x 14 cm. Musée d'Histoire de la Médecine, Paris (99.01.2)

Paul Gachet *fils*, "Collection du Dr. Gachet": vol. II, Cézanne (1928); vol. III, part 1, Van Gogh, paintings (1928); vol. III, part 2, Van Gogh, drawings and prints (1920–40). Unpublished catalogue raisonné of the Gachet collection. Three leather-bound volumes, 28 x 22 cm. Wildenstein Institute, Paris

Paul Gachet *fils*, Draft entry for the unpublished Gachet collection catalogue, corresponding to P.G. II-37, Cézanne's *Jeune paysanne (Tête de jeune fille)*. Handwritten on paper. Michael Pakenham collection

Letters
From the Van Gogh Museum (Vincent van Gogh Foundation), Amsterdam:
Vincent van Gogh to his brother Theo, June 3, 1890 (b687 V/1962) (cat. no. 13a, fig. 90)

Dr. Paul Gachet to Theo van Gogh, July 27, 1890 (b3265 V/1966)

Dr. Paul Gachet to Theo van Gogh, ca. Aug. 15, 1890 (b3266 V/1966)

Sketchbook
Vincent van Gogh's Auvers sketchbook, 1890; includes a page (cat. no. 22e) formerly owned by Dr. Gachet. Linen-covered sketchbook with blue-lined graph paper sheets, 13.4 x 8.5 cm, 160 pages. Van Gogh Museum (Vincent van Gogh Foundation), Amsterdam (D384 m/1975)

Drawings by Paul van Ryssel (Dr. Paul Gachet)
Vincent van Gogh on His Deathbed, 1890. Charcoal on paper, 31 x 26 cm. Dated lower right: 23 juillet 1890. Annotated on the back, in pencil: Vincent van Gogh 1890 / à son lit de mort. Private collection

Sunflower, 1890. Pencil on paper, 16.8 x 11.2 cm. Signed lower left: PvR. Dated and inscribed lower right: Le Tournesol /1890. Van Gogh Museum (Vincent van Gogh Foundation), Amsterdam (D774 V/1962)

Etchings by Paul van Ryssel (Dr. Paul Gachet)
From the Van Gogh Museum (Vincent van Gogh Foundation), Amsterdam:
Alternate impressions of:
Cat. no. 46c, *Madame Gachet at the Piano* (P448 V/1962); cat. no. 46e, *Old Community House at Auvers*, also called *View of Auvers-sur-Oise* (P453 V/1962); cat. no. 46f, *Murer's Walnut Tree: Old Road at Auvers* (P452 V/1962); cat. no. 46k, *Monticelli Pictor* (P462 V/1962)

Invitation for "Les Éclectiques," 1874. Etching, 20.5 x 28 cm (b5002 m/1992)

The Hautes Bruyères, Valley of the Bièvre, 1872. Etching, 12.6 x 9.8 cm (P442 V/1962)

From the Bibliothèque Nationale de France, shown in New York only: cat. nos. 46d, 46g

Surrogate Images
For prints owned by Gachet that are unavailable for loan or have not been located, these surrogate impressions are exhibited:

For cat. no. 10b: Paul Cézanne, *Head of a Young Girl*. Van Gogh Museum (Vincent van Gogh Foundation), Amsterdam (P765 V/1975)

For cat. no. 10c: Paul Cézanne, *Entrance to a Farm, Rue Rémy in Auvers*, 1873. The New York Public Library, Astor, Lenox and Tilden Foundations, Print Collection, The Miriam and Ira D. Wallach Division of Art, Prints and Photographs (MMA.048.247)

For cat. no. 10e: Paul Cézanne, *Guillaumin at the House of the Hanged Man*. The Metropolitan Museum of Art, New York, Gift of Dr. Ralph Weiler, 1960 (60.563.46)

For cat. no. 38a: Camille Pissarro, *At the Water's Edge*, ca. 1863. Museum of Fine Arts, Boston, George Peabody Gardner Fund (inv. 63.323)

Camille Pissarro, *Hills at Pontoise* and *The Oise at Pontoise*. The New York Public Library, Astor, Lenox and Tilden Foundations, S. P. Avery Collection, Print Collection, The Miriam and Ira D. Wallach Division of Art, Prints and Photographs (MMA.048.248, 249)

Camille Pissarro, *Paul Cézanne*, 1874. The Metropolitan Museum of Art, New York, The Elisha Whittelsey Collection, The Elisha Whittelsey Fund, 1948 (48.152)

Selected Bibliography

The abbreviations for catalogues raisonnés listed below, which are used in the Summary Catalogue to identify works of art, correspond to the bibliographic references as follows:

Chappuis:	Chappuis 1973
Cherpin:	Cherpin 1972
D:	Delteil 1923
Daulte:	Daulte 1959, 1971
F:	Faille 1928, 1970, 1992
Gray:	Gray 1972
JH:	Hulsker 1980, 1996
Kraemer:	Kraemer 1997
P&V:	Pissarro and Venturi 1939
R:	Rewald 1996
S&F:	Serret and Fabiani 1971
V:	Venturi 1936
W:	Wildenstein 1974, 1991

Adhémar 1954
Jean Adhémar. *Honoré Daumier.* Paris: Éditions Pierre Tisné, 1954.

Adhémar and Lethève 1954
Jean Adhémar and Jacques Lethève. *Bibliothèque Nationale Département des Estampes: Inventaire du Fonds Français après 1800.* Vol. 8. Paris: Bibliothèque Nationale, 1954.

Aix-en-Provence 1953
Jean Leymarie. *Cézanne: Peintures, aquarelles, dessins.* Exh. cat., Aix-en-Provence, Musée Granet. Aix-en-Provence and Nice, 1953.

Almanach de la sauté 1874
Almanach de la sauté. Paris: R. Lesclide, 1874.

Almanach fantaisiste 1882
Almanach fantaisiste pour 1882 de la Société des Éclectiques. Paris: Alphonse Lemerre, 1882.

Amsterdam 1905
Catalogus der tentoonstelling van schilderijen en teekeningen door Vincent van Gogh. Exh. cat., Amsterdam, Stedelijk Museum. Amsterdam, 1905.

Amsterdam 1990
Evert van Uitert, Louis van Tilborgh, and Sjraar van Heugten. *Vincent van Gogh: Paintings.* Exh. cat., Amsterdam, Rijkmuseum Vincent van Gogh. Milan: Arnoldo Mondadori Arte, 1990.

Andersen 1970
Wayne Andersen. *Cézanne's Portrait Drawings.* Cambridge, Mass., and London: The MIT Press, 1970.

Anfray 1953
Louis Anfray. "Une énigme Van Gogh." *Art-Documents,* no. 39 (December 1953), p. 5.

Anfray 1954a
Louis Anfray. "Van Gogh: Méthode d'examen d'un tableau." *Art-Documents,* no. 40 (January 1954), pp. 6–7.

Anfray 1954b
Louis Anfray. "L'énigme du cuivre gravé: *Portrait à la pipe du Dr Gachet,* attribué à Vincent van Gogh." *Art-Documents,* no. 42 (March 1954), pp. 1, 8–9, 11.

Anfray 1954c
Louis Anfray. "La verité torturée: Vincent van Gogh à Auvers-sur-Oise." *Art-Documents,* no. 43 (April 1954), pp. 4–6; no. 44 (May 1954), pp. 4–6.

Anfray 1954d
Louis Anfray. "Le cuivre gravé par Vincent van Gogh serait un 'Portrait d'Arlésienne.'"*Art-Documents,* no. 45 (June 1954), pp. 8–9.

Anfray 1954e
Louis Anfray. "Sur la présence de Vincent et Théo van Gogh à Montmartre." *Art-Documents,* no. 49 (October 1954), pp. 11, 13.

Anfray 1954f
Louis Anfray. "Pèlerinage à Auvers-sur-Oise sur la tombe de Vincen[t et]Théo van Gogh." *Art-Documents,* no. 51 (December 1954), pp. 4–5.

Anfray 1955
Louis Anfray. "Vincent van Gogh et les historiens: Faisons le point." *Les cahiers de Van Gogh,* no. 1 ([1955]), pp. 5–6.

Anfray 1958a
Louis Anfray. "De la recherche méthodique en matière d'art; L'énigme du cuivre gravé." *Les cahiers de Van Gogh,* no. 3 (1958), pp. 8–11.

Anfray 1958b
Louis Anfray. "Essai de psychologie de Van Gogh." *Les cahiers de Van Gogh,* no. 4 (1958), pp. 11–18.

Artaud 1974
Antonin Artaud. *Van Gogh: Le suicidé de la société.* In *Oeuvres complètes,* vol. 13, pp. 9–64. Paris: Éditions Gallimard, 1974.

A travers sa grille 1952
"A travers sa grille, j'ai arraché a Paul Gachet . . . des souvenirs qu'il ne publiera jamais." *Samedi-soir,* no. 341, January 12–18, 1952, p. 2.

Auvers-sur-Oise 197–
Yves d'Auvers. *Les impressionnistes d'Auvers-sur-Oise: 1ère exposition rétrospective de 1856 à 1907, autour du Dr Gachet.* Exh. cat., Auvers-sur-Oise. N.p.: G. M. Drancy, [1973?].

Bailey 1997a
Martin Bailey. "At Least Forty-five Van Goghs May Well Be Fakes." *The Art Newspaper* 8, no. 72 (July–August 1997), pp. 21–24.

Bailey 1997b
Martin Bailey. "Cent Van Gogh remis en question." *Le journal des arts,* no. 39 (May 30, 1997), pp. 1, 13–15, 16, 25, 26–27, 28.

Bang 1991
Mette Marie Bang. "Van Gogh's Palette." In *A Closer Look: Technical and Art-Historical Studies on Works by Van Gogh and Gauguin,* ed. Cornelia Peres et al., pp. 50–60. Cahier Vincent, 3. Zwolle: Waanders Publishers, 1991.

Bernard 1891
Émile Bernard. "Paul Cézanne." *Les hommes d'aujourd'hui* 8, no. 387 (May 1891), n.p.

Bernard 1926
Émile Bernard. *Souvenirs sur Paul Cézanne: Une conversation avec Cézanne; La methode de Cézanne.* Paris: [R. G.] Michel, Éditeur, [1926].

Bernheim-Jeune 1914
J[osse] and G[aston] Bernheim-Jeune, eds. *Cézanne.* Paris: Bernheim-Jeune, 1914.

Bernheim-Jeune 1919
J[osse] and G[aston] Bernheim-Jeune, eds. *L'art moderne et quelques aspects de l'art d'autrefois.* 2 vols. Paris: Bernheim-Jeune, 1919.

Berson 1996
Ruth Berson. *The New Painting: Impressionism 1874–1886, Documentation.* 2 vols. San Francisco: Fine Arts Museums of San Francisco, 1996.

Berthold 1958
Gertrude Berthold. *Cézanne und die alten Meister: Die Bedeutung der Zeichnungen Cézannes nach Werken anderer Künstler.* Stuttgart: W. Kohlhammer Verlag, 1958.

Bever 1905
Ad. van Bever. "Les aînés: Un peintre maudit, Vincent van Gogh (1853–1890)." *La plume* 17, no. 373 (June 1, 1905), pp. 532–45; no. 374 (June 15, 1905), pp. 596–609.

Bonnici 1989
Claude-Jeanne Bonnici. *Paul Guigou 1834–1871.* Aix-en-Provence: Édisud, 1989.

Boston 1973
Barbara S. Shapiro. *Camille Pissarro: The Impressionist Printmaker.* Exh. cat., Boston, Museum of Fine Arts. Boston, 1973.

Bouillon 1987
Jean-Paul Bouillon. *Félix Bracquemond, le réalisme absolu: Oeuvre gravé, 1849–1859, catalogue raisonné.* Geneva: Skira, 1987.

Bouret 1954
Jean Bouret. "Van Gogh, le mal aimé et Van Gogh, le trahi!" *Le franc-tireur,* November 25, 1954.

Bouvenne 1883
Aglaüs Bouvenne. *Notes et souvenirs sur Charles Méryon, son tombeau au cimetière de Charenton Saint Maurice.* Paris: Charavay Frères Libraires Éditeurs, 1883.

Bredius 1934
A. Bredius. "Herinneringen aan Vincent van Gogh." *Oud Holland* 51, no. 1 (1934), p. 44.

Cabanne 1992
Pierre Cabanne. *Qui a tué Vincent van Gogh?* Paris: Quai Voltaire, 1992.

Cadorin 1991
Paolo Cadorin. "Colour Fading in Van Gogh and Gauguin." In *A Closer Look: Technical and Art-Historical Studies on Works by Van Gogh and Gauguin,* ed. Cornelia Peres et al., pp. 10–19. Cahier Vincent, 3. Zwolle: Waanders Publishers, 1991.

Cadorin, Veillon, and Mühlethaler 1987
Paolo Cadorin, Monique Veillon, and Bruno Mühlethaler. "Décoloration dans la couche picturale de certains tableaux de Vincent van Gogh et de Paul Gauguin." In ICOM Committee for Conservation, *8th Triennial Meeting, Sydney, Australia, 6–11 September, 1987: Preprints,* vol. 1, pp. 267–73. 3 vols. Los Angeles: The Getty Conservation Institute, 1987.

Castagnary 1874
Jules-Antoine Castagnary. "Exposition du Boulevard des Capucines: Les impressionnistes." *Le siècle,* April 29, 1874.

Cayeux 1954
Jean de Cayeux. "Les secrets de M. Gachet." *Réforme,* December 25, 1954.

Ces toiles 1954
"Ces toiles sont-elles de Van Gogh?" *Le Figaro littéraire,* December 4, 1954, p. 1.

Cézanne Letters 1937
Paul Cézanne. *Correspondance.* Ed. John Rewald. Paris: Éditions Bernard Grasset, 1937.

Cézanne Letters 1978
Paul Cézanne. *Correspondance.* Ed. John Rewald. Rev. ed. Paris: Éditions Bernard Grasset, 1978.

Chappuis 1973
Adrien Chappuis. *The Drawings of Paul Cézanne: A Catalogue Raisonné.* 2 vols. London: Thames and Hudson, 1973.

Chartrain-Hebbelinck 1969
Marie-Jeanne Chartrain-Hebbelinck. "Les lettres de Paul Signac à Octave Maus." *Bulletin des Musées Royaux des Beaux-Arts de Belgique* 18, nos. 1–2 (1969), pp. 52–102.

Chastel 1954
André Chastel. "Autour de la superbe donation Gachet: Les peintres d'Auvers-sur-Oise." *Le Monde,* November 27, 1954, p. 9.

Cherpin 1972
Jean Cherpin. "L'oeuvre gravé de Cézanne." *Arts et livres de Provence,* no. 82 (1972); includes preface by L. van Ryssel [Paul Gachet], "Cézanne à Auvers: Hommage à la memoire de mon maitre," 1956.

Clark 1974
Kenneth Clark. "Book Reviews: The Enigma of Cézanne." *Apollo* 100 (July 1974), pp. 78–81.

Clermont-Ferrand 1995
Armand Guillaumin, 1841–1927: Gravures et lithographies. Exh. cat., Clermont-Ferrand, Musée des Beaux-Arts. Clermont-Ferrand, 1995.

Coffignier 1924
Ch[arles] Coffignier. *Couleurs et peintures.* Paris: J.-B. Baillière et fils, 1924.

Colomer 1993
Claude Colomer. *Ernest Cabaner, 1833–1881: Musicien catalan, grand animateur de la vie parisienne, ami intime de Rimbaud et des impressionnistes.* Revista Terra Nostra, nos. 82–83. Perpignan: C.R.E.C., 1993.

Cooper 1936
Douglas Lord [Douglas Cooper]. "Shorter Notices: Paul Cézanne [First Official Exhibition in France, Musée de l'Orangerie]." *The Burlington Magazine* 69, no. 400 (July 1936), pp. 32–35, 37.

Cooper 1947
Douglas Cooper. "Van Gogh Exhibition: Musée de l'Orangerie, Paris." *The Burlington Magazine* 89, no. 529 (April 1947), pp. 104–5.

Cooper 1955
Douglas Cooper. "The Painters of Auvers-sur-Oise." *The Burlington Magazine* 97, no. 625 (April 1955), pp. 100–106.

Cooper 1975
Douglas Cooper. "Le centenaire de l'impressionnisme." *Revue de l'art,* no. 28 (1975), pp. 78–85.

Cooper 1983
Douglas Cooper. *Paul Gauguin: 45 lettres à Vincent, Théo et Jo van Gogh, Collection Rijksmuseum Vincent van Gogh, Amsterdam.* The Hague: Staatsuitgeverij; Lausanne: La Bibliothèque des Arts, 1983.

Coquiot 1917
Gustave Coquiot. "Armand Guillaumin." *Le carnet des artistes,* 1917, no. 2 (February 15, 1917), pp. 3–5.

Coquiot 1919
Gustave Coquiot. *Paul Cézanne.* Paris: Librairie Paul Ollendorff, [1919].

Coquiot 1923
Gustave Coquiot. *Vincent van Gogh.* Paris: Librairie Ollendorff, 1923.

Courbet Letters 1996
Petra ten-Doesschate Chu, ed. *Correspondance de Courbet.* Paris: Flammarion, 1996.

Courières 1924
Édouard des Courières. *Armand Guillaumin.* Paris: Henri Floury, Éditeur, 1924.

Courthion 1976
Pierre Courthion. *Impressionism.* New York: Harry N. Abrams, [1976].

Daulte 1959
François Daulte. *Alfred Sisley: Catalogue raisonné de l'oeuvre peint.* Lausanne: Éditions Durand-Ruel, 1959.

Daulte 1960
François Daulte. "Un provençal pur: Paul Guigou." *Connaissance des arts,* no. 98 (April 1960), pp. 70–77.

Daulte 1971
François Daulte. *Auguste Renoir: Catalogue raisonné de l'oeuvre peint.* Vol 1. *Figures, 1860–1890.* Lausanne: Éditions Durand-Ruel, 1971.

Défossez 1997
Bernard Défossez. "Un mauvais procès; L'affaire Gachet." *Vivre en Val-d'Oise,* no. 46 (November 1997), pp. 7–13.

Delteil 1923
Loÿs Delteil. *Le peintre-graveur illustré.* Vol. 17. *Camille Pissarro, Alfred Sisley, Auguste Renoir.* Paris: Chez l'auteur, 1923.

Delteil 1925
Loÿs Delteil. *Manuel de l'amateur d'éstampes des XIXe et XXe siècles.* 2 vols. Paris: Dorbon-Aîné, 1925.

Delteil 1927
Loÿs Delteil. *Méryon.* Paris: Les Éditions Rieder, 1927.

Distel 1989
Anne Distel. *Les collectionneurs des impressionnistes: Amateurs et marchands.* Paris: La Bibliothèque des Arts, 1989.

Distel 1990
Anne Distel. *Impressionism: The First Collectors.* Trans. Barbara Perroud-Benson. New York: Harry N. Abrams, 1990.

Doiteau 1923–24
Victor Doiteau. "La curieuse figure du Dr Gachet: Un ami et un amateur de la première heure de Cézanne, Renoir, Pissarro, Van Gogh." *Aesculape* 13 (August 1923), pp. [169]–73; (September 1923), pp. [211]–16; (November 1923), pp. [250]–54; (December 1923), pp. [278]–83; 14 (January 1924), pp. [7]–11.

Dortu 1971
M. G. Dortu. *Toulouse-Lautrec et sou oeuvre.* Vol. 6. New York: Collectors Editions, 1971.

Drouot 1975
Archives Camille Pissarro. Sale cat., Paris, Hôtel Drouot, November 21, 1975.

Drouot 1989
"Vols." *La gazette de l'Hôtel Drouot* 98, no. 16 (April 21, 1989), p. 51.

Drouot 1993
Collection du Docteur Gachet: Estampes et dessins du XVe siècle aux impressionnistes; Important ensemble de dessins de Louis van Ryssel. Sale cat., Paris, Hôtel Drouot, May 15, 1993.

Duret 1878
Théodore Duret. *Les peintres impressionnistes.* Paris: H. Heymann & J. Perios, 1878.

Duret 1906
Théodore Duret. *Histoire des peintres impressionnistes: Pissarro, Claude Monet, Sisley, Renoir, Berthe Morisot, Cézanne, Guillaumin.* Paris: H. Floury, Libraire-Éditeur, 1906.

Elgar 1954
Frank Elgar. "Van Gogh et les peintures d'Auvers-sur-Oise." *Carrefour* 11, no. 533 (December 1, 1954), p. 8.

Essen, Amsterdam 1990
Roland Dorn et al. *Vincent van Gogh and the Modern Movement, 1890–1914.* Exh. cat., Museum Folkwang Essen; Van Gogh Museum Amsterdam. Emsland: Luca Verlag Freren, 1990.

Faille 1928
J.-B. de la Faille. *L'oeuvre de Vincent van Gogh: Catalogue raisonné.* 4 vols. Paris and Brussels: Éditions G. van Oest, 1928.

Faille 1930
J.-B. de la Faille. *Les faux van Gogh.* Paris and Brussels: Éditions G. van Oest, 1930.

Faille 1939
J.-B. de la Faille. *Vincent van Gogh.* Trans. Prudence Montagu-Pollack. London and Toronto: William Heineman Ltd., [1939].

Faille 1970
J.-B. de la Faille. *The Works of Vincent van Gogh, His Paintings and Drawings.* Rev. ed. Amsterdam: Meulenhoff International, 1970.

Faille 1992
J.-B. de la Faille. *Vincent van Gogh, The Complete Works on Paper, Catalogue Raisonné.* 2 vols. Rev. ed. San Francisco: Alan Wofsy Fine Arts, 1992.

Feilchenfeldt 1988
Walter Feilchenfeldt with Han Veenenbos. *Vincent van Gogh & Paul Cassirer, Berlin: The Reception of Van Gogh in Germany from 1901 to 1914.* Zwolle: Uitgeverij Waanders, 1988.

Fernier 1977–78
Robert Fernier. *La vie et l'oeuvre de Gustave Courbet: Catalogue raisonné.* 2 vols. Geneva: Fondation Wildenstein; Lausanne and Paris: La Bibliothèque des Arts, 1977–78.

Flanner 1955
Genêt [Janet Flanner]. "Letter from Paris." *The New Yorker,* January 1, 1955, pp. 53–56.

Florisoone 1949
Michel Florisoone. "Deux grands chefs-d'oeuvre de Van Gogh entrent au musée du Louvre." *Bulletin des Musées de France* 14, no. 6 (July–August 1949), pp. 139–50.

Florisoone 1952
M[ichel] F[lorisoone] et al. "Van Gogh et les peintres d'Auvers chez le docteur Gachet." *L'amour de l'art* 31, nos. 63–65 [special album] (1952).

Gachet 1864
Dr. Paul-Ferdinand Gachet. "Hygiène publique." In *Almanach parisien.* Paris: Fernand Desnoyers, 1864.

Gachet 1870
B. de Mézin [Dr. Paul-Ferdinand Gachet]. *Promenades en long et en large au Salon de 1870.* Paris: Librairie de la Publication, [1871].

Gachet 1875
Dr. Paul-Ferdinand Gachet, ed. *Annuaire de la santé et de l'hygiène pour l'année 1875.*

Gachet 1928
Paul Gachet. "Catalogue raisonné des oeuvres d'Amand Gautier formant la collection de son ami le Dr P. Gachet." Auvers, 1928 (unpublished).

Gachet 1940
Paul Gachet. "Lettres du peintre Armand Gautier à son ami le Dr P.-F. Gachet." Auvers, 1940 (unpublished).

Gachet 1947
Van Ryssel [Paul Gachet]. "Les artistes à Auvers de Daubigny à Van Gogh." *L'avenir de l'Ile-de-France,* no. 51, December 18, 1947, pp. 1, 4.

Gachet 1952
Paul Gachet. *Cézanne à Auvers/Cézanne graveur.* Paris: Les Beaux Arts, Éditions d'Études et de Documents, 1952.

Gachet 1953a
Paul Gachet. *Souvenirs de Cézanne et de Van Gogh à Auvers: Arrangement et notes de Paul Gachet, 1928.* Paris: Les Beaux Arts, Éditions d'Études et de Documents, 1953.

Gachet 1953b
Paul Gachet. *Van Gogh à Auvers, Histoire d'un tableau: Un modèle de Vincent van Gogh et le tableau qu'il en fit, Mademoiselle Gachet au piano.* Paris: Les Beaux Arts, Éditions d'Études et de Documents, 1953.

Gachet 1953c
Paul Gachet. *Vincent van Gogh aux 'Indépendants.'* Paris: Les Beaux Arts, Éditions d'Études et de Documents, 1953.

Gachet 1953d
Paul Gachet. *Un peintre méconnu, Pierre Pilon (1824–1912).* Paris: Les Beaux Arts, Éditions d'Études et de Documents, 1953.

Gachet 1954a
Paul Gachet. *Paul van Ryssel, le Docteur Gachet, graveur.* Paris: Les Beaux Arts, Éditions d'Études et de Documents, 1954.

Gachet 1954b
Paul Gachet. *Vincent à Auvers: "Les vaches" de J. Jordaens.* Paris: Les Beaux Arts, Éditions d'Études et de Documents, 1954.

Gachet 1954c
Paul Gachet. *Cabaner.* Paris: Les Beaux Arts, Éditions d'Études et de Documents, [1954].

Gachet 1956a

Paul Gachet. *Le docteur Gachet et Murer: Deux amis des Impressionnistes.* [Paris]: Éditions des Musées Nationaux, 1956.

Gachet 1956b

Paul Gachet. Untitled memoir in *Tombeau de Cézanne, 23 octobre 1956,* pp. 24–29. Paris: Société Paul Cézanne, 1956.

Gachet 1957a

Paul Gachet. *Lettres impressionnistes, Pissarro, Cézanne, Guillaumin, Renoir, Monet, Sisley, Vignon, Van Gogh, et autres, Mmes Pissarro, Lucien Pissarro, Mme Théo van Gogh, Théo van Gogh, Murer, Dr Gachet, Méryon.* Paris: Bernard Grasset Éditeur, 1957.

Gachet 1957b

Paul Gachet. "Les médicins de Théodore et de Vincent van Gogh." *Aesculape* 40 (March 1957), pp. 4–37.

Gachet 1959

Paul Gachet. "A propos de quelques erreurs sur Vincent van Gogh." *La revue des arts, musées de France* 9, no. 2 (1959), pp. 85–86.

Gachet 1994

Paul Gachet. *Les 70 jours de van Gogh à Auvers: Essai d'éphéméride dans le décor de l'époque (20 mai–30 juillet 1890), d'après les lettres, documents, souvenirs et déductions, Auvers-sur-Oise, 1959.* Edited with commentaries by Alain Mothe. Paris: Éditions du Valhermeil, 1994.

Gachet Obituary 1909

Obituary of Doctor Paul-Ferdinand Gachet. *La chronique des arts et de la curiosité,* 1909, no. 3 (January 16, 1909), p. 23.

Gachet Unpub. Cat.

Paul Gachet. Collection du Dr. Gachet. Vol 1: Pissarro, Monet, Renoir, Sisley, Eva Gonzalès, Monticelli, Guys, Delpy, Oller, Piette (1928). Vol 2: Cézanne: Peintures, aquarelle, pastels, dessins (1928). Vol. 3: Van Gogh; Première partie: Peintures. Van Gogh; Seconde partie: Dessins et estampes (1928). Vol. 4: Guillaumin: Peinture, pastel, aquarelle (1940). Auvers-sur-Oise, 1928–40, and annotated by Gachet thereafter. The Wildenstein Institute Archives, Paris.

Gauthier 1953

Maximilien Gauthier. "La femme en bleu nous parle de l'homme à l'oreille coupée." *Les nouvelles littéraires, artistiques et scientifiques,* no. 1337, April 16, 1953, p. 1.

Golbéry 1990

Roger Golbéry. *Mon oncle, Paul Gachet: Souvenirs d'Auvers-sur-Oise, 1940–1960.* Paris: Éditions du Valhermeil, 1990.

Graetz 1963

H. R. Graetz. *The Symbolic Language of Vincent van Gogh.* New York: McGraw-Hill Book Company, 1963.

Gray 1972

Christopher Gray. *Armand Guillaumin.* Chester, Conn.: Pequot Press, 1972.

Gray 1991

Christopher Gray. *Armand Guillaumin.* 2d ed. [Chester, Conn.: Brush-Mill Books], 1991.

Guérin 1944

Marcel Guérin. *L'oeuvre gravé de Manet.* Paris: Librairie Floury, 1944.

Harris 1970

Jean C. Harris. *Edouard Manet Graphic Works, A Definitive Catalogue Raisonné.* New York: Collectors Editions, 1970.

Hofenk de Graaff et al. 1991

J. H. Hofenk de Graaff, M. F. S. Karreman, M. de Keijzer, and W. G. T. Roelofs. "Scientific Investigation." In *A Closer Look: Technical and Art-Historical Studies on Works by Van Gogh and Gauguin,* ed. Cornelia Peres et al., pp. 75–85. Cahier Vincent, 3. Zwolle: Waanders Publishers, 1991.

Hoog 1984

Michel Hoog. *Musée de l'Orangerie: Catalogue de la collection Jean Walter et Paul Guillaume.* Paris: Éditions de la Réunion des Musées Nationaux, 1984.

Hoschedé 1890

Ernest Hoschedé. *Brelan de Salons.* Paris: Bernard Tignol, Éditeur, 1890.

Hulsker 1980

Jan Hulsker. *The Complete Van Gogh: Paintings, Drawings, Sketches.* New York: Harry N. Abrams, 1980.

Hulsker 1988

Jan Hulsker. Review of *Van Gogh à Paris,* 1988; *Van Gogh in Arles,* 1984; *Van Gogh in Saint-Rémy and Auvers,* 1986; and *Vincent van Gogh à Auvers-sur-Oise,* 1987. *Simiolus* 18, no. 3 (1988), pp. 177–92.

Hulsker 1993

Jan Hulsker. *Vincent van Gogh: A Guide to His Work and Letters.* Amsterdam: Van Gogh Museum, 1993.

Hulsker 1996

Jan Hulsker. *The New Complete Van Gogh: Paintings, Drawings, Sketches.* Amsterdam: J. M. Meulenhoff; Amsterdam and Philadelphia: John Benjamins, 1996.

Jerusalem 1994–95

Joachim Pissarro and Stephanie Rachum. *Camille Pissarro, Impressionist Innovator.* Exh. cat., Jerusalem, The Israel Museum. Jerusalem, 1994.

Kostenevich 1995

Albert Kostenevich. *Hidden Treasures Revealed: Impressionist Masterpieces and Other Important French Paintings Preserved by The State Hermitage Museum, St. Petersburg.* New York: Harry N. Abrams; St. Petersburg: The Ministry of Culture of the Russian Federation, The State Hermitage Museum, 1995.

Koyama-Richard 1993

Brigitte Koyama-Richard. "Zasshi 'Shirakaba' ni yotte tsutaerareta Gohho no imēji [Van Gogh's Reception in 'Shirakaba' in Japan]." *Musashi Daigaku Jinbun Gakkai Zasshi* 24, no. 4 (April 1993), pp. 333–78.

Kraemer 1997
Gilles Kraemer. "Essai de catalogue raisonné de l'oeuvre gravé et lithographié de Jean-Baptiste Armand Guillaumin, 1841–1927." In *Armand Guillaumin: "De la lumière à la couleur,* pp. 90–92. Exh. cat., Belfort, Musée d'Art et d'Histoire. Belfort, 1997.

Krumrine 1990
Mary Louise Krumrine et al. *Paul Cézanne: The Bathers.* Translation of exh. cat., Kunstmuseum Basel. New York: Harry N. Abrams, 1990.

Lacambre et al. 1990
Isabelle Compin, Geneviève Lacambre, and Anne Roquebert, with the collaboration of Anne Distel, Claire Frèches-Thory, and Claude Pétry. *Musée d'Orsay: Catalogue sommaire illustré des peintures.* Ed. Geneviève Lacambre. 2 vols. Paris: Réunion des Musées Nationaux, 1990.

Lamort de Gail 1989
Sylvie Lamort de Gail. *Paul Guigou: Catalogue raisonné.* Vol. 1. Paris: Éditions d'Art et d'Histoire ARHIS, 1989.

Landais 1997
B[enoît] L[andais]. "L'affaire Van Gogh: Le docteur Gachet par Gachet?" *Connaissance des arts,* no. 542 (September 1997), pp. 106–17.

Landais and Tasset 1997
Benoît Landais and Jean Marie Tasset. Interview. *Le Figaro,* October 7, 1997.

Langstroth 1973
T. A. Langstroth. "Phloxine." In *Pigment Handbook,* ed. Temple C. Patton, vol. 1, pp. 629–33. 3 vols. New York: Wiley, 1973.

Lannoy-Duputel 1989
Michèle Lannoy-Duputel. *Hippolyte-Camille Delpy, 1842–1910: Invitation au Voyage.* Paris: Le Léopard d'Or, [1989].

Le Masque Rouge 1903
Le Masque Rouge. "La fin de Van Gogh." *L'action,* January 12, 1903.

Leroi 1892
Paul Leroi. "Silhouettes d'artistes contemporains: Rodolphe Piguet." *L'art* 53 (December 1892), pp. 268–74.

Leroy 1874
Louis Leroy. "L'exposition des impressionnistes." *Le charivari,* April 25, 1874.

Leymarie and Melot 1971
Jean Leymarie and Michel Melot. *Les gravures des impressionnistes: Manet, Pissarro, Renoir, Cézanne, Sisley.* Paris: Arts et Métiers Graphiques, 1971.

London 1977
John Bensusan-Butt et al. *Lucien Pissarro 1863–1944.* Exh. cat., London, Anthony d'Offay. London, 1977.

London, Paris, Boston 1985–86
John House et al. *Renoir.* Exh. cat., London, Hayward Gallery; Paris, Galeries Nationales du Grand Palais; Boston, Museum of Fine Arts. [London]: Arts Council of Great Britain, 1985.

London, Paris, Washington 1988–89
Lawrence Gowing et al. *Cézanne: The Early Years 1859–1872.* Exh. cat., London, Royal Academy of Arts; Paris, Réunion des Musées Nationaux/Musée d'Orsay; Washington, D.C., National Gallery of Art. London: Royal Academy of Arts/Weidenfeld and Nicolson, 1988.

Los Angeles, Chicago, Paris 1984–85
Richard Brettell, Sylvie Gache-Patin, Françoise Heilbrun, and Scott Schaefer. *A Day in the Country: Impressionism and the French Landscape.* Exh. cat., Los Angeles County Museum of Art; The Art Institute of Chicago; Paris, Galeries Nationales d'Exposition du Grand Palais. Los Angeles: Los Angeles County Museum of Art, 1984.

Macke 1912
August Macke. "Die Masken." In *Der Blaue Reiter,* ed. [Wassily] Kandinsky and Franz Marc, pp. 21–26. Munich: R. Piper & Co., Verlag, 1912.

Maison 1968
K. E. Maison. *Honoré Daumier: Catalogue Raisonné of the Paintings, Watercolours, and Drawings.* 2 vols. London: Thames and Hudson, 1968.

Malraux 1951
André Malraux. "Une leçon de fidélité: A propos de l'entrée au Louvre de la collection Gachet." *Arts: Beaux-arts, littéraire, spectacles,* no. 338 (December 21, 1951), p. 1.

Marly-le-Roi, Louveciennes 1984
Marie-Amélie Anquetil and Marie-Amynthe Denis. *De Renoir à Vuillard: Marly-le-Roi, Louveciennes, leurs environs . . .* Exh. cat., Musée-Promenade de Marly-le-Roi-Louveciennes. [Louveciennes], 1984.

Meier-Graefe 1904
Julius Meier-Graefe. *Entwickelungsgeschichte der Modernen Kunst.* Vol. 1. Stuttgart: Verlag Jul. Hoffmann, 1904.

Melot 1996
Michel Melot. *The Impressionist Print.* Trans. Caroline Beamish. New Haven and London: Yale University Press, 1996.

Mérimée 1830
J.-F.-L. Mérimée. *De la peinture à l'huile.* Paris: Mme. Huzard, Libraire, 1830.

Minneapolis, New York 1962
The Nineteenth Century: One Hundred Twenty-Five Master Drawings. Exh. cat., Minneapolis, University Gallery, University of Minnesota; New York, Solomon R. Guggenheim Museum. [Minneapolis]: University of Minnesota Gallery, 1962.

Miquel 1985
Pierre Miquel. *Le paysage français au XIXe siècle.* Vol. 4. *1840–1900: L'école de la nature.* Maurs-la-Jolie: Éditions de la Martinelle, 1985.

Mohen 1987
Jean-Pierre Mohen. "Gabriel de Mortillet et 'Le musée préhistorique.'" In *Art, objets d'art, collections: Hommage à Hubert Landais, études sur l'art du Moyen Âge et de la Renaissance, sur l'histoire du goût et des collections,* pp. 220–22. Paris: Blanchard Éditeur, 1987.

Monneret 1978–81
Sophie Monneret. *L'impressionnisme et son époque: Dictionnaire international illustré.* 4 vols. Paris: Éditions Denoël, 1978–81.

Montfort 1972
Juliana Montfort. "Van Gogh et la gravure, histoire catalographique." *Nouvelles de l'estampe,* no. 2 (March–April 1972), pp. 5–13.

Montgolfier 1992
Bernard de Montgolfier. *Le Musée Carnavalet.* Musées et Monuments de France. Paris: Amis du Musée Carnavalet, 1992.

Montifaud 1874
Marc de Montifaud [Marie-Émilie Chartroule]. "Exposition du Boulevard des Capucines." *L'artiste,* ser. 9, 19 (May 1874), pp. 307–13.

Moore 1993
Gene M. Moore. "Conrad, Dr. Gachet, and the 'School of Charenton.'" *Conradiana* 25, no. 3 (1993), pp. 163–77.

Mothe 1987
Alain Mothe. *Vincent van Gogh à Auvers-sur-Oise.* Paris: Éditions du Valhermeil, 1987.

Moulhérat
C. Moulhérat. "Analysis of the Supports in the Collection of Dr. Gachet." Internal report, Research Laboratory of the Musées de France.

Munk 1993
Jens Peter Munk. *Catalogue French Impressionism, Ny Carlsberg Glyptotek.* [Copenhagen]: Ny Carlsberg Glyptotek, 1993.

New York 1954
Exhibition of Paintings by L. Van Ryssel. Exh. cat., New York, Wildenstein. New York, 1954.

New York 1955
Loan Exhibition Van Gogh. Exh. cat., New York, Wildenstein. New York, 1955.

New York 1959
Loan Exhibition Cézanne. Exh. cat., New York, Wildenstein. New York, 1959.

New York 1986–87
Ronald Pickvance. *Van Gogh in Saint-Rémy and Auvers.* Exh. cat., New York, The Metropolitan Museum of Art. New York, 1986.

New York 1994
Cara D. Denison et al. *The Thaw Collection: Master Drawings and New Acquisitions.* Exh. cat., New York, The Pierpont Morgan Library. New York, 1994.

New York, Columbus 1987
Aaron Sheon. *Paul Guigou, 1834–1871.* Exh. cat., New York, William Beadleston Inc. & The Artemis Group; Columbus Museum of Art. New York: William Beadleston, 1987.

New York, Paris 1992–93/1995
Masterworks from the Musée des Beaux-Arts, Lille. Exh. cat., New York, The Metropolitan Museum of Art; Paris, Grand Palais. New York: The Metropolitan Museum of Art, 1992.

Norman 1998
Geraldine Norman. "Fakes?" *The New York Review of Books* 45, no. 2, February 5, 1998, pp. 4–7.

Ottawa, Chicago, Fort Worth 1997
Colin B. Bailey et al. *Renoir's Portraits: Impressions of an Age.* Exh. cat., Ottawa, National Gallery of Canada; The Art Institute of Chicago; Fort Worth, Kimbell Art Museum. New Haven and London: Yale University Press; Ottawa: National Gallery of Canada, 1997.

Otterlo 1990
Johannes van der Wolk, Ronald Pickvance, and E. B. F. Pey. *Vincent van Gogh: Drawings.* Exh. cat., Otterlo, Rijksmuseum Kröller-Müller. Milan: Arnoldo Mondadori Arte, 1990.

Outhwaite 1969
David Outhwaite. "Vincent van Gogh at Auvers-sur-Oise." Master's thesis, Courtauld Institute of Art, 1969.

Pakenham 1996
Michael Pakenham. "*Paris à l'eau-forte* de Richard Lesclide." In *Pratiques d'écriture: Mélanges de poétique et d'histoire littéraire offerts à Jean Gaudon,* ed. Pierre Laforgue, pp. 65–79. Bibliothèque du XIXe siècle, 16. [Paris]: Klincksieck, 1996.

Paris 1870
Ministère des Beaux-Arts. *Salon de 1870: Explication des ouvrages de peinture, sculpture, architecture, gravure et lithographie des artistes vivants exposés au palais des Champs-Élysées le 1er mai 1870.* Exh. cat. Paris: Charles de Mourges Frères, 1870.

Paris 1874
Société Anonyme. *Première exposition 1874, 35, boulevard des Capucines, 35: Catalogue.* Exh. cat., Paris, Galerie Nadar. Paris: Imprimerie Alcan-Lévy, 1874.

Paris 1877
Catalogue de la 3e exposition de peinture [third Impressionist exhibition]. Exh. cat., Paris, 6, rue le Peletier. Paris, 1877.

Paris 1891
Société des Artistes Indépendants. *Catalogue des oeuvres exposées, 1891.* Exh. cat., Paris, Salon des Artistes Indépendants. Paris, 1891.

Paris 1899
Paul Cézanne. Exh. cat., Paris, Galerie Vollard. Paris, 1899.

Paris 1903
Société des Artistes Indépendants. *Catalogue: 19e exposition, 1903.* Exh. cat., Paris, Salon des Artistes Indépendants. Paris, 1903.

Paris 1905
Société des Artistes Indépendants. *Catalogue de la 21me exposition, 1905.* Includes "Exposition rétrospective Vincent van Gogh (1853–1890)." Grandes Serres de la Ville de Paris, Cours de la Reine, Greenhouse A. Separate numeration on pp. 13–16. Exh. cat., Paris, Salon des Artistes Indépendants. Paris, 1905.

Paris 1906
Société des Artistes Indépendants. *Catalogue de la 22me exposition, 1906.* Exh. cat., Paris, Salon des Artistes Indépendants. Paris, 1906.

Paris 1907
Société des Artistes Indépendants. *Catalogue de la 23me exposition, 1907.* Exh. cat., Paris, Salon des Artistes Indépendants. Paris, 1907.

Paris 1907–8
Portraits d'hommes. Exh. cat., Paris, Bernheim-Jeune et Cie. Paris, 1907.

Paris 1908a
Société des Artistes Indépendants. *Catalogue de la 24me exposition, 1908.* Exh. cat., Paris, Salon des Artistes Indépendants. Paris, 1908.

Paris 1908b
Vincent van Gogh. Exh. cat., Paris, Galerie Druet. Paris, 1908.

Paris 1925
Vincent van Gogh. Exh. cat., Paris, Galerie Marcel Bernheim et Cie. Paris, 1925.

Paris 1930
Centenaire de la naissance de Camille Pissarro. Exh. cat., Paris, Musée de l'Orangerie. Paris: Musées Nationaux, 1930.

Paris 1936
J[acques]-É[mile] Blanche and Paul Jamot. *Cézanne.* Exh. cat., Paris, Musée de l'Orangerie. Paris, 1936.

Paris 1937a
Guillaumin. Exh. cat., Paris, Galerie de l'Élysée. Paris, 1937.

Paris 1937b
Vincent van Gogh, sa vie & son oeuvre. Exh. cat., Paris, Exposition Internationale de 1937, Nouveaux Musées, Quai de Tokio. Paris: L'Amour de l'Art, 1937.

Paris 1938
Sélection d'oeuvres de Guillaumin (1841–1927). Exh. cat., Paris, Galerie Raphaël Gérard. Paris, 1938.

Paris 1939
Centenaire du peintre indépendant Paul Cézanne, 1839–1906. Preface by Maurice Denis. Exh. cat., Grand Palais, Société des Artistes Indépendants. Paris, 1939.

Paris 1941
Centenaire de A. Guillaumin (1841–1927). Exh. cat., Paris, Galerie Raphaël Gérard. Paris, 1941.

Paris 1953
Monticelli et le baroque provençal. Exh. cat., Paris, Orangerie des Tuileries. Paris: Éditions des Musées Nationaux, 1953.

Paris 1954–55
L. van Ryssel, Germain Bazin, and Albert Chatelet. *Van Gogh et les peintres d'Auvers-sur-Oise.* Exh. cat., Paris, Orangerie des Tuileries. Paris: Éditions des Musées Nationaux, 1954.

Paris 1955
Tableaux de collections parisiennes, 1850–1950. Exh. cat., Paris, Galerie Beaux-Arts. Paris, 1955.

Paris 1966
[Marie Thérèse Lemoyne de Forges, Geneviève Allemand, and Michèle Bundorf.] *Collection Jean Walter—Paul-Guillaume: Catalogue.* Exh. cat., Paris, Orangerie des Tuileries. Paris: Ministère des Affaires Culturelles; Réunion des Musées Nationaux, 1966.

Paris 1973
Georges Manzana-Pissarro. *Manzana Pissarro.* Exh. cat., Paris, Galerie Dario Boccara. [Zoug: Les Clefs du Temps, 1973].

Paris 1974
Hélène Adhémar and Maurice Sérullaz. *Cézanne dans les musées nationaux.* Exh. cat., Paris, Orangerie des Tuileries. Paris: Éditions des Musées Nationaux, 1974.

Paris 1980
Hélène Adhémar et al. *Hommage à Claude Monet (1840–1926).* Exh. cat., Paris, Grand Palais. Paris: Éditions de la Réunion des Musées Nationaux, 1980.

Paris 1988
Bogomila Welsh-Ovcharov et al. *Van Gogh à Paris.* Exh. cat., Paris, Musée d'Orsay. Paris: Éditions de la Réunion des Musées Nationaux, 1988.

Paris 1990
Jean Monneret. *Vincent van Gogh au Salon des Indépendants en 1888–1889–1890 et 1891, ou, la passion selon Vincent.* Exh. cat., Paris, Grand Palais. Paris: Société des Artistes Indépendants, 1990.

Paris, London, Philadelphia 1995–96
Françoise Cachin et al. *Cezanne.* Exh. cat., Paris, Galeries Nationales du Grand Palais; London, Tate Gallery; Philadelphia Museum of Art. Philadelphia: Philadelphia Museum of Art, 1996.

Perruchot 1955
Henri Perruchot. "La fin énigmatique de Van Gogh." *L'oeil,* no. 10 (October 1955), pp. 12–17.

Pickvance 1992
Ronald Pickvance. *"A Great Artist Is Dead": Letters of Condolence on Vincent van Gogh's Death.* Ed. Sjraar van Heugten and Fieke Pabst. Cahier Vincent, 4. Zwolle: Waanders Publishers; Amsterdam: Rijksmuseum Vincent van Gogh, 1992.

Pissarro and Venturi 1939
Ludovic Rodo Pissarro and Lionello Venturi. *Camille Pissarro, son art—son oeuvre.* 2 vols. Paris: Paul Rosenberg, Éditeur, 1939.

Pissarro Letters 1980–91
Janine Bailly-Herzberg, ed. *Correspondance de Camille Pissarro.* 5 vols. Paris: Presses Universitaires de France; Éditions du Valhermeil, 1980–91.

Ponce 1983
Haydee Venegas et al. *Francisco Oller, un realista del impresionismo.* Exh. cat., Museo de Arte de Ponce, then traveled. Ponce, 1983.

Pontoise 1994–95
Christophe Duvivier. *Norbert Goeneutte, 1854–1894.* Exh. cat., Musée de Pontoise. Pontoise, 1994.

Potter 1984
Margaret Potter. *The David and Peggy Rockefeller Collection.* Vol. 1. *European Works of Art.* New York: Privately published, 1984.

Ravoux-Carrié 1955

Adeline Ravoux-Carrié. "Les souvenirs d'Adeline Ravoux sur le séjour de Vincent van Gogh à Auvers-sur-Oise." *Les cahiers de Van Gogh*, no. 1 ([1955]), pp. 7–17.

Reff 1960

Theodore Reff. "A New Exhibition of Cézanne." *The Burlington Magazine* 102, no. 684 (March 1960), pp. 114–18.

Reff 1962

Theodore Reff. "Cézanne's Constructive Stroke." *The Art Quarterly* 25, no. 3 (Autumn 1962), pp. 214–27.

Reff 1975

Theodore Reff. "The Literature of Art: Cézanne's Drawings [review of Adrien Chappuis, *The Drawings of Paul Cézanne: A Catalogue Raisonné*]." *The Burlington Magazine* 117, no. 868 (July 1975), pp. 489–91.

Reff 1997

Theodore Reff. Review of *The Paintings of Paul Cézanne, A Catalogue Raisonné*, by John Rewald. *The Burlington Magazine* 139, no. 1136 (November 1997), pp. 798–802.

Reid 1977

Martin Reid. "Camille Pissarro: Three Paintings of London of 1871. What Do They Represent?" *The Burlington Magazine* 119, no. 889 (April 1977), pp. 251–61.

Reid 1986

Martin Reid. "The Pissarro Family in the Norwood Area of London, 1870–1: Where Did They Live?" In *Studies on Camille Pissarro*, ed. Christopher Lloyd, pp. 55–64. London and New York: Routledge & Kegan Paul, 1986.

Reidemeister 1963

Leopold Reidemeister. *Auf den Spuren der Maler der Ile de France: Topographische Beiträge zur Geschichte der französischen Landschaftsmalerei von Corot bis zu den Fauves.* Berlin: Propyläen Verlag, 1963.

Rewald 1952

John Rewald. "Gachet's Unknown Gems Emerge." *Art News* 51, no. 1 (March 1952), pp. 16–19, 63–66.

Rewald 1969

John Rewald. "Chocquet and Cézanne." *Gazette des Beaux-Arts*, ser. 6, 74 (July–August 1969), pp. 33–96.

Rewald 1978

John Rewald. *Post-Impressionism from Van Gogh to Gauguin.* 3d ed., rev. New York: The Museum of Modern Art, 1978.

Rewald 1983

John Rewald. *Paul Cézanne, The Watercolors: A Catalogue Raisonné.* Boston: Little, Brown, and Company, 1983.

Rewald 1996

John Rewald. *The Paintings of Paul Cézanne: A Catalogue Raisonné.* Ed. Walter Feilchenfeldt and Jayne Warman. 2 vols. New York: Harry N. Abrams, 1996.

Rivière 1921

Georges Rivière. *Renoir et ses amis.* Paris: H. Floury, Éditeur, 1921.

Rivière 1923

Georges Rivière. *Le maître Paul Cezanne.* Paris: H. Floury, Éditeur, 1923.

Rivière 1927

Georges Rivière. "Armand Guillaumin." *L'art vivant* 3 (July 15, 1927), pp. 553–54.

Rouart and Wildenstein 1975

Denis Rouart and Daniel Wildenstein. *Édouard Manet: Catalogue raisonné.* 2 vols. Lausanne and Paris: La Bibliothèque des Arts, 1975.

Sablonière 1957

Margrit de Sablonière. "Meer klaarheid omtrent Vincent van Gogh." *Museumjournaal*, ser. 3, no. 2 (June 1957), pp. 41–42.

Saltzman 1998

Cynthia Saltzman. *Portrait of Dr. Gachet, The Story of a Van Gogh Masterpiece: Modernism, Money, Politics, Collectors, Dealers, Taste, Greed, and Loss.* New York and London: The Viking Press, 1998.

San Francisco 1959

Thomas Carr Howe. *The Collection of Mr. & Mrs. William Goetz.* Exh. cat., San Francisco, California Palace of the Legion of Honor. San Francisco, 1959.

Saunders and Kirby 1994

David Saunders and Jo Kirby. "Light-Induced Colour Changes in Red and Yellow Lake Pigments." *National Gallery Technical Bulletin* 15 (1994), pp. 79–97.

Schneiderman 1990

Richard S. Schneiderman with the assistance of Frank W. Raysor, II. *The Catalogue Raisonné of the Prints of Charles Méryon.* London: Garton & Co.; Scolar Press, 1990.

Schweppe and Roosen-Runge 1986

Helmut Schweppe and Heinz Roosen-Runge. "Carmine-Cochineal Carmine and Kermes Carmine." In *Artist's Pigments: A Handbook of Their History and Characteristics*, vol. 1, ed. Robert L. Feller, pp. 255–83. Cambridge: Cambridge University Press; Washington, D.C.: National Gallery of Art, 1986.

Seni and Le Tarnec 1997

Nora Seni and Sophie Le Tarnec. *Les Camondo ou l'éclipse d'une fortune.* Hébraïca. Arles: Actes Sud, 1997.

Sergent 1950

Louis Sergent. "Un portrait de la mère de Daumier." *Daumier* 1; *Arts et livres de Provence* 18 (January 1950), pp. 28–30.

Serret and Fabiani 1971

G. Serret and D. Fabiani. *Armand Guillaumin, 1841–1927: Catalogue raisonné de l'oeuvre peint.* Paris: Éditions Mayer, 1971.

Stein 1986

Susan Alyson Stein. *Van Gogh: A Retrospective.* New York: Hugh Lauter Levin Associates, 1986.

Sterling and Adhémar 1958–61

Charles Sterling and Hélène Adhémar. *Musée National du Louvre: Peintures, école française XIXe siècle.* 4 vols. Paris: Éditions des Musées Nationaux, 1958–61.

Tardieu 1891
Eugène Tardieu. Salon review. *Le magazine français illustré*, 1891, no. 2 (April 25, 1891).

Ting Tun-ling 1875
Ting Tun-ling. *La petite pantoufle.* Translated by Charles Aubert. [Paris]: Édition Franco-Chinoise [1875].

Tralbaut 1967
Marc Edo Tralbaut. "A propos du tableau 'Fleurs et feuillages' de Van Gogh acquis récemment par le Nationalmuseum de Stockholm." *Van Goghiana* 4 (1967), pp. 78–105.

Tralbaut 1969
Marc Edo Tralbaut. *Vincent van Gogh.* New York: The Viking Press, 1969.

Travers Newton 1991
H. Travers Newton. "Observations on Gauguin's Painting Techniques and Materials." In *A Closer Look: Technical and Art-Historical Studies on Works by Van Gogh and Gauguin,* ed. Cornelia Peres et al., pp. 103–11. Cahier Vincent, 3. Zwolle: Waanders Publishers, 1991.

Trublot 1886–87
Trublot [Paul Alexis]. "À minuit." *Le cri du peuple,* July 25, 1886, May 13, 1887, November 15, 1887.

Trublot 1887
Trublot [Paul Alexis]. "Trubl'au vert—Trubl'Auvers-sur-Oise." *Le cri du peuple,* August 15, 1887.

Vanbeselaere 1937
Walther Vanbeselaere. *De hollandsche periode (1880–1885) in het werk van Vincent van Gogh (1853–1890).* Antwerp: De Sikkel, 1937.

Van der Wolk 1987
Johannes van der Wolk. *The Seven Sketchbooks of Vincent van Gogh: A Facsimile Edition.* Trans. Claudia Swan. New York: Harry N. Abrams, 1987.

Van Gogh Letters 1911
Lettres de Vincent van Gogh à Émile Bernard. Paris: Ambroise Vollard, 1911.

Van Gogh Letters 1914
Brieven aan zijn broeder. Preface and notes by J. van Gogh-Bonger. 3 vols. Amsterdam: Maatschappij voor Goede en Goedkoope Lectuur, 1914.

Van Gogh Letters 1952–54
Verzamelde brieven van Vincent van Gogh. Ed. J. van Gogh-Bonger. 4 vols. Amsterdam and Antwerp: Wereld Biblio-theek, 1952–54.

Van Gogh Letters 1958
The Complete Letters of Vincent van Gogh. 3 vols. Greenwich, Conn.: New York Graphic Society, [1958].

Van Gogh Letters 1960
Correspondance complète de Vincent van Gogh. Trans. M. Beerblock and L. Roelandt. Introduction and notes by Georges Charensol. 3 vols. Paris: Gallimard/Grasset, 1960.

Van Gogh Letters 1977
Letters of Vincent van Gogh 1886–1890: A Facsimile Edition. Preface by Jean Leymarie; introduction by V. W. van Gogh.

2 vols. London: The Scolar Press; Amsterdam: Meulenhoff International, 1977.

Van Gogh Letters 1990
Han van Crimpen and Monique Berends-Albert, eds. *De brieven van Vincent van Gogh.* 4 vols. The Hague: SDU Uitgeverij, 1990.

Van Heugten and Pabst 1995
Sjraar van Heugten and Fieke Pabst. *The Graphic Work of Vincent van Gogh.* Cahier Vincent, 6. Zwolle: Waanders Publishers; Amsterdam: Van Gogh Museum, 1995.

Van Uitert and Hoyle 1987
E[vert] van Uitert and M[ichael] Hoyle, eds. *The Rijks-museum Vincent van Gogh.* Art Treasures of Holland. Amsterdam: Meulenhoff/Landshoff, 1987.

Venturi 1936
Lionello Venturi. *Cézanne: Son art—son oeuvre.* 2 vols. Paris: Paul Rosenberg Éditeur, 1936.

Venturi 1956
Lionello Venturi. "'Hamlet and Horatio,' A Painting by Paul Cézanne." *The Art Quarterly* 19, no. 3 (Autumn 1956), pp. 270–71, 273.

Vibert 1892
J[ehan] G[eorges] Vibert. *La science de la peinture.* Paris: Paul Ollendorff, 1892.

Vinchon 1958
Jean Vinchon. "En marge des dessins de folies [*sic*] du Docteur Paul Gachet." Lecture given in Paris at the Société d'Histoire de la Médecine in 1958; privately published, pp. 9–22.

Vollard 1914
Ambroise Vollard. *Paul Cézanne.* Paris: Galerie A. Vollard, 1914.

Vollard 1919
Ambroise Vollard. *Paul Cézanne, huit phototypies d'après Cézanne, lettres de M. M. Jacques Flach, de l'Institute et André Suarès.* Paris: Éditions Georges Crès & Cie, 1919.

Walther and Metzger 1997
Ingo F. Walther and Rainer Metzger. *Van Gogh: L'oeuvre complèt, peinture.* Cologne: Taschen, 1997.

Washington, San Francisco 1986
Charles S. Moffett et al. *The New Painting: Impressionism 1874–1886.* Exh. cat., Washington, D.C., National Gallery of Art; San Francisco, The Fine Arts Museums of San Francisco. San Francisco, 1986.

Welsh-Ovcharov 1976
Bogomila Welsh-Ovcharov. *Vincent van Gogh: His Paris Period, 1886–1888.* Utrecht and The Hague: Editions Victorine, 1976.

Wildenstein 1974
Daniel Wildenstein. *Claude Monet: Biographie et catalogue raisonné.* Vol. 1. *1840–1881, peintures.* Lausanne and Paris: La Bibliothèque des Arts, 1974.

Wildenstein 1991
Daniel Wildenstein. *Claude Monet: Catalogue raisonné.* Vol. 5. *Supplément aux peintures; Dessins; Pastels; Index.* Lausanne: Wildenstein Institute, 1991.

Index of Owners

This index lists known former and current owners of works that appear in the Summary Catalogue. Galleries named for individuals are listed by surname. References are to page number and P.G. number (see Reader's Note to the Summary Catalogue, p. 187).

General Index

Note: Page references for illustrations are in *italics*. Page references for principal discussions of catalogue entries are in **boldface**. The following reference sections of this book, not fully indexed below, may be consulted individually: The Checklist of Artists and Works, the Summary Catalogue, the Checklist of Copies, and "Paul Gachet Characterizes His Father's Collection."

Abrassard, Anthony, 282
Aguiar, Dr., 128
 Houses at Auvers, 128
Alexis, Paul (alias Trublot) (1847–1901), 9, 12, 287
Allain, Major, 279
Aman-Jean, Edmond-François (Amand-Edmond Jean) (1858–1935), 19 n. 14
Amiet, Cuno (1868–1961), 87
Andréas, Ernest André (1868–1899), 23 n. 84, 179
Anfray, Louis, 16, 91, 101, 162, 173 n. 15
Antoine ("the actor's brother"), 268
Artaud, Antonin (1897–1948), 173 n. 15
 Van Gogh le suicidé de la société (Van Gogh, Suicided by Society), 16
Aryton, Tony, 271
Asselineau, Charles, 20 n. 52
Astruc, Zacharie (1835–1907), 281
Aurier, Albert (1865–1892), 21 n. 63, 265, 268, 269
Au Tambourin (restaurant), 102
Auvers, 12, 15, 128
 as cradle of the new movement in painting, 6
 printmakers in, emblems used by, 124
 See also: Photographs, anonymous; and views painted of, under Cézanne, Paul; Gogh, Vincent van; Ryssel, Louis van; and other artists

Barcinski, Casimir, 33
Barenne, Odette, 272
Bargue, Charles (d. 1883), drawing manual of, 94, 179
Barnes, Dr. Albert C., 23 n. 91. *See also* Index of Owners
Barrès, A.
 Dr. Paul Gachet (1894), *10;* fig. 9
 Marguerite Gachet (1894), *10;* fig. 10

Marguerite Gachet as a Child (ca. 1879), *5;* fig. 5
Paul Gachet fils *as a Child* (ca. 1879), *5;* fig. 4
Baticle, Jeannine, 25 n. 102
Baudelaire, Charles, 4, 125
Baudin, Jean-Baptiste, 274, 287 n. 6
Baudry, Étienne (1830–1908), 7–8
Bazin, Germain, 16, 25 n. 102
Bellio, Georges de (1828–1894), 8
Benoît, Pieter (1834–1901), 9, 279
Bernard, Émile (1868–1941), 11, 12, 21 n. 63, 28, 179, 265, 267, 269
 Paul Gachet fils (1926), 28, *32;* fig. 33
 Van Gogh's letters, 1911 edition of, 86
Bernard, Monsieur (industrialist), 273
Bibliothèque Nationale de France, 134, 162. *See also* Index of Owners
Bigny, Théophile (1866–1952), 19 n. 22, 243ff.
Bin, Émile (1825–1897), 179, 282, 283, 287
Blaizot, Quartermaster, 280
Blanche, Dr. Émile (1820–1893), 269
Boch, Eugène (1855–1941), 68
Bock, Théophile de (acquaintance of Theo van Gogh), 264
Boll (Paris official), 287
Bonaparte, Charles-Louis-Napoléon, 273
Bonger, Andries (brother of Johanna van Gogh) (1861–1934), 268, 269
Bonger, Mlle Betsy, 151, 284
Bonnard, Madame, 285
Bonvin, François (1817–1887), 144, 179
Boudin, Eugène (1824–1898), 281
Bouilly, Joseph, 4–5, 18 n. 11
Bourgeois, Alfred, *Ernest Hoschedé* (1890), *8;* fig. 8
Bourgeois, Léon, 23 n. 79
Bouvenne, Aglaüs (1829–1903), 9, 20 n. 52, 179, 280, 282
Bovard (merchant), 44
Bracquemond, Félix (1833–1914), 144, 179, 281
Brascassat, Jacques-Raymond (1804–1867), 179, 276
Bresdin, Rodolphe (1822–1885), 144, 179, 281
Bruyas, Alfred (1821–1877), 4, 18 n. 4, 261, 277, 285
Buckman, Eduard, 97, 173 n. 1, 173 n. 6
Buhot, Félix (1847–1898), 20 n. 30, 144, 179, 272, 281
Burion, Amédée, 287

Cabaner, Ernest (1833–1881), 9, 20 n. 50, 270, 282
Cabrol, Dr. Jean (1813–1889), 24 n. 100, 276, 278, 280, 285
Cadorin, Paolo, 87
Caillebotte, Gustave (1848–1894), 8, 12
Callias, Nina de, 9
Cals, Adolphe-Félix, 281
Camondo, Count Isaac de (1860–1935), 58, 153, 174 n. 25. *See also* Index of Owners
Carabin, Rupert (1862–1952), 9, 255
Caribbean, connections with Auvers group, 128
Caro (paint manufacturer), 107
Carpentier (supplier), 138
Cassanova (theater director), 278
Cassirer, Paul, 167, 174 n. 35. *See also* Index of Owners
Castagnary, Jules (1830–1888), 36
Castets, Blanche, 5–6
Causin, Ernest, 20 n. 52, 287
Cézanne, Louis-Auguste (father of Paul Cézanne), 19 n. 28, 285
Cézanne, Paul (1839–1906), 6–7, 8, 9, 11, 12, 13, 36–70, 114, 118, 124, 128, 142, 143, 144, 159, 160, 171, 172, 280, 281
 The Accessories of Cézanne: Still Life with Medallion of Philippe Solari (1872), **48–49**, *49,* 50, 65, 66, 201; cat. no. 4
 photograph of, before restoration, 48, *49;* fig. 46
 X-radiograph of, 65, 66; fig. 47
 Bouquet in a Small Delft Vase (1873?), **56–58**, *57,* 170, 175 n. 36, 203, 260; cat. no. 8
 copies after, *56,* 58, 67, *67,* 148; cat. nos. 8a, 8b; fig. 51
 X-radiograph of, 67, *67;* fig. 50
 Bouquet with Yellow Dahlia (1873?), **50–51**, *51,* 119–20, 159, 202; cat. no. 5
 copy after, 50, *50,* 148; cat. no. 5a
 copies after, 243–47
 Crossroad of Rue Rémy, Auvers (1872), **46–47**, *47;* cat. no. 3
 Dahlias (1873), 50, **58–60**, *59,* 163, 166, 173 n. 10, 174 n. 25, 175 n. 36, 203, 260; cat. no. 9
 copy after, *58,* 60, 148; cat. no. 9a
 Dr. Gachet and Cézanne Making an Etching (ca. 1872–73), 28, *29,* 210; fig. 24

exhibition in honor of, 1954–1955, Paris, Orangerie, 16, 91, 159

and the Gachet collection, 14–15, 17

cataloguing of, 185–87

by scholars, 160–61

dispersal of, 163–72

donations, lending, and sales, choices and decisions regarding, 159, 170, 173–74 nn. 21, 22

consequences of, 174 n. 23

imperfect knowledge of, 174–75 n. 35, 187

protectiveness toward, 160–62

hand-printed opening pages of an album of Japanese prints once owned by Vincent van Gogh, **102–3**, *102;* cat. no. 24a

integrity of, conflicting views on, 173 n. 16

membership in Legion of Honor, 15

photographs of, *5, 15, 17;* figs. 4, 15, 17, 18

portraits of, *6,* 28, *32, 33;* figs. 6, 31, 33, 34

presence at Vincent van Gogh's death, 11

pseudonym of, 14

recollection of, by Michael Pakenham, 270–72

reconstitution by, of a still life by Paul Cézanne, 164, *164;* fig. 80

reputation of, attacks on, 15–17, 162

Souvenirs of Cézanne (n.d.), 56, **64**, *64;* cat. no. 11

Souvenirs of Van Gogh (n.d.), **102–3**, *103;* cat. no. 24

as subject, 28

as suspected forger, 162, 167

writings of, 7, 14–15

Le docteur Gachet et Murer: Deux amis des impressionistes (book), 18 n. 1, 153, 177–78

on his father, difficulties with, 3

Paul van Ryssel, le docteur Gachet Graveur (booklet), 144

Souvenirs de Cézanne et de Van Gogh à Auvers, 64

unpublished catalogue of Gachet collection, 162, 185–88

Gachet collection

checklist of works in, 179–84

copying of works in, made under the direction of Dr. Gachet, 243–55

described and characterized by Paul Gachet *fils,* 177–78

donations to the French state and museums, 3, 159–75

first emergence of, 159

lending of artworks from, 168

provenance of works in, 170–72

sale of artworks from

documentation of, 163ff.

Paul and Marguerite's income from, 161–62

size of, 160

uneven quality and intimate nature of, 159–60, 172

Gachet family

inventory of household goods, 289–91

rumors and slander about, 15–18, 162

Gachet house in Auvers, opened to the public, 17. *See also* Gachet, Dr. Paul, house of

Galletti (caricaturist), 30 n. 1. *See also* Index of Owners

Gandoin (Paris art dealer), 138

Gauguin, Paul (1848–1903), 9, 10, 69, 107, 112, 180, 264

Gauthier, Charles, 31 n. 11

Gautier, Amand (1825–1894), 4, 8, 18 n. 4, 19 n. 24, 20 n. 48, 24 n. 100, 27, 33, 48, 160, 180, 273, 275, 276, 277, 278, 279, 282, 283, 284, 285, 287, 288 n. 20

Asiatic Cholera in the Jura (1859), 27, *28,* 282; fig. 23

Dr. Paul Gachet (1859–61), 4, 13, *26,* 27, 74, 284; fig. 19

detail of, fig. 1

P. F. Gachet (1854), 27, *27;* fig. 21

P. F. Gachet (1856), 27, *28;* fig. 22

works in Gachet collection, 18 n. 6

Gautier, Théophile (1811–1872), 27

Geffroy, Gustave (1855–1926), 12

Gevaert, François-Auguste (1828–1908), 9, 279

Ginoux, M and Mme Joseph-Michel, 263

Godfrin, Paul, 286

Godmer, Émile-Jean-Baptiste (1839–1892), 28, 33, 281

Goeneutte, Norbert (1854–1894), 12, 13, 24 n. 100, 28, 33, 144, 272, 283, 285, 287

copies after, 252

Dr. Paul Gachet (1891), 12–13, 28, *30,* 74, 283; fig. 28

Dr. Paul Gachet (1892), 28, *31;* fig. 29

Paul Gachet fils (1893), 28, *32;* fig. 31

visiting card of, *12;* fig. 11

Woman with a Lantern (Marguerite Gachet) (1893), 28, *32;* fig. 32

Gogh, Johanna van, née Bonger (Mme Theodore van Gogh, later Mme Cohen-Gosschalk) (1862–1925), 10, 11, 13, 22 n. 77, 23 n. 90, 71, 141, 167, 243, 284. *See also* Index of Owners

Gogh, Theodore van (1857–1891), 9–10, 11, 19 n. 22, 23 n. 90, 24 n. 97, 71, 283. *See also* Index of Owners

correspondence, 259–69

relations with Dr. Gachet after his brother's death, 11

Gogh, Vincent van (1853–1890), 10, 23 n. 90, 28, 159, 160, 172, 283, 284, 285, 287

admirerer of works in Gachet collection, 170

by Cézanne, 56, 58, 199–200, 203–4

by Guillaumin, 114, 120

by Pissarro, 131

album of Japanese prints once owned by, *102,* **102–3**; cat. no. 24a

L'Arlésienne, 69, 76, 261, 262, 263, 264

arrangement of objects associated with, **102–3**, *103;* cat. no. 24

Auvers period, unsolved dating issues of, 171–72, 174 n. 25, 175 n. 37

Blossoming Chestnut Branches (1890), 166, *166,* 167, 174 n. 24; fig. 83

Branches of an Almond Tree, 174 n. 24

Branches of Flowering Acacia, 167

Café Scene, also called *Counter at Ravoux's Inn* (1890), **94–97**, *96,* 228; cat. no. 22e recto

canvases used by, types of, 68–70

Chrysanthemums (1886), 167, *168;* fig. 85

The Church at Auvers (1890), *14, 15,* 68, 69, 76, **84–86**, *85,* 90, 104, 108, 159, 163, 221, 262; cat. no. 17; fig. 13

copy after, *84,* 86, 106, 154, 221; cat. no. 17a

detail of, 104, *105;* fig. 61

paint sample from, 106, *107;* fig. 65

X-radiograph of, *68,* 69; fig. 53

copies after, 247–52

copies by Blanche Derousse, 243, 247–51

showing original colors, 105–6

Cornflowers and Poppies, 166

Cottages at Jorgus, 167

Cows (after Van Ryssel and Jordaens) (1890), 24 n. 99, **90–92**, *91,* 167, 170, 219; cat. no. 20

copy after, *92,* 154; cat. no. 20b

Daubigny's Garden, 174 n. 31

Dr. Gachet's Garden (1890), 11, **78–80**, *79, 80,* 82, 84, 104, 159, 217, 261, 262; cat. no. 14

copy after, *78,* 105–6, 154, 217; cat. no. 14a

detail of, 104, *105;* fig. 62

paint sample from, 106, *107,* 108; fig. 64

drawings by, in Gachet collection, 207–11

brought to Auvers by artist, 175 n. 38

decisions by Gachet *fils* regarding fate of, 173 n. 21, 174 n. 27

exhibition of in 1905, 174–75 n. 35

subsequent provenance of, 173 n. 21

fading and discoloration of pinks and purples in paintings from Auvers, 104–13

The Farm of Père Eloi (1890), **92–93**, *93*, 225; cat. no. 21

Flowering Peach Trees, 107, 111, 113

Fritillaries in a Copper Vase, 153, 174 n. 25

and Gachet, first meeting with, 10–11

The Garden of the Asylum in Saint-Rémy (1889), 16, 170, *171*; fig. 89

detail of, *158;* fig. 76

grave of, 31 n. 9

growing fame of, 15–16

Head of a Young Man with a Hat (1890), **94–97**, *95*, 227; cat. no. 22d verso

Hind Legs of a Horse (1890), **94–97**, *95*, 227; cat. no. 22d recto

Huts in the Sunshine: Reminiscence of the North, 172

In the Orchard (1883), **98–101**, *100*, 101, 229; cat. no. 23c

Irises, 107

Japanese prints owned by, 24 n. 100

letters of, 162, 259–69

to and from Theo, 15, 74, 77, *77*, 154, 218, *258;* cat. no. 13a; fig. 90

The Little Stream (1889–90), 22 n. 77, 167, *167*, 174 n. 22; fig. 84

Mademoiselle Gachet at the Piano (1890), 11, 28, 80, 102, 108, 166–67, 168, *169*, 264; fig. 87

Mademoiselle Gachet in the Garden (1890), 11, 78, **80–81**, *81*, 82, 84, 106, 108, 111, 159, 218, 261, 262; cat. no. 15

copy after, 154, 218; cat. no. 15a

detail of, 108; fig. 67

The Man Is at Sea (after Demont-Breton) (1889), 167, 168, 170, 175 n. 35; fig. 88

paint tube of, 110, *111;* fig. 74

palette of, 108, *108;* fig. 66

pigments used, and fading, 104–13

The Pink Orchard, 107, 113

Pink Roses, 111, 166

Portrait of Doctor Paul Gachet (1890), 11, 22 n. 68, 24 n. 99, 69, **74–78**, *75*, 82, 88, 106, 110, 111, 114, 159, 218, 283; cat. no. 13; fig. 13

copy after, 106; cat. no. 13b

detail of, 106, 110; fig. 73

paint sample from, 106, 110; fig. 72

photograph of, 74; fig. 55

Portrait of Doctor Paul Gachet "with books" (1890), 74, *76*, 261, 263, 283; fig. 56

photograph of, fig. 57

Portrait of Dr. Gachet (The Man with a Pipe) (1890; copper plate for an etching), **98–101**, *98*, 100; cat. no. 23a

Portrait of Dr. Gachet (The Man with a Pipe) (1890; four states of the etching), 11, 16, 22 n. 76, 22 n. 77, 91, **98–101**, *99*, 100, 229, 264, 283; cat. no. 23b

Portrait of Eugène Boch, 68

portraits of, **148**, *148*, 150; cat. no. 47

on his deathbed, 11, 140, **140–41**, *140*, 141, *141*, 266, 283; cat. nos. 41, 41a, 41b, 41c

posthumous exhibitions, 11

1905, Amsterdam, 159, 173 n. 2

1905, Paris, 71, 74, 86, 88, 93, 100, 159, 174–75 n. 35

1937, Paris, 15, 93

1947, Paris, Orangerie, 15

The Potato Eaters (1885), 22 n. 76, **98–101**, *100*, 101, 229; cat. no. 23d

reproductions of his work, Gachet *fils* unwilling to allow, 71

Roses, 174 n. 25

Roses and Anemones (1890), 69, **82–83**, *83*, 84, 103, 106, 108–9, 111, 167, 219; cat. no. 16

detail of, 109, *109;* figs. 68, 69

paint sample from, 109, *109;* figs. 70, 71

X-radiograph of, *68*, 69; fig. 52

Saint Paul's Hospital in Saint-Rémy, 69

Seated Woman with Child (1890), **94–97**, *94*, 228; cat. no. 22a

Self-Portrait (1889), *14*, 69, 71, **71–73**, *73*, 76, 114, 159, 168, 214, 261, 263; cat. no. 12; fig. 14

copy after, 71, *72*, 154, 214; cat. no. 12a

sketchbook of, pages owned by Dr. Paul Gachet, 172; cat. no. 22

souvenirs of (arrangement by Paul Gachet *fils* of objects associated with), cat. no. 24

Starry Night, 68

suicide of, 11

technical studies of works of, 68–70, 104–13

Thatched Huts at Cordeville, Auvers, formerly known as *Thatched Huts in Montcel* (1890), 11, 22 n. 68, **88–89**, *89*, 159, 221–22; cat. no. 19

Two Chickens (1890), **94–97**, *96*, 228; cat. no. 22e verso

Two Children (June 1890), *14*, 22 n. 75, 69, 71, **86–88**, *87*, 104, 107–8, 159; cat. no. 18; fig. 14

copies after, *86*, 87, 105, 154, 221; cat. no. 18a, 18b

detail of, 104, *104*, 105, 106; figs. 60, 63

X-radiograph of, 69, *69;* fig. 54

Two Children (June–July 1890), 87, *88;* fig. 58

The White Orchard, 107, 113

Wildflowers and Thistles (1890), 166, 167, *168;* fig. 86

Woman, Man, and Child Walking (1890), **94–97**, *94*, 228; cat. no. 22b

Woman in Checked Dress and Hat (1890), **94–97**, *95*, 227; cat. no. 22c verso

Woman with Striped Skirt (1890), **94–97**, *95*, 227; cat. no. 22c recto

Workers in the Fields, 171

works by, in Gachet collection, 212–30

sold, 163–64, 166–70

Gogh, Vincent van, Foundation (Amsterdam), 16, 161, 167. *See also* Index of Owners

Gogh, Vincent Willem van (nephew of Vincent van Gogh), 10, 11, 15, 16, 23 n. 90, 168, 261

Gogh, Willemina van ("Wil," sister of Vincent van Gogh) (1862–1941), 84

Gogh brothers, tombs of, at Auvers, 24 n. 100

Goncourt, Edmond and Jules de, *La fille Élisa*, 102

Gonzalès, Éva (1849–1883), 7

works by in Gachet collection, 196

Gray, Christopher, 122

catalogue raisonné of Guillaumin, 161

Grisi, Mlle Carlotta, 278

Gru, Eug., 282

Guardia, J. M., 277

Guérard, Henri (1846–1897), 7, 20 n. 30, 144

Guérard, Jean, 20 n. 41

Guigou, Paul (1834–1871), 160, 181, 276

Guillaumin, Armand (1841–1927), 6–7, 8, 13, 48, 61, 63, 142, 144, 159, 160, 161, 163, 164, 172, 280, 281

Bridge over the Marne at Joinville (1871), *161*, 162; fig. 77

copies after, 253–54

The Man Is at Sea (after Demont-Breton), 174 n. 35

Reclining Nude (ca. 1872–77), **120–21**, *121*, 159, 231, 262; cat. no. 29

Sailboats on the Seine at Bercy (1871), **118**, *118*, 233; cat. no. 27

Self-Portrait (ca. 1870–75), **114–15**, *115*, 120, 159, 230, 262; cat. no. 25

Still Life with Flowers, Faience, and Books (1872), **119–20**, *119*, 236; cat. no. 28

copy after, 119, *119*, 148, 236; cat. no. 28a

The Sunken Road, Snow Effect (1869), **116–17**, *117*, 124, 232; cat. no. 26

copy after, 116, *116*, 148; cat. no. 26a

Photograph Credits

The Art Institute of Chicago, © 1998, all rights reserved: fig. 82; P.G. II-4

Photograph ©, reproduced with the permission of The Barnes Foundation (tm), all rights reserved: P.G. III-8

Courtesy of Christie's Images: fig. 56; P.G. III-32, recto and verso

© La Grande Photothèque de Provence, Christian Loury: fig. 79; P.G. II-16

© Matsukata Collection, The National Museum of Western Art, Tokyo: P.G. III-3

The Metropolitan Museum of Art, New York, the Photograph Studio: cat. no. 10c; D13, p. 193

© Photothèque des Musées de la Ville de Paris / cliché Toumazet: P.G. IV-6

Copyright © Museo Thyssen-Bornemisza, Madrid: P.G. III-22

Courtesy, Museum of Fine Arts, Boston: cat. no. 38a; D2, p. 192

Nationalmuseum, SKM, Stockholm: P.G. III-21

Oeffentliche Kunstsammlung Basel, Martin Bühler: fig. 87; P.G. III-20

Ohara Museum of Art, Kurashiki, Japan: P.G. III-34

Copyright © The Pierpont Morgan Library: P.G. III-30

Research Laboratory of the Musées de France, Odile Guillon: figs. 60–63, 66–69, 73, 74; Jean-Paul Rioux: figs. 64, 65, 70–72

© 1998, Sotheby's, Inc.: fig. 88; P.G. III-6